Eyes on Labor

Eyes on Labor

NEWS PHOTOGRAPHY AND AMERICA'S WORKING CLASS

Carol Quirke

OXFORD
UNIVERSITY PRESS

OXFORD
UNIVERSITY PRESS

Oxford University Press is a department of the University of Oxford.
It furthers the University's objective of excellence in research,
scholarship, and education by publishing worldwide.

Oxford New York
Auckland Cape Town Dar es Salaam Hong Kong Karachi
Kuala Lumpur Madrid Melbourne Mexico City Nairobi
New Delhi Shanghai Taipei Toronto

With offices in
Argentina Austria Brazil Chile Czech Republic France Greece
Guatemala Hungary Italy Japan Poland Portugal Singapore
South Korea Switzerland Thailand Turkey Ukraine Vietnam

Published in the United States of America by
Oxford University Press
198 Madison Avenue, New York, NY 10016

www.oup.com

Library of Congress Cataloging-in-Publication Data
Quirke, Carol.
Eyes on labor : news photography and America's working class / Carol Quirke.
p. cm.
Includes bibliographical references and index.
ISBN 978-0-19-976822-6 (hardcover : alk. paper) — ISBN 978-0-19-976823-3 (pbk. : alk. paper)
1. Labor unions—United States—History—20th century. 2. Labor unions—United States—Pictorial
works. 3. Labor movement—United States—History—20th century. 4. Labor movement—United
States—Pictorial works. 5. Photography—United States—History—20th century.
6. Documentary photography—United States—History—20th century.
I. Title.
HD6508.Q57 2012
331.880973—dc23 2011047913

For my Donnas

niece, Donna Lubell Quirke Hornik

and mother, Donna (Radja) Quirke

and for my father, John Quirke

{CONTENTS}

{ ACKNOWLEDGMENTS }

Photographer Lewis Hine said, "If I could tell the story in words I wouldn't need to lug around a camera." If a photo had told this story, I wouldn't have lugged around this project for so long. A historical book is a solitary labor and yet the finished result requires the active help of many.

This work is stronger for the insights of those scholars who have commented on it at conferences, as reviewers, or as friends. Thank you Ann Fabian, Jack Metzgar, Alan Trachtenberg, Laura Katzman, Kate Sampsell, Peter Bacon Hales, Linda Gordon, Janet Zandy, Eileen Boris, Dan Leab, Helen Langa, Tom Doherty, Donald Solfchalk, Carol Giardina, Hilary Anne Hallett, Chris Brown, Jacob Kramer, and Curtis Marez. This book began at the City University of New York's Graduate Center. There, scholars whose passion for the past did not preclude a commitment to creating a more just future enriched my life and thinking. Kathleen McCarthy, Thomas Kessner, David Nasaw, Carol Berkin, and Barbara Winslow's support mattered much. Without the CUNY Writing Fellows program, there would be little to read here now.

Archivists and librarians whose support was crucial to the book's completion include Erika Gottfried at the Robert Wagner Labor Archives at New York University's Tamiment Library, Pamela Whitenack at the Hershey Community Archives, James Quigel and Barry Kernfeld at the Historical Collections and Labor Archives at Penn State University, Carol Lockman and Marjorie McNinch of the Hagley Museum and Library, Rodney Ross of the National Archives, Denise Gose of the Center for Creative Photography, Mark Pascale of the Art Institute of Chicago, Rosemary Haines of the Library of Congress, Karen Gelles of the Greeley Library at SUNY Farmingdale, and Laurie Wermter of University of Wisconsin's Memorial Library. Joseph Turrini, formerly of the Catholic University's Archives, was incredibly helpful with the Philip Murray papers. At the Chicago History Museum, Russell Lewis offered a wonderful welcome and Lesley Martin helped obtain crucial imagery in an awful pinch. William Brewington of Grinberg Assets helped with images of the Memorial Day Massacre. Rosemary Hanes of the Library of Congress helped sort through the Massacre footage. Much appreciation to Laurie Fink-Green, whose expertise got me through the process of securing photo rights, and Diane Aronson who offered editorial insights on some sticky sections.

The small public college where I teach, SUNY Old Westbury, has a historic focus of educating nontraditional students. I honor their wisdom, a wisdom often bought at great cost. I am lucky to work with wonderful colleagues: Liz Ewen and Ros Baxandall, who left a big imprint at the college, and Laura

Anker, Jermaine Archer, Sherry Baker, Aubrey Bonnet, John Friedman, Mandy Frisken, Karl Grossman, Joe Manfredi, Andrew Mattson, Samara Smith, Lois Stergiopoulos, and Denton Watson. Your commitment to our students inspires. Steven Serr aided greatly with photo reproduction. Old Westbury's financial support made this book possible. Special thanks to the provost, Patrick O'Sullivan, to Tom Murphy, director of sponsored programs, to the dean of arts and sciences, Barbara Hillery, for her warm humor and support, and to my union brothers and sisters in the United University Professions.

I am indebted to those who lived through this turbulent time and shared their stories. Mollie West, Yolanda "Bobby" Hall, and Les Orear, all associated with the Illinois Labor Historical Society, generously shared their insights on the Memorial Day Massacre and CIO-era labor journalism. Seventy years after the labor movement revolutionized our lives, nothing has blunted their political engagements. Similarly, former *PM* and Photo League photographer Arthur Leipzig and Mimi Leipzig recollected Arthur's profession as it was being defined in the mid-century. A special thanks to Julian and Sylvia Wolff, who've shared their passion for the world of photography.

To the reviewers of this manuscript, whose close reading and knowledge of the field have pushed me to write a stronger book, thank you. Humanities editor Shannon McLachlan and assistant editor Brendan O'Neill from Oxford University Press have been incredibly supportive, and I am grateful.

"It's all right to have a soft heart as long as you have a hard eye," stated leftist photographer and painter Ben Shahn. These scholars and mentors blessed me with both. Gerald Markowitz's generous spirit and open encouragement taught me the academy could be a friendlier place. He helped me articulate my arguments more boldly. Stuart Ewen opened up his home, his teaching, and his thinking to me. I've learned much from his skillful synthesis of complicated thinkers; his scholarship informs this project. Joshua Freeman always pushed for more and helped figure out how to get there. He is a true advocate for students; his sage advice has been crucial throughout. Lou Masur, now at Trinity College, opened a door for me when I first took his Nineteenth-Century U.S. Historiography course, and he's been opening them ever since. He modeled cultural history at its finest, and he was a nimble advisor, poking me when necessary but otherwise letting me play. Every adverb is here without his consent.

This is a better work for the close, caring readings by friends and colleagues. Nancy Berke, Linda Grasso, Phyllis van Slyck, Linda Camarasana, and Lara Vapnek offered crisp commentary on my work—and a lot of good food, wine, and talk. Marcella Bencivenni, Evelyn Burg, and Dan Wishnoff, fellow Graduate Center students, read and reread portions of this manuscript over many years. You've pushed my work in a stronger direction and always renewed my spirits. Your engagement as scholars, as professors, and as friends nurtures my own.

Thanks to family members Dolores and David Frost, and Caroline and James Radja for their insights on 1930s Chicago. Friends and family kept me going all this time: Jean Halley and Jacob Segal, Janet LeMoal, Carole Cushing, Diane Frey, Pat Ambrose, Sr. Kieran Therese Quirke, Sr. Mary Cecile Quirke, Eileen Linden, Tom and Jeanne Radja, James and Melissa Barnett, Paul and Marcia Radja, Nicole Radja and Calbee Mundy, Sharon Quirke and Phil Reece, Michael Quirke, and Sheila Quirke and Jeremy Hornik. To all the little stinkers who make me laugh: Milo, Cy, Penelope, and Thomas—and our little man Jay. Those more grown, Alex, Carolyn, and Jakob Reece, provoke loving smiles. Donna Quirke Hornik, your grit and intellectual dexterity and sweet, sweet smile are always with me, even though you are not. I'm saying "yes" with you, somewhere. My mom and dad, Donna (Radja) Quirke and John Quirke, taught me that the road is long and sometimes twisted, but hewing to it, no matter the obstacle, takes you somewhere unexpected. Their paths, and those of my grandparents Celia (Morley) Quirke, Jakov Radja, and Draga (Marasović) Radja, so touched and trammeled by a century of history, have made me sensitive to its design.

Quinn—my companion—you console and compass; I ride the roller coaster with you. Vives en la casa de mi corazón.

Eyes on Labor

{ Introduction }

"The Central Instrument of Our Time"

This project began serendipitously. Before graduate school I was a community organizer with welfare recipients and public housing residents during the presidencies of Ronald Reagan and George H. W. Bush. Their neoconservatism blamed the poor for their circumstances, vilified "welfare queens," and promised that a voluntary "thousand points of light" should address social ills. I wondered about popular visualizations of the poor and working poor during the Great Depression, when Franklin Delano Roosevelt's New Deal expressed responsibility for the nation's most vulnerable citizens. I looked at the popular picture magazine *LIFE*, associated with documentary photos of Depression-era victims. *LIFE* lay at the crux of the new, national "culture of sight and sound," an expanding mass culture that coalesced in the 1930s.[1] Contrary to expectations, *LIFE*'s pages showed few Americans on relief or welfare. Only a few stories, largely critical, discussed New Deal public works projects. *LIFE* documented the nation in black and white, but its America seemed closer to the Technicolor Land of Oz than dowdy, dust bowl Kansas.

LIFE's portrait of America had something unexpected, however: hundreds of photos of workers fighting to establish unions. *LIFE*'s portrayal was contradictory. Workers appeared heroic, but also menacing and sometimes passive. *LIFE* lampooned labor leaders, but also addressed them with the respect due to America's corporate heads. Workers' demands were accepted as a right in a bounteous America, while at other times they were treated with a disdain meted to the overreaching. White workingwomen appeared as sexy starlets, though black, brown, and immigrant women were hardly noticed. African-American and immigrant men were largely ignored as well. *LIFE*'s pages hinted at clashes over American workers' status at the heart of mass culture. Millions of readers watched as one of the century's great dramas—the unionization of industrial workers—was waged in *LIFE*. In 1941 critic and author James Agee called the camera "the central instrument of our time," and unions and businesses, like *LIFE*, used the camera eye to represent workers and their unions.[2] *Eyes on Labor* identifies and maps this emerging mid-century portrayal of labor, and asks what effect news photography had upon organized labor as it renegotiated its place in U.S. society.

"It Isn't Only What You Do That Counts, But What People *Think* You're Doing"

When sociologists Robert Lynd and Helen Merell Lynd returned to their fabled "Middletown" in the mid-1930s, they observed that whenever labor demanded collective bargaining rights from employers, local papers featured front-page photos of strikers being dragged off to jail. Such coverage could be purposeful. Business associations such as the National Association of Manufacturers (NAM) relied on news photos' seeming veracity to stem public support for organized labor. In 1937, when questioned by the newly established National Labor Relations Board (NLRB), the "King of Strikebreakers" Pearl Bergoff related how one corporate head "staged" violence to discredit labor. News photos in the mainstream press made unionists seem responsible for violence, while identifying corporations and "peaceful [back-to-work] pickets" with "America, free land and all that stuff." Scholars have noted that NAM appropriated the "forgotten man" for its free enterprise campaigns, and also the significance of corporate right-to-manage campaigns in the 1940s. Little appreciated, however, was how public relations strategies capitalized on news photography's seeming objectivity to malign labor. These campaigns succeeded in the 1930s, at the height of the New Deal and labor's uprising.[3]

J. B. S. Hardman, labor educator and editor, wrote, "It isn't only what you do that counts, but what people think you're doing," and unions noted the growing influence of the news and photography to shape public understanding of their movement. Unions strategized with government officials, news reporters, church leaders, and other allies to ensure that the public interpreted news photographs to labor's benefit. And unions professionalized their newspapers, increasing their use of photos to attract membership and inform the public. Hardman, who edited the Amalgamated Clothing Worker Union's *Advance* from the early 1920s, surveyed the labor press in 1928 and found it thrown together with the "proverbial paste jar and scissors." Two decades later, he and his fellow labor editors considered the labor press a "hardy institution" at its "apex of effectiveness and influence." Trained journalists now edited labor's papers, and news photos bolstered the union message.[4]

This transformation in union communications coincided with the explosive growth of the Committee of Industrial Organizations (CIO), later renamed the Congress of Industrial Organizations, and the American Federation of Labor (AFL). Working men and women sparked one of the century's biggest news stories as they recast America's social and political relations. Throughout the 1930s, workers in hamlets and cities—from factories, coal mines, packing houses, beauty shops, elevators, and even movie projectionist booths—demanded unions. Workers wanted higher wages, greater job security and safety, and better lives for themselves and their families. By the decade's end, nine and a half million workers were unionized.[5]

Historians first touted labor's new economic and political muscle as a "new phase of national history," a "Third American Revolution," or a "revolutionary response to a revolutionary situation." Laborers—especially white, male laborers and their families—joined in the mass consumer economy in ways unimaginable a few decades earlier. Union contracts won workers more leisure and vacation time, facilitating this participation. While unions never achieved their ambitiously envisioned welfare state, evolving forms of public and private social security shielded workers and their families from economic catastrophe due to disability, illness, unemployment, and old age. Over time scholars became more circumspect about labor's gains, but few contest that American workers commanded greater political, social, and economic authority in 1950 than in 1900 or 1930.[6]

Corresponding with labor's newfound strength was a populist aesthetic that suffused America's visual culture. Hollywood's *Meet John Doe*, the "forgotten man" of *The Gold Diggers of 1933*, and the sassy working girls of *Kitty Foyle* and *Baby Face* entertained movie audiences coast to coast with the exploits of beleaguered but scrappy workers. And images of the strapping male worker embodied the symbolic importance of productive labor to the nation-state. Showcased in *LIFE* photographs, this icon was also celebrated in post office murals and federal office statuary, in advertisements, and even in the architectural bas-reliefs and decorative motifs of capitalism's cathedrals such as Rockefeller Center. Documentary photography also enshrined this era's common man and woman. The Farm Security Administration's (FSA) encyclopedic photographic catalog of American life valorized agricultural laborers, and many other New Deal agencies documented average citizens' lives.[7] As the nation moved to war, the manly worker and then Rosie the Riveter emphasized workingmen's and workingwomen's contributions to the nation's defense.

Such imagery was long taken at face value, but recently scholars have come to see contradictory impulses and consequences in this obsession with American workingmen and -women. Hollywood's movies put the little guy on the screen, but the dream factories' homespun narratives "dictated the conversion of all political, sociological and economic dilemmas into personal melodramas." One film historian maintains that such films undermined the possibilities for any public, collective response.[8] And the "heroic laborer" found in sculpture or in the pages of a union newspaper was never simply democratic. Gendering work in the overblown body of the manly worker redressed the failure all classes of men felt, but this gendering of labor coincided with social and economic strictures for American women.[9] Where scholars once unabashedly celebrated the FSA Photography Section's documentation of the common man, they now allege it produced a nostalgia for the "agrarian, small-town way of life" torn asunder by New Deal technocrats.[10] And scholars of wartime imagery argue that patriotic images of workers had a conservative influence. If feminist historians and filmmakers who first excavated Rosie the Riveter believed that she illuminated women's contribution to the nation's

economic health and war-preparedness, they now assert that Rosie's image offered middle-class women "self-actualization" while demanding "duty" and "sacrifice" from working women. Others argue that motivational posters of workmen "transform[ed] employees into factory combatants," meeting company needs to "instill factory discipline." Idealizing efficient, stable producers, elided labor's collective contribution to productivity and its sacrifices for the war effort.[11]

This revisionism among visual culture scholars opened up new ways to think of mid-century imagery, but it did not explain the organized laborer who appeared in *LIFE*—or in labor's papers. Many of these studies retain the narrow focus on the same radical or populist imagery: images of the "down and out," farm workers, or Rosie. And many analyses, on specific photographers or institutions like the FSA, do not examine how such populist imagery entered a larger dialogue about working men and women. Historical investigations produced from the standpoint of cultural producers—admen, public relations specialists, or Hollywood filmmakers—often treat class as an abstract relation, ignoring concrete battles between labor and capital.[12]

Neither do labor historians explain workers' representation in *LIFE*, or even in union papers for that matter. Those working in the tradition of E. P. Thompson and Herbert Gutman have been less concerned with how labor is represented. They remain focused on working-class or union culture and seem more interested in what workers *do* than in symbolic struggles over labor. Exceptions do suggest the promise of exploring visual representation: Steve Ross's study of workers and early film, Nan Enstad's examination of news photographs of early twentieth-century garment workers, and Gary Gerstle and Elizabeth Faue's research into labor press iconography.[13] Scholars have also identified how mass cultural tools like union media strengthened the movement. Lizabeth Cohen's lively chronicle of Depression-era workers, *Making a New Deal*, upended the conception of mass culture as politically anaesthetizing. Cohen argues that mass culture conquered earlier ethnic divisions, and that unionists' use of mass communications, especially radio and labor papers, built their unions and the New Deal welfare state. Similarly, Michael Denning premised a mid-century "laboring of American culture," sharing Cohen's optimistic view that union culture, and unionists' participation in a national mass culture, strengthened unionism through a "cultural front." Neither scholar, however, explores visual imagery to any great degree.[14]

News photos of workers deserve attention because of their increasing prominence in the machinery of national public opinion making and their influence on labor relations. By the late 1930s changes in technology permitted images of striking Kentucky miners to make their way into magazines lying in Park Avenue apartments. Just as quickly, workers streaming out of Henry Ford's industrial mecca traveled, in pictures, to rural outposts in Alabama or Arizona. With the more rapid transmission of photographs, U.S. media corporations borrowed the photo journal format pioneered in Europe in the 1920s. Americans

responded with delight. *LIFE* appeared in November of 1936; by 1939 it had built a circulation of over two million. Nearly ten times that many read it each week, making it the nation's most read—and looked at—magazine.[15]

Americans increasingly interpreted their world though pictures, and the news photographs they looked at had a particular authority as transcriptions of reality. Their apparent absence of style gave readers the illusion of objective truth. Roy Stryker, who headed the FSA, called news photos "noun and verb pictures"; they seemed straightforward descriptions of reality.[16] Arthur Rothstein, who worked under Stryker at the FSA and who became *LOOK* magazine's photo editor said, "A person viewing a good news photograph should have the feeling that he is seeing reality. He is never conscious of the photographer or of his camera." Even a publication like *LIFE*, known for its innovative use of the photograph, sought photographers who suppressed their personal style for the sake of "photo-truth."[17] As *LIFE* told readers in a 1940 advertisement that met readers' eyes with a blow-up photo featuring a piercing gaze, the publication's editorial viewpoint was based on the camera's neutrality; it was "an all-seeing eye with a brain" (Fig. I.1).[18] News photos' immediate legibility, explained the American Society of Magazine Photographers (ASMP), "embody an idea made clearly apparent." The distinctive "impartial" style of news photography is tied to its institutional context: the purveying of objective facts about "fast moving events."[19] Indeed, the photos under study here often appear banal. Their persuasiveness lies less in their expressiveness than in their commonsense truthfulness.

The photograph's increased prominence came at a time when the "news" was redefined as a product, leading many Americans to read the same news. Over the early twentieth century, chain news corporations developed—including Gannett and Hearst. Wire services and the national syndication of columnists such as Walter Winchell, Dorothy Thompson, and Heywood Broun, boosted standardization.[20] While local dailies remained a steady source of news, the modern, national newsmagazine also emerged in the twenties and thirties as publishers extended the mass markets built for women's and family magazines earlier in the century. Media entrepreneurs also enlarged news audiences by altering their rhetoric to appeal across class lines. *LIFE*'s parent, TIME Inc., exemplified such changes. Its founders' idea was that "news" was too cumbersome for busy readers. Americans would appreciate pithy recapitulations instead. The ironic but expressive "Timespeak" of these modern news gatherers mixed high and low cultures and increased the use of photographs to build readership.[21] As a result of such changes, labor's mobilization reached an expanded public in fundamentally new ways.

Current scholarship tells us much about the multiple and contradictory meanings of the common man, but little about visual images of actual workers at a moment of great collective transformation.[22] A generation of scholars has shown how visual imagery reconfigured ideology, culture, and politics, but they have shed little light on one very common way workers were depicted: the

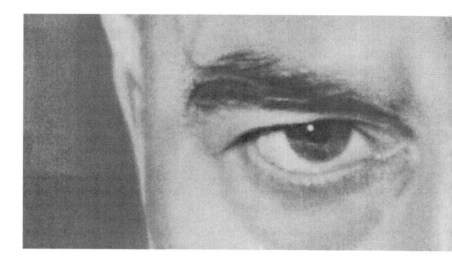

Neither Myopia, nor Hyperopia, nor Astigmatism !

THREE BASIC DEFECTS of editorial vision can easily afflict organs of public information . . .

MYOPIA — the shortsightedness that comprehends little beyond the domestic scene, naively envisioning our land as a self-sufficient, tight little isle.

HYPEROPIA—the farsightedness that is so preoccupied with what's happening over the horizon that it is scarcely aware of tremendous things astir at home.

ASTIGMATISM—the distorted perception that results from eyeing all subjects from too partisan, too sectional, too romantic a viewpoint.

LIFE, from its inception, has attempted to keep refreshingly free from any such faults of focus. It has, in fact, brought into being not only its own completely new picture-and-word editorial technique but also a completely new editorial viewpoint. And it is this unique viewpoint which has made of LIFE's news-camera a penetrating, all-seeing *eye with a brain!*

For instance, in covering the biggest news in the world—the War—LIFE foreswears both whole-hog sensationalism and superficial sugar-coating.

It reveals this great human tragedy with vividness, clarity, and objectivity. It illuminates and interprets history-in-the-making. And, even more

important, LIFE functions as an eye that looks *two ways at once*—it sees and reports the conflict as waged 3,000 miles away . . . and at the same time sees and interprets the inescapable impact of that conflict on present-and-future American living.

It would be, however, evidence of defective editorial vision to let the war *monopolize* LIFE's

attention. So, LIFE's new editorial technique continues to serve as the most lively, understandable means of helping Americans to comprehend and enjoy intelligently the land they live in.

For instance, in LIFE's absorbing pages, readers chug 1350 miles with a pretty yachtswoman down

FIGURE I.1 LIFE *touts its "penetrating, all-seeing eye with a brain," in this advertisement.* LIFE, *May 25, 1940. Copyright 1940 Life Inc. Reprinted with permission. All rights reserved.*

he exciting Inland Waterway . . . and later go
a Bingo Party in Lowell, Massachusetts, where
800 merchants, mothers, mill hands, reliefers,

ONE OF LIFE'S FULL-COLOR ART REPRODUCTIONS

very week play America's No. 1 indoor game.
hey see, as only LIFE can show, the screwball
ublicity gags of Venice, California, most eccen-

"LIFE GOES TO A PARTY"

ic community of an eccentric state . . . and wit-
ess the gloomy pall of a "blacked out" American
ity—St. Louis, the smoke-ridden.

It is an exciting and enriching experience to fol-

low in LIFE's color pages the contributions Amer-
ica's outstanding painters are making to a genuine
American Art. It is healthful culturally, too, to
be kept up-to-date, via LIFE's picture-and-word
reviews, on the latest movie or play.

And whether it is reporting a college houseparty,
a Revenue raid on Southern moonshiners, the ter-
rible trek from the Dustbowl, or presenting a pho-
tographic essay on the great Northwest, LIFE
provides an absorbing, continuous course in how
our fellow-citizens live. People are discovering
more and more that its advertising pages, too, are
an interesting, integral part of the entire informa-
tive, illuminating cross section of modern Ameri-
can living that is LIFE.

Come Mars or high water, LIFE is dedicated

to the proposition that its vigorous, new-age jour-
nalism entails a high obligation. It is the obliga-
tion to inform many millions of Americans*—in
LIFE's own unique and modern way—about *all*
things that color and shape modern American
living.

LIFE, as "America's Most Potent Editorial
Force," directs that force wholeheartedly toward
effecting a truly enlightened America.

*For an enlightened America is the world's
greatest hope!*

 ʹ ʹ ʹ

**Latest figure— 19,900,000 audience each week—
scientifically established and reported by LIFE's
Continuing Study of Magazine Audiences.*

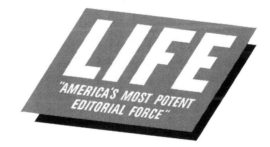

news photos of working people who struggled to unionize in the 1930s and 1940s. By the late 1930s, news photos shaped public opinion as never before, and photos of workers demonstrated news photography's central public role. Labor and business's growing aptitude for crafting visual messages meant that the new national media became an arena for competing messages about organized labor. And because mass media publishers flirted with including working Americans in their audience, they increased their coverage of labor. News photographs documented workers' revolution in the nation's economic, political, and cultural landscape. *Eyes on Labor* argues that news photos also made that revolution.

"The Viewfinder Is a Political Instrument"

Photographs have long been considered the acme of realist representation. As nineteenth-century essayist Oliver Wendell Holmes wrote, photographs were a "mirror with a memory"; they reflected what lay before the camera eye. Mimesis had defined Western artistic aims and styles for centuries, and photography's chemical and mechanical processes linked a belief in scientific progress with a belief in nature and God. English photographer William Henry Fox Talbot titled the first photo book, *Pencil of Nature*, divulging that century's view of photography as a scribe for God's handiwork. Writing about the stereoscope for *Atlantic Monthly* readers, Holmes expanded on this view: "It is no toy: it is a divine gift, placed in our hands nominally by science, really by that inspiration which is revealing the Almighty through the lips of the humble students of nature." Artisan-photographers fulfilled God's mission by reflecting their surrounding world in landscape, portrait, and urban scene. The ever astute Holmes also hinted at photography's ability to fabricate meaning: surfaces become solid, the medium could "cheat" the senses, and the proliferation of images would "skin" reality, leaving substance behind.[23] Like Holmes, Americans came to understand that photography could depart from truth, though most never relinquished a belief in the medium's hold on the real.[24]

Though photographs contain evidence of "the real," photographs are never, as Peter Bacon Hales notes, "a repository of facts, a raw slice of the past."[25] This analysis, like much scholarship today, assumes that photography not only reproduces the world, but constructs a way of seeing it as well. These ways of seeing are not neutral; they are political. In Alan Trachtenberg's formulation, "The viewfinder is a political instrument," something that business and labor understood.[26]

Multiple factors shape what can be seen and how it is seen. Formal elements such as focus, lighting, and angle contribute to a photo's "argument." Photographers make aesthetic and editorial decisions in the field and in the darkroom that determine how "reality" is read. What the photographer includes and excludes from the photo's frame shapes its meaning, as does the photographer's vantage. A photograph taken from behind a line of strikers is more likely to express their

point of view than one taken from behind the gates of a factory plant. A photo shot from below tends to magnify the subject, whether a corporate leader, a workman in uniform, or a mammoth factory. Available technology also shaped what viewers could see. In 1919 photographers documented the largest labor uprising ever, where one in five workers struck, by showing strikers and their opposition—whether Pennsylvania constabulary or Harvard students—in posed, static shots. They had to; the camera and film could not yet capture motion.

Words, in titles, captions, and photo stories, also "anchor" a photograph's meaning. Together, words and pictures had a lot of pull—*LOOK*'s Arthur Rothstein claimed that twice as many people looked at a photo and its caption than read a story. But the very same photograph could be attached to opposing arguments or story lines.[27] A union paper might publish a photo of a line of strikers with a dynamic composition stressing their numbers to emphasize activism's promise, and a mainstream news source might caption this photo to imply organized labor's threat to American values.[28] Hence, a photo's institutional context, who commissioned and who disseminated a photo, is crucial to understanding its ideological work.[29] A publisher's desire to capture a market, as well as a publisher and editorial staff's politics, shaped specific publications' editorial stance. And labor papers would rarely print stories or photos deemed contrary to union interests. Of course sometimes photographers and editors were constrained by technology, and by the events themselves—things happened so quickly that photos could not be composed as carefully as possible. Photographers' and publishers' intents are not definitive in explaining a picture's reception either—viewers could reinterpret its meaning.

While "noun and verb" pictures predominated in the news, distinct realist styles also circulated, implying different messages. "Evidence-style" realism erased the photographer's presence to an even greater degree than in news photography. The subject would be centered in the foreground, the camera's angle straight at the subject, the lighting and focus clear throughout to provide an optimal view of the subject. In this style the subject appeared so neutral that the photo seemed to make no argument whatsoever.[30] In contrast, documentary photos, Roy Stryker believed, were "adjective and adverb" pictures. Their realism had depth and tugged at the emotions. For documentary photographer Dorothea Lange, documentary images were "loaded with ammunition."[31] The news also featured images typically associated with corporate photography—promotional shots of workers on the job, company towns, and corporate headquarters. Such photography suggested an idealized order authored by the corporation. In these classic, timeless compositions, nothing intruded on the world that the corporation created. Unlike evidence-style photographs that demonstrate what was, these photographs suggest what could be; they were simultaneously didactic and inspirational.[32] Also found in the news were photographs that might be called "hyper-real," photographs that offered affirming visions of the United States and its citizens. Promotional photography idealized but seemed devoid of life. Hyper-real photographs were

vital, exuberant, and burnished, much like a Hollywood production. Unions also availed themselves of this buoyant realism to motivate their rank and file.[33] Whether in new dailies, national news magazines, or labor papers, editors' decisions to depart from the traditional news style and publish alternative forms of realism often signaled a desire to emphasize a specific message.

Teasing meaning from photographs is tricky. Photos appear unmediated, but, as photographer-critic Martha Rosler quips, "Photography is dumb."[34] Photographs record reality, but not slavishly: photographs construct how we see that reality. *Eyes on Labor* analyzes photographic technology, visual vocabulary, rhetoric and style, accompanying text, and the institutional context that sought to shape a photo's interpretation. Photos are a slippery evidentiary source for the historian, but as Lawrence Levine concluded in a discussion of 1930s documentary photography, their "contradictions and paradoxes" contain the same challenge of any rich historical source.[35]

Framing Organized Labor

Despite news photography's growing influence in the mid-century, an uneven archival record makes it difficult to plot a full historical narrative of photography's use by unions, corporations, and the mass media. Labor cared about public perception and employed photography to a greater degree than ever before, but unions left few records about their understanding of this medium. For example, Philip Murray's papers at the Catholic University of America, with records covering his presidencies at the Steel Workers Organizing Committee and the CIO, include very little about publicity or the use of the visual. Similarly, few records in the United Steel Workers of America's papers at Penn State's Historical Collection and Labor Archives are from the union's longtime news editor, Vincent Sweeney.

The same can be said for corporations. My research found that even industries most attuned to the visual neglected to articulate or save records about their visual strategies, as other historians have noted.[36] At the Hershey Chocolate Corporation, which used imagery to develop its brand from the early twentieth century, their publicist kept voluminous files of internal and external communications. His papers offer detailed evidence of corporate publicity and brand strategies, even as few records directly address imagery. Similarly, the National Association of Manufacturers initiated full-blown public relations campaigns against unions and these are well documented in their papers—but leaders' discussions only glancingly comment on news imagery.

A more daunting obstacle is some corporations' refusal to open their archives, or their licensing fees, for rights to reprint photos. The TIME-LIFE archive has a closed-door policy to most researchers, despite—or perhaps because of—a growing sense of Henry Luce empire's effect on American life. And ironically, some of the mid-century's most seen images are the ones that

companies charge prohibitive fees to reproduce, making scholarly investigation and dialogue more difficult.

Eyes on Labor compensates for these archival limits in two ways. First, I read the patterns of meaning from large bodies of photographs over time, within and across publications, to plot distinctive themes that emerge in mid-century news imagery about labor. Identifying and tracking such patterns demonstrates change over time and space, and confirms the decision making of editors, publishers, publicists, and union and corporate leaders, even when their decisions were not articulated or recorded.[37] Such patterns offer important clues about the symbolic battles over labor's status, though, as we'll see, the messages were neither unified nor stable.

Second, the book uses case studies guided by a historian's traditional sources: archival records of internal union and business dialogue, oral histories and memoirs, Congressional investigations, and newspaper accounts. While such records provide limited direct reference to photography, in combination, photos and archival records allow a greater reconstruction of the motives, goals, and reactions to photography produced in this era. *Eyes on Labor* embeds a formalist reading of representative photographs most directly in the histories of labor and of visual culture, but also in the histories of public relations, consumer culture, and the mass media. It identifies critical interactions between news photography and labor's advances and retreats from 1919 through 1950, showing how labor moved from the nation's margins to the mainstream.

The narrative case studies—located in small-town Pennsylvania; in Manhattan, the heart of the nation's publishing industry; in Washington, D.C., congressional hearings; and in Chicago union halls—illustrate the twentieth-century transformations in labor and in publishing, permitting an in-depth analysis of how news photography shaped conceptions of organized labor. Chapter 1 examines stereographs of the 1877 Railroad Strike, photogravure and tabloid coverage of the 1919 strike wave, and national news magazine representation of the CIO's founding in the mid-1930s. Photojournalism was in its infancy, and the chapter identifies the innovations in news photography that made labor's story so visually compelling during the second half of the 1930s.

Chapter 2 tracks *LIFE*'s coverage of labor, particularly the CIO, from the publication's inception in November of 1936 to WWII. While the AFL attracted more members in the 1930s and 1940s, it was the CIO's bold invitation to industrial workers that shook up America's economic equation.[38] This study identifies *LIFE*'s hearty embrace of the CIO and its activist strategies. The publication, an emblem of mid-century American culture, featured a complex portrayal of labor that tens of millions of Americans encountered by the time the country entered WWII. Even as *LIFE* accepted organized labor, tensions in its coverage of labor's growing stature suggest larger ambiguities over labor's political and social redefinition in American life.

Turmoil heightened the stakes of labor representation and mobilized unions and corporations to advance claims about organizing workers and their goals.

Chapter 3 elevates the significance of a 1937 sit-down strike at the Hershey Choc-
olate Company by illuminating news photography's unacknowledged role in
labor struggles. Corporate public relations experts used photography to tar a
union drive locally, but photos also discredited the CIO sit-down technique to
mass audiences created by *LIFE*, *Newsweek*, and other national magazines. Chap-
ter 4 investigates the opposite, highlighting labor's growing awareness and ability
to shape the meaning of contested images. This case study establishes how "con-
clusive" photographic evidence—news photos and a Paramount newsreel—at
first proved demonstrators' guilt for the Memorial Day Massacre. The massacre is
one of the most commonly represented labor events of the twentieth century, and
news photographs made the event infamous. By the late 1930s unions and their
allies employed public relations tools and the power of photographic imagery to
prove strikers' innocence and condemn conventional union-busting techniques.
Both conflicts transpired in 1937 at the height of CIO rank-and-file mobilization.
Once this mobilization faltered, union numbers increased modestly until World
War II, mostly among AFL affiliates, not the CIO. Moreover, labor relations were
increasingly routinized and less fought at the bar of public opinion.

By 1950 some thirty million Americans received a labor paper in their home.[39]
The book also offers case studies of two newspapers of the CIO, which used mass
culture to a far greater degree than the AFL. The *Nation* identified both papers in
1953 as among the labor movement's more sophisticated. Chapter 5 explores *Steel
Labor*, the newspaper of the United Steel Workers of America (USWA), from 1936
through 1950. This union was the largest in the CIO's first decade, one bankrolled
by United Mine Worker leaders for its critical importance to labor's organization.
Lizabeth Cohen identifies *Steel Labor* as crucial to broad rank-and-file support
for the CIO. *Steel Labor* communicated the importance of rank-and-file discipline
and adherence to rule of law with visual imagery. Over time *Steel Labor* radical-
ized its message to readers, even as it sketched the rewards of unionism in private
and personal terms, not as collective gains. This chapter examines photography in
tandem with illustration, as the newspaper deployed different types of imagery to
communicate distinct messages. Chapter 6 examines one of the CIO's radical
New York City unions, Local 65 Wholesale and Warehouse Employees Union,
and its newspaper, *New Voices*, also from 1936 through the early 1950s. This
union so embraced culture that its paper was entirely written and produced by
its members—including the paper's photos. Local 65 left some 30,000 images,
an unusual archival trove from which to explore mid-century labor's cultural
production. Rank-and-file photographers took images that did the work of a
union organizer, enticing workers into union struggle and educating them
about collective action. Photographers represented the union as a haven of
racial, ethnic, and gender diversity and advanced arguments about workers'
rights to live a full, expressive life. These case studies evidence CIO response to
the broader political and cultural environment, as well as the diversity and
complexity of the CIO's self-representation and representation to the general
public.

Eyes on Labor reveals attitudes about workers that divided and that joined Americans, sometimes across class lines. The heroic laborer, for example, is rightfully understood as a mid-century, populist icon. But media companies employed this icon to sound a threat about organized labor, and unions suppressed this icon when leaders felt an activist message was detrimental. And, as common as the heroic laborer was in this period, so were images of workers happily enjoying the consumer goods newly available to them.

Photographs characterized workers, their leaders, and their methods for achieving unionization. Were workers militant warriors establishing their unions, or were they quiescent—directed by bosses or labor leaders? Was rank-and-file activism a necessary, even entertaining jolt to American society, or was it a threat? Were organized labor's leaders a new managerial elite, or were they thugs and dictators? *LIFE*'s documentation of the nationwide wave of sit-down strikes in 1936 and 1937 was open and gleeful at first. Unexpectedly, some labor publications' imagery expressed unease about rank-and-file militancy. Even at the height of twentieth-century populism, imagery in mass publications and in labor papers alike ignored workers' collective power, insisting on the power of businessmen, corporate heads, or labors' leaders to forge the good life for workers.

As many chapters indicate, the news often focused on the violence endemic to labor mobilization. Photos and captions mostly implied that organized labor was responsible for civil chaos. Corporations even fomented violence, knowing that photographs would document it and labor would bear the blame. Unions responded in distinct ways; some depicted wounded members as exemplars of union might, but others ignored strike violence even when its own membership was victimized.

How were the rewards of unionism portrayed in news photos? Labor unions and corporations alike suggested a consumer "fable of abundance" as a prize for union membership. Whether it was the bounty of financial gains expressed in jumbo checks given to workers much as a lottery win in labor papers, or a brightly imagined consumer paradise sketched for workers as one might find in *LIFE*, workers' aspirations, their gains and security, were often spelled out in the concrete and material.[40] Images of solidarity, community, or collective, public security rarely appeared in photographic prints as something worth fighting for.

Unions, corporations, and media companies often divided workers by race and gender in the news photographs they published. Women workers rarely appeared as coparticipants in the quest for social and economic justice, but rather as objects for consumption. This gendering of labor had implications for how workers were perceived in the larger culture, and how workers perceived themselves. The needs of black workers or immigrant laborers rarely made the news—unless it was in the papers of more radical unions and political organizations. Photos in the labor press and the mass media presented workers as normatively white. Even in the more egalitarian labor press black workers were most often represented as tokens. This too ignored the reality of America's workforce, limiting workers' solidarity.

News photos often addressed proper relations between the classes. Are company heads friends or foes to the ordinary worker? How were workers' and managers' identities depicted? In the mainstream press, corporate leaders like Walter Chrysler or Henry Ford were humanized in folksy fables in which the camera eye perused their domestic lives and hobbies. Such tales made corporate heads "everyman," enhancing identification with corporations. Visual narratives of class harmony were also common in the national press. On the other hand, workers' home lives were often ignored. Workers existed in the vacuum of their institutional or work lives. Hence *Eyes on Labor* considers how these visual silences placed a damper on labor's political and economic demands.

The elisions, ambiguities, and contradictory messages about labor offer historians clues about labor's status in the mid-century. Negotiations over labor's place occurred in front of factory gates in Akron and Detroit, as well as in political centers, state capitols, and Washington, D.C., but they also unfolded in the pages of an ever more national, standard, and photographic news.

Union leaders believed, notwithstanding the populist aesthetic of the New Deal era, that the mainstream media often treated struggles for unionization, and for the rights of flesh and blood workers, unkindly. Organized labor's frustration with the mainstream press is apparent in one 1938 *CIO News* cartoon. It addressed the Copeland Committee, which tracked ties between organized crime and organized labor. The cartoon showed two grinning, corpulent men who represented ship owners and congressional investigators. The investigator painted a canvas of "the American Seaman" with a palette of lies, slander, and red-baiting.[41] The square-jawed model stood in near military precision with arms by his sides, erect posture, and a bland, forward-looking gaze. In the committee's canvas, he was a brute: his simian features were dwarfed by his oversized chest; his tightly grasped club seemed sure to fall on some unhappy object unless pacified by the liquor in his other hand. The caption, "It's an Art," commented on the committee's success in transforming laborers into a menace. It emphasized labor's awareness of its "public relations nightmare" in the press.

Eyes on Labor explores this anti-union bias, but it also shows how workers could be accepted as participants in American life in ways unimaginable prior to the thirties. Messages in news photographs of organized labor never fell along expected lines. Union newspapers promoted consumerism for workers as much as capitalism's cheerleader, *LIFE*. Black workers and women workers were ignored both by the mainstream press and by the labor press. Photo journals celebrated labor's activism as a fad; while labor papers could be more circumspect, using imagery to promote members' obedience. This cacophony of images about organized labor makes sense—labor was asserting a new place for itself in society. Photographs offer crucial evidence about business and labor uncertainty when facing the question of labor's place in the polity, but they also reveal the players' aspirations as they reimagined this polity.

"The Quick Nervousness of Pictures Is a New Language"

ORGANIZED LABOR BEFORE PHOTOJOURNALISM

In 1942, for the first time, a news photograph won a Pulitzer Prize. The winner was an image of eight United Auto Worker (UAW) members pummeling a scab the previous year (Fig. 1.1). The photographer, *Detroit News*'s Milton Brooks, made the walls of Henry Ford's fortress-like River Rouge plant a backdrop.[1] Brooks caught UAW members in full attack, with clubs and fists pulled back before striking. Their ill-fated target held his coat over his head and curled his hands round his face. The strikers' facial expressions draw the eye. Several, intent on their beating, had their tongues out; others bit their bottom lips. Brooks traded on a crucial photographic quality, the capturing of a split second. Yet the photographer framed the attack with timeless compositional rules. The onlookers created a horizontal line along the Rouge's wall, pierced by the triangle made by the inner group of assailants. The wide-legged stance of many of the photo's participants echoed this triangular pattern. This first-ever Pulitzer-winning photo was newsworthy and aesthetically powerful; it also signaled the momentous changes that unionization was making in workers' lives.

When United Auto Worker members beat their opponents at River Rouge the conflict was physical and immediate. But the camera captured and constructed an ideological battle as well. News photography's claim on "the real" offered a potent tool to unions, employers, and news corporations. Each sought to harness the medium's apparent objectivity to make competing claims about workers, unions, labor's aspirations, and ideals for labor-management relations. This chapter charts the intersection of these two revolutions in American life: the growing authority of news photography and organized labor's consolidation into a vital movement.

The complex, contradictory portrayal of labor that emerged in mid-century news photography redefined labor's place in the U.S. polity. As this chapter's examination of the strike waves of 1919 and 1934 demonstrates, a photographic news emerged early in the twentieth century. But photos figured little in labor's

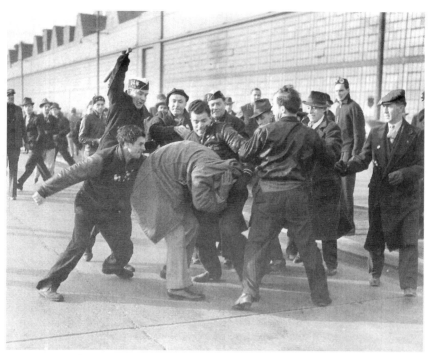

FIGURE 1.1 *Milton Brooks, Strike at Ford Motor's River Rouge Plant, Dearborn, Michigan, April 3, 1941. Reprinted with permission.* Detroit News *Photo Archive.*

political fortunes in that century's first decades. By the late 1930s, however, technologies and distribution methods brought news photos to audiences more rapidly, camera use was democratized, and national mass audiences were built. Labor's status would be transformed in the pages of an ever more national, standard, and photographic mass media.

"Photography Was Slow"

Images of workers and their struggles had long caught the public's eye. The nineteenth-century industrial revolution augmented the nation's economic might, but it had a reverse effect upon many workers. Millions of skilled and unskilled laborers were reduced to degraded circumstances, dependent on their employers' whims. Workers fought back. In perhaps "the earliest surviving photographs of an American labor dispute," Pittsburgh photographer Seth Voss Albee captured the tumultuous 1877 railroad strike. Considered the first nationwide strike, with outbursts of violence in Illinois, Pennsylvania, and Maryland, this strike portended another half century of intense labor turmoil. Albee's forty-two stereograph cards of the conflict were marketed in a set, as stereograph cards often were in this era.[2] His cards showed the infamous roundhouse, which

strikers burned to the ground, the machine shop's remaining brickwork, and the hulking metal of engines, wheels, and rails (Fig. 1.2). These remnants of labor unrest appeared much like the classical monuments that were such a common subject of the stereographic cards filling American middle-class parlors. In many of the pictures onlookers stood stock-still, overseeing the wreckage and regarding the camera eye before them. This would be the only way that viewers could see these protesters; film technology could not capture motion. These stereographs seemed more like souvenirs of an event than "news" photographs. Similarly, with the 1894 railway strike centered at Chicago's Pullman Car Company, photos of the National Guard protecting the company town circulated as postcards; imagery here too was static.[3]

Editors of the nineteenth-century illustrated press also explored labor's activism, including the 1877 railroad strike, more localized strikes of the 1880s, and the notorious 1892 strike at Homestead, Pennsylvania. The illustrated press was the primary means by which Americans visually educated themselves about current events. As Joshua Brown writes, illustrations in *Harper's Weekly*, *Frank Leslie's Illustrated News*, and the *Illustrated American* made the news "palpable," even as events were "constructed . . . into visual performances" that imparted "cause and effect" narratives. These illustrations often resonated with the reading public because they were drawn from on-the-spot eyewitness sketches or from photographs. Yet those directly based on photos often had, in publisher Frank Leslie's words, a "corpse-like literalness."[4]

Illustrations of the 1892 Homestead steel strike demonstrate these diverging modes of representation. In this conflict, the Amalgamated Association of

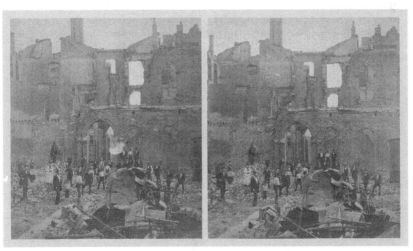

FIGURE 1.2 *Seth Voss Albee, American, active 1870–1880. Albumen stereograph card of 1877 Railroad Strike, "Rear of Union Depot, with Ruins of General Superintendent Gardiner's Palace Car in Foreground," 36 x 28½ inches. Photograph © 2011, Carnegie Museum of Art, Pittsburgh.*

Iron and Steel Workers (AAISW) fought to retain control of the work processes after Andrew Carnegie introduced newer technologies. For more than a decade the union stymied Carnegie's attempts to assert command, winning several strikes. Carnegie then hired Henry Clay Frick, who locked out workers in 1892, fortifying the plant with arms. Workers resisted, keeping replacement workers out. But Frick brought in Pinkerton agents, who sought to force access to the plant. He then called for state support once workers routed the Pinkertons.[5] *Frank Leslie's* cover drawing of the laborers' initial skirmishes with Pinkertons mimicked Eugene Delacroix's famous 1830 "Liberty Leading the People," with a woman astride a railway track, her arms raised skyward (Fig. 1.3). The working-class crowd carried the instruments of battle and exemplified the fight for freedom, transplanted to an American context. This grand battle scene employed the conventions of historical painting, implying the weightiness of the subject. Inside the weekly were cruder images of crowds of rigidly posed men, based on photos. Similarly, in *Harper's Weekly*, images of the conflict appeared on the cover and interior. W. P. Snyder made the cover illustration of the Pinkertons' surrender to striking unionists from photographs taken by B. H. L. Dabbs. In the image the Pinkerton agents appear noble, even relaxed, before moving up the hill to meet an anonymous mob of strikers

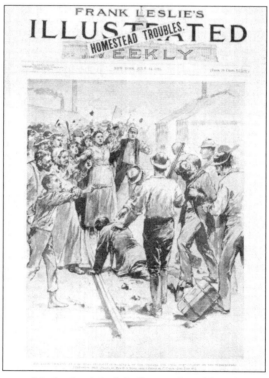

FIGURE 1.3 *Homestead Strike*, Frank Leslie's Illustrated Weekly, *July 14, 1892.*

poised to club them. Engravings of photos, like the *Harper's* cover, eliminated distracting detail and emphasized a particular narrative. The *Harper's* image, unlike the more populist *Leslie's*, indicated middle-class suspicion of workers. The Amalgamated ultimately lost its battle at Homestead, leaving the union a shell. It would take nearly fifty years for the nation's largest industry to negotiate with organized labor as full partners.

Also for middle-class audiences, but in a different vein, New York reformer Jacob Riis produced studies of working and poverty-stricken New Yorkers. Riis recorded the haunts of "the Poor, the Idle, and the Vicious" in 1888 with the aid of two members of New York's Society of Amateur Photographers. The introduction of mass-produced dry plates in the 1870s increased the number of photographer-hobbyists. More portable cameras, with faster shutter speeds requiring less light and time for proper exposure, also appeared by the 1880s. And *blitzkriegpulver*, or magnesium flash powder, made it possible to capture indoor or night scenes. Riis, a *New York Sun* police reporter, exploited these technological changes and turned the camera eye on urban life. His resulting article, "Flashes from the Slums: Pictures Taken in Dark Places by the Lightning Process," promised a threatening lower-class squalor, as did images titled "White Slaves," "Growler Gangs," and "Street Arabs." Riis then wrote a pivotal Progressive Era text, *How the Other Half Lives*. Its images, such as "Baxter Street Alley" and "Bandit's Roost" recorded working New Yorkers' cramped neighborhoods, though the subjects' assessing gazes and their resolute stances could menace middle-class audiences. Riis's text differentiated the deserving working poor from the "dissolute," laborers from toughs (Fig. 1.4).[6] But Riis and his colleagues' photographs—of shoemakers, abject English coal heavers, Bohemian cigar makers, and "sewing and starving" sweatshop girls—looked hardly any different from New York's tramps and beer-dive denizens.

Riis and his audiences privileged photographic truth, but they typically encountered the "poor and idle" in crude, single-line wood engravings, as in "Flashes from the Slum," or in more finely crafted line drawings in *How the Other Half Lives*. The halftone, which made it possible to print text and photograph on the same page, remained unusual. Stephen Horgan produced the first halftone for the *New York Daily Graphic* in 1880. "A Scene in Shantytown" showed several workers' hovels on a patch of Manhattan schist. But the halftone's use remained inhibited until the century's turn: newsprint quality was poor, handmade drawings stood out better, and newsroom deadlines made finding pertinent photos difficult. Resistance by sketch and graphic artists also slowed the halftone's use. Photo-friendly papers, like New York's *Herald* or *World*, printed at most four to eight photographs through the early 1890s, and Horgan, who continued to refine the process, was told by one New York paper that "the idea was lunatic." Only magazines and weekly papers—with longer deadlines and better paper—published more. Even in books, illustrations

FIGURE 1.4 *"Shoemaker, Broome Street," ca. 1890. Museum of the City of New York, Jacob A. Riis Collection.*

remained the norm—in Riis's *Other Half* only one-third of the images were halftone photographs.[7]

During the twentieth century's first decades the news became more photographic as technological barriers shrank, new modes of distribution developed, and publishers sought broader audiences. George Eastman developed flexible film in 1888, and later his Kodak and other "miniature" cameras enhanced interest in photography. More significantly, the Graflex camera, invented in 1898, revolutionized press photography. *Camera: A Practical Magazine for Photographers* described the Graflex in 1902 as a device able to photograph "things . . . precisely as they are seen, at the desired instant, and with the requisite speed." Photographers could see the image right side up, unlike earlier cameras that inverted the image in the viewfinder, and the camera allowed the photographer to turn the camera vertically or horizontally. The Graflex used glass plates or film, facilitating its use. The development of independent agencies that collected and commissioned photographs for distribution in metropolitan dailies and magazines also led to an increasingly photographic news. George Bain set his agency up, the first, in 1898, followed soon afterward by Harris and Ewing, Brown Brothers, and Paul Thompson agencies.

These agencies built a carefully cataloged cache of photos through freelance photographers; for crucial events they sent photographers out on assignment. In this same period, mass-market periodicals like *Collier's* and newspapers like the *Chicago Daily News* began hiring their own in-house photographers. The Pulitzer and the Hearst organizations also capitalized on photography's pull, which they thought would augment their working-class and immigrant readership.[8]

These changes in photographic practices touched working-class Americans' lives. After Jacob Riis, visual data had become integral to Progressive Era reform. The Russell Sage Foundation commissioned photos from Lewis Hine for their *Pittsburgh Survey*, which delineated the breadth and constraints of workers' lives. And the *Survey*, a periodical for reformers, social workers, and policy makers, published Hine's photo-essays of child laborers. Hine also made posters for the National Child Labor Committee that indicted mass-production, using advertisers' idiom and novel photomontage techniques. As Maren Stange writes, photos were to provide apparently objective, measurable information as the title "survey" indicated; they also publicized reform efforts. Such reform photography circulated in general circulation magazines as well. The middle-class *McClure's* published articles about mining families faced with industrial disasters, or "working girls'" tight budgets, accompanied by documentary-style photographs that lent credence to narratives of working-class adversity.[9] The Bain and Brown Brothers photo agencies and news syndicates like E. W. Scripps's United Press (UP) covered major labor struggles, such as the 1910 strike of Philadelphia trolley workers, which led to a citywide general strike, or the 1912 "Bread and Roses" strike in Lawrence, Massachusetts. In the latter, immigrant workers led by the Industrial Workers of the World (IWW) walked off their jobs after manufacturers cut their pay. Strikers achieved national attention and publicity helped lead them to victory. News photographs were published more, but they were more apt to appear in monthly or weekly magazines, such as the *Literary Digest, McClure's, American Magazine,* or *Collier's*, than in dailies like the *New York Times*.[10]

News photos did figure directly in some labor strikes. In New York City, the nation's publishing capital and its center of garment production, women workers struck in 1909 in the fantastic Uprising of the Twenty Thousand. Angered by long hours of toil, tinderbox factories, and limited pay, women organized the marginalized workers that male unionists neglected. At a Cooper Union mass meeting, Clara Lemlich demanded to speak as union and Socialist leaders dithered over how to meet working women's needs. Lemlich called for a general strike. In support were the "mink brigades" of elite women and middle-class reformers, suffragists, and women's club members, many from the Women's Trade Union League, who joined strikers on the picket line and bailed them out of jail. Immediate gains were ambiguous, as many went

back to work without union recognition, and union officials compromised on safety. Nonetheless, within a decade more than half of all women garment workers were unionists. Women's feat consolidated the International Ladies Garment Workers Union (ILGWU), a bulwark of industrial organizing in the 1920s and 1930s.[11]

Photos of the uprising built women's confidence in the strike as a strategy and in themselves as political actors. As Nan Enstad posits, the "lady-like" dress of workers photographed by New York's papers echoed workingwomen's sense of "utopian entitlements." Pictures of women strikers allowed other garment workers to imagine themselves heroines in urban struggle—a struggle they might win. Of course, limited safety code enforcement led, less than two years later, to the infamous Triangle Fire, which left 146 men and women dead. Photos of the 1909 uprising and the 1911 fire appeared in local papers, and in national magazines such as *McClure's*, *Collier's*, and the *Literary Digest*. As Ellen Wiley Todd argues, though photos documented the travesty, their framing by news editors might have left some aghast and others transfixed by the spectacle of urban life.[12]

Just five years later, in 1914, photos played a new role in events surrounding the Ludlow Massacre. Here Colorado's United Mine Workers of America (UMW) struck in September of 1913 for union recognition, increased wages and the eight-hour day, as well as for miners' right to rent from whatever boardinghouse, or frequent any doctor, they chose. Their employer, the Colorado Fuel and Iron Corporation (CFI) forced 10,000 miners out of company housing into tent colonies. By December the pro-union governor relented to business pressure; the National Guard secured nonunion labor for the corporation. Ongoing skirmishes between the Guard, company security, and strikers ensued. The following April, the National Guard fired point-blank on the tent colonies, and then burned down the tents, leaving thirteen women and children dead. Armed unionists fought back. In total, sixty-six strikers, scabs, security agents, and bystanders died in the protracted coal wars. Middle-class opinion journals criticized the CFI, and the leftist *Masses* offered dramatic illustrations such as John Sloan's cover drawing, which showed a child hanging limp from a miner's hand—in the other hand was a pistol pointing out of the drawing's frame, suggesting protracted turmoil.[13]

Bad publicity stemming from the Ludlow massacre led to two corporate strategies affecting labor. John D. Rockefeller Jr., the CFI's nominal head, commissioned the expertise of W. L. Mackenzie King, who orchestrated what became known as the Rockefeller Plan, or the Colorado Industrial Plan. The plan publicized employee representation plans (ERPs), in which companies organized in-house representation for their workers to prevent unionization. Rockefeller also procured Ivy Lee's services. This pioneering public relations specialist recommended the design of photo-laden posters and employee magazines promoting class harmony, which he produced for the CFI

by 1915. Many companies implemented this strategy. By the 1920s workers contributed their own domestic snapshots to house publications, as Elspeth Brown writes, so that laborers would envision themselves as loyal corporate family members.[14]

Even though news photography became far more common, contemporary visual culture should not be read back into the twentieth century's first decades. At that time photos were still seen in limited numbers, often appeared static, and had a smaller audience than they would have several decades later. Todd's study of the Triangle Fire's photographic coverage maintains that New York papers offered 900 photos weekly, which sounds substantial. Averaged out, however, an entire paper might offer only 10 photos daily. In contrast, today's *New York Times* offers over 50 images in the front section alone. Photos still appeared more in magazines than in papers—and a national mass audience was still in the future. In 1910, *Collier's*, at half a million subscribers, and *McClure's* at nearly that, had the most readers. Most publications had far fewer. Also, technology still limited what could be seen. According to a contemporary photo magazine, the Graflex captured motion up to "the speed . . . of an express train," yet most photos still looked motionless and staged. Indeed many were staged. The early professionalization of the field led many news events to be covered from a consistent, fixed vantage, in special areas set up for photographers. This was because changing film magazines and coordinating the aperture and exposure remained cumbersome. With the Graflex, "one little slip and [the] work is in vain." Although the Graflex was considered a "hand camera," photographers were often helped by assistants who toted their camera, plate holders, tripod, focusing cloth, and carrying case. As a result photographers came back to their agencies or papers with only a few images.[15] And news photos recorded events as if rituals. As Peter Bacon Hales writes of news imagery from the Bain Agency, "An observer might be forgiven for seeing the entire urban scene as a synthesis of parades . . . labor parades, commemorative parades, protest parades."[16] Photographs had an immobility suggesting timelessness, not fast-paced events.

Two innovations in news publishing, the rotogravure press and the tabloids, captured labor conflict anew in 1919 and 1920. In the rotogravure, half-toned photos were engraved on a thin copper cylinder that could be put through a high-speed press. Publishers made photograph-packed supplements from this technology, and these supplements typically appeared in a paper's Sunday edition.[17] Fifty papers had them by World War I's end, with New York's *Mid-Week Pictorial* being the most popular. Rotogravures offered a limited national audience a weekly visual recapitulation of the news. The tabloids pushed photojournalism in another direction. As Michael Carlebach notes, the tabloids were backbone to the 1920s' "spectacle and ballyhoo." Tabloids filled the front, back, and center pages with photographs. Their visual and rhetorical style paralleled the jangle of twentieth-century life.[18]

The wave of strikes just after World War I brought one of five workers out on strike. A general strike of shipworkers first erupted in Seattle in late January 1919, and hotel maids, violinists, and garbage collectors joined in solidarity two weeks later. Simultaneously, in Lawrence, Massachusetts, where immigrant textile workers had thrilled many with their earlier 1912 Bread and Roses strike, workers struck again. In the Midwest, Chicago garment workers walked out, winning the forty-four-hour week. Each month from March through August brought hundreds of strikes. In August, New York was paralyzed when transport workers left their jobs. Gotham's other strikers included jewelry makers, pharmacists, and Broadway actors. In October, longshoremen in Hoboken, New Jersey, joined Manhattanites and Brooklynites and tied up the docks that were the conduits to national and international trade. The strikers stranded ocean-liner passengers, and left food to rot and mail to pile up. Boston elicited national attention in September when its police force struck. The cradle of liberty became the capital of libertinage with looting and gambling on the Commons. But the biggest national strike involved steelworkers, a third of a million, who came out en masse on September 22, 1919. Western Pennsylvania steel towns became "armed camps" where workers and organizers were beaten at corporate whim. In Gary, Indiana, steelworkers who were former veterans got around martial law by donning their uniforms and parading around. By November, bituminous coal workers left the mines. In total, four million Americans walked off their jobs in 1919, a number that was unsurpassed until the 1937 CIO upsurge.[19]

Labor's activism had multiple roots. As World War I began, labor volatility grew, leading Woodrow Wilson's National War Labor Board (NWLB) to accede to labor's right to organize, a "first" in "the nation's history." The NWLB also mandated the eight-hour day. Companies agreed to the board's closed shop and wage and hour controls as governmental cost-plus contracts assured them profits. With federal support, union membership doubled to 5.1 million by 1920.[20] With the war's end, unions sought to consolidate those gains. Their demands for better wages and job security were often joined with "bold visions of social change" inspired by socialist, One Big Union, communist, or religious ideals. Some even countenanced nationalization of key industries.[21]

Such hopes were misplaced. After the war Wilson suspended the NWLB, and federal attempts to lead voluntary cooperation between labor and management failed. Most corporations saw no need for continued dialogue.[22] Attacks on radicals further weakened labor. Concerned that the Bolshevik revolution might gain a foothold in the United States, the federal government stepped up its surveillance, detention, and deportation of radicals, culminating in the red-scare dragnets. Business hastened to link their open shop "American Plan" movement with this political repression. This mix of worker expectation, corporate backlash, and governmental noninterference contributed to 1919's volatility.[23]

The rotogravures and the tabloids presented news photos of this labor strife to growing numbers of Americans. The *Mid-Week Pictorial*, a rotogravure, began circulating nationally in 1914 to provide Americans with imagery of World War I. As late as 1919, the *Pictorial's* pages remained filled with photos of the marred splendor of Continental capitals and Europe's ravaged country-side, returning troops in parade, and portraits of world leaders negotiating the peace. Part visual digest of war events, part memento, the *Pictorial's* coverage had gravitas.[24] An emphasis on international affairs and a desire to establish a permanent record limited the *Pictorial's* strike coverage, however. Readers would with difficulty guess the extent of that year's labor strife. Indeed, there was no coverage of the strike wave until August. Even with hundreds of thousands of Americans on strike, the *Pictorial* covered only five—the New York City strikes of transit workers and longshoremen, the Boston police strike, and the nationwide strikes in steel and coal.

The *Pictorial's* visualization of strikes suggested that unions ruptured established authority and order. America's corporate and governmental elite represented order; the *Pictorial* presented them in traditional headshots. Their stern countenances and pursed lips signaled leaders' purpose, as did their directed gazes. Union leaders appeared only three times in the *Pictorial*. Photographs also showed the army poised to assert "necessary restraint."[25] Soldiers typically stood at full attention, their rifles slung over their shoulders. In more menacing photographs soldiers stood with their guns perpendicular to their bodies as they marched forward toward their foe. Workers appeared in three guises: as part of anonymous street crowds, being restrained or beaten by police, or working diligently under managerial supervision. For example, in three pages addressing the Boston Police strike, photos showed the National Guardsmen called out by Massachusetts Governor Calvin Coolidge against "looters terrorizing the city." Similarly, in the steel strike, the Pennsylvania Constabulary used "necessary force" to restrain what it called "sullen and threatening" workers. Photos showed a small number of workmen attired in suits and caps and fedoras strolling through Homestead's business district. Readers might have empathized with the strikers, but the constabulary, with their extended arms and upswept billy clubs, and the photos' captions proposed that labor activism led to violence.[26]

When depicted as types, or when represented as under managerial supervision, workers lacked the menace imputed by strike coverage; they seemed almost benign. The *Pictorial's* lengthy story on the November coal strike had a cover photograph showing a miner in profile. Garbed in work clothes and carrying the day's water and lunch pail, he appeared ready to labor (Fig. 1.5).[27] He carried himself well, with a dignified pose and expression. Yet even though the miner was alert and poised to light his cigarette, he looked immobile. The photo's narrow depth of field emphasized the subject as an object of study. Unlike Lewis Hine's documentary studies in which workers look directly and searchingly at

FIGURE 1.5 *Cover,* Mid-Week Pictorial, *November 13, 1919. Private collection.*

the camera, demanding contact and recognition from the viewer, this miner looked away (Fig. 1.6).[28] He was instead a type, in the cover's words, "typical of the 400,000 who went on strike." The *Pictorial's* depiction relied on an evidence style used in mug shots, anthropological studies, and medical photography. These forms of photography all intend to give a total view of the human as object. They help the spectator to categorize.[29]

Photos inside the *Pictorial* visually educated readers about mining from a managerial standpoint; there was little about the strike. The photos drew on a corporate-photography style and they showed miners working above and below ground.[30] Readers could marvel at the intricacies and risks of miners' jobs, but the photos framed the worksite as an organic whole that operated independently of individual laborers' consciousness. The strong diagonal lines of the machinery and infrastructure, and its pure dwarfing bulk, impressed themselves upon the viewers' eyes (Fig. 1.7). Even photos of miners poised with their hammers seemed static, as if placed in a predetermined order established by managerial foresight.

The rotogravures, including the *Pictorial*, made bold advances in bringing photos to readers, but photography's effect upon labor remained limited.

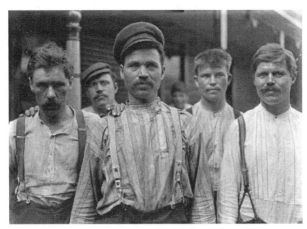

FIGURE 1.6 *Lewis Wickes Hine, steelworkers, "At a Russian Boarding House, Homestead, Pennsylvania, 1909." Photography Collection, Miriam and Ira D. Wallach Division of Art, Prints and Photographs, The New York Public Library, Astor, Lenox, and Tilden Foundations.*

"Photography was slow;" photos could take days, even months, to appear. In the 1920s, nationally known press photographers relied on slipping their photos into the hands of "corruptible porters or trainmen," to get photographs to "waiting clients." Speed could require unusual measures. As late as 1933, photos of the attempted assassination of Franklin Delano Roosevelt had to be flown from Miami to New York to be printed.[31]

Taking photographs also remained unwieldy. The Speed Graphic's introduction facilitated picture taking, but it still weighed over six pounds and required advance planning to find the right vantage. Former *PM* and Hearst news photographer Arthur Leipzig complained about the camera, "It was big, it was heavy, it was uncomfortable." Photographers typically took only a few photos; they were forced to load film for each shot. Editors expected one "climactic" image and papers typically printed a lone photo. The news was less visually immediate.[32]

Most Americans hardly saw the same news, either; a national news audience was still not fully developed by 1920. Magazines with a national range such as *Collier's, Illustrated Weekly Sun*, the *Literary Digest*, and the *Saturday Evening Post* had increased subscriptions, and several of these sold more than a million copies each week or month. Yet magazines of the late 1930s achieved far greater market penetration.[33] Nationalizing tendencies in the metropolitan news were also limited. The fifty rotogravure supplements founded prior to World War I's end were concentrated in twenty-nine cities. Following a nexus of media established in the mid-nineteenth century, readers from the populous Northeast, Midwest, and mid-Atlantic regions enjoyed them. Only six cities outside these regions—Los Angeles, Denver, Louisville, Birmingham, Nashville, and New Orleans—had such supplements.[34] Because rural papers

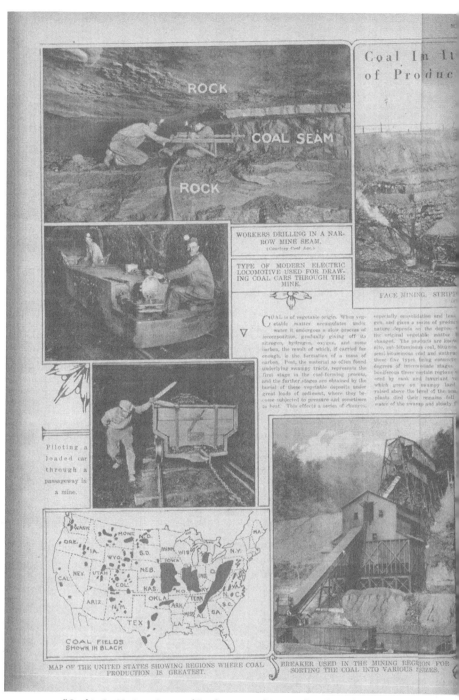

FIGURE 1.7 *"Coal in Its Various Stages of Production and Mining,"* Mid-Week Pictorial, *November 13, 1919. Private collection.*

rious Stages
and Mining

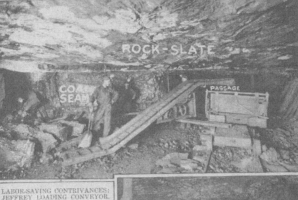

ROCK-SLATE

COAL SEAM

PASSAGE

LABOR-SAVING CONTRIVANCES;
JEFFREY LOADING CONVEYOR.
(Courtesy Coal Age.)

Miner breaking up huge pieces of
coal so that they may be easily trans-
ported in waiting car.

...sition of vegetable matter of in-
...ess thickness. By slow subsidence
...thick layer of vegetable matter sank
...eth the water and became gradually
...ed by sand, mud or other mineral
...her washed out from shore. This
...is way coal is found in strata or

...hese veins in most cases are hori-
...al with the surface of the earth. When
...coal is located a sloping shaft is sunk
...Then one, two or three main pas-
...ways are dug into the seam. From
...e main passageways smaller corridors
...ch run generally at a right angle
...en off these passageways rooms are
...into the seams. These rooms vary

in size according to the extent of the seam.
Connecting passageways enable many
gangs to work at the same time. Small
trolley or hand cars serve to carry the
coal to the main passageway, where it is
loaded into larger receptacles and hoisted
to the surface. After the rooms have
yielded all their coal the walls between
are broken out, all coal and supports re-
moved, and the roofs allowed to fall in.
Seams of coal vary from six inches to
twenty or thirty feet in thickness. Much
timbering has to be done to make the
mines safe. The work is arduous and
dangerous. Gas is a deadly enemy, the
striking of water may flood the mine, or
the dreaded cave-in may lead to death
from crushing or starvation.

Driller mak-
ing holes for
the insertion
of dynamite
charge for
blasting.

ROCK

COAL
SEAM

...WORK IN THE BOWELS OF THE EARTH DRIVING THEIR WAY WITH PICKS
INTO THE THICK SEAM OF COAL.

DIAGRAM OF COAL MINE SHOWING METHODS
OF REACHING, MINING, AND TRANSPORTING
THE COAL.

could not afford the high-speed printing presses using stereotypes, rural Americans more often saw local news in postcards instead of in their papers.[35] Americans saw the news far more than before, but not as they would two decades later.

Tabloids also covered the 1919 strike wave. America's first, the *New York Daily News*, began publication in 1919. Joseph Medill Patterson, the *Daily News*'s primary publisher, promised that the *News* would offer "the best and newest pictures of the interesting things that happened in the world." Patterson believed that with pictures, "the story . . . can be grasped instantly." The *Daily News* became New York's most popular, if not its foremost, daily. Labor's story was part of the *Daily News*'s staple "shock, titillation and gritty realism."[36]

The *News*'s record of the 1919 strikes presaged shifts in twentieth-century journalism and mass culture toward greater intimacy, and some recognition of labor and its needs. While representing America's economic elite, the *Daily News* also portrayed labor's leaders. Company heads like U.S. Steel's Eldred Gary appeared often, typically in the three-quarters bust portrait, implying their mastery. Yet the *News* also featured sour-faced Samuel Gompers, grasping a stubby cigar in his hand.[37] And Gompers appeared presiding over AFL meetings with patriotic bunting as a backdrop. The former cigar maker, who founded the AFL in 1886, was at this point "a confidant of presidents and businessmen." Gompers had rejected seeking redress for workers' ills with politics; he argued for a narrower "bread and butter unionism." Though the *Daily News* printed mug-shot style photographs of other union heads—with the frontality and brutal lighting characteristic of an evidentiary document—and though its headlines railed against "reds" and the I.W.W., it showed leadership addressing large crowds or attending high-stakes meetings in Washington, D.C. [38]

The *News* also published images of strike violence. *Daily News* readers could see strikers' opponents: the Harvard students led by football coach Percy Haughton who raised weapons against striking Boston Police; the Mounted Constabulary of Pennsylvania whose "mettle" would be "tested" by strikes; and the U.S. Regulars, soldiers home from the war who as strikebreakers made top-notch longshoremen. The *Daily News* identified with these authorities. And it also emphasized the disruption of strikes—Staten Islanders forced to ferry their vegetables to market, continental travelers ending their travels with trunks atop their backs, and New Yorkers "legging it" along the East River. [39]

But the *Daily News* was not uniformly against workers. It showed them helping stranded passengers onto impromptu transport during New York's rapid transit strike, sprightly dressed laundresses in a picket promenade, and mining families hugging one another while looking imploringly at the viewer. *Daily News* readers were treated to photographs of mustachioed immigrant steelworkers daintily holding up letter-sized announcements of their job action; striking New York jewelers standing snappy in suits and brimmed hats; and coal workers off the job and "off after rabbits."[40] *Daily News* photographs

were hardly pro-labor, but they represented workers and labor struggle with greater variety and, at times, even sympathy.

"Photography was slow" at the *Daily News* as well. Subjects seemed stiff and posed, and readers rarely saw events unfolding. Its coverage of September's Boston Police strike had retailers and their employees scowling at the camera. They held their arms tightly across their torsos, pistols cocked as if to shoot. Another set of photos showed a Harvard man in suit and boater hat, his arm outthrust with a drawn pistol (Fig. 1.8).[41] At the height of the steel strike, in October, the *Daily News* devoted a centerfold to labor troubles. Readers could see an army general meeting the mayor of Gary, Indiana, after federal troop mobilization, and troops marching through the shopping district with caissons. Photos of delegates to Wilson's industrial summit aimed at building dialogue between industry and labor were also printed. But in these photos farmers, union leaders, and corporate heads all appeared similarly in head shots. Though photos equated union leadership with traditional elite, a plus for labor, the photos communicated little about labor specifically. The bottom photograph of a crowd of longshoremen on a wildcat strike seemed to offer a diverse group of workers, yet they remained static. In each photo the subjects—whether a handful or hundreds—stood clumped together, sometimes self-consciously standing before the camera eye as with the Boston retailers, other times posing themselves in gestures of power. Even a bulky matron being passed from a truck into the spindly arms of a waiting man during New York's transit strike seemed poised in midair, notwithstanding her grin and the *News*'s lighthearted representation.[42]

If the *Mid-Week Pictorial* looked backward with its presentation of heroic leaders, marching armies, and well-ordered monuments to industrial capitalism, the *Daily News* signaled transitions in twentieth-century media toward a visually kaleidoscopic and democratic presentation of current events. Nonetheless, *Daily News* publisher Patterson's claim that readers could "grasp instantly" the story through photographs just wasn't so. Individual photos typically lacked a clear narrative, and the layout conferred no additional meaning. A photo of docks full of remittances from immigrant New Yorkers to their European homelands sat beside a photograph of the Irish Republic's provisional president, Eamon DeValera, meeting with Chippewa Indians garbed in full headdress; photos of striking coal workers joined Wellesley coeds costumed as goats and elephants.[43] *Daily News* photographs presented slivers of reality. A full picture of events, even with multiple photographs, rarely emerged. The *Daily News* was not a mainstream news vehicle either. Though many in the middle-class read the *Daily News*, it was perceived as lowbrow. Journalism critics such as Silas Bent complained that tabloids spoke to those of "the lowest mental common denominator."[44] In 1919, the papers with the greatest number of images, the *New York Daily News* and the *Mid-Week Pictorial*, had circulations below one million. Most readers lived near New York. This was a far cry from the tens of millions of Americans who would see the same photo with

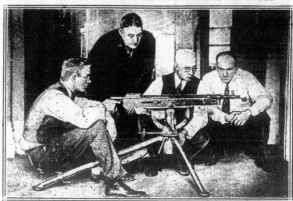

FIGURE 1.8 *Boston Police Strike,* Daily News, *September 16, 1919.*

nearly the same message in *TIME, LIFE,* or *Newsweek* in the late 1930s. And few Americans, including workers, received their news—with photographs—from a labor viewpoint. Americans did not share a national visual news culture.

Coverage of the 1919 steel strike exemplifies photography's limited political influence. Progressive religious reformers associated with the Interchurch World Movement (IWM) joined the Bureau of Industrial Research to analyze

the strike's failure. They faulted the curtailing of civil liberties in steel districts, violence, the steelworkers' inadequate organization, and misinformation that news organizations filtered to the general public. The IWM's *Report on the Steel Strike of 1919* chronicled the strike, and documented workers' twelve-hour work day and miserable wages. Their ancillary report, *Public Opinion and the Steel Strike*, was even longer. Both reports were important enough for corporate "under-cover men" to try to suppress them.

A hallmark of Progressive reform was a sensitivity to the power of public opinion, which explains the IWM's focus on press coverage of the strike. The IMW found Pittsburgh papers uniformly biased against strikers, despite seven metropolitan dailies. As a result, "a marked agreement existed between the viewpoint of Pittsburgh newspapers and the viewpoint of Pittsburghers, 'The Pittsburgh mind.'" The researchers believed that news coverage promoted corporations' aims. Readers received no investigative or independent eyewitness accounts, no historical synopsis of the conflict or summary of opposing viewpoints. When workers' demands were mentioned, they seemed "unwarranted"; grievances were "unfounded." Violence was attributed to strikers "as a matter of course"; and workers were depicted as foreign, alien, and Bolshevik. *Public Opinion and the Steel Strike* maintained that Pittsburgh's papers were more anti-union than local papers in other steel towns, but that Pittsburgh coverage had a "weighty" influence on national news.[45]

Blindsided by the negative press after WWI, labor began building its capacity to get its story out. In the 1920s, labor's supporters established the Federated Press, labor's first national news service. Labor editors even bought their own paper mill to ensure that they could print their dailies and reach the public.[46]

For all the reformers' attention to how the press aroused public opinion against labor, *Public Opinion and the Steel Strike* ignored corporate and journalistic use of photos against labor. Ironically, the IWM's reports used photos. Clearly reformers understood photos' persuasiveness. And corporations took aim at the IWM reports' photos. *Iron Age*, a trade paper, charged that the IWM "faked" strike photographs to press their case against the steel companies. The *Wall Street Journal* reprinted these claims to a broader audience. Despite the IWM usage of photography, and despite their attention to publicity's power, the IWM did not comment on news photography's influence.[47] Their concern with publicity focused on the power of the word, not the image.

Tenuous Prosperity

The strike wave continued several years after 1919, but labor took a defensive position as corporations sharpened their attack on wages and on unions themselves. After 1922, strike actions dropped precipitously.[48] Labor's retrenchment registered in dwindling membership. Between 1920 and 1923 the AFL lost

some 1.5 million workers, a 25 percent loss. One in five workers was a unionist in 1920; a decade later the figure dropped to one in ten.[49] Internecine warfare contributed to labor timidity. Gompers and shifting groups of allies sidelined or expelled progressive and socialist elements of the AFL, squelching utopian and radical visions for economic equity.[50]

Even so, labor turbulence had stung corporations. To ward off bad publicity, nurture corporate identification, and maintain productivity, some forward-thinking corporate liberals set up dressing facilities, cafeterias, health-care services, newspapers, and even sports teams.[51] Companies also pushed profit-sharing, stock ownership plans, and unemployment insurance. The U.S. Chamber of Commerce's head cloaked them in the golden rule's lambent light, claiming that business followed the "decent and right conduct of Jesus of Nazareth." Up-to-date notions of psychological assessment and managerial efficiency informed other programs. Businessmen thought these corporate welfare programs would limit turnover, enhance workers' loyalty, and blunt labor conflict by giving workers a stake in capitalism.[52]

The roots of these programs lie in the nineteenth century, as some reformers came to believe that technology, rational organization, and mass production could alleviate material want and transform the world. Edward Bellamy's *Looking Backwards* (1888) popularized the notion that an efficient, nationalized economy could provide for all with the ease of a trip through the pneumatic tubes that were the circulation system for the new consumer economy. Architects of the social sciences imagined the possibilities in terms no less dazzling. Wharton professor of economics Simon Patten argued that mass production made scarcity, or a "pain economy," obsolete. Instead, Americans would indulge in the new "pleasure economy."[53] Additionally, from the late nineteenth century, growing numbers of the middle class demanded an amelioration of industrial capitalism's ravages, pushing corporations along. Religious, labor, and political reformers developed some of the first experiments in welfare programs for workers. Many reformers, including progressive businessmen, imagined expanding democracy into the economic realm.[54]

Corporations professed a new world, where workers put aside worries of privation and shared corporate financial success, relinquishing their war with capital. Yet for most workers this world was chimerical. Corporations dominated the employee representation plans (ERPs) they established, and even so, by 1928 only 400-odd firms had them. The most creative welfare programs, which responded to labor's activism, were discontinued by the mid-1920s. And experiments with fringe benefits: pensions, vacations, holidays, and overtime pay, remained that—experiments.[55]

Business-fueled prosperity was also illusory. Union workers in printing, the building trades, the automobile and rail industries, skilled laborers, and those in the Midwest could buy the new consumer economy's refrigerators, vacuum cleaners, and automobiles.[56] Their wages had increased in real dollars,

and a few did enjoy pensions, vacations, and stock ownership. But for many if not most workers, economic security and leisure were an advertiser's dream. Wage increases were slight. Manual workers, women factory hands, African-American and immigrant workers, common laborers, foundry workers, Southerners, and Northeasterners did worse. Common laborers in steel made less in 1929 than they made in 1892—nearly four decades earlier. Few worked the eight-hour day. Steel workers averaged nearly fifty-five-hour weeks; one in seven toiled more than sixty hours.[57]

Contributing most to workers' insecurity was persistent unemployment. Annually, most workers lost at least one month's wages due to illness or layoff. And unemployment never fell below ten percent from 1923 through 1929. The net result of limited wages and intermittent employment was working-class poverty. Even in the midst of the 1920s boom, 40 percent of Americans lived in poverty.[58] The Depression shattered even this.

The Depression, Working Americans, and the CIO's Rise

The October 1929 stock market crash marks the Great Depression's beginning in public imagination, though many economic sectors had faltered from the mid-decade. The Depression's ravages continued through the 1930s. Addressing the average U.S. locale, "Middletown," in 1937 the Lynds wrote, "The great knife of the depression had cut down impartially through the entire population cleaving open lives and hopes of rich as well as poor." But the knife was not impartial; workers bore the brunt of the Great Depression's thrusts. Small companies slashed wages, and by 1931 progressive firms like National Cash Register and International Harvester followed. Even behemoths like U.S. Steel and General Motors (GM) cut wages by 10 percent; Ford reduced them by one quarter.[59]

Many workers had no wages whatsoever. Two weeks after the crash, claimed one public official, the number of unemployed climbed from 700,000 to three million. By the 1932 election, one-quarter of the workforce—thirteen million—had no work. When Hoover left office four months later, that number had risen to fifteen million, one in three workers.[60] Specific communities, demographic groups, and industrial sectors were hit harder. By November 1932 half of African-American workers could not find a job. Toledo's unemployment rate was 40 percent, New England mill towns suffered 60 percent unemployment, and in Illinois and Pennsylvania coal towns an astonishing 90 percent lacked work. Many Americans with jobs clocked in only one or two days of work a week, hardly enough to sustain their families.[61]

America's limited welfare state meant meager aid for these unemployed. Prior to the Depression, Hoover, a progressive technocrat, railed against "excessive fortunes" and favored unions. But even as he extended the state's capacity to aid business, Hoover recoiled at state support for workers, pushing only

minor public works projects. Americans could not "squander" themselves "into prosperity," he admonished. Hoover's head of the President's Organization for Unemployment Relief, AT&T's Walter Gifford, told a Senate committee in 1931, "Federal aid would be a disservice to the unemployed."

Upon taking office in 1933, Roosevelt instead pledged assistance to the "forgotten man at the bottom of the economic pyramid." His promise gave him workers' votes and a place in their hearts, even when his commitment wavered.[62] The cadre of "brain trusters" he brought into government, the economy's continued failure, and labor and radical activism drove Roosevelt to bold government experimentation. One New Deal administrator, Rexford Tugwell, a Columbia University economics professor, wrote as a young adult, "I shall roll up my sleeves, and make America over!" Tugwell's commitment to change had been shared by middle-class reformers and laborites for a half century; it informed many New Deal experiments. Roosevelt's secretary of labor, Frances Perkins, the first female Cabinet member, was a devoted social justice advocate. Riis's *How the Other Half Lives* played no small role in her initial commitment. In 1911, she had stood helplessly by as women fell off window ledges and the fire escape of the Asch Building during the Triangle Fire; her work investigating factory conditions for the state of New York resulted in path breaking reform legislation.[63] Like Perkins, social experts in voluntary organizations, the social sciences, foundations, state and local government, and even business had crafted state legislation to better workers' lots in the 1920s. Many of these reformers contributed to FDR's regulatory and welfare state or mentored those who would.[64]

FDR's New Deal ushered in a sea change in relations between the state, business, and working Americans and their unions. Rejecting Hoover's voluntarism, FDR's administration immediately hired millions of Americans for public works projects. His administration worked with major business figures—retailer Edward Filene, GE's Gerald Swope, and U.S. Steel's Myron Taylor—along with foundation staff, academics, and industrial relations specialists to craft the Social Security Act, a cornerstone of America's growing welfare state.[65] Most crucial for organized labor was the effect of the National Industrial Recovery Act's (NIRA) section 7(a).

The NIRA was intended to remedy a recovery-resistant economy. The act's National Recovery Administration (NRA) legalized industry-based price codes to raise prices and profits, limit competition, and stabilize industry and the economy. In return business committed to eliminating child labor, guaranteeing minimum wages and maximum hours, and ameliorating work conditions.[66] Section 7(a) specified that labor and business should negotiate hours, wages, and conditions through collective bargaining.

The Depression's devastation led many workers to reconsider their relationship to corporations and the state. In collective action, workers asserted their economic demands; unions became the most potent vehicle for worker protest.[67]

But the AFL, which coasted through the 1920s, was ill-prepared for workers' interest.[68] Leaders remained obsessed with jurisdictional questions; many still shunned the unskilled industrial laborer. In the Depression's early years, the hobbling organization became weaker, and unions cut funding for staff organizers, strike support, union newspapers—even leaders' salaries. As the Depression deepened, the number of strikes dropped to the lowest number in the century. Desperate, unions bargained over wage cuts.[69] By 1932 the AFL relinquished its half-century commitment to voluntarism, voting for state-guaranteed unemployment insurance. Some leaders believed that governmental support might offer further security, and the UMW's John L. Lewis and Sidney Hillman, of the independent Amalgamated Clothing Workers Union (ACWU), advocated for the NIRA.[70]

With the NIRA's 7(a), workers poured into unions to strengthen their economic hand. Some AFL leaders understood its stimulus to organization. Lewis hailed it as "the greatest single advance for human rights since Abraham Lincoln's Emancipation Proclamation." UMW staff entered the field proclaiming that "the President wants you to organize," and the UMW reversed its disastrous decline of the 1920s.[71] Ninety thousand steelworkers entered the Amalgamated Association of Iron, Steel, and Tin Workers (AAISTW); 100,000 autoworkers tripled the number of auto union locals; and 60,000 rubber workers joined up. Even in the nonunion South, tens of thousands of textile workers imagined their new day with the NIRA.[72]

Yet few in business embraced collaboration; some gave lip service to dialogue while stalling or fighting unions outright, leading to turmoil. This corporate cold shoulder resulted in 1934's spectacular strike wave. In Minneapolis, the Teamsters called a general strike. By spring the city's civic association and police engaged in armed warfare with strikers. Workers at Toledo's Electro Auto-Lite plant came out too. Shooting in the streets left several dead. Another week, another strike, this time of San Francisco longshoremen. Again, dead littered the streets. On Labor Day, East Coast and Southern textile workers struck in a "human tidal wave." Overall, in 1934 some one and a half million workers participated in 1800 strikes.[73]

Front-Page Conflict

This time Americans could see workers, police, the National Guard, and private security duking it out in the national media. *TIME*, then the nation's premier news magazine, reported on the industrial tumult. The magazine conferred a new authority on organized labor by placing bust shots of its leaders side-by-side with governmental or corporate officials. During the San Francisco general strike, *TIME* offered portraits of the longshoremen union's Harry Bridges and the city's mayor, Angelo Rossi, suggesting their

equal stature.[74] In six months of coverage, however, only two photos of the strikes appeared. One, of the Minneapolis general strike, showed a teamster swinging a bat at full extension. No one approached the circumference of his bat except a lone scab crouched like a sick animal in the photo frame's corner. The second photo showed Wisconsin's Walter Judok Kohler, bathroom fixture king and proponent of "model industrial towns." His workers struck, wrote *TIME*, and kept "loyal" workers under siege inside the plant. The photo showed a grim Kohler rearranging his hat after encountering strikers' barricade.[75] *TIME* represented the union and corporate chiefs negotiating the nation's labor relations equally, but the few workers it represented showed them fomenting disorder.

TIME's upstart competitor *Newsweek* offered a more sympathetic look at labor: it included a range of subjects and it transmitted labor's viewpoint on their struggles. The magazine did not forgo photographs of violence. It showed the photo of the bat-swinging Minneapolis teamster, and its coverage of Toledo, San Francisco, Seattle, and Southern labor strife emphasized violence. One scene of the National Guard marching against Ohio strikers was so warlike that editors ironically advised readers that the scene was not from "the Western Front." Though *Newsweek* portrayed traditional labor relations players—corporate heads like Republic Steel's Tom Girdler and Bethlehem Steel's Eugene Grace, and union chiefs like Bridges and steel's Michael Teague—its coverage went deeper. It showed rank-and-file leaders in steel, new governmental labor administrators, and privately paid strikebreakers. And *Newsweek*'s photographs did not always imply labor was to blame for violence. Its photos of an inquest into the death of two strikers at Toledo's Auto-Lite showed jurors huddled around a table, possibly examining evidence. The photo transmitted a quiet, still feeling. Its caption stated that the inquest resulted in a "turn in public opinion in favor of workers." By relaying public support for labor and offering a different perspective on strike violence, *Newsweek* suggested that violence did not inhere in labor's activism. Its coverage of San Francisco's July general strike showed police chasing strikers through the streets. Below that, *Newsweek* printed a photo of two wounded protesters and below that a photo of unionists' "sidewalk memorial" (Fig. 1.9). A worker had, in *Newsweek*'s caption, "inscribed in chalk, 'Murdered by Police.'"[76] The chalk lettering, its central position in the composition, and the arms and hands of the unionists who surrounded the words heightened the union message's visibility. *Newsweek*'s photo recorded workers' feelings about their peers' death for an audience of tens of thousands.

Newsweek's cover photos also packaged labor conflict into a stylized, modern entertainment. In "Mopping Up in Minneapolis," the photographer looked down on that city's general strike. Eight men armed with rifles and billy clubs stalked the street (Fig. 1.10).[77] It was a sunny day; the men and their shadows contrasted starkly with the background. The direction of the men's bodies and weapons, the glances they sent to opposing corners of the photograph, their configuration into two lines that waved across the composition, and the scene's framing

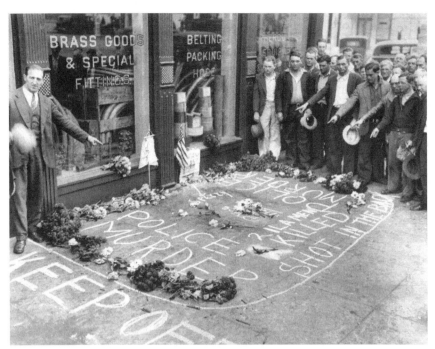

FIGURE 1.9 *Acme news agency photograph of "sidewalk memorial" to two strikers, Nick Burdoise and Harry Sperry. The dockworkers were shot and killed by police on July 5, 1934, just outside the International Longshoremen's Association's (ILA) hall, and another eighty were wounded, provoking the San Francisco General Strike. Employers had attempted to break their strike by opening the port. On July 14,* Newsweek *published three photos of the conflict. The first showed police chasing strikers after bombarding them with tear gas; the second showed two wounded strikers.* Newsweek's *caption to this third photo pointed out to readers the unionists' charge that the men were "Murdered by Police." © Bettmann/CORBIS.*

lent the photo vitality. The image's lack of identifying context made it seem possible that the armed men might exit the picture frame and walk off into any community in America. Equally dramatic was a portrait of a workman appearing on *Newsweek's* cover during September's textile strike.[78] His eye-narrowing disdain and thumbs-down gesture made a direct, if cryptic, proposition to the viewer. The spot lighting from below sculpted his features and hand but left the rest in deep darkness, further exaggerating the photo's intensity.

Both cover photos compel with their ambiguity. Michael Carlebach calls the "leering" laborer "thuggish," as his squint suggested a threatening assessment of the viewer; he could have been a Hollywood tough from a popular gangster movie. The "moody" portrait had been produced by Chicagoan Valentine Serra for an ad agency. Similarly, the Minneapolis police who seemed ready to shoot in any direction hardly resemble the forces of law and order. But each photo's dramatic, even cinematic, ambiance overshadowed any implied threat. The police could be cowboys in a western shootout. The workman in

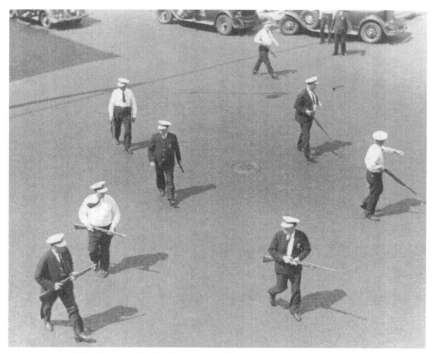

FIGURE 1.10 *This photograph of police with clubs and rifles at the ready appeared on the cover of* Newsweek, *on July 28, 1934. It is of the Minneapolis General Strike. The publication cropped out the policeman in the far right, making the photo more dynamic.* Newsweek *placed this caption on the cover: "Mopping Up in Minneapolis." Courtesy of the Minnesota Historical Society.*

cap was a thinking subject, even though a studio photographer constructed his image. The 1919 *Midweek Pictorial*'s cover photo of a miner let readers examine the worker's stance, clothing, and belongings; he was an object. *Newsweek*'s thumbs-down workman addressed readers directly. His implied subjectivity was new. The cover photos suggested multiple viewpoints toward labor, including a more engaged, at times respectful, relationship with the nation's workforce. *Newsweek*'s "bold" pictures and its openness to U.S. labor pointed to a new direction for news coverage of labor.[79]

Despite the massive 1934 labor upsurge, and the new ways of representing labor, corporations retained the upper hand. FDR's commitment to unions was limited; he told reporters that the Royal Society of Geography could promote workers' interests for all he cared.[80] And the NIRA failed to protect labor. In case after case, industry after industry, NRA boards sided against labor, even ignoring their complaints of being fired for attempting to organize.[81] The NIRA's deathblow came in May 1935, when the U.S. Supreme Court found it unconstitutional.[82] The AFL's timid attachment to industrial workers and its organizational ineptitude also kept the NIRA from being a potent lever for

change. Once mass activism failed to produce contracts, and even resulted in firings, workers fled the unions they had just joined. Of the 100,000 workers who flocked to autoworker locals from 1933 to 1934, only 20,000 remained at the end of 1934. Steel fared worse. The AAISTW retained only 8,600 members of the 100,000 who signed union cards from 1933 to 1934.[83]

Labor and its allies rebounded, however, with the 1935 passage of the National Labor Relations Act (NLRA), often called the Wagner Act after its sponsor, New York's senator, Robert F. Wagner. The Tammany Democrat rose from an ethnic, tenement-dwelling past, but retained his knowledge of the "haunting . . . insecurity" of workers' lives. He was an ally of Secretary Perkins, who had forced Wagner to wiggle through a hole intended as a fire escape when she conducted her factory investigations in the 1910s. As a New York assemblyman, he found Roosevelt "impossible," but as a U.S. senator, he became an outstanding proponent of New Deal legislation. Joining him were a range of corporate elite, Walter Teagle of Standard Oil, GE's Swope, Twentieth Century Fund staff, Taylor Society members, and AFL leaders, all convinced that America's economic recovery depended on labor's economic clout—with employers and with their pocketbooks.[84] The Wagner Act revolutionized labor's place in America by protecting the right to organize and institutionalizing state-administered rule-of-law unionism. Provisions in the act kept employers from dismissing or blacklisting workers who organized, and outlawed company unions and "unfair labor practices." The act established the National Labor Relations Board (NLRB), which decided what constituted a bargaining unit and arbitrated disputes between corporations and unions. Once a unit elected its representative, the NLRB certified the union, offering governmental oversight. The NLRA required corporate negotiation with workers' representatives.[85]

The Committee of Industrial Organizations (CIO) coalesced in tandem with these legislative and administrative developments. Lewis and Hillman feared a reprise of the earlier failures of 1919 and 1934 and pushed the AFL to capitalize on industrial workers' anger. Lewis, though suspicious of the state, had learned from the UMW's shifting fortunes during and after WWI that its hand influenced labor's successes. The former coal miner was given to oratorical flourishes gained as a youthful amateur actor, and he galvanized working audiences and captured the eye of the press. Lewis made his way to the top of the UMW in 1920, after beginning as an organizer a mere decade before. A master tactician, Lewis seized the main chance, often aggressively. Hillman, a Hart, Schafner, and Marx cutter during Chicago's 1910 garment workers strike, was known for his "sweet reasonableness," and worked with companies to arbitrate labor relations. The Yiddish-speaking immigrant learned from Progressives like Jane Addams, Florence Kelley, and Edward Filene, who sought industrial democracy—for Hillman this meant labor having "a right to a voice in the conduct of industry."[86] These men coordinated the CIO from within the AFL's confines. Joining them were Charles Howard of the International

Typographical Union, the ILGWU's David Dubinsky, and heads of four smaller unions. Leaders pooled resources and expertise to coordinate campaigns by industry, not craft, in steel, autos, and rubber.[87] The AFL professed a desire to reach these new sectors. But it reneged on its promises to fund the organizing drive in steel by $750,000; members failed to contribute even 1 percent of this sum. The rank and file, particularly rubber and autoworkers, rejected the federation's vacillation and wanted to move. The CIO ran with their energy.

In the aftermath of FDR's 1936 landslide, a victory based on labor's support, workers' discontent erupted in a series of strikes. Many used a new technique: the sit-down. When GM autoworkers sat down in the last days of 1936, they widened the scope of the sit-down phenomenon. In eight months, from September of 1936 through the following May, close to half a million Americans sat down on their jobs.[88] The sit-downs offered spontaneous redress for shop floor grievances, but most often workers were forced to strike to get the collective bargaining rights the Wagner Act ostensibly protected.[89] In October, some 9,000 workers struck, in January, 44,000 workers, and in March, four times that amount. In sheer numbers of job actions, there had never been so many strikes. Transit workers in New York, chocolate workers in Hershey, Pennsylvania, Chicago pencil makers and Detroit golf-ball producers, wet nurses, charwomen, lunch delivery boys, pie bakers, glassmakers, bed makers—all sat down to gain the upper hand with their bosses. CIO leaders struggled with being, in Sidney Hillman's words, "successful beyond expectations." CIO leadership had rarely organized these sit-down strikes, but neither did they reject them.[90]

The sit-down tactic pushed union drives forward, particularly before the Supreme Court affirmed the NLRA's constitutionality in March 1937 in its *Jones and Laughlin* decision. The tactic countered management's traditional union-busting techniques—techniques that companies had not abandoned despite the Wagner Act. Because company heads were loath to damage plants or equipment, labor foiled the violence that companies continued to employ. And by establishing their presence in the plant, workers defended against nonunion labor, or "scabs." The decision of FDR and several "New Deal" governors not to marshal troops against strikers made the technique feasible. The tactic also nurtured collective morale. The sit-downs did not always win union representation, as with GM, nor did they necessarily bolster public support. But workers across the nation, in all kinds of industries, told management and the general public that they were relying on themselves to obtain collective bargaining rights. It was, truly, the uprising of 1937.[91]

"The Central Instrument of Our Time"

Americans now saw labor's mobilization as they never had before. Technological changes, such as miniature high-speed cameras—particularly the Leica, Contax, and Ermanox—and high-speed film gave photographers

greater versatility in covering news events. Over the course of the decade "action" and "candid" photography became increasingly popular. Photographers in the press capital of New York City had borrowed these cameras from the Europeans by the late 1920s, but it was not until the mid-1930s that they came into more general use. Thomas McAvoy's and Sammy Schulman's candid photographs of FDR, made with such cameras, convinced editors to exploit this instrument.[92] Flashbulbs and light meters also became common in the 1930s. According to Shulman, "The flash bulb took the stiffness out of news photography. It removed the invisible clamps from behind the heads of the subjects of news pictures." Photos could be taken with less exposure time, in darker places, and importantly, the taking of the photograph was less intrusive; the news cameraman was no longer "a brandishing madman who filled places with thumping explosions of fire and smoke."[93] The tabloid's "candid moment" became common in the 1930s. Henry Luce, publisher of the nation's first photo magazine, *LIFE*, suggested a rationale: "Today I may not be in a mood nor feel the need to read the finest article about the Prime Minister. But I will stop to watch him take off his shoe." John Martin, who directed *LIFE* in its development, suggested the novelty of this style, claiming that photographic subjects had to be cajoled "into being candid, candidly cameraed."[94] Publishers did not universally embrace the Leica. Low-quality newsprint demanded the high-contrast shots of the Speed Graphic, so this camera remained the industry standard in news dailies until the 1960s. But *LIFE* and other venues increasingly created intimate, off-the-cuff renditions of reality, refashioning a casual attitude to the news.[95]

Photos of news events also reached Americans sooner—news photography was no longer "slow." In 1924 American Telephone and Telegraph connected New York, Boston, San Francisco, and Los Angeles with a telephotograph system that could transmit small photographs between these cities. But when the Associated Press (AP) perfected its wire transmission system for photographs in 1935, "for the first time in history the news picture and the news story rode the wires together." Editors of a 1939 text about news photography claimed that this "technological advance . . . has counted more than any other single factor in making photographic news reporting practical." A photo could be taken, developed, printed, and sent across the wires in mere hours. AP's president vouched that with wired photographs, the news could be told "more rapidly, more graphically, more completely, and with the honesty and fairness of the camera." Within two years portable transmission and reception systems made "picture reporting . . . available in every corner of the nation, however remote." The wires facilitated the growing visuality of American news and American culture.[96]

The AP president's notion of the camera's "honest and fair" appraisal of events offers another clue for the photo-driven 1930s. With the photo's ubiquity today, it's hard to imagine how fresh the joining of text and photograph still was. Reformers, advertisers, the rotogravure press, the tabloids, and magazines

had all integrated imagery and text. But photos were not as prominent within newspapers, magazines, and labor journals as they would be in the late 1930s. As late as 1937, a key event such as the Memorial Day Massacre, in which Chicago police killed ten strikers and sympathizers was represented in only one, or at most two, photographs in many metropolitan papers. Only Chicago, New York, and Washington D.C.'s papers carried multiple photos. Some major dailies, like the New Orleans *Times Picayune*, had not a single image.

Giving the photograph greater currency and salience in public consciousness and debate toward the end of the 1930s were New Deal agency experiments with the photograph, the bold joining of image and text by media companies like TIME-LIFE, and the increased deployment of photos by corporations and unions.[97]

The Depression provoked photographers to represent it and directed public attention to the photographic message. Radical photographers and filmmakers of the Film and Photo League participated in an international movement initiated in Germany in the 1920s. They depicted economic and social tumult in cities across the nation, though their efforts were little seen. Art and commercial photographers also felt compelled to capture the Depression's effects. Dorothea Lange, one of the 1930s most famous documentarians, described taking her first photograph of San Francisco's downtrodden. A portraitist, Lange saw a breadline from her window, recorded it, and then left her studio for the streets. Lange had no language to explain her photos. Photographers like Riis had photographed New York City's marginalized, and Lewis Hine had developed a decades-long record of America's industrial workers by this point. Yet the practice of "social photography," as Hine called it in 1909, this attempt to "sympathetically interpret" photography as a "lever for social uplift," was dormant.[98] The "documentary" photograph received its name only in 1938.[99]

The government harnessed and promoted this new style. FDR's New Deal agencies, particularly the Resettlement Administration (RA), later renamed the Farm Security Administration (FSA), employed photographers to chart the distress of unemployed and low-wage agricultural workers. Tugwell, the RA's head, had found photos an excellent pedagogical tool for the Columbia University economics courses he taught. There he had employed a former student, Roy Stryker, to produce a photo-heavy economics text. Tugwell hired Stryker to publicize the RA and FSA's work through photography. Stryker recruited well-known artists, including Lange, Walker Evans, and Ben Shahn, and handed cameras to relative unknowns like Russell Lee and Jack Delano. Under FDR many other government agencies also used photos to promote the growing welfare and regulatory state to Americans. This federal experiment in mass persuasion elevated the status of the photographic image in social and political discourse.[100]

The FSA's trove of photographs was featured in many special exhibitions, fueling new artistic forms. FSA photos appeared in a major exhibition at New

York City's Grand Central Palace. And Lange and her husband-collaborator economist Paul Taylor; novelist Richard Wright; and critic James Agee and photographer Walker Evans experimented with integrating text and image in, respectively, *American Exodus, Twelve Million Black Voices,* and the classic *Let Us Now Praise Famous Men. Fortune* and *LIFE* photographer Margaret Bourke-White and her husband Erskine Caldwell made their own photo book, *You Have Seen Their Faces.* Whether wild with stereotype, as in Bourke-White's work, earnest and emotional, as in Lange's effort, or cantankerous and self-conscious, as in Agee and Evans's project, the photo book emerged as an emblematic form of this period.[101]

Corporate America, attentive to the photographs' pull, employed them more than ever. In 1925 only 6 percent of news advertisements used photos, as magazines "advanced haltingly" toward their use. With the Depression, ads featuring photographs "won increasing favor." A 1932 George Gallup poll maintained that "readers . . . ranked photographs as more effective than other illustrations" as photographs conveyed "sincerity." Internal corporate publications, such as employee handbooks and newsletters, and public relations campaigns increasingly relied on photographs to impart their message. Managers believed that photography's "realism" addressed consumers' and workers' worries.[102]

New forms of photojournalism also propelled the photograph's pull in public discourse. Luce's TIME Corporation built a media empire by reimagining how magazines used photographs. Like Lange, who had no name for the documentary, the photographers and editors at *LIFE* fumbled to describe their mission. One *LIFE* photographer later claimed that he "was not thinking in terms of photojournalism" when he took pictures. "The term hadn't even come up yet." *LIFE* managers instead used the awkward "mind-guided camera."[103]

The labor press that reached the millions of Americans joining the AFL and CIO also became more photographic. In steel, hundreds of thousands of workers became unionists. Many must have leafed through the Steel Workers Organizing Committee (SWOC) paper, *Steel Labor.* By 1940, almost 400,000 Americans received it in their homes; two years later some 657,000 received it. Libraries also carried labor papers. SWOC alone distributed *Steel Labor* to some seventy-five colleges and universities in the first eighteen months of its organizing drive. Similarly, tens of thousands of New Yorkers read *New Voices,* the paper of New York's warehouse and retail workers union. When the war started the publication was sent around the globe to appreciative members. By the mid-1940s some 800 labor periodicals reached sixteen million unionists. If one or two family members read the labor press, posited one labor editor, such papers would reach a "third or better" of the American public.[104]

The labor press had long met trade unions' instrumental needs. These "house organs," in trade union editor and educator J. B. S. Hardman's words, were the union's "announcing device." Union papers also enlisted membership

in campaigns, providing the framework for a larger union movement. Newspapers legitimated the union to prospects who were frightened that joining such an organization could lead to their dismissal. And editors believed their papers were a "lone" voice for working Americans' concerns. As a "battle arsenal in fighting for what the unions are out to achieve," workers' papers "counter[ed] the controlled opinion of the daily press and its vested interests."[105] Union publications' significance to rank-and-file workers should not be overstated. Some members saw union newspapers as so much "preachin.'" One union official complained of "bundles of union papers gathering dust on the shelves of local meeting halls." Union papers, which often served as leaders' mouthpieces, could avoid dissent and larger social concerns, making them uniform and dull.[106]

Such caveats notwithstanding, labor papers drew corporations' attention. Whether as an act of symbolic might or because they thought the union message incendiary, one major corporation tried to keep *Steel Labor* out of its company town.[107] And corporations kept tabs on the labor press to remain up-to-date with the union movement and their own workforce.[108] Edward Bernays, public relations pioneer and advisor to some of the most successful U.S. corporations, believed that labor papers were a force to be reckoned with in the nation's "duplicating, crisscrossing and overlapping . . . web of communications."[109]

The CIO exploited mass cultural trends, and unions modernized their papers using imagery, particularly photographs, to do so. In a 1926 survey, union news editors believed that visuals would "spice" up their papers. By 1936, they did.[110] *Steel Labor* and *New Voices* reflected this trend toward editorial and visual sophistication. *Steel Labor* hired an outside journalist as editor, exemplifying the increasing professionalism of labor papers. It also offered cartoons, illustrations, and photographs supplied by unionists, the staff photographer, government agencies, and even the wire services. *New Voices* was also a professional, innovative paper. In keeping with the union's activist bent, members wrote copy and edited the paper. In an unusual move, warehouse workers even took most of the photographs. Other CIO unions sent their copy to Washington, D.C., for the *CIO News* editor to lay out. Les Orear, the *Packinghouse Worker*'s first editor, identified photography's significance: "The picture is the focus of the eye, and the eye leads the mind. . . . Everybody wants to look at the pictures." Orear bought photos from metropolitan dailies and commissioned photographers to create "action." In all three union papers editors used a tabloid style, seeking popular appeal.[111] This new labor journalism offered workers modern outreach tools aimed at their concerns as workers, as prospective unionists, and as citizens.

Nevertheless, some resisted photography. Suspicion toward the image had long roots in American culture, and was evident in Puritan revulsion toward Catholic icons. Perhaps as an outgrowth of this Puritan past, the late nineteenth-century *Nation* editor E. L. Godkin criticized the false intellectual entitlement and sensational mores of America's acquiring class. His essay "Chromo

Civilization" referenced the brightly colored chromolithographs that democratized image possession. Well after the nineteenth-century "frenzy of the visual" that revolutionized seeing in the West, with mass-production technologies like the chromolithograph and the photograph, one editor claimed that too many pictures "might pull down the integrity of the American press."[112]

Many in the news business considered photographs subservient to the word; they believed that photos spoke to the emotions and society's lower strata. Even at *TIME*, dissension persisted over the status, popularity, and possibilities of showing the news through pictures. Managing editor Ralph Ingersoll wrote that photographs were "regarded as a sort of mechanical sideline to the serious business of fact narration—a social inferior which, on certain regrettable and accidental occasions, may steal the show." Daniel Longwell, a photo editor at Doubleday, whom Luce hired to kick-start the use of photographs in his publications, wrote that when the "charming, affable and exceedingly intelligent" *TIME*'s editors were "faced with a picture other than a face," they "become insufferable stuffed shirts" who "start talking about *TIME*'s traditions." *TIME*'s admen found that businessmen also had reservations. Wrote one *LIFE* chronicler, "Many advertisers . . . had a low regard for pictures, they thought, scornfully, snapshots of babies and dogs would never hold the readers' attention long enough to make it worth the advertiser' dollar." Luce's advertising head P. I. Prentice concurred, believing that no "large segment of the American public wants to see a lot more pictures." The *Mid-Week Pictorial*'s limited circulation at the time, at "about 10,000 newsstand sales," seemed to confirm his belief "that the American public's tongue is not hanging out for just any picture magazine."[113]

The "stuffed shirts" were wrong. Americans wanted to "perceive simply" what James Agee called "the cruel radiance of what is." Photography enjoyed greater salience in public culture because of the variety of players who relied on it to shape perception. And Americans responded to visual news. The Cowles brothers, who ran the *Des Moines Register* and who founded *LOOK* in 1937, conducted opinion polling that showed circulation doubling with a Sunday pictorial supplement. Their evidence suggested that "readers were three to four times as likely to look at a picture as a news story."[114]

Photographers made the mass communication networks symbolized by the newsstand and the new mass magazines a common icon from this period. In 1938, FSA photographer John Vachon photographed a newsstand in Omaha, Nebraska. National magazine covers for *Colliers*, *Screenland*, *True Story*, and *Redbook* and picture magazines like *Look*, *Pictorial Review*, and *LIFE* vied for a viewers' attention, much as to a prospective consumer.[115] Many photographers showed Americans engaged in their increasingly visual world as embodied by *LIFE*. A National Youth Administration photographer showed two teenagers from rural, Quoddy, Maine. One talked on a shortwave radio; the other read *LIFE* in bed. Another government photographer caught a retiree

enjoying *LIFE* beside his car in a Florida trailer park, suggesting the picture magazine's appeal across the age spectrum. As the magazine's eponymous title implied, *LIFE* was everywhere.[116] So, too, were photographs.

Not all shared Agee's reverence toward the photograph. For Alfred Kazin. "the fascination of the camera represented, in a word . . . a kind of sick pride in its fiercely objective 'realism.' The camera did not fake or gloss over; it told 'the truth of the times.'" Kazin criticized the camera for fostering a "fractured" and passive relationship to reality. But, like Agee who saw the camera as "the central instrument" of this decade, Kazin believed in Americans' confidence in the ever more ubiquitous photograph.[117]

Longwell, a diligent employee, goaded Luce to get *LIFE* off the ground. "Minds are getting restless," he told him. Americans demanded a journalism in keeping with the times. In 1936, mere months before *LIFE* came off the presses, Longwell pushed a wavering Luce: "The quick nervousness of pictures is a new language as sure as Rudyard Kipling or Ernest Hemingway were. Or *TIME* itself."[118] *LIFE* editors soon turned to the "quick nervousness" of this new picture language to depict labor's mobilization.

Consuming Labor

LIFE MAGAZINE AND MASS PRODUCTION
UNIONISM, 1936–1942

The great revolutions of journalism are not revolutions in public opinion
but revolutions in the way in which public opinion is formed.

—ARCHIBALD MACLEISH

The photograph is the most important instrument of journalism since the
printing press.

—HENRY LUCE[1]

"Everybody's Doing It" headlined one *LIFE* magazine photo-essay showing
Americans sitting down on strike in March of 1937. The headline suggested
workers' glee as they fought to establish unions. Taking advantage of the
National Labor Relations Act (NLRA), workers in unorganized industries
took over the plants—or taxis, hotels, stores, bowling alleys, even movie
projection booths—where they worked, forcing employers to negotiate.[2] By
December 1936, rank and file's creative sally was in full swing. Thousands sat
down nationwide.

LIFE's cheery headline universalized, minimizing class differences and
translating socioeconomic issues into entertainment terms. In "Everybody's
Doing It," the "loafing" and "lolling" kitchen staff, replete with their chefs'
toques, grinned at the camera from Washington D.C.'s Willard Hotel; Perth
Amboy barbers perched in their clients' chairs; and "girl" strikers "slept snug-
gly" in a wooden buggy inside the National Pants Company. The lone disqui-
eting notes were photos of an "embarrassed" Memphis strikebreaker shorn of
her skirt by unionists but captured for the delectation of *LIFE*'s viewers' eyes,
and one of the Chicago taxi strike, in which drivers, arms upheld, stood under
the surveillance of a plainclothesman with pulled revolver. The photo-essay
also featured an Illinois driver whose roadster was mired in muck. He "sat
down" to pressure his town to upgrade its road. Here *LIFE* implied the tactic's
faddishness, one any citizen might imitate.

The publication's wide-armed embrace of labor's tactics was short-lived. By the time this photo spread appeared in March 1937, *LIFE*'s stance toward labor was turning cautionary. The magazine worried with increasing stridency about social strife accompanying labor's organization. But while *LIFE* rejected activism, it also championed stable, rule-of-law unionism and its rewards for the average worker. It admired labor's new leaders, seeing them as part of a new power equation in American life. *LIFE*'s ambiguous portrayal offers a window into shifting social and economic relationships in the late 1930s. *LIFE* recorded workers' enhanced participation in the American polity, but *LIFE*'s pictures did more: its representations recast working Americans into the nation's mainstream.

"A Penetrating, All-Seeing Eye with a Brain"

From the start, *LIFE* was a smash hit. A quarter of a million copies were sold on *LIFE*'s first day, within three months it sold one million copies weekly, and by 1938, *LIFE*'s circulation doubled. In 1939 editors thought that each issue passed through the hands of nineteen million readers. No magazine was read by as many Americans; it sold better than Hearst's chain papers. *LIFE* was read by the middle class more than by workers, and although *Collier's* and the *Saturday Evening Post* edged out *LIFE* in circulation, it had taken them decades, not months, to build such circulation. The radio and movies drew larger, more diverse audiences too. But as circulation numbers attest, and as the TIME-LIFE's media empire indicated, the company's product expressed American aspirations. *LIFE*, more than any other mass-market publication, brought the nation together in the mid-century.[3]

Henry Luce, *LIFE*'s publisher, saw magazines as a national "glue," arguing that "because we are a vast continental nation," the magazine "far more than the newspaper . . . [holds] the country together in a nationwide community."[4] This he knew personally. A child of middle-class missionaries, Luce had spent his youth in China, where he learned of America through the pages of *Ladies' Home Journal*, the *Outlook*, and mass-produced children's fare. As one biographer writes, Luce's unusual upbringing fed his quest for purpose. At the elite Hotchkiss School and then Yale, Luce interacted with an emergent American corporate aristocracy, which stoked class resentments and a drive to power.[5]

Luce's goal with *LIFE* was selling America to itself. Luce wanted to mold opinions, not just publish the news. Luce had an abiding faith in Americans' just character and generous spirit. America's prowess came from its technological know-how, its business mastery, and its national character, based on a disposition as innocent and sweet as the Fourth of Julys Luce remembered from his youth in China. He hitched his sense of the nation's beneficence to his arguments for U.S. global hegemony. Luce thought that if citizens rightly

understood America's greatness, they could undertake the nation's rightful role in world affairs.[6]

Luce intended his picture magazine to reflect the highest image of America, even if *LIFE* took regular excursions down the nation's seamier side. Photographer Carl Mydans observed, "We had an insatiable drive to search out every fact of American life, photograph it and hold it up proudly, like a mirror, to a pleased and astonished readership.... America had an impact on us and each week we made an impact on America."[7] Americans took note. Hollywood mogul Sam Goldwyn, historian Carl Van Doren, illustrator James Montgomery Flagg, and movie star Ginger Rogers wrote to commend *LIFE*. "All the newsreels on your knee," said Flagg. "*LIFE*," Rogers wrote, "makes still pictures move and talk." An insurance executive told *LIFE* he could not "resist the temptation" to buy "cheap illustrated papers." With *LIFE* he felt no shame. Photographer Elliott Erwitt remembered, "before television, [*LIFE*] was terribly important ... when it came out was a great event. You had to see it to see what was going on."[8]

Luce's publications were central to the growth of a fully realized, national mass culture. Luce fancied himself an opinion maker, but his status rested on business savvy. The magazine revolution had begun with the twentieth century. Publishers slashed magazine prices and attained mass circulation. They covered costs with advertising revenue as corporations peddled their mass-produced wares. Magazines were agents in this new consumer culture—they promoted it—and were themselves consumer products. Luce and coeditor, fellow Hotchkiss and Yale alumnus Britt Haddon, founded *TIME* in 1923 to match the tempo of modern times. They filched news from metropolitan dailies and, with some "slicing, trimming, flavoring, coloring and packaging," made it "more salable than ... real life."[9] Along with chain papers that had nationalized and standardized such as Gannett and Scripps, the wire services, syndicated columnists, and Sunday magazine supplements, *TIME* contributed to millions of Americans traversing the same reading terrain.[10] *TIME*, then *LIFE*, joined respectable journalism and sensationalism, presenting "timely" issues meant to ground Americans in a modernizing environment. In a 1939 speech, Luce told the Stamford, Connecticut Women's Club that TIME-LIFE was "exclusively devoted" to keeping "certain people widely and variously well informed" so that they could "understand where we stand between the mud and the stars."[11]

Luce wanted to be the first U.S. publisher of a picture magazine.[12] In Germany, France, and Britain photo magazines caught on in the 1920s. German workers even produced their own photo magazine, the *Arbeiter Illustrierte Zeitung*, drawn from Germany's worker camera clubs. Over the 1920s and 1930s magazines such as *Vanity Fair*, *Collier's*, and *Newsweek* experimented with photography's allure.[13]

Luce invested heavily in *LIFE*'s start-up and rearranged staff at *TIME* and *Fortune* to prioritize *LIFE*. He also hired top European photo editor Kurt Korff

to get *LIFE* off the ground. The company obtained rights to all AP photos, getting access to thousands of images from foreign and domestic sources. When AP's wire photos proved inadequate for story lines, the company hired additional photographers and stringers.[14]

LIFE's success required circulation and ad sales. Hence *LIFE*'s panorama displayed a shifting admixture of *LIFE* photographs and America's growing consumer culture embodied in advertisements. Like *LIFE*, the ads straddled mud and stars: with promotions for Ex-Lax, "The original chocolated laxative" that "gave a gentle nudge" for "when nature forgets," to the visionary "Cities of Tomorrow."[15] It could be difficult to discern a line between the two, as editors borrowed from advertisers' rhetorical strategies. Daniel Longwell believed that "LIFE came right out of the advertising world of the U.S.," and a Macy's ad executive refined the magazine's early design elements. Conversely, pollster George Gallup, then at the ad agency Young and Rubicam, thought that advertisers should "adapt" *LIFE*'s photojournalistic techniques. Other advertisers touted they so copied *LIFE*, "You can't tell ads from editorial pages."[16] Readers of *LIFE* encountered the changing world around them in photographs, but they also confronted the wonderful abundance of corporate advertising. Hence even as the magazine tackled social problems, it submerged readers in a world where consumerism's promise dwarfed all else.[17]

LIFE was not just a purveyor of consumerism, but itself a consumer product. *LIFE* hired hundreds of researchers, writers, and photographers whose work was shaped by editors to ensure product consistency. This mass production technique effaced any individual voice. Dwight Macdonald, a fellow Yale alumnus, who flirted with Trotskyism in the 1930s, and who fled the company after Luce insisted he rewrite an article on U.S. Steel's oppressive labor policies, described TIME-LIFE's insistent standardization:

> Like all machines it is vastly impersonal, its products bear the name of no individual author, appearing as pronouncements *ex cathedra* with the whole weight of the organization. . . . The mechanism is unparalleled in journalism. A corps of researchers gather the raw material from newspapers, libraries, interviews, phone calls, learned and technical journals, cables and telegrams from special correspondents all over the world. A corps of writers strain this material clear of all editorial bias and fabricate it into articles . . . [and] . . . picture captions. A corps of editors, headed by Luce in person, revise the finished product word by word, removing any last lingering odor of partisanship.[18]

Each week *LIFE*'s "omniscient," mass-produced voice shaped current events into a consumer good.[19]

TIME-LIFE products had branded personalities—*TIME*'s was that of a smart-alecky insider, and *LIFE*'s was more "relaxed." For Luce, *TIME* made "enemies," but *LIFE*'s "business" was "making friends." Begun in the same year

that Dale Carnegie's *How to Win Friends and Influence People* became a best seller, *LIFE* kept readers in the know like a next-door neighbor.[20] Luce combed over each issue to ensure the magazine's "CHARM," and management told staff to "definitely plot and plan" as "charm does not come naturally out of news." As Daniel Longwell reminded staff, "*LIFE* can lash out, but *LIFE* does like people." Luce concurred, writing in the margins, "Excellent!" and "Swell."[21]

Recognizing *LIFE* as a consumer product in an expanding mass marketplace explains *LIFE*'s embrace of labor. When Americans went to the movies or to a newsstand for a magazine, they wanted to be enticed by something new. Simultaneously, consumers sought good value for their money; their purchase needed predictability.[22] With *LIFE* Americans got a product in which high and low mixed, a product in which news was entertainment and entertainment was news, and a product that reflected their best aspirations. Luce infused *LIFE* with his pro-business views, his American boosterism, and his corporate liberal ideals. Upper-level management and writing staff shared his Ivy League credentials and elite milieu. But TIME-LIFE employed well-known dissenters. Only a heterogeneous staff could produce such broad market appeal.[23] Welcoming labor as consumers meant more sales for the corporation.

Of course it was pictures that made *LIFE* stand out. Luce believed that future historians, without "fumbling through dozens of newspapers and magazines," could get an accurate picture of that era by leafing through *LIFE*. Alfred Kazin had criticized Americans' naïve trust in photography's fractions of reality, but *LIFE* proclaimed this to be a strength. The magazine would "make an effective mosaic out of the fragmentary documents which pictures, past and present are . . . reveal[ing] . . . the nature of the dynamic social world we live in."[24] *LIFE*'s picture editor Wilson Hicks thought that the publication's photographs "entered . . . the world-wide battle for men's minds," and that they were full of "social, political or cultural report and commentary."[25] Luce believed the picture magazine appropriate for a new mass era. He feared "the great new physical reality in society—crowds" on "American beaches . . . in the movies . . . even the crowds advertisers yearn for—mass circulation." He believed that only if they had "a clearer image of itself and a broader sense of common referents" could Americans retain their democratic promise.[26]

LIFE transformed how photographs were used in mass-market publications.[27] Editors' sophisticated layouts of multiple images and text guided interpretation of photographs. Luce believed that by "publishing pictures in groups of 2 to 20" *LIFE* created synergy, in which "the whole will be more interesting and significant than the sum of its parts."[28] Juxtaposition and sequencing of photographs created relationships and implied narratives. Hicks called this "the third effect." Headlines, captioning, and often a larger narrative gave further meaning to *LIFE* photographs. *Words and Pictures*, photojournalism's "bible," written by Hicks, suggested an equal partnership. Words pin down the "emotional and cognitive values" of a photograph according to

another long-time photo editor; they "identify . . . explain relationships and elaborate."[29] LIFE editors called their stories the "significance paragraph," and LIFE's narratives were known for their tidy beginnings, middles, and ends. One biographer credits Luce with coining the term "photo-essay," as Luce believed that "photos, if properly chosen and sequenced properly, with minimal words, could communicate like literature."[30]

LIFE insisted that seeing conferred knowledge. Its most dramatic illustration of this formula came in a 1940 ad of a pair of eyes with an intent stare. The eyes spanned two full pages; editors tightly framed them for further emphasis (see pages 8–9).[31] The ad maligned the "afflictions" of other news organizations' "editorial vision." LIFE's "completely new editorial viewpoint" had its roots in its "penetrating, all-seeing eye with a brain"—the camera.[32]

LIFE told readers that they received "the full picture" on almost any subject. Luce promised this kaleidoscope in the magazine's prospectus. He liberally borrowed this formulation from employee Archibald MacLeish, populist poet, future Librarian of Congress, and yet one more Hotchkiss and Yale alumnus: "To see life: to see the world; to eyewitness great events; to watch the faces of the poor and the gestures of the proud; to see strange things—machines, armies, multitudes, shadows in the jungle and on the moon; to see man's work."[33] In seeing, Americans could know—just about everything. Seeing offered the panoply of human experience: awe, pleasure, excitement, sadness, pity, and edification. Who readers saw also constituted a totality:

> Hundreds, perhaps thousands of people contributed their photographic presence to the pages of this issue. French aristocrats, New York stock brokers, Montana barkeeps, gooney golfers, English judges at prayer and English ladies in the rain, babies, farmers, sailors, doctors, crowds, a high school class, a one-legged man, a strip artist, a bearded Russian, The President of the United States and the late Sarah Bernhardt.[34]

This long, heterogeneous list implied that the camera missed nothing.

LIFE signaled the publication's visual democracy and bold vision. As subjects before the camera eye, all were transformed into a homogeneous product; LIFE annulled distinctions of class, ethnicity, region, and education. Hollywood celebrities, corporate heads, and East Coast socialites were linked with Middletown, USA. That men and women of all social strata could own what the camera captured—if they plunked down a dime—contributed to LIFE's visual democracy.

Luce aspired for a "class" magazine, but he wanted a mass audience. Roy Larsen, who began as TIME's circulation manager in 1923, maintained that LIFE's competition, LOOK, was going for the "mass crowd," those who read the tabloid the New York Daily News. He "predicted" that LIFE "would be the class and the mass." Luce worried about catering to "the mob," but he dismissed a strictly highbrow, or even middlebrow, production. Staff understood

that photos spoke across classes: "the bank president and the truck driver." Luce kept *LIFE*'s price low to compete with other mass magazines. One study they commissioned showed that the "D" groups, the "great mass of working people," read *LIFE* at rates almost comparable to their competitors. Other class tiers read *LIFE* more than workers, but *LIFE* told advertisers that the "D" group mattered.[35]

Luce wanted Main Street readers and *LIFE* had middlebrow fare, but the publication featured the salacious, the celebrated, the cosmopolitan, and the carnivalesque.[36] *LIFE* reveled in sensationalist stories of gangsters, the feeble-minded and their offspring, country hicks, and New York socialites. *LIFE* showcased Luce's high-flown ideas—along with those of Walter Lippmann and Winston Churchill—but it was also a kiosk for consumer culture, a county fair for regional trends, and an after-hours club for the insalubrious. Luce included organized labor in *LIFE*'s imagined national community, a huge shift for magazine publishers. Luce's politics shaped *LIFE*, but his desire to reach the largest consumer base did as well.

Luce could seem businessmen's best friend and labor's enemy. In a 1929 speech the publisher claimed, "Business is essentially our civilization." He thought a business "aristocracy" could best lead the nation, and he denounced FDR's populism and pushed Republican positions in his publications.[37] TIME-LIFE staff criticized Luce's pro-business slant, and Dwight Macdonald called Luce corporations' "great mouthpiece."[38] Ralph Ingersoll, an editor that Luce had nabbed from the *New Yorker*, and who went on in 1940 to found *PM*, an innovative, photograph-laden tabloid, attacked *TIME*'s labor coverage. Ingersoll wrote Luce in the mid-1930s that *TIME*'s "well-fed, newly rich Yale boys" could see unions only as something "to be laughed at, baited, ignored." Two of Luce's associates, columnist Dorothy Thompson and promotions writer Laura Hobson, also believed Luce was insensitive to labor's difficulties.[39]

But Luce's personality, his commitment to abundance, and his staff's heterogeneous viewpoints kept his publications from a pro-business absolutism. Luce wanted his publications to be "*for* Private Capitalism," as he wrote to his staff in May 1937, yet he claimed his publications' objectivity lie in offending both right and left.[40] If Luce despised Roosevelt, he advocated a Keynesian economics with federal responsibility for full employment and adequate shelter.[41] His business publication *Fortune* included labor leaders in roundtable discussions of pressing economic concerns, implying that a technocratic, liberal consensus was possible.[42] Luce tried to curb antibusiness animus, but he employed "dissenters," "prima donnas," and "Old Bolsheviks." When conservatives red-baited photojournalist Margaret Bourke-White in the 1940s for her Soviet ties, Luce rebuffed their demands to fire her. And unlike other publishers, Luce didn't fight his employees unionization. His publications' market success indicated that a diversity of perspectives made good business sense.[43]

Luce's embrace of labor as full participants in American life was reflected in *LIFE*'s pages. *LIFE* did not present a "classless" world. It did exclude the under-privileged and their pressing problems. *LIFE* shrank from depicting the poverty endured by millions of Americans in the Depression, though it depicted poverty's ravages abroad.[44] And African Americans rarely entered the pages of *LIFE* except in stereotyped form; other ethnicities were also rarely represented.[45] But the American workers who joined unions—especially CIO unions—appeared again and again in *LIFE*'s pages, more than any other theme. In the publication's first year, *LIFE* presented labor's uprising in almost two-thirds of the issues, even if just in a captioned photograph. Organized labor was the subject of seven feature stories in its first full year of publication, only two of which criticized unions. Luce commended these lead stories, believing them a perfect rationale for *LIFE*'s "Big News-Picture Story of the Week." Labor's upheaval also appeared regularly in the "*LIFE* on the American News-front" feature, which published photos drawn from the wire services, "the most newsworthy snaps made anywhere in the U.S."[46] No other news story merited such attention.

LIFE distorted labor's story, minimizing workers' difficulties and their contributions to a growing union movement. But the magazine sometimes laughed with labor, as if readers were in on the fun of its activism, and it never baited labor as harshly as other mass magazines did. *LIFE*'s openness to unions was evident in its initial acceptance of the sit-down, and it applauded organized labor as a building block to American prosperity.

"The Softest Sit-Down"

When *LIFE* first hit newsstands in November 1936, the nation faced the first stages of a social and economic revolution with organized labor's sit-down strikes. *LIFE*'s early portrait of labor simultaneously celebrated and diminished its struggles. Two assumptions underlie its coverage: that corporations were beneficent, and that workers should participate fully in the American Dream. Such assumptions were often false—leading to the strikes covered in *LIFE*'s pages. However faulty the editors' assumptions, they explain the competing narratives, elisions, and unlikely emphases in the magazine's labor coverage.

Luce touched on labor in arguing that *LIFE*'s editorial stance was unique—a more personal and less political journalism. "The sit-down strike is not Labor Problems or Big Words between a dozen men you don't really give a damn about. In *LIFE*, the hot news of the sit-down strike is that people sit down! Or don't. So simple . . . So relaxing."[47] Editors advertised that labor's mobilization justified their mission "to see life, to see the world, to eyewitness great events." The sit-down offered "the most striking example of collaboration between

news and pictures." In this "new phrase in Labor's vocabulary," *LIFE* showed readers "what the Michigan Sit-Downers looked like when they sat, how they looked the first day—the twenty-ninth day—how they hung out of factory windows to chat with friends and family, how they slept, ate, shaved, didn't shave—in most people's mental memory there was nothing to draw on for the answers." The publication's "new visual data . . . became for all time part and parcel of its reader's personal horde of images."[48] In trading on photography's capacity to convey truth, editors suggested that photos established meaning through multiplicity. Absent from this rhetoric and from photo-essays was an inquiry into the reasons for strikes: What were workers' job conditions, salaries, and living situations? What were corporations' labor relations? Instead, *LIFE* gave readers a "slice-of-life" portrait of how workers shaved, how they sat, what they packed before they struck, and what wives did at home during a strike.

LIFE displayed its complicated attitudes toward strikes in its first cover story addressing the sit-downs, "U.S. Labor Uses a Potent New Tactic." Intimate and playful toward the strikers, the January 1937 photo story simultaneously asserted corporate power and bounty. The cover photograph showed Henry Ford's magnificent River Rouge plant, inspiration for modernist photographers such as Edward Weston and Charles Sheeler, who emphasized technology and industry's grandeur in austere, unpeopled images (Fig. 2.1). *LIFE*'s Russell Aikins instead posed Henry and Edsel Ford gazing calmly at one another.[49] Their bodies echoed the stacks and beams above. The tight framing of the plant and its owners integrated them into the industrialscape of jutting geometry and monumental architecture. Father and son were tied to industrial prowess. In a photo-essay about the sit-downs, *LIFE* first asserted the corporation's links to American progress with business's most beloved, homegrown characters. The article never explained why the Fords, who employed the world's largest private army solely to keep unions out, achieved cover status, particularly as the strike was at General Motors.[50]

In contrast to the alert and sober Fords, strikers wielded their "potent new tactic," while asleep. The feature photograph showed Standard Cotton Company auto supply workers "snuggling into wool stuffing" and nestled into separate corners of a room (Fig. 2.2).[51] Its disarrayed clutter made the space resemble the immigrant tenements of Jacob Riis's *How the Other Half Lives* taken a half century earlier. *LIFE* rarely employed such a documentary aesthetic that showed workers' dirty work sites. This aesthetic might evoke readers' sympathies, and it flew against the image of the well-ordered corporate landscape. But this voyeurism into working-class struggle also fed readers' personal "horde of images." Seeing the "other half" can also distance viewers. *LIFE* rarely represented middle-class subjects with such intimacy.[52] This photograph remade the factory into a cozy, disorganized nook, and it elided workers' conscious commitment to struggle—workers dozed.

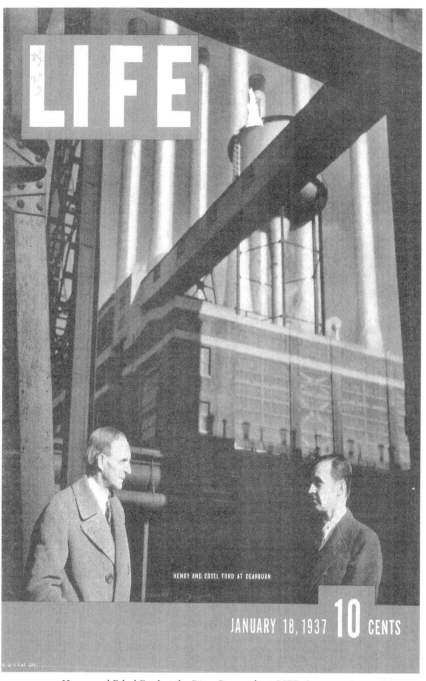

FIGURE 2.2 *Cover story photograph of United Auto Worker (UAW) sit-down strikers at the auto-supplier Standard Cotton Products Company. LIFE, January 18, 1937. Photo by William Vandivert. LIFE* used by permission of The Picture Collection Inc. Copyright 1937 and 1938 The Picture Collection, Inc., reprinted with permission. All rights reserved.*

Managerial power was unquestioned, and the photo-essay made corporate power concrete. A striking aerial photograph of Detroit's downtown filled half of the second page (Fig. 2.3). The photograph's tonal contrast—the vertically thrusting skyscrapers glowed white in the sun as they rose out of a darkened morning mist—imbued the motor metropolis with majesty.[53] Facing the Detroit panorama were full-body portraits of Chrysler Corporation's Walter P. Chrysler in heavy overcoat and fedora and GM's Alfred P. Sloan in Chesterfield and spats. Their stature paralleled Detroit's civic splendor, a splendor they had created. Sloan and Chrysler filled the page, and were cut out from their context and placed on the page's white background. Separating them from an identifying context exaggerated their monumentality. The text cemented the message of corporate prowess. "The lords of Detroit are men of strength and pride in their achievement. They organized their business with the greatest efficiency the world has ever known and the thing they made has rolled forth to change the character of every civilized country." The story invalidated workers' demands by celebrating the "generous . . . rewards" given by businessmen who "granted

A DETROIT *NEWS* PHOTOGRAPHER TOOK THIS IMPRESSIVE PICTURE OF DETROIT'S TOWERS AS THEY ROSE OUT OF AN EARLY MORNING MIST INTO SUNSHINE

DETROIT FACES ITS FIRST GREAT STRIKE

The Automobile Industry, which means Ford, Chrysler and General Motors, finds itself highly vulnerable

THE towers you see in the picture above are the youngest towers of any great city in the world. They belong to Detroit and Detroit as an industrial metropolis is only as old as the machine which made it great. Since the first assembly line began discharging automobiles, Detroit has known no faltering in its mighty march. Now it is the fourth city in the land, built in one generation by men who are still its rulers.

The lords of Detroit are men of strength and pride in their achievement. They organized their business with the greatest efficiency the world has ever known and the thing they made has rolled forth to change the character of every civilized country. Their rewards have been generous. They could be generous in return. They have granted some of the highest wages and shortest hours in the industrial world.

Good employers, the motor manufacturers have never had a serious labor strike, never fully realized what a perfect target they would make. Each company is a giant assembly line, fed by bodies, tires, windows, upholstery and all sorts of parts. A small minority of workers, by shutting off the supply of a few parts, could shut down the whole assembly line.

There are three big units in this big industry. One is Henry Ford, whose vast River Rouge Plant, which appears behind him and his son on the front cover, is apparently impenetrable by any union. Another is Chrysler, with which the United Automobile Workers have a working agreement. Third and biggest unit is General Motors. Against this industrial giant the union launched its attack and presently 80,000 of General Motors' 200,000 employes were out of work.

FIGURE 2.3 *UAW sit-down strike cover story showing aerial view of downtown Detroit and two "lords of Detroit," Walter Chrysler and Alfred Sloan, from* LIFE, *January 18, 1937.* LIFE® *Text: copyright 1937 The Picture Collection Inc. Reprinted with permission. All rights reserved.*

Chrysler Corp. is chiefly Walter P. Chrysler. **General Motors** is chiefly Alfred P. Sloan Jr.

some of the highest wages and shortest hours in the industrial world." The titans of industry posed themselves, in cameo shots, in magnificent portraits, and behind their desks exuding authority. *LIFE* displayed their earthly creations. Frequent full-page spreads of mills belching productive smoke for all America accompanied smaller photographs of strikers. This visual strategy tied corporations to American progress. Readers might have identified with the sleeping, relaxing, and playing workers, but America's path—indeed civilization's—lay with the nation's businessmen.[54]

"U.S. Labor Uses a Potent New Tactic" then offered two pages of how "twelve hundred strikers eat, sleep, and keep house." Photographs showed men hanging out windows, lounging, cleaning up in the Fisher One Body plant, and, as advertised—shaving (Fig. 2.4).[55] *LIFE* documented an important task of strike management, as organizers maintained morale by keeping strikers busy.[56] But *LIFE*'s focus on strikers at leisure obscured workers' job struggles. The horde of images about how workers "slept, ate, shaved" focused readers upon the banalities of struggle, but told little about workers' concerns, beyond a general statement that the UAW demanded action from GM on wages, hours, working conditions, and sole bargaining authority. The strikers existed in the confines of the factory when directed by their bosses, or as strikers who lounge, gossip, and maintain themselves. Even then they depended on their wives, who brought warm breakfasts to the factory.

The photo story's last pages joined hints of workers' activism to an inside look at a worker's home that exposed without elucidating. One page showed rank-and-file leader Bud Simons, leader of an initial strike against the November 1936 speedup, who spoke to a large group of workers. The headline, "Bud Simons Spends the Night Away from Wife and Children," located activism within a narrative that, as one historian suggests, "represents a threat to the social order" through the absence of the father (Fig. 2.5).[57] Across this page were five photographs of Hazel Simons, who "must be both mother and father" for their children. Evident in the photo-essay's details were impoverishment. One photograph of the Simons's daughters showed them tucked into bed. The caption read, "Lotus has a doll but the bed has no sheets." Sympathetic readers might have empathized with the Simons's material difficulties—though judgmental ones might have seen marks of the Simons's improvidence. *LIFE* did present the family as deeply concerned with domestic values like cleanliness. But Simon's absence from the home—along with the male neighbor who visited their home to iron—suggested unsettling possibilities as well. The "inside" examination of workers lives offered no substantive understanding of the issues compelling them to strike, beyond a lack of bedding.

The strike seemed less an economic action than a social occasion, with *LIFE* offering more on gender roles than economic life. In *LIFE*, workers appeared in the least self-directed poses, as they slept, hung out, or were cared for by their

wives. As fathers, men provided for their families. They looked uncomfortable within the home itself, strangers in women's domain.[58] Middle-class men sat with purpose at their desks or stared with directness at the camera. Industry's titans—the Fords, Chryslers, and Sloans—commanded respect at every level. Workingmen barely possessed themselves. The Americans who sacrificed their livelihood, and even their lives, for unionization were lost—*LIFE* depoliticized their actions.

LIFE's strike stories also transformed economic actions into a lot of fun. This lighthearted "everybody's doing it" approach to labor's activism was best represented in a March 22, 1937, story of a sit-down at Detroit's Woolworth Five and Dime. The story appeared in the section "*LIFE* Goes to a Party." Photographer William Vandivert captured a "feminine group" of "campers" and their "sit-down picnic" (Fig. 2.6).[59] The story told readers, "The newest type of camping excursion is attended not by children of the rich but by members of the working classes, takes place not in the great outdoors but in stores and factories where strikers lock themselves in, picnic among sales counters and assembly lines until some sort of settlement is reached."[60] For the perky Woolworths' workers, "sleeping on the counters was all part of the fun." Photographs showed strike denizens atop cosmetic counters and a cute threesome with their heads peeking out from their bedding. *LIFE* thought the salesgirls' favorite sport was sliding down the store's banisters, though girls also embroidered, knit, sang, and danced to stave off boredom.

LIFE's "sit-down picnic" showed what "fun" strikes were, and it promoted a gender binary by putting traditional women's activities to the fore. Women fed the store's canaries and themselves, did laundry and swept, and even made themselves up. A photo of one striker's valise allowed viewers to inspect her lingerie and toothpaste.[61] *LIFE* told readers that the girls broke dates to sustain their strike, but they kept "an eye on the future" by not forgetting to "prink," or maintain makeup and hair.

LIFE's levity toward the Woolworth strike indicated no menace from the unionists' collective struggle; indeed no struggle seemed to exist at all. *LIFE* reported the lone complaints though a class-conscious ditty written for this strike: "Barbara Hutton [troubled Woolworth heiress] has the dough, *parlez-vous*. How she gets it, sure we know, *parlez-vous*. We slave at Woolworths' five and dime, the pay we get sure is a crime." The jaunty song lyrics became packaged entertainment for *LIFE* readers. *LIFE* obscured class strictures by equating workers' activism with a party and by its gender focus: the fun that girls could have when they got together for a sleepover, girls who were, nonetheless, ever mindful of keeping up appearances. Moreover, the story's last pages, with its advertisements of long-limbed women striding beside Chrysler sedans, or jauntily swinging a golf club for Saráka, a concoction promoting "intestinal toning," displayed *LIFE*'s overarching editorial formula, a formula that interwove news stories into a larger consumerist fantasy (Fig. 2.7). The Woolworth

TWELVE HUNDRED STRIKERS EAT, SLEEP AND KEEP HOUSE . . .

FISHER BODY CORP. makes the bodies for all General Motors cars. Its plants at Flint, Mich., about 60 miles from Detroit, are two of the biggest and most vital of those closed by the strike against G. M. Workers sat down in both plants on Dec. 30 and have held them ever since. The pictures on these two pages were made at Plant No. 1, where two shifts of sit-down strikers keep 1,000 men in the plant at all times. Chief amusement is leaning out the windows to talk with friends and families. Homer Martin, president of the United Automobile Workers, announced that the strikers would not leave until General Motors agreed to a national conference on wages, hours and working conditions, with U.A.W. recognized as the sole bargaining agent for all employes.

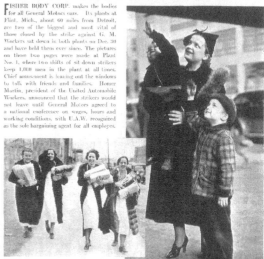

Strikers wives bring bread to the factory. Some, like Mrs. Mary Tignis at the right, also bring their children to wave up to Daddy on a top floor.

FIGURE 2.4 *UAW sit-down strike with sit-down strikers at GM Fisher Auto Body plant. LIFE, January 18, 1937. LIFE® Text: copyright 1937 The Picture Collection Inc. Reprinted with permission. All rights reserved. Photos by William Vandivert. Copyright The Picture Collection Inc. Reprinted with permission. Photo of women delivering bread, staff of LIFE © Bettmann/CORBIS.*

... IN GENERAL MOTORS' FISHER BODY PLANT NO. 1 AT FLINT

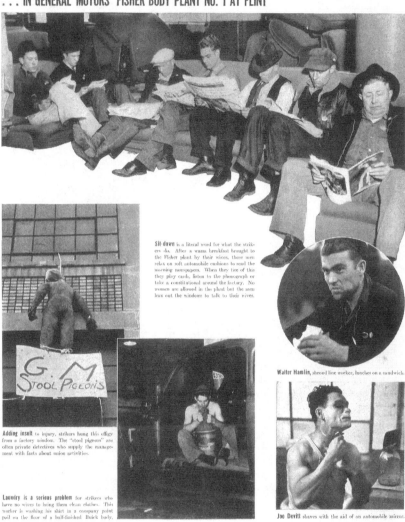

Sit-down is a literal word for what the strikers do. After a warm breakfast brought to the Fisher plant by their wives, these men relax on soft automobile cushions to read the morning newspapers. When they tire of this they play cards, listen to the phonograph or take a constitutional around the factory. No women are allowed in the plant but the men lean out the windows to talk to their wives.

Adding insult to injury, strikers hung this effigy from a factory window. The "stool pigeons" are often private detectives who supply the management with facts about union activities.

Laundry is a serious problem for strikers who have no wives to bring them clean clothes. This worker is washing his shirt in a company paint pail on the floor of a half-finished Buick body.

Walter Hamlin, shroud line worker, lunches on a sandwich.

Joe Devitt shaves with the aid of an automobile mirror.

BUD SIMONS SPENDS THE NIGHT AWAY FROM WIFE AND CHILDREN

BUD SIMONS is a torch solderer in Fisher Body Plant No. 1 at Flint. His job is to solder over the welds on the door frames of each Buick body as it comes along the assembly line. Bud has had his job for three years averaging seven months of work a year and getting between 90¢ and $1.10 an hour. He and his family live in a six-room frame house in Flint. They hold a lease on the house and some day, if they keep up the payments, they may own it.

When the United Automobile Workers Union began its drive in Flint, Bud was an early rooter. In December he became plant chairman. Since the strike began, Bud has spent every night away from his family. He can usually be found talking to the men in the plant or laying down rules about food, cleanliness, replacements and so forth. Mrs. Simons does her part in the daytime by working in the soup kitchen which sends in food to the sit-downers. But at night she must be both mother and father to her three children, as the pictures on the opposite page show.

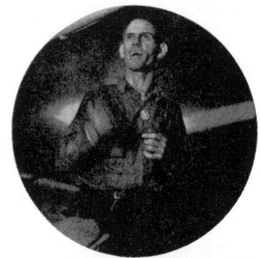

Bud Simons, unshaven after 80 hours in the plant, talks to the strikers.

A mass meeting of 1,200 strikers is held in Fisher No. 1 with Bud Simons *(left on platform)* presiding, an organizer speaking.

FIGURE 2.5 *UAW rank-and-file leader "Bud Simons" with Fisher One workers and women's auxiliary member Hazel Simons at home, LIFE, January 18, 1937. LIFE* used by permission of The Picture Collection Inc. Copyright 1937 and 1938 The Picture Collection, Inc., reprinted with permission. All rights reserved.*

At home Mrs. Simons dries Lotus after her evening bath.

Yvonne, Lotus and Beryle undress in the living room.

A neighbor, Bob Fickes, comes in to press his pants.

While her husband spends the night in the plant, Mrs. Simons prepares Lotus, her youngest, for bed.

Lotus Simons, aged 3, and Yvonne, 7, are abed at the usual hour (8:30). Lotus has a doll but the bed has no sheets.

DETROIT'S LARGEST 5-&-10¢ STORE PROVIDES A SIX-DAY CAMPING GROUND FOR THESE STRIKING SALESGIRLS

Life Goes to a Party

In the chief Woolworth store in Detroit
where 110 strikers are on a sit-down picnic

The newest type of camping excursion is attended not by children of the rich but by members of the working classes, takes place not in the great outdoors but in stores and factories where strikers lock themselves in, picnic among sales counters and assembly lines until some sort of settlement is reached. Youngest, prettiest, most prevailingly feminine group of such recent "campers" were the 110 girls in Detroit's main Woolworth store who went on strike Feb. 27, spent six days in the store. Camp broke up when the girls were granted a 5¢ per hr. wage increase.

Camp Song: *Barbara Hutton has the dough, parlez vous.*
Where she gets it, sure we know, parlez vous,
We slave at Woolworth's five and dime,
The pay we get sure is a crime,
Hinkey Dinkey parlez vous.

Sleeping on counters like this is part of the fun on the six-day Woolworth camp outing in Detroit. As in any other well-run camp, curfew is sounded at 11 p.m., after which no union men or reporters may enter. Right, three typical faces.

FIGURE 2.6 *Detroit Woolworth's strike, LIFE, March 22, 1937. Photos by William Vandivert. LIFE® used by permission of The Picture Collection Inc. Copyright 1937 and 1938, The Picture Collection, Inc., reprinted with permission. All rights reserved.*

ding down the banisters to the basement is a pop-
r sport with these funloving strikers at Camp Wool-
worth. Visited by their families and in touch with their
friends by telephone, the girls' spirits are excellent.

Doing their own laundry, girl campers hang their things
out on the store fire escape to dry off properly.

eeding the store's canaries every day is one of the camp
ores Woolworth campers cheerfully and efficiently
rform. All goods in the store are well cared for.

Sweeping up the debris which accumulates on the store's
floors is another daily task which the girls, run by com-
mittees of their own choice, take upon themselves.

This contented Woolworth striker is happily licking a
spoonful of ice cream between her various camp duties.
Note the curlers which she is wearing in her hair.

FIGURE 2.7 *Woolworth's strike, LIFE, March 22, 1937. Photos by William Vandivert.*
LIFE® used by permission of The Picture Collection Inc. Copyright 1937 and 1938
The Picture Collection, Inc., reprinted with permission. All rights reserved.

A good appearance is maintained by Woolworth girls who comb their hair in the women's rest room and do not allow their camping excursion to interfere with their primking. Although they kept the store's three telephones busy breaking dates the first day of the strike, they have an eye on the future.

Helpful literature like that displayed below finds few readers among the Woolworth campers. Most of them are sufficiently good-looking to make scholarly study of romantic technique unnecessary. Store counters like those below are kept shipshape throughout the strike.

HOW TO GET YOUR MAN AND HOLD HIM

10¢

one male at right has dropped the Woolworth Store to see rl friend. Later he goes out uys her a chocolate fudge sun— Like many another camper, ears curlers in her hair.

Camp equipment is this overnight bag holding lingerie and tooth paste.

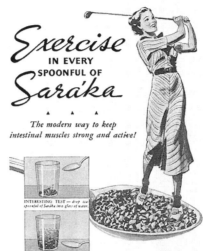

girls' play conjured the ease enjoyed in the advertisers' imaginary world of abundance, minimizing class distinction.

As Dana Frank describes, when these 108 women, many of them teenagers, struck, they "took on one of the biggest corporate and consumer icons of the century, with two thousand stores in five countries." They sought union recognition, but also raises, seniority rights, an eight-hour day with overtime, union hiring, and perks like free uniforms and laundering. The happy "campers" won almost all their demands, instigating union drives by sales girls in Akron, New York, East St. Louis, Tacoma, San Francisco, and Duluth.[62]

Treating the sit-down as a fad tamed and trivialized workers' activism. Organized labor's potent new weapon implied no more risk than pole standing or lindy hopping. One set of photographs featured Stanley Sumsky's "private sit-down strike" on an East River raft. Unconcerned with wages or working conditions, Sumsky offered a "gesture of self expression, an eloquent protest against an insensate world." Workers struck when "the Button King" was sued by his wife over a liaison with a blonde New Yorker. The workers, believing their employer had big pockets, took to the streets joined by his bitter wife. In another story, workers conducted "lie-down strikes" as they dodged tear gas. And a March photo-essay on a Detroit hotel strike showed the "softest sit-down," that of a waitress who enjoyed a room's mattress at the Hotel Book Cadillac. One "Speaking of Pictures" section profiled John Lewis "sitting down." *LIFE*'s visual pun on labor's new tactic brought the CIO's leader down a notch by emphasizing his formidable girth as he leaned back, perched perilously on two legs of a spindly chair.[63]

LIFE's lighthearted approach muted class hostility and portrayed management as sympathetic to labor's needs. A November 1936 photograph showed strikers at Bendix Products, an Indiana auto subcontractor. The strikers had over "300 games of bridge and poker in progress" after "friends sent in food, two accordions, [and] playing cards." Wives were concerned about their husbands' warmth, and "the company amiably agreed to keep the heat on." A story of a Grace Lines shipping strike showed workers' quarters with their "homey comfort, beds with 'clean white sheets and attractive covers'" and "heavy Turkish towels for the shower." Seamen reclined on deck in the tropical sun, whiling their time away reading and sunbathing. One photograph showed the seaman's work conditions, but it maintained that managers required "no scrubbing on hands and knees." Here *LIFE* calmed any concern readers might have by asserting corporate goodwill.[64] *LIFE* photo stories rarely explored working conditions, hours, or salaries; these remained opaque.

"One Sit-Down Strike Is Ended by Another" demonstrated *LIFE*'s obscuring of class relations. Walter Fry, owner of an automobile seat cover factory, "announced that he was sitting down too," to bring the job action at his plant to a close. Photos showed Fry conducting business from his cot, being served coffee by his secretary, and being welcomed back into the domestic fold by

female staff once the strike ended.[65] The photo-essay transmuted workers' job struggles into affection toward a boss-patriarch who mimicked his workers' own discontent. The picture story suggested that the powerful are in charge, the boss is really loved by his workers, and female workers in particular love to care for the boss.

LIFE erased women's class in favor of their pretty faces or gorgeous gams. In 1938 LIFE showcased a strike of San Francisco department store workers by printing a photo of the workers being carried off in the arms of adoring males. LIFE claimed that the "shopgirls, famous for their good looks, good manners, and good clothes, looked less like the popular conception of unionists on strike than college girls." A year later the magazine applauded striking chorines in their high heels and dancewear who "treated Angelinos to the prettiest picketing pictures of the year." The "ten beautiful legs" picketed not their employer, but the union for failing to protect their interests. Like the Woolworth's strikers, women's attractiveness made them newsworthy. In positing working women as objects of desire, LIFE blurred the boundaries of class. Like college coeds or Hollywood starlets, the women could be enjoyed; their activism entertained.[66] LIFE depoliticized women's activism, and it deployed women to make light of class frictions more generally.

LIFE's jocular approach excluded socioeconomic tensions, minimized how class shaped workers' lives on and off the job, and even reversed power relations. LIFE trivialized workers' demands and the dangers striking workers faced. Hidden by these stories was managerial opposition to unions, which could be fatal. Instead workers engaged in a fad so popular that the bosses got in on the act. LIFE's glib coverage embraced workers and wove them into the publication's gleeful portrait of America—here LIFE broke from the anti-unionism of other mass-market publications. But the publication did not maintain this easy acceptance for long.

"The Nation's No. 1 Problem"

By mid-spring of 1937, LIFE's growing preoccupation with strike violence joined a chorus against the sit-downs and labor activism.[67] The thrust of LIFE's photo-essays maintained that union activism led to civic turmoil. The TIME-LIFE archive is closed to researchers, so it is impossible to know exactly why LIFE's stance altered, though factors internal and external to LIFE offer some explanation. When LIFE began, the TIME-LIFE enterprises were in flux. Popular Front figures like Ralph Ingersoll and Archibald MacLeish initially shaped LIFE's editorial content. But Luce soon argued that he intended to support business. After Macdonald left the company, MacLeish also became increasingly critical of Luce magazine's editorial policies, and he departed.[68] Events external to LIFE also have bearing. With the "second hundred days" of

New Deal legislation, such as the Wagner and the Social Security Acts, conservative and business groups such as the Liberty League, the National Association of Manufacturers (NAM), and the U.S. Chamber of Commerce sharpened their attacks on Roosevelt. Most important were attacks on labor. Business leaders maligned the sit-down from the start, and by the spring their attacks were at a fevered pitch. Resolutions against the tactic appeared in the House and Senate in the same month that *LIFE* hardened its criticism of labor. The AFL, which sought to undermine the CIO, became a vociferous critic. By this point Luce had advised Ingersoll to tone down *TIME*'s labor coverage and had fought with Macdonald over his article on U.S. Steel.[69]

Strike violence dominated *LIFE*'s coverage of union activism by mid-1937. The first major photo-essay stressing disorder, "In Auto Strike Some Women Talk While Others Arm with Clubs and Break Windows of Chevrolet Plant," was published in February.[70] The article introduced readers to women leaders who "talked"; an English Labor Party MP who criticized auto "royalists"; and Cornelia Bryce Pinchot, feminist, progressive, and wife of former Pennsylvania governor Gifford Pinchot, who renounced her class privilege by telling Flint workers she abhorred corporations that employed Pinkertons. The English MP cut a lively figure with her upswept arms. What drew attention most were the repetitive upthrust lines of clubs that strikers carried. Additional photos showed the Flint "Women's Emergency Brigade" carrying clubs and "their standard equipment" of "red arm bands and red berets." After breaking factory windows, the women paraded, "still swinging" their clubs "defiantly." These two photographs, on opposite pages, had the women marching in strong diagonal lines toward the photo-essay's center, which showed a man breaking windows at Chrysler. In the first photograph the man's club lay by his side. The next shot captured the moment he broke the window. The simulated slow-motion shots further emphasized violence. Unionists had broken windows, but only after police shot tear gas into the plant.[71] *LIFE* included a photograph showing a striker carried out of the Fisher Body plant on a stretcher. In a recurring elision, *LIFE* discussed the strikers' violence, even though the unionist was the victim. *LIFE*'s conclusion returned to the women, claiming that after a day of strike support the Women's Brigade, "like the knitting women of the French Revolution," returned to innocuous, feminine pastimes. But here *LIFE* evoked Madame Defarge, the bloodthirsty knitter of Dickens's *Tale of Two Cities*, leaving open the possibility that these women weren't so innocent.

Sometimes *LIFE* employed its earlier playful tone, while condemning labor's tactics. In "Sit-Down Strikers Proclaim the Spirit of 1937," *LIFE*'s feature photograph showed a pugnacious group of strikers who beat snare drums and carried picket signs and even an effigy. The title evoked the "spirit of '76," making these men twentieth-century revolutionaries. *LIFE* lauded Lewis's leadership and CIO victories gained with "less bloodshed and bad feelings than have often occurred after one minor strike." But then *LIFE* parroted the

NAM and other staunch anti-unionists who galvanized public opinion against strikes when they told readers, "The sit-down is a forcible seizure of somebody else's property. As such it is clearly illegal under any concept of law."

LIFE editors closed with disquieting images and text that contradicted the article's earlier lightness. *LIFE* admonished: "The spirit of good fun which prevailed among . . . strikers . . . did not obscure the fact that the sit-down was the Nation's No. 1 problem." *LIFE* offered further censure from America's elite, among them a former Harvard University president, who maintained that legislation must be passed against the "armed insurrection, defiance of law, order and duly elected authority" that was "spreading like wildfire." Photos justified this condemnation: a large closeup showed "strikers' weapons," meat hooks and cleavers from Newton Packing Company workers.[72] The formidable cleavers glinted from the photograph's compositional center, a second cleaver stretched across the top third of the photo. The photograph was taken with a traditional "evidentiary" style. As photo historian Jon Tagg describes it, such photographs have a sharp focus throughout and a direct, eye-level vantage. Lit equally in all parts, there is no exaggeration, shadow, or high contrast, as detail is prized. Developed in conjunction with police practice, this style connotes extreme neutrality.[73] Such photos seemed to offer concrete proof of labor's transgressions and objectified business fears.

In contrast to *LIFE*'s depiction of strikes as unruly and violence prone, the publication invoked the state as the guarantor of law and order. *LIFE*'s title for a January 1937 photo story, "Governor Murphy and the National Guard Bring a Truce to the Automobile Strike," matched the story's visual argument—military force sustained peace. Murphy had called in the National Guard to keep the automaker from forcing the plant open. *LIFE* did not explain this to readers. Instead, the magazine printed photos of the forces of disorder, strikers who overturned automobiles. In contrast, the Guard marched in tight formation through Flint's streets, the tents of their "headquarters" laid out in repetitive geometric patterns. Both images suggested order. Murphy prevented the bloodshed often associated with strikes by persuading GM to negotiate with the UAW. One would have had to read with care to learn this.[74]

LIFE also contrasted the idealized stability of small, company towns with the anarchy stemming from labor activism. One story of an April sit-down by workers at the Hershey Chocolate Company visualized corporate munificence with a portrayal of a grandfatherly Milton Hershey and his nonstriking "loyal" employees on one page. Pitted against them, on the second page, were the ungrateful unionists who brought violence (see pages 144–145; the Hershey strike will be the focus of the next chapter).[75] Similarly, in 1938, *LIFE* devoted five pages to a strike at Maytag, the washing machine maker. "Troops Close Iowa's Maytag Plant: Washing Machine Company Had CIO Trouble" set Fred Maytag's Iowa hamlet, established in the late nineteenth century, as the scene for "CIO Trouble."

The feature story opened with the strike drama—photos of a stern Guardsman, with rifle held taut across his chest, whose job, according to the caption, was to keep "willing workers from working." *LIFE* suggested that labor—with New Deal support—limited Americans' freedom of choice, a slogan of business and conservative groups; in this case the National Metal Trades Association and the NAM were involved. *LIFE* introduced the corporation in its second-page subtitle "A Story of the Industrial Expansion That Has Made America Great." *LIFE* linked the nation's democracy with entrepreneurial capitalism. "Only in a great democracy could the Maytag Company have flowered from the seedling factory . . . into the sprawling colossus. . . . Only through such burgeoning in a thousand cities and towns could America have become the great industrial democracy it is today." *LIFE* co-opted the term "industrial democracy," a decades-long cry for labor's voice in the economic sphere and the polity and transferred responsibility of attaining such democracy to corporations.[76]

LIFE then drew readers into the life of the company's founder, who began his career as a delivery boy, had an egalitarian belief in "working" with "the boys," and developed a product so effective that proud farmers' wives placed them in their parlors. Here *LIFE* drew on the resonance of the self-made man, as they had with Hershey. Stories of social mobility advanced the ideal of a classless nation.[77] *LIFE* described the Maytag foundry as so "modern" and "organized" that workers "never had to leave their posts." The article gave no workers' comment on this feat of assembly engineering that left them toiling in the same spot for hours. Photos that may have come from the corporation's own promotional materials linked Maytag's rural and entrepreneurial experiment with industrial progress. Small images on the left showed Maytag's original factory, Fred Maytag on one of the trains that transported his goods, an assembly line, and a Maytag washer. On the right were panoramic photos of the huge, fourteen-acre "cradle of the Maytag plant," the trains that carried Maytag merchandise nationwide, and workers at the foundry. Lacking Detroit's grandeur, these photographs still suggested greatness. They extended past a single page, and the strong diagonal lines in two photos, and the birds-eye view of two others, contributed a sense of focused dynamism evocative of Maytag's personal rise and America's relentless opportunities. *LIFE* emphasized the beneficence of the recently deceased Fred Maytag, claiming that no Iowan doubted he had been a "just and considerate employer." The bulk of the photographs displayed his generous gifts to Newton, Iowa: the hospital, pool, YMCA, and outdoor band shell.

Workers' needs were little acknowledged or represented, making organized labor's insistence on a strike incomprehensible. But rural Iowan workers—those who had left their farms or nearby mines—had flocked to the CIO in the spring of 1937, and in a week's time established Local 1116 of the United Electrical Radio and Machine Workers of America (UE). They were irked by Maytag's

control, which pressured them to contribute to local charities, and even buy milk from particular vendors; intermittent employment also angered them. These Iowans made Newton a CIO town, organizing workers in local grocers and national chains like Montgomery Ward. But the company fought back in 1938, imposing a 10 percent wage cut, despite substantial profits. Inflaming the situation was the company's creation of the Jasper County Farmers and Taxpayers Association, which sought to keep strikers from obtaining any food aid during the strike, and Maytag's success at replacing the mayor and the police chief, who had sympathized with labor. When local unionists were jailed under WWI-era red scare statutes, a local judge promised to free them—but only if they accepted the company's wage cuts. None of this corporate-political alliance was visible in *LIFE*'s story; it noted only workers' dickering over "high wages." The magazine's account acknowledged that the conflict was less violent than typical, but it asserted that union demands threatened America's concord. The final page, headlined "Bitter Wage Dispute Turns a Tranquil Iowa Town into a Military Encampment," and the image of Iowa "rioting" with a single photo of a "picket belaboring a non-striker" suggested that unions brought disruption.[78]

After 1937 *LIFE*'s coverage of labor activism coalesced around the theme of violence. Under headlines such as "Fear and Faction Stir U.S. Labor," "Many Small Strikes Keep Labor Pot Boiling and the Police Busy," "Strike Pattern of 1938: Gas and Guns," and "Bayonets Keep Pickets at Bay in Bloody Harlan," readers could see police lugging strikers off to jail, strikers brawling, strikers immersed in teargas, and strikers beaten bloody on the ground.[79] The 1939 "Picture History of the Auto Workers Union" showed photos of "wild rioting." Strikers broke windows in one and another image had Ford thugs beating up UAW workers. Here *LIFE* depicted a well-documented case of corporate-sponsored violence. The caption noted only that Ford's security gave the UAW its "first big setback." The theme's consistency and accompanying photographs implied that disorder and violence inhered in labor activism itself.[80] *LIFE*'s limited attempt at explanation could be found in glancing references associating violence with union infighting or with labor's Communist Party ties. In this era of intense class division that *LIFE* itself documented, the magazine associated violence with internal conflicts, hiding corporations' role.

Embodying this intraclass war was a heroic laborer—a 1930s visual culture icon.[81] Traditionally representing workers' power and solidarity, in *LIFE*'s pages the "man with a gun symbolize[d] the violence which has ruled the steel strike." In *LIFE*'s narrative of "civil war," the battle was "not only of Capital against Labor, but of worker against worker" (Fig. 2.8). Titled "The Man with a Hoe Takes Up a Gun," the photo showed an armed vigilante standing at relaxed attention, his benign smile at odds with his upthrust rifle, full chest tattoo, and defined muscles. The picture's viewpoint magnified the vigilante's stature, and the limited depth of field heightened the focus on the Michigan steelworker who

LIFE ON THE AMERICAN NEWSFRONT: THE MAN WITH THE HOE TAKES UP A GUN

This man with a gun symbolizes the violence which has ruled the steel strike. It is a battle not only of Capital against Labor, but of worker against worker. It has raised afresh the gravest issue now facing the U. S.: Shall labor relations be governed by force or by law?

The man above, Leonard Olds, is a worker at the Newton Steel Co. in Monroe, Mich. He is one of thousands of armed vigilantes, special and private police who, siding against their fellow workers, have been patrolling strike-torn steel towns from Monroe to Johnstown, Pa. After three weeks, 70,000 workers were idle and steel production had fallen from 92% to 76% of capacity.

"We are engaged in a civil war," wrote Pundit Dorothy Thompson in high alarm, "and unless the struggle is returned to the arena of law, that civil war will extend itself into a class struggle which may destroy the American democracy."

FIGURE 2.8 *Armed vigilante for Newton Steel Company, Monroe, Michigan, in "The Man with the Hoe Takes Up a Gun," LIFE, January 28, 1937. Text: copyright 1937, The Picture Collection Inc. Reprinted with permission. All rights reserved.*

took up a gun against unions. Editors appropriated a long-held symbol of workers' strength, inverting it to represent a civil turmoil they connected to unionization. Corporate-funded vigilantism had been a trademark of steel's industrial relations since workers' rout at the 1892 Homestead Strike. Here "the man with a hoe," a title harkening back to agrarian revolutionaries, suggested a robust individualism countering collective union struggle. The story did explore how the Wagner Act intended to limit conflict and suggested that companies contributed to discord. Nonetheless, the photo story maintained that the Wagner Act didn't "compel unions to accept any responsibilities," following the contours of a public relations critique developed by the rabidly anti-union NAM. The result was a "class struggle which may destroy the American democracy." *LIFE*'s stories on steelworkers employed by Weirton or Wheeling Steel, anti-union strongholds, also employed an iconic heroic laborer. The magazine used the trope sparingly. This portrayal appears deliberate, suggesting labor's strength only when appropriately muzzled.[82]

LIFE's coverage associated labor—not corporations—with violence. In the Little Steel Strike of 1937, some of the bloodiest attacks by police and corporate security forces occurred at the Bethlehem and Republic Steel plants. Violence was worse at Republic Steel. Republic's president, Thomas Girdler, led the Little Steel contingent, and he admitted with brazen confidence, "Sure, we got guns." After the Little Steel turmoil, which led to eighteen deaths in Illinois and Ohio, *LIFE* readers were treated to four photographs of "Weapons of Industrial Warfare . . . Seen by the U.S. Senate" (see page 182).[83] The photos were part of Girdler's public relations campaign that implicated labor for violence. By printing these four evidence-style photographs, *LIFE* helped Girdler insinuate to the American public that unions, not corporations, caused the violence. Historically the United States has had the fiercest labor struggles of all Western industrial nations. As Stephen Norwood writes, in likelihood this was because it was the only "advanced industrial country where corporations wielded coercive military power," resulting in more "spontaneous violence."[84] *LIFE* rarely shied away from sensationalist fare—violence sells. Nonetheless, in *LIFE* unions were the harbingers of violence. The magazine ignored the state and corporations' roles in making confrontations violent.

When corporate- or state-sponsored violence was widely and publicly acknowledged, *LIFE* emphasized the camera's capacity to record violence, instead of focusing on the agents of that violence. One of the best-known photographs of corporate violence against workers was of the "Battle of the Overpass" outside Ford's River Rouge plant. Ford had long relied on an internal security force, whose head, Harry Bennett, had ties to organized crime and fascist militias.[85] *LIFE* printed four photographs showing Bennett's minions, who gave a "terribly professional beating" to UAW organizer Richard Frankensteen and others who leafleted the plant. One image showed a dazed Frankensteen cradling his head in his hands. *LIFE* relayed Ford's contention

that unionists provoked security and UAW claims that "Ford deliberately ordered its men to beat them." The step-by-step photographs of the beating, the bloodied Frankensteen, and the story's notice that the NLRB sided with the UAW upheld the strikers' story.[86] But "Pictures Testify at Ford Hearing" centered its narrative on the photographic medium as evidence, the basis of the product LIFE sold. This minimized attention on Ford company brutality. Ironically, Ford security forces chased photographers to break their plates, but LIFE forwent this anecdote, so germane to its own project.

LIFE's coverage of the 1937 Memorial Day Massacre, in which Chicago Police killed ten labor sympathizers in the first week of the Little Steel strike, also minimized the focus on corporate- and state-sponsored violence. Photos helped congressional investigators find Chicago Police and Republic security forces responsible for unnecessary brutality. In LIFE's photo-essay the slant was on the camera's capacity to record truth. "Senate Conducts an Investigation by Pictures" was the subhead to the story of the La Follette hearing, which established that police shot at strikers as they fled a mass rally, and then beat them mercilessly (see pages 176–177).[87] LIFE treated readers to eighteen film stills from a Paramount newsreel, one of the few publications to offer readers such extensive coverage. These stills, along with the portraits of the committee's chairs Robert La Follette and Senator Elbert Thomas poring over photographs, emphasized the camera's power to capture truth, as much as the violence that had occurred.

When violence was imputed to strikers, the camera "hid itself." Readers were drawn into scenes of mayhem, and action was put to the fore. And evidence-style photographs of the weapons of war documented violence as sharply as the knives in the pictures. In LIFE's rare explorations of corporate or state wrongdoing, on the other hand, the camera became the subject, which obscured the violence and its agents.[88]

LIFE's photo-essays also naturalized corporate violence against labor. An April 1937 feature article acknowledged the import of the U.S. Supreme Court decision that found the 1935 Wagner Act constitutional, suggesting that it helped unions in their "imminent fight" against Ford and textile manufacturers. In LIFE, the "well paid and treated" Ford workers incongruously fought for unionization. Henry Ford, however, resisted being told "how his business might be run." LIFE told readers that John Lewis threatened that Ford would "change his mind" once workers exercised their muscle, suggesting labor's brute force. The story conceded that Southern textile workers had tougher working and living conditions.[89] LIFE concluded that despite Wagner Act protections, textile workers would encounter a "strong opposition to organizing but also considerable precaution against strikes, like the machine gun nest shown at the right." For LIFE, machine guns that could kill workers were a "considerable precaution," and its labor relations equation made employers' extreme violence a given.

Page 21

Ford's police chief and personnel head is Harry Bennett, shown bleeding above in 1938. A demonstration of workers at Ford's gate turned into a battle between workers and police. In the ruckus, Mr. Bennett was knocked out. Four Communists were killed.

Mr. Bennett's work is cut out for him. Henry Ford depends on him to stall unionization. Though he sat lazily with feet on desk a few days ago, he is working hard to keep down workers' discontent, discourage agitators, gird the plant should the struggle turn to violence.

FORD AND TEXTILES
TO BE WAGNERIZED

The Wagner Act *(page 19)* forbids employers to discriminate against or coerce union workers. Labor unions move therefore under the protection of the law of the land in organizing workers, demanding union recognition. Two major subjects for immediate Wagnerization by CIO unions are Ford and southern textiles.

There are 100,000 workers and potential union members at the great plant that Henry Ford built on the shores of the River Rouge, near Detroit. Here, on two square miles, stands the biggest auto plant and the most remarkable example of large-scale industrial integration in the world: an immense auto manufacturing and assembly plant, a full-size steel mill, a glass factory, a rubber-tire factory under construction. Last year, Henry Ford made 1,000,000 automobiles. His workers are well paid and treated. The CIO will fight not for better pay but for recognition. This is exactly what Mr. Ford will not give. He does not want anyone but his general staff *(opposite)* to tell him how his business might be run. Mr. Ford proclaimed: "We'll never recognize any union." CIO's John Lewis retorted: "He'll change his mind." When the Wagner decision came, Mr. Ford changed his tune but not his mind. He said he never kept any worker from joining a union, hinted at a wage increase to forestall unionization.

Meanwhile, the CIO textile union faces the harder job of organizing the southern textile industry. Scattered over ten states and therefore hard to organize, are 1,200 textile mills with 400,000 unorganized workers. The South's low wages, plentiful labor supply and powerful local prejudice against anything smacking of radicalism, has attracted many textile mills from the north. Though protected by the Wagner Act, CIO textile union knows it will find not only strong opposition to organizing but also considerable precaution against strikes, like the machine-gun nest shown at the right.

A strange steel structure has been erected at the Bemis Mill at Talladega, Ala. It is peaceful enough now but guards could sit in safety behind its steel plates and poke machine guns out through its triangular openings. If the CIO textile unionization drive becomes serious, violence might break out, machine guns and guards be necessary.

FIGURE 2.9 LIFE *discusses potential violence resulting from CIO campaigns for union recognition in "Ford and Textiles to Be Wagnerized," LIFE, April 26, 1937. LIFE* used by permission of The Picture Collection Inc. Copyright 1937 and 1938 The Picture Collection, Inc., reprinted with permission.*

The photo-essay went further, domesticating corporate violence as a labor relations strategy. In its first page, top managers appeared seated around a table for lunch, while another photo had Henry Ford "tinkering" with his watch collection. In another picture he greeted a one-legged African-American groundskeeper at his Georgia estate. *LIFE*'s caption,

Ford's message to his employees, was "We're all workers together." *LIFE* humanized Ford, and suggested class and racial harmony (Fig. 2.9). Across from these tranquil scenes *LIFE* showed corporations readying for battle. The top two photographs were of Ford's Harry Bennett. In the first Bennett was bloodied from an earlier battle with unionists at Ford's plant gates in 1934. Mentioned, but not depicted, were the four "Communists" who were killed. The second photograph had Bennett at his desk, talking on the telephone. The caption told readers that Bennett was "working hard to keep down workers' discontent, discourage agitators, [and] gird the plant should the struggle turn to violence." The textual assumption was that violence came from the outside, and Mr. Bennett would contain it, an assumption at odds with the facts. Below these photographs sat another photo documenting textile's unionization; it showed "a strange steel structure" at the Bemis Mill in Alabama. The structure was designed to allow guards to "sit in safety" and "poke machine guns out." According to *LIFE*, "if the CIO textile unionization drive becomes serious, violence might break out, [and] machine guns and guards [might] be necessary." This caption asked readers to suspend sympathy with the workers. Machine guns, guards, and the ensuing violence were "necessary." More extraordinary than the "strange steel structure" for gun-toting guards, was its depiction. Three little girls lounged against its base. Their bared knees, short skirts, and innocent expressions negated the structure's purpose. The story sanctioned violence by asking readers to consider violent repression an appropriate response to unionization. Simultaneously, imagery and text tamed the vehicles of that violence for *LIFE* readers so they would not question the potential shooting of workers.

A limited response by labor and by readers suggests *LIFE*'s message got across, though it is difficult to know for certain given the company's closed archive. Labor seemed to lose patience with the Luce publications over time, though there is no direct evidence about *LIFE*. *Fortune*'s focus on violence annoyed one CIO publicity staff member enough to write in protest. Cedric Fowler responded to *Fortune*'s statement that "peace has not characterized past drives." He wrote to *Fortune* staff, "The two largest organizational drives (textile and U.S. Steel) have been free of violence. . . . It is also true that the CIO much prefers to secure collective bargaining rights without strikes. . . . When violence does occur it is invariably promoted by the companies."[90] When *Fortune* staff sought out a response from John Lewis to Thomas Girdler's charges of union anti-democracy, in 1937, Lewis's secretary, Ralph Hetzel, wrote with asperity that Lewis might at some point "write an article suitable to the importance of your pages." Lewis's ego was large, but CIO staff seemed stung by TIME-LIFE's anti-unionism. Similarly, letter writers to *LIFE* indicated dissenting views. One Knoxville, Tennessee, *Journal* staff photographer sent a photo, titled "Alcoa Affair," to the "Pictures to the Editor" section. It showed police shooting directly at strikers. The photographer's text indicated

that the shooting left two dead. Similarly, in 1939, a Germantown, Pennsylvania, woman complained to *LIFE* editors that her patience had become "practically threadbare" with *LIFE*'s "news" of labor troubles during strikes. She protested, "Do you suppose some time you could tell us how the strikers feel about their own battles instead of how *we* are supposed to feel?" She pointed out that photos showed nine police officers ganging up on an unprotected striker. She criticized *LIFE*'s homogenizing voice. *LIFE* titled her letter "She Speaks for Herself," capturing her grievance, but also isolating her. Without archival access, it is impossible to know whether editors muzzled public response, whether readers didn't care enough to write, or whether there were too few working-class readers to respond. But letter writers indicate an awareness of *LIFE*'s power to shape perception, a perception they did not always share. This correspondence to *LIFE* offers only slight clues to how *LIFE*'s arguments were understood by labor and the public.[91]

Just Like in the Movies

LIFE condemned labor's tactics, but it never repudiated organized labor. Indeed, *LIFE* represented organized labor and its leaders, particularly CIO leaders, as the face of the future in an affluent America. Here Luce's view came through. Luce proselytized for American freedom, equity, and affluence. *LIFE* was his platform to sell this faith. For Luce, American prowess lie with the nation's productive capacity: "At least two thirds of us are just plain rich compared to all the rest of the human family, rich in food, rich in clothes, rich in entertainment and amusements, rich in leisure, rich." Luce's faith in the nation's democratic freedoms, "the faith of a huge majority of the people of the world," including the nation's free economic system, fed his internationalism. *LIFE*'s first editorial, "The American Century," advanced Luce's argument for American global hegemony. In yoking scientific progress, abundance, and democratic freedoms, Luce meshed America's twentieth-century quest to reorganize itself socially to accommodate the nation's colossal productive capacity with its democratic creed, and then globalize it.[92] Luce's conviction that labor should enjoy a high standard of living, that its representatives should have some voice at the work site and in the nation's political sphere, allowed his publications to reimagine a new world for American workers and their unions.

Mass culture had incorporated workers as subject and audience since the mid-nineteenth century. Horatio Alger's *Ragged Dick* told the story of a lowly shoeshine boy whose initiative and morals propelled him upward, and the book's popularity made Alger's name a stand-in for rags-to-riches American success. Working-class audiences jump-started the movie industry at the century's beginning, and though moviegoers thrilled to gossamer romances spun through with consumerism, in the 1930s they responded to scrappy workers

who challenged social hierarchies with guns and sex. Advertisers even added workers to their consumer imaginary in the Depression. To appear populist, these prophets of consumerism, long loath to acknowledge workers or production, now represented those lower on the socioeconomic scale in "advertising in overalls" campaigns.[93]

Like earlier mass culture forms, *LIFE* transitioned America from a consumer society that eluded many workers to a culture of affluence that embraced workingmen and -women. In *LIFE*'s tales of abundance, workers rose as a class with their union's aid, not just individually as in the movies. *LIFE* repackaged workers' earlier demands for an "American standard of living" into the idiom of mass consumption. Its photo-essays enjoyed the resonance of earlier tales and myths that saturated mass-cultural production: tales of rags-to-riches, of industriousness, of heterosexual romance, and of paternal, small-town relations. *LIFE* photo stories borrowed from these narratives and translated America's complicated class transformations into vital black-and-white photos that were hard to dispute.

In multiple stories from 1936 through the advent of WWII, workers participated in America's promise. *LIFE* narratives typically spelled out this promise in private terms, such as the nineteenth-century ideal of hearth and home or the twentieth-century mass-cultural rhetoric of heterosexual play. As in the strike stories, *LIFE*'s workers lacked autonomy and self-direction unless in the private sphere. If at work, the bosses directed them—though workers rarely labored in *LIFE*. And union leadership directed workers' political and economic aims. *LIFE* celebrated union leaders as mediators who ameliorated labor relations and stabilized the economy, giving them a positive face then rare in mass media. Implicit in *LIFE*'s acknowledgment of labor's political and economic ascent was a critique of earlier social and economic difficulties—yet despite the documentary's authority in this period, *LIFE* did not represent workers' difficulties. Instead, *LIFE* posited corporate heads, even those who fought unions tooth and nail, as partners working with unions to better workers' lives.

"The Common Steel Worker Gets His Pay Raised to $5 a Day" introduced readers to Andy Lopata, whose world was to be revolutionized by the steel industry's new wage and hours standards. *LIFE* sent Alfred Eisenstadt to the heart of Pennsylvania steel country to photograph Lopata and his wife in their home. Eisenstadt, an internationally acclaimed photojournalist, was known for his celebrity and political portraiture. For this assignment he took his signature portraits and documentary photographs to be woven into a *LIFE* story.[94] The feature photograph was a closeup of Lopata (Fig. 2.10). His begrimed, sweaty face marked him as a worker, though his teeth—perfectly white, perfectly straight—strong jaw, and crinkled eyes idealized him. Lopata could be a Hollywood leading man. Lopata's grin and his outward-looking gaze announced his better future. The camera's upward tilt toward Lopata paralleled *LIFE*'s story

LIFE

VOL. 2, No. 11 MARCH 15, 1937

THE COMMON STEEL WORKER GETS HIS PAY RAISED TO $5 A DAY

This one is Andy Lopata who worked seven years in the Jones & Laughlin plant at Aliquippa, Pa. for $3.80 a day. There are 500,000 like him in steel mills from Bethlehem to Chicago.

Page 17 LIFE Mar. 15

FIGURE 2.10 *Former Jones and Laughlin worker Andy Lopata in "The Common Steel Worker Gets His Pay Raised to $5 A Day," LIFE, March 15, 1937. LIFE® used by permission of The Picture Collection Inc. Copyright 1937 and 1938 The Picture Collection, Inc., reprinted with permission. All rights reserved.*

of steelworkers' upward-looking fortunes. The photograph's cropping, which showed only Lopata's face and pulled him from his daily context, universalized Lopata's gain to all workers.

Editors then described a typical worker's day, a common *LIFE* layout strategy: Lopata typified the common worker, and multiple photographs delineated the totality of his, and hence any workers', life.[95] In "After Eight Hours at the Steel Mill the Common Worker Comes Home Dirty, Tired," seven photos outlined his day from morning until night. Sent to work with a dinner pail by his barefoot wife, Lopata headed off for the three-mile hike as wife and child stood on the porch; at night his wife bathed him outside by the water pump. At

day's end, a photo showed Lopata "flopp[ed] down" on the grass, catching his breath after work. A final picture showed him and his wife heading to Sunday services, concluding the common workers' average week.

LIFE captured important elements of an average worker's day, while eliding Lopata's work and activism. Only one photo showed Lopata laboring. Most photos showed the "common steel worker" cared for by his wife or at leisure. His single act of self-direction came when he walked to his job. LIFE also ignored Lopata's sacrifice for the CIO. LIFE told readers that steelworkers' raises were due to "peak production, the CIO, and the far-sighted statesmanship of steel." But rank and file's contribution was crucial to CIO achievements. Steelworkers had flooded into the Steel Workers Organizing Committee (SWOC)—giving the notoriously anti-union industry pause. Laborers received raises at Jones and Laughlin Steel and Republic Steel because the companies were fighting unionization. Lopata himself never received a raise—Jones and Laughlin had fired him for joining the CIO. Such hardball tactics were legion in steel industry regions. Carnegie-Illinois Steel had refused protection to the nation's own secretary of labor, Frances Perkins, warning that it might not be safe for her to address workers there. In Aliquippa, Jones and Laughlin's base, the company enjoyed such impunity that it jailed a union activist in an asylum. Unionists called Aliquippa the Little Siberia of America—this was Lopata's home. When LIFE's story appeared, six months after Eisenstadt took the photographs, Lopata's sole income came from the Works Progress Administration (WPA). Readers would have had to read closely to learn of his firing. And this detail was ensconced in a narrative of corporate beneficence that ignored the draconian labor policies of the remaining steel companies who refused negotiation.[96]

For LIFE, America's ruling elite—the statesmanlike "steel masters," their wives, and labor's representatives—altered steelworkers' fate.[97] LIFE's CIO was one man: John Lewis. The magazine's seven candid portraits of Lewis, which spanned the top of two pages of the photo-essay, had Lewis posing, looking directive, pensive, and even entreating. Powerful men attracted Luce, and this "leading candidate for man of the year" fit the bill as a photogenic member of a new national elite. LIFE's focus on Lewis, however, gave strength to critics who found him a dictator.[98] Below Lewis's photos lie seven studio portrait bust shots of corporate leaders. LIFE contrasted the single leader, whose strength lay in his capacity to persuade the masses, with the composed corporate heads, whose inner stability matched their place in American society. The headline told readers they were the "Steel Masters Who Made Peace" with Lewis and his CIO. But only Myron Taylor and Benjamin Fairless from U.S. Steel and its affiliate Carnegie-Illinois "made peace" by negotiating with SWOC.[99] The other three corporate heads were virulent anti-unionists. Jones and Laughlin's president had illegally fired unionist Lopata. Ernest Weir had fought unions for decades. Tom Girdler, soon to be elected president of the American Iron and

Steel Institute, pledged to hold the line against unions, with bloody conse-
quences for Midwestern steel workers. Also pictured were General Electric's
Gerard Swope, longtime corporate liberal who had signed with the United
Electrical Workers, and Walter Chrysler, who negotiated with the UAW only
after his workers struck.[100] The largest portrait on the page was of a fur-clad
Mrs. Myron Taylor, who, after seeing "John L. Lewis stalking about the lobby
of Washington D.C.'s Mayflower Hotel," urged her husband to "Bring him over
here."

This curious mix of portraits illustrates *LIFE*'s circuitous logic, a logic that
obscured class inequities while imagining society in domestic terms. The
photo story gave the masters of labor and of industry equal time, but hid the
activism of hundreds of thousands of workers supporting Lewis. And *LIFE*
depicted competing economic interests and labor relations as if they were a
social tiff that could be resolved with a dash of feminine wiles. As Irving
Bernstein notes, the "encounter" between Lewis and the Taylors "exploded a
bombshell in the Mayflower dining room." Lewis had charmed Mrs. Tay-
lor.[101] But *LIFE*'s narrative had labor negotiations turn on the personal and
on the female, with Taylor heeding his wife's advice and coming to terms
with Lewis. *LIFE* ignored Taylor's political and economic rationales for nego-
tiating with the CIO. Instead *LIFE* celebrated a host of corporate heads, all
equally beneficent.

What did unionists want? Here *LIFE*'s story turned on higher wages and
middlebrow aspirations. Along with the photos of Lewis and the corporate
elite appears a small photo of machine lathe operator Bill Blair at home in his
Homestead "cottage." The family was seated in the parlor, and Blair's daughter
played the piano for his family's enjoyment. Their circumstances could not
make up for the images of scarcity visible in Lopata's story: the barefoot wife,
the washing off outside, the unpaved road to church. Nonetheless, the Blairs
suggested a goal of middle-class, family-oriented leisure and enlightenment
that Lewis and the steel masters could attain for workers.

The photo-essay's conclusion reasserted corporate might. *LIFE* editors
reminded readers that the steel master's domain was the American economy's
base, as "autos, cans, gadgets keep furnaces boiling." As with the "Auto Lords" of
Detroit, *LIFE* visually reminded readers of the steel industry's productive power
with two pages of photos taken by corporate photographer Margaret Bourke-
White (Fig. 2.11).[102] Bourke-White, who studied with early modernists Clarence
White and Ralph Steiner, began as a freelance commercial photographer, and
within several years was the star photographer at *Fortune*, and then *LIFE*.
Bourke-White added her trademark flair, monumentalizing industry and
giving it a mysterious and burnished aura. In the large photographs the plant's
darkened interior contrasted with light from the precisely placed windows and
the fires of production. They were taken from below, in Bourke-White's favored
"caterpillar" vantage, which enhanced the photos' drama through a vertiginous,

1 The man in this picture is shoveling limestone into an electric furnace at Republic Steel's Massillon, Ohio plant. If you looked through the spout (*left*), you would see ten tons of iron being boiled into high-grade steel.

2 Steel cooks in this furnace from three to five hours. The two vertical bars overhead are electrodes through which passes a current, producing a heat of 3,300° F. When the steel is ready to tap, the floor beneath the spout is lifted and a giant ladle (*right*) is lowered.

AUTOS, CANS, GADGETS KEEP FURNACES BOILING

Before 1930 the bulk of steel's 55,000,000 tons a year output went into buildings, rails, transportation. Railroads alone consumed 25% of all steel production, buildings another 30%. Today both are below normal with railroads at 11%, buildings at 13%. Steel's current boom is based on other, newer factors in U. S. life. First of these is the startling skyrocket of automobile sales, especially since the introduction of the all-steel "turret top." At left, through a maze of mammoth gears and flywheels, you see one of the titan die presses which stamp out 90 turrets an hour from sheets of steel plate. Autos, which once consumed 16%, now consume 25% of all U. S. steel. Another factor is the ever-mounting popularity of canned foods and beverages. Beer in cans now keeps many a furnace boiling day and night. To Europe goes boatload after boatload of U. S. steel, as foreign nations vie in furious armament races, compelling

Page 20 LIFE Mar. 15

FIGURE 2.11 *"Autos, Cans, Gadgets Keep Furnaces Boiling,"* LIFE, March 15, 1937. LIFE ® *Photos by Margaret Bourke-White. Copyright The Picture Collection Inc. Reprinted with permission.*

upward angle. Below were three photographs of the products that kept "furnaces burning."[103] The text described a transformation in industrial production: from steel for industry in the first industrial revolution, to steel for consumer goods. This conclusion reflected the story's initial concern with the common steelworker, as he would have to buy autos, cans, and gadgets for any economic

3 The furnace is then tilted up by an electric hoist and ten tons of molten steel come gushing out like liquid sun through the spout into the brick-lined ladle. When drained, the furnace is set down again, reloaded with iron ore and scrap for the next heat.

4 The ladle is swung out over a row of ingot molds on flatcars and drained through a valve operated by the man on the extreme left. When cooled, the ingots are sent to the rolling mill to be rolled into plate and bars for autos and gadgets.

their light industry manufacturers to turn abroad to have their orders filled. Hence an export market better than any since 1929. Stainless-steel furniture, household trimmings, home and office gadgets such as represented by the chromium steel pots and goblets on this page consume still more tonnage of fine-grade alloys from the roaring electric furnace above. Finally, when building recovers—a turn soon expected by the Iron and Steel Institute—it will require even more steel than in the heyday of the building boom. Stainless-steel moldings, store fronts, and portable factory-built steel houses will then likely send steel output soaring even more.

Page 21 LIFE Mar. 15

upturn. Yet the story simultaneously effaced workers' contribution; photos showed only one worker. The photos hid workers' labor, stressing instead a bloodless production orchestrated by owners and managers. Much as Frederick Taylor sought to take the intelligence out of the workman's cap and give it to managers, these photos depicted production as a rigid and hierarchical managerial order. *LIFE*'s story about the common steelworker ended with an encapsulation of work from a managerial standpoint. Within this narrative of social

and industrial production the "far-sighted statesmanship of the steel owners" and the statesmanlike Lewis contributed to change. Workers were welcome recipients of the nation's largesse, not agents of change in America's economy and society.

LIFE celebrated the new moderate administrative unionism in another 1938 story on the International Ladies Garment Workers Union (ILGWU). Their affirmation was reflected in the infectiousness of the smiles of the two "garment workers at play" that LIFE put on its cover (Fig. 2.12).[104] LIFE sent Otto Hagel and Hansel Mieth to photograph Yetta Henner's life—the life of a "common garment worker." Hagel and Mieth, Central European political refugees who came to the United States in the Depression's midst, had been rebuffed by the WPA for their "propagandistic" work. Hagel and Mieth had photographed the 1934 San Francisco general strike and the lettuce packers' strike in Salinas, California, and had represented the vigilantism of California agricultural districts in terms no less indicting than the Grapes of Wrath. But LIFE hired Mieth in 1937 and gave Hagel commissions. Both photographers hewed to the documentary

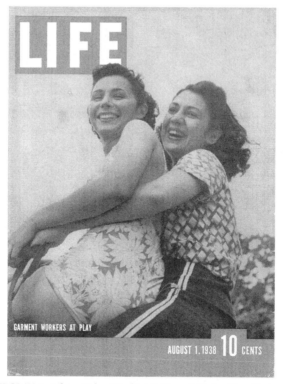

FIGURE 2.12 *ILGWU members Helen Wachtel (left) and Gladys Kamilhair at Unity House. Photo by Hansel Mieth. LIFE, August 1, 1938. LIFE® used by permission of The Picture Collection Inc. Copyright 1937 and1938 The Picture Collection, Inc., reprinted with permission. All rights reserved.*

ideal that exposing "the chasm between rich and poor" could promote social change.[105] Their photographic investigation of the ILGWU dramatized this chasm for immigrant garment workers, but *LIFE*'s narrative transformed workers who had a toehold in the American Dream into those who already shared in America's promise.

"A Great and Good Union Points the Way for America's Labor Movement" suggested this potential with two photographs that filled the first pages (Fig. 2.13). Readers could see "Where ILGWU Works"—dozens of garment workers at a white goods factory who labored in clean, open conditions. Their reward appeared in "Where ILGWU Plays," a photograph of men and women unionists cavorting at Unity House, the ILGWU's "million-dollar" recreational facility in the Catskills.[106] These opening photographs offered an economic transformation from labor to leisure that unions attained for workers. *LIFE*'s text sounded their regular chorus: activism turned popular opinion against labor; the sit-down epidemic "alarmed" even "many a Labor sympathizer."[107] But *LIFE* argued for unions' right to exist. It chided union rank and file for not learning to "live within the union"; here *LIFE* joined corporations in complaining that the Wagner Act did not limit strikes. But for *LIFE*, the ILGWU, a "well-seasoned union," had learned such "vital lessons." It was "shiningly free" from corruption, worked cooperatively with management, and "settle[d] most disputes before they become costly, embittering strikes."

The next two pages showed how the ILGWU, "Born of Sweat, Hate and Fire" had become "A Happy Army, 250,000 Strong." Echoing the previous pages, the story stressed a transition from sweatshops to the organized shop— even organized fun. *LIFE* acknowledged employers' abuses, abuses that readers would have been well aware of given the half-century effort to reform garment workers' lot.[108] Photographs showed a turn-of-the-century sweatshop; a march from the "uprising of 1909," in which tens of thousands of women took to New York City streets; and a large photograph of the 1911 Triangle Fire in which 146 workers died trying to escape the smoke and flames in their locked workshop. According to *LIFE*, such sweatshops in "dark filthy bedrooms lofts and basements" predominated, leading workers to seek security in unionization. But *LIFE* asserted that as of 1933, sweatshops were "a thing of the past." Editors' titling suggests that the union was born in the crucible of sweat and fire. Here *LIFE* admitted workers' rational motivations for unionization. *LIFE* superimposed a cartoon of "the Waistmaker Boss" upon photographs of the 1909 march and the 1911 fire. His grotesque maw devoured his workers. The caricatured boss and his exaggerated features substituted for America's economic system; *LIFE* did not directly confront contemporary social inequality.

The next page showed the "sodden machine serfs" transformed into the "Happy Army" who rallied at Madison Square Garden and danced in a cancan line. The dancers, from the ILGWU's hit theater revue "Pins and Needles," had gone to Broadway and then the White House. *LIFE* told readers how this

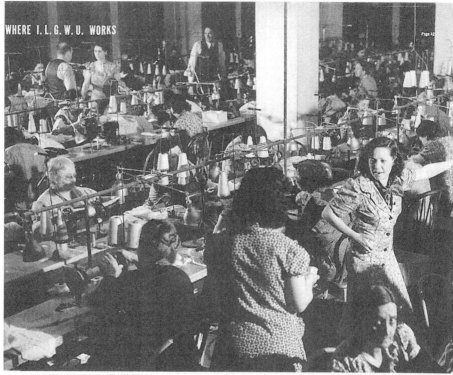

I. L. G. W. U.

INTERNATIONAL LADIES' GARMENT WORKERS' UNION

A GREAT AND GOOD UNION POINTS THE WAY FOR AMERICA'S LABOR MOVEMENT

In the exciting days of 1936 and early 1937, when C.I.O. was enlisting fresh thousands weekly in its giant-springing new unions and almost every day's newspaper blazoned a new triumph, the forward march of Labor appeared irresistible. Now the march is halted. Labor's army is marking time, fighting to hang on to its gains.

What stopped it? The Depression, chiefly. And the A.F. of L.-C.I.O. split in Labor's own ranks. And a third factor, intangible but mighty: public opinion.

Public opinion swung against Labor partly because of skilful anti-union propaganda, partly through genuine impatience with the self-seeking ambitions and feuds of Labor leaders. The defiant, sometimes violent spirit of the great Sit-Down epidemic alarmed many a Labor sympathizer. When FORTUNE polled the country last spring on what American insti-

tutions were most in need of reform, not only the general public but factory workers themselves put "labor unions" at top of the list.

But the great fact remains that within this decade America has ceased to be a "non-union country" and can now be characterized as a "trade-union country." This is not merely a matter of statistics. It is not merely that there are today 7,500,000 American wage earners in unions whereas there were less than half that number in 1932. America may now be called a trade-union country because the essential character of American industry has changed from non-union to union.

Labor unions have made a lot of news and a lot of noise but so far Americans have had little chance to find out what it is like to live in trade unions or to live *with* trade unions. A trade union is a big group of people—sometimes just large, sometimes

staggeringly huge. The International Ladies' Garment Workers' Union, for example, is 250,000 people, about as large as General Motors and, with members' families, equal to Boston, larger than the tenth largest city in the U. S. It is exactly like no other union, for each has its own flavor. They differ as churches or cities or high schools. But the differences which set I.L.G.W.U. off from other unions are unimportant compared to the fact that, in cutting a pattern for itself, it has also cut a pattern for the future American trade union.

The I.L.G.W.U. is old. It was born 38 years ago and hence is mature among American unions. The United Automobile Workers of America is a bumptious freshman union whose bones, marvelously stretched by quick growth, are beginning to sag and ache where the joints are not well knit. In the case of U.A.W., not only have the employers yet to learn

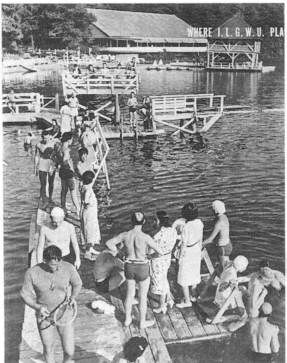

THIS IS THE BOAT DOCK AND SWIMMING FLOAT AT MILLION-DOLLAR UNITY HOUSE

how to live with the union but the auto workers themselves have still to learn how to live within their union. In well-seasoned unions, both of these vital lessons have already been learned. And nowhere have they been better learned than in I.L.G.W.U.

I.L.G.W.U. is big. Its quarter of a million members, concentrated in the larger cities of U. S. and Canada, make their living making ladies' garments, fifth largest U. S. industry. They design, cut, stitch, embroider, trim and press ready-to-wear coats, suits, dresses, knitwear, negligees, corsets, panties. A third of them are Italian, a quarter Jewish, three-fourths women.

The history of this union began in 1900 when eleven men, representing seven unions and 2,000 cloak makers and pressers, met in New York to consolidate all ladies' garment workers into a single union. The union was formed. It grew. In 1909 came the historic strike known as the "Uprising of the 20,000," the revolt of the shirtwaist makers. Twenty thousand New York waist makers struck for six months. They lost but the lessons they learned were well applied next year when I.L.G.W.U. won a general strike, known today as "The Great Revolt." An agreement with employers, set down under the eye of Louis D. Brandeis as impartial arbiter, became a charter of union rights. In 1926, the union was disrupted when Communists got control, called a disastrous strike. When it was over and lost,

David Dubinsky, whose cutters' union had stayed out of the strike, gained control, lent money to bankrupt locals, purged Communists, nursed I.L.G.W.U. back to health—and led its great march under the New Deal.

I.L.G.W.U. is rich. It is shiningly free from graft and racketeering. The union keeps contracts, accounts publicly for its $5,000,000 annual budget. It has been helpful in regulating the industry, once ridden by cut-throat competition, now stabilized greatly by wage-and-hour minimums. It has developed an arbitration system which settles most disputes before they become costly, embittering strikes.

Like any sensible union, I.L.G.W.U. has a clearly defined program, which is much the program every forward-looking union hopes to follow in its battle to better the worker's position. I.L.G.W.U. objectives lie in three fields, whose 1, 2, 3, both in importance and chronological sequence are 1) Economic; 2) Educational and Social; 3) Political. I.L.G.W.U. has, to a great extent, accomplished its Nos. 1 and 2. It has boldly started No. 3. No union in America has advanced further than this.

In Economics, the advance is overwhelming. Thirty years ago the industry stank of the sweatshop and the cruelest kind of exploitation. Workers toiled 16 hours a day for $2 to $8 a week. Today they get $15 to $35 for working 35 hours a week, only a

few hours more than they once worked in two days.

Educational and Social activities are inseparable. Their joint aim is to make each member a better, more union-conscious unionist. In union classrooms, the workers are taught the history, the problems and the future of Labor. They are trained in union tactics and strategy. The union clubrooms, its dances and its games fill a social gap which might elsewhere be filled by a church or Y.M.C.A. The most spectacular manifestation of the social aspect is shown on pages 48-51 in pictures of I.L.G.W.U.'s million-dollar Unity House.

In Politics, the union is young but strong. It was once an adage that no one could deliver the American labor vote to any man or party. Today, Labor is up to its brawny neck in politics, particularly the C.I.O. and most particularly the I.L.G.W.U. It was a pioneer and bulwark of New York's successful American Labor Party, formed in 1936 to support Roosevelt. The great number of its members vote with A.L.P. Though the historic background of I.L.G.W.U. is Socialist, the orientation today is New Deal Democrat. There are still a few thousand Socialist votes, fewer Communist, precious few regular Republican. Many I.L.G.W.U. members are young girls who never had any interest in voting. The union is arousing their interest, educating them politically, thus bringing to the polls a class of voters that never before entered into a politician's calculations.

CONTINUED ON NEXT PAGE

(continued)

UNION SPORT

Local 62's basketball team gives Yetta plenty of good, vigorous exercise. It also builds up union spirit, just as a college team builds up college spirit.

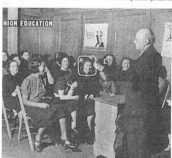

UNION HEALTH

At I.L.G.W.U.'s health center, which cost $250,000, Yetta pays little for medical and dental care. The center's staff includes top-notch specialists.

UNION EDUCATION

Yetta studies Public Speaking & Social Psychology in an I.L.G.W.U. classroom (*above*), takes Boy Friend Hy Stofsky to a union dance (*below*).

UNION SOCIAL LIFE

I. L. G. W. U. ONE OF THE 250,000 WHO SPENDS MOST OF HER LIFE WITHIN HER UNION

YETTA HENNER TRIMS PANTIES

If she lived in some small American town, a middle-class Yetta Henner might play basketball on the high-school alumni team, go to a church dance, listen to a ladies' club lecture. But Yetta Henner lives in New York City, is poor, works as a finisher (she snips loose threads off rayon panties) in the Mitchel Schneider shop and belongs to I.L.G.W.U.'s Local 62. So Yetta, as shown at left, exercises, learns, dances within her union. Yetta is 21. She joined the union in 1933 when she took her present job. Her Russian-born father, a presser, has been a member since the general strike of 1910. Her earnings average $17. She pays 35¢ a week dues to her local, easily gets her money's worth. Not all I.L.G.W.U. members are as close to their union as Yetta. Someday most may be. Yetta herself shows promise as a union organizer.

YETTA BELONGS TO AN ORTHODOX JEWISH FAMILY. SABBATH EVE, MENFOLK WEAR HATS AT TABLE

YETTA LIVES AT 248 RIVINGTON ST., A TENEMENT IN NEW YORK'S LOWER EAST SIDE GHETTO

FIGURE 2.14 *ILGWU member Yetta Henner at work, at union social, educational, and welfare activities, and at home, LIFE, August 1, 1938. Photos by Hansel Mieth. LIFE® used by permission of The Picture Collection Inc. Copyright 1937 and 1938 The Picture Collection, Inc., reprinted with permission. All rights reserved. Henner's Lower East Side "ghetto" tenement, photograph by Otto Hagel, 1937. Collection Center for Creative Photography, University of Arizona, © The University of Arizona Foundation.*

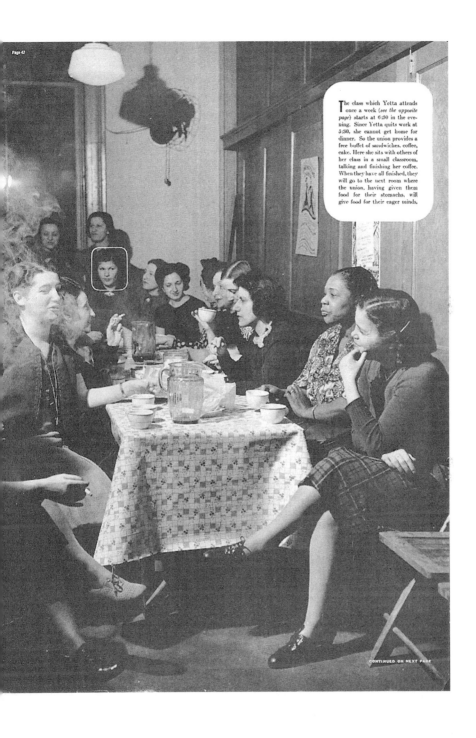

The class which Yetta attends once a week (*see the opposite page*) starts at 6:30 in the evening. Since Yetta quits work at 5:30, she cannot get home for dinner. So the union provides a free buffet of sandwiches, coffee, cake. Here she sits with others of her class in a small classroom, talking and finishing her coffee. When they have all finished, they will go to the next room where the union, having given them food for their stomachs, will give food for their eager minds,

CONTINUED ON NEXT PAGE

"satire on capitalism . . . netted a neat capitalistic profit of $35,000." Here unionists became entrepreneurial capitalists who had fun to boot.

In the fifth and sixth pages *LIFE* followed an emblematic garment worker's day. In one cameo image Yetta held up the panties she trimmed for a living.[109] This was one of two photographs of work in a thirty-three photo, twelve-page photo-essay. *LIFE* did document the benefits that Yetta's union conferred, such as a basketball team that built union spirit like "a college team," her union health-care center with its "top-notch specialists," and a union dance, where Yetta brought "Boy Friend Hy Stofsky" (Fig. 2.14). *LIFE* also printed photos of Yetta ensconced in her immigrant life: at home with her Orthodox Jewish family where "menfolk wear hats at table"; of Rivington Steet—pushcarts visible—where Yetta lived in a tenement; and of a smoke-filled hall where garment workers enjoyed coffee before union classes provided "food for their eager minds." In these photographs the space collapsed around the subjects. Indeed, editors outlined Yetta's face to help readers locate her within the picture's frame. The photographs pressed in on the reader with the details of Yetta's domestic and neighborhood milieu. The tight framing and shallow spaces Hagel and Mieth had composed with their photos expressed the cramped world of New York City's Lower East Side, a world that workers like Yetta would soon leave with union support.

The following four pages represented workers' new world with photos of the union's "summer resort, Unity House." The ILGWU's workers' retreat gave readers a visual respite.[110] The setting was so open and pastoral, workers' enjoyment so gleeful and heterosocial, that *LIFE*'s headline told readers that the camp made "A Fine Setting for a Movie" (Fig. 2.15). *LIFE* actualized this claim by laying out photos to look like movie stills. A couple found diversion in a leisure activity that referenced the magazine's project—they were snapping one another's picture—while other photographs showed snuggling couples. More unionists socialized on the camp's expansive lawn and on blankets, against the broad trunk of a tree, and on scattered Adirondack chairs. Here *LIFE*'s text sketched a movie-like melodrama of a panty-stitching girl garment worker who lost her beau because of her union devotion. At Unity House she immediately met another boy who joined her in economic—and romantic— solidarity. Both were dazzled by the union's facilities. The faux scenario ended with four pages of landscape photographs of three couples in silhouette, dwarfed by the fir trees that surround them, and the "lovely lake . . . center of camp life and romance," glinting in the sun. This "$1,000,000 country-club hotel for ILGWU members" epitomized ideals *LIFE* held dear. The members look like nothing so much as the dozens of portraits of American youth and college coeds that *LIFE* regularly featured as part of its portrayal of the American good life.

In *LIFE*'s America, workers laid claim to Shangri-La because of an administratively run union like the ILGWU that negotiated without conflict. With the

FIGURE 2.15 *ILGWU Unity House Resort, LIFE, August 1, 1938. Photos by Hansel Mieth, LIFE® used by permission of The Picture Collection Inc. Copyright 1942. The Picture Collection, Inc., reprinted with permission. All rights reserved. Photos by Hans Knopf, Getty Images.*

exception of the 1909 march, *LIFE* ignored how activism built the union. Workers were recipients of the union's leadership, much as workers were recipients of corporate largesse. The father of the new unionism was David Dubinsky, an Eastern European Jew who emigrated from Poland after being exiled to Siberia for his socialism. He joined the ILGWU just after the Triangle Fire and moved his way up to the highest levels of union leadership, in the midst of internecine warfare between Socialists and Communists in the union. Dubinsky championed the CIO and the New Deal.[111] A full-page portrait had Dubinsky looking toward the camera, as he sat behind his desk in union headquarters. An inset photo showed Dubinsky riding his bike down the middle of a Manhattan street. *LIFE* told readers that "it is his middle of the road position in the Labor movement which makes" him "one of the most important men in America."[112] Photographs showed the leader with his general executive board and arbitrators, much as photographs of the titans of industry were seen in their boardrooms. Here *LIFE* represented Dubinsky as a leader responsible for great changes in American society. As an administratively organized power that spoke for millions of American workers, unions were respected as a voice that "sat at the table" with industry and that entered the political sphere as an organized bloc.[113] *LIFE* celebrated the new unionism and its bureaucratic machinery that ensured stability in labor relations and in American life, a stability that would be crucial as the nation inched toward war.[114]

Readers acknowledged *LIFE*'s embrace of labor—though some rejected the magazine's failure to represent workers' difficulties, while others maintained organized labor had it easy. One letter to the editor suggested details in the publication's own stories contradicted the thrust of their reporting. A SWOC organizer complained about the antilabor bias of *LIFE*'s "ivory-tower editors." He demanded that *LIFE* "do a real job on Labor by sending staff photographers into steel towns like Johnstown, Bethlehem, Sparrows Point, Steelton and Lackawanna where Labor is still fighting for recognition. Let the American people see where and how the workers live. See the utter waste of human life, see the future generation growing up, emaciated, in rags, all but homeless." The writer encapsulated *LIFE*'s failure to document the deprivation in workers' lives. Other readers took an opposite tack. One middle-class writer thought that Ford workers enjoyed goods "better than the average college trained man can afford." Any difficulties arose from workers' laziness. Another protest came from a farmer who suggested Ford workers should trade places with them to understand backbreaking work. Writers did not question *LIFE*'s camera-eye. Union supporters suggested that *LIFE* should see more, implying that the camera captured reality. And the farmer used *LIFE*'s visual facts to argue against relief for urban workers.[115] Readers recognized the coherence of *LIFE*'s argument, even if they disagreed with it.

War Power/Manpower

As war became a reality with Hitler's aggressions and Pearl Harbor, *LIFE* moved to representing workers and their unions as crucial to national productivity and war readiness. *LIFE* had promoted the nation's industrial prowess as the consequence of the bold foresight of America's corporate fathers. Now labor—as manpower—contributed to this might. "Production for Victory" was organized labor's WWII slogan, and it was *LIFE*'s too. *LIFE* continued to use earlier narrative threads suggesting labor relations volatility made the nation vulnerable when it should be asserting itself globally. And in the two years before war, *LIFE*'s attacks on strikes became shriller. But *LIFE* insisted on dialogue with labor, endorsing CIO leaders who suspended strikes and cracked down on militants in exchange for federal support for unions.

These threads came together in an August 1941 investigation of union infighting. *LIFE* featured Lewis, who had hurt his stature in the CIO by endorsing Wendell Willkie against FDR in 1940, and two ascendant leaders, Lewis's once loyal lieutenant—now CIO president—Phil Murray, and Lewis's ally-adversary, Sidney Hillman of the Amalgamated Clothing Workers Union (ACWU).[116] *LIFE* told how Lewis advocated a return to AFL-style voluntarism, believing governmental support for labor fickle. Like Samuel Gompers before him, Lewis thought labor must retain its threat of economic activism. His UMW threatened to strike for the closed shop in the captive mines, mines devoted to extracting coal for steel production. The magazine reported that communists, with their vociferous demands for rank-and-file militancy, had allied with Lewis. Arrayed against Lewis were former allies who retained an allegiance to FDR's New Deal. They supported the war effort and believed that government help would consolidate unions' organizational stability and a coveted political importance. Murray advanced conservative corporatist views, seeking cooperative relationships with management; Hillman built his reputation on such cooperative experiments, leading FDR to appoint him to the National Defense Mediation Board (NDMB) and then the Office of Price Management (OPM).[117]

LIFE's sympathies were evident from the opening pages of "CIO Internal Conflict Brings This Great Revolutionary Movement to Crossroad." Sounding like a CIO pamphlet, *LIFE* applauded the federation's "social revolution," which "organized the great unorganized masses of the mass-production industries" to rally for "a controlling voice in the conduct of U.S. business and government" (Fig. 2.16). But *LIFE* warned that Lewis's voluntarism promised future explosiveness. *LIFE* depicted Lewis, who "hates Roosevelt, the British ruling class, and Sidney Hillman," in a full-page portrait.[118] Taken and lit from below, darkness shrouded much of Lewis's face. The high contrast and harsh lighting intensified the hypnotic quality of his eyes, which were framed by his trademark bushy eyebrows. Lewis appeared as a menace from one of the era's

He hates Roosevelt, the British
ruling class and Sidney Hillman

64

FIGURE 2.16 "C.I.O. Internal Conflict Brings This Great Revolutionary Movement to Crossroad," LIFE, August 25, 1941. Text copyright 1941, The Picture Collection Inc. All rights reserved. Photo by Thomas MacAvoy, reprinted with permission.

IN WASHINGTON, C.I.O. PRESIDENT PHILIP MURRAY PREFERS HIS PANELED OFFICE IN UNITED MINE WORKERS BUILDING TO ONE IN C.I.O. NATIONAL HEADQUARTERS OVER A STORE

C.I.O.

INTERNAL CONFLICT BRINGS THIS GREAT
REVOLUTIONARY MOVEMENT TO CROSSROAD

A new disease, sprung up in America during the past eight years, is not yet listed in the medical books. But few others have such power to warp and poison a man's mind and soul. The name of the disease is Roosevelt-hatred. It appears most virulently in those who have once been the President's supporters. Currently its No. 1 victim, with the possible exception of Burton K. Wheeler, is John Llewellyn Lewis (*opposite page*), whose affliction began when, after his United Mine Workers had dropped $500,000 in the 1936 Roosevelt campaign kitty, the President refused to let him name a new Secretary of Labor, called down "a plague on both your houses" in the A. F. of L.-C. I. O. civil war, and omitted Mr. and Mrs. Lewis from important White House guest lists.

In part because of this fact, the C. I. O. is now passing, as have other great revolutionary movements in the past, through a stage of violent internal conflict. The Hamilton and Jefferson, or Stalin and Trotsky, of this conflict are John Lewis and Sidney Hillman. The outcome of their struggle, a skirmish of which was being fought last week at the United Auto Workers convention in Buffalo (*see pp. 70-71*), may profoundly affect not only the immediate future of U. S. Labor and the U. S. defense program, but also the long-term pattern of American life.

The nine angry men who met in a room of the Hotel President in Atlantic City on Oct. 20, 1935 to found the C. I. O. began a genuine social revolution. Their immediate rebellion was against the conservative inertia of their fellow leaders of the American Federation of Labor. But their far goal was to revolutionize American life by organizing the great unorganized masses of the mass-production industries and thus rally a strength which for the first time in U. S. history would give Labor a controlling voice in the conduct of U. S. government and business.

Of the co-founders of the C. I. O., Lewis, their leader, having given his promise when he came out for Wendell Willkie, retired from its presidency last November and has since ostensibly devoted himself exclusively—in almost unbroken public silence—to his United Mine Workers. Hillman, a devoted New Dealer, is Labor boss of the defense program as Associate Director General of OPM. Caught between them is Philip Murray (*above*), Lewis' longtime lieutenant in the Mine Workers who succeeded him as C. I. O. president. Last week Mr. Murray lay ill in Pittsburgh. Some imaginative Hillmanites thought it not impossible that his illness had a psychic origin in the conflict between his intellectual attachment to the ideas of Sidney Hillman

and his emotional loyalty to the person of John L. Lewis.

Before Hitler double-crossed Stalin, the big problem of C. I. O.-in-defense was what to do about the Communists. They are still in the C. I. O. ranks. And no less an authority than Communist-hating Sidney Hillman fears that, long nurtured to conspiracy and a conspiratorial payroll, some of them may turn Nazi agents if Germany beats Russia. But now that the Party Line has turned, the prime current importance of the C. I. O. left-wingers is that most of them are partisans of John L. Lewis. Through them, through his place as head of C. I. O.'s financial mainstay (the Mine Workers) and through his well-organized machine and high prestige, Lewis remains a great power in C. I. O. Already there are rumors that the restive ex-president may, especially if Murray's health remains bad, attempt at the November convention to regain his old place at the official top. If he does, the leader of most of the union workers in U. S. defense industries will—unless the C. I. O. itself is split as a result—be a man who hates the British ruling classes, mortally fears a British victory and believes that a U. S. President who has betrayed Labor is dragging the nation into war solely to save his own political hide after making a complete bust of his domestic program.

CONTINUED ON NEXT PAGE 65

The day shift at Douglas Aircraft pours out of the Long Beach plant at 4 p.m. Some of the departing workers go over to the bicycle racks and wheel off home. But most of them crowd out behind the sandbag barricades in foreground through an underpass to the parking lot which is shown on opposite page. There are many women in the throngs but in their slacks and work clothes they are not easy to distinguish from the men. There were only a few hundred women working in the aircraft war plants in 1939. Now there are many thousands of them.

FIGURE 2.17 *"The Workers Show Spirit,"* LIFE, *October 12, 1942. Photos by J. R. Eyerman, on bottom right, LIFE® used by permission of The Picture Collection Inc. Copyright 1937 and 1938 The Picture Collection, Inc., reprinted with permission. All rights reserved. Photos by Mark Kauffman, on left and upper right, Getty Images.*

HE WORKERS
HOW SPIRIT

e Douglas Aircraft Co. today employs more people
—the exact number is a secret—than all the Holly-
movie studios put together. Southern California's
tries now employ about 350,000 people, almost two
a half times as many as they employed two years ago.
e workers have come from all over. The once-neg-
d and unwanted migrant farmers, today eagerly
at after by expanding industries, have a cocky little
to quote to each other: *Come on you Okies and At-
let's take Japan. We took California without losing a*

The movies have lost few steady workers to war
s but the periphery of the movie industry has moved
war work—pretty girls who came out to act and had
le their time as car hops; old actors useful only as
s; even script writers and studio musicians. The Cal-
shipyard on Terminal Island in fact found enough
ians in its ranks to form two full-fledged orchestras.
e workers are mostly young. But there is a visible
of people over 50 who came out to retire in the
ornia sunshine and now have decided to pitch in
help. A great many people who don't have to work
taken war jobs. Most of them are untrained but are
igent enough to pick up the simple skills quickly.
e are, of course, plenty of malingerers among them.
being a young, new group, the workers generally
a brisk amateur enthusiasm which responds won-
lly to new production quotas and the need for speed.
barrage balloons and patrol planes always overhead,
anti-aircraft batteries all over the place, with men
aform all around, war workers have become infect-
th the excitement of war. So far they haven't been
ing long enough to become blasé about their jobs.

Parking lot at Douglas stretches out for 40 acres, is packed with workers' cars. This is only part of the lot. Although some workers travel by bus and bike, the greatest number come by auto, which makes tire and gas allotments a head-ache. Southern California's industrial area sprawls so wide-ly that some men make a daily 80-mile round trip to work.

welder works on an exhaust manifold at Ryan Aeronautical. She is Mabel Ahlahl, 22, of ers, N. Dak., formerly a waitress. "I know soldiers that are across right now," she says. "If tired of working, I stop to think what I've got to do for those kids. Then I start in again."

Army wife does spot-welding at Lockheed. She is Mrs. Prisclla Maury. Her husband, Major Maury, and her father, Colonel Bunker, are missing on Bataan. Anxious to work, Mrs. Maury has a good record. Her mother, Mrs. Bunker, stays home and minds the four Maury children.

CONTINUED ON NEXT PAGE

low-budget horror movies. Across from him lay a half-page photograph of his successor, Murray. *LIFE*'s text suggested that Murray was caught between Lewis and Hillman. The magazine depicted him as an elite manager in a posed tableau.[119] Ensconced in the national UMW headquarters, Murray sat behind the wide expanse of his desk as a secretary served him. Unnamed, pipe-smoking minions buttressed all corners of the desk. An Oriental carpet drew *LIFE* readers into this scene of genteel authority.

The story moved to the CIO's past, whose "history [was] one of violence." *LIFE*'s text acknowledged that a "class war" had made "America safe for industrial democracy" but it implied that labor had caused the "war." Twenty photographs of labor's past was exactly what *LIFE* pledged: twenty photographs of violence. More than half of the photographs documented brutality against strikers: the Battle of the Overpass, the Memorial Day Massacre, the Little Steel Strike, and the Hershey strike. Photographs showed loyal workers, police, or corporate-financed "security" attacking labor. These photos were subsumed under the "CIO Movement . . . the violent phase of the New Deal revolution."[120] The text did note the "long, sordid history of company spies, police brutality, yellow dog contracts and fired strikebreakers, when Labor was . . . the underdog," but this acknowledgment came through the frame of Lewis's reminiscences. Locating corporate- and state-sponsored violence in Lewis's perspective removed *LIFE*'s authority.[121] *LIFE* contrasted Lewis's views with those of Hillman, the rational labor leader who understood labor's "rough" past but who sought a mature, farsighted labor movement that put national interest above labor's interest. His "longtime gospel that Labor can only prosper when Industry does too" led him to favor "negotiation and partnership."

The photo-essay's next two pages represented this mature unionism in a story on the UAW's fight against Ford. *LIFE* contrasted the "big headlines and spectacular photographs" of the UAW's four years of battles against Ford with "the real work of organizing." The article implied that the organizing, which took place "quietly, unspectacularly, with little publicity," was new for the UAW. *LIFE*'s photo story sympathetically portrayed Harry Ross, "a typical CIO organizer." Ross worked twelve- to eighteen-hour days, was eloquent, and exhibited great loyalty to the union. The result of his "house canvasses, beer garden chats and endless meetings" was a majority vote for the UAW. The article acknowledged Ford as "the greatest anti-unionist in the land," and one caption acknowledged that thugs beat an organizer's wife at her front doorstep. But the photo-essay did not represent this. Its twenty photographs of the CIO's "history of violence" reinforced the story's binary of immature and mature labor organizing. And the story suggested that Ford workers chose the UAW because of its persistent, safe organizing. But members might have voted for the CIO years before if that had been possible. CIO methods had not changed—Henry

Ford's had. With pressure from his wife and son, he admitted that unionism could no longer be fought with "brass knuckles."[122] The federal government's pressure eased Ford's decision, of course.

The story's final two pages celebrated the 1941 Buffalo convention, where Hillmanites beat out Lewisites for UAW control. For *LIFE*, Hillman's success meant that "communists, Nazis, Fascists and fellow travelers" would have no place in the labor movement. Instead, Hillman's dream of negotiation, class partnership, and productivity would "profoundly affect not only the immediate future of U.S. Labor . . . but also the long term pattern of American life."

The CIO's decision to partner with the government gave industrial workers the security and public authority its leaders had craved. Right after Pearl Harbor, the CIO, sensitive to public displeasure over earlier strikes, committed itself to the no-strike pledge. In 1942, in compensation, the National War Labor Board established a maintenance-of-membership provision whereby unions represented all employees at a work site and corporations were authorized to withhold dues from workers' paychecks for unions. Unions stabilized. Companies that refused to bargain with unions could no longer hold the union hostage, nor could factions of employees who withheld dues.[123]

Cultural producers like *LIFE* made one path more politically feasible to the general public. *LIFE* remained hostile to activism but welcomed labor with new visual strategies once this political and economic compact was struck, celebrating workers contribution to production. Photographs of the belching smokestacks and twirling gears of American production now joined pictures of men and women working on the line at their machines (Fig. 2.17).[124] Unlike *LIFE*'s early corporate photography with its managerial viewpoint that erased workers, photographs now acknowledged individual workers as participants in the nation's industrial setup. As consumers who should enjoy national abundance, and as the manpower necessary to win the war, workers were intrinsic to *LIFE*'s America.

When Henry Luce founded *TIME* with Britt Haddon, they imagined they would remake the news—turning ponderous information into vital knowledge meant to bring busy Americans into fast-paced modernity. With *LIFE*, Luce dreamed much bigger. He thought his publication could solidify Americans' sense of their nation as the land of plenty. By letting Americans see themselves as Luce thought they must, the nation's citizenry could make America the land it should be. Luce surrounded himself with the best he could buy— poets and novelists and critics and photographers hailing from New York, the Midwest, and even Central Europe. *LIFE*'s portrait of the nation included workers, whether shaving or sleeping or prinking or striking, and it depicted workers' mass-production unions and union leadership as crucial participants in its reimagined America.

Bitter Kisses

PICTURES OF THE HERSHEY CHOCOLATE
SIT-DOWN STRIKE, APRIL 1937

In the midst of the 1937 sit-down wave, Paul Shafer, a Michigan congressional representative, denounced the CIO and its "sit-down technique, imported from foreign shores," which "injected . . . fear, ferment, force, and extortion" into American society. His attack centered on the "workingman's Utopia" of Hershey, Pennsylvania. Everyone knew that the company's founder paid from his "own purse" excellent wages and a bonanza of recreational and educational advantages; the strike was unwarranted. Nonstriking employees, "innocent citizens," and local farmers with a "vested interest" in Hershey's corporate success fought back, assaulting the strikers. Shafer concluded: "Here was a collision between two mobs and the bigger mob won." Americans would not indulge the CIO, Shafer predicted, and "a small series of civil wars" would ensue unless politicians confronted the sit-down scourge.[1]

Shafer's invocation of Hershey to castigate the CIO was astute. Few corporations had such positive associations. By the 1930s, Hershey Chocolate was *the* American chocolate company; its corporate persona was one of all-American good citizenship. The company's founder, Milton Snavely Hershey, had built an industrial mecca in the nation's rural heart. Hershey reconnected modern factory workers to the land and its inhabitants—industrious, plain-living farmers—claiming to stiffen workers' backbone. Simultaneously, he brought the joys of mass consumption to this rural hamlet. Hershey's reputation was of an innovative corporate paternalist and a generous philanthropist—he had relinquished his fortune for orphan boys. Ideologically, Hershey linked yeoman self-sufficiency with an Algeresque, urban, business know-how. In Hershey's world, work inspired virtue and class divisions did not intrude. Souvenir booklets, recipe books, postcards, magazine interviews, newspaper articles, and radio programs trilled with the dulcet cadences of Hershey's image: how a simple man remade himself and produced a million-dollar corporation, a town, and philanthropies from the simple cloth of American values.

The CIO United Chocolate Workers' strike against Hershey turned on traditional grievances: the desire for better wages and working conditions, and collective bargaining rights, though workers also sought greater control over their lives. Americans learned instead about the magnanimous corporation and loyal workers and farmers who stood by its side. To defeat the CIO, Hershey managers used their long-cultivated corporate image, adapting traditional union-busting techniques to a mass consumer economy.[2] Business associations like the National Association of Manufacturers (NAM) and other anti-unionists did one better. Trade associations, politicians, pollsters, and editorialists used Hershey's image of corporate rectitude to malign the CIO and striking workers. They catapulted a small strike to national attention by using public relations strategies that exploited transformations in twentieth-century news, including its nationalization, standardization, and increasing reliance on photography. Their denunciation of the CIO echoed in ostensibly objective news stories. A nationwide audience read the same story: of a generous corporate America and the unions that spurned such generosity, tearing apart close-knit communities. This audience saw the same news photographs of a small group of agitators threatening chaos in a small town that embodied America's best.

"The Story of a Barefoot Boy"

The ingredients of the Hershey myth were founder Milton Hershey's accomplishments—a multimillion-dollar corporation, a town informed by cooperative principles, and one of the nation's most well-endowed orphanages. From the Hershey Chocolate Company's inception in 1903, the founder cultivated his business, but just as assiduously his model industrial town and philanthropies. Hershey had a keen sense of the import of image in a consumer economy, and his in-house public relations staff tended his personal and corporate reputation. A 1924 *Liberty* magazine article, titled "The Story of a Barefoot Boy and Two Silver Shillings and How They Grew into a Wise Chocolate King and 'A Million, Billion, Trillion Dollars.' And of an Almost Fairylike Domain in Pennsylvania, Where This Emperor of Industry Is Letting Poor Orphan Boys Spend a Dazzling Fortune" indicates the fairy tale proportions of his story, disseminated by a burgeoning mass media decades before the 1937 strike. Hershey's story endures in Tin Pan Alley lyrics, TV documentaries, and biographies to this day.[3]

The company's image, so identified with its founder, melded competing visions of America. Hershey's personal rise, a "popular 'rags to riches' story," pictured the "barefoot boy running from door to door in Lancaster, PA." This "hero" in a "modern 'pluck and toil' story" reveled in not being a "conventional capitalist." For one reporter, "Mr. Hershey [was] a simple, democratic

man of purely American type, who has not been spoiled by the possession of money and does not think [it] gives him omniscience." A sagacious businessman of Mennonite stock, he was "bewildered by his millions" and selflessly gave it away. Hershey attacked "systems of patronage" as "Americans resent it, they love independence and self-reliance." Yet workers in his village had no vote. Hershey advocated cooperation, yet he grumbled that employees' irresponsibility forced him to take the reins of his amusement park.[4] Hershey brought Progress with a capital "P" to Hershey, his "country town with a metropolitan air," transforming it into Pennsylvania's "Summer Playground." Simultaneously he extolled Jeffersonian agrarianism, complete with its disdain for the city. An uneducated, and in many ways incurious man, he profited by bringing the latest forms of middlebrow, commercial, and mass-cultural entertainment to his corner of the nation. Hershey's story represented everything that was good about America, in part because he amalgamated early twentieth-century America's messy contradictions.[5]

The chaos of Hershey's early years fed the Hershey myth. His father's business and agricultural debacles forced the family to move thirty times. Uprooting themselves during the Battle of Gettysburg, "little shaver" Hershey vowed, according to numerous published anecdotes, "I betcha when I get to be worth a million, billion, trillion dollars, I'll take care of little boys." Graduating from his father's school of hard knocks, Hershey apprenticed but failed as a printer, tried his hand selling confections in Philadelphia, then produced caramels in a Chicago "State Street basement," ultimately going bust in Denver, New Orleans, and New York. On his fourth attempt, Hershey hit it big with Lancaster caramels, selling the company for a cool million dollars.[6] In 1898 Hershey returned with his wife to Pennsylvania, near his grandfather's farmstead. He constructed an industrial enterprise and town, "not to make more money" but to do something "worthwhile."

In returning to his roots Hershey bucked the tide of urbanism; his disregard for the city was central to his image. Hershey liked to relate how businessmen, usually city slickers, laughed at his vision of a harmonious industrial settlement. For Hershey, cities "never seemed natural." In Jeffersonian spirit he continued, "The very foundation of our national life, the whole prosperity of our country rests on the intelligent work of the farmer." He railed against "city drift" where farm boys were "swallowed up in inconspicuous mediocrity." And he sounded Jefferson's clarion in descrying cities for breeding "trouble with workers."[7]

Hershey's backward-looking restraint and selflessness was another feature to the myth. Hershey advocated the economics of scarcity even as he promoted consumerism. Stories told how fashion meant "nothing to him"; his "apparel" was of "the most simple and conservative kind." Hershey believed that nothing "should be discarded" until it "has outlived its usefulness." Hershey cared so little for things, according to published stories, that he gave his mansion to the

town as a country club, retaining for himself only a few rooms.[8] Despondent at their failure to bear children, Hershey and his wife founded the Hershey Industrial School for "normal, white, orphan boys" in 1909. The orphans exemplified Hershey's yeoman ideals, living in farm homes, doing chores, and learning a trade. A *Survey Graphic* writer, in 1924, compared the boys' lodgings, which harkened back to Hershey's "Pennsylvania Dutch streak . . . in contrast with the model provisions" made for the orphanage's livestock. The author also criticized orphans' anachronistic education, which segregated them from other nearby schoolchildren. Hershey had endowed the school with ownership of all Hershey enterprises, even as he continued to control both. The myth has Hershey endowing the Industrial School anonymously. U.S. Supreme Court Justice Charles Evans Hughes told humorist Will Rogers that the chocolate producer was "one of the world's philanthropists who hides his light under a bushel." As the *Liberty* article indicates, Hershey's altruism was touted nationwide by the early 1920s.[9]

One manager described Hershey as both a "saint" and a "devil . . . like the rest of us human beings, he was probably a little of both"—a more just description than the airbrushed publicity tales. He prized "loyalty . . . above education or brains." Recounted one manager, "It would never do to say 'no' to Mr. Hershey." Despite such rigidity, no one believed Hershey ruthless. Grown men were brought to tears when reminded of Hershey's personal dominion over the town. Even strikers found him "firm but with integrity."[10]

The myth of a homespun Hershey cannot obscure his businessman's savvy: Milton Hershey contributed to the nation's nascent mass consumer market and culture. Indeed, the Hershey Company epitomized the arc of America's consumer economy, which linked production with consumption, and corporations with a global reach to the domestic lives of Americans. When Hershey sold Lancaster caramel, he retained rights to the chocolate covering them. He then "pioneer[ed] . . . continuous manufacturing" in chocolate; his machinery became the industry standard.[11] By moving to Pennsylvania he vertically integrated operations. Hershey bought up dairy farms and correctly surmised that Pennsylvania farmers would sell milk inexpensively.[12] To control a key ingredient, sugar, he established a second Hershey in Cuba. With twice as many workers as in Pennsylvania, this Hershey became the "largest sugar producing company in the world." By 1937, Hershey was the largest chocolate producer in the world.[13]

Hershey bragged that he never advertised, but he understood brand identification. Even Hershey's daily consumption of half a pound of chocolate was used for promotions.[14] He printed his name on chocolate bars and on their plain brown paper wrappings; the Kiss's shape provoked immediate recognition. In the 1920s and 1930s the Hershey Kiss Kids, two apple-cheeked youngsters, boy and girl, adorned point-of-sale promotional boxes. In one poster the girl daintily aimed a "kiss" at the boy's expectantly pursed lips (Fig. 3.1).[15]

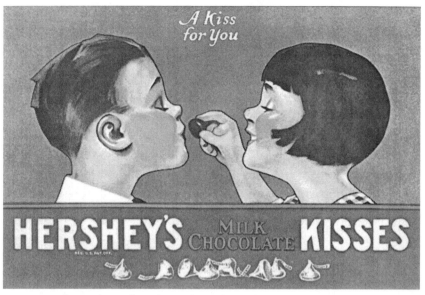

FIGURE 3.1 *"A Kiss for You," Hershey Kids, product packaging, box wrapper, 1925–1950.*
Courtesy of Hershey Community Archives.

The company also produced point-of-purchase posters and window dis-
plays for grocery stores, and candy and soda shops. The brand's sentimental
imagery often included references to the magical town with its main avenues
of Chocolate and Cocoa, and bulk Kisses containers had a photograph of the
Hershey factory melded into the rural landscape.[16] The oft-printed Hershey
recipe booklet praised chocolate as a convenient, easily digestible and nour-
ishing food, a "meal in itself," with more calories than beef and "abundant
protein of a more nutritious value than . . . even the best of cereals" (Fig. 3.2).[17]
Endorsements from recognized nutritionists and Bernarr Macfadden, editor
of *Physical Culture* magazine, furthered the corporate brand.[18] And photo
postcards from Hershey visitors mailed to friends and family advertised town
amenities and the chocolate. Cards showed Hershey's "Old Homestead farm";
cows hitched to the "sanitary milking machines"; factories with "natural land-
scape," shrubbery spelling "Hershey Cocoa"; a busy downtown avenue; and
Hershey Park leisure scenes (Fig. 3.3). Hersheytown was industrious and fun,
rural and cultured, diverting and commercial.[19]

Hershey's sales strategy tendered the narrative of Hershey's ideals trans-
forming the countryside, transforming workers' lot, and even transforming
American social relations. Hershey imagined a town of worker homeowners—
the middle-class ideal—with leisure, educational, recreational, and cultural
activities close at hand. He added a host of community services including the
Hershey Inn, a bakery, laundry, gas stations, a bank, a department store, lum-
beryards, and even an abattoir. Hershey believed that management and labor

A Cookery Expert's New Recipes

COCOA has always proved a very important and valued ally in my work. Aside from the delicacy and richness of flavor it imparts, cocoa contains qualities which at once recommend it strongly to the dietitian and nutrition specialist.

Because of its comparatively small fat content, cocoa is easily digested and is therefore an excellent food for children. It is especially to be recommended for the child who must be encouraged to take milk, for he will usually drink his proper quota if cocoa is added in correct proportion.

For the invalid and persons of delicate digestion I have always found cocoa one of the most nourishing and easily assimilated of products. Because of its concentrated nutriment, it becomes, when milk is added, an almost perfect food.

In all my cookery experiments cocoa is a much prized product. It is so convenient, so easily added to other ingredients, so ready for use — besides adding so exquisite a quality and toothsomeness to my cakes and desserts. I have formed the habit of adding cocoa to a great many of my simple recipes, thereby improving them immeasurably.

Caroline B. King

Woman's Editor
The COUNTRY GENTLEMAN

HERSHEY CHOCOLATE COMPANY
Hershey, Pennsylvania
The Chocolate and Cocoa Town

FIGURE 3.2 *Hershey Chocolate Company, "A Cookery Expert's New Recipes," ca. 1922–1927. Courtesy of Hershey Community Archives.*

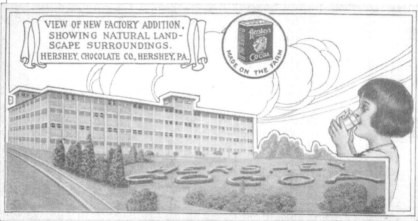

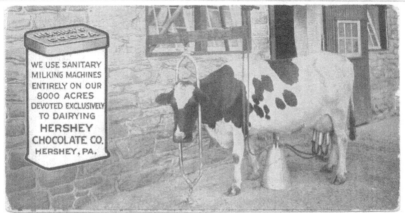

FIGURE 3.3 *Hershey Chocolate Company, Hershey Chocolate postcards, 1909–1918.*
Courtesy of Hershey Community Archives.

could live harmoniously, though Hershey molded these social relations. As his publicist wrote in one article, "In one sentence, Mr. Hershey makes chocolate and men."[20]

Hershey's ideals proved remunerative. Hershey Park, organized as a cooperative venture under City Beautiful principles for workers' relaxation, became a profit-turning amusement park.[21] Beginning with a baseball diamond, a playground, a zoo, and a swimming pool, by the century's second decade, the park boasted a merry-go-round, and then a roller coaster and a miniature railway. Hershey amalgamated the town, its services, and its recreations under the Hershey Estates Corporation in 1927, acknowledging its moneymaking character.[22] Ten thousand visitors came to the chocolate paradise in 1928, the number doubled one year later, and by 1934 66,000 people enjoyed Pennsylvania's Playground. The company claimed that 200,000 people visited the rose garden in the mid-thirties; a quarter million used the Hershey Arena for sporting events (Fig. 3.4).[23]

During the Depression Hershey enhanced his empire through massive capital projects—more golf courses, a community theater, a 15,000-seat outdoor stadium, a sports arena, and the Hotel Hershey. Radio announcer Lowell Thomas described this pastiche "palace" drawn from Hershey's memories of Mediterranean ports and a "Cuban hacienda" as "outpalacing the maharajas," though *Fortune* snickered at its "execrable interior decoration." The press called these Depression-era additions examples of the founder's civic-mindedness; individual detractors noted that depressed wages let him expand at less cost.[24]

A 1926 version of Hershey's promotional booklet, *The Story of Chocolate and Cocoa* spelled out Hershey's experiment in narrative and photos in the same contours as mass-market magazine articles, radio broadcasts, and newsreels (Fig. 3.5).[25] The cover's colored lithograph, of well-dressed cultivators from an indeterminate tropical land who harvested cacao pods, conformed with an interior story of Hershey, who bought beans from Africa, Asia, the Americas, and the Caribbean. The cover enticed consumers with exoticism, much as visits to Hersheytown were intended to entice with leisure. *The Story of Chocolate and Cocoa*'s first photograph was an aerial view that showed the chocolate factory "nestled" into a Pennsylvanian landscape, in "the foothills of the Blue Ridge Mountains" (Fig. 3.6).[26] The booklet described Hershey's town, where "winding streets were mapped through picturesquely undulating ground." Photos depicted the town's groves of trees, its filtered mountain water, and the "pathways and roadways like white ribbons" that "lead to pleasant vistas and quiet retreats." Equally impressive, according to the booklet, were the "uniformly large and attractive houses," with "velvety lawns" owned by the town's workers. In Hershey's industrial experiment a "community of mutual interests" reigned, and the workplace was transformed into a site of leisure, even contemplation.[27]

FIGURE 3.4 *Hershey Chocolate Company, Hershey Park brochure, ca. 1940. Courtesy of Hershey Community Archives.*

HEY PARK
GROUND OF PENNSYLVANIA

FIGURE 3.5 *Hershey Chocolate Corporation, cover drawing,* The Story of Chocolate and Cocoa, *1928. Courtesy of Hershey Community Archives.*

HERSHEY, PA.
"THE CHOCOLATE AND COCOA TOWN"

FIGURE 3.6 *Hershey Chocolate Corporation, frontispiece, aerial view of park and town, from* The Story of Chocolate and Cocoa. *ca. 1928. Courtesy of Hershey Community Archives.*

Hershey's promotional materials denied class divisions. Hershey had "no wrong side of the tracks"; the "story book town . . . almost persuaded a visiting socialist to renounce his creed." Even the factory partook of Hershey's pastoral vision. *The Story of Chocolate* showed the "factory's walls covered with ivy," its "airy rest rooms" with "plenty of space for dancing," and its grassy stretches for the lunch hour, which evidenced Hershey's devotion to his employees' "comfort and welfare." Photos of the factory had it "fronted by parks" and "surrounded by wide open spaces." In this classless world, it helped that workers were absent.[28]

By the late 1930s millions of Americans had encountered Hershey: a simple man who loved his workers, gave his home for the town's leisure, and gave his fortune to orphan boys, while modestly refusing to tell a soul. This Hershey had little complexity; instead mass media venues snapped up Hershey as an exemplar of American success. A few venues questioned Hershey as one of many "self-made men with narrow egotism," but most Americans consumed the Hershey myth as the company lovingly crafted it, with all its treacly sweetness.[29]

"The Workers Live in but Are Not Part of This Utopia"[30]

Most workers revered Hershey, but they had to square this devotion with their lives' inadequacies. They had many gripes: limited wages, overwork, and little chance to enjoy Hershey's amenities. Some targeted managers for their ire, others the immigrant workers in their midst, and yet others Hershey himself. Milton Hershey was as frugal with his workers as he was with his wardrobe. A plant superintendent diplomatically called him "economical." No one knew this better than the industrial workers who labored long hours for meager pay. "Hershey was a low-pay place, notoriously so," remembered a payroll supervisor. Seasonal dips in chocolate production and Depression-era cutbacks meant that workers came home with smaller paychecks.[31]

Prior to the 1933 National Industrial Recovery Act (NIRA) maximum hour limits, workers labored ten- and twelve-hour days, six and often seven days a week. Managers threatened workers seeking time off with dismissal. Recalled a worker, one man who sought a Sunday off to visit with "relatives coming in from Indiana" was told by his foreman: "Well, if you take Sunday off, don't come to work Monday."[32] Workers chafed under arbitrary management, particularly the foremen's. Just weeks before the strike, a "Hershey citizen" who was "not a radical, just a working man who has tried to be faithful" wrote directly to Hershey. He complained of overpaid managers, pay inequalities between skilled and unskilled laborers, and favoritism shown to the managers' friends, individuals who "walkes around the factory doing nothing, and still drawes a big Salary." His letter encapsulated workers' grievances. Many remained committed to the founder, even as his utopia failed to deliver. Two

factory workers maintained that "before unionization, you just were at the discretion of the foreman, you took what he gave you, or else . . . The dirty jobs were reserved for people he didn't like." One manager revealed that foremen enjoyed playing "lord and master," and that "almost the lowliest foremen" had the power to fire workers.[33] A woman worker described the ignominy of managerial surveillance: "You were watched every minute . . . as if you were going to walk away with something, and that's very hard for a person." Even bathroom breaks were monitored. Italian workers found management particularly hard: they received the lowest wages and the worst jobs. Chocolate workers complained of speedups, and contended that conditions at the Hershey factory were as bad as "sweatshops were elsewhere."[34]

Workers also knew Milton Hershey to be capricious. Hershey was renowned for firing "slackers" without ascertaining the circumstances behind a worker's actions. This could have devastating consequences. Asserted one former manager, "When you did that to anybody back in the 1930s, it was almost a death sentence, because jobs weren't available."[35]

More than anything, workers resented Hershey's control in their lives. Some were vexed by corporate pressure to get workers to live within Hershey's town. Claimed one who refused, "I live in Lebanon. I go home quick. Too much Hershey. I can't stand!" At one point during the Depression the company ruled that workers living outside a specific radius would be laid off. This resultant surplus labor force sowed fear among workers. To appease managers, some workers hid their politics; others shopped at Hershey's Department Store.[36] The company prohibited workers from making money on the side, increasing its economic control. It fired those who did, such as the man who bought a Harrisburg taproom as an investment. The company threatened another worker's family with eviction if he opened a bar. A third worker did so; the company fired the entire family. Milton Hershey didn't want women to work once married, believing they had "other duties in the home." As a result, Hersheytown had many secret marriages. The company maintained control at the work site, within the community, even within the heart of workers' domestic relations. Some concluded that Hershey was a "czar," the town a "benevolent autocracy."[37]

Even Hershey's amenities generated friction and hostility. Samuel Hinkle, a chemical engineer in upper management thought, "Hershey wanted to see people have a good time, [but] he didn't ever take great pains to provide the leisure hours for them. That was misread by many people as . . . a move against people enjoying themselves." Workers' income also excluded them from town pleasures. Workers complained that the Hershey store's goods cost too much, and they were angered that the company pocketed the profits. The town jewel, the Hershey Community Club, charged fees that workers couldn't afford.[38] Workers with neither time nor money to avail themselves of town advantages, sometimes wistfully, sometimes bitterly, complained of watching visitors motor in from near and far, perhaps enticed by zingy write-ups in the mass-produced

Mobil or Esso maps. Alda Garosi remembers sitting near the window of the community club to listen to music and watch people dance. She and her neighbors couldn't join in because "they just didn't have that kind of money." The *Christian Century*, a progressive Protestant magazine that espoused the social gospel, concluded that workers lived in a utopia they could look upon only from a distance.[39]

In early 1937 Hershey workers began meeting to unionize the Chocolate Paradise. This was not the first attempt. At Ignazio Romanucci's request, the Industrial Workers of the World tried to mobilize workers in Hershey two decades earlier. The 1930s offered workers new opportunities to press their claims, and many struck, with the perceived support of the federal government and the Wagner Act. Labor's exploits filled daily newspapers and national magazines. And in nearby anti-union bastions the steel lords bargained with labor. Hershey workers first met undercover, fearing they might lose their employment. As the drive built, workers met in surrounding villages. Within a short time the union signed up over 80 percent of the workforce of 2,100, a high proportion. These workers hadn't just signed cards; they paid dues, indicating strong commitment.[40]

Milton Hershey's impetuousness and vaunted philanthropies fed organizing efforts. Early in the drive, Hershey "charged . . . right up front," to a "packed house" meeting. He regaled workers with the familiar story of Hershey's founding. Remembered one audience member, "the big mistake he made was when he said, 'and I have this Industrial School up here for orphans and it costs me $1,500 a year for each boy I have up there.'" Angered workers applauded when Hershey charged back out. A father of eight who made $800 a year then stood and articulated a common feeling; he couldn't understand how Hershey could allot orphans more money than his own children. Hershey's peacemaking had backfired.[41]

Hershey managers responded to the initial CIO threat by giving workers small raises. As the drive continued winning converts, Hershey gave 20 percent across-the-board raises, trying to stem the union's popularity. "The hue and cry at the time was that, gee, here Detroit was paying five dollars a day. . . . [F]ive dollars was big pay." Hershey workers imagined dramatic gains for themselves. The CIO dispatched Miles Sweeney to organize Hershey workers, and speakers from nearby coal regions also rallied them. Perhaps because the drive was so successful, the company signed with it on March 17.[42]

But dissension reigned among managers; some rejected unionization. Sam Hinkle remembered that "a nucleus of people" found the closed shop "very revolting." They blustered about engaging in their own strike if an agreement was signed. Trouble began when the company let 150 workers go during slack season, among them rank-and-file leaders.[43] Suspecting that the company was trying to break the union, members met the next day, April 1, and decided to strike. Workers demanded a union shop, dues checkoff, and reinstatement of

their laid-off leaders. Union supporter Warren Plebani thought that union leaders "weren't moving as fast as the members thought they should. . . . The membership took it right out of the officers' hands."[44] Experienced CIO hands failed to convince workers to slow their pace. "The public was so riled up they couldn't even get through to them. . . . [I]t was like a spontaneous explosion. Boom! There it goes!" The drive's main leaders, John Loy and Russell (Bull) Behman, themselves Hershey workers, had never led a campaign. Their naiveté led them to assert demands too precipitously. Hershey workers must have been buoyed by CIO sit-downs elsewhere; they thought the tactic a "novelty" worth trying.[45]

The chocolate workers sat down in the factory on April 2. Workers swept through the plant telling coworkers to lay down their tools. It was warm, and strikers hung out the windows, sometimes razzing those who hadn't joined in, sometimes throwing chocolate bars down to watching children. Workers didn't secure the plant's premises, the usual practice; perhaps they retained a trust in the company's paternalism, or perhaps organizers' inexperience showed. Some strikers, particularly women, went home at night; others received "good night kisses" from their husbands before bedding down in the factory. Neighbors dropped by to show support, lead songs, and bring sandwiches and liquor to bolster sit-downers' spirits.[46] At one point strikers even left the plant to meet Hershey managers' preconditions for further negotiations. W. R. Murrie, Hershey's president, praised them for the plant's "spotless" condition.[47] But negotiations broke down, and workers moved back into the plant the next day.

Despite Murrie's kind words, workers faced a formidable opponent as managers girded for battle. On the strike's first day, managers handed clubs to "loyal" workers who supported them. Management also stirred up resentments between unionists and the outside community. They printed up flyers, such as "Sit Down Strike Is a Strike Against Orphan Boys," to tarnish strikers' activism. "Swat that Fly," another pamphlet, characterized as "hate material" by one Hershey manager, blamed the strike on Italians.[48]

The conflict came to a head with an invasion of these loyal workers and nearby farmers who tore strikers out of the plant. On Monday, April 5, the farmers protested their lost milk sales. Thousands of anti-unionists paraded in lines, four abreast and two miles long. Their signs proclaimed their Americanness and commitment to Hershey. Other signs decried the strikers' ingratitude. The next day loyalists met in the Hershey Community Theater, pledging themselves "to the corporation and opposed to the closed shop plan demanded by the CIO."[49] Two thousand then paraded in neighboring Palmyra. On Wednesday, April 7, over 10,000 farmers and Hershey Estates workers held a mass meeting in the Hershey Sports Arena. College boys from the Lebanon Valley College joined in, as did members of the Hershey Bears, the town's hockey team.[50] They gave strikers an ultimatum: "Come out or we'll bring you out."

When it wasn't met by noon, the entire contingent, led by flag- and rifle-carrying American Legion members, advanced. Strikers had been "parad[ing] snake-dance fashion on the flat roof, singing their songs and shouting, college yell fashion." When they heard that the loyalists were coming, strikers thought it a "big joke." Only as strikebreakers reached the plant did organizer Bull Behman yell for strikers to run. Women were bundled out of the plant for protection. Other strikers "jumped out of the windows, jumped off the roofs." Some outran their pursuers, while others were beaten on the streets and sidewalks of the chocolate village.[51]

Farmers and other loyalists rammed down doors and broke windows to get inside. Once there, bloody hand-to-hand combat broke out with the still-trapped strikers. Strikebreakers used their clubs, and strikers responded with "used milk bottles and some chairs." One striker pushed an ice pick through the belly of a loyalist. But loyalists won. They forced the vanquished strikers to run a gauntlet. Equipped with bullwhips, pitchforks, pipes, pick handles, and chains, the strikebreakers formed a line two deep. Rose Gasper recalled, "It was a terrible, terrible time. The farmers were lined outside . . . hitting [the sit-downers] with clubs." Another worker recounted, "They marched them through the line, hit them on the head, spit on them, called them names, told them to get out of town, [and there was] blood running down from their heads." Strikebreakers singled out Italians for special attention. One man, a child at the time of the incident, remembers his sister being hit by a woman in the crowd, as a man yelled, "Get out of town, you little wop."[52]

Visible in much that occurred was the corporation's imprint. Managers took advantage of high tempers; they may have fomented the violence. Initially the corporation bought the farmers' milk; it then claimed it could no longer. Rumors circulated through town that newly hired "outsiders" called the strike, a code word for anti-American radicals, probably Italians. Milton Hershey himself spread such rumors.[53] The creamery's supervisor spoke at anti-union rallies and visited farmers and Estates workers at home asking them to remain "the way we used to be—all friends." Managers followed the supervisor's appeal by requesting that workers sign loyalty oaths. Allowing anti-unionists to use the community center, theater, and sports arena gave them logistical support. The company signaled its moral approval by "review[ing] the marchers" and applauding their efforts.[54]

Most press accounts focused on the farmers, often painting them in broad brushstrokes as upright, American Mennonites, with their "legitimate gripes" of lost milk sales, but many anti-unionists were not farmers. As one Hershey manager later put it, "Well, they said it was farmers, but whoever it was, I don't know." Some unionists believed that the company imported paid strike-breakers uniformed in spanking new farmers' overalls. Many strikebreakers were American-born Hershey Estates workers, those who worked in the commercial enterprises such as the country club, whom management had set against the factory hands.[55]

The company enjoyed control at the plant throughout the strike. Loyal-ists battered down doors, but others walked right through an entrance, as strikers never forced management and foremen out. The actions of state police also imply corporate involvement. From the century's beginning, Hershey had hosted the School of Instruction for Pennsylvania's State Con-stabulary, called "Pennsylvania's Cossacks" by labor supporters. In the strike's midst, police milled about on Chocolate Avenue, which was "flooded with people" but according to local press, before the loyalist takeover and ensuing melee, "there was not a uniformed policeman in sight." When police returned, they drove the crowd from the factory but did not aid beaten strikers.[56] The Hershey Corporation sheltered state police in a nearby barracks. Many workers believed that Hershey "controlled the police" and "told them when to come out and when not to come out." Pennsylvania's New Deal governor George Earle agreed. He ordered a "sweeping investiga-tion . . . into the disorder," claiming the "bloodshed" was preventable, "a disgrace to the Commonwealth."[57]

Despite the CIO's rout, things first looked encouraging for the union. Man-agers thought the revolt devastated Milton Hershey—"Hershey couldn't under-stand why they were moving against him like that after he had provided all these facilities. . . . It cut him to the quick." As a result they sat down with CIO leaders to agree to renew production. Workers returned the following Monday, April 12.[58]

But Hershey's sorrow did not paralyze him or top managers, who then out-maneuvered the CIO. The company established a loyal union that ran against the CIO in an NLRB-monitored election. This company union maintained that the CIO threatened peace and security, the closed shop was a "base injus-tice," and Milton Hershey would have fixed any problem. They convinced other workers, who voted two weeks later, 1,542 to 781, against the CIO.[59] The company charged that the results vindicated their contention that the CIO had manipulated workers. The CIO countered that workers responded to "fear psychology." The CIO sought relief from the NLRB, which invalidated the company union as illegal under the NLRA. The company then tapped the AFL, which was always happy to compete with the CIO for another shop. The AFL won—ultimately becoming the largest and strongest candy local in the AFL's Bakery and Confectionery Workers' International Union.[60]

Hershey mourned his lost utopia, but he was never maudlin. Managers remember union leaders "disappearing." One fired CIO activist found hun-dreds of former workers at the nearby employment bureau—the company had fired them. And Milton Hershey personally rewarded his allies. A year after the strike, he made a $27,000 donation to the American Legion post that led the loyalty parade.[61] Hershey rarely donated to organizations outside his con-trol, and may have been acknowledging the tactical support the American Legion gave to the anti-unionists and the corporation.

A few months after the strike the company packed its arena with 8,000 cele-brants for a rousing eightieth birthday party for Milton Hershey. Universal sent a newsreel cameraman and showed him cutting a three-foot-tall cake. Ministers gave speeches lauding the amenities that would make other workers "green with envy." But some workers believed the town's compact irrevocably broken. Fathers and sons, brothers and sisters, husbands and wives "split up, couldn't talk to each other, because one favored the union, the other one didn't."[62]

The Hershey Company kept out the CIO, but more significant was the bat-tle's resonance in national discourse. Manager Sam Hinkle asserted, "While we [Hershey] weren't the chief nationally prominent operation" of industries facing the CIO, the Hershey strike was "the high water mark of the sit-down strike." Hinkle made no idle boast; he captured the conflict's relevance in shaping public opinion about the CIO and its tactics.[63]

"News Is Not an Inanimate Thing"

The Hershey strike became a national sensation in the spring of 1937. No evidence indicates that Hershey promoted it, but other corporate interests propelled the story to national attention. The NAM had been a union foe from the first decade of the twentieth century. It revived its flagging membership in 1933 with a com-mitment to counter New Deal "radicalism and demagoguery," and its support of unions. NAM advised companies on how to keep unions at bay, and it fought the NLRA in Congress. The peak association adapted its earlier anti-union tactics to a public sphere altered by a nationalized and visual media apparatus.[64] For NAM, public relations strategies were critical to this attack. Events in the chocolate kingdom were a public relations dream, as were news images of the conflict.

Edward Bernays, an innovator in the field of public relations from WWI, contended that its essence was "the engineering of consent." Writing in the 1940s, Bernays encapsulated decades of field experience. He thought events could be shaped to enhance public receptivity to specific messages. For Ber-nays, news was not "an inanimate thing. . . . The overt act . . . makes news, and news in turn shapes the attitudes and actions of people."[65] He told public rela-tions experts to create news, giving the public a distilled message to make its truth unassailable.

NAM followed Bernays's techniques. One scholar claimed that the "new NAM sought to sell free enterprise the way Proctor and Gamble sold soap." The association conducted market research to settle on "free enterprise" as its mes-sage, linking it with bedrock American liberties: freedom of speech, of religion, and of the press. NAM maintained that what benefited business, benefited the nation's citizenry. Free enterprise, which they defined as managerial control without union interference, defined America's essence. Business must only explain this to the average American. Small manufacturers like Tasty Baking or

Bon Ami, but also major U.S. corporations—Eastman Kodak, E. I. du Pont de Nemours, and the Generals: General Mills, General Electric, and General Motors—embraced NAM's no-union gospel.[66]

NAM understood that the "news" was a key battleground in its campaign against organized labor. James Selvage, NAM's public relations officer, wrote in an April 1937 memo to member organizations, "Now more than ever strikes are being won or lost in the newspapers and over the radio." Selvage acknowledged government's affirmation of unions and businesses' need to reach the public, claiming that "with the settlement of strikes being thrown more and more into the laps of public officials, the question of public opinion becomes of greater importance." NAM's president also touted public relations as a crucial anti-union weapon. At NAM's January board meeting William Warner told members that future "industrial success" depended upon "industrial relations." "Fixing labor responsibility" for hostilities was one of "industry's greatest current problems." Warner urged business to impress on "the public mind" that "labor responsibility" was a "prime requisite for the protection of society itself against both oppression and disorder."[67]

NAM argued that "collective bargaining" with a sole bargaining agent was anti-American. It marshaled "factual information" to "stimulate" the public's "realization of the need of law enforcement and order." NAM also sought to get papers to publish "stories and pictures of industrial and business men, with the accent on those who have either started at the bottom . . . or who started their own companies on a shoestring and became big." NAM's campaign embraced meritocracy, class harmony, and voluntaristic relations—just the ideals Hershey represented to the American public.[68]

Press releases and position papers were not enough—NAM pushed members to "animate the news" to stop unionization. The Mohawk Valley Plan, or formula, did just that. James Rand, NAM member and owner-president of the Remington-Rand Corporation, the world's largest office equipment maker, developed the plan. The Federal Labor Union (FLU) had struck at his New York Mohawk Valley plants in 1936.[69] Remington-Rand labeled the campaign's leaders "agitators" who attracted only a small following. The company also armed special police. It instigated "citizen's committees," composed of locals whose interests aligned with business. Mass citizens' meetings demonstrated community support for employers. But meetings also made news. The company catalyzed a "back to work" movement of "loyal employees" to demoralize strikers, further discrediting them before the public. Finally, the company "opened" the plant, with force if necessary. The opening "spectacle's" speechmaking and flag raising rallied upheld the sacrosanct "right to work." As long as the company's hand wasn't evident, any violence made unions appear a threat to civil society. The Mohawk Valley Plan created the impression that most workers and community members shared corporate America's commitment to free enterprise—without union interference or disorder.[70]

Rand understood the news's increasing dependence on photographs to "tell" the story, though scholars have ignored this piece of the plan.[71] The NLRB investigated the plan in 1937. It focused on how mass media, particularly a visual news, advanced NAM's anti-union agenda. The NLRB called Pearl Bergoff, a thirty-year veteran, "King of the Strikebreakers." Bergoff told the NLRB that Rand had the strikebreakers enter the plant despite the many picketers outside. Bergoff thought this premature and dangerous.[72] But he misunderstood Rand's aims:

> BERGOFF: He told me that he had the photographs taken . . . not only
> moving pictures but still photographs, to be used in the newspapers,
> showing the strikers throwing stones at the men that were trying
> to enter the plant. Rand talked about the pictures. He said he had
> photographs about the assault and my people had done wonderful work
> and started to congratulate me . . . on the brilliant work I had done, and
> I said I didn't see anything brilliant about it, the men had gotten into
> the plant the best way they could while they were under a shower of
> bricks, and he was taking pictures of it. Naturally he had them showing
> peaceful pickets (the "back to work" pickets) America, a free land, all
> that stuff. . . . I was sore as the devil at Rand.
> TRIAL EXAMINER WOOD: Were you accusing Rand of staging this thing?
> BERGOFF: I did, to tell you the honest truth.[73]

Bergoff's bemusement may have been disingenuous, but Rand believed he had a "formula" to nurture anti-union opinion. With the strike over, Rand congratulated members of the Citizens Committee for helping out. "Two million business men have been looking for a formula like this and business has hoped for, dreamed of and prayed for such an example." NAM disseminated Rand's plan in the article "A Community Organizes!" in its July 1936 *Labor Relations Bulletin*. The article told how "Aroused citizens, determined that no group should place itself above law and order by restricting the rights of others, organized to safeguard the 'right to work.'" NAM excoriated this "coercion of majority groups by small minorities," calling union activists "organized mobs."[74]

No archival evidence documents Hershey abiding by the Mohawk Valley Plan. Yet the contours of the events at Hershey bear an unmistakable resemblance. And, as the national press trumpeted the Hershey story to millions of Americans, it mirrored NAM's aims—replete with photographs showing the dangers of the CIO.

"Civil War in Hersheytown"

In May of 1937, the NAM-affiliated trade publication *Mill and Factory* produced a cover story indicating the Hershey strike's value against the CIO. Written for industrial managers and subscribed to by 23,000, "Civil War in Hersheytown" was reproduced as a booklet for Hershey citizens during the company's battles

with the CIO. Senator Robert La Follette's congressional staff placed the booklet in their investigative files on antilabor practices, and *Mill and Factory* used the tactic at least one more time at Weirton Steel later in 1937. "Civil War" exemplified how public relations used the news, including photography's graphic vitality, to awaken Americans to the "whole black mess" engendered by the CIO.[75]

Hartley Barclay, *Mill and Factory*'s editor, described inevitable hostilities between American democratic values and the minority who threatened them—foreigners and outside CIO activists. Upholding democracy were anti-union workers and the "salt of the earth" pious farmers, predominantly Mennonite, who fought for their livelihoods and their beloved benefactor. For Barclay, the Hershey conflict illustrated the "Divided States of America," but the conflict was of ideals—not classes. In Barclay's rendition of the clash, the corporation was absent and "innocent of any connection . . . with the instigation of the upheaval."[76]

Invoking Hershey's magnanimity, *Mill and Factory*'s editor cast doubt on labor's rationale for striking. Barclay contrasted the "dingy mill towns of the textile industry and the soot and rust bitten towns of the steel industry" with the "green-swarded model village nestled in the foothills of the Blue Ridge Mountains." Hershey laid out everything for workers' pleasure and comfort. "[The plant] is a miniature of perfection in the artistic as well as utilitarian design and construction. Even the terrazzo factory floors are both attractive and easy to clean." For Barclay, Hershey labored so that workers needn't. "The well-paid factory workers . . . have none of the usual worries of factory workers. . . . Ninety percent of the jobs here are soft snaps. Hard back-breaking work is unknown." As the ultimate democrat, Hershey wanted workers to share "equal privileges," and "deluxe scale" services. "Factory workers even breathe air-conditioned air."[77] Barclay's depiction of Hershey's generosity and foresight discredited strikers' complaints. With Hershey workers grumbling, could any workers' grievances be justified?

Four pages of photos drawn from the Hershey Corporation of "The Most Beautiful Industrial Village in America" sustained Barclay's claims.[78] An aerial view of the chocolate factory had smoke pouring from the chimneys, but the photo emphasized the town's order more than its productivity (Fig. 3.7). The image treated viewers to the plant's entryway, with its circular driveways, followed by successive levels of the factory receding into the background. The horizontal lines of the factory were balanced by a vertical reaching into a background of trees and fields. The compositional order was reminiscent of an eighteenth-century architectural rendering of a country estate, and the vertical line into the landscape enhanced the text's message of a "green-swarded model village." Underneath this photo lie two columns of photos with Hershey's town attractions: the Italianate "club house which is open to all," the "luxurious swimming pool for employees," the "miniature railway in the village playground," and dancers in the "palatial ball-room." The images' sequence suggested that the

factory produced a life of play for workers, where they might swim, dance, play hockey, or tool around in a miniature railcar, matching the message of "softsnap jobs." Another of the four pages documented Hershey's "Ideal Housing for Workers," with photos and captions suggesting that the homes "exceeded" suburban life in the "finest regions." Only Hershey residents would have known these homes were largely reserved for managers.[79]

FIGURE 3.7 *"Civil War in Hersheytown," Mill and Factory, May 1937, article reprinted as a pamphlet, page 7. Courtesy of Hershey Community Archives.*

"Civil War in Hersheytown" devoted only one page to production. Head-lined "Short Hours and High Wages in a Model Plant," the booklet presented work antiseptically (Fig. 3.8).[80] Two photos showed not the factory, but Her-shey's vaunted "windowless" office building and a quaint-looking, tile-roofed shop. This conjunction linked modernity and tradition with Hershey, and substituted white-collar workers' office buildings and shops for the factory.

SHORT HOURS AND HIGH PAY IN A MODEL PLANT

Completely air-conditioned, this windowless office building fur-nishes noiseless, dustless, perfectly illuminated offices.

Ideal working conditions exist in the model fac-tories operated by Hershey.

The Loyal Work-ers particularly emphasize the fact that they have no objec-tion to any union. They only object to allow-ing a minority of C.I.O. members to interfere with their right to work.

FIGURE 3.8 *"Civil War in Hersheytown,"* Mill and Factory, *May 1937, article reprinted as a pamphlet, page 8. Courtesy of Hershey Community Archives.*

The lone images of the factory's interior showed employees standing alongside conveyor belts. With eyes downcast toward their tasks, workers' arms reached out much like the levers of a machine. As with much industrial photography, images emphasized order, the order that managers created. Workers, like machines, were manipulated, their consciousness erased. Such pictures sustained the notion of easy labor, and the well-lit, clean conditions exemplified the company's promise of a product "never touched by human hands."[81]

"Civil War in Hersheytown" then compared Hershey's paternalistic, ordered town with union threat. Barclay introduced strikers to readers by describing himself lost in Hershey's environs, and encountering the Italians of nearby Swatara, whose "dingy, squalid houses" contrasted with the "Mennonite villages." Barclay heard the Communist "Internationale" from "a nearby house on which the blinds had been completely drawn," conforming to his depiction of strikers' subterfuge and radicalism. Barclay also reported that strikers substituted Communistic lyrics in their "red-covered songbook," satirizing the nation's patriotic hymns.[82]

Mill and Factory's imagery also linked strikers with communism, foreign interference, and danger. Photostats showed the "red-covered songbook," the lyrics to the "CIO parody on 'My Country 'Tis of Thee,'" and "Red Book" phonograph records. A Photostat of an affidavit traced the songbook to local union organizer Russell Behman.[83] The booklet also printed a note from the "black hand," to demonstrate CIO intimidation. Of course the "black hand" also raised the specter of Italian criminality. "Civil War's" evidence-style Photostats supported the publication's contention of foreign strikers who were ideologically and socially outside the pale. A photo of Behman, sitting in pajamas and robe in his parlor, showed a revolver "within hand's reach" (Fig. 3.9).[84] The pistol butt had clearly been cut and pasted next to the unionist's hand. Seeking to transmit a message about the strikers' danger, editors' transparent tampering suggests they expected audience agreement.

But photographs also undercut the message of CIO danger, as "Civil War" printed photos of strikers as a disreputable crowd—like adolescent hooligans. One image juxtaposed a photo of two smirking youth above a Photostat of song lyrics ridiculing the Supreme Court. The largest photo showed the CIOers underneath a banner proclaiming "We Shall Not Be Moved."[85] The crowd joked around and ate sandwiches as women ladled soup (Fig. 3.10). Atop this photo, pasted-in text told readers that these workers had "big red CIO song books."[86] Mass-media photos often showed strikers in menacing, militaristic lines. These strikers appeared relaxed, even as text pointed to their "'red' tendencies." Were editors unable to find images that made workers look threatening? Did they believe their narrative so convincing that photos weren't required? Or were they unwilling to acknowledge workers' agency?

Unlike the agitators, Hershey's majority united in their love of employer and nation. Loyalists included townspeople; patriotic American Legion members;

Russell Behman, president of the C.I.O. local, interviewed reporters with a revolver within his hand's reach.

One of the men at the next table looked over with a grim smile. "If you're one of them newspaper guys you'd better shut up," he warned.

"What have you got against newspapermen?" I asked.

"Aw, yer all just a bunch of rats and yuh'd better get the hell out of here if yuh don't want to get hurt."

Needless to say, I finished up my sandwich and coffee and got the hell out. I asked directions to Hershey and was told "it's just up the road a piece." I later learned that the outlying village in which this incident occurred was an Italian section known as Swatara and that the majority of the sit-down strikers at the Hershey plant were made up of this foreign group. Earlier in the afternoon a United Press reporter had been seriously beaten. It was thought to have been strikers who had broken the glass in the automobile of another press representative. I decided to wait to come back to this section until I had obtained a pass from Russell "Bull" Behman, president of the Hershey local of the United Chocolate Workers Union of the C. I. O.

Hersheytown was quiet as I drove in at two o'clock in the morning.

The following day I questioned as many people as I could find and all refused to talk. It was obvious that both the loyal workers and the sit-down strikers had clamped a lid on statements by their members. It was only later, after obtaining credentials from both sides, that I was able to get to the bottom of the affair.

With few exceptions newspaper reporters and photographers spent most of their time sitting around in easy-chairs waiting for news to be made by the actions of one side or another. They amused themselves by asking each other in a joking manner, "How would you like to be an Industrial Baron like Hershey?" This industrial baron built a mansion which he turned over to his employees and he now lives in only three rooms on the second floor. It is impossible for reporters to make more accurate investigations under existing conditions in strike-bound communities and their courage and fairness is self-evident in their presence on the scene of the conflict.

The Farmers

The newspaper accounts of the riot differed in important particulars. One of the major questions was that of whether or not the riot was intentionally planned by strike-breakers hired by Hershey or whether it was really a spontaneous reaction against the sit-down strikers by angered farmers. A careful investigation has convinced me without any doubt that the farmers and independent union members were responsible for the trouble, that strike-breakers were not present and that the Hershey Company was innocent of any connection whatsoever with the instigation of the upheaval. I called on a large number of farmers in such nearby towns as Palmyra, Annville, Cleona, Hanoverdale, Elizabethtown, Hummelstown and others. Every man told the same story. They were not active in the fight. Oh, no! But they knew all about it. They knew the Governor wanted to apprehend those who had been in the fray. They admitted having been in Hershey, that they sold milk to Hershey Chocolate Corporation; that they thought the riot had been a good thing; that they thought the sit-down strike was contemptible and Un-American; that they thought the Orphan Foundation which controls the Hershey Chocolate Corporation deserved support of all local citizens; that they thought the C. I. O. was getting pretty tough when it attacked an institution which exists for the purpose of supporting and educating orphans; that they hoped the C. I. O. had learned its lesson; and that they would stage another battle if another sit-down occurred. They did not say, as the strikers did after the fight, "We should have had machine guns and tear gas."

They knew lots of other farmers who thought the same thing and who also knew all about it, but also were not there. They gave me names of their friends who also were not there. After interviewing about sixty farmers and milk trucking contractors who said the same thing, I decided that the only way that Governor Earle or Madame Frances Perkins could have her labor investigators produce any evidence against the farmers would be to identify the men individually from their parade photographs accompanying this and other articles. State officials under Governor Earle have promised to do this. Following typical C. I. O. tactics I have conveniently forgotten the names of the farmers who were not there. For their own benefit, I hope the Pennsylvania State or U. S. Labor Department field men do not ask too many questions of the Mennonites. It is against Mennonite religious principles to go into debt so you can appreciate what they think about anyone from Washington, D. C. They recently asked a U. S. Court for an injunction because they did not want to be burdened with a P. W. A. debt for the construction of a schoolhouse. They have plenty of money to buy whatever they want. As far as strike-breakers are concerned, one of the complaints of the camp-followers who flock to the scene of labor disorder at the first signal is the fact that Hershey officials would not even interview representatives of strike-breaking agencies. Mr. Hershey has been too smart to give Governor Earle of Pennsylvania that kind of an opportunity to smear his enterprises effectively. Mr. Hershey had fair warning because Governor Earle expressed his disinterest in sit-down strikes. Governor Earle heard charges that Railway Audit and Inspection men had been employed by the Hershey Chocolate Corporation. But after investigation, even the pro-striker citizens in Hershey laughed at this news release. Railway Audit and Inspection gave me an official denial of Earle's charges One of the men cited by the Governor's advisers was employed six months before the union was organized and the other had been employed for over a year. By contrast, however, no one can deny the fact that Art Shields, of the Daily Worker, Central Organ of the Communist Party, U. S. A., was one of the out-of-town associates of the C. I. O. pickets in Hershey on April 9.

The Big Red Song Book from Behman

SONGS FOR WORKERS

FIGURE 3.9 *"Civil War in Hersheytown,"* Mill and Factory, *May 1937, article reprinted as a pamphlet, page 5. Courtesy of Hershey Community Archives.*

most Hershey employees, who loved Hershey Kisses so much they paid their full retail price; and the thrifty, industrious Mennonite farmers who shared Hershey's vision. Barclay encountered workers in night's dim, but he met loyalists by daylight in their rural homes and farmhouses. For Barclay, the farmers' stood for all loyalists. They had "a strong; but simple faith. They believe in God, They are patriotic. They are democratic in all their habits. They live close to the

At their union meeting their President said the government is sympathetic to the actions of C.I.O. union.

porter friends, "What's the use of having a union card if you can't give a break to other unions?" I wondered whether they realized that the significant, tragic, truth that lies in this event which I have just described is that when such incidents as these are repeated in Akron, Cleveland, Detroit, Flint, Worcester, Massachusetts, and scores of other cities the traditional American freedom of the press has been shattered in an unprecedented manner.

This military labor dynasty has imposed a reign of terror upon the American Press and nothing is being done about it. The Supreme Court decision upholding the Wagner Act will not improve conditions. In defense of the courage of the reporters who dare to stay on the job under these conditions, I protest for them and ask relief from these un-American methods. No one can blame any reporter for not reporting this meeting under these conditions. Any fair-minded person can blame only the system which permits these events to happen.

The Farmers' Rebellion

On March 14th, the Hershey Chocolate Corporation signed an agreement with the Chocolate Workers Union with respect to seniority rights.

The plant was originally occupied Friday, April 2nd, by not more than four hundred sit-down strikers out of a total of 2,300 Hershey employees. The C. I. O. demanded a closed shop and a check-off system of collecting union dues. Hershey Chocolate Corporation refused this demand and denied they had violated seniority rules in the cases of the members of the C. I. O. negotiating committee by not re-employing them after the shut-down for the Easter holidays. The Corporation replied that the C. I. O. union demanded preferential treatment for its members and this request was refused.

Having lost a market for more than 800,000 pounds of milk per day and $150,000 total income while the Hershey plant was completely closed for a period of five days, the hundreds of United Brethren and Mennonite farmers of the region held a number of meetings to determine what they could do to restore their income. The loss of income to them exceeded $14,000 per day. On Monday, April 7th, they held a joint parade with non-union workers, showing a total of 8,000 men and women. George Sanders was elected head of the anti-strike committee appointed to negotiate with the strikers to re-open the plant. Foster Wagner was appointed spokesman.

The 2,300 non-union factory employees had grown restive during their enforced vacation because of their loss of $150,000 wages. On Tuesday, April 8th, about 1,500 of them met in the auditorium of the beautiful Community Club building and organized a loyal workers union.

They joined with the farmers who had organized under a Committee of Twelve in asking the strikers union to preserve peace and completely reopen the portion of the plant needed by the farmers.

The loyal worker union members and farmers mustered early Wednesday. The local American Legion Post 386 drum corps led the parade to the huge hockey arena completed last fall for the Hershey amateur hockey team which recently won the Eastern Hockey League Championship. O. B. Keck, the commander of the post, said the Legion turned against the sit-downers after they raised the C. I. O. flag above the American Flag on the Hershey flag-pole. The American Legion later supplied traffic direction for the crowd of 8,000 by-standers in the streets.

The anti-strike committee first set a deadline for evacuation of the plant by sit-down strikers at noon, Wednesday, April 7th.

They received a threat from the sit-downers, "If you start any trouble, God help you," was the message. An accompanying illustration shows a striker carrying a steel pipe weapon concealed behind his back, so it is obvious that the strikers were not unarmed.

The anti-strike committee then set a new deadline at 1:00 P. M. A committee which included some C. I. O. as well as loyal worker union leaders went into the plant to arrange a truce while a growing crowd of spectators assembled outside.

The fight started in the milk separator plant. 2,500 loyal-worker-union members and farmers had paraded up to the main factory entrance from the Sports Arena at one o'clock when they were notified that the negotiating committee had entered the plant to meet the C. I. O. leaders for a conference.

The sit-down strikers yelled, hooted and jeered negotiations to reopen the plant. They said they would keep the plant closed until negotiations with the Union were reopened by the Corporation. The farmer-loyal worker union group was nervous and fearful because the strikers had warned them that several thousand C. I. O. members and sympathizers were en route to Hershey from other parts of Pennsylvania to lend aid to the sit-down strikers by picketing the plant and aiding in supplying food. Russell Behman, president of the strikers union repeatedly said before and after the riot that 25,000 C. I. O. members from Allentown, Tower City, Lancaster, Lebanon and other points were coming to Hershey to aid the sit-down strikers. But the 25,000 did not show up then or later.

The original fight in the separator plant spread a battle fever through the crowd. Strikers at the factory entrance further inflamed the crowd by jeering and yelling and calling the loyal union workers scabs, rats, finks and other unprintable names, according to eye-witnesses.

FIGURE 3.10 *"Civil War in Hersheytown,"* Mill and Factory, *May 1937, article reprinted as a pamphlet, page 11 Courtesy of Hershey Community Archives.*

soil. They do not waste food, time, money or property, no matter whether it is their own or belongs to someone else. They are slow to anger . . . They have no poverty or debt."[87] Farmers' love of nation was so great they could toss off not one, but all three verses of the "Star-Spangled Banner" with a "deep and moving sincerity." The booklet emphasized farmers' participation at the antistrike rally with a photo showing a group of Mennonites sitting in the front row. Editors

and did not appreciate the great economic losses they imposed on the farmers and the degree of provocation which this created. The union leaders should not have permitted insults by any one member or non-member to the American Flag. They should have been better trained. The rumor that they appealed for financial help from other unions and failing to receive more than $150 from this source received help from radical and Communist groups has definitely hurt the C. I. O. reputation locally. Their leaders over-sold the members on the possibility of receiving aid from the Governor. Whether or not it is true, as strikers told me, that Governor Earle phoned Behman from Harrisburg and told them to picket the plant I do not know. Although C. I. O. did actually picket the plant almost within twenty-four hours after the battle.

Loyal Workers Union Organizes

To know why the Hershey farmers and anti-strike workers acted as they did, we must realize their philosophical and environmental background. These people have a strong but simple faith. They believe in God. They are patriotic. They are democratic in all their habits. They live close to the soil. They do not waste food, time, money or property, no matter whether it is their own or belongs to someone else. They are slow to anger. They go to church because they want to worship God. They are opposed to oath taking, military service and theological learning. Those who are members of the Mennonite Sect hold strictly to simplicity of life and worship and often live in separate communities.

In the photographs of the loyal workers union members, you will see a number of black garbed little women, wearing the scalloped bonnet of the Mennonite religion. Strict Mennonite men wear no buttons on their clothes, often have long square beards, and when they sit down to supper, all the men-folks eat alone. The women wait on them during dinner and cannot eat until the men have finished. They paint their farm-gates blue when they have a marriageable daughter in the family. They have no poverty or debt in their communities. One old Mennonite with whom I talked, made brooms during the winter and sold them from house-

With a deep and moving sincerity, the anti-strike assembly sang this significant verse of the "Star Spangled Banner" which is scarcely remembered by most people.

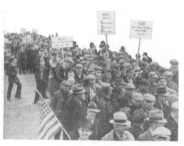

FIGURE 3.11 *"Civil War in Hersheytown,"* Mill and Factory, *May 1937, article reprinted as a pamphlet, page 13. Courtesy of Hershey Community Archives.*

accentuated the antistrikers' agrarian rectitude by pasting an enlarged closeup photo of three elderly farmers into the crowd (Fig. 3.11).[88] Women figured prominently in two of four images on another page, as did the American flag and picket signs pledging loyalty to Mr. Hershey. The women's broad smiles and their dressy attire suggests that the editor may have sought to soften the anti-unionists' militarism, though these women also marched in rows, as did the "farmers" in another image; all were poised for battle.[89]

Barclay's blow-by-blow account of events between loyalists and unionists at Hershey corresponded with the Mohawk Valley Plan. Barclay painted the strikers as a minority of outsiders, with a mere 400 workers of 2,300 closing the plant. He argued that community members enforced order against strikers. Mennonite farmers who lost milk sales joined Hershey Estates workers who

lost wages. The booklet described the citizenry's parading and an American Legion membership who believed strikers insulted the nation by raising the CIO banner above the U.S. flag. After the loyalists retook the plant, once blood coated the plant's terrazzo floors, the "American flag was [raised] again to the top of the mast" to a "lustily" sung National Anthem. "Civil War in Hersheytown" showed no photographs of loyalists beating strikers—though they were readily available, and many had been published in local papers. Barclay closed his tale of hostilities at Hershey with a vision of class harmony: righteous workers who owned the joys of the workplace and pledged their allegiance to one another, to the nation, and to the company founder. Loyal workers and farmers had a single purpose, "to get back to our jobs."[90]

"Civil War's" illustrations furthered Barclay's drama—perhaps photos couldn't tell the tale Barclay or the NAM wanted. The booklet's cover drawing of the pre-battle rally showed a long line of broad-jawed troops marching three abreast, rifles raised against their shoulders (Fig. 3.12).[91] Beside them strode a line of well-dressed men and fur-clad women. Their upthrust picket signs promised townspeople's 100 percent American citizenship. Pushed against the Hershey plant stood the laborers, their caps and moustaches were marks of their immigrant status. The high point of the composition was the affront Barclay most decried, the CIO flag flying above the U.S. flag, even in its red, white, and blue glory. The roughly drafted illustration appeared drawn by crayon or charcoal, conveying a sense of immediacy. Here *Mill and Factory* editors chose a visual language that scholars associate with "social concern." Illustrators in *The Masses*, a leftist periodical from the early decades of the twentieth century, often used this style because it made the image seem unfinished, an "affront to the commercial market."[92] "Civil War" appropriated this visual vocabulary to raise the specter of CIO violence.

Barclay's "neutral . . . reportage" suggested that the conflict's stakes were far greater than a win or loss at Hershey; his attack on the CIO was less subtle—he went at it with a broadax. The United Chocolate Workers Union, and the CIO generally, was likened to "a military type of labor dictatorship"; its leader John Lewis was "the No. 1 Octopus of America today." The CIO undermined American ideals, substituting "the mockery of a Communist philosophy." With the CIO stood the federal government, and Pennsylvania officials who ignored law itself in their support of the labor behemoth's gains.[93]

The farmers and loyal workers, the "all-American" side, were free from poverty and dependency, and they rallied to the flag and to the generous company founder. They exemplified the "religious and patriotic ideals of an overwhelming majority of citizens." The battle was thus unequal: labor and government allied against the average American, as represented by the Hersheyites. Barclay claimed that the unfortunate American public was "without adequate facts" to understand the scourge of unionization.[94]

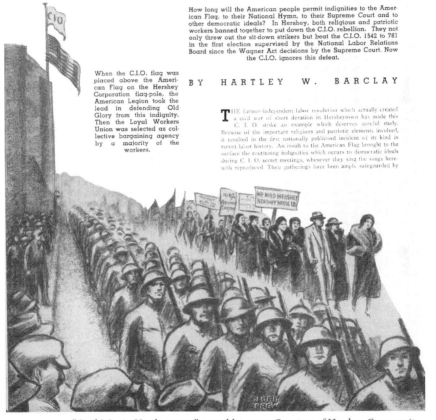

REPRINTED FROM MAY, 1937 ISSUE OF MILL AND FACTORY

Civil War
in HERSHEYTOWN

How long will the American people permit indignities to the American Flag, to their National Hymn, to their Supreme Court and to other democratic ideals? In Hershey, both religious and patriotic workers banned together to put down the C.I.O. rebellion. They not only threw out the sit-down strikers but beat the C.I.O. 1542 to 781 in the first election supervised by the National Labor Relations Board since the Wagner Act decisions by the Supreme Court. Now the C.I.O. ignores this defeat.

When the C.I.O. flag was placed above the American Flag on the Hershey Corporation flag-pole, the American Legion took the lead in defending Old Glory from this indignity. Then the Loyal Workers Union was selected as collective bargaining agency by a majority of the workers.

BY HARTLEY W. BARCLAY

THE farmer-independent labor revolution which actually created a civil war of short duration in Hersheytown has made this C. I. O. strike an example which deserves careful study. Because of the important religious and patriotic elements involved, it resulted in the first nationally publicized incident of its kind in recent labor history. An insult to the American Flag brought to the surface the continuing indignities which occurs to democratic ideals during C. I. O. secret meetings, whenever they sing the songs herewith reproduced. Their gatherings have been amply safeguarded by

FIGURE 3.12 *"Civil War in Hersheytown," pamphlet cover. Courtesy of Hershey Community Archives.*

The tensions and ambiguities in *Mill and Factory*'s visual depiction of the Hershey strike offer insights into NAM's perspective. Strikers appeared as rowdy adolescents and "documented" Communists. Their ambiguous depiction as thugs and adolescents suggests the need to name them as a threat and diminish them at the same time, much as the Mohawk Valley Plan sought to identify strikers as a danger and simultaneously as cowards. Hewing to

"documentary" accuracy was less crucial than impugning the CIO in any fashion possible. The publication's news-style photographs showed loyal anti-unionists as gray, bewhiskered farmers, while simultaneously representing them in bold drawings of fur-clad women and uniformed men, bayonets at the ready. "Civil War in Hersheytown's" dramatic cover, with men and women poised to bring down the CIO, seems to match the editor's hopes: that Americans, recognizing the danger of the CIO, would stand up against it.

"Civil War in Hersheytown" outlined NAM's perfervid fantasies about the CIO and an idealized response for an appreciative audience of corporate members. When mass-market magazines depicted the strike, their stories were less polarized, and they printed photos of the violence in Hershey. Nonetheless, coverage of the strike in national media venues repeated the thrust of "Civil War in Hersheytown's" arguments—and its visualization.

"The Public . . . Must Step into the Picture"

Letters and telegrams of support poured into Hershey's corporate offices. The company's treasurer, Ezra Hershey, received one from a Cleveland supporter who told Hershey that the company's "victory" was "leading news in all papers the whole industrial world is looking to Hershey . . . for leadership in new spirit of industrial relations."[95] The Hershey strike was small: unlike the steel, auto, or rubber industries organized by the CIO, very few workers were involved. But NAM affiliates and elected officials hostile to labor mentioned Hershey together with these industrial giants. The national news media pounced on this story. A beloved consumer product, an eccentric boss, a farmer's uprising, and a workingman's paradise: how could the national press not take up this story? Much like "Civil War in Hersheytown," press, businessmen, and politicians implicated the CIO for wrecking an ideal industrial experiment. Few attacked like *Mill and Factory*. Nonetheless the booklet's argument reverberated in businessmen's addresses, politicians' missives, and the national news. Photographs introduced Hershey's utopia and visualized the disturbances wrought when the CIO came to town.

Business groups attacking unions circulated the Hershey story in eighteen regions, reaching some 5,000 businessmen along with mass radio audiences.[96] William Frew Long, general manager of the NAM-affiliated Associated Industries of Cleveland, addressed the Cuyahoga County Bar Association. His denunciation of the CIO was broadcast over Cleveland radio. Long argued that the public demanded "actions against these unlawful seizures." Opinion polls showed it would countenance "the use of force to expel sit-down strikers." Why? Because "it is but a short step, or perhaps I should say 'an easy slide' from a sit down in those plants to a sit down on our farms and in our homes." Any handyman, cook, or gardener could sit down in one's home and claim a property

right in it. Farmers in Hershey knew as much. They "were quick to note" how the sit-down was "bringing this form of lawlessness pretty close to home." For Long, Hershey farmers vindicated a forceful response to the sit-downs.[97]

Tennessee's Memphis Business Advisory Council and the Memphis Chamber of Commerce made a similar pitch in the pamphlet "Industrial Strife and the Third Party." Memphis business elite argued that events at Hershey and in the industrial centers of Michigan and Ohio "offered a vivid illustration of what the Public will do when confronted with a situation which affects the community as a whole." The "breakdown of Law and Order in many communities" led "the Third Party" to "step . . . into the picture" to address labor's affront to property rights. The tract claimed to describe public reaction against labor, but it was an instruction manual for Tennessee businessmen to initiate their own anti-union citizens committees. To draw the "public . . . into the picture," the pamphlet reproduced outreach materials from other business-led citizens committees.[98] If farmers could step up, why not threatened citizens anywhere?

The Hershey strike also figured prominently in politicians' attacks against the CIO. Right after the April conflict, two state representatives denounced the CIO and Pennsylvania's New Deal governor, George Earle. Robert Woodside and William Habbyshaw told of farmers outraged at lost milk sales, and at the disrespect shown to Milton Hershey, who "had given away even the roof over his own head in his unselfish effort to build a model community." Woodside and Habbyshaw maintained that much like American revolutionaries who populated Pennsylvania's valleys, farmers fought back even though strikers were rumored to have machine guns. Farmers' "keen sense of justice" was an all-American justice, because "the farmer is the backbone of the American civilization." They continued, "No laboring man knows more about labor. No man arises earlier, puts in more hours or works harder than the farmer. No brow perspired more profusely. No man is in a position to appreciate the problems of labor more than the farmer." If an ideal citizen, the farmer was also "a business man who must buy, sell and employ. All farmers own property and appreciate that a property right is a human right which must be respected." For Woodside and Habbyshaw, the farmer, amalgam of yeoman virtue and business perspicacity, deserved support for his attack on unionism. The politicians complained that Governor Earle, "mimicking Washington, kept a discreet silence" on the sit-down strategy. The representatives warned Earle, "You cannot sow the seeds of anarchy and reap orderly government." Once again, in public debate the farmer stood for all Americans and meted out a necessary, homegrown justice. Michigan Representative Paul Shafer also referenced Hershey in his threat of civil war with CIO sit-down strikes. Like NAM officials, Shafer swore that if the CIO wasn't checked, John Lewis would become "the king maker of this Nation, the irresistible power behind the throne." The charge that Lewis threatened a "dictatorship of the communistic kind" rang out in the nation's chambers of power.[99]

National media spread a similar story to audiences of millions. Hershey's executives—perhaps anxious to know how the corporation fared in the press— kept track of strike coverage. They counted over 300 editorials and stories about the strike in their Pennsylvania hamlet. Small-town papers and big-city dailies such as the regional *Philadelphia Inquirer*, the *New York Times*, and the *Washington Post* covered the strike. So did the mass-market news magazines, such as *TIME*, *LIFE*, and *Newsweek*—and the traditional middle-class periodicals like the *Literary Digest* and the *Christian Century*. The *Christian Science Monitor* described the "revolt of Pennsylvania farmers against a minority sit-down of Hershey chocolate plants" a "straw . . . in a gathering gale of public disapproval." It editorialized that "labor has mistakenly reverted to the old method of its oppressors" and that public revulsion would retard labor's advances. The *New York Times* inveighed against "reckless leaders of labor." Much like Pennsylvania's representatives, their editorial sounded the familiar refrain that "violence breeds violence." In almost the same words as NAM, the *Times* argued that "the third party is the general public, typified at Hershey by the farmers" who would fight back. Editorial cartoonists also took up the Hershey strike. In the *Philadelphia Inquirer* a staunch Mennonite farmer marched with a milk can full of "Business as Usual" and a paddle under his arm. A frightened laborer, "the sit down problem," hightailed it off into the horizon. The farmer's response, "Heck, that warn't no problem!" indicated comically what the text threatened, that the third party would protect his own. Under the caption "Bitter!" another cartoon showed John Lewis recoiling with disgust after biting into a Hershey Chocolate bar.[100]

News stories were more dangerous to the CIO than editorial commentary—the news appeared objective. National news stories covering Hershey lacked "Civil War in Hersheytown's" virulent anti-unionism, but they echoed NAM's stance—often in the words of Hershey's public relations staff. Some reporters copied verbatim from Hershey publicity. With minor differences, Americans nationwide read a similar tale. The CIO intruded into Hershey's classless idyll, long ordered through the sagacity and magnanimity of its founder. Most national media narratives were mis-en-scène, the setting that Milton Hershey and his company had tended through their internal public relations staff. The Mennonite farmers often appeared as players. The story contrasted Hershey's paternalism and his rural haven against ungrateful workers whose demands disrupted the most ideal experiment. Photographs of the town—many of them provided by the corporation—and of the strike violence suggested that the CIO's shattering of Hershey's harmony was a foretaste of future events across the land. As one story claimed, "Hershey is America in miniature."[101]

Hershey's agrarian surroundings, its touches of modernity, and its small-town democratic relations all introduced strike stories. *Newsweek* offered the lengthiest description of town attributes, though other media venues found

much to commend in Hershey. *Newsweek*'s title, "Hershey, Candyland, City of Dreams," clued readers to its joys: "The air is always sweet in Hershey, PA. A dreamy aroma of hot chocolate and benevolence hangs over the town and its 3,500 dwellers. They pay no local taxes; a candy factory gives them their jobs and their luxurious clubs, schools, churches and shady streets." *Newsweek* recited "Chocolate Town . . . superlatives," claiming that this "cooperative community" expressed "industrial paternalism at its best," replete with its "ivy-clad factory."[102]

Newsweek described the town and its worker-residents just as Hershey promoted them. Town highlights seemed accessible to all; in Hershey class was irrelevant. Workers received Hershey's largesse passively: they were "given jobs" and the town's amenities without paying taxes. *Newsweek* even printed the popular Hershey anecdote that workers' "improvidence and distrustfulness" led Hershey to expand Hershey Park. Workers had neither the moxie nor the cooperative vision to help themselves, even when it came to their own fun. Milton Hershey's unremitting paternalism was a foil to the employees' ungratefulness.

Other magazines relayed a similar tale. *TIME* wrote of the "neat clean grassy model town" with "model schools, stores, theatres, sporting grounds, community centre." For *Business Week*, Hershey looked more like a "college town . . . rather than an industrial center. The air is fresh, the grass is green, and people look happy," and "schools, parks, houses, recreation centers, golf courses—all are the finest." *LIFE*'s story told how Milton Hershey built a factory in the middle of a cornfield and built a model town for workers with not one, but four golf courses. Hershey had built the production site not for America's favorite chocolate bar—but as a pleasure valley for workers' enjoyment.[103]

In all stories Milton Hershey's generosity authored the utopia. In *TIME*, "Ever since the big factory had begun to make money, abstemious Founder Hershey poured it out to make his people happy." *LIFE* wrote that Hershey had "turned over the whole establishment to the Hershey Industrial School for Orphans." Hershey dedicated his prowess not to himself, but to America's future. What was his he gave to his workers—making Hershey the ultimate communitarian. *Newsweek* noted that "his own white-pillared mansion he gave to his employees as a country club. He kept nothing for himself but clothes, furniture—and enough securities to insure a comfortable living." What wouldn't "founder Hershey" do for workers?

Workers and their demands were not portrayed in mass-market articles with any depth. *TIME* suggested that workers thought Hershey interfered with organizing by targeting unionists in its seasonal layoffs. *Business Week* added workers' belief that they weren't paid well enough, though it concluded that the town expansion "backfired when . . . newcomers led older workers into the union." For *Business Week*, "old-time Hersheyites," all American born, wouldn't have struck, if not for the out-of-towners (many of them foreign born) who

Milton Hershey had kindly "given jobs in public works projects during the Depression." This was the corporation's stance, that alien workers took advantage of Hershey's generosity. *LIFE* acknowledged that paternalism had its downside: "the only serious criticism of Mr. Hershey is that he treated his workers too much like children." *Newsweek* saw workers' desire for autonomy as a lure. The CIO was the "serpent in Mr. Hershey's garden . . . proffering not knowledge but independence."

As in NAM's "Civil War in Hersheytown," news stories erased the corporation from the conflict. The principals were union workers, led astray by the outsider CIO against loyalists: nonstriking Hershey employees and Mennonite dairy farmers. *Newsweek* repeated *Mill and Factory*'s charges of the CIOers' lapse of patriotism, they placed their banners higher than the American flag, which further enraged loyalists. These "outraged countryfolk, including many a bearded and bonneted Mennonite . . . rattled into town in their flivvers" and "stormed the plant," making strikers run a "walloping, stone-pelting gauntlet." *LIFE*'s title "In Mr. Hershey's Utopia Farmers and Strikers War" encapsulated the two sides in this war: loyalists who were represented by farmers with their small-town values, and strikers, who represented threatening change. Dependency, ingratitude, and violence were workers' defining characteristics.

Mr. Hershey stood above reproach, an exemplary planner and munificent donor, the aggrieved but uninvolved party. With his arcadia dashed, idealist Hershey could do nothing but cry. *TIME* began its story "Upheaval in Utopia" with the image of "79-year-old Milton Snavely Hershey" who "watched the violent vanguard of the times come swirling into his candy utopia" with "tears coursing down his wrinkled cheeks." *LIFE* and *Newsweek* ended their stories with the weeping Hershey. Only *Business Week* editors forwent this delectable anecdote.

Photographs vivified the message of a corporate paradise torn by CIO activism. Magazines ran far more photos of the Hershey strike than typical. As America's foremost photo journal, *LIFE* offered the most sophisticated photo narrative. Its two-page photo spread had two distinct realities on each page. The first page illustrated Hershey's ordered utopia with company publicity photos. On the second page news photos documented strike violence. Each page's content, but also these distinct photographic styles, made an argument about the events at Hershey (Fig. 3.13). *LIFE* began by delineating the town's attributes; the publicity photographs came from Hershey's own files.[104] The first shot, the oft-published aerial view of the town spanned the entire page top. The caption identified Hershey's factory and its auditorium, but the photo was taken from such a distance that each seemed equivalent, erasing the factory as a site of labor. *LIFE* also printed a bird's-eye view of the "largest outdoor swimming pool . . . in Pennsylvania," evidence of the multitudes congregating at town attractions. The aerial view afforded an overview and imparted a sense of order.[105] These aerial shots integrated work space and leisure, landscape and townscape into an organic whole defined by the founder's vision.

Ostensibly viewers received a closer view of Hershey through photographs of the "fun park in the center of town" and the "pretty little houses on spotless streets." In each photo a deep line moved from the foreground to the background, a visual device that drew the viewer into each photo and hence the town. Both shots nonetheless resisted intimacy. The photos gave a clear view of town attractions, but the contents were displayed so matter-of-factly that they were "plain speaking" to the point of banality.[106] Unlike industrial photography that often monumentalized a subject, the town amenities were approachable. And photos of this "chocolate paradise" also avoided advertising's slick allure and hot promise. These photographs were tepid. Nor were they clinically cold evidence-style photographs, for they did not have to convey the idea that what was being seen was absolute truth. Almost like the simple brown-and-silver wrappers of Hershey bars, the style suggested that you could trust the contents. Look if you'd like, but what Hershey provided was not up for debate, and therefore the photos demanded little. They were visual shorthand to the myth.

In contrast, *LIFE* used news-style action photography to document workers' activism and the reaction against it. The news photographs provided forward momentum to the visual narrative, but also tension.[107] *LIFE* intimated strikers' menace though its first photograph, which spanned the entire page. The caption told readers that strikers "brandished clubs," and the photo showed strikers strung along the top of the plant, their arms and their clubs silhouetted against the sky. The factory's blocky modernity jolted in contrast to the quaint homes and faux windmills of Hershey, and the angle and cropping of the photo conveyed a compositional energy that added to the drama. *LIFE* led readers to the climax with its caption: "By this time the strikers are totally scared." The next two shots showed "loyal workers and farmers parad[ing] past the plant" and then "rushing . . . the factory." Both pictures were taken from an angle that cut into the landscape and events, emphasizing motion but also disjointedness. These photos were so dynamic that they appeared as movie stills, orchestrated action shots moving to a specific end.

The climax came in *LIFE*'s next shot, a potent symbol of violence. The photograph showed local CIO leader John Loy, who had just been forced from the plant into the gauntlet. Centered in the frame, his bloodied nose a focal point, Loy was propelled to the foreground of the photo frame and hence toward the viewer. A second man whose upraised arms suggested self-protection or supplication joined him. The two were surrounded by the bodies and arms of "loyal workers" who pushed the men forward and the arms of yet others who pummeled them. This maelstrom of arms heightened the photograph's sense of chaos and violence.

A fitting epilogue was found in the final image that showed grinning loyal workers. They held high picket signs with slogans such as "Do Not Bite the Hand That Feeds You" and "You Can't Eat C.I.O." These signs reminded readers of workers' debt to their employer. In cutting out the loyalists from their context

LIFE ON THE AMERICAN NEWSFRONT: IN MR. HERSHEY'S UTOPIA FARMERS AND STRIKERS WAR

THIS IS THE CENTRE OF THE MODEL TOWN OF HERSHEY, IN THE MIDDLE FOREGROUND IS THE AUDITORIUM, IN THE BACKGROUND THE FACTORY

Hershey, Pa. is a model town conceived and built by the man who makes the chocolate bars. Thirty-four years ago Milton S. Hershey (*left*) built his milk chocolate factory in a Pennsylvania cornfield to be near the supply of milk. The plant prospered and good Mr. Hershey built around it a model workers' town with houses, schools and community buildings, swimming pools and four golf courses. Then he turned over the whole establishment to the Hershey Industrial School for Orphans. The only serious criticism of Mr. Hershey has been that he treated his workers too much like children. But lately the United Chocolate Workers, an affiliate of CIO., got a foothold in the Hershey plant and on April 6 called a sit-down strike. Some 600 workers held the factory while 1,400 others, loyal to Mr. Hershey, got angrier and angrier. What ended the strike was the sudden appearance of a horde of farmers who sell 800,000 pounds of milk a day to the company. Rattling into town in their flivvers, they joined forces with the loyal workers, stormed the plant, evicted the sit-downers. On the steps of his office stood old Mr. Hershey, now 79, with tears rolling down his cheeks.

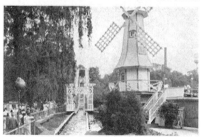

A fun-park in the centre of town provides amusement for Hershey children. In the centre above is a chute-the-chutes. The windmill is the entrance to a caterpillar roller coaster.

The outdoor swimming pool (*above*) is the largest in Pennsylvania. In the airview at the top of the page, taken earlier, you can see the excavation for the pool in the foreground.

Pretty little houses on spotless streets are the homes of Hershey workers. The entire town is held in trust by the Hershey estates for the benefit of the Hershey Industrial School.

FIGURE 3.13 *"In Mr. Hershey's Utopia Farmers and Strikers War," in weekly* LIFE *on the American Newsfront feature,* LIFE, *April 19, 1937. Text copyright 1937, The Picture Collection Inc. Reprinted with permission. All rights reserved. Photos on left courtesy Hershey Community Archives.*

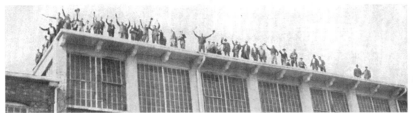

ATOP THE HERSHEY FACTORY ON APRIL 6, SIT-DOWN STRIKERS WAVED ARMS AND BRANDISHED CLUBS

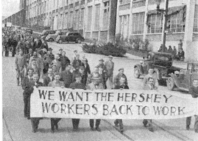

On Chocolate Avenue, the main street of Hershey, loyal workers and farmers paraded past the plant on the morning of April 7. By this time the strikers were thoroughly scared.

Then the farmers arrived and together loyal workers and farmers rushed the factory. They battered in the door, ordered the strikers to drop their weapons and come out running.

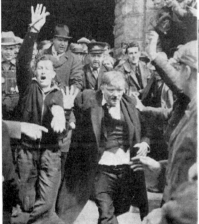

Out came the strikers. They were forced to run a gantlet of farmers and non-union workers who pushed, paddled, tore and beat them. Then the victors held another parade (*right*).

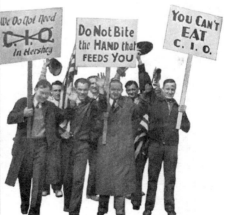

and placing them against the white background of *LIFE*'s pages, the editors delivered a moral for readers outside the confines of time and space. *LIFE* embellished their tale with another visual gesture—editors placed a cameo of Milton Hershey amid the photos of his town, offering a visual parallel to the story of a lachrymose Hershey watching his shattered utopia. The capitalist-philanthropist

confronted the bedlam strikers provoked from the stable site of his creations. He judged the violence before him, much as viewers of the magazine might have after reading the article.[108]

Other national news magazines spun a similar tale. Similar to *LIFE*, *Newsweek*'s full-page photo spread of "Chocolate Town" contrasted Hershey's order with workers' pandemonium.[109] *Newsweek* also printed the picture of the beaten John Loy being ejected from the plant. Editors surrounded it with four Hershey publicity photographs that spoke to Milton Hershey's munificence. Three of the four images were aerial shots: of the Hotel Hershey, Hershey Park, and the Hershey School. The luxurious grandeur of the hotel; the pastoralism of Hershey Park; and the school's institutional architecture—all these details were stripped away because of the distance of the shot, so each subject lost its specificity. This vantage equalized each subject to the viewer, as did the subject's centering in the picture frame. As equivalents, these photos became interchangeable pieces in Milton Hershey's larger plan. The breadth of Hershey's vision was heightened by the relationship of the town to the surrounding countryside. The photographs wove the built environment into the natural environment. This paralleled the public relations spin on the town, an industrial utopia in an arcadian setting. The viewer was treated to Hershey's valley as a whole that could be visually consumed, each town attribute another bauble on a chain. *Business Week*'s also detailed a lengthy list of town highlights to be identified in its aerial view of what Hershey had wrought.[110]

Mass-market magazines such as *LIFE* or *Newsweek* broke with more localized communication beginning in the early twentieth century, and by the 1930s they had become an avenue for national opinion making. The message imparted to a national audience about the Hershey strike was as standardized as Hershey's 5-cent chocolate bars. The media story bore the corporation's imprint. Fancifully put, the vision was of a worker utopia in which town inhabitants imbibed the sensual odor of chocolate while teeing off each morning at one of the town's golf courses. The corporation figured in this tale as the purveyor of workers' pleasure. The workers' aims in striking were obscure, matching Hershey's befuddlement at his broken utopia. The destructive result of their activism was clear, however.

The Average American and the Sit-Down

George Gallup, who headed the newly established American Institute of Public Opinion, joined Representative Shafer, *Mill and Factory*, and NAM-connected business leaders in predicting that Americans, especially rural Americans, were so riled up that "the Hershey riot might be duplicated in many parts of the U.S." Gallup argued that a congressional resolution against the sit-down as "illegal and contrary to sound public policy" was nothing but a limp slap at the

CIO. "The average American," said Gallup, "is not prepared to be tolerant of the sit-down." Like Hershey farmers, the public thought that force should be used to remove employees sitting down in the plants they occupied. With the Hershey strike, the pollster had an authoritative example with which to frame his results against the CIO.[111]

Of course "the public" was being constructed and standardized during the same era that the news was reconfigured. George Gallup and other opinion meisters established themselves at this time as a force in America's political and cultural landscape. Keen to nail down where Americans stood, pollsters crafted new notions of Americans and their attitudes that made the public an objective thing, a product—instead of a sphere in which citizens contended over their concerns. Public opinion polling and photographs were both part of the twentieth century's move to a politics of imagery. Daniel Boorstin's discussion of public opinion polls complains, "The rising interest in public opinion and public opinion polls illustrates . . . the rise of images and their domination over our thinking about ourselves. . . . Now the citizen can see himself in the mirror of the opinion polls. . . . Public opinion, once the public's expression, becomes more and more an image into which the public fits its expression."[112]

When the public looked in the "mirror" in the spring of 1937, two images of America could be seen. One America, suffused with traditional values, embodied the best America had to offer: an America without class divisions, where the bosses were generous, the majority of workers were loyal and happy, and farmers—America's bulwark—upheld the nation's revolutionary past and protected its established values. News photographs illustrated this workers' haven, with its suburban homes, its factory-cum-college, and its world of fun. Millions of Americans read a story produced by the Hershey Corporation—a corporation they connected with each time they savored a Hershey Kiss—drawing on the myth of corporate beneficence and the workers' paradise long cultivated by the company and depicted through the company's photographs. This myth was well ensconced in the nation's consciousness, in part because mass media outlets put it there.

News photographs in an expanding mass media allowed Americans to "see" a second nation in which a minority of outside CIO agitators, with their muddled, illegitimate demands, menaced American ideals and aspirations. The agitators were amorphous—perhaps foreign, perhaps outsiders, but probably lazy and always fractious. News photos documented the discord labor unions sowed; they documented how Americans fought back; and they realized NAM's "Divided States of America." Is it any wonder that in a Pennsylvania village and in the larger sphere of national public opinion the Hershey Corporation won its strike?

Hundreds of thousands of workers sat down in late 1936 and early 1937. As we saw in the last chapter, autoworkers and rubber workers, Woolworth's clerks and even hotel maids struck to attain collective bargaining rights. One

month before the Hershey conflict, mass-market magazines like *LIFE* had been open to labor's demands. They now negatively portrayed the sit-downs and the CIO. Other mass-cultural venues with millions of readers, like the *Saturday Evening Post*, attacked labor's activism even sooner. Labor felt the power of this assault. Len De Caux, editor of the *CIO News*, believed that "owners could use the mass media like faucets to turn 'public opinion' on or off, to keep it under quiet control, or make it a surging torrent for class . . . war." De Caux remembered, "Never had I seen so sharp and sudden a switch of 'public opinion' as that on the CIO in the late spring and early summer of 1937."[113] De Caux may have overstated corporate control of the media, but there is no doubt that with the Hershey strike, the account told over and over was a story whose contours had been designed by NAM. The sit-down at Hershey attracted only limited CIO resources then, and hence little attention by labor historians today. Publicity surrounding this strike suggests that when historians examine unionism's successes and failures, they must gauge public relations' power to animate the news. Hershey joined many stories in the publicity barrage, so it would be impossible to know what turned the tide against labor in a public sphere increasingly influenced by the mass media. However, by speaking to a news apparatus that increasingly visualized current events, corporations—by altering events and by framing how they were seen—could curry favor before the general public. Indeed, they sought to create the very public that rejected union tactics.

"Strike Photos Are Star Witnesses"

PHOTOGRAPHS AND NEWSREELS OF CHICAGO'S MEMORIAL DAY MASSACRE, MAY 1937

The picture stood again in his mind; two lines like two rows of . . . toy soldiers; move one line up into position, stand the other against it, then the first line goes bang, bang, bang and the second line is all knocked down. That was the simple picture. Out of that he had to find meaning.[1]

The Hershey Chocolate strike received much attention in its time, but little since. In contrast, news images from the Memorial Day Massacre, a central event in the 1937 Little Steel strike, attained iconic status. For decades, this "story as savage as any in the dark annals of American labor struggles" has largely been understood through simple pictures. The massacre was yet another instance of industrial relations through brute force, but this time a news cameraman recorded the violence on film as it transpired. Paramount News had dispatched Otto Lippert from the Indy 500 races to the southeasternmost reaches of Chicago, where Lippert filmed it. News photographers also captured the melee, and the Associated Press (AP) and World Wide Photos (WWP) wired their content nationwide.[2]

These images figured in fierce public debate over labor's civil rights, ultimately becoming potent symbols of twentieth-century struggles for industrial democracy. One classic work on the documentary maintains that photos of the "tangled crowd" beneath the "policeman's truncheon" join Dorothea Lange's unemployed and Walker Evans's sharecroppers as Depression-era icons. Painters and filmmakers, novelists and essayists, all used as inspiration the black-and-white news images seen by millions of Americans. Today college textbooks, popular histories, and film documentaries reproduce this imagery to exemplify the furious opposition that unions faced.[3]

Yet there is a single recent study of "one of the great events in American labor history." Early histories of the massacre focused on the events leading up to the tragedy, measuring its effect upon the Steel Workers Organizing Committee (SWOC) and the Committee of Industrial Organizations (CIO). In these histories the incident was a "turning point," as corporations checked

SWOC's forward momentum. SWOC then pursued legal strategies instead of organizing.[4] Some argue the incident increased public hostility toward unions.[5] Certainly unionists from as far as New York City complained of the massacre's chilling effect upon organizing.[6] One historian examined the La Follette Committee's censure of Chicago Police during its investigation into the abuses of labor's civil rights, and earlier histories identified the ruthless anti-union tactics of Republic Steel and police. These histories criticized SWOC for mishandling the mass picket, however, and found a pro-labor bias in the La Follette Committee. The new labor history, with its hallmark attention to rank-and-file mobilization, sympathetically reassessed steelworkers' mass activism and the La Follette committee—with little new research into the essential contour of events.[7]

This chapter revisits these events by examining struggles over the visual evidence, struggles to assign meaning to simple pictures. One magazine headline about these infamous images asserted, "Cameras Don't Lie," and in large part the massacre's contemporaries and its historians have treated newsreel footage and news photographs as indisputable evidence, transcriptions of reality.[8] But an untold story can be found in new evidence and old, three Paramount newsreels, distinct newsreels that heretofore have gone unnoticed, along with captioned news photos appearing in national press and metropolitan dailies. In the weeks after the massacre, the same iconic photographs and newsreel footage purported to show strikers as a "riotous mob," a representation justifying police action. New and old scholarship alike ignores the intense drama over the meaning of the Memorial Day news images.

Those attentive to historic fact would reject the notion that images of the massacre could be interpreted any way. But imagery of the massacre sustained labor's claims only after labor intervened, demanding and attaining a rereading of these images. This rereading took place at Chicago rallies, in Washington, D.C., congressional rooms, and crucially, within a newly nationalized, photographic media. Here labor and its allies proved adept at using the public relations techniques that corporations and business associations like the National Association of Manufacturers (NAM) had long employed. Labor's newfound political might included its ability to renegotiate its representation in the new nationalized media of "sight and sound." Without a scoop story that trumpeted victims' testimony; without an orchestrated press campaign by the Senate subcommittee charged with investigating civil rights abuses against labor; and without the ever more nationalized, visual mass media—these photos might have remained documents with limited meaning for labor.[9] Images of the beaten and murdered workers of South Chicago are forceful symbols of social and political transformation for workers only because labor and its allies brought the facts behind these images to life.

"Memorial Day—Why?"

One SWOC organizer, George Patterson, jotted a penciled note on a folded piece of paper, "Memorial Day—Why?" Church deacon and former head of the employee representative plan that brought the U.S. Steel drive to fruition, Patterson was one of many arrested for the protests. He knew that SWOC and the Republic Steel Corporation were at loggerheads; the company would not sign a contract. He also knew firsthand that Chicago's police brass deemed any labor trouble an opportunity to assert, in the words of one patrolman's organization, a "semi-police pogrom against the Communist Party."[10] Its infamous red squad, led by "Make" Mills, a Russian émigré and a former Socialist, kept tabs on unionists and associated them with the Communist Party. During the U.S. Steel drive, police arrested organizers who leafleted for littering. As the national CIO drive heated up, police were determined to prevent sit-down strikes or flying squadrons in Chicago. They refused to let more than a few picketers stand outside Republic Steel, despite a city corporate counsel ruling affirming mass pickets' legality. Patterson was himself arrested the first night of the strike. Insider that he was, Patterson's note expressed the bewilderment of many; no one foresaw what happened.[11]

The events surrounding the Memorial Day conflict remain sketchy in some particulars, but are largely uncontested. Steel was the biggest prize to those organizing mass production industries, particularly to John L. Lewis. Once solidly union, by the century's turn, with the infamous 1892 Homestead strike and corporate consolidation, steel became the bulwark against industrial unionism.[12] Lewis's United Mine Workers (UMW) had a special interest in organizing steel because of the industry's control of coal in the captive mines. In the spring of 1936 the UMW bankrolled the CIO to spark organizing in steel. SWOC hired some 500 organizers to comb steel-making regions nationwide to mobilize workers. A natural target was the Calumet region of South Chicago and northwest Indiana, the world's largest steel-producing region.[13] SWOC developed cross-racial and cross-ethnic alliances and used cultural activism and an expanding mass media to build the union.

The tactics worked at first. SWOC gained collective bargaining rights with steel's biggest producer, U.S. Steel, in March of 1937. SWOC then pressed other companies for similar agreements. By mid-May the union forced Jones and Laughlin, a solidly anti-union firm and the nation's fourth largest steel producer, to sign. But the "Little Steel" corporations—Republic, Bethlehem, Inland, Youngstown Sheet and Tube, National, and American Rolling Mill—refused to negotiate.[14]

Little Steel organized itself under the leadership of Republic Steel's CEO and president Thomas Girdler. Girdler made sure that he didn't have to make good on his pledge to retire and dig potatoes rather than permit unionization.[15] As head of security for Jones and Laughlin, he so circumscribed the liberties

of steelworkers living in its company towns that labor called him the "czar" of "Little Siberia of America." Girdler preferred the title "benevolent dictator."[16] Republic Steel enjoined its employees from taking outside work, even side jobs like house painting. Girdler wanted greater dependence on the company paycheck. He employed members of the same family, heightening workers' economic vulnerability. Girdler's intransigence toward labor attracted other steelmakers. In a slap in the face to U.S. Steel, which urged compromise, the American Iron and Steel Institute (AISI) elected Girdler their president just before the Little Steel strike. Girdler had close ties to the anti-union "brass hats" who led NAM.[17]

Girdler relied on traditional union-busting techniques, and he advocated the Mohawk Valley Plan that sought to tarnish organized labor in the public's eyes. Girdler thought the plan could be applied to an entire industry.[18] Settling with unions was "the easy thing to do," but it didn't make it "the right thing," and he offered protection for his 400,000 employees from labor leaders' so-called anti-democratic depredations. Girdler wasn't above brandishing brutal force if the velvet glove of public opinion failed. He fired 90 percent of the workforce at Republic's Canton plant, and he stockpiled plants with nearly $50,000 worth of tear gas and munitions. Girdler believed SWOC's ties to workers were too feeble to withstand a strike, so he provoked one prematurely at Ohio and Chicago area plants on May 26, 1937.[19] The strike was soon joined with three others in the Little Steel contingent. In total, 78,000 workers came out in seven states.[20]

Chicago organizers had worked for months to mobilize workers; they saw a strike as inevitable. In earlier steel drives ethnicity and race divided workers, so SWOC reached out to Hungarians, Croats, Poles, Mexicans, and African Americans to unite them in the campaign.[21] At the beginning of May, organizer Joe Riffe claimed that union authorization cards poured in at a rapid pace, and a little less than two weeks before the strike he reported workers were "ready for the break." Chicago organizers ended their staff meeting on the night of May 13, proclaiming for the first time, "Amen in good faith with the Lord and John L. Lewis." Their prayers were answered when four days later 500 Republic workers showed up to a mass rally with a "marvelous enthusiasm" and some 3,000 assembled in the days before the strike. SWOC organizers believed that their problem was holding workers' enthusiasm within bounds.[22]

Despite momentum, Girdler's hunch proved partially correct as perhaps as many as one-third of the workforce stayed inside the plant.[23] Republic kept production going to strengthen the perception that strikers kept loyal workers from exercising their democratic right to work and support their families. In Chicago managers also tricked union men to go out early, giving the company the upper hand. The first hours of the strike were uncoordinated; men dribbled out of the plant and found no picket. But SWOC soon organized a round-the-clock picket presence. The union relied on the thousands of striking workers, almost 25,000 living in the Calumet region.[24]

Republic Steel had an ally in Chicago police, who hamstrung union hopes to establish a mass picket. Though officers disagreed about how many strikers could picket, those on-site enforced a limited number, often permitting fewer than a dozen.[25] On May 26, the first day, police jailed twenty strikers who headed for the plant, including four union organizers—George Patterson was one. Things were quiet on Thursday, but the next day when a thousand picketers marched on the plant a scuffle occurred. Police fired warning shots into the air. Chicago's newspapers carried full-page photo stories of the "army of strikers" involved in the "vicious clash," and metropolitan dailies across the nation carried a photo of strikers with their torn flag.[26] SWOC alleged that company goons were beating strikers, even women, and that police harassed workers walking anywhere near the plant. It filed an NLRB suit, telegraphed Roosevelt to request a federal investigation, and maintained that Republic Steel's security forces were ordered to "shoot to kill." The company countered that strikers threatened the families and property of loyal workers still in the plant.[27]

Counting on Chicago mayor Edward Kelly's support, SWOC organizers planned a Memorial Day rally to force a showdown on the right to a mass picket. Early that morning unionists and their families met at Sam's Place— Dine and Dance, their informal strike headquarters. They were joined by sympathizers: physicians, Hull House social workers, students from the University of Chicago and a local high school, and ministers and lay members of several church social action groups. Some came with their dates; other local residents who saw the commotion showed up "just to see what was going on." The crowd, estimated between 1,500 and 2,500, enjoyed picnic lunches or grabbed sandwiches prepared by the women's auxiliary.[28] The throng listened to speakers and sang songs as children "played tag among the crowd." Despite the earlier frictions, "the crowd was jolly" or "holiday like," with many women and children dressed in their Sunday best.[29]

After the speeches a cry went up to establish a mass picket at Republic Steel's gates. The crowd joined behind two flag bearers moving diagonally across a long field to the plant's entrance. Meeting them and strung out in a long line, as one striker remembered, "just like those skirmish lines in movies of old-time battles," were Chicago police, about 300 strong. They were there, at three times their force, according to one police official, to avert "a massacre."[30] Excitement ran high on both sides. The police stood alert, waiting for commands. Strikers entreated the police to let them through. Most in the crowd were peaceful, though some carried makeshift weapons: sticks and rocks, pipes and tree branches. When strikers pushed forward, and perhaps in response to a branch thrown from behind their lines, police "charged like a bunch of demons" with tear gas, billy clubs, and bullets. Some recalled strikers "trapped like rats, panic stricken, terrified"; others saw the marchers crying and "holler[ing] like sheep" as they scattered in all directions. One witness described police beating an old man trying to crawl away as if they were "playing with a bug before you

step on him." A labor journalist recounted that police "dragged" the wounded by their feet, as if "dead dogs."[31]

Four died that day, six more died soon afterward, and ninety were wounded, thirty-five by gunshot. Almost all of the gun wounds appeared in the victims' backs or sides, including an eleven-year-old boy who was shot in the heel and a baby who was hit in the arm.[32] Some claimed police shot those who helped the injured. One woman said the police chased her, shooting all the time, and one man died when police grabbed him by a makeshift tourniquet that was his lone link to life, and stuffed him into a paddy wagon. Once at the hospital police refused to let unionists help burdened medical staff, dragged the wounded off of gurneys, and kept family members from visiting the dying.[33]

From the start union leaders named the dead strikers martyrs to a glorious cause and accused police of murdering the innocent in cold blood. Union wives marched on city hall with banners calling on Mayor Kelly to "wipe the blood off your hands." John Lewis called it a "planned murder." SWOC's Philip Murray expressed his "shock" and "indescribable horror" at the shooting. Van Bittner, director of SWOC's Midwest campaign called the "shooting down [of] defenseless men, women and children . . . one of the most disgraceful affairs that has ever taken place in the annals of our country."[34] A local of the Brotherhood of Locomotive Fireman and Enginemen passed a resolution "protesting the inhuman, unchristian, and uncivilized slaughter carried out by the Chicago police," and the Chicago Church Federation's resolution "deplored the killing of the steel marchers." SWOC South Chicago locals wrote to Chicago's mayor and President Roosevelt, demanding "immediate removal" of responsible police figures and a federal investigation into their "degenerate sadism."[35]

The next day 5,000 massed in a parade in nearby Indiana for the "Fallen Heroes of the Republic Steel Picket Line." Bandaged participants of the carnage stood on stage at a union gathering to "eulogize the dead" and galvanize the living.[36] Leo Krzycki, whose Memorial Day speech detractors blamed for the massacre, rallied members at yet another Indiana mass meeting. "We are going to fight on to victory regardless of the cost of lives of our martyrs. . . . We have gone half way to meet the Republic Steel Company. . . . If they are on the square there will be no trouble. If they are not we're ready to spill our blood in large quantities in the middle of the road."[37] Three days after the shooting a multiple wake was held at SWOC's organizing office at South Chicago's Eagles Hall. SWOC members managed traffic at major commercial thoroughfares as police kept their distance. Paying their respects, reported the *Chicago Daily News*, were more than 7,000 sympathizers in "dusty overalls from the mills, and in clean overalls on their way to the mills, squat Croatians, sallow-skinned Poles, awed Negroes, bustling Nordics and phlegmatic Mexicans. Spacing them were tradesmen in shirt sleeves and housewives in summer prints."[38] Nine days after the massacre, on June 8, outraged Chicagoans, 5,000 strong, filled the Civic Opera House to decry the killings and

demand constraints upon police action. Future Illinois senator Paul Douglas, poet Carl Sandburg, and union and civil rights leader A. Phillip Randolph joined professors, publishers, religious, and union leaders in this display of solidarity under the banner of the ad-hoc Chicago Citizens Rights Committee. Seventeen days later a motorcade left Gary, Indiana, and wended its way through the Southeast Side to Republic Steel, where union members left a wreath honoring the dead with a guard to watch over it. They then made their way to a SWOC rally at Chicago's Stadium, then reputed to be the largest labor gathering in Illinois history. There they heard mention of a newsreel by Paramount that "showed in all its excruciating horror the brutality of the police attack."[39] This newsreel became unionists' most important ally.

Unionists and their sympathizers campaigned to avenge the wrongs done in South Chicago, and to demand workers' basic civil liberties. They worked behind the scenes to mobilize press and congressional support to advance the union's claims.

"War in America!"

Local and national press reported on labor's flurry of activities, but their accounts were typically hostile. Chicago's police, politicians, and Republic Steel blamed strikers for the conflict; their explanations formed the backbone of most news stories. Police said that unionists, some 5,000 strong, wanted to storm the gates to get at employees who remained on the job. Police shot to defend themselves and loyal employees.[40] Chicago officials notified the press that dozens were jailed and that additional suspects were sought. They claimed that many strikers were foreigners and that the state's attorney would expose the agitators' Communist ties. Republic Steel scoured the lists of arrested and wounded participants, to prove they were outsiders.[41]

The *Chicago Tribune*'s first headline, "Riots Blamed on Red Chiefs," encapsulated a common thrust in press stories. The *Tribune*, Chicago's premier paper and the nation's largest circulating daily, ran headlines on the injured police officers—none of whom was hospitalized—and had articles alleging that the CIO advocated Bolshevism. *Tribune* readers were told that "half a pint of whiskey had been supplied to each of the marchers," and that a Mexican fired the first shot. Lacking the *Tribune*'s rabidity, other locals advanced a similar rationale.[42]

Because of the standardization and nationalization of news, most Americans read a story much like Chicago's.[43] The *New York Times*'s front-page story blazoned "4 Killed, 84 Hurt as Strikers Fight Police in Chicago." Two of its six story subheads averred "Steel Mob Halted" and "1,000 Marchers Fail in Effort to Close Republic Plant." Stories told of one striker who shot a blue steel automatic from arm's length straight at police, razors atop picket signs, and unionists asserting that they tried to breach the plant gates. Later stories

alleged protesters were Communists and indicated that the union drilled members to disarm police. When a police officer showed off his .45-caliber bullets to a reporter and crowed "We're ready for them and boy am I eager," readers might have thought his response acceptable.[44] Other metropolitan dailies purveyed this same rationale. A mob of foreigners and radicals, inflamed by listening to SWOC speakers, crossed the field to enter the Republic Steel plant. Whether they were "a rag-tag army" or a tightly drilled force led by "200 young huskies," they threatened law and order. Police action was regrettable but necessary. National news media such as *TIME, LIFE,* and *Newsweek* gave readers the same story with minor differences in detail: a few slingshots and union leaders spurring on the crowd with the call "The mill must be closed." Even White House staff, moved by AP newspaper accounts, believed that "police had very considerable justification for the action they took."[45]

Chicago Police argued that photographs proved their innocence: "pictures at the start of the fight [are] cited by police as showing they did not begin the hostilities."[46] But photos did not appear to buttress police claims. Some revealed a teargas-filled field with marchers in the distance, and others showed police

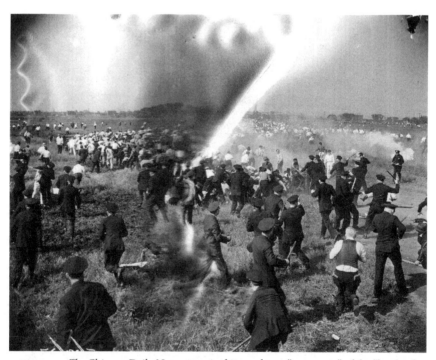

FIGURE 4.1 *The* Chicago Daily News *promised its readers a "panorama" of the "battle of policemen and strikers" as the battle was at its "peak." The* Daily News *inserted numbers into the photograph, directing readers to a striker beating a policeman, strikers "retreating from the advance of a single policeman," and three police with revolvers. June 1, 1937. Photographed by* Chicago Daily News *photographer, Courtesy Chicago History Museum.*

pummeling picketers. The captions and stories, however, suggested a battle between equals. A *Chicago Daily News* photo taken at the "peak" of battle captured the backs of retreating strikers: the mob consisted of those foolhardy enough to look back and face the camera (Fig. 4.1).[47]

In a *Chicago Tribune* photo that has become one of the massacre's most reproduced images, a woman held out her palms to police, beseeching them to stop (Fig. 4.2).[48] Around her lie the fallen strikers and the arm of one man who reached up into the air. By following it, one sees a police club just before it moves downward to hit him. The *Tribune's* caption, "At the Height of the Battle—Here are policemen using their nightsticks and tear gas to subdue their attackers," evoked a battle against ruthless strikers, but the images show abject strikers trying to stave off further violence. Another photo showed "women in mob subdued by police"; this image too has become iconic (Fig. 4.3).[49] In "Police Aid Injured," Chicago's *Tribune* even published a photograph aiming to show how police helped the victims. The *Tribune's* photogravure section repeated charges of communism the next weekend. Under the headline "Reds Send Workers to Tragic Battle with Police," the *Tribune* told how strike leaders urged strikers to break into the plant, and how the protesters threw missiles and opened fire on police.[50]

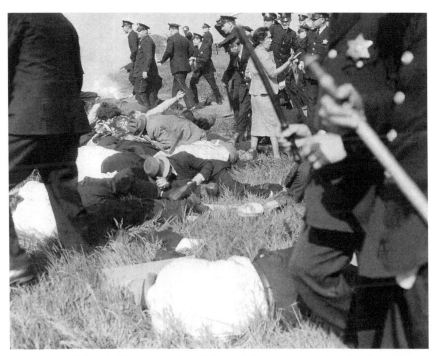

FIGURE 4.2 *Taken on May 30, 1937 by a* Chicago Tribune *photographer, the picture shows Lupe Marshall facing Chicago Police, unaware that protesters behind her have been shot. The photo appeared in many metropolitan news dailies, and was discussed in the La Follette hearings. Courtesy, AP Photo/Paramount Pictures, Inc.*

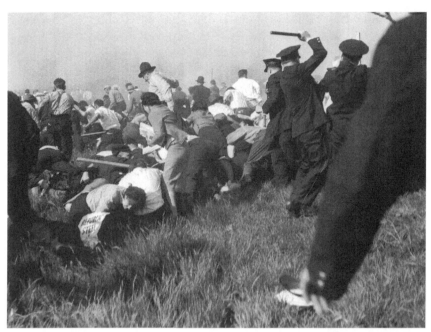

FIGURE 4.3 *Photo taken on May 30, 1937 by* Chicago Tribune *photographer Carl Linde. The many women in the crowd received comment in news stories and in the La Follette hearings. Courtesy, AP Photo/Carl Linde.*

Editors generally captioned photographs in line with police accounts, just as they had with their news stories. Titles, captions, and other text attempt to anchor an image's meaning.[51] No evidence suggests editors acted with antilabor bias—with the exception of the anti-union *Chicago Tribune*. However, by reproducing the police rationale, captions and other text reinforced it.

Again national papers and magazines followed Chicago's lead. An AP photograph splashed across the *San Francisco Chronicle*'s front page showed six bodies huddled on the field as four policemen stalk the only two protesters who remained upright.[52] One of the officers brought his whole body into belting down the striker (Fig. 4.4). The dynamism of his action grabs the eye, which explains why it has been so reproduced. The *Chronicle* did something unusual with this photo to ensure that all was visible: it outlined the police club, the shirts of the fallen victims, even the shirt cuffs of the police, and the papers hanging out of picketers' pockets. This retouching made the image less believable, offering a surreal touch absent from most other papers' publication of the photo. The *Chronicle*'s headline, "War in America!" suggested a civil strife tearing at the nation's very fabric. This same photo appeared in *LIFE*, the *Washington Post*, the *New York Times*, the *New York Herald Tribune*, and the *New York Daily News*. The photo indicated a one-sided battle, but most captions evoked an all-out riot or a clash of equals.[53]

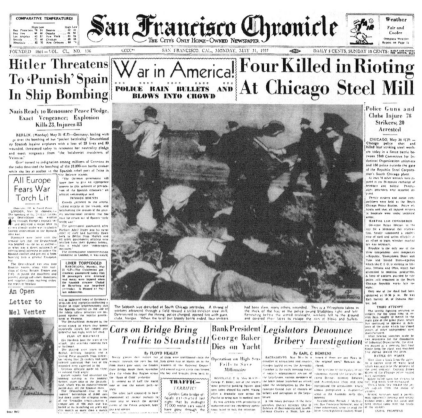

FIGURE 4.4 *Front page of the* San Francisco Chronicle, *May 31, 1937. This photo appeared in many newspapers and magazines—the* Chronicle *editors outlined the bodies of the protesters and the police billy clubs. Courtesy* San Francisco Chronicle *and Chicago History Museum.*

Similarly, an AP photo carried by the *New York Times* displayed the backs of running strikers as police chased close behind with batons at the ready. It was captioned, "The Start of the Battle Near the Republic Steel Plant" (Fig. 4.5).[54] The *Times's* caption for a photo in which the mass of strikers had moved far to the background read, "Fatal Battle Between Chicago Police and Steel Strikers." In this battle strikers fled. National magazines such as *TIME* carried the same photograph. *TIME's* caption was "The Battle of the Republic Barrier."[55]

In Chicago, newspapers even employed sophisticated photo story layouts akin to cinematic "storyboards" that justified police action. The *Chicago Daily News's* panoramic shot of the field outside Republic Steel had numbers instructing how to read the image. The numbers delineated the story's actions: a policeman being punched in the face, "the helpless heap of strikers," police drawing revolvers, and "the striker's army in retreat before the advance of a single

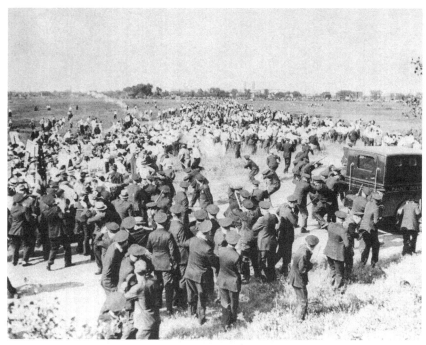

FIGURE 4.5 *This AP photo of strikers running from police on the field outside Republic Steel was published in the* New York Times, *June 1, 1937, with the headline "As Striking Steel Workers and Police Clashed in South Chicago" and the subcaption "At the Start of Battle." Courtesy AP Photo.*

policeman with upraised club." Here the *Daily News*, deliberately or not, utilized a tenet of the Mohawk Valley Plan: calling strikers cowards.[56] The *Chicago Tribune's* "picture story" had even greater narrative construction (Fig. 4.6). Each image was numbered, and inset titling explained events in a narrative arc.[57] "1 The Inspiration": moved by Leo Krzycki's inflammatory words "the crowd became a mob"; "2 The Warning": alerted by police to stay away the armed crowd moved forward; "3 The Battle!": tear gas and clubs proved ineffectual so police shot to repel the mob. Plots develop causal relationships between random events in time and space. Chicago papers bridged the gaps between police accounts and pictorial documentation by creating credible stories for the photograph's contents.[58]

There are few indications of labor's thinking about this anti-union press, but it must have taken its toll. At an organizers' meeting, Henry (Hank) Johnson, the South Chicago organizer, said that members' spirits were good but that newspaper propaganda provoked misunderstanding. George Patterson, the local organizer who was arrested for the massacre, recorded his feelings about the photograph's effect years later: "I remember sitting down reading the paper, the *Tribune*, in the restaurant down . . . on Randolph Street . . . right after

PICTURE STORY OF SOUTH CHICAGO BATTLE

In this yard at Sam's place at 11317 Green Bay avenue, just across the field from the Republic Steel company's plant at South Chicago, a crowd of C. I. O. steel strikers met yesterday afternoon to hear an oration by Leo Krzycki, regional director of the C. I. O. After listening to Krzycki and other speakers, the crowd became a mob—and just across the prairie was the object of their hatred, the Republic plant, where nonstriking employes remained at their tasks, protected by police.

Across this field surged the strikers. They picked up clubs, slingshots, and brickbats. Those who could find no other weapons stripped their own cars of cranks and gearshift levers. Many carried heavy steel bolts for missiles. As they neared the plant they met a line of policemen barring their way. Those in front stopped; those in the rear crowded forward. Capt. Thomas Kilroy of the police stepped forward and asked the crowd to disperse. "We must do our duty," he warned.

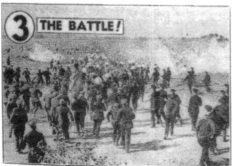

The answer to Capt. Kilroy's warning was a shower of missiles from those who were hidden deep in the mob of strikers, and the battle was on. Pushed from behind, the rioters surged forward. Those in front, forced to battle by their less brave allies in the rear, took a terrific beating from the police. Police answered gunfire with tear gas and more gunfire. The tear gas was ineffectual and police clubs and gunfire turned the rioters back only after the loss of four lives.
[TRIBUNE Photos]

FIGURE 4.6 *Back page "picture story" of the Memorial Day massacre,* Chicago Tribune, *May 31, 1937.*

Memorial Day. I saw pictures of myself, pictures of strikers lying on the ground, and I turned around to watch the reaction of the customers. It was amazing how they'd shake their heads and say, 'These damn workers, they ought all to be shot.' I was horrified." One victim's mother "shoo[ed] off" vendors of the *Tribune* and Hearst papers because she was so angry.[59]

In line with immediate condemnation of the strikers, Paramount edited its newsreel footage into *Steel Strike Riots Sharpen CIO Crisis.* The newsreel portrayed a riotous mob akin to Chicago Police's description of events. Newsreel companies tended not to cover the controversial. The less stodgy Paramount had the lone newsreel camera on the field.[60] Otto Lippert captured most of the Memorial Day confrontation on film; in all he gave five and a half minutes of footage to Paramount. The company's first newsreel began with melodramatic music and an opening text that stated that the film's "graphic picture" showed "not arguments, but facts." The music wound down, as a narrator introduced footage of "loyal workers"—the narrator informed viewers this was how the company referred to them—who smoked, read papers, and lounged alongside card tables. These workers smiled at the camera in a closeup, followed by a deep-focus shot of them sitting in an ordered row of cots arranged by the company. The camera gave free reign to the viewer's examining eye, presenting the workers as innocuous, almost domesticated, with nothing to hide. Strikers who, according to the narrator, "demonstrated by night and by day," appeared as faces that crowded all four corners of the screen. The sharp contrast between the dark night sky and the bright lights that were used to film the rally enhanced the sense of violence, as did the raucous din that could be heard. Unlike the lounging, knowable workers, strikers seemed an anonymous, agitated crowd. The newsreel then cut to the Memorial Day events. The announcer informed viewers that the CIO had not been formally voted upon, suggesting that it did not represent workers, as the film footage panned across police on the field. According to the announcer, strikers advanced on the plant four times as police "pled" for strikers to leave. He then stated, as text flashed on the screen, "But the arguments failed. The riot that followed is herewith described by the most impartial of all reporters—the newsreel camera." Once again the film promoted itself as a purveyor of unvarnished truth. But Paramount left out footage of an officer who grinned at another right after the shootings, and it did not include footage they had of strikers and their children on the picket lines. Much like a B-grade Western, Paramount's cast represented the opposing forces of order versus lawlessness.[61]

Steel Strike Riots's music and sound intensified the drama of the "the graphic picture of Chicago riots." After the scene of police meeting strikers on the field, melodramatic music welled up in tempo and volume, indicative of the coming strife. A mounting drum roll built anticipation. The roll was the expectant sound familiar from Hollywood movies: the drum beats before a cavalry charge or a firing squad fusillade. It grew faster and louder, leading to an

explosive boom from which the sounds of the shots on the field could be apprehended. Besides the shots of bullets and tear gas, only a panicked exclamation from the crowd after the shooting had begun could be heard, along with isolated exclamations like "Hey, hey" or "Boy oh boy." The newsreel's music evidenced the mining of news for entertainment that was common. But the music also made a proposition.[62] The added drum roll advanced the argument *Steel Strike Riots* implicitly made—that strikers deserved to be shot for failing to heed the police pleas. Like national press coverage, Paramount's first newsreel about the massacre recreated events in a story that rationalized police action.

"Pictures Not Fit to Be Seen"

Despite its bad press, labor persisted in its claim that police attacked without provocation. Like police, they argued that photographs proved their innocence. At the June 8 Civic Opera House meeting of the ad-hoc Citizens Rights Committee, Reverend Raymond Sandford, who had been on the South Chicago prairie, promised, "There are stills . . . of the riot, stored away in a good safe place."[63] Former *Chicago Daily News* reporter and novelist Meyer Levin, best known today for his novel *Compulsion*, also spoke. Levin questioned how the press interpreted massacre photographs: "Study the newspaper photographs. They show, again and again, police charging with drawn guns after a fleeing crowd, police stumbling over the bodies of fallen citizens. There is not one picture of strikers attacking." Levin led the Opera House crowd through a slide show of the massacre based on photos he had compiled from sympathizers on the field. The ad-hoc Citizens Rights Committee had leaders like Randolph, Douglas, and Sandburg, and included civic and church groups like the Chicago Civil Liberties Committee and the Methodist Federation of Social Service, and the more radical Artists' Union, the American Youth Congress, and the Socialist Party. This broad-based coalition was the first to publicly demand that Paramount release its newsreel footage.[64] Representative Jerry O'Connell (D-MT) read Levin's charges into the *Congressional Record*, adding that national press was "false and garbled." The *Nation* attacked newspapers for improperly using photographs that gave "overwhelming evidence that the police attacked and followed up the attack with wanton brutality." Similarly, labor reporter Mary Heaton Vorse wrote for the *New Republic* that "pictures give irrefutable evidence" that police clubbed the innocent.[65] These activities by labor and its allies made a demand for labor's basic civil liberties. But news media gave scant attention to their claims.

And Paramount shelved its newsreel *Steel Strike Riots* immediately after the massacre. In suppressing the politically volatile, it followed newsreel production and distribution traditions that emphasized the novel and spectacular, the

sporting and adventurous, but rarely the controversial. Depictions of class struggle worried studio executives and their Wall Street backers, and footage touching on class antagonisms bore the brunt of censorship or self-censorship far more than the salacious.[66]

Nothing in Paramount's corporate papers addresses the company's rationale for keeping *Steel Strike Riots* under wraps. However, in response to a request from the Chicago Citizens Rights Committee to exhibit the film at the Opera House, the company's General Editor, A. J. Richard, responded:

> Our pictures of the Chicago steel riots are not being released any place in the country. . . . We show to a public gathered in groups averaging 1,000 or more and therefore subject to crowd hysteria. . . . Our pictures depict a tense and nerve-wracking episode which in certain sections of the country might very well incite local riot and perhaps riotous demonstrations in theaters leading to further casualties. For these reasons of public policy, these pictures . . . will stay shelved. We act under editorial rights of withholding from the screen pictures not fit to be seen.[67]

Paul Douglas, a University of Chicago professor of economics who would become Illinois's senator in 1949, chaired the Citizens Rights Committee, and he sought allies to get the filmed evidence. He wired Robert La Follette Jr. and his staff, sharing his concerns that the "crucial facts" contained in the film be obtained "before [the film] is tampered with in any way." Douglas suggested a sensitivity to filmed evidence's malleability. But the La Follette Committee had already subpoenaed and viewed the film.[68]

Had La Follette's investigators failed to secure the film, *Steel Strike Riots'* condemnation of the union might have remained Paramount's sole edit. Several investigative bodies sought the footage—none sympathized with labor. The Illinois assistant state's attorney wanted the newsreel to buttress his claims that rally speakers inflamed the mob, resulting in the killings. The conservative Senate Committee on Post Offices and Post Roads, organized to counteract the pro-labor La Follette Committee, also pursued the film to prove labor's strong-arm tactics. So did Chicago's judiciary, historically antagonistic to labor.[69] La Follette's committee got it first, and by nailing down detailed narratives that better explained the events in Chicago and by breaking the story just right, they dispelled the widespread view that strikers were to blame.

"Word-Picture"

Reporter Paul Anderson, a La Follette Committee ally, broke the story of the newsreel's contents and was the first mainstream journalist to suggest that police killed strikers without cause. Anderson, a muckraker with a natty dressing style, was an early advocate of the La Follette Committee. He thought

the "made-to-order" committee would be a counterbalance to corporate aggressions against labor. He went to Chicago just days after the massacre; the *St. Louis Post-Dispatch*'s editors thought "the stuff coming . . . from Chicago just isn't plausible." Anderson uncovered victims' stories to develop a full account from the unionists' perspective. A La Follette Committee confidante, he also got access to the Paramount newsreel footage.[70] Anderson's surefire storytelling, including his titillating exposé of the newsreel's contents, altered how Americans understood events in Chicago.

On June 16, Anderson's first account unwound as the newsreel did. Like the camera, he followed the "straggling strikers" walking across the field; unlike the camera, he focused upon a barely visible American flag, a symbolic foil to his description of police injustice. He contrasted the crowd's earnest mission, their insensibility to what happened around them, with the police's "appallingly businesslike" dispatch of violence; the size and sex of some victims against the officers' brawn; the crowd's excited babble with their screams once the shooting began. Anderson reached for poetry when he detailed the "terrific roar of pistol shots" that caused "the front ranks [to] go down like grass before a scythe," but nothing was too indelicate for examination. He described Sam Popovic, whose "brains literally had been beaten out." He believed this to be the man who ran the police gauntlet and never came out. "Policemen are as thick as flies, but [Popovic] elects to run the gauntlet. Astonishingly agile for one of his age and build, he runs like a deer, leaping a ditch, dodging as he goes. . . . Will he make it? The suspense is almost intolerable to those who watch. It begins to look as if he will get through. But no! . . . He is cornered. Quickly the bluecoats close in." Anderson wrote of the young man who hopped on one leg into the paddy wagon, and the older man whose bent back carried the burden of all the bloodied bodies on the field. He described one man who, paralyzed by a bullet, "raises his head like a turtle, and claws the ground." Anderson heard two words out of the recorded din, the "distinct ejaculation: 'God Almighty.'" His ending: a "disheveled" policeman who scowled, and then smiled and dusted his hands off before striding past the camera. What more fitting conclusion to his tale of "police attack"?[71]

The next day Anderson's second story emphasized strikers' passivity. He noted that photos taken from behind police lines showed running strikers' backs. Few faces were seen. He set police fury against a singular touch of kindness. "A policeman placed a square of paper [a picket sign?] under the man's head—and did it gently." Anderson observed two strikers fighting back, underscoring his neutrality. Anderson again tied his story to the Paramount footage by quoting a La Follette Committee staffer who compared it to coverage of the crashed Hindenburg. Attached to this article were two AP photos: one of strikers running from the police, juxtaposed with a second of a man lying prone, captioned "shot in the back." Images like these had condemned strikers in newspapers nationwide; they now demonstrated police culpability.[72]

Anderson's series culminated with a full-page Sunday spread on June 20. He intercut eyewitness accounts with newsreel footage that fit together "with all the neatness of a jigsaw puzzle." Anderson's primary source was Lupe Marshall, a slight Mexican-American social worker. The *Post-Dispatch* printed three photos of her: one, a bust portrait, showed the smiling Hull House employee in a sprightly bonnet and polka-dot blouse, an upstanding, if tiny, citizen.[73] Flanking her were two stills from Memorial Day showing Marshall being beaten by police.

Anderson unearthed other compelling testimony. He found one union flag bearer who fought to keep the American flag off the ground until he, too, was shot; and the Youngstown employee whose doctor told him, "Your head looks like a battlefield and your body like a barber pole." He dug up stories aired once and then never again heard. Six Chicago Theological Seminary students claimed that machine-gun fire whizzed past them from behind Republic's plant gates. In another, bystanders whose homes sat beside the prairie heard a commanding officer call out to his underlings, "All right men, let them have it!" Anderson returned to police efficiency on the field; this time they were "grimly methodical, as if . . . killing snakes." Toward the finish of his series, Anderson solicited police comment and relayed their story as they'd given it all along: police shot to preserve order. After Anderson's story their justification failed to pass muster. Accompanying the *Post-Dispatch* story was a photo of police crossing the field, batons and billy clubs casually slung over their shoulders or swinging by their sides. Much like photos of strikers that appeared with regularity in this era, the police spanned the entire frame and crossed it at a diagonal, an angle often used to transmit danger. In this photo, captioned "The Return from a Bloody Victory," these police appeared the organized threat they railed against.

Paul Anderson exploited the newsreel's suppression as a wedge to reopen dialogue about events at Republic Steel. He then constructed a story culled from the newsreel's visual details: the evil, businesslike police and the hapless pickets; the words that captured all—"God Almighty!"; a raised flag and a toppled flag; and a policeman who wiped his hands and grinned when it was all over.

The Midwestern reporter received almost immediate recognition. John Lewis quoted liberally from Anderson's account at the June 17 Soldiers Field rally and claimed that the film showed that "workers were deliberately murdered in cold blood by the Chicago Police Department as a friendly favor to the Republic Steel Company." The *New York Times* reprinted his first article almost whole, as did the *Chicago Daily Times* and the *Daily Worker*. *TIME* commended "news hawk" Anderson and printed a condensed version of the "clean copyright scoop." Chicago's *Daily News*, which had offered no firsthand account of events in its own backyard, had one of its reporters recount "eyewitness" details that were a far cry from their earlier anti-unionism.[74] The

National Headliners Club awarded Anderson a gold medal for his exposé, which they thought transformed public attitudes toward the strike. His "torrid" story made "those Harlan County investigation yarns sound like bedtime stories." Reporters called Anderson's evocative description of the massacre's imagery an "extraordinary word-picture," and that term has stuck as shorthand for Anderson's account, relied on to this day.[75]

"Stories Exhibited"

A congressional investigation offered the final parry to the police rationale for necessary force. Beginning in 1936, the La Follette Committee investigated corporate espionage and extralegal violence against unions. Labor sympathizers had recommended congressional involvement to turn publicity's glare upon expected corporate assaults. The press had certainly published extensive coverage of strike violence in the past, for example with the 1914 Ludlow Massacre, the 1919 strike wave, and the 1934 upsurge. But slow shutter and film speeds meant that the actual violence was not recorded. Government and citizens groups had also scrutinized anti-union violence. Labor failed, however, to pin down and restrict such abuse.

Reformers thought that effective publicity could fuel public outrage against such tactics. Heber Blankenhorn, an industrial economist at the National Labor Relations Board (NLRB), instigated the move to publicity. Blankenhorn was a former labor reporter with the New York *Sun* during the great labor crises of the teens—the Triangle Fire and the textile workers' strike in Lawrence, Massachusetts, led by the Industrial Workers of the World (IWW). He gained more experience with propaganda's power in the Committee of Public Information during World War I, and went on to staff the 1919 interfaith investigation of the steel strike. For Blankenhorn, "What civil rights were won depended perhaps more on incessant talking about them in the papers than in arguing in court," though more concretely he claimed that the committee's job was to "dig out the rats."[76] He rallied New Deal Democrats, NLRB members, and union leaders to lobby the Senate Committee on Education and Labor to investigate abuses of labor's civil rights.

Wisconsin's Robert La Follette and Utah's Elmer Thomas cochaired the resulting subcommittee. Their investigation exposed the spy rackets, the fake "citizens committees," and the violence that companies employed to block unionization. The Republican La Follette took his father's Senate seat in 1925, maintaining "Fighting Bob's" progressive politics. La Follette was a quick study, who had a clear awareness of publicity's power. Thomas, a classics scholar who had proselytized in Japan as a Mormon, was a staunch New Dealer who coauthored the Civilian Conservation Corps Act. The committee's top two staffers had unusual pedigrees. Robert Wohlforth, the committee

secretary, was an alumnus of West Point and a liberal Connecticut Republican whose skill assisting the Nye Committee against munitions profiteering brought him to Blankenhorn's attention. John Abt, the committee's counsel, was a Chicago-based corporate lawyer turned Communist Party member knowledgeable about that city's strong-arm techniques against radicals. Abt had worked for the Agricultural Adjustment Administration before joining the committee. These men and their underlings used their labor contacts to determine which cases to pursue. Wohlforth and Abt did the background work: they met with witnesses, subpoenaed evidence, and prepared the briefs that La Follette and Thomas used in questioning. SWOC's president, Philip Murray, acknowledged the support that labor could expect from the investigators' watchful eyes, claiming that the committee "promise[d] to be instrumental in wielding public opinion more strongly behind us."[77]

Ironically, Wohlforth remembered that La Follette "had to [be] drag[ged] screaming into some of these things. [He] didn't want to touch the Chicago Memorial Day Massacre, so I barreled up here and wrote my own subpoena and got the film. He didn't want to do that any more than eat sour apples." The committee had been wrapping up its business, after stupendous exposés. La Follette's committee had documented General Motors' industrial espionage, the quasi-police state in Kentucky's bloody Harlan County, and corporate stockpiling of munitions. It may be that La Follette hoped to conclude his investigations. La Follette's biographer thought that "inwardly he seemed to regard the investigation as an unpleasant, though necessary chore that it was his duty to perform."

Committee staff didn't trust Chicago officials' story, so Wohlforth got a friend at Paramount to provide the film for the committee's screening; it's unlikely Anderson got it for them. Wohlforth, La Follette, Thomas, and Abt watched the film "in great secrecy," examining each frame individually, and they left the screening believing that the film showed a massacre. La Follette authorized Abt, Wohlforth, and three other staff members to conduct a ten-day investigation in Chicago. Additional prodding from Blankenhorn led to the public hearings.[78]

The committee's skillful examination of witnesses, its strategic use of photographic evidence, and its public relations savvy led to a public reinterpretation of the visual evidence. After La Follette's congressional hearings in late June and early July, police explanations for the incident seemed implausible, even laughable. Many times during the hearings Senators La Follette and Thomas assured witnesses that police were not on trial. When the committee's work was finished, however, the police stood condemned.

The senators first impugned the police account promoted by the national media in the weeks after the massacre. Police brass, Commissioner Allman, and Chief Prendergast justified their officers' actions while divesting themselves of responsibility for what transpired. Next called was Police Supervisor

Mooney, the highest commanding officer on the field. Mooney testified that when police asked strikers to disperse, they surged forward without provocation with a barrage of bolts, stones, automobile parts, and bricks. Mooney hadn't ordered the police to shoot—had he, 200 would have been shot, not 40. La Follette brought out still photographs only after Mooney finished. Mooney admitted that the strikers in the photo, taken a few seconds after the "battle," were all "going the other way."[79] When Senator Thomas asked whether running strikers could have outflanked the police, Mooney demurred (Fig. 4.7). The police assault "demoralized" the strikers. La Follette then asserted that medical reports indicated strikers were almost all shot in the back. The commanding officer's smugness closed the single option visibly feasible: if strikers were running away, but not attempting to outflank police, then police shot retreating strikers.[80]

Next, Mooney's subordinate, Captain Kilroy, expressed sympathy for strikers. Kilroy alleged that he "pleaded" with men and woman to leave, but after a revolver shot and a hail of debris, "the crowd and police all met force together" and "everyone was for themselves." Thomas asked if this meant that police became a "mob." Kilroy wiggled, responding that "they were part of the mob when the mob was around them." When asked how to explain the bullets in victims' backs, he ventured that strikers aimed at police but hit their own. Those assembled in the Senate hearing room laughed. La Follette brought out the pictures, suggesting they were taken some time after the shooting began. Kilroy slipped, claiming that they were taken immediately afterward. The photos indicated a crowd rushing from police. Kilroy's riot that engulfed police

EXHIBIT 1341

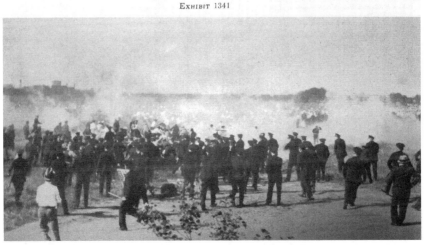

FIGURE 4.7 *"Exhibit 1341," from July 1937 La Follette Committee hearings. Courtesy Senate Committee on Education and Labor,* Violations of Free Speech and Rights of Labor: Part 14, The Chicago Memorial Day Incident, *75th Cong., 1st sess., 1937.*

officers never existed. La Follette then proffered a picture of Kilroy watching as police beat downed workers. Pressed to explain, Kilroy said that the victim looked as if he were "posing for a picture" (Fig. 4.8).[81] More laughter. The captain ended with a tale of his tapping a striker with a "2 by 4." The striker ran toward him, but Kilroy's blow landed on the striker's back. Once again, laughter filled the hearing room.[82] Photos impeded Kilroy's professions of empathy and police innocence.

La Follette never bludgeoned police with photographs as if images held the truth; instead he let police hang themselves with the particulars of their own stories. Mooney's contention that strikers could never outflank police prevented any other explanation for what could be seen in photographs but that strikers wanted to run away. Kilroy's tale of strikers intermixing with police was never visible, even from the first moments of the shooting. His cajoling of strikers to leave the field was belied by his neglect toward underlings' brutality. Mooney and Kilroy had been two of the most prominent voices in news media. La Follette discredited both and, according to the *Christian Science Monitor*, raised "a grim curtain" for what would be revealed.[83]

EXHIBIT 1350

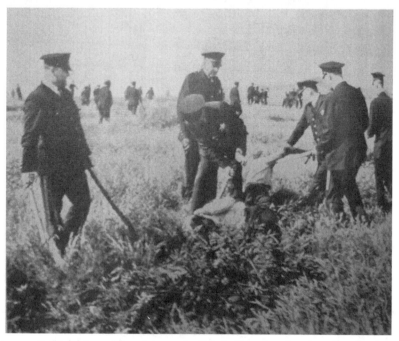

FIGURE 4.8 *"Exhibit 1350," from July 1937 La Follette Committee hearings. Courtesy Senate Committee on Education and Labor,* Violations of Free Speech and Rights of Labor: Part 14, The Chicago Memorial Day Incident, *75th Cong., 1st sess., 1937.*

The next day Chicago police chose more slippery means to deal with La Follette and the "sheaf of photographs" he "flashed" at them.[84] Sergeant Lyons called strikers a "Mexican army," to undermine support for victims by suggesting they weren't "American." His statement also undercut, however, the idea that strikers were organized. Sergeant Lyons testified that what appeared to be batons in photographs were creases in officers' pants; guns in police hands he transformed to photographic smudges or the strikers' missiles; police pulled not guns from holsters, but hankies from pockets. This creative sally made even "the usually poker-faced" La Follette laugh. Lyons begged the committee to show the picture with police "standing with their arms behind their backs." Lyons alone questioned the medium of photography. Yet his hyperbole fell before La Follette's sober explanations. That evening the *Christian Science Monitor* reported "Strike Riot Photos Are Star Witnesses," for "senators were aided at every point with photographs" in interrogating recalcitrant police.[85]

The committee called Officers Woods, Higgins, Igoe, and Kelly to the chair. They conjured sawed-off shotguns and nickel-plated pistols. However, no guns were collected from the field. Police explained that the picketers were high on marijuana. "The eyeballs are red, there is a facial grimace; at times they break out in hilarious laughter. . . . They had a monotonous chant, CIO, CIO." Under La Follette's relentless interrogation, police stories became wilder by the minute. On the second day spectators booed and hissed police. Concluded *TIME*'s reporter, "Chicago Police convicted themselves of boobery, if not butchery."[86]

William Daly, Chicago's assistant corporate counsel, "came a long way to present [Chicago's] case," but he repeated testimony given a week earlier to the conservative Post Office Committee. Daly held that "the ordinary everyday American, a man that works for a living" would never try to secure his rights through collective action. Those on the field must have been foreigners or Communists. Daly read a preponderance of court cases supporting the decision of Chicago's finest to disperse a crowd by killing them, promising that "agitators who led and encouraged the assault . . . will not go unwhipped of justice."[87]

Ralph Beck, a *Chicago Daily News* stringer, testified next. The slight Beck could barely be heard. What his testimony lacked in volume it made up for in ethos. A fellow reporter claimed that Beck's words "struck the most sweeping blow at the police case." The general mood of the crowd was picnic-like. Speakers exhorted but were not inflammatory. Unlike police witnesses, who had difficulty establishing their location, Beck had stood eight inches from Kilroy. He repeated Kilroy's words to the strikers better than Kilroy. Beck corrected La Follette when he spoke of pickax handles. Police had hatchet handles, forty to be precise. In place of police diffuseness, Beck mastered particularity. Beck contradicted the strikers who claimed they had no weapons. He saw a small number, a total of thirty-five or forty, with eight

pipes. Nonetheless, he thought strikers carried no weapons to the front line, and they were packed too tight to club police. Beck established a specific chain of events including the definitive moment of the shooting. Hundreds stood on the prairie outside Republic Steel, and the chain of events eluded almost all who left oral or written record, but not Ralph Beck.[88]

La Follette called labor's sympathizers only after he mangled police stories. Union staff and members, allies and bystanders told stories that resonated in the general but varied in the particular. Most denied Communist ideology or weaponry on the field, and they described police brutality experienced or witnessed. La Follette's questions pulled out the horror that day. One man, Fleming, whose house abutted the field, told how his daughter fainted when she realized that police were shooting. A next-door neighbor who crowded around the window with Fleming's family was anxious to get a better view. He went outside and found police combing residents' gardens. Police later maintained that the sticks, refuse, and tomato ties they had pulled from the ground were strikers' weaponry.[89]

Lupe Marshall was the sole woman called, and she received the most press attention. Her well-tailored suit seemed anomalous to the day's brutality, and she was one of the few participants identifiable from the newsreel and photographs. Her story brought events to life. Marshall worked at Hull House, and she told the committee that she attended the rally to study Mexican laborers as a "volunteer social worker."[90] She joined a "jubilant" group of women "going towards the front" who were "singing" and "kidding each other." She told of reaching the police line, their batons swinging back and forth. And then the shooting. "The police were closing . . . their ranks and crowding us, pushing us back . . . and I said to one of the officers in front of me, I said, 'There are enough of you men . . . to see that order is kept.' And he answered me 'Like hell! Like hell! Like hell! Like hell there are!'" When talking with police she heard "a dull thud toward the back . . . of my group, and as I turned around there was screaming going on in back, and simultaneously a volley of shots. It sounded more like thunder. . . . [F]or a minute I couldn't imagine what was happening. I had seen this man with his revolver out, but I couldn't believe that they were shooting." Her incomprehension captured other participants' disbelief. "The people that were standing in back of me were all lying on the ground face down. . . . I tried to run, but I couldn't: the road was closed by these people there . . . and I didn't want to step on them." She described further police brutality: "I noticed that a policeman had just clubbed an individual [who] dragged himself a bit and tried to get up, when the policemen clubbed him again. He did that four times. . . . Every time he tried to get up the policeman's club came down on him." Marshall testified that she intervened on his behalf: "The man's shirt was all bloodstained here on the side," but the police dragged him nonetheless. She screamed, "'Don't do that. Can't you see he is terribly injured?' And at the moment . . . somebody struck me from the back again and

knocked me down. As I went down somebody kicked me on the side here. . . .'"
Then La Follette asked her:

SENATOR LA FOLLETTE: How much do you weigh, Mrs. Marshall?
MRS. MARSHALL: I weigh 92 pounds now. I weighed 97 when this happened.
SENATOR LA FOLLETTE: And how tall are you?
MRS. MARSHALL: 4 feet 11.

Her interlocutor had no need to remind spectators of the bulky backs of police seen in photos. Marshall said police threw her into the paddy wagon with a kick to the backside, and then piled sixteen wounded on top of one another, not a one who could hold his own head up. Marshall's description of the ride to Bridewell Hospital left Paramount's filmed story. She told of a policeman with "tears rolling down his eyes" when one of the victims died with his last word "Mother" incomplete. At the hospital, however, police dumped bodies on the concrete floor. Marshall described emergency-room triage, a doctor poking his fingers through the holes in one victim's head. Getting no response, he moved on.[91]

Marshall measured words to their full, indicting effect. Her bafflement at the shots that sounded like thunder, the downed man hit four times, the tight quarters of the paddy wagon turned hearse, the man with five holes in his head and the doctor's probing fingers. What shone through was the unremitting harshness of police. Paul Anderson first shared her story. It then appeared in *TIME* and metropolitan dailies nationwide; CBS radio thought she "knocked them dead on the stands." The photo of Marshall imploring police as her companions had fallen became one of the massacre's most reproduced images.[92]

La Follette then called Harry Harper, who had lost one eye from a police bullet. Police neglected his wound after the fray, threatening the other. Harper's head was "swathed in bandages," and the press reported that Harper was "guided in and out of the hearing room by his wife." Harper stated that he had joined the marchers to calm his nervous mother. One of her sons was inside the plant; another was out on strike. Harper had hoped to find the brother inside Republic Steel when a policeman told him to watch himself, or "I'll fill you full of lead." Here Harper's testimony faltered. La Follette read aloud Harper's earlier affidavit, enacting Harper's disability to the Washington crowd. Harper finished by telling spectators that he was "of the same faith of some of these officers." He invoked the Ten Commandments and wondered whether the officers had forgotten the biblical injunction against killing. Harper made La Follette's hearing room a pulpit to condemn police action.[93]

La Follette used photographs to help labor's witnesses bolster their explanation for the Memorial Day events. SWOC organizer Joel Riffe testified that the union controlled the crowd and that picketers had no weapons. La Follette immediately contradicted Riffe's assertion with a photo of strikers holding

several sticks in their hands. La Follette didn't let Riffe develop a story as he had police, leaving Riffe's integrity mostly intact. Gus Yuratovic next testified that he had asked picketers to drop any sticks and stones. His statement limited the photographs' damage. La Follette also allowed union witnesses to construct stories from the photographic details that most damned police: the many women in the crowd, and how they fell with men astride them after the shooting; the vacant eyes and inert hands of the victims; and the roving groups of police who lashed out at the most vulnerable.[94]

The committee's handling of the Paramount newsreel attained the "Madison Avenue" image that La Follette and his staff planned. The committee perched the moving picture screen in front of the hearing room for all three days. The press heralded this as the "first time in congressional history" that a motion picture was used as evidence. The film was shown in the midst of striker testimony, just before lunch. This timing was a common tactic to reach the afternoon extra edition.[95] La Follette asked the custodian of the Senate Office Building to clear seats for police commanders so they could sit near the screen. Newspapers reported his dramatic gesture. Somewhere between 500 and 1,000 people crowded the room that day, and "not even standing room remained."[96] La Follette had cameraman Orlando Lippert explain the ordering of the newsreel's shots and Wohlforth announce the additional exhibition of an altered version he made to clarify the footage's contents. In this film Wohlforth slowed the action by printing each frame twice. He also froze fourteen frames that recorded police malice. The committee's film captured the essence of the scene outside Republic, but it also framed the events by accentuating police misconduct.[97]

The crowds and the press reacted much as La Follette and his investigators had hoped: "An audience freely sprinkled with Senators, office workers and Capitol attaches" gave a "general groan" to scenes of a policeman whacking a fallen striker. At least one woman fainted and was taken for first aid. With a final flourish, La Follette called police officials back to the front to conclude his questioning, asking each one whether they still approved of the officers' conduct. Not one repudiated what they saw, but newspapers reported their public humiliation.[98]

One historian writes that the Paramount newsreel "climaxed the hearings" and "demolished virtually every claim made by the police"; another claims it "utterly shredded the police version of Memorial Day."[99] Certainly the committee organized the hearings to give top billing to the film and photographs. But some contemporaries disagreed, finding the newsreel inconclusive. Moving pictures were "expected to tell their own story," said the *Christian Science Monitor*. Though of "tremendous emotional impact" and "of the greatest historical importance," the film failed to "finally reveal who precipitated the fatal clash." In real time the newsreel was "too rapid to grasp details." *TIME* magazine concurred: events in the film happened so quickly that they left an

impression of "furious confusion"; the still photographs were "sharper." *TIME* claimed that the Paramount film was an "anticlimax" to the harrowing tales offered by survivors. *Newsweek* believed the film to be "less eloquent than the Chicago coroner's report that seven of the dead were shot in the back."[100] These dissenting judgments suggest the limits of the newsreel's documentation. It "spoke" once previously marginalized stories—the stories that SWOC, Anderson, and La Follette strained to move into the public arena—finally achieved a full hearing.

In July 1937 the committee issued a report condemning police action that Memorial Day. It concluded that the police attack was unprovoked, that police shot with the crowd in "full retreat," and that in the aftermath police "treatment of the injured was characterized by the most callous indifference to human life and suffering. Wounded prisoners of war might have expected and received greater solicitude." The committee singled out photographic evidence to demonstrate the crowd's mood prior to the shooting and the immediate retreat of the strikers before the shower of police bullets. The "immediate cause" of the shots could not be established visually as Lippert was changing his lens, but Beck's near photographic memory supplied the missing links.[101]

La Follette never treated photographic evidence as absolute truth, tying it to other evidence such as medical reports or eyewitness testimony, but newspaper coverage was less subtle. Headlines such as the *New York Times*'s "Riot Photos Force Police Admission" questioned the police account, and stories now purveyed the union stance that police action was unprovoked. The *Washington Post* went furthest in concluding that "police went berserk," but a Louisville *Courier-Journalist* columnist called Chicago's police "frightening, bungling amateurs," and even the Youngstown *Vindicator*, a staunch critic of the strikers, now editorialized against police's "shocking brutality." Journalists seemed impressed with how the report "was voluminously illustrated with pictures."[102] Some newspapers printed stills from the "suppressed film" showing police chasing strikers with their upswept billy clubs. They were much like the still photographs that had been used to condemn strikers. Others printed photos of La Follette carefully examining photographs or waving them at the audience. Magazines and dailies whose mission was purveying photographs took the most advantage of the newsreel's public prominence to tout their own product. *LIFE* claimed that La Follette "conduct[ed] an investigation by pictures" (Fig. 4.9). The publication showed La Follette and Thomas poring over photographs, policemen James Mooney and Thomas Kilroy considering them, and the essay printed a full page of Paramount newsreel stills.[103] The New York *Daily News* also printed Paramount stills under the heading "Film That Told Chicago Riot Story to Senate." The stills followed one man's progress from sign-carrying protester to "knocked cold" victim. The *Daily News* concluded, "But the Pictures Tell His Story," suggesting that, contrary to their own treatment, narration was unnecessary.[104] Much as Paramount did, this press promoted the notion that no greater truth existed than what met the eye.

NEWSREEL SHOWS SOUTH CHICAGO MEMORIAL DAY RIOT IN WHICH TEN WERE KILLED

Senate committee conducts an investigation by pictures

Senator La Follette examines a photograph of the riot. Testimony revealed that all ten of the dead demonstrators were killed by police bullets, that seven were shot in the back.

Police captains in command at the riot were Thomas Kilroy (*above*), and James L. Mooney (*below*). Under Senate questioning, both stuck to the story their men fired in self-defense.

Something bloody and terrible happened on a field in South Chicago, Ill. last Memorial Day. The known facts are these: At 4 p.m. a crowd of between 1,000 and 2,500 C.I.O. sympathizers, including women and children, began a march toward a Republic Steel plant which was crippled by the steel strike but still running. About a block from the plant gates they encountered 180 to 300 Chicago policemen lined up across a strip of open field. A battle ensued in which ten demonstrators were killed and more than 100 other persons, including 23 policemen, were injured (LIFE, June 14).

Police claimed that the demonstrators were armed, had started the battle with a shower of missiles and a shot or shots. The demonstrators claimed that they had approached peacefully, been met by an unprovoked barrage of tear-gas bombs and revolver shots. Chairman Robert M. La Follette Jr. of the Senate Civil Liberties Committee promptly set out to hear the varying testimony, study news pictures of the battle, determine exactly what had happened and who was to blame. Most important evidence was a newsreel taken by a Paramount photographer. Paramount officials refused to release the film for public showing because they feared it would inflame movie crowds, start riots. Senator La Follette subpoenaed the film and on July 2 showed it in a Capitol committeeroom in Washington. Simultaneously it was released throughout the land. The film lasts six minutes, is accompanied also by the actual sounds of the battle—shots, screams, yells. The pictures below and on page 73 are sequences from the film.

This is what Senators saw on the screen

C. I. O. DEMONSTRATORS AND CHICAGO POLICE COME TOGETHER BEFORE REPUBLIC STEEL PLANT. AN ARGUMENT ENSUES OVER PICKETING THE PLANT

FIGURE 4.9 *"Newsreel Shows South Chicago Memorial Day Riot in Which Ten Were Killed: Senate Committee Conducts an Investigation by Pictures," LIFE, July 12, 1937. Text: copyright, 1937, The Picture Collection, Inc. Reprinted with permission. All Rights Reserved. Stills courtesy of Grinbery Film Libraries.*

WHILE CAMERAMAN CHANGES LENSES, THE BATTLE STARTS. NEXT SHOTS SHOW POLICE CHARGING C. I. O. CROWD WITH CLUBS, GAS BOMBS, REVOLVERS

DEMONSTRATORS BREAK AND RUN. POLICE FLAIL LAGGARDS. ONE MAN FALLS TO THE GROUND, AS IF SHOT. POLICE CLUB HIS PROSTRATE BODY

A PLACARD-BEARER ON GROUND (LEFT) WORKS HANDS AND FEET FRANTICALLY TO WARD OFF CLUBS. WHEN BLOWS FALL, HE OPENS MOUTH, YELLS

 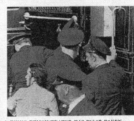

POLICE CLUB AT HER BACK (ABOVE). A BLEEDING GIRL IS HUSTLED INTO PATROL WAGON. BELOW, A DYING DEMONSTRATOR HAS PULSE TAKEN

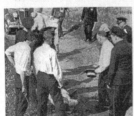

One witness at the hearings said that after the police shots the crowd reversed its path "like the slats of a venetian blind."[105] His analogy also describes the relationship between stories and pictures of the massacre. CIO mobilization, Paul Anderson's superb investigative journalism, and the La Follette committee's investigation reversed the perceived slant of the photos. If millions nationwide had seen a mob of CIO strikers at South Chicago, they now viewed the lengths to which corporations and civil authorities went to stop unionization.

Reel Stories

Paramount reworked its footage to tell the American public a new story about South Chicago events. Historians have always written about Paramount's footage much as Paramount promoted it, "the most impartial of all reporters," and they've assumed a single version. But the filmed story shifted over time. Making different stories from the same footage was common practice. Three distinct edits of the Memorial Day story exist: *Steel Strike Riots*, which condemned union actions, was the first; Paramount then spliced its footage to tell two radically different stories, only one of which was ever nationally exhibited.

Paramount's second story, *Conflict Between Police and Strikers Near the South Chicago Plant of the Republic Steel Company, Memorial Day, 1937*, humanized the strikers and offered a more neutral view of the organizing drive.[106] As with *Steel Strike Riots*, the title offered clues to a less skewed portrayal of conflict. Police and strikers received proportional coverage with a pan shot of strikers marching in front of the gates, and then a shot of police stationed outside the entrance. The film switched back and forth between long views of the conflict site and closeup looks at the picketers' faces and signs. A young boy on a bike rode past the camera, a sly grin on his face and a "Don't Scab" sign attached to his handlebars. Another boy with a baseball hat walked down the middle of the street, as a father and a toddler crossed the road holding hands. *Conflict Between Police and Strikers* pulled the workers from the anonymous masses of *Steel Strike Riots*; these unionists were appealing family men.

The newsreel also detailed police actions, showing officers gathering in back of the paddy wagon and receiving instructions from their commander. Then the footage of the mass of strikers moving across the field appeared. Viewers could see a mild confrontation between strikers and police. But the narrator did not rationalize police action by claiming they "pled" for strikers to leave the field. Instead the film showed a young man in a fedora trying to engage police. The cries "Listen, listen" and "Move" interrupted the general hum between the crowd and the police line. The strikers seemed intent but hardly rabid. The shooting and cleanup operation by police then followed. Union members and sympathizers might have recognized *Conflict Between*

Police and Strikers as their version of events that day—but it probably never left the "darkened, velvet-draped" committee room. Written accounts about Paramount's theatrically released newsreel mention neither strikers on the street nor the bicycling boy with the "Don't Scab" sign.[107]

Instead Paramount released a third story to the general public the day La Follette's hearings ended. Its simple title, *What Happened at South Chicago, Memorial Day, 1937,* suggested straightforward answers to the questions circulating since strikers had been shot down.[108] The narrator's declaration, "Now It Can Be Shown," matched the bolded explanatory text on the screen. Paramount reminded viewers of its scoop; it "alone covered the clash." Head shots of La Follette and Thomas appeared, as the narrator introduced their investigation. The camera then zoomed in on La Follette as he thanked Paramount for making the newsreel footage available. But the committee saw *Conflict Between Police and Strikers* and Wohlforth's version that had slowed shots of visible police violence, not *What Happened at South Chicago.*

Paramount's announcer then emphasized the camera's objectivity, he read the declarative text as it scrolled down the movie screen: "The following pictures, made before and during the trouble are shown exactly as they came from the camera, WITHOUT EDITING . . . as presented before the U.S. Senate Subcommittee in Washington" (emphasis theirs). *What Happened at South Chicago* then cut to some, but not the entire, footage of police shooting at protesters. Paramount edited out the lone visible gun in the footage. Only from there did the camera follow the events as Lippert recorded them.

What Happened at South Chicago separated the shooting from the events leading up to it. There were no establishing shots to the conflict, and hence there was a jarring break from La Follette's official endorsement to the shooting. The film put the killing under a microscope, but no sense could be made of its origin. There were no strikers' signs, no marching, and no police readying themselves—just the victims as advanced by the La Follette investigation.

What Happened at South Chicago told a story about Paramount's telling of the story. The newsreel's protagonist was truth itself.

By placing Paramount's role in purveying the truth center stage, *What Happened at South Chicago* elided the footage's earlier suppression. Senators La Follette and Thomas may have lent their imprimatur to spread committee findings to a nationwide audience with an immediacy impossible in print. As La Follette told viewers, "This film . . . merits the attention and study of all citizens of this country."[109]

Steel Strike Riot Sharpens CIO Crisis, which was edited days after the conflict and which justified the full-scale assault on strikers, may never have been publicly exhibited.[110] In the intervening month Paul Anderson's newsreel "word-picture" and the La Follette Committee's investigation into the strike events altered the permissible story line. Ironically, Paramount edited a more neutral story in light of the event's reinterpretation, which hinged on its own

footage as irrefutable evidence. Film studios liked to create a product to match their audience's desires, even with the "news." *Steel Strike Riots* corresponded to the immediate condemnation of strikers, but by the time Paramount released its footage on July 2, 1937, *Strike Riots*'s story line was no longer reasonable.[111]

Paramount released *What Happened at South Chicago* nationally, right after the hearings, claiming that feelings were no longer at a "white heat" given the failed Little Steel drive. Chicago's Crime Prevention Bureau banned the film, however, under standard practice of "forbidding motion pictures of conflicts between labor and capital." The city of St. Louis censored the footage, judging it "unfit for women and children." Labor sympathizers spent the summer seeking to overturn such bans.[112] Complained University of Chicago professor T.V. Smith, "The whole world has seen the pictures, why not we? . . . Why does [the City of Chicago] not let us judge facts for ourselves from the pictures? Why do men choose darkness rather than light?"[113]

But the images alone failed to enlighten. Orlando Lippert documented actual events: strikers and police milling about before they met on the field, strikers running desperately away from police, and police mercilessly seeking victims. Lippert was an excellent craftsman: his clean focus, closeup and panoramic shots imparted the expected news-style clarity. But as a news cameraman Lippert was shaping the story even as the events unfurled, he changed lenses to better tell his story. The filmed events happened so quickly, however—much as they had for those on the field—that it was nearly impossible to sort out what transpired. Only by slowing down the film into stills that can be set against other forms of evidence, much as La Follette had, did the images become proof. To impart meaning in real time, the film footage required the narrative that editing conferred. Paramount's "impartial eye" constructed three distinct tales from the same events: giving lie to *What Happened at South Chicago*'s claim that the event was pictured, "without editing," and *Steel Strike Riots*' presentation of "not arguments, but facts."

"Look at the Pictures"

Public dialogue about the Memorial Day events was permeated with discussion of photographic imagery, as the police and the Republic Steel Corporation also sought to use photographs to their advantage. Despite photography's greater pull in popular and political culture, contemporaries were preoccupied with whether the medium provided the "full picture," and unionists and their foes argued whether photos arbitrated or obscured truth.

In the aftermath of the killings, some officials called for surveillance cameras to be installed in riot wagons. Chicago's Alderman John Massen wanted police to carry "moving picture cameras . . . into labor conflicts or other civil

strife." One local paper, the anti-union *Daily Calumet*, editorialized in outrage against the Massen resolution: "Are we to discard the lie detector and all else and rely upon the movie camera to prove or disprove certain charges in times of strife? . . . Those who have been to Hollywood will tell you, never believe anything you see in the movies, because they can make black white and bend you to their way by clever camera tricks."[114] The *Calumet* noted the camera's dual capacity to document and fabricate, but it criticized the resolution only after the police came under national censure.

Discussion of news photographs also dominated a congressional inquiry aimed at drumming up negative publicity against CIO strikers. Republic used the U.S. Postal Service to provision workers who stayed in the plants, sending so much through the mail that postal officials finally claimed it was "physically impossible to handle Republic's request." The company then showed up to the post office with witnesses and photographers, and when postal employees balked at carrying any more, the story made front-page news, prompting an inquiry. Conservatives on the Senate Committee on Post Offices and Post Roads spearheaded an investigation into CIO interference into the delivery of the mail. The entire investigation, a Republic Steel publicity stunt, had been considered by NAM as a tactic months earlier.[115]

Girdler's testimony before the committee received much press. He called SWOC's president an "out-and-out liar," and reduced complaints about Chicago's troubles to a simple equation: of the 100 wounded, only 14 were Republic employees, clear evidence of outside agitation.[116] Girdler claimed his plants were surrounded by mobs "armed with everything under the sun," and as proof he brought photographs certified by Youngstown's chief of police.[117] His move was effective. *LIFE* magazine printed a page of four photos, certified by the police chief's signature, and a description of the strikers' "exotic instruments . . . a machete, a bolo, and a tomahawk" (Fig. 4.10). Seeking to preempt the Paramount newsreel rumored to show police shooting at peaceful pickets, Girdler brought his own newsreels of strikers, "pulling up railroad ties, wrecking switches and forcibly rerouting freight cars." When one senator asked Girdler whether there was "bad blood" between himself and the CIO, Girdler replied, "Look at the pictures"; photographic evidence explained his animus.[118]

The Post Office Committee also called William Daly, Chicago's assistant corporate counsel. Like Girdler, Daly brought photographs "no more authentic than these photographs taken by the photographers of these great newspapers of Chicago."[119] Daly annotated the photographs to guide senators through their interpretation. He pointed to "implements in hands of mob," police "with their hands behind their back," police permitting "peaceful picketing," and police ducking from missiles thrown by picketers. Captains Mooney and Kilroy also testified, and Mooney used Daly's photographs to show how police were beaten to the ground, giving them rationale to shoot. Getting wind that the Paramount newsreel was to be seen by La

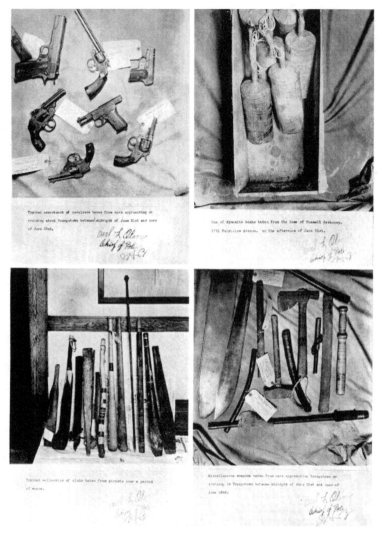

Follette's investigators, they asked that the Post Office Committee pay close attention to the still "pictures, which are just as good as any motion picture." Police brass refuted one form of photographic evidence with another.[120] South Carolina's senator Josiah Bailey took potshots at the newsreel few had seen. He believed that Chicago policemen were "entitled to a little show,"

and he demanded that Paramount edit into the newsreel the still photographs that "proved" strikers were to blame. For extra measure, he maligned the medium generally. Filmed evidence was no different from a melodrama one plopped down half a dollar to see.[121]

Photographs also figured prominently in renewed attempts by Chicago officials to blame strikers for the massacre. Chicago's coroner did not determine responsibility for the deaths until after the La Follette hearings were over. The Cook County Coroner put off his investigation for several weeks so that state's attorney Alexander Napoli and undercover anti-red agent Make Mills could establish the strikers' ideological commitments and menace.[122] The coroner and the state's attorney did not have photographs to buttress their claims, but the authority of photographic representation still hung over the proceedings.

Red-baiting and innuendo filled Chicago's official investigation. Local press gave a lot of attention to a high school student who went to the SWOC rally at the behest of her teacher. The teacher could not be questioned; ostensibly he had fled to Russia. A friend of victim Sam Popovic was called to testify that Popovic had joined the Communist Party. When he demurred, calling the victim a "good churchman," the assistant state's attorney, Mel Coghlan, insinuated that the witness must be Communist.[123] The union lawyer, Ben Myers, called on Dr. Jacques, who testified that strikers' wounds were on their backs and sides. The assistant state's attorney cross-examined Jacques. Unlike other witnesses, who were asked directly whether they were Communists, Jacques was asked whether that was his real name, if it weren't Jacobsen? When Jacques bridled, the assistant attorney persisted: "Are you a Jew?" and then "Are you ashamed of being a Jew?"[124] In this Chicago courtroom, to be Jewish courted suspicion.

Reports of Chicago's investigation in that city's papers focused on testimony by two press photographers, Carl Linde and John Puslis. Their status as photographers gave them a privileged position in dialogue over who was at fault for the massacre, even if they had no pictures to sustain their stance. Linde testified that "the marchers started throwing bricks, and attacked the police first," and Puslis claimed he heard a shot from behind the strikers' lines. Chicago papers demanded to know why La Follette had ignored this evidence straight from the camera(man)'s eyes. Much was made of the fact that Lippert missed the first seconds of the shooting. In the words of Chicago's *Daily Times*, the newsreel "obviously did not catch the seconds of action that provoked the shooting by police"; it was an "incomplete picture."[125]

The jury saw the Paramount newsreel, though no records indicate which version they saw or what they made of it. Like Mooney at the Post Office Hearings, city counsel Bernard Hodes called on Paramount to include the AP photographs that showed Puslis's and Linde's stories to be true "in fairness to the Chicago police." Without photos of mob violence, the film is "an obvious slander to our city." The *Tribune* continued its attack on the CIO by offering readers

two photos: one of a Chicago policeman holding tight to the weapons ostensibly carried by strikers that day, and the second, of a crowd running from police, though an arrow in the photo pointed to a large club that counsel Hodes claimed was thrown from the crowd. Both images were intended to counter pictorial evidence with its equal.[126]

The coroner's jury of six unemployed American Legion members took fifty minutes to uphold the "police action as 'justifiable homicide.'" Local press reported Coroner Frank Walsh's words that the inquest "presented a full and fair picture of the riot," unlike the La Follette Committee that "badgered Chicago police witnesses and turned the hearing into a CIO forum." Chicago's mayor supported this conclusion, as the "La Follette Committee was so far away from the scene they knew nothing of conditions." As Thurlow Lewis, a United Mine Worker lawyer who represented SWOC workers, observed, Chicago "still looked" on the massacre "with different eyes than the rest of the world." In Chicago the strikers remained condemned, and photographs—or the photographer's eye—proved their culpability.[127]

"The Deep, Deep Red Will Never Fade"

John L. Lewis predicted "that the butchery of our people will be legally avenged by the resentment of the public when it becomes acquainted with the real facts."[128] Lewis's predictions proved only partially correct, mirroring the equivocal result of the massacre on its victims, on the steel drive, and on its place in history.

The La Follette Committee achieved its intent with the hearing, derailing corporate practices used to subvert unionization. "Never again could a stockholder stand up in a corporate meeting and ask how much money was being spent on corporate spying."[129] The committee's research uncovered nothing new: company spies and harassment were common knowledge. Rather, the "detailed record . . . [that they] publicized" and the well circulated photographs put a brake on corporate union-busting activities.[130]

But Republic Steel still pursued its antagonistic labor strategies. Within days of the massacre, events heated up in eastern Ohio and western Pennsylvania. One Republic plant district manager wondered why the police chief of Massillon, Ohio, didn't "do like the Chicago police had done. They knew how to handle a situation." In Canton, Ohio, the National Guard "herded" strikers into an office basement at Republic Steel, where company photographers took their pictures. The company's citizens' committees and back-to-work movements muddied the issues, providing fodder for those seeking to limit unions. This negative publicity and surveillance left its mark. The day the La Follette hearings began, President Roosevelt expressed growing frustration at the labor impasse. He attacked steel barons and union workers, pronouncing "a plague on both your houses." Without federal support, the steel drive faltered.[131]

The company ultimately paid for its intransigence. In the months after the massacre, Republic reputedly lost $4 million in production, and it lagged in profits to stockholders.[132] SWOC sued the company, and their case went to the Supreme Court. The company was forced to pay restitution to workers fired for union activities, and it also paid victims bringing wrongful death suits. But union gains were not unqualified. The national SWOC helped jailed strikers in their legal battles, but they advised them to admit guilt and pay the fines. SWOC feared keeping the incident in the public eye.[133]

Ambiguity about the event remained in the union's own remembering. At each biannual convention the USWA rallied delegates with the sacrifice of its Memorial Day martyrs. Yet leaders kept resolutions that demanded redress from the South Chicago locals from reaching the floor. Leaders allowed resolutions only in watered-down form.[134] Decades later, Republic Steel's Local 1033 and the USWA District 31 commemorated the massacre. In their program they included a song that honored the Memorial Day dead with lyrics that evoked the brutality of "Girdler's mill" and "Girdler's cops" and rallied workers to remember the fallen. "That deep, deep red will never fade/From Republic's bloody ground./The workers, they will not forget,/They'll sing this song around."[135] The lyrics' appeal went unheard. Local 1033 named their hall after one of the martyrs, but only some thirty years afterward. In South Chicago the massacre marginalized union leaders and "discredited the local union." Republic Steel paved over the spot where workers were killed for a parking lot.[136]

Flesh-and-blood workers were forgotten, perhaps repressed. Remembered instead were the flickering, unstable images in celluloid and silver nitrate. These images have come to stand for the brutal class conflict of the 1930s, even as the struggles over the meaning of these images faded away. Histories of the massacre emphasize photography's authority, obscuring the CIO's power to define these photographs' meaning through its ties with the state and its growing sophistication at shaping mass media images of labor.

Steel Labor and the United Steelworkers of America's Culture of Constraint, 1936–1950

A year before steelworkers gave their lives on Chicago's Southeast Side, *Steel Labor*, the newspaper of the Steel Workers Organizing Committee (SWOC), threatened labor conflict with class-conscious imagery. *Steel Labor*'s first cover, which appeared on August 1, 1936, had a drawing of a mill, smoke issuing from its stacks. Out of the smoke thrust two fists: "Fist against fist, worker against owner," the caption explained. "As long as there is oppression of one by the other there will always be bitter strife and test of force." The drawing's broad, dramatic strokes simplified the action, emphasizing labor's "raw power."[1]

That year's Labor Day issue trumpeted SWOC's commitment to social change with a front-page image of the "heroic laborer." This idealized worker held aloft a torch; his musculature forced his shirt open, exposing his bulky physique (Fig. 5.1).[2] He dwarfed two others peeking out from the side. The light blinded one man; the other reached mightily for it. The accompanying article rallied workers with the catchwords of class struggle. Steelworkers were "breaking the shackles of economic and political servitude." The "petty political czars and industrial autocrats" were "trembling!" The text left no doubt as to labor's glorious future, of "industrial freedom, democracy and a fuller life." The monolithic worker led the way.

Because the paper's first editor, J. B. S. Hardman, matured when the "labor question" was *the* social question he believed workers and their unions a wedge for profound social change. His heroic laborer drew on a visual tradition suggesting that class struggle emancipated, such struggle would ensure that all Americans shared in the nation's economic, social, and political promise. But Hardman's tenure at SWOC was brief, as was this expansive vision.[3]

Steel Labor's new editor rejected allegoric visualizations of class struggle. Vincent Sweeney followed Hardman in January 1937. For Sweeney, workers didn't shake up the status quo—with leaders' help they joined it, incrementally. A prosaic, 1946 portrait of union president Philip Murray exemplifies Sweeney's focus on leadership (Fig. 5.2).[4] Murray stood before a radio microphone, addressing a broadcast audience about corporations' refusal to bargain with unions. Depicting him made sense. Workers certainly loved the genial, "conciliatory" Murray.

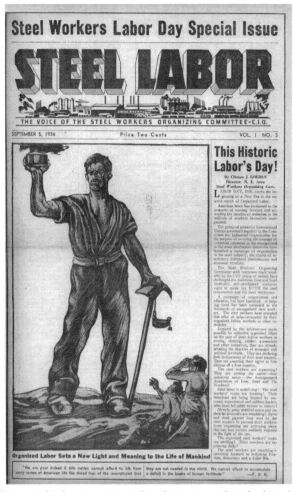

FIGURE 5.1 *"Organized Labor Sets a New Life and Meaning to the Life of Mankind," cover illustration,* Steel Labor, *September 6, 1936. United Steelworkers of America. Communications Department Records. Courtesy of Historical Collections and Labor Archives, Special Collections Library, The Pennsylvania State University.*

His past and his awareness of the steel industry's continued intransigence made him distrust corporations. A coal miner by age ten, Murray immigrated to Pennsylvania from Scotland at sixteen—without losing his recognizable burr. His parents and eight siblings had been expelled from company housing in the century's first years after Murray was fired in a dispute that escalated to a strike. The company then hounded him out of town. Murray rose through the UMW's ranks, becoming Lewis's trusted "right-hand man," even though Lewis kept him, like all subordinates, on a short leash. The devout Catholic rejected "isms," but was a committed Democrat. He believed in industrial councils to negotiate differences between management and workers; from World War I he had converted

USA-CIO PRESIDENT PHILIP MURRAY telling the nation Truman's proposed fact-finding legislation is aimed at weakening and ultimately destroying labor unions. He also scored the Administration's appeasement of big business in the radio address delivered over the American Broadcasting System.

FIGURE 5.2 *"Murray Charges: Truman Proposal First Step Toward More Savage Laws Against Labor,"* Steel Labor, *January 1946. United Steelworkers of America. Communications Department Records. Courtesy of Historical Collections and Labor Archives, Special Collections Library, The Pennsylvania State University.*

to the belief that federal intervention was crucial to union gains.[5] *Steel Labor's* portrait of Murray consolidated union demands and union might in the figure of the union president, a strategy Sweeney relied on.

This transition, from a populist icon to a leader-focused embodiment of unionism, identifies a crucial shift from an earlier idealism to moderation after World War II. CIO unions demanded a more equitable distribution of America's wealth and a more robust welfare state. But unions accepted large corporations as a given, leaving America's class structure unchallenged. SWOC, which became the USA-CIO in 1942, later renamed the United Steelworkers of America (USWA), settled for a "higher standard of living." This "assure[d] the fulfillment of our national aspirations," in Murray's words. Unions remade industrial relations, but renounced a remaking of American society. Just as organized labor hit its zenith in members and political might, the labor question "receded like some faint echo from the distant past." An earlier generation's belief that society required a "democratization of industry," in which workers participated in the decisions that shaped their lives, became implausible.[6]

Steel Labor is a key cultural text in the CIO's organizing. It offers a touchstone to CIO leaders' thought as well as that of USWA leaders. Central to the nation's economy, "barometer of a nation's freedom . . . barometer of a nation's strength," steel lie at the heart of mid-century political and economic transitions. Because of its economic importance, and because steel had long been a bulwark against industrial unionism, SWOC was the first organizing drive initiated by the CIO. Ultimately, as Judith Stein maintains, "Although the postwar world was not built only of steel, the steel companies, the steelworkers union, and steelworkers were at the center of the New Deal compact between capital and labor." Many of SWOC's national and regional staffers were tied to John Lewis, whose UMW dominated the CIO. Once Lewis stepped down, Murray took the CIO's helm.[7] These CIO leaders thought *Steel Labor* essential. They rejected a member's suggestion to rely on the established, if progressive, *People's Press*, as the union's paper of record. This would have eased their administrative burden. Their financial investment also attests to their commitment.[8]

Leadership modernized CIO publications, including *Steel Labor*, in sync with the committee's development. SWOC distributed close to 200,000 copies in 1936; by 1940, twice as many received the paper at home. In 1944 the union claimed one million members—all potential readers.[9] Hardman later claimed that labor papers were "an extended, written replica of the local union meeting." They documented union life: elections, strikes, social activities, and legislative campaigns. They were also ideological vehicles. In some unions, members and leaders alike shaped the message. But at the USWA, leaders framed internal debate.[10]

CIO unions, vital proponents of social change, might mobilize—but they also pushed moderation, as the steel workers' newspaper illuminates. *Steel Labor* ignored volatile subjects and union weakness. Only after consolidating did the union regularly depict rank-and-file activism. *Steel Labor*'s members received a modulated message: be good and your union shall reward you. Members became part of an imaged community bound by the conventions of a staid, gender-divided, associational life, with modest demands for inclusion in the promise of American life.

"Breaking the Shackles"

CIO leaders dispatched Hardman, from the Amalgamated Clothing Workers Union (ACWU) to get *Steel Labor* running. He had edited the ACWU's *Advance* from 1920. Hardman's activism spanned several continents and linked nineteenth-century revolutionary militancy with twentieth-century industrial unionism. Jailed for his socialism under the czar, Hardman met Vladimir Lenin before fleeing Russia, and years later he sipped beer in New York with Leon Trotsky. He instilled in *Steel Labor* a commitment to sweeping economic and social change.[11]

Hardman's printing of the heroic labor drew from its earlier resonance. Nineteenth-century worker societies used men's bodies in seals and banners to symbolize labor's power and unity.[12] "Manliness" preoccupied unionists as they responded to an ever more exigent industrial discipline.[13] In the twentieth century this icon circulated among leftist and radical workers' unions, parties, and states, and was featured in Industrial Workers of the World (IWW, or Wobbly) publications, along with illustrations in the *Masses*. The government took advantage of the figure's populism with WWI-era posters showing a muscled laborer pushing up his sleeves to boost war production.[14]

By the 1930s the heroic laborer retained a radical resonance—the works of Diego Rivera and Hugo Gellert offer a few examples, but the image circulated more widely. In federally funded public art, workingmen's strength and solidity stressed their contribution to the larger polity and offered solace to citizens under extreme economic stress. Georgia farmers and New Jersey oil workers, Colorado fruit pickers and Pennsylvania steelworkers all flexed their muscles for America's New Deal—a contract involving all kinds of Americans, even those previously ignored. This universal symbol for labor typically seemed a "native-born American," which elided gender and ethnic inequalities.[15] Nonetheless, when this figure appeared in *Steel Labor*, it was a common, albeit ambiguous, image signaling labor's power.

Hardman also printed cartoons that asserted class conflict in more comical terms. In one cartoon a menacing silhouette of a worker was poised to sock a clownish, bloated figure representing "Five Billion Dollars Worth of Steel."[16] Labor's size and overblown fist marked him a bully, even a back-alley lowlife. The jiggling, frightened moneybags was caricatured as a weakling—a foregone loser. His fallen cigar, popped top hat, surrendering white-gloved hand, and the "open shop" club that lie ineffectually at the side offered notes of levity, however. Hardman's polarizing discourse of class made conflict both necessary and unthreatening.

Hardman also published images proposing unionism's utopian promise. In "The Unorganized Millions," steelworkers massed above a working mill and streamed toward and through a monolith composed of the letters CIO. In reaching the metaphoric union "sun," they achieved higher wages, shorter hours, and better working conditions (Fig. 5.3).[17] Such imagery was common in the early twentieth century. IWW drawings used this "vision of the future" or "a better tomorrow," as did early twentieth-century advertisements, and in them the end goal and the vehicle for getting there were the same.[18] In *Steel Labor*, under Hardman, workers' united struggle brought a new dawn.

But *Steel Labor* rarely documented activism or conflict with the camera, despite its growing prominence in the news. An exception, a 1936 photo spread, "Huge Labor Day Demonstrations," included "Two Views of Labor on the March."[19] The photo spread had three tiers of photos; on the top and bottom crowds marched to the rally. The angle of the compositions animated the shots,

FIGURE 5.3 *"The Unorganized Millions," illustration,* Steel Labor, *December 5, 1936. United Steelworkers of America. Communications Department Records. Courtesy of Historical Collections and Labor Archives, Special Collections Library, The Pennsylvania State University.*

stressing dynamism, and the line's length accentuated the marchers' numbers. But *Steel Labor's* layout channeled this collective prowess into identification with authoritative figures: the events' three main speakers. Shown in full body shots at the microphone—the UMW district president and two sympathetic public officials, Governor George Earle of Pennsylvania, and that state's senator, Joseph Guffey—appeared in the center of the white page. The speakers' layout and their disconnection from any identifying context emphasized their centrality, as did their printed speeches. Labor was on the march, but its strength sustained the officials who rallied them. A second five-photo picture story about a SWOC "flying squadron" also indicated activism's importance by recording a leafleting squadron that "invaded Weirton, West Virginia," a company town whose rabidly anti-union CEO unions long denounced. The tightly framed photos showed union members pouring out of their cars, and captions named the participating members.[20] But picture stories emphasizing mobilization were unusual, mostly appearing after the union's first decade. By 1936 camera technology allowed members to take photographs, as the Weirton photos indicate. The union could hire local photographers or pay for photos already taken, as was done in other CIO locals and nationals unions. Instead, *Steel Labor* under Hardman used cartoons and drawings to enact a struggle between organizing workers and corporate power. Struggle was proposed as an ideal, but not depicted with the most powerful realist vehicle, the camera. Even strikes involving thousands of workers—for example, the 5,500 who struck at Wheeling's Portsmouth, Ohio, plant—were not visually acknowledged in *Steel Labor.*[21]

Steel Labor represented authoritative leadership as the heart and soul of union life. CIO union leaders confronted *Steel Labor* readers in issue after issue, page after page (Fig. 5.4). In the publication's first year, nearly a third of all the images were straight portraits of leaders, typically studio-style bust shots. Placed in a three-quarter view, leaders looked at the viewer or off to the side

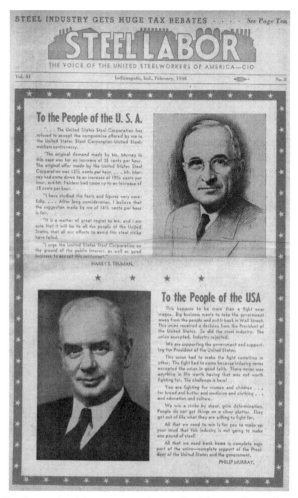

FIGURE 5.4 *"To the People of the U.S.A./To the People of the USA," President Harry Truman and President Philip Murray, Steel Labor, February 1946. United Steelworkers of America. Communications Department Records. Courtesy of Historical Collections and Labor Archives, Special Collections Library, The Pennsylvania State University.*

in a more visionary stance. A decade after the union's inception, photographs of then CIO president Philip Murray, regional directors Van Bittner and Clifton Golden, secretary-treasurer David McDonald, and other leaders still prevailed. Traditionally portraiture implies mastery, as the subject in dialogue with the photographer composes their image.[22] *Steel Labor*'s union officials had the same stern, uncompromising poses of corporate and political leaders. Other images were more akin to head shots, mundane markers of the union official. Even candid shots of speeches suggested decorum more than inspiration, with leaders standing before the microphone with little visible beyond the podium and other speakers' faces. Candid shots are intended to impart

liveliness, but in *Steel Labor*, neither the speaker nor the crowd, when visible, appeared animated.

The sheer number of these photos forces the question of why Hardman and Sweeney relied on such repetitive imagery. Portraits certainly personalized the union. Steelworkers were often suspicious of unions, and their ethnic conservatism, the decimated 1919 strike campaign, and employers' ardent anti-unionism hardened distrust.[23] Giving leaders a commanding presence asserted the union's stature and viability.[24] Portraits also identified leaders who sought to cultivate personal support. Later labor communicators have joked at "grab-and-grin" shots in which union presidents shake hands with union guests, politicians, and other power brokers. SWOC's leaders had tight control, but they still sought to instill organizational loyalty.[25] *Steel Labor's* portraits of union leaders made them, literally, the union's "face."

Hardman's editorship was brief—only six months—but it points to cultural constraints within the steelworkers union that even the veteran Hardman operated within. Under Hardman the paper's imagery was full of tensions: between the idealized drawings of heroic labor and photographs of union leaders' decorous authority; and between the absence of struggle in photos and an idealized vision of struggle implicit in the heroic laborer. Vincent Sweeney minimized the tensions in *Steel Labor*, in large part because he substituted a moderate vision in line with where CIO leaders were headed.[26]

"Factual Reporting"

Philip Murray hired Sweeney, "one of this country's outstanding newspapermen," from the *Pittsburgh Press*, where he was Sunday editor. He brought fifteen years of journalism experience. His father had been a steelworker in the Pittsburgh and Donora mills. The son moved up, attending Notre Dame, working for local and metropolitan papers and then the International News Service before joining the *Press*. He retained the title of the steelworkers' publicity director until retiring twenty-five years later.[27] Sweeney's migration from journalism to public relations matched the careers of many corporate public relations specialists, as did his duties. Sweeney fed daily updates to a thousand commercial media outlets, addressed external press requests, ghostwrote speeches, and built organizational allies.[28]

Sweeney's tenure in the news dailies may explain his desire for "factual reporting" instead of "generalizations." Before SWOC's second convention in 1940, he explained his editorial vision: "A factual news story of a new contract, labor Board victories, men reinstated with back pay and the like is of interest . . . because that type of story is based upon specific fact." This was the most expansive explanation of the paper's direction he ever gave. Once lauded at a convention for his concision, Sweeney's reports became more condensed

over time, rote reexplanations of the paper's function, making it difficult to surmise his aims.[29]

Sweeney's politics probably influenced the images he published in *Steel Labor*. Many SWOC leaders were conservative Catholics. Len De Caux, *CIO News* editor and former Wobbly, described them as a Catholic cabal. He thought Sweeney, the devout Catholic, an ardent anticommunist.[30] Sweeney's choice of imagery matched his interest in the facts and nothing but. Yet *Steel Labor*'s "factual" photos were imbued with a moderate, even conservative ideology about the role of members in the union and workers' place in society.

Sweeney's editorial policy meshed well with the union's culture and leaders' aspirations. The USWA was one of the CIO's most top-down unions. One might not go so far as DeCaux, who believed that the union was "as totalitarian as any big business," to grant leaders' dominance. Murray believed that staff members must retain control given steelworkers' lack of union experience and inherent conservatism. Leaders institutionalized their authority by limiting internal democracy. They discharged or transferred organizers who won members' loyalty; this threatened leaders' control.[31] And despite his misgivings about corporations, Murray still advocated negotiation over turmoil with managerial "partners." This made the USWA more moderate than other CIO unions.[32] By portraying union leaders at the heart of union operations, *Steel Labor* promoted this way of seeing to members. This personalistic focus was less of a challenge to conventional views of power, and it freed the union from having to be responsive to a broader set of demands.

Sweeney further truncated *Steel Labor*'s visual representation of unionism. The heroic laborer disappeared almost entirely. He halved class-based imagery in his first year, and much of what appeared did so right after he assumed editorship, suggesting some institutional lag. After July 1937, perhaps in response to the failed Little Steel drive, class-based imagery seemed banished. Sweeney retained the heroic laborer for outreach appeals alone.[33] Sweeney's injunction against "generalization" is brought to mind. The outreach appeals were persuasive. Here the hulking men and their inciting promise of collective achievement were safe. Sweeney also discarded the visual trope of unionism for a better tomorrow.

Sweeney resurrected such imagery during WWII to promote steelworkers' patriotism. The USWA was committed to the war effort. In June 1942, in exchange for labor's no-strike pledge, the federal government forced corporations to accept maintenance of membership contracts. One USWA accountant called the National War Labor Board (NWLB) mandated agreements "manna from heaven." They increased union membership and hence the USWA's financial and institutional stability.[34] Sweeney returned the manly labor to *Steel Labor*'s pages as "The Man Behind the Man Behind the Gun," or as member-soldiers.[35] He also brought back the image of "a better tomorrow" by linking

STEEL LABOR June 30, 1942

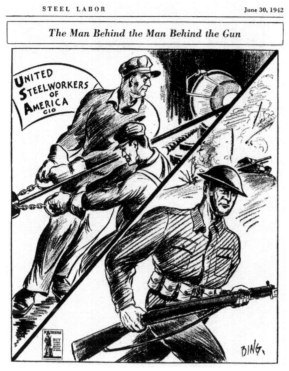

FIGURE 5.5 *"The Man Behind the Man Behind the Gun," illustration by Bing, Steel Labor, June 30, 1942. United Steelworkers of America. Communications Department Records. Courtesy of Historical Collections and Labor Archives, Special Collections Library, The Pennsylvania State University.*

the union with a strong America (Fig. 5.5). Conflict and collective strength were now strapped onto the engine of America's war mission. That advertisements for Coca-Cola, Philco, and the U.S. Rubber Company embraced the common workman to suggest patriotism made Sweeney's decision safe.[36] Sweeney's restoration of such visual themes suggests that, consciously or not, his earlier exclusion was not arbitrary.

Sweeney retained only one class-based set of images throughout the 1930s and 1940s—its portrayal of corporate power as a fat capitalist. *Steel Labor* typically designated the often rotund, effete man as the "anonymous steel baron," though specific company owners, such as Republic Steel's Thomas Girdler or Carnegie Illinois's Benjamin Fairless, also appeared with luxury trappings: a pin-striped suit or tails, pince-nez glasses, cigar, and top hat. The full history of the portly capitalist has not been written, but at some point in the late nineteenth century, the image of one social group fattening off another emerged. Thomas Nast used the heft of New York City's Boss Tweed to criticize feeding at the public trough, and Joseph Keppler, editor of *Puck*,

STEEL LABOR, *August 1, 1936*

Steel Industry Pledges "All Our Resources" in Fight Against Unionization
(See Editorial on Page 4)

FIGURE 5.6 *"Steel Baron," editorial cartoon,* Steel Labor, *August 1, 1936, United Steelworkers of America. Communications Department Records. Courtesy of Historical Collections and Labor Archives, Special Collections Library, The Pennsylvania State University.*

used the figure to criticize monopolization. His drawing "The Bosses of the Senate" caricatured the lobbying power of the trusts in their towering, bloated moneybag bodies and distorted features. The capitalists' girth underscored the inequality of social relations and their parasitical relationship to the social body.[37] In the 1910s and 1920s, Art Young and Robert Minor, illustrators for the radical *Masses,* often drew this type of figure, as did the IWW. By the 1930s, this well-established symbol also circulated in mainstream culture, perhaps most recognizably as the real estate mogul in Parker Brothers' "Monopoly" board game, first sold at the Depression's height. Some argue that by the 1930s, the sixty-year stereotype of the tuxedo-clad moneybags was so clichéd that it had lost its bite, but radical leftists still condemned oligarchy with this figure.[38]

Steel Labor's capitalist could be pitiable, fleshy, and incapable of fending for himself in a fight, but in other images the figure's size indicated his forbidding power (Fig. 5.6).[39] In both types corporate power was to be reviled. This figure suggested the union's need to acknowledge a formidable opponent *and* diminish

him, parallel to leaders' need to convince workers that they could win collective bargaining rights, even though defeat remained a possibility. The corpulent or menacing capitalist disappeared during WWII, reappearing only after the USWA began to mobilize for federal support against unemployment and economic insecurity in the war's aftermath. This shift indicated a need to appease corporate and public opinion during the war. It also evidences Sweeney's attention to the ideological nuances of imagery, even if he never articulated these meanings in words.

Standard Quiescent Workers

Steel Labor's early representation of the men and women who poured into SWOC articulated their circumscribed place in the union. Photographs identified individuals, but in such a standardized way that it repressed their significance to union struggle. Images also prescribed members' "right behavior": paying dues, or attending a convention or district meeting. Workers' role in collectively creating the union was rarely acknowledged or promoted; imagery did not inspire solidarity or engagement.

Steel Labor's staid, rigid compositions of workers suggested their insignificance and pliability. A *PM* magazine photographer explained:

> Photography of groups can be one of the most absorbing of photographic problems. It can also be the most boring. . . . The photographer who regards group photography as a test of his imagination and ingenuity produces the most interesting, the most delightfully arranged photos, and the indifferent cameraman produces group pictures which bore one at the first (and only) fleeting glance.[40]

In *Steel Labor*'s photos, members rarely interacted; instead they stood stock-still, shoulder to shoulder, whether at a picnic or at a local meeting—passive offerings to the camera (Fig. 5.7).[41] Individual members received a mark of recognition, but little more.

Photos further ordered members through their composition. In union elections, members lined up single file, and at conventions workers sat upright in chairs stretching out to the ends of the hall in symmetrical lines. These photos stressed union's growing strength through numbers, but the shots' tightly composed geometry equally emphasized organization. This compositional rigidity was often reemphasized in the photo's tight framing so that the static lines of seated members filled every inch of the photo's frame (Fig. 5.8).[42] The composition, the photographer's point of view, and the men's expressions and poses make these pictures of male steelworkers fit the *PM* photographer's description of group photographs that bored with a "fleeting glance."

News of SWOC Union in Pictures

FIGURE 5.7 *"News of SWOC Union in Pictures,"* Steel Labor, *August 30, 1940. United Steel-workers of America. Communications Department Records. Courtesy of Historical Collections and Labor Archives, Special Collections Library, The Pennsylvania State University.*

25,000 Represented in Philadelphia District Convention

Here are some of the 550 delegates representing 25,000 organized steel workers in the Philadelphia, Pa., district of SWOC, who held their second annual convention at the Amalgamated Clothing Workers Center on February 17. Chief purpose of the convention was to draft a model agreement to replace contracts expiring this year. Speakers included Philip

Murray, SWOC chairman; David J. McDonald, SWOC secretary-treasurer; Leo Krzycki, of the Amalgamated Clothing Workers, and Charles Weinstein, A. C. W. of A. joint board manager in Philadelphia. Delegates attended from Berwick, Wilkes-Barre, York, Lancaster, Philadelphia and New Jersey. Michael Harris, SWOC sub-regional director, presided at the convention.

FIGURE 5.8 *"25,000 Represented in Philadelphia District Convention,"* Steel Labor, *March 29, 1940. United Steelworkers of America. Communications Department Records. Courtesy of Historical Collections and Labor Archives, Special Collections Library, The Pennsylvania State University.*

On the other hand, *Steel Labor* represented workers who followed bureaucratic unionism's dictates with greater visual impact. Imagery delineated activities for good unionists. Photos and illustrations showed workers stuffing ballots in election boxes to demonstrate proper procedures for winning collective bargaining rights (Fig. 5.9).[43] Editors often included instructions to such self-evident imagery. Team players—those locals winning elections, those with large memberships, and those paying dues—made frequent appearances, typically in the staid group photos described above.[44] A few uncharacteristic photographs highlight *Steel Labor's* rote standardization. Photos from a Pueblo, Colorado, local emphasized individuals' involvement in its playful quirkiness. In one photo, two unionists posed, one a slight man of ninety-four pounds, and the other, "Tiny," who weighed three times that and stood 6′ 3″ tall. This photo and its caption suggested that across the spectrum, "big and small" workers' involvement was indispensable. *Steel Labor* later featured the same union in a "slice-of-life" snapshot. In it members leafleted outside a factory, suggesting activism's value. With WWII, *Steel Labor* also acknowledged members by printing portraits of USWA soldier-members and snapshots of patriotic efforts such as war bond drives, or union-sponsored parade floats.[45] Such photos, however, were rarities.

Steel Labor's workers engaged in prescribed behaviors, and were ordered, but anonymous. Workers did sit at convention halls, perhaps in tidy lines. Yet members could be photographed as active subjects at meetings, holding their hands up, straining their bodies forward to listen, applauding, or even appearing bored. By presenting the predominantly male membership in a formulaic, humdrum form, *Steel Labor* proposed that they were necessary but subsidiary contributors to the movement.

FIGURE 5.9 *"Your Duty Is to Vote," Steel Labor, February 1945. United Steelworkers of America. Communications Department Records. Courtesy of Historical Collections and Labor Archives, Special Collections Library, The Pennsylvania State University.*

Steel Labor's cartoons also promoted this conception of a conforming rank and file. In them, workers of all sizes, ages, and ethnicities—though not races—discussed how the union might better their jobs and home lives. Cartoons also addressed members' responsibilities to the union. "This Union Must Go On" showed two sets of men chatting. One man confirmed his belief in SWOC, only because it was "here to stay." The two union delegates who overheard knew better. They recognized "what a swell bunch of steelworkers are in the union" after attending a recent convention. The scene's realism was undercut by the second man's response. He parroted Phil Murray, saying, "The job of making this the strongest union in the world is up to us now." In "Sound Advice," four workers conferred over a speech that one was going give as shop

delegate at SWOC's first convention.[46] The speaker seemed proud but nervous about his new leadership role, abetted by his peers' comments that he should read "like those radio announcers" or a "U.S. Senator." As two others walked by, one commented to the other: "He'd better take that chew out before he starts to talk or the guys in th' front row will get a shower bath." This cartoon sympathized and mocked. Though both cartoons represented the pride and pleasure members received by participating in a united, deliberative body, they simultaneously suggested unionism's circumscribed boundaries. Rank-and-file workers discussed their issues and concerns but did not create the conditions of union struggle. Their discussion lay within a predefined context enforced by gentle belittling.

Gender also played an important constraining role in cartoons, by showing the unorganized as physical or metaphorical weaklings. Elizabeth Faue observes the frequency of visual tropes of male impotency in 1930s union literature. "Unorganized workers were caricatured as weak, immature, and fearful; they were depicted as younger brothers, children and street brats."[47] *Steel Labor* fits her description perfectly. One cartoon showed two thin, thread-bare, slope-shouldered men—a haggard father and his son—being browbeaten by a stout, unsympathetic, wife. "You pay your dues today. If there had been a union in the mill twenty-five years ago, we'd be a lot better off."[48] The cartoon's indignity lay in the title: "And Dad, Too, Knows That Is True" (Fig. 5.10). That an unattractive, nagging wife better understood the union's worth was a sorry state indeed. Only with organization would workers be self-sufficient.

Steel Labor's binary drew on pervasive gender ideologies in the larger culture, including gender tropes in this era's syndicated comic strips. Readers of 700 papers, for example, enjoyed the lovable shortcomings of J. R. Williams's machine shop workers.[49] Even so, there were consequences to dichotomizing workers as organized and strong, or unorganized, puny, and exploited. Faue contends that the masculinization of labor imagery diminished solidarity in the labor movement. Gendering constructed a vision of union strength as universal and unitary, ignoring women's needs. In *Steel Labor* cartoons, women's role could be acknowledged but was negatively characterized. Even when the woman pushed for unionism, she lay outside the struggle for economic justice. Her concerns did not extend past the circle of her family. For an affirming masculinized vision—heroic labor—Sweeney substituted a plea that used gendered stereotype to promote unionization.

"What's the Union Coming to When It Can Find Such Beautiful Girls"

Women, in feminine guises, played a new role in *Steel Labor* with World War II. Their presence reflected women's workforce participation. If white, they brightened *Steel Labor*'s pages. Sometimes they appeared as the familiar Rosie

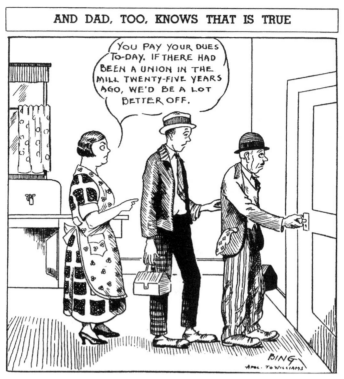

FIGURE 5.10 *"And Dad, Too, Knows That Is True,"* cartoon by Bing, Steel Labor, *November 19, 1937, 6. United Steelworkers of America. Communications Department Records. Courtesy of Historical Collections and Labor Archives, Special Collections Library, The Pennsylvania State University.*

the Riveter; but more commonly they were attractive, bouncy "girls." After the war, *Steel Labor* presented women as stalwart supporters of their husbands and hence the union. Women's depiction had visual panache. Whether as girls with big smiles and attractive figures or as sustainers of home and hearth, images of women far outnumbered their participation in the union. Their portrayal reflected actual demographic changes, but more importantly added a spark that *Steel Labor* lacked.

Prior to WWII the industry employed few women, even in administration. Explained a Department of Labor Women's Bureau's *Bulletin,* "Steelmaking is a heavy and dirty business and women workers have been taboo."[50] Shortages of cheap labor, as a result of the war, broke this tight male work culture. By 1943, women accounted for over 10 percent of the employee base: 8 percent of the production workforce and 32 percent of the white-collar positions. In sheer numbers, however, a woman walking through the mill's gate to work would likely don heavy work boots and join the men on the shop floor; three-quarters of women worked in production.[51] As World War II progressed, women took

FIGURE 5.11 *"Women in Steel,"* Steel Labor, *May 1944. United Steelworkers of America. Communications Department Records. Courtesy of Historical Collections and Labor Archives, Special Collections Library, The Pennsylvania State University.*

jobs from men whose seniority rights, so tenuously secured by the union, got them first dibs on easy jobs as a reward for years of hard service.[52]

Before the war, the paper represented women with the same staid formulas employed for men, only occasionally trading on women's gender.[53] The war changed this. A May 1944 article, "Women in Steel," addressed the 80,000 women new to the industry and the union, and the cover photo illustrated this new approach. Two-thirds of the page comprised photographs of two women delegates (Fig. 5.11).[54] Slim and well dressed, the women posed in feminine stances, one with her legs crossed and the other in the classic Grecian bend. The photo's cropping narrowed and broadened with the lines of one woman's body, setting off her legs and accentuating her pose. *Steel Labor* framed

women to be consumed by the eye, much as women were presented in mass magazines or Hollywood's celluloid fantasies. Rosie the Riveter these women were not. The article discussed women's crucial importance to the war drive, but nothing in the images pointed to women's work status.

Steel Labor did print Rosie-style photos, attesting to women's capacity for any job and their contribution to the war effort.[55] Feminist scholars first saw Rosie as a representation of women's wartime opportunities. Later scholars stressed her femininity and duty—Rosie was not as feminist as she first seemed.[56] *Steel Labor* displayed this ambiguity. In the photo spread "Steel Women of District 33," women decked out in overalls and work boots, the uniform of working-class maleness, sported head scarves, a lone feminine touch (Fig. 5.12).[57] The text told readers of the women's jobs and of their recognition of "the value of union organization." The caption then undercut its direct description with the caption: "Minnesota sunshine lights up the faces of a quartet of ladies." Capturing the women's glee, the sprightly caption was at odds with their husky figures and the broad expanse of their overalls. Captions of male workers designated identity or activity. This caption employed the glib text of mass-market magazines to package women's relationship to the work site and the union. Even when represented as producers, women provided a decorative counterpoint to *Steel Labor*'s male workers.

As women's numbers in steel grew, they became attractive window dressing for the paper. Cameras followed the lines of a woman's body as she worked or focused on her smiling visage as she posed by her machine. Men weren't represented this way. A photo spread, "USA-CIO Locals in Pictures," demonstrated this gender divide (Fig. 5.13).[58] Groups of men were frontally posed, stock-still, shoulder-to-shoulder, with union banners, flags, and emblems—a typical presentation. Women's photos emphasized their personality. *Steel Labor* offered a closeup of "Victory Girl," Anna Czech. Editors cropped the photo so that her head, haloed by the Steelworkers' emblem behind her, stood out. On the page's bottom lay a picture of "four lovely WOW's." This picture, also tightly cropped, captured the four bobbing, smiling faces as they led back through the frame. The women expressed individuality, unlike photos of male members. Another group photo of girls atop a stage, smiling beguilingly at one another and at the camera, crowned a story celebrating the opening of the nation's largest local headquarters in Gary, Indiana.[59] The women's interrelationship enlivened the picture. Their single column line posed women chest to back, allowing for the greatest exploration of the women's faces. The headline's alliteration, "Gary Girls Give Glamour to New Hall," was playful. Here Gary girls' bodies and smiles celebrated union strength. One newspaper photographer claimed, "No machine in the world can qualify as an interesting news picture unless it is teamed with a feminine smile on top a pair of well turned gams."[60] *Steel Labor* left off the gams, but as in the mass media, women brought pizzazz.

Steelwomen of District 33

ONE OF MANY TASKS performed by women at the Coolerator Co. at Duluth is coating metal strips with grease. Applying the brush above is Lois Peterson of Coolerator Local 1096.

WELDERS Ann Hudak (above, left) and Jemina Banks carry their torches at the Zenith Shipyard at Duluth, Minn. Both are members of USA Local 2542. They're standing on the deck of one of the ships they helped construct for the Navy.

OFFICE WORKERS employed at the American Steel & Wire Co. plant in Duluth are represented by Local 3391. Two members are pictured above: Florence Puhl (left) and Joyce Stensund.

★

MINNESOTA SUNSHINE lights up the faces of a quartet of ladies from the track gang in the giant open pit of the Mesabi range at Hibbing. Members of Oliver Iron Local 2381 on the left are (left to right) Marie Vuicich, Ruby Swanson, Ann Hietala and Mary Ano.

★

OLD-TIMERS in the steel industry never expected women to perform the wide variety of jobs they now hold in the mines, mills and fabricating plants under contract with the Steelworkers' Union. It is admitted everywhere that today's manpower shortages would be even more critical were it not for women such as those pictured on this page. Tens of thousands are employed in the industry and they have not only learned their jobs but also the value of union organization.

FIGURE 5.12 *"Steel Women of District 33," Steel Labor, January 1945. United Steelworkers of America. Communications Department Records. Courtesy of Historical Collections and Labor Archives, Special Collections Library, The Pennsylvania State University.*

News of USA-CIO Locals in Pictures

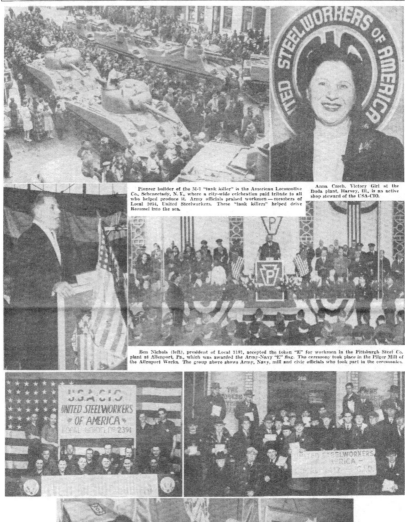

Pioneer builder of the M-7 "tank killer" is the American Locomotive Co., Schenectady, N. Y., where a city-wide celebration paid tribute to all who helped produce it. Army officials praised workmen — members of Local 2054, United Steelworkers. These "tank killers" helped drive Rommel into the sea.

Anna Czech, Victory Girl at the Buda plant, Harvey, Ill., is an active shop steward of the USA-CIO.

Ben Nichols (left), president of Local 1187, accepted the token "E" for workmen in the Pittsburgh Steel Co. plant at Allenport, Pa., which was awarded the Army-Navy "E" flag. The ceremony took place in the Pilger Mill of the Allenport Works. The group above shows Army, Navy, mill and civic officials who took part in the ceremonies.

These union employes of the Spiral Department at Heisler Brothers Co. of Newcomerstown, O., are taking an active interest in combatting absenteeism. Bottom row, left to right: R. Ankrum, W. M. Neal, R. Goodwill, L. Brady, A. Callentine and B. Meeks. Center row: R. Herbert, E. McCune, G. Richardson, V. Berg, E. Corbett and E. Reed. Standing: W. Byard, W. Whitis, W. Clark and P. Jones.

Penokee Local 2412, USA-CIO, Ironwood, Mich., is ceaselessly pushing the sale of War Bonds. The War Bond committee consists of Dan Misuraco, John Redgoski, Frank Ernt, William Dublin, Axel E. Tenlen and Gerald Hewitt. These four lovely WOWs are members of their unit at the Ammunition Container Local 2673, USA-CIO, Harvey, Ill. Left to right: Jeannette Curzydel, Virginia Garity, Alma Matlock and Lottie Maczka.

FIGURE 5.13 "News of USA-CIO Locals in Pictures," Steel Labor, May 28, 1943. United Steelworkers of America. Communications Department Records. Courtesy of Historical Collections and Labor Archives, Special Collections Library, The Pennsylvania State University.

Steel Labor rarely depicted the African-American women who comprised a large portion of the unionized female workforce as objects of desire. One photo of four black women workers from the Timken Roller Bearing Company had them staring uncompromisingly at the camera eye (Fig. 5.14). They had the weighty decorum of union leaders, matching the caption, "Count on Women to Show the Way."[61] In keeping with the dictates of mass culture, and a majority white membership that was anxious about racial intermixture, Steel Labor could not represent black women members with playfulness. Their gravity, of course, accorded them far greater respect than would be found in mass media portrayals.[62]

Steel Labor's strict gender binary differentiated members' social roles in and outside the union. Borrowing the *PM* photographer's words, *Steel Labor's* photos of men "bored," but photos of women were "delightfully arranged"; this gender distinction still dominates Western art and mass culture.[63] Women may have enjoyed imagining themselves as attractive, attention-grabbing figures, or as the "workmanlike" Rosie, but *Steel Labor*, like mass culture, insisted on their difference. Men would have had to work to take women seriously as unionists, and women might have as well.[64]

COUNT ON WOMEN TO SHOW THE WAY

About 90 per cent of the workers in the Savannah plant of Timken Roller Bearing Co., Canton, Ohio, are women—which probably accounts for the 120-to-1 vote in a Labor Board election. The USA-CIO has won overwhelming victories at seven plants. Mrs. Esther Archer (left), president of Local 2777, is the mother of three children, all of school age. With her, left to right, are Johnetta Humphries, financial secretary; Julia Simmons, recording secretary, and Effie Clark, treasurer.

FIGURE 5.14 *"Count on Women to Show the Way,"* Steel Labor, *January 22, 1943. United Steelworkers of America. Communications Department Records. Courtesy of Historical Collections and Labor Archives, Special Collections Library, The Pennsylvania State University.*

Perhaps women's representation can be understood as the union paper's attempt to negotiate women's entrance into the union through cultural means. The national union and some locals understood women had to be included to keep the union strong. But other locals joined corporate management who "did not welcome the advent of women into the mills." Assuming that women would "return to their peace-time activities" once the war ended, they did not think it "worthwhile to encourage activism or develop leadership." Women must have felt burdened by this knowledge. At the 1942 USWA convention, delegate Anna Kordich donned a mask of submissiveness when making a speech for equal pay for equal work, a policy with leaders' support. Kordich couched her demand with an assurance: "Men, we are here to protect you in the future." Even so, a disdainful male delegate replied with an irate digression suggesting how much white manhood could be threatened: "So far as the women are concerned, that's all right. That's the greatest thing in the world. Maybe the Indians will have this country again just like they did, and they will put the squaws to work."[65] The delegate's discomfort, articulated in gender and racial terms, suggests *Steel Labor*'s work. Pictures embodied the union's conflicted relationship to women members. *Steel Labor* recognized women's contribution to the war effort, but at every step the publication reminded members that women were "girls." Girls were contingent laborers, not a serious threat to men's jobs or gender roles.[66]

Steel Labor's cartoons show how gender differentiation could shade from adulation to negative stereotyping. In one cartoon, two soldiers inspected a photo of one of the "gals" at home. The gal was no pinup, as her Peter Pan collar and glasses connoted. One soldier said to the other, "I know, but how she can turn out planes." Here the humor turned on the irrelevance of a woman's attractiveness under the dire circumstances of war. Yet the cartoon still reinforced the male gaze, with women as the object of that gaze. In another war-era cartoon, a woman was seen in her kitchen stomping on cans as her husband admonished, "Just try an' remember dear, flatten 'em after they're empty." This cartoon played on homefront war imperatives that required women's labor. Recycling tin was a patriotic act. But women's unswerving and irrational commitment was put to comic relief. Another cartoon envisaged the Bureau of Labor Statistics as a comely woman, "The Sweetheart of Industry," being caressed by a fawning, elderly, tuxedo-clad capitalist.[67] Here women's physical attractions, passivity, and lack of discrimination became tropes to complain about low wages and the renewed fight against big business. Cartoons made attractiveness, passivity, and irrationality—"womanly" traits—the object of hilarity.

With reconversion, the union addressed women less as girls and more as mothers and housewives. Its postwar mothers and wives had all the vibrancy of the "real" found in photo journals like *LIFE* or the documentary photographs of the FSA. In a human-interest story presaging the 1946 strike,

"Mrs. Marie Rigot, Wife of a Striker," Rigot tended a pan on the stove, while holding her daughter in one arm (Fig. 5.15).[68] Her gingham apron added another layer of domesticity. Rigot believed that her "man" was "fighting for something" all workers "should have," increased wages. Her husband's ill health, the result of years "pickling" steel with acids, led her to "back him all the way." Rigot, like other women in the article, showed solidarity by "walk[ing] an extra block to find food for less" and limiting the "temptations" of additional household expenses. *Steel Labor* suggested that controlling family consumption was critical to weathering a strike, as women set aside money from home economies. A second article in this issue maintained that "women's stake in the union" was for the "weekly pay envelope," which brought "dignity and self-respect." The battle for higher wages "brought the women to the forefront." Here *Steel Labor* represented women's concern as limited to the domestic sphere and deriving from their social roles as wives and homemakers. Men were wage earners and unionists; women's political engagement arose from their private, familial needs.[69]

MRS. MARIE RIGOT, WIFE OF A STRIKER

FIGURE 5.15 *"Mrs. Marie Rigot, Wife of a Striker,"* Steel Labor, *February 1946. United Steelworkers of America. Communications Department Records. Courtesy of Historical Collections and Labor Archives, Special Collections Library, The Pennsylvania State University.*

At the 1940 Wage and Policy convention in Chicago, that city's mayor, Edward Kelly, told the assembled workers of his working-class roots, "where men were real men and women were real mothers."[70] After the war, *Steel Labor*'s women were no longer girls: they became "real mothers." Women ideally fought *from* the private, domestic sphere, and men fought *for* this sphere. An April 1948 story prepared members for their next set of wage negotiations, and it lionized the family as unionism's ideal. This front-page story had three photos. In the top photograph a woman turned away from the stove toward her son, whose devotion seemed evident from the upward cant of his head. Below this photo was a group of children in an iris eye cut out. The photo's closeup vantage emphasized each child's sweet expression and vulnerability. Below the children was a typical group photograph of rank-and-file men at a meeting, sitting in ordered rows, passively listening. In this layout union men literally provided the base for the domestic ideals for which each member should strive.

In the postwar era, *Steel Labor*'s imagery diminished the focus on women's sexuality, putting maternal, domestic qualities to the fore. Barbara Melosh noticed this phenomenon in New Deal public art. She argues that an "aesthetic of containment" limited the "insistent physicality" mass consumer culture ascribed to women. In *Steel Labor*'s photographs, however, women retained an insistent presence, through the gendered characteristic of nurturance. Women asserted themselves in the home, not in the public sphere. The union consigned women into this role as mother-citizen-consumer; they were necessary but subsidiary players.[71]

Ironically, *Steel Labor*'s mother-citizen-consumer imagery granted women more authority than the union conferred upon them inside the union. Dorothy Patterson, Chicago unionist George Patterson's wife, galvanized members in the initial drive at U.S. Steel by setting up a women's auxiliary. George Patterson later claimed that national leaders undermined women's involvement. Debate over women's activism at national conventions supports this view. In 1944 the USWA entered a resolution to "encourage" the organization of women's auxiliaries for "legislation and political action." Delegates complained that this gave women inadequate scope; they deserved concrete representation. Murray demurred. He thought auxiliaries might "run counter to the function of local unions . . . take over the work that ordinarily belongs to the local unions." He raised the red flag of "an uncontrollable auxiliary" leading to division within the union. Whether Murray feared "unruly women," as Patterson charged, or whether the president pandered to members' own prejudices is unclear, but leadership sought to limit women's engagement.[72]

Steel Labor's visual representation of women as unionists and then as family members indicated what women's place in the union should be, redefined women's wartime role, and pulled on readers' emotional strings. This approach naturalized certain ways of looking at women and constituted the

union's gender norms. *Steel Labor*'s gender division could limit solidarity among members, thereby hurting the labor movement. Women were represented not as workers or as allies in union struggle, but as desired objects: during the war years, in a sexual sense, and in the war's aftermath, as representatives of domestic security and stability for which union members should endeavor. Photographs reminded members of women's provisional place in the union, as cute playthings or as women tied to the home in their support of the movement. Much as Patricia Cooper has written for UE members at Philco, "Male leaders sought to integrate women into the union, but primarily with respect to social activities and in keeping with a belief in sexual difference." Cooper shows how the UE incorporated the assumed interests of women, which "separated the sexes and marginalized" them. *Steel Labor*'s "gender bias . . . was structured into the fabric of unionism," confirming Lizabeth Cohen's argument of reconversion as a moment when gender roles were circumscribed so as to "delegitimate the civic authority women had gained on the home front during WWII."[73]

Women's representation did more than negotiate women's presence; their images brightened *Steel Labor* and humanized the content—giving the paper life. As one caption for a photograph of a bevy of women workers qua Colorado cowgirls exclaimed, "What's the union coming to when it can find such beautiful girls in one local union?"[74] *Steel Labor* set up women to be consumed. What the paper lacked in political vibrancy it could substitute with women's appeal. Such representations depoliticized women as subjects. *Steel Labor* wove male members into a growing mass culture that viewed women as different. *Steel Labor*, like many mass cultural venues, gave its male audience the same rewards as mass culture. And, women—as representations only— were a vivacious substitute for *Steel Labor*'s desiccated representations of male workers, union leaders, and union life.

"Peaceful, Quiet, Efficient"

Until the second nationwide postwar strike wave in 1949, *Steel Labor* seemed to have a near moratorium on representing activism. After the Chicago massacre the steelworkers' campaign faltered and national leaders pursued legal and administrative redress to gain collective bargaining. But workers still struck. The Little Steel strike continued in the Pennsylvania and Ohio River valleys for months afterward. And locals resorted to strikes to force negotiation.[75] Strikes were often short, involving hundreds, instead of the tens of thousands, of workers at the corporate giants. Some endured for months, however, and delivered victories against historic union-busting firms, for example the 1938 Crucible Steel strike. Because the USWA is understudied, determining these skirmishes' significance is difficult.[76] Many *Steel Labor* articles had USWA leaders professing their

support for activists, but the paper's editor must have considered a union's most economic powerful tool—its ability to deprive corporations of employees' labor—unrepresentable.[77]

Sweeney began representing rank-and-file contributions to union building in 1946. Strikes surged before WWII's end, intensifying after GM came out in November. The USWA's 1946 strike was its first national action, and it was crucial that the union win. Jack Metzgar comments, in this test of member discipline, "That 800,000 steel workers would go out and back on cue was by no means to be taken for granted."[78] Many feared labor's post–WWI's debacle, believing workers' gains might be washed away. Labor confronted a business class, which insisted on managerial prerogatives, including a willingness to constrain wages despite crippling inflation. Once the steelworkers came out on January 21, over two million Americans were on strike—the largest number ever at one time. Now *Steel Labor* printed pictures of members on the picket lines, much like images that had appeared in national magazines, metropolitan dailies, and other union newspapers for years.[79]

But *Steel Labor*'s description of one picket line as "peaceful, quiet, efficient" encapsulated the photos' message. In "USA Pickets Strong Everywhere," seven photographs showed unionists massed in front of company headquarters, stressing their powerful numbers. But strikers lacked dynamism. Motionless, their picket signs were held in repetitive, straight lines. The photographer's straight vantage further deadened the photo. In some photos, workers' direct gaze compensated, but most shots were taken from such a distance that workers were mere bodies. Some photos did document members on the march, but these were equaled by photos of workers sitting in ordered rows at meetings. *Steel Labor*'s photos still promoted passivity more than mobilization or collective strength.[80]

Steel Labor further muted any activist message by integrating photographs into narratives stressing the union's patriotism and its popular support. The paper introduced the 1946 strike in its February issue, with portraits of President Truman and union president Murray bound together with a bright red border studded with white stars. The textual message "To the People of the U.S.A." (see photo on page 193) conflated the nation's citizenry with the union's membership. Indeed, USA—the union's acronym from 1942 through the early Cold War—proclaimed the union's allegiance. The article reminded readers that Truman affirmed union goals. *Steel Labor*'s next issue featured a photo of workers parading through town. Their flag, made translucent by sunlight, waved at a taut angle. The caption explained that community leaders and the American Legion, typically a union foe, led the parade, proof of USWA patriotism. Further articles featured a Catholic priest who supported striking as an economic weapon, saying that his "knowledge of theology, of the encyclicals of the Pope, of the Constitution of the United States" led to this stance, and also the "100,000 Ex-GI's" who were "100 percent with the union in its fight." Enlisting opinion leaders and the nation's favored sons in the union

fight was good public relations. But these depictions far outnumbered pick-
eters on the line, suggesting a continued discomfort representing activism.
Ironically, an article in *LIFE* may have more class-consciously documented
workers' struggles. In "The Great Steel Strike Begins," Allen Grant's intimate
documentary studies of rank-and-file union members offered a greater sense
of workers' motivation for striking than the union's own coverage. The story
opened with a portrait of a grizzled but upright thirty-year steelworker who
warmed his hands over an outdoor fire while taking a break from picketing.
Also depicted were a Czech-American duo, father and son employees, and an
African-American open hearth worker who was also photographed with his
female relatives, ensconced in their parlor's comfort. A full-page photo showed
George Ackerman, veteran of the 1892 Homestead strike, standing with solem-
nity before a bulking memorial monument to one of labor's greatest defeats.[81]

In 1949 *Steel Labor* more fully represented member involvement. The strike
for pension benefits was fought with the slogan "People—Like Machines—
Wear Out!" For months, photos had educated readers about the expected
battle. A June cover photomontage anchored the organizing process at the
work site; it showed a drawn mill tower at the top.[82] The montage had a quo-
tation from the trade paper *Iron Age*, testifying to management's "stiff front"
against labor's "excessive" demands. The bottom corner showed Murray
calling on unionists to organize those who were "a millstone around our eco-
nomic necks." "Let's Be Ready!"—the montage's handwritten title—had four
shots of unionists signing up other members. The shots were static, but in
conjunction with other visual elements, the photos were an injunction to
mobilize.[83] Two months later, crushes of workers prepared for a strike in a
full-page photo spread, "On the Verge of a STRIKE!" Outside the Gary, Indi-
ana union headquarters, a throng of gleeful workers paraded with their sub-
district director up on their shoulders. September's photos had workers
leafleting and tabling, with one photo even showing a unionist typing up
union cards, a rare document of the humdrum work necessary to build mem-
bership.[84] Despite such groundwork, the union struck in October. *Steel Labor's*
November issue carried photographs of strikers out "coast to coast." Many
were closeups showing unionists' faces and signs. The photos had an imme-
diacy lacking in earlier images. Photos also stressed workers' numbers through
the proliferation of signs.[85]

Steel Labor's imagery became combative over time, inverting conceptions
of the political and visual cultures of mid-century America. When the CIO
mobilized in the 1930s, the union rarely showed unionists actively involved,
as it did during the postwar era, complicating notions of a politicized 1930s
and a quiescent labor movement in the 1950s. Why *Steel Labor's* imagery
became more daring is unclear. It may be that as the union got off the ground,
worker and governmental support was untried; perhaps the union lacked the
confidence to use a mobilizing message. By the 1946 strike, given the USWA's

no-strike pledge and the union's many steelworker-veterans, its Americanism was less assailable. Moreover, the nation's president and his fact-finding commission sanctioned union demands for higher wages. In 1949 the union no longer feared for its institutional life. Members came out with discipline. Depicting activism may have seemed less of a risk to leaders.

In its first decade *Steel Labor* minimized activism, and also neglected the violence that corporations and the state meted out to workers during the initial drive in steel. This gap suggests SWOC's bounded dialogue between leaders and members about unionization's sacrifices. During the Republic Steel fiasco, for example, SWOC convinced many that police slay unionists without cause, and photos helped them do so. But *Steel Labor* did not print a single photo of Chicago's massacre, nor of Little Steel violence in Ohio. Instead, the paper printed editorial cartoons that denounced Chicago's police and showed the La Follette Committee confirming unionists' story. *Steel Labor* shrouded anti-union violence in federal support, hiding the cost to workers.[86] The papers of the ACWU, the UE, the United Wholesale and Workers Union, and the United Packinghouse Workers of America all memorialized the steelworkers.[87] Mass-market magazines like *LIFE*, the *Saturday Evening Post*, and the metropolitan news dailies made strike violence the predominant theme when covering labor. The USWA offered members no response to such attacks.

By the late 1940s *Steel Labor* acknowledged strike violence—guardedly. It finally printed photographs from the Memorial Day Massacre, including the photograph of the thin Mexican social worker Lupe Marshall running from police. Yet editors joined photos to an account that forgot workers' activism. In three separate articles, *Steel Labor* recounted how "a roar of gunfire and tear gas, shot by police, greeted" SWOC's "peaceful parade," and it claimed that police "charged" the strike meeting. These accounts masked how strikers marched toward police to establish a mass picket. In *Steel Labor*, unionists could be victims, not agents for change.[88]

Steel Labor's imagery remained moderate in comparison to other CIO newspapers. As "Let's Be Ready!" suggested, activism was defensive, predicated on workers' need to prepare for negotiations. *Steel Labor* never promoted activism, as the *United Automobile Worker* or the *UE News* did. Both papers' coverage of the 1946 strike wave featured large, front-page photographs of picket lines. Editors' placement underlined the strike's paramount importance in achieving union goals.[89] The UAW's captioning of photos also emphasized class divisions. A two-page photo spread of a New Jersey GM strike recorded members' words of dedication: "We licked GM in '37 and we can do it again—that's what the boys are saying, and believe me they mean it." *UE News* profiled activism to an even greater degree. Its January 19 issue filled four pages with picket lines in Massachusetts, Pennsylvania, and New York. Its "man-in-the-streets" format had editors asking members

"what they're fighting for." *UE News* showcased individual members and elicited their voices. The union connected individual commitment with a union's collective strength.[90] The paper mediated how members spoke with one another, but it also facilitated connecting with activists, something *Steel Labor* never did.

Other unions represented strike violence to stoke members' anger and commitment. When Los Angeles police stormed a UE picket line in 1946, metropolitan dailies carried photographs of the event to a nationwide audience. *LIFE* printed a two-page photo story that headlined the violence and impugned picketers for "violating a court order." *UE News* reprinted these photographs along with photos of union response: organized mass protest. UE's mobilization led to the resignation of the city's deputy police chief; hence the paper documented how rank-and-file activism could counter violence.[91] In another visual response, the paper printed a closeup of a woman member, captioned "Knocked Unconscious." Editors joined this photo with her vow that "no one is going to push me around and get away with it." *UE News* promised that corporate force would be met by member force.

UE News also commented on the unequal treatment that union activists received from the law. In "A Study in Contrasts," it printed photos from an anti-union publicity stunt conducted by Montgomery Ward's president, Sewell Avery. Avery was carried from his offices by U.S. soldiers in 1944. He sat in their arms, almost as if presiding from an executive chair, a sour grimace on his face. As *TIME* wrote, "His grey hair unruffled, his blue suit coat buttoned, his hands folded benignly across his stomach, his eyes half-closed, Avery looked every inch an Oriental potentate being borne by slaves." After soldiers deposited him in his chauffeured car, however, Avery left smiling—his task was completed. This photo's wide circulation in the mass-market press spoke to corporations' continued ability to shape the news agenda. Avery resisted an injunction against Ward for refusing to accept NWLB-ordered maintenance of membership contracts. The picture was intended to communicate corporations' firm resolve to maintain managerial prerogatives and limit government and labor "interference." *UE News* responded by placing Avery's photo against that of striking union members who got "clubbed" by police. *UE News* stressed the caring attentions that the state gave corporate heads who knowingly broke the law, giving membership a class-conscious reading of their struggle for social justice. Ironically, at the USWA 1944 convention, Murray contrasted Avery's kid glove treatment with the "limp carcasses" carried off the field in Chicago after the Memorial Day massacre. He averred their photos did not circulate "on the front pages of the newspapers throughout the country," as Avery's did. But *Steel Labor* had not printed photos of these victims either. It contrasted with other union papers, like *UE News*, which responded to common mass-media narratives and acknowledged the physical brutality workers might encounter when attempting to strike.[92]

As in the 1930s, media venues in the postwar era still attacked labor for the violence accompanying strikes. Despite *LIFE*'s admiration toward Murray's moderation and willingness to acknowledge workers' difficulties, once CIO strikes began in 1946, the publication argued, the public "shudder[ed]" at the prospect of "contagious strike violence." *LIFE* editorialized that business should accept Truman's recommended wage hikes, but it fulminated against union irresponsibility; contracts were not "one-way streets." Here *LIFE* echoed NAM's charge that labor had "sacrificed . . . public support and dangerously alienated Congress." Strikes proved labor's unreliability.[93] Luce's other publication, *TIME*, also lauded Murray as moderate, giving him a coveted cover, in contrast to Walter Reuther, who demanded that GM "open the books," with all the power of his "shock troops" and "panzer divisions."[94] *Steel Labor* offered no response to the media barrage; perhaps USWA leaders still thought that violence might scare off potential members. The USWA's continued silence meant that members had no guidance on the battles surrounding them, nor on the violence they might face.

Steelworkers were not asked to see their economic battles as shared with other unionists—to develop solidarity or a broader awareness of their class concerns. Conflict was visually repressed. Michael Schudson's description of "capitalist realism," mass-media's limited exploration of grave social issues, described some union media as well. *Steel Labor* could be said to have an organizational realism that shied away from documenting the devastation that anti-unionism had upon the union, its members, and their families. *Steel Labor* ignored issues that deeply affected workers and evaded areas of union weakness. Difficult subjects were addressed in drawn imagery and cartoons, a step away from the camera eye's realism.[95]

The Union "Jackpot"

Steel Labor's pallid representation of workers' organizing efforts paralleled its depiction of their lives. It ignored the economic strictures that members faced, barely taking advantage of the camera to explain workers' need. In contrast, the paper delineated union rewards as concrete, material gains to individuals. *Steel Labor* translated the goal of collective struggle into private aims.

It would have been easy to document the exigency of steelworkers' lives. The union's quest for higher wages, a guaranteed annual wage, and portal-to-portal pay—pay for activities conducted while on the job, but not previously covered by wages, such as walking from the plant's entrance to the actual site of work—was predicated on workers' economic want. Many workers' pay barely reached the poverty line. The union promised to better workers' livelihoods and to create security, which attracted workers. During World War II the USWA lobbied the NWLB for increased wages.[96] The union relied upon a

long-held tenet of the labor movement, that workers deserved an American standard of living. As Murray put it, unionists should have "paintings on the wall, carpets on the floor and music in the home."[97]

After the war the USWA turned free enterprise rhetoric against corporations by claiming that high wages kept the nation's economy afloat. Workers' insufficient wages meant less purchasing. By "putting money into the hands of consumers—workers who buy—we can have full employment, build greater job security, keep factories going and remove the threat of depression." Contending that corporations' "sit-down strike" in production prevented workers "from getting radios, washing machines, children's underclothing and often much needed goods," the union argued that wage gains added to "national purchasing power."[98] Despite the USWA's tying of national economic stability to workers' gains, *Steel Labor* did not emphasize class-based inequities.[99]

Throwing in high relief the union's unwillingness to record workers' difficulties was a rich vein of documentary photography addressing such hardship. As early as 1909, Lewis Hine, as part of the *Pittsburgh Survey*, photographed steelworkers in nearby Homestead. Union leaders must have known of his work. Many of the Farm Security Administration photographers also explored steelworkers' lives. Walker Evans's iconic photographs of shacks and tenements in grimy steel towns circulated widely in the 1930s. Arthur Rothstein toured the same region, and Marion Post Wolcott entered workers' homes in steel's southern center, Birmingham, Alabama. John Vachon commented on steelworkers' lack of security with his photo of a Georgia beggar, formerly a proud Pennsylvania steelworker. The Communist *Daily Worker* went further, elucidating how management used its company-owned housing as leverage against workers during strikes.[100] Even *LIFE*'s Alfred Eisenstadt depicted steelworkers' meager shelter and worn clothing. But the closest that *Steel Labor* came to documenting workers' needs was its photos of stalwart, aproned mothers struggling to make ends meet. The editors did criticize members' substandard housing with cartoons and illustrations.[101] But *Steel Labor* never recorded how workers' low salaries and limited security stunted their lives with the power of the camera eye.[102]

Steel Labor didn't hesitate to depict unionism's rewards in concrete terms, as a dollars-and-cents "bonanza," with all photography's power of the real. Certainly NLRB enforced back wages for dismissed workers, and contractual vacation benefits were momentous wins. Guaranteeing members that participation in a union drive would not lead to their firing was a crucial shift for unionization and for workers' full citizenship. The NLRB and U.S. Supreme Court decisions sustained workers' rights to organize and the shrewdness of leaders' legalistic strategy.

Sweeney communicated workers' new security with two kinds of images. Photos often showed the checks for back pay reimbursement themselves. Here *Steel Labor* used the photos as pure "index," documents of money that workers

won. Viewers could gaze upon the indisputable marks of union success. Captions shaped such a reading, as in "Here Is What the Union Did for One Man."[103] A second visual strategy was to capture workers' glee upon receiving back pay. In "J. & L. Workers Get $10,000 in Back Pay," ecstatic workers waved their checks before the camera eye after the NLRB ordered their restitution. The picture affirmed the union's safeguarding of jobs and the financial remuneration for activists who risked their livelihood.[104] In "These SWOC Men Hit the Jackpot for $1,000 Each," two members of the Pittsburgh Engineering Works glowed as they examined their back pay "jackpots." The picture's title and the contents emphasized unionism's hefty financial gains. Back pay implied a previous activism, to be sure, yet the happy smiles and tangible checks obscured that activism. Photographs promoted the union with its court case as the active agent for change. The workers became passive recipients in this sweepstakes.[105]

Securing paid vacation time, another union victory, received similar visual treatment. In January 1941 SWOC won a suit against Republic Steel for vacation back pay; workers received over half a million dollars. *Steel Labor* proclaimed this victory with a full-page photographic spread of a "jackpot" theme reaching rococo proportions.[106] Seven photographs showed workers enjoying the fruits of the union drive (Fig. 5.16). Five of the shots depicted workers, grins on their faces, holding their checks aloft. The entire photo spread was framed by sixteen checks, literal documents of the workers' gains. Here, the extravagant image of munificence offered nothing to workers beyond the money at hand. The vacation paycheck border was a potent symbol for the workers' bound desires. Victory was not the suggestion of utopian possibilities, the heroic worker creating a new future, or a collectivity of workers asserting their demands. Instead it was large numbers of men and women, checks in hand, happy at their fate, one that could be registered in specified monetary amounts. Similarly, the cartoon "Christmas Greetings from USA-CIO" showed union wins like "Better Vacation" and "Dismissal Pay" packaged as gifts beneath the holiday tree. These presents were given, not something union leaders and members alike fought for.[107] Such depictions minimized worker activism, solidarity, or even involvement.

If the union was embodied through individual leaders, members were at their most individual as recipients. Steelworkers may have understood their role in achieving these gains, but *Steel Labor* did not represent workers in more active roles. The paper's depiction never tied monetary gains to any larger agenda for its membership or for the working class. J. B. S. Hardman's union for a "better tomorrow" was unspecified, yet it did propose a different world. *Steel Labor*'s later photographs of financial bounty had material gain alone uniting members.

In the postwar era *Steel Labor* turned to visual iconography encouraging the "American Dream." This aspirational imagery delineated private gain as unionism's primary goal. In a twelve-panel comic strip, "Why an Annual

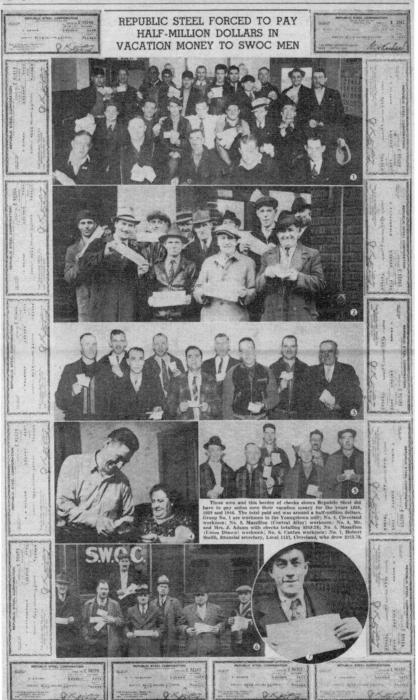

FIGURE 5.16 *"Republic Steel Forced to Pay Half-Million Dollars in Vacation Money to SWOC Men,"* Steel Labor, *January 31, 1941. United Steelworkers of America. Communications Department Records. Courtesy of Historical Collections and Labor Archives, Special Collections Library, The Pennsylvania State University.*

Wage," the paper described workers' financial straits. "Jonathon and the other boys can't even buy food and clothing, let alone indulge in a few 'Luxuries'— like having a few beers or taking the wife and kids to a movie once in a while." The next panel identified Jonathon's modest dreams for an annual wage: "I might even be able to own a car some day." When a union contract secured the wage, "the wife got her new washing machine and furniture," while "fixing up the house was Jonathon's number one project." Jonathon, and we must assume the wife, were happy, and the cartoon said that local merchants were too.[108] *Steel Labor* also envisioned workers' "home sweet home" as a "detached single family home in a suburban setting," paralleling the ideals promoted by mass media venues like *LIFE*. A front-page article on Social Security legislation told readers that it was "no cure-all for the problems facing retired workers and their families," but "a step in the right direction." Its three-color illustration of such security showed a couple reclining in Adirondack chairs on their verdant front lawn, under a leafy tree (Fig. 5.17).[109] Beside them lay their well-groomed dog, and behind them their green-shuttered ranch house. In using mass culture's visual idiom, *Steel Labor* offered a middle-class, suburban and individualized promise that elided the actual conditions of steel workers' lives. Moreover, the USWA was a strong advocate of collective solutions to individual and public problems. They fought for social security and also public housing. But the union's failure to represent collective solutions such as public housing suggested that these political goals were less attractive.

Commentators have bemoaned the anesthetization of consumer society and its conservative influence on the labor movement—but workers would not have turned their noses up at their financial betterment. As Judith Stein points out, as late as 1942 the average steelworker could afford to buy a coat every six years and a pair of shoes every other year. Close to one-third of steelworker families didn't have a bathroom in the home; over 10 percent lacked running water.[110] And it wasn't until a decade later, in the 1950s, that the average steel-worker even moved out of poverty. Jack Metzgar concluded that the bureaucratic unionism of the 1950s wrought "an amazing transformation of daily life that fully justifies, depending on where you sit, dividing the American Century into before the union and since." Nelson Lichtenstein's suggestion that New Deal and union consumerism was neither "de-radicalizing" nor bourgeois, as mass production and consumption would be "foundational components of a humane capitalism and a reinvigorated democracy," seems a fair assessment of these gains for workers.[111]

Yet *Steel Labor* refused to visualize any other hallmarks of the good life, or any other inducements to unionize. The newspaper obscured how workers as members, individually and united, were responsible for gains in security, and it elided how necessary conflict was to achieving these gains. In place of rank-and-file activism, the union as organization with its new rule-of-law administrative unionism became the vehicle for change. The focus on union

FIGURE 5.17 *"The New Social Security Law—and You!"* Steel Labor, *August 1950. United Steelworkers of America. Communications Department Records. Courtesy of Historical Collections and Labor Archives, Special Collections Library, The Pennsylvania State University.*

jackpot didn't ask workers to question U.S. class relations or economic in-
equality. Nor did it ask workers to imagine producing a different world or a
different culture. A union newspaper could represent the newfound leader-
ship skills gained by workers to enhance members' understanding of the
democratic process; it could depict the union as a vibrant community or as a
collective voice in national policy making and economic decision making.
Steel Labor did none of these. Privatism pervaded *Steel Labor*—its photo-
graphs ignored members' collective work and their collective promise, and it
ignored success unless it was translated into personal, material terms.

"This Is Our Newspaper, Fellows"

USWA leaders sought to inculcate dutiful members who appreciated unionism,
but some members disputed such aims. Delegates at the 1942 and 1944 conven-
tions criticized *Steel Labor*, a criticism applicable to the newspaper's imagery.
At the 1942 convention Sweeney offered his ever more succinct report, and
President Murray again lauded *Steel Labor* as "the outstanding labor publica-
tion in the United States today." A contentious disagreement then ensued
between members and leadership over the report. A delegate from Lorain,
Ohio, which was hit hard by the 1937 Little Steel strike, objected to *Steel Labor*'s
"weakness and conservative policy." He told other delegates, "You can talk to
any steel worker who has read our paper for four years and unless he has other
sources of information he knows little or nothing about the labor movement."
He demanded a paper that would "educate our rank and file in the purposes of
our organization." A California delegate concurred, claiming that *Steel Labor*
didn't "reflect the interests and activities of the rank and file" because only a
few men edited it.[112]

Others disagreed, with one member asking for the same paper, only "bigger
and better." Murray weighed in. He described *Steel Labor*'s assistance to the
union's organizing mission and reminded members he handpicked Sweeney.
Murray told delegates that it was not their place to criticize this "exceptionally
good paper"; the international executive board alone could do so. Delegates
would not be put off, and another Lorain member, Delegate Broadfoot, took
up where the first left off. His awkward speech indicates a certain discomfort
speaking in public—or perhaps too much convention imbibing. Nonetheless,
he criticized the paper's focus on organizational minutia and, by extension,
leaders' values:

> If [Sweeney] would get out a paper to steelworkers which we can absorb,
> he can give us educational news, things we can really learn something
> from. We are not dummies in steel. . . . Brother Murray tells you and me
> and all of us that Brother Sweeney is doing as he is told to do. . . . But

whose union is this? Is it Brother Murray's Union or is it our Union? . . . Let's all get back of this *Steel Labor* . . . to be our educational organ, not only to tell us how many delegates and how much of a per capita tax they are getting from such and such a local throughout the country. . . . This is our newspaper, fellows.

Someone again defended the paper, and the convention hall filled with boos. Possibly the dissenters attacked the paper alone. But tangential discussion often masks larger arguments. *Steel Labor* was a convenient hook to criticize the union's antidemocratic leanings, its promotion of member passivity, and its emphasis on duty over movement building. Murray chided delegates for their ungentlemanly behavior, and another worker proposed that the paper become "the official organ to win this war." Sweeney's report passed by a unanimous vote.[113]

At the next convention, another dispute occurred over *Steel Labor*. One delegate criticized its failure to educate members about political issues outside the union, and another questioned its content, claiming that the articles' length deflected workers' interest. Murray again defended it—this time with more defensiveness. Sweeney had "won his spurs" at the *Pittsburgh Press*, and "he is a union man—union minded." Murray recited the paper's contents, page by page, concluding, "The newspaper is open. It is your newspaper." But he reminded the assembled of the international executive board's supervisory mandate. After 1944, Sweeney obviated criticism by meeting with members in small groups. [114]

Steel Labor's distinctive "patterns of meaning," in text and imagery, reflected leaders' thinking and their attempts to shape workers' attitudes. Though union leaders and Vin Sweeney left no records about their use of visual imagery, their choices over time reflect an awareness of imagery's resonance. Photographs and cartoons sanctioned specific behavior for social change, hardly criticized corporate practices, and depicted workers' aspirations as a celebration of patriotism and individual gain with a dollop of women's smiles to brighten the whole. By fostering perceptions of racial and gender division among workers; by promoting a dutiful, passive membership over engaged activism; and by ignoring the rank and file's hard work and sacrifices, *Steel Labor*'s editors and union leaders naturalized certain ways of understanding union struggle and union rights. They closed doors to other ways of seeing the worker in society, making other forms of opposition and other demands less imaginable.

Debate between the convention delegates and the USWA's president Murray demonstrates that this project was never complete. Some wanted a voice in shaping union discourse.[115] Ultimately, however, *Steel Labor* represented leaders' views. Leaders appeared to welcome comments and participation, but they forestalled involvement, keeping the paper in Sweeney's hands.

Nonetheless, for the paper to engage members' attention at all, *Steel Labor* must have encapsulated workers' aims. Workers' full participation in the

American polity was a radical claim eluding many, especially low-level indus-
trial steelworkers. As SWOC's women's auxiliary member Florence Green-
berg, speaking to the 1938 National Health Conference, stated, "Only a few
years ago, my people—the steel workers, the packinghouse workers, the Inter-
national Harvester workers—did not know what it mean to demand that their
needs, their lives, their happiness be considered. They were only half Ameri-
cans with no voice in the Government, with no part in planning this democ-
racy."[116] One has only to look at the FSA photos of steelworkers' dismal
housing, or news photos of violence befalling striking workers, or consider
that Pennsylvania steel town officials used police to keep the U.S. secretary of
labor Frances Perkins from meeting with a group of "red" workers to recog-
nize the new world that unions created for workers. Men and women, union-
ists and their families now had a voice with the corporation, and within their
communities often denied them. Male workers may have warmed to *Steel
Labor*'s imagery: they themselves might have desired the "private" goals of a
suburban-styled "home sweet home" or a wife happily ensconced in her
kitchen. Women workers might have enjoyed caring for their families without
stinting, the luxury of not working outside the home, or being featured in the
paper as buoyant, attractive, union supporters.[117]

Like many unions in the 1930s and 1940s, the USWA borrowed techniques
and messages from the mainstream media, strengthening their hand. Leaders
consolidated their own emergent view of unionism, one that stressed their ef-
ficacy, membership's pliancy, and individualist gains for workers. Unions
cemented their power during the war, reshaping the contours of American
society and helping workers attain more security than ever before. But unions
relinquished their dream for industrial democracy. They failed to achieve the
substantial role that they desired in economic planning or the far-reaching
welfare state they lobbied for. The cultural sphere—specifically, *Steel Labor*'s
photos—contributed to these transformations and their limits.

Not all union papers were as depoliticizing and individualistic as *Steel
Labor*. Moe Foner, who edited several union papers from the late 1940s, main-
tains that "if [members] see that instead of stories about officers there are
interviews and pictures of workers on the job and in their homes, they under-
stand that the publication—and by implication the union—is about the mem-
bers."[118] As the following chapter shows, Local 65, a New York City warehouse
workers union, showed members as individuals and as part of a collective,
creating an ever mobilizing, vibrant union.

"This Picture Shows What We Are Fighting For"

LOCAL 65 DISTRIBUTIVE WORKERS' RANK-AND-FILE PHOTOGRAPHY, 1933–1953

Camera clubs are the town hall meetings of American photography. . . .
[T]hey are a credit to our democracy.

—BARNEY COLE, PHOTO LEAGUE PHOTOGRAPHER AND CRITIC[1]

In the fall of 1951, distributive workers poured into their eleven-story Manhattan union hall for a photo exhibition. Fellow members had taken pictures about their local, "The Fighting 65," which the crowd commented on."[2] Of the striker who walked the picket line with his toddler in hand one member wrote, "This picture really shows what we are fighting for." Another related, "The exhibit makes me realize the great struggles of our members in building up this union. . . . It makes me feel proud to be a member." A third connected job struggles with devotion to family: "[The exhibition] highlights graphically how our daily fight for security and better conditions revolves around a better life for our family." These members responded exactly as their president, Arthur Osman, had hoped; he wanted members to be constantly organizing and identifying their union as a "second home."[3]

His strategy succeeded. Local 65 began as a handful of workers at H. Eckstein & Sons, a hosiery and white goods wholesaler on Orchard Street in Manhattan. In September 1933, these workers met in Osman's Brooklyn home to celebrate the birth of his first son and "conspired" to form a union. Osman had moved up the ladder quickly at Eckstein's. This in-house hosiery buyer, unafraid of pressing his employer for better conditions, had, in one scholar's words, the ability to make everyone feel like a winner. Born near Warsaw in 1908, Osman and his family followed his father, an exiled anticzarist, to Siberia. Freed as a result of the Russian Revolution, the family fled, but fighting diverted them to Mongolia. From there they immigrated to the United States. Osman was young, in his mid-twenties, when he began Local 65. He described conditions in the industry, of beginning at nine in the morning and "sneaking out" at midnight. An eighty- or ninety-hour workweek was normal—the first signed contracts won sixty hours.

Workers had no security as bosses fired at will, and "vacation" layoffs were common. Ventilation was poor; shops were often filthy. This 5'5" man with a Yiddish accent and a slight twitch is little known, but friend and foe alike perceived his knack for organization. Four years later, in 1937, Osman connected 65 with the CIO's Textile Workers Organizing Committee, founded by David Livingston, at about the same time that 65 had begun.[4]

Livingston, born in 1915, described himself as a mongrel—his Jewish forbears were from the Pale, but also Germany and England. His roots in the clothing business were deep: a paternal uncle sold Civil War shoddy, and his dad was a traveling clothing salesman. These were the industry's aristocrats, though Livingston described a Loman-like existence, with his father dying in penury. He attended Columbia University and believed himself to be one of four Jewish freshmen. Columbia and the Depression radicalized him; he joined the National Student League. Lack of funds kept him from pursuing a law degree. Instead he became a stock clerk at Macy's and then a shipping clerk for L. Fabrikant in Manhattan's garment district, which he ultimately organized, like Osman, with no outside support. From there he moved on to the other piece good shops, or shops converting greige piece fabric from mills to clothing fabric.[5] Once these two locals joined, in 1937, their union had 1,000 workers. Twenty years after its founding, there were 18,000 members. Local 65 was one of the largest in the New York area, though it served other marginalized workers nationwide under the Distributive and Processing and Office Workers of America (DPO), which they established in 1948. They covered Planters Peanut workers in Memphis and Virginia, citrus packers in Bay City, Florida, and tobacco workers in Charleston, South Carolina—the DPO had some 40,000 members at that point.[6]

The union's phenomenal growth came from Osman's imaginative leadership and the broad array of political, educational, social, and cultural activities that leaders instituted to secure member loyalty and enrich workers' lives; the photo exhibition was just one example. Cultural programming, in which rank-and-filers secured "an understanding of what the Union is," drew Local 65 leaders' attention, particularly activities in which unionists represented the union itself.[7] They pushed members to work—and play—to celebrate the union in song, skit, and pageant. Osman personally founded the union's newspaper, *New Voices*, so that rank-and-filers could document and shape their organizations' growth. Early on, leaders even organized a rare union activity—a camera club—and then a volunteer *New Voices* "photo staff."[8]

The photo staff packed *New Voices* with their images. Photographers followed members to their work sites, to their picket lines, but also to their theater performances, boat trips, and picnics, in keeping with an organizing strategy that melded shop floor, community, and cultural activism. Monumental photomurals adorned union headquarters and spruced up May Day floats, "pictures

in a flash" mirrored union convention highlights, and nightclub visitors went home with souvenir portraits. But *New Voices* was the most important venue for these photographs. Nearly every page had at least one. Key organizing drives, mass investitures at Madison Square Garden, wartime blood drives, and major cultural events all merited a full page or two of photographs. From 1938 though 1941 *New Voices* printed more pictures, the layouts became increasingly complex, and editors devoted the last page to photographs. By 1942 the paper featured fifty photos each issue, and union shutterbugs wanted to call the paper "Labor's Picture Newspaper."[9] After the war, *New Voices*' photo stories increased in range and sophistication: members could learn about anticommunist attacks on the union, members traipsing to Coney Island, or the union's own nightclub.

New Voices' photographs were not mere documents: they did a union organizer's work. Photos had an "organizing eye" that enticed workers into struggle, educated them about collective action, and modeled activities for campaign success.[10] Pictures promoted ideals for members, as a collective and as individuals. Photographers represented the union as a haven of racial, ethnic, and gender diversity. And union cameramen and -women advanced the argument that workers had a right to a full, expressive life. *New Voices*' images solidified union spirit during the photo staff's heyday: from its inception in 1938 until the early 1950s when the group lost momentum as Cold War anticommunism threatened the union and transformed American politics and culture.[11] Local 65 photographs documented union aspirations and were a tool to achieve them for New York's working men and women.

"You're a Witness for God Knows How Many People"

Taking advantage of the craze in popular photography, Local 65's Education and Recreation Program designed its first photography class in 1937 at members' suggestion. Students from this class formed an amateur camera club. Club members—there were between ten and twenty men—"clamored" for instruction, and the union invited in politically sympathetic professionals to "cover the fundamentals of photography."[12] The club set up a borrowing library, and ran outings and nature hikes for picture-taking opportunities. Its first darkroom was a fire exit between two fire doors, with members wandering through the passageway at any moment. But soon the union constructed "the most modern darkroom of any trade union in New York City," so popular that club leaders had to arrange a waiting list. Camera club members organized snapshot contests and planned documentaries showing members at work across New York's boroughs. In its early years the camera club envisioned a metro "trade union camera council," and in the early 1950s the union considered establishing camera clubs nationwide. Their ambitious goals never came to pass, but 65ers were unusually enthusiastic about members' visual expression.[13]

At some point in 1938, with the camera club in full swing, *New Voices'* editor Jack Paley became inspired to fill the newspaper with motivating images. He bought a dedicated camera and convinced some members to take pictures for the paper. They became known as the *New Voices* photo staff. Technically independent, the groups' leaders were virtually synonymous, and their projects often overlapped. Even so, they jostled for time and space in the darkroom. Ultimately the camera club served members' creative needs, while the photo staff's explicit mission was to achieve organizational goals and moving the union's vision forward.[14] Paley coordinated the photo staff—they received assignments to cover union departments and special events. Once their assignments were complete, photographers registered their film, recorded identifying information, and captioned the prints. Photographers left the print selection, layout, and photo cropping to the editor.[15]

Camera club members shot nostalgic landscapes, risqué photos of their wives, and men tossing babies over their heads, but the *New Voices* photo staff disparaged such aesthetic concerns and its "Central Park shots." They had no patience for the club's "endless critiques of the 450th time you've seen a print." They even scoffed at "Ashcan School" iconography, in which camera club members explored the grit and vitality of working-class, urban life, as had path-breaking artists of early twentieth-century New York. Neither was the photo staff interested in the avant-garde compositional experiments or photomontage that European radicals advocated.[16] They believed that their distinctive mission was to "objectively" document union life as photojournalists. In 1946, photographer Moe Weinstein told a union reporter, "We have to see for 25,000 people and it's no cinch." Former photo staff chair Ed Roth concurred: "You're a witness for God knows how many people."[17] They felt a deep responsibility for representing the union and workers' struggles.

New Voices' photographers still wanted their images to pack a punch however. They trained one another in an apprenticeship system, and they pored over photographs to find effective visual strategies, brainstorming new lighting, composition, and points of view. When member Paul Choplin found a handy trick for capturing the drama of mass meetings by catching a speaker in profile with the audience in the background, other staff applauded. They forswore the posed group shots and the endless portraits of union presidents of other union papers. And they met with *New Voices'* reporters to ensure that their photos reflected news articles.[18] In late 1940 the photo staff convinced the union to purchase a professional Speed Graphic press camera. They even made themselves badges to get the best vantage in crowded meetings and at picket lines. Fearing police brutality, photographers insured their equipment too.[19]

New Voices' photographers enjoyed recognition from their avocation. "That's all amateur's . . . their life's ambition . . . [to] have your pictures printed in the newspaper," said Ed Roth. They pressed the editor to award them *New Voices* bylines, a battle they won only episodically. Their excitement spilled

outside the Local 65 community. One photo staff member wrote letters home to his mother "full of news about the Union and about his work on the . . . Photo Staff." Bob Franklin had snapped photos "ever since he was a little boy." He supplemented his income with freelance jobs.[20] *New Voices'* cameramen freelanced for New York unions that requested their services; early member Leo Choplin even sold photos to *LIFE* magazine. Several members became battalion photographers in the army: one member, Al Pune became a photographer for the National Maritime Union; another, Al Silverstein became a baby photographer; and yet another, Gabe Solomon, opened up his own camera shop. The staff was largely composed of single men—indeed, Ed Roth, who became photo staff chair in 1941, remembers photographers being so broke that they often hung out at his home. The staff's few women endured jokes about men relieving themselves in the sinks. Roth described the atmosphere as "clannish," but inhospitable seems closer to the mark.[21]

"You're Making News Tonight"

New Voices was Osman's pet project. Osman committed his time and money to its founding in 1934—other board members couldn't see the point. It took him two years to convince the board to cover its costs. In Osman's mind, *New Voices* was "by far, the most important instrument of education in our union." He believed that the newspaper should keep members "posted on organizational activities" and be a source of information for "the problems confronting them." Osman wanted the paper to bring "the messages of great labor leaders and other progressives . . . into [workers'] homes." He equally wanted the paper to be a workers' forum, "an avenue for self-expression."[22]

Osman handed Paley the editorship in September of 1937. Paley had organized the BIB company warehouse, a winning campaign, but the company shut down as a result. After several months of unemployment, the union hired him. The paper thrived under his attention. He later joked that *New Voices* was good "for a bunch of amateurs." He saw his role less as a traditional editor than as a facilitator. "I wasn't much of an editor, leave alone being a writer, but . . . I was a pretty good organizer. I got a lot of people in the shops to write for the paper. You'd be surprised the tremendous talent that existed." Committees edited and administered the paper. From January 1940, *New Voices* expanded its coverage and was printed twice monthly. The paper's circulation went from several hundred in its first year, to 10,000 in 1940, to twice that right after the war.[23] Irving Baldinger took over in 1944 and continued Paley's committee structure, believing that it kept the paper going full throttle, despite a "seemingly endless turnover in full time personnel" due to the war. Once the paper began publishing the news of local department store unions in January 1945, editors renamed the paper *Union Voice*, which it kept until 1954.[24]

One poster in union headquarters that asked members to share activities taking place in their local meetings bubbled, "You're Making News Tonight." The poster conveyed two ideas simultaneously: that member involvement was newsworthy, and that unionists should author their own stories.[25] Editorials and columns importuned members to write, send in letters, and pull in advertising quotas. Workers took the injunctions seriously; they went to writing classes, joined the "movie critics club," and attended mailing parties to get the paper out. The "Letters to the Editor" section filled one, and sometimes two or three, pages, issue after issue. Often editors could not print all the letters they received. During World War II member-soldiers writing from the South Seas, South Carolina, Tunisia, and Texas expressed their continued affinity with the union and its paper. Wrote one, "Without *New Voices* I was like a soldier without his rifle." Another shared his *New Voices* with Southern GIs who enjoyed the paper despite their "cuss[ing] organized labor for all they were worth."[26]

Readers' suggestions led to innovations. In 1942 members asked for information on crew and section leaders and editors added a "Meet the Members" page. Readers' request for a tabloid-style "man-in-the-streets" section resulted in a column called "Inquiring Photographer." Members expounded on Dior's androgynous fashions—men and women alike preferred Marilyn Monroe's more "womanly couture"—3-D movies, husbands doing housework, and Social Security.[27]

New Voices began as Osman's project, but Paley got hundreds of members to adopt it as theirs. The 1942 article "*New Voices* Goes to Press" indicated the communal "elbow grease" necessary for its production:

> Yes the ideas and energy of hundreds of 65ers make up an issue of *New Voices*. Take the last issue. . . . 18 members wrote in letters giving ideas and telling of their experience, and 20 shops and crews sent in resolutions on such public issues as the Western Front and the anti-poll tax bill. 15 members in the army sent in letters from camps from all over the world. The NYMCO and Woolworth Warehouse took over a page apiece to write about what's doing in these unorganized plants. 27 shop stewards and organizers sent in news stories on contracts, arbitration and other organizational problems and advances. 15 stewards of Section B-3 submitted sketches about themselves and their crews to make up the "Meet the Members" page.
>
> Additional features came from the pens of ten members who together made up a page of songs and poems; the Recreation Department committees contributed two articles on their activities, and the Soldiers' Welfare committee wrote up its current campaign. Besides the 28 pictures taken by the photo staff, there were 33 ads. . . . All in all about 200 members had a hand in making that issue.[28]

New Voices was Local 65's symbolic center. Members even lugged copies to the first CIO convention they attended—they were astounded that other unionists hadn't done the same.[29]

"I Had Never Seen a Union like That"

Local 65's commitment to photographing its struggles can't be disentangled from the union's desire for an active, engaged membership. A former staff member who became one of the nation's best known labor and cultural publicists, Moe Foner, described Local 65's savvy leadership, and its unusually active rank and file:

> 65 was a big eye-opener. I had never seen a union like that, of that size, capable of doing so many different things, and whose leaders were very, very sharp and able people. . . . If you attended staff meetings led by Arthur Osman, you could not help if your pores were open, you would learn a great deal . . . how to work at a union and how to involve workers in activities.[30]

Foner believed Osman, an "organizational genius."[31]

Never just a union, Local 65 was "a business establishment, a political institution, an educational and recreational society, a cooperative movement and a social service center," contributing to its distinct "community of interests." "Making 65ers feel like 65ers" consumed union leadership and the scale and scope of activities they developed was unparalleled.[32] In the union's first year, it planned baseball games and boat trips up the Hudson, founded *New Voices*, and organized an education committee that offered classes in public speaking, labor history, and current events. As membership diversified, classes in English, typing, and knitting addressed unionists' desires. The union sponsored a lending library and a bevy of athletic teams.[33] They soon developed cooperatively run welfare programs providing sick benefits and health care, established a buyers' cooperative that sold inexpensive clothing and home goods, and created a hiring hall. An early chronicler of the union claimed, "They were not sure whether they wanted to call themselves a union, a club, or some other name. . . . They rented so-called headquarters which they called 'club rooms.' . . . The first expenditures were on a Ping-Pong table and a radio."[34]

Headquarters was the locus of these activities. As Foner recollected, "There was something rocking in that building all day long—choruses, classes, entertainment, you name it. . . . The union was the center of people's lives—not for everybody, but for . . . a very, very large number of people." At the union's final headquarters, christened Thomas Mooney Hall for San Francisco's radical labor leader whose jailing made him a cause célèbre, members found Club 65, and an eleven-story, air-conditioned building with an open penthouse terrace,

a darkroom, a library, a drama group space, meeting rooms, the welfare offices, and the hiring hall.[35] Staff estimated in 1942 that upward of thirty-seven meetings were held each night, drawing in hundreds; by 1945, the paper touted the 22,000 monthly visitors to Club 65. Such estimates are imprecise, but because Local 65's staff constantly assessed activities' appeal, we have more information than typical about participation. Staffers estimated that one in ten union members organized the recreational activities for general membership. At the union's Saturday night "socials," members were often turned away for lack of room.[36]

A common *New Voices'* photo vaunted the bustle at headquarters by depicting the schedule board or the receptionists who dispatched members to meetings. The board listed dozens of activities (Fig. 6.1).[37] This iconic photo reminded members how to navigate headquarters, but it also testified to the import of rank-and-file participation to Local 65's larger mission. The photo educated members about union aspirations.

Not all unions sought or achieved such participation. Some headquarters felt like "tombs" with little rank-and-file activity. Other union halls welcomed members, but their "club-like" atmosphere made women or black members feel excluded.[38] Local 65's inclusiveness and its multi-faceted programming militated against such alienation.

FIGURE 6.1 *Local 65 schedule board*, New Voices, *May 1, 1940. United Automobile Workers of America, District 65 Photograph Collection, Tamiment Library, New York University.*

Osman's expansive, culturally driven unionism and the distributive workers' avid response have several explanations. The "65 fraternity" met institutional needs. The hiring hall and the in-house welfare programs tied members' economic security to their union's health. And social activities brought in needed funds for organizing work. The annual Hudson River boat trips provided a healthy chunk of the union's early budget; some social events, like dances, remained sizeable moneymakers.[39] Social and cultural activities also limited factionalism among a membership that was geographically scattered, white- and blue-collar workers, men and women, and a "United Nations" of ethnicities. *New Voices* regularly printed stories of rank-and-filers who'd come to accept the union once they'd played basketball, picked up a camera, or played in a pageant. "Sing While You Fight," the union's song, articulated the reciprocal relationship between culture and organizing for the union.[40] Activities that did not strengthen the union were "looked upon as worthless," according to one organizer. A vibrant union headquarters that workers identified as theirs also attracted new members. One organizing tactic consisted of "leading large numbers of workers into the union by the process of escorting [them] to the union headquarters en masse." Once there, they encountered "photography exhibits organized by the Camera Club" in which prospective members learned about "union progress." Argued one staff person, union headquarters "shows what 65ers can build for themselves; it shows our strength, it shows that no man can break us."[41]

Members had personal reasons to respond as well. Their youth and their status as "singles" led them to see the union as a natural haven for socializing and romantic opportunity. According to Osman, they lived in "hot and stuffy tenement homes" where "there was nothing for them." During the Depression even a movie ticket might be too pricey. Leaders described that at headquarters they could "sit, play cards, play checkers, listen to the radio," or "come up, congregate, have a beer, and snooze."[42] Cultural activities minimized white-collar members' discomfort toward unionism, offering "upward mobility." Once economic times bettered, members matured, and the union's ethnic base broadened, members still maintained their allegiance to social activities.[43]

Ethnic traditions and geographic location also sparked the union leaders' interest in workers' involvement. Leaders and members were acquainted with mutual aid associations and Socialist organizations such as the Workman's Circle that assumed working people deserved a rich cultural life. And 1930s New York brimmed with cultural activity involving working people. Cultural workers organized their own unions—the Writers Union, the Artists' Union, and the Newspapers Guild. Independent cultural production flourished, such as the Group Theater and the Workers Laboratory Theater, Café Society, which featured leftist and interracial entertainment, and art galleries that promoted socially conscious artists such as Philip Evergood and Ben Shahn. And New

York City was home to the garment unions that pioneered educational and cultural activities. The populist, federally funded arts programs such as the Federal Writers Project, the Federal Theater Project, and the Works Progress Administration's (WPA) Federal Arts Project were particularly strong in New York.[44]

Ideological commitments also spurred 65's cultural engagement. Many members and leaders had Communist Party (CP) ties. Leaders rarely acknowledged this relationship, but as one student of the union reckons, Local 65's organizing strategies, political commitments, and cultural experiments all suggest this connection. Local 65 supported the Scottsboro Boys and the Spanish loyalists, and it sounded the dangers of German fascism. May Days were occasion for the union to parade with eleven-piece bands, floats, and banners.[45]

Local 65 was "a bastion of the left," in its politics and in its enthusiastic embrace of culture. In this period Communists allied with liberal groups to fight fascism in the Popular Front. The Front was driven in New York City by those, like Local 65ers, who were familiar with earlier forms of labor education and socialist traditions that melded culture and politics into demands for a "people's century." Michael Denning maintains that the Popular Front emphasized workers' cultural production, including workers' use of mass cultural tools for political liberation.[46] Once again, New York, with its writers, playwrights, musicians, and visual artists and its cultural apparatuses in radio broadcasting, Broadway, and publishing was fertile ground.

The city also became an important locus for radical photographic activity and leftist publishing. As Foner explained years later, "This is the period of *LIFE* magazine. And so obviously the left had sources of funds, and people went to rich people and got money and tried to make a go of it."[47] Popular Front journalistic experiments of the 1940s such as *Friday* and *PM* published there, and the New York Photo League, committed to "chang[ing] the nature of the world we live in," met in Manhattan. The league, with roots in the earlier internationalist Film and Photo League, promoted social documentary photography and ran its own school, where working-class adults learned from America's top photographers, such as Dorothea Lange, Paul Strand, and Margaret Bourke-White.[48]

Local 65's photo staff joined other leftist photographers who used the camera as a political weapon. Photo League members and *PM* and *Friday* photographers gave hands-on training to Local 65 members, and Sid Grossman, and Robert and Cornell Capa, three influential League members hung out at Local's 65's darkroom, as did photographers from the *Daily News*, the *Journal*, *Friday*, and *PM*. Local 65 photographers and their visitors sometimes swapped prints to help one another meet a deadline.[49] Never insular, 65 photographers joined a broader, New Deal–era movement identifying culture as a fulcrum for social change.

"We Had to Have 100% Organization"

Local 65 also had instrumental reasons for its cultural commitments. For there to be any union, distributive workers had to identify strongly with their union. The challenges to such identification were many. Many workers were observant Jews with strong "religious scruples" and ethnic or familial ties to their bosses, making them distrust unions. Distributive workers also had, in Osman's words, "the 'Dead End' jobs that kids took when they got out of school." Some spoke only Yiddish, were illiterate, and had difficulty pursuing other employment. Others were young, upwardly mobile Jews whose career hopes had been dashed by the Depression. They took positions as stock boys, shipping and receiving clerks, sweepers, and messengers—work with all the skill and prestige of "flipping hamburgers." Such workers couldn't see devoting themselves to bettering a job that they had no intention of keeping. To build the broadest base, Osman had the union include salesmen and white-collar workers with an Algeresque belief in their individual capacity to surmount economic limitations.[50]

The industry's structure produced further barriers to organization. Distributive workers toiled in an atomized industry. White goods, dry goods, glassware, and novelties were only a few of the goods they worked with. A large warehouse might have 100 workers; two or three per shop was not uncommon. Distributive workers did not share the same employer, which can build group cohesion. Owners hired seasonally, and workers took these jobs by default so turnover was high. The industry was also volatile. Hard-won battles at a shop might push an owner to go out of business and set up under a different name.[51] Contracts were established on a shop-by-shop basis—slow, arduous work.

Over time, the workforce's increasing heterogeneity posed new challenges. The union branched out to other wholesalers in 1935, expanding into more ethnically diverse shops. Said one former organizer, "The ethnic composition of membership was almost a prototype of New York City."[52] By the war years, nearly a quarter of the members were African American. Growing numbers of women also joined Local 65. In 1937 women made up one-quarter of membership, and with World War II they comprised half. The union's expansion meant members' homes and work sites were scattered across the five boroughs—making outreach more difficult.[53]

In a 1968 interview, Arthur Osman reminisced, "[Local 65] could not survive unless it involved the total membership in struggle. We had to have 100 percent participation." Osman knew that Local 65 had to mobilize more than one shop to achieve and enforce bargaining agreements. Leaders might call thousands of members to the streets in solidarity with a shop of ten strikers.[54] To increase the possibility of victory, Local 65 members also organized informal community boycotts. Osman explained: "We chased the boss to where he lived and caused him trouble in his synagogue or in his church. . . . We discovered for us to win with our limited power we had to involve the whole

community, many communities." *New Voices* encouraged members to "picket by phone," giving members the phone numbers of businesses they struck against to tie up their lines. They also mobilized public opinion against non-bargaining companies: for example, during the 1953 Hearn's Department Store strike they had their drama group petition on the "Great White Way."[55]

"Organize the House Next Door" was never an empty slogan—distributive workers did just that as they snaked through the dry goods establishments of New York City. From their beginnings on Orchard Street, Local 65 organized small manufacturing wholesalers in buttons, novelties, and white goods; made inroads into New York's major department stores: Lerners, Macy's, Blooming-dale's, and Hearn's; and by the mid-1940s campaigned in warehouses that transported goods globally. The security drive, to attain 10,000 members by mid-1941, and the "7 in 7" defense drive, for another 7,000 members in seven months by December 1941, tripled the union's size. In 1940 the union had 5,000 members, and by December 1941, three times as many.[56]

Cultural projects like *New Voices* and its photo staff were one of several tactics Osman employed to achieve "wall-to-wall organization." Local 65's constitution required members to attend biweekly meetings to ratify union business plans or to stand on picket lines. Thousands came to mass meetings—at times so many that they couldn't fit in the hall. Some complained about long, pointless meetings, but participation ran about 50–65 percent in the union's first decades. Other unions were lucky to have turnouts of 10–20 percent.[57]

Despite rank-and-file involvement, leaders still exerted tight control. The union's crew system kept leaders connected to membership but also let them keep tabs on grievances. An early critic believed its commitment to democracy was nothing more than "myth and ideology."[58] Leaders never got members to share all union positions; indeed, the union's Communist orientation and its insistence on racial equity repelled some members.[59]

Nonetheless, Local 65 retained distributive workers' active backing for decades, despite repression by the federal government and other unions' aggressive raiding. Most communist unions faltered once they left the CIO. Local 65 could not have prospered as it did, even maintaining membership after leaving the CIO in 1948, without solid member support. In an unusual move, leaders also rejected the dues checkoff, in which contacts specified that union dues were taken from employee paychecks. Most CIO unions embraced this arrangement because it made their jobs easier, even if they depended upon corporations to administer it. Local 65 required members to pay at the union hall, to keep a closer connection to them.[60] After attending the first CIO convention in 1937, Osman boasted, "We were pointed out as the only local with a written constitution who practiced genuine democracy with our rank and file." Osman added that CIO delegates thought Local 65 were "leaders of the progressive forces." The union's opponents concurred. A decade later, a women's clothing store manager maintained that Local 65ers

were "the ideological leaders . . . the guiders . . . the mentors . . . [and] their union is without a doubt the most militant and most aggressive of all of the distributive unions in New York City . . . from my own knowledge the most aggressive union in New York." [61] Local 65's commitment to organizing and mobilizing—and its innovative cultural and social programming sustained the solidarity needed to solidify the union and make it a progressive leader.

"The Fighting Army of Local 65"

Animating *New Voices* was editor Paley's goal. He gave members cameras to "liven up the paper, to make it a more effective instrument in mobilizing the membership to organize the unorganized."[62] It worked. One letter writer told of a member who received *New Voices* in Dallas, Texas. He found the paper a "ray of sunshine in a cloudy world." The writer continued, "I'll bet *New Voices* has more pictures than *PM*," the innovative Popular Front publication. Barney Cole, a *Popular Photography* freelancer, thought *New Voices* most unusual, as Paley's "intelligent journalism" and photographers' "enthusiasm" was a "combination impossible to beat." He criticized most labor papers as "monotonous," as "they usually consist of a picture of one of the union leaders, a cheesecake shot of some bathing beauty from Florida . . . and a shot or two of a meeting. The result is deadly, one issue hardly distinguishable from another." *New Voices* was instead "one of the best union papers in the country, excelling particularly in its photographic layouts." [63]

New Voices' pictures convinced distributive workers of the significance of mobilization. Leaders and organizers showed up at shops with *New Voices* during recruitment drives. Organizers believed that the paper put a friendly face on the union. "*New Voices* is helping to organize, 'although the men aren't talking, they're thinking." Local 65 became a "lively topic for discussion" instead of a "secret dangerous operation."[64] Staff also solicited articles for *New Voices* from prospects and members. And in hard-to-win campaigns, workers were assigned their own pages to tighten ties to the union. During organizing campaigns the paper printed many photographs of members distributing *New Voices*, emphasizing the link.[65]

New Voices' photos had distinctive patterns in their content, iconography, composition, and layout that drew members in. Content educated members about the traditional elements of a campaign: outreach to build membership and strikes for collective bargaining rights. Possible attack from the police or corporate thugs, boycotting, the contract vote, and union investiture were also featured. Editors sequenced and captioned photos to further promote organizing.

Two major membership drives on WWII's eve, the security drive and the "7 in 7" defense drive, exemplify Local 65 photographs' "organizing eye." To

spread its message, the union increased *New Voices'* publication, from monthly to biweekly, and doubled circulation to 17,000, corresponding to membership growth. Editors printed photographs of picket lines on the front page to greet the eyes of unionists and potential members alike. Photos of the local's trademark mass pickets and pictures of small groups of picketers filled virtually every issue until the CIO no-strike pledge in 1941.[66]

"Picketing for Pact," from a security drive strike, exemplifies the visual strategies that made strikers' activism look dynamic. Warehouse workers at a textile house went out when owners refused to sign (Fig. 6.2). The photo appeared, as typical, on *New Voices'* front page. Also as common, this photograph captured workers "on the line." Here picketers' signs announced "The Employees of Golding Brothers Are on Strike," and their white placards pulled the viewers' eyes across the image. Local 65 photographers monumentalized their subjects by photographing from below or from a vantage slightly to the side of the strikers. The resulting angle of the picket line, from foreground to background, made a more dramatic composition.[67] In "Picketing for Pact," two strikers looked at the photographer, while a third turned away at the photo's edge as he followed the picket line. The photo offered a space for the viewer to enter, inviting them into the process of walking the line.

As with "Picketing for Pact," many *New Voices* photographs set union struggles within the larger urban context, normalizing the strike. Street lamps, tall buildings, and a patch of sky between the buildings worked activism into New

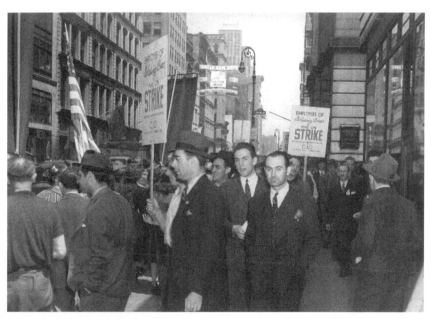

FIGURE 6.2 *"Picketing for Pact,"* New Voices, *May 15, 1940. Courtesy of the Tamiment Library, New York University.*

York's everyday life, easing tensions raised by the dynamic quality of the images. Pedestrians shared the same sidewalk with strikers. And cameramen shot close enough to identify strikers' clothing and expressions, along with the name of the company that fellow workers fought against. For example, photos of a Lane Bryant strike included the company's corporate logo on the sides of the retailer's awning. The contrast of the logo's vivid lettering against the awning's canvas, and the strikers' placards reinforced activism's importance in a brand name, consumer economy.[68]

New Voices' most common photos were of 65's signature mass actions in which, as Arthur Osman put it, sheer numbers compelled "employers to bargain collectively in good faith." *New Voices'* "organizing eye" encouraged solidarity among distributive workers citywide and signaled the union's commitment to strength in numbers. Photographing the "line of march" was the photo staff's biggest responsibility. Ed Roth thought it a plum assignment.[69]

Mass action shots emphasized sheer numbers over individual engagement. Tight frames edited out the struggle's specifics, and editors cropped liberally. In "Before Working Hours," a line of International Mutoscope workers picketing in New York's film district, Long Island City, stretched from one end of the photo's frame to the other. Editors' cropping emphasized the line of workers, which seemed to extend in either direction past the photograph's frame, suggesting limitless pickets.[70]

Birds-eye views and street-level shots of mass pickets predominated, however. In the aerial shots, photographers stood on cars or hung out of nearby building windows. Again, picketers continued past the photo's frame, accentuating their numbers. The photographer's distance transformed the pickets' bodies into stylized lines. The rounds of strikers' hats and heads and their square placards broke from the massed bodies, adding variety. This vantage communicated a choreographed order as the strike line was distinct from nearby pedestrians and other street activity, unifying picketers into a collective whole that worked toward one end.[71] In "Telling New York," the line of pickets, a "broad river flowing with hats," streamed from the photo's upper right-hand corner to the lower left (Fig. 6.3).[72] Strikers so crowded together that only the hats divulged their numbers. The word "Strike" could be read over and over as the picket signs reached toward the photographer and hence the viewers' eyes. If the marchers were "Telling New York," many listened. Bystanders interacted with strikers or turned to watch the spectacle.

New Voices' mass action shots also included many taken at street level, where the photographer faced the picket line. Viewers could see strikers' expressions and gestures, which individualized the activists.[73] In "Union-Wide Mobilization," one striker near the front gazed at the photographer, inviting the viewer into the struggle. While the majority focused on one another, their expressions and signs still beckoned to the viewer (Fig. 6.4). The strength of their action was signaled by their bodies, which filled the composition. Pickets in

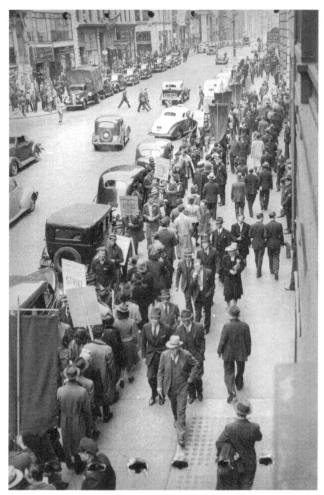

FIGURE 6.3 *"Telling New York," New Voices, April 15, 1940. Courtesy of the Tamiment Library, New York University.*

front filled the frame from top to bottom, and the line of strikers behind them receded to the photo's frame.

Editors Paley and Baldinger made mass action photographs even more dynamic through layouts and cropping. They often cut a series of steps into mass picket photos, placing the captions within the traditional photographic square. Indeed, the photo staff had to convince the novice editors to cut the prints, and not ruin photographers' negatives. In "We Will Make Sterling Sign," the picketers massed along the sidewalk, stretching from corner to corner. The cuts made by the editors touched a series of columns on the building where the picketers had pressed themselves. With each cut, this cropping measured picketers' augmenting numbers. This photo's peculiar cropping emphasized the point that the union sought to drive home: District 65 "Will Make Sterling Sign."[74]

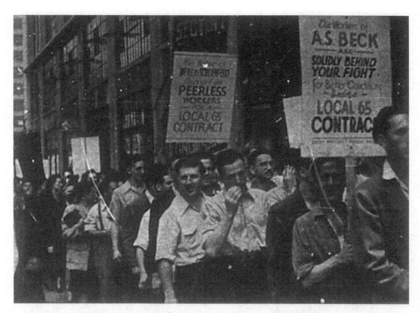

Union-Wide Mobilization As the Security Drive came tearing down the home-stretch, and was getting ready to pass the gauntlet to the new '7in 7' Defense Drive, the Peerless Sample Card workers were completing preparations for a Labor Board election. One thousand 65ers showed their solidarity in a noon-hour demonstration, Wednesday, May 28, at 200 Hudson St. The Peerless workers went to the polls, Tuesday, June 3, and declared 65's their Union by a 133-99 vote.

FIGURE 6.4 *"Union-Wide Mobilization,"* New Voices, *June 1, 1941. Courtesy of the Tamiment Library, New York University.*

In New York, as in other industrial centers, strike violence was not uncommon, and when corporate security physically attacked members, *New Voices* offered up the wounded as valiant heroes. Most compelling was the cover photo of thousands of Local 65 members marching "in solemn service" for Irving Pickover, a member killed by a Wiz Novelty Company scab. Pickover was memorialized in poetry and a quarter-page portrait a decade later. *New Voices* often printed closeups that showed unionists exposing their wounds or bandages. Typically shots were straight and "evidence-like." The victims gazed away from the viewer, presenting their injuries and bruises for readers' perusal. For example, in "Slugged," Sol Feder, who had been beaten by company-paid gangsters, exhibited his smashed, broken nose. The photo's caption challenged other members to sacrifice themselves by reminding them that "the picket line is maintained with increased vigor as members rally behind the Sterling strikers." In other shots, such as "Stabbed by Strikebreaker," wounded unionists stared directly at the camera. One worker with bared torso and compressed smile seemed oblivious to the violence visited upon his body; his photo was an invitation for others to join in.[75]

This message of necessary sacrifice compelled in "National Container Mass Demonstration." There was no crowd, as the description implied, but a lone

figure (Fig. 6.5).[76] A bandage round his head indicated the end result, a casualty. The subject's expression was enigmatic: intense, yet rueful or accepting of what had befallen him. Heightening the ambiguity were his misshapen lips, the lump that pulled the right side of his face downward, and his position facing the camera even as his gaze glanced away. He sat mildly hunched, his beautifully formed hands lying limp between his legs, fingers casually interlaced. His powerful legs, spread as if poised to stand, contradicted this passivity. Yet the kerchief tied around his head, and its sprightly bow, akin to what a Hollywood starlet might don, added another incongruous note. It wrapped his face, setting it off from the rest of his body, offering the poignancy of his expression as a gift. The striker's image indicted the company for the violence

FIGURE 6.5 *Photograph of striker who was wounded at a National Container mass demonstration, February 1941. United Automobile Workers of America, District 65 Photograph Collection, Tamiment Library, New York University.*

wreaked upon workers. But the subject was ennobled too. The photo evokes Paul Strand's street portraits of the 1920s. Strand humanized his subjects by allowing viewers to see the oppressed but not pity them. His subjects have a degree of self-possession, even dignity.[77] The injured National Container striker entreated the viewer to consider not only the injury and its perpetrators, but the choices that brought the striker to this place. Indeed, the photo on the wall, of a blur of children, was a reminder of the families that strikers fought for. The beaten worker symbolized Local 65's struggle.

New Voices photographers documented the violence that befell members and insisted on workers' self-conscious sacrifice for their future. They were careful to show the results of violence—but never to show any violence as it transpired—they feared it might be used to "lambaste the trade union movement."[78] *Steel Labor*, as we saw, printed few images of violence, and the same was true for the *CIO News*, the national CIO's monthly paper. Even in unions where rank-and-file activism built the union, like the United Auto Workers (UAW), the results of corporate or state violence upon labor were rarely represented as boldly as in *New Voices*. The *Packinghouse Worker* did document violence by showing off members' wounds. Because the subjects did not engage with the camera, however, it was more difficult to connect individual workers' sacrifice with their desire for a union. And, the communist-led United Electrical (UE) workers, as we saw, did recognize members' courage in facing off teargas and mounted police.[79] National press such as *LIFE* and the metropolitan dailies played up violence, often holding unionists responsible for it. Local 65's direct rejoinder confronted corporate and state violence, named the culprits, and asked members to consider a similar sacrifice. Local 65ers encountering police who administered "widespread terror" were advised to respond with "whirlwind organizing drives in the field," as one photo's caption, "Wielding Clubs," enjoined.[80]

With WWII and the union's no-strike pledge, *New Voices* stopped printing strike photos; mobilization became undesirable. Local 65 did strike against companies refusing to abide by National War Labor Board standards, but *New Voices'* photos of these strikes lacked their earlier vitality.[81] With the war's end, strikes returned as a tool for organizing and contractual pressure, and the paper reverted to its mobilizing formulas. Its coverage of strikes became more sophisticated, with multiple photos, often arranged in a photo-essay format, such as in "Coast to Coast and Cuba Too" or "65ers Unite, Fight for Justice—Reap the Fruits of Victory."[82]

Local 65's archived photos underscore *New Voices'* formula; the paper did not print photos detailing the everyday moments of strikes—such photos lacked punch. The 1945 "National Container Demonstration" documented a strike in all its lack of cohesion (Fig. 6.6).[83] Viewers could see the minutes wasted on a picket line, the stalling and bluffing required to force the boss to negotiate. Picketers walked the warehouse's length. Some marched, while others

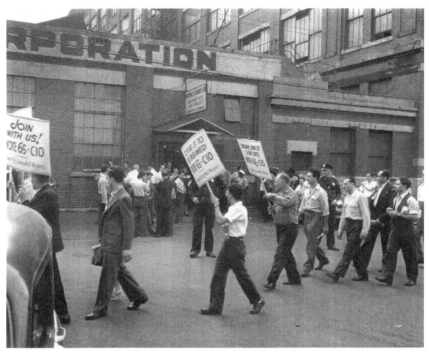

FIGURE 6.6 *Unpublished photograph, National Container Strike, 1945. United Automobile Workers of America, District 65 Photograph Collection, Tamiment Library, New York University.*

milled about, casually conversing. The line had many gaps, and signs were held at all angles. Some strikers carried papers and handbags; others lit cigarettes. Many appeared drawn to something outside the photo frame, though a few bystanders looked at the camera or the marchers. Viewers could apprehend the drama in the scowl of the policeman, the sharp march forward of some pick-eters, or some participants' intent gaze. But the photo also documented strikes' tedium. There was no center, no special narrative, no "decisive moment," and no vitality.

 New Voices' photos celebrated activism more than most union papers. In the *CIO News*, strikers almost always appeared in an ordered, even rigid fash-ion standing against a factory gate or company entrance. If carrying picket signs, they held them parallel to their bodies. *Steel Labor* offered even less ac-tivism. Certainly other papers emphasized rank-and-file mobilization. The *United Automobile Worker* of the UAW, *UE News*, and the ILGWU's *Justice* had powerful strike photographs. But these papers rarely printed as many photo-graphs, nor as prominently on the front page.

 Photographers also delineated the range of organizing activities needed to secure a union: leafleting work sites when inaugurating a drive, leafleting the general public for consumer boycotts, and feeding strikers at soup kitchens or through grocery distributions. These photographs modeled such activities

May 1, 1940. NEW VOICES

SOLIDARITY WITH SI-HE-GO STRIKERS

The spirit of solidarity behind the SI - HE - GO ers. David Livingston, chairman of the Organization
strikers was again illustrated last week when union Department is shown presenting these package to
food workers contributed food packages to the strik- the pickets.

FIGURE 6.7 *"Solidarity with Si-He-Go Strikers,"* New Voices, *May 1, 1940. Courtesy of the Tamiment Library, New York University.*

and, unlike strike photos, were often posed and static.[84] In "Solidarity with Si-He-Go Strikers," David Livingston, then organizing director, distributed food to a grateful woman as other members circled around them (Fig. 6.7).[85] Captions even self-consciously trumpeted the staging of these didactic shots. In "Uptown Minute Men," the caption informed readers that dues-paying members were "visiting members who are delinquent," and then noted that "these members . . . are also a bunch of fine actors as this impressive pose illustrates."[86] The contrast between the dynamic strike and mobilization photographs and the passive, staged shots of other organizing activities asserted a hierarchy of activism. Street mobilization photographs' aesthetic power contended that this was workers' most important duty.

Still, Local 65 photographers almost never lost an opportunity to make the union look more inviting. Like all union newspapers, *New Voices* photographed elections and contract ratifications, signs of organizing victory. Most papers offered the "deadly" and "hardly distinguishable" group photographs. *New Voices'* photographers enlivened such occasions. In "The Winner—Local 65!" a group of twenty new unionists ranged themselves together and mugged

THE WINNER—LOCAL 65!

Empire Corrugated Paper workers leaving their establishment after voting Local 65 as their col-
lective bargaining agent in a close Labor Board election last week. The results in this Brooklyn Ware-
house plant are another milestone of progress in the whirlwind campaign to bring the banner of union-
ism to the corrugated paper workers throughout the city.

FIGURE 6.8 *"The Winner—Local 65,"* New Voices, *July 1940. Courtesy of the Tamiment
Library, New York University.*

for the camera (Fig. 6.8).[87] Some leaned their heads back, with gleeful laughs.
Others smiled coquettishly. Still others stood, arms crossed, defiantly ac-
knowledging the camera, resembling Lewis Hine's famous studies of Pennsyl-
vanian steelworkers. Hine's photos, taken a generation earlier, invite viewers to
empathize and seek dialogue with the subjects (see page 29).[88] Similarly, these
unionists' expressiveness broke the typical group shot mold and established a
relationship between older and newer unionists.

The "Sea of Upraised Hands," a photo of workers who had just signed an
agreement with Lerner's clothing store, shows how the photo staff enlivened a
staple photo. The photographer's high vantage made hundreds of workers visible.
Their arms were held high; their hands waved at the camera (Fig. 6.9).[89] The
workers sat under a banner that spanned the photo's horizontal frame, emphasizing
its message, "Organize Your Next Door Neighbor." The photo's passive framing cut
right into the workers, suggesting that their numbers extended past the frame. The
faces of some workers packed the foreground, while the arms of the workers behind
them filled much of the remainder. The repetitive arms, hands, and faces created
irregular patterns that led one's eye through the photo. Here photographers trans-
formed an everyday meeting into a portrayal of vivid member commitment.[90]

When workers at Eckstein's began organizing in 1933, they fantasized about
a union big enough to fill Madison Square Garden. In December 1941, with
their security and "7 in 7" drives completed, and 16,000 members strong, Local

FIGURE 6.9 *"Sea of Upraised Hands" is the caption to a photograph of new members sitting under the banner "Organize Your Next Door Neighbor," New Voices, February 15, 1941. United Automobile Workers of America, District 65 Photograph Collection, Tamiment Library, New York University.*

65 could do just that. Putting on such an extravagant investiture was no easy task. Months before, the CIO failed to attract even 5,000 unionists to the Garden. Local 65 leaders "shudder[ed]" at the CIO's "catastrophe." The Victory Festival would celebrate 65's organizing prowess; they believed it the "biggest challenge we have ever taken."[91]

Despite leaders' fretting, over 20,000 "jammed" the January 1942 rally. An aerial photo of the festival on *New Voices'* cover stressed the power of united numbers. Taken from the back of the hall, the photo showed four crowded sections of unionists on the Garden's floor, the packed bleachers, and the filled balcony rows rising up on either side of the hall. The vantage conveyed the sheer numbers amassed and unified the multitude into a single force, "the fighting army of Local 65," as their accompanying flags proclaimed. Months later, a British magazine reprinted one of the rally photos. Member Emanuel Cohen, an army private stationed in England, saw it, and he told *New Voices'* readers that the reprint was "proof that Local 65 and its policies are not only watched by American labor, but by labor throughout the world. . . . Keep the Green Banner flying."[92]

"65 Unites Us—Americans All"

Local 65 photographers' "fighting army" was united, but it comprised a diverse lot: men and women, black and white, and a host of ethnicities.[93] Success demanded a wide-armed embrace of all. Leaders and members' sensitivity to anti-Semitism and xenophobia, and their communist ties strengthened their resolve to be an agent of change in racial and gender relations.[94] Local 65 cameramen helped. They resisted mass culture's highly charged and stereotypic visual strategies for representing gender and race. Unlike mass-cultural venues that often erased women and African Americans, their photographs visually integrated both into the union's "full and rich" life. Photographers presented women and African Americans as cocreators and corecipients of union life.[95]

Women weren't brought into the union until a 1935 strike at the union's original shop, Eckstein's. And Local 65's first non-Jewish member, an African-American porter, was hired in 1937. Some members had to be convinced to extend the union past New York's Lower East Side, but others were proud to leave Orchard Street's confines to serve all marginalized workers in the distributive trades. Over time, leaders cautioned members that they needed more gentiles, more women, and more African Americans to represent their workforce. Early photos in *New Voices* trumpeted the union's diversity (Fig. 6.10).[96] The caption for a photo of the Empire State Glass Decorating, Section D-2, "United Nations in a Local 65 Shop!" greeted members from Puerto Rico, Italy, Russia, China, Britain, Germany, and Poland.

Local 65 emerged as an early union leader for racial equality. At the 1936 AFL convention, Osman pushed the foot-dragging craft unions to desegregate. Leaders and members rallied for antilynching legislation, and fought discriminatory hiring practices at the 1939 World's Fair. Seven years before Jackie Robinson integrated baseball in 1947, unionists marched in May Day parades holding picket signs denouncing baseball's segregation. They protested the racism at the heart of the riot that rocked Detroit in 1943, and showed support for the integration of Cicero, Illinois, in 1951. In the early 1950s they mobilized 3,500 members against segregation at Metropolitan Life's "model" apartment community, Stuyvesant Town, and in 1954 they feted the NAACP with "Mr. Civil Rights," Thurgood Marshall, as the main speaker.[97]

Local 65's demands for gender equality were not as thoroughgoing. It pushed for comparable worth, an unusual position in this era. And it made familial and domestic concerns, such as rent and food prices, central to the union's agenda. Local 65's sensitivity to these gendered, or "community," concerns, as historians call them, was unusual, though not unique as we saw with the USWA.[98] However, the union rarely questioned women's subsidiary role in society or in the home. Some members blamed women for the constraints they faced, believing that women didn't try hard enough or should stop knitting in meetings.[99] It was only with World War II that the union promoted women's

United Nations in a Local 65 Shop! While the recent Cairo and Teheran conferences showed the United Nations know how to fight together, these 65ers employed at Empire State Glass Decorating, Section D-2, give a demonstration of how united people can work together for the same purpose—Victory over the Axis. Shaking hands, front row, are 4 members representing the 4 leading United Nations: left to right, Berta Tates (American), Gerald Cantor (Russian), Margaret Conklin (British) and Lee Chee (Chinese). Remaining members of shop, behind them, raise their hands in the "V" sign, showing how they greet the Cairo and Teheran decisions. Among them are members of Porto Rican, Italian, Polish, and German descent.
(New Voices Staff Photos)

FIGURE 6.10 *"United Nations in a Local 65 Shop!"* New Voices, *December 9, 1943.*
Courtesy of the Tamiment Library, New York University.

activism—to make up for decimated male leadership. The photo staff was less egalitarian, and only with the war did significant numbers of women get involved. After the war their numbers dwindled again.[100]

Locals 65 pushed racial and gender equity at the work site and within the union. After establishing a Harlem satellite headquarters in the late 1930s, the union invited Harlem members downtown to join the hiring hall. The hall insisted that employers hire African Americans and women. Members applauded. Ernest Bradley, an African-American employee of Zadek Feldstein, thought 65 "one of the best organizations a Negro could join." For the first time, he could leave his permanent position as delivery man, and work "inside the house." Resisting employers, such as Lane Bryant or Arthur Beir, were sent only black or female prospects, or were threatened with strikes. Women wrote to *New Voices* in gratitude for policies addressing gender discrimination, and one Catholic claimed that the union got her job back from an employer that feared her pregnancy would leave them in the lurch. *New Voices* also encouraged members to challenge prejudice and take matters into their own hands. One article, "How Gimbels Waitresses Won," explained how white

waitresses insisted that African Americans be permitted to work with them—confronting an institutional racism that kept black women in the kitchen and white women in the front of the house.[101]

Local 65 diversified its staff and leadership along racial, gender, and ethnic lines. Cleve Robinson, an African-American man, served for decades as the union vice president.[102] He was working in Dadourian Export Company's used clothing warehouse in 1946 when he met a 65 organizer "roaming the streets." Robinson organized his shop. His coworkers then elected him shop steward. He became a staff organizer before being elected vice president. *New Voices*' columnist Lillian White Upshur educated unionists about black workers' concerns, but Upshaw was never "ghettoized" into addressing only their needs. She may have come to leaders' attention after writing the paper a letter commending the union: "Local 65 was really a Melting Pot with all races, creeds, and colors fighting for happiness." Mollie Genser was an executive board member for the organizing department, "number one, in importance" in union hierarchy.[103] The proportion of women and African Americans in leadership positions never equaled its proportion of membership, but the union treated this as a problem to tackle. Local 65 might have done more in the fight for racial and gender equality; most unions did far less.

Cultural pluralism united members and was crucial in fighting social inequalities. "National affairs" groups affirmed ethnic cultures and built interethnic solidarity. At suppers and socials, such as the "Irish Easter Celebration" commemorating Dublin's Easter Uprising, the "Italian Fiesta," or the "Negro, Spanish and Jewish Affairs Dance," members danced under banners proclaiming "NO Discrimination." By the late 1940s, *New Voices* announced its diversity in the bilingual *La Voz Hispana*. Newspaper articles extolled the "first great organizer in Irish history," Saint Patrick. Local 65 celebrated the nation's first "Negro Week," and held classes on "the Negro in American Life" or "Women in America: Past and Present."[104] Other unions pandered to their members' racism, limiting solidarity. One leader of a steelworker's local claimed, "Race feeling is bad enough so that we can't have a women's auxiliary here, because although the men mix all right in the mill, they wouldn't mix on the dance floor."[105]

Local 65 was different. Morris Doswell, an early African-American member, recalled with pride his union "that did everything in [its] power to break down discrimination" in and outside the organization.[106] A white warehouse steward, Bob Ackerman, echoed Doswell by crediting Local 65 with reversing the racism he learned as a child:

> When I joined Local 65, the only good Jew, I felt, was a dead one. . . . Once I went to a dance where there were Negroes and whites and I couldn't take it, I ran out of the place . . . Today I know twenty Negroes out here who would give their arms to save my rights. And the same with the Jews. I learned to hate when I was a kid . . . But I've learned different in Local 65.[107]

Women members thought Local 65 challenged "subtle forms of discrimination" that held them back such as age or looks.[108]

New Voices promoted the union's egalitarianism in its depiction of members, men and women, black and white. In *New Voices*, the color of one's skin made little difference to one's representation. Photos vaunted the union's diversity—integrating black and white members in pictures of crew meetings and picket lines. Photos emphasized black leadership, such as the photo of Thelma Dailey teaching white and black members how to type. At a time when *de facto* Jim Crow kept most Northern whites and blacks from socializing, both groups mingled in photos, for example, in pictures of band practice or dances (Fig. 6.11).[109] Photographs of dances in the union hall or dinners at its supper club showed African-American and white couples joined in the fun together. And years before the Southern lunch counter sit-ins, 65's photos showed white waitresses bringing food to tables of African Americans and whites. *New Voices* also printed photos of the Negro History Exhibition, where mixed crowds examined African-American contributions to the nation's past.[110]

Other unions' photos of job actions or social events were often monochromatic, with few pictures of blacks and whites working, picketing, or playing

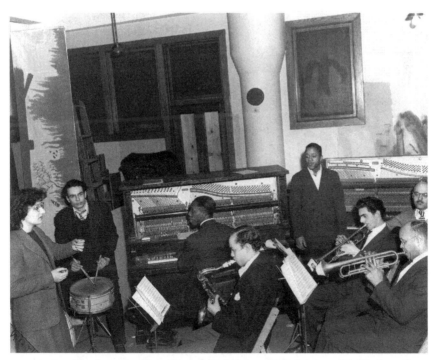

FIGURE 6.11 *Band practice, New Voices, March 1, 1944. United Automobile Workers of America, District 65 Photograph Collection, Tamiment Library, New York University.*

together. And in other union papers, photos of women or African Americans frequently joined articles aimed at proving union diversity. For example, SWOC sought to eliminate racial and ethnic divisions that hindered earlier organizing drives. Its photos of black members—black membership equaled about 15 percent of total membership—signaled their union's new inclusiveness. Similarly, the ILGWU with a growing black membership by the 1940s printed photos of African-American workers to promote their heterogeneity. But the ILGWU restricted black and Puerto Rican leadership, and SWOC also limited blacks' roles in their union. In these union papers, photos projected an ideal that leaders did not fulfill.[111]

Of course, labor media's limited representation of African Americans was benign in light of a mass visual culture that erased, or worse, denigrated them. Photo historian James Guimond claims that mid-century photo journals presented a homogeneous, "lily-white vision of America." Minority groups were rarely represented, or "were . . . segregated in photoessays devoted to 'America's Problems.'"[112] This was the era of Step'nfetchit, of the Hollywood mammy, stock characters that "invited ridicule" or nurtured racism.[113] Major photo publications such as *LIFE* magazine employed visual stereotypes such as a photograph of an African-American man whose mouth was spread wide with golf balls for readers' chuckles, or a story on watermelon farming that showed the back of a shirtless African American, taking produce to market in his buggy, with an inside shot of a "pickaninny" eating the melon.[114] Hearst's photo syndicate fired one photographer, Arthur Leipzig, for filing pictures of racial intermixing in a Harlem neighborhood. They wanted white youth only. In 1950, at *LIFE*, editors debated the propriety of printing a photo of white teenage girls embracing the black pop singer Billy Eckstine. Local 65's antiracism is best gauged in its photograph of a union WWII blood drive. Blood purity remained a social obsession: Local 65 even organized a protest against the Red Cross, which segregated the blood of black citizens from that of white citizens. And *New Voices* printed a picture of members Benno Nordheimer, a white man, and Eunice Tucker, a black woman, donating blood.[115] In "Union Solidarity Spelled Out in Blood," the two lie side by side. Nordheimer's arm cradled Tucker's, their "fraternal ties" unequivocal.

New Voices photographers made black workers "ordinary." In affirming their normalcy, union photographers humanized African Americans. These photos envisioned a world where black and white Americans worked and played together. Integrating African Americans into the everyday life of the union was a radical act.

New Voices wove women workers into union life as well, though their visual message matched the union's more limited stance on gender equality. *New Voices'* photos of women as crew members, picketers, workers laboring in their shops, or students in union classes rarely marked women's gender—with one exception: occasionally the paper printed "pinup" or cheesecake photos of

women, paralleling women's sexual objectification in the larger culture.[116] The union held "beauty contests" at its annual picnics, and during the war *New Voices* asked women to compete as "65 girls" for soldiers overseas. Women didn't rally to becoming 65's Betty Grable; editors repeatedly urged women to supply their photos to the foundering "beauty hunt." *New Voices* asked readers, "Where are the girls?" While the paper extolled its "bevy of eye fillers," it never limited its representation of women to this narrow form of "exaltation."[117]

"Girls" predominated in mass-market magazines and even the labor media.[118] *LIFE*'s coverage of the rise of the CIO presented women strikers as cute starlets in a labor drama that had less consequence for women workers than keeping up appearances. And *LIFE*'s editors seemed more interested in exposing strikers' "undies" as police carted them off to jail than in exposing the labor conditions they worked under. *Steel Labor*'s pictures of "girl" members animated an otherwise staid paper. Women's bodies appeared as prizes, or at a minimum decorative entertainment to an assumed membership of male readers.[119] Local 65 believed organizing women was its mission; union stability depended on it, and *New Voices* traded on women's sexuality far less.

Nor did the paper react to women doing "men's work" by masculinizing them. *New Voices* could represent female laborers as "one of the boys." Some wartime photos present women as the now familiar "Rosie," such as Helen Sosdian "strid[ing] through the textile market, a bolt of goods slung over her shoulders."[120] But Local 65 used this visual trope sparingly, indicating more comfort with women doing "men's work." *Steel Labor* feminized women with "bright" captioning; *New Voices* tended to address men and women similarly.

Photographers also dispensed with this era's gendered maternal trope. Dorothea Lange's "Migrant Mother" offers the exemplary image of a woman who, despite obstacles, tended her brood. *Steel Labor* used such imagery during the postwar reconversion. Feminist scholars argue that the maternal trope buttressed a populace challenged by deep economic and social insecurity. Despite apparent approbation, such imagery burdened. Limiting women to the maternal role celebrated women within a hierarchy in which "male" labor and shop floor actions were paramount. Women were trapped in essential roles as mothers, obscuring their needs as workers. Local 65 focused on women's maternal concerns for low food and rent costs, but photographers envisioned women as unionists with these concerns, not as mothers alone.[121]

Local 65 photographers did not employ the other gendered icon of the 1930s: the burly male worker. Socialist-realist canvases, statuary, and murals idealized growing union power with this icon. Mass media and labor media also employed this visual trope. Even unions with a predominantly female membership, like the ILGWU, embodied successes with such imagery. Equating union strength with this male figure excluded women and, as Elizabeth Faue argues, "shape[d] the subsequent relationship of women to labor unions . . . undermining the basis of inclusive working-class solidarity."[122]

Local 65 proclaimed its radicalism in its militant numbers and its diverse union community, not an idealized, heroic labor.

Local 65 didn't ignore gender. Women might be seen at a packing line in a crisp white uniform and cap; proudly seated behind a hand operated machine with protective gear and jewelry and feminine coiffure; working the "addressograph machine" in the *New Voices* office; or conducting a swing band. Photographers documented the era's gender trappings, but their cameras did not construct gender as actively as mass media representations. Photos of women unionists never struck at sexism in the ways that images of black workers struck at racism, but union photographers imagined women as full participants in the quest for union might and community.

Union photographers' "organizing eye" valorized all members, facilitating the continued identification and involvement of Local 65's diverse membership. Ironically, its bold vision consisted of nothing more than eschewing this era's typical visual strategies and treating each member, regardless of race or gender, with respect.

"Study and Play in the Organized Way"

Making 65ers "feel as if . . . a 65er in 65s own home" lie at the heart of union organizing strategies.[123] The union's renovated penthouse restaurant and night-club epitomized this ideal. Announcing its April 1953 grand opening was a front-page photomontage of Club 65's entrance, doors flung open to greet readers (Fig. 6.12). Four photos of the restaurant's shining tables and "spotless array of coffee urns, steam tables, dishes and trays" led through these doors: a photographic "welcome mat."[124] Strong diagonal lines created by aisles, lighting, counters, and tables pulled the readers' gaze into the serving line, kitchen, bar, and hence into the supper club. Having figuratively entered Club 65, readers then encountered two pages of photos of members dining, dancing, drinking, and imbibing the club atmosphere (Fig. 6.13).[125] The article complimented the "finest bar in town," adorned with a mural painted by *New Voices'* art editor; the "handsome fixtures and lighting"; and the "crisp cleanliness" and "good taste throughout." It claimed that "it was the little copper table lamps that added 'just the right' touch," and informed members of the restaurant's quality food for which "prices were within reach," and of the supper club's affordably priced shows produced by Local 65ers. *New Voices* stated that according to one veteran reporter, "in all his years covering labor news he had never seen the like—a Union Headquarters designed from top to bottom to cater to the needs of the membership."[126]

Club 65 typified Local 65's social and cultural activism. Murals, modern fixtures, and elegant table lamps pointed to the union's belief that workers had a right to the best, most contemporary things that money could buy. But in

FIGURE 6.12 *"Club 65 Now Open,"* New Voices, 1953. *Courtesy of the Tamiment Library, New York University.*

REPRESENTATIVES of the major New York newspapers and wire services were present for the great occasion, as were hundreds of District 65 members and friends.

This was the event long-awaited—the opening last Tuesday of the fabulous new Club 65 at 13 Astor Place—with a sparkling self-service Restaurant and luxurious Bar on the 10th Floor, and the glittering Penthouse Supper Club on the 11th Floor.

Members, friends and the press marveled at the handsome fixtures and lighting, the air of crisp cleanliness throughout, the spaciousness and overall beauty.

A veteran reporter said that in all his years covering labor news he had never seen the like—a Union Headquarters designed from top to bottom to cater to the needs of the membership.

Everyone noted the extensive, varied menus—and the prices, designed for the pocketbooks of working men and women.

And District 65ers from all parts of the Union glowed with pride at this latest, dramatic addition to their 11-story Headquarters, by far the finest in the labor movement.

Impromptu "tours" took place all week as members and friends went through the 10th floor kitchen, with its ultra modern central refrigeration system; completely automatic dish washing equipment; huge pressure cookers and ovens.

Men who had served K.P. in the army were pleased to note the automatic floor washing set-up.

Union Voice Photo by Bob Dobbs

THE FIRST CUPS OF COFFEE in Club 65's new self-service Restaurant are sampled by four attractive clerical staff members (left to right) Harriet Wurf, Mildred Cornacchia, Mary Oliva and Irene Mamousos. They found the coffee delicious, the Restaurant appearance inviting, and the food tasty and inexpensive. A wide and varied menu each day offers a choice of served hot dishes, carved-to-order hot sandwiches, pastries, salads, and all other features of a smart, wholesome Restaurant.

Union Voice Photo by Frank Kiernan

IN GOOD TASTE THROUGHOUT is the handsome new self-service Restaurant of Club 65, occupying the 10th Floor at 13 Astor Place. Experts in the field of restaurant design regard the new Club 65 as an outstanding achievement. Al Bernknopf, Club 65 Director, and Sol Molofsky, Recreation Director, "nursed" the entire project along, working closely with officers of District 65 and DPO Pres. Arthur Osman.

RESTAURANT, BAR

A GIMBEL Dept. Store 65er said, "It's so comfortable, I could spend the rest of the day here!" Her's was typical of the reaction of members to the new self-service Restaurant and Bar on the 19th Floor at 13 Astor Place.

From the moment you step off the elevator and through the huge, stainless steel doorway, an atmosphere of relaxation and cleanliness greets you at Club 65.

A Corrugated member said, "This is the place to bring unorganized workers. It shows what 65ers can build for themselves; it shows our strength; it shows that no one can break us."

Union Voice Photos by Kerbess and Tellix

ONE OF SEVERAL refrigerators which hold meats and other foods is shown by Leon Hirshman, assistant general manager of Restaurant.

VIEW OF SERVING AREA shows spotless array of coffee urns, steam table, dishes and trays. Restaurant is geared to serve approximately 1200 members a day, including those eating supper before a meeting, and others who will stop for a snack after a meeting. Quality of food and inexpensive prices are expected also to attract many members who do not have meetings on a given evening. It will be fun to eat at the Union!

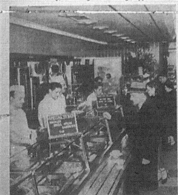

PRICES WITHIN REACH are an important feature of Club 65, as the many members who sampled the Restaurant's offerings the first few days can testify.

'FINEST BAR IN TOWN' is consensus of opening day visitors, who admired mahogany wood and formica top, and beautiful mural on back wall painted by Union Voice Art Editor Stanley Glaubach. And at the bar, too, the prices are "right," the service friendly, and the customer made to feel he's a 65er in 65's own home.

M 4

Union Voice

FIGURE 6.13 "Club 65 Now Open," New Voices, 1953. Courtesy of the Tamiment Library, New York University.

THE SUPPER CLUB

SOME said it was the beautiful little copper table lamps that added the "just-right" touch, other 65ers felt it was the smooth music and lively show that put it over. Add them up and the consensus of opinion is that the beautiful new Penthouse Supper Club, opened Saturday night, March 28, was a WOW.

If opening night was any sign, the Supper Club will be thoroughly appreciated by 65ers who have been looking for a place where they can spend an enjoyable evening in a relaxed, yet smart atmosphere. More and more, members will latch on to this opportunity to get a good meal, dance and see a show at a price they can afford.

SERVICE WITH A SMILE is the way it's done at the Supper Club. The UV cameraman might have had something to do with these smiles, though.

DANCING ON HIGH on the new, extended stage went over big, as nimble couples shown enjoying Sam Faso's music-making will testify. Unlike the two-by-four dance floors in most night spots, on this one you can even waltz.

COMIC Billy Sands emceed show on opening night, got lots of laughs.

OFFICERS AND WIVES, including DPO Pres. Arthur Osman, at head of table in rear, joined birthday celebration for Sue Robinson, wife of '65' Sec'y-Treas. Cleveland Robinson (both in foreground).

ANNIVERSARY PARTY was among several occasions celebrated that night. Above, Mr. and Mrs. B. Schneider observe 25 years of married life. Mrs. Schneider is a 65er, as is her son Larry of Winston TV.

reminding members of the value they'd receive, the article rejected the notion that a mass consumer economy erased class differences. Workers achieved the good life through unionism. The union provided culture to membership and unionists' own collective labor produced this culture. The photo story's message paralleled a description of union culture made a decade earlier. "It was Union community in the full sense of the word. Not only did the members work together, and organize together—they played together, danced and studied and planned together—making the Union the gateway to the Pursuit of Happiness."[127] Invoking this mantra of American independence revealed Local 65's serious aims: workers had a right to culture, and the union would strive to attain this for them.

Local 65 leaders had instrumental reasons for their interest in culture, but they also believed that policy makers had to consider the "problem" of filling workers' new leisure time. *New Voices'* articles and committees debated workers' lack of culture.[128] One recreational leader wrote that the local should fill in the breach:

> It is only natural that workers should look to their trade unions for advancing their interests. . . . There is no public agency or free private enterprise to which a member can turn in his neighborhood for satisfaction of his recreational needs. Is there a community where a worker can join a band to develop his saxophone playing? . . . The same situation holds true for chorus, dramatics, sports, film and other activities.[129]

Local 65 wanted to "lay the groundwork for a real people's cultural movement in New York City." Osman claimed it a "recognized . . . leader in such work," and later observers concur.[130]

The union even promised active members a bonus—"romance the union way." Mass cultural texts like *LIFE* used the narrative of heterosexual romance to frame and resolve many social and political dilemmas. In *New Voices*, romance was activism's reward. The paper's "Meet the Members" page offered tips on members' relationship status, notifying readers when someone was "available." Many members found their mates through the union, including David Livingston, the photo staff chair Ed Roth, and organizing leader Molly Genser, who married Sol Molofsky, the head of the recreation program. Photos of weddings and newborn children offered constant reminders of successes in the "heartthrob department." The 1939 cartoon "In Union There Is Strength and Life" represented the enticement of union life in almost the same terms as *LIFE*'s ILGWU Unity House story—two members met at camp, romanced one another in a boat on a lonely lake, and married.[131] In *LIFE*, romance erased the class dimensions of workers' lives. Instead, *New Voices* linked members' intimate lives with their political and economic lives. Romance was also represented as an equal partnership, with men and women finding camaraderie in love, and in union.

Local 65 culture grew organically from earlier working-class practices, members' ethnic backgrounds, and commercialized culture. When members nursed a beer in the union hall, they participated in working-class rituals nearly a century old. Those who acted in a drama group pageant, joined a sing-along, or formed a musical band participated in popular cultural pursuits leading back to socialist, Yiddish, and other ethnic group activities. Some of this working-class culture was commercialized by the nineteenth century's end. Members who danced at their own nightclub participated in just such an amusement.[132] Other Local 65 activities were pursued by millions of working and middle-class Americans by mid-century. Members who hiked along the Hudson partook of the "naturalism" that Bernarr Macfadden popularized in his mass circulation *Physical Culture* in the 1920s. And Local 65's theatrical productions were presented to over 150,000 New York unionists, and to cross-class audiences at the 1939 World's Fair.[133]

Local 65's vibrant culture was also created from newer mass cultural forms dependent on industrial production and mass audiences. Some of the music industry's finest entertainers—jazz pianist Earl Hines, singer Sarah Vaughan, and blues guitarist Leadbelly—brought their rhythms to the union's Saturday night socials. Members joined other leftists to produce Frontier Films's *Native Land*, a Popular Front exposé of the labor spy racket; some scenes were even filmed in their headquarters. And 65ers' movie critics circle rated movies for ideological correctness and entertainment value.[134] Even the tunes for organizing sing-alongs drew from the accents of mass culture as one stanza to their security drive song "10,000 Members by 1941," shows: "Now all get in step, and let's get hep/Like the gators do in jive/No jitterbug can cut his rug/Til his quota is filled for 65."[135] The paper *New Voices* similarly evidenced a sophisticated grasp of mass culture.

New Voices' photographers posed a question to readers: What couldn't they do under their union's aegis? Photographs illustrated union life: workers attending lectures in American labor history or learning practical skills such as first aid, borrowing books from the union's lending library, or viewing an art exhibition (Fig. 6.14).[136] Editors joined such edifying images with photos of members regaling audiences as comedians, strumming guitars and tooting horns, and dancing in their boat trips up the Hudson. Members bounced balls, swung bats, and swam. They trouped across the stage in intimate sketches, and across Madison Square Garden's floor in grand pageants. Members imbibed cocktails at union functions. They lindy-hopped, mamboed, sambaed, and waltzed across the pages (Fig. 6.15).[137]

Photographs of social and cultural activism appeared neutral: slice-of-life documents of a robust, vivacious union. The viewer saw the action as it happened. This transparency deceives, as the gay exuberance of Local 65ers matched the hyperreality of photos in *LIFE Magazine*, where life was always bountiful and optimistic.[138] The attributes of the good life as represented in

FIGURE 6.14 "New Union Book Shop," New Voices, June 29, 1944. Courtesy of the Tamiment Library, New York University.

LIFE—heterosexual romance, communal interaction, and high-stepping fun—matched New Voices' photographs. Photographers didn't so much create an alternate vision of leisure, education, or the good life—they employed mass culture's visual rhetoric to tell members that they could find its utopian promise within their union home.

New Voices' editors sequenced and captioned the photos in a formula suggesting that member involvement was a prerequisite to achieving this ideal. Grouped together on the back page or in the centerfold, the juxtaposed photos articulated a distinctive workers' culture that unionists themselves produced and consumed. A 1939 photo spread of a Hudson boat trip exhibited this pattern, which persisted into the 1950s (Fig. 6.16). An "iris view" in the center of the page showed a crowd of members pressed against the two levels of the boat's rails.[139] Members seemed gleeful, but their strict division as a result of the boats' railings and levels held them within the figurative order of the union. A large banner identified the union. Its central position and bold text drew the eye, anchoring the entire photo spread. Photos from the day's activities, of "militancy at the plate" (baseball batters), couples dancing, groups performing before microphones, and two large photos of members enjoying the high jinks of their compatriots, radiated from the central pivot of unionists standing behind their banner. New Voices' readers faced the "fun for all" that Local 65

FIGURE 6.15 *Dances at Local 65, in 1939, 1940, and 1949. United Automobile Workers of America, District 65 Photograph Collection, Tamiment Library, New York University.*

FIGURE 6.16 *Hudson River boat trip,* New Voices, *1939. Courtesy of the Tamiment Library, New York University.*

brought them. Like audience members, they could enjoy the union's "Wholesale Talent." But readers could also envision themselves as cultural producers or subjects: a "song bird," the "militant" batter, or the beauty queen, "Miss United Wholesale."

Editors laid out photos in dialogue with one another, driving home the point that workers enjoyed unique access to culture because of their union. *New Voices* idealized a collective political and cultural life. The 1940 article "Members

FIGURE 6.17 *"To a Community Party on Long Island,"* New Voices, 1953. *Courtesy of the Tamiment Library, New York University.*

Demand More Union Socials" was topped by two photos of a St. Patrick's Day dance. The caption celebrated "the wearing of the green" with two men, Larry Shapiro, playing the guitar, and Max Bagel, "rhumbaizing" a union ditty. A second photo showed dancers encircling another whose "boogie-woogin" drew their attention. The union's "community of interests" linked performers and audiences—their St. Patrick's celebration a fusion of mass and ethnic cultures. A decade later, in "To a Community Party on Long Island," editors printed photos of 65ers and their children singing and dancing to the tunes of an accordionist and horn blowers (Fig. 6.17).[140] At the page's bottom, a picture spanned the bottom and it showed members grouped around a picnic table, with drinks and hot dogs, cheering their successful party. Consciously or not, the editor's layout suggested that the base of union celebration was member participation.

In *New Voices*, members' skills, talents, and labors built a lively culture that outshone anything outside the union. In "A Tale of Two Night Clubs," member Bob Dobbs described the indignities of taking his wife to a Broadway night-club. Eveningwear-clad guests swept past, a regimented flurry of activities parted money from their wallets, leaving them little chance for dancing on the stamp-sized dance floor. Dobbs concluded, "They say it's a lot more fun because you really can't afford it. They don't know what they're talking about." The story's photos and captions showed Club 65's prices "at rates to fit workers' purses," a dance floor where they could "rub elbows and bump into friends," rank-and-file entertainment, and "shows that always feature audience." The couple laughed over drinks, danced, and conversed with the union vice president. Unlike *Steel Labor*, which presented suburban ranch homes as if they were within workers' reach, "A Tale of Two Night Clubs" reminded members that the nation's abundance was not necessarily theirs. And it suggested that union camaraderie was better than "rubbing elbows with Park Avenue or Times Square," a common theme in the paper.[141] The "tale" hinted at the fun, intimacy, and personal development they'd achieve by participating in their activist union.

Lacking Local 65's wide-ranging social and cultural activities, most union newspapers couldn't possibly attain *New Voices'* visual interest. Their photographs of holiday parties, dinners, and sports teams failed to enliven. As with *Steel Labor*, many labor papers' conventional group photographs had unionists in straight lines in ascending rows, looking at the camera eye, often without a smile. Members at a party could be unionists arriving from the negotiating table. Such standardized photographs appeared in school yearbooks and corporate publications, and they conveyed little about union contributions to a richer cultural life for U.S. workers.[142]

Even a pioneer of union culture and education, the ILGWU, did not coax members into activism or expressiveness with their paper's pictures. *Justice's* photographs showed off the union's cultural jewels and aimed the spotlight on individual artist-members.[143] For the ILGWU's nationally known drama *Pins and Needles*, editors used full-body shots of cast members; for its choir, the paper printed head shots of singers. Also printed were frequent shots of union president David Dubinsky with celebrity attendees to *Pins and Needles* performances. *Justice* offered the staple group shots that made no connection between cultural activities and the union. Unlike *New Voices*, editors did not group photos together to suggest that the union was a collaborative site of cultural production and consumption.[144] *New Voices'* photographs showed a rambunctious "second home" where members worked and played together, but *Justice* invited member-readers home as guests sat back to watch the children perform.

From its first days, Local 65 took its members' needs—for edification, for expression, for association—seriously. By making their "Union the gateway

to the Pursuit of Happiness," union leaders involved thousands of working-
class New Yorkers in a union where they could sing, knit, paint, dance, learn
history, or just enjoy a beer with other members. Photographers docu-
mented these activities. But just as Osman understood that cultural pursuits
bound workers in tight solidarity, photographs in *New Voices* proposed that
each member could, through the union, pursue individual and collective
happiness.

"The Photo Union"

In 1953 the *Nation* rated the *New Voices* "outstanding in the labor press" with
the well-financed national papers of the AFL, the CIO, and *Steel Labor*.[145] *New
Voices* continued to innovate in its strike coverage and cultural emphasis. In
the union's 1953 strike against Hearn's Department Store, the paper printed
trademark mass action shots, but developed sophisticated photo stories dra-
matizing union struggle with a new visual rhetoric. In "A Hearn Striker Talks
to New York," Helen Cooney stood tall beside a flagpole (Fig. 6.18).[146] The
American flag flew beside her, as Cooney reached out her lanky arms to steady
herself on the microphone. Wife of a WWI veteran and mother to WWII and
Korean War veterans, Cooney insisted on workers' need for seniority rights,
severance pay, and economic security. She asserted member patriotism as the
union was being red-baited. Cooney spoke to supporters from a sound truck.
New Voices' editors cut her figure from this context, placing her photo so that
her body spanned the page from top to bottom. They monumentalized Cooney,
giving the prim, erect woman authority, much as *LIFE* insisted on the power
of Detroit's auto barons. *New Voices* universalized Cooney's struggle as all
workers.[147]

The paper also offered in-depth photo stories of striking workers. "Why
We're on Strike at Hearns" had two domestic portraits: one of the seven-
member Walter Ferrara family crowded around their sofa, and of Katherine
Flynn, a fifty-year employee. Flynn explained that she was the "sole means of
support" for her sister and that she struck for job security, which Ferrara, a
twenty-year employee, also wanted. Another story, "American Labor's Newest
Heroines" compared the elderly women strikers at Hearn's, many of them
grandmothers, with Mother Jones and the nineteenth-century Lowell mill
girls. These heroines, with "bad feet, varicose veins, and high blood pressure,"
stood "on the line, rain or shine." Unlike the imposing Mother Jones, these
women's smiles were bashful, though their direct gaze suggested their will to
achieve security. Strike photographs still showed members on the lines, but
also speaking, petitioning, crowning the Queen of the Strike, and massaging
their aching feet. One cover featured four photographs of the Hearn's strikers
as they appeared on the new medium of television, on the network WABC, in

FIGURE 6.18 *"A Hearn Striker Talks to New York," New Voices, June 28, 1953. Courtesy of the Tamiment Library, New York University.*

May 1953. Another *New Voices* photo featured a group of Industrial Container strikers "grab[bing] a quick snack" while on the picket line. The men, elderly and young, stared at the camera with a mix of expressions—woeful, antagonistic, seemingly embarrassed, under a sign that linked low wages with life's possibilities: "Of course we're bachelors. How can we marry on $34.00 a Week?" In one iris-view cover photograph, matronly women marched, parasols and strike placards poised against the sun. *New Voices* extolled these strikers' commitment, but it gave them personality, piquing readers' interest and empathy. Significantly as well, the paper's photographs represented women in the growing service industries of the twentieth century's second half. Many other unions ignored women's quest for equality on the job and gave short shrift to them as potential members or as unionists who might broaden labor's agenda past the work site.[148]

The *New Voices* coverage of the Hearn's strike, much like "Club 65 Now Open," promised a labor journalism and photography in stride with an ever more sophisticated mass media.[149] This promise was not fulfilled. District 65, as it was renamed after reaffiliating with the CIO in 1953, remained a progressive union that organized marginalized workers, but it never enjoyed the propulsive force of its first decades. The union was twice investigated for communism by the U.S. House of Representatives, first in 1948 and again in 1952. The second time, U.S. assistant attorney Roy Cohn jailed Paley, then the union's secretary-treasurer, and the union's new president, David Livingston, for refusing to surrender union records. Earlier, rank-and-file workers had voted against complying with Taft-Hartley's requirement that leaders sign affidavits claiming they weren't communists. Ultimately leaders decided survival required reaffiliation. With this, the union lost its organizing edge. Osman's departure may also have had some effect: he became the DPO president in 1948 when the union first broke with the CIO, and ultimately was "exiled into Siberia" as DPO's southern area director and executive vice president.[150] The union's organizing became less creative, it limited cultural activities deemed less directly tied to members' welfare. And the paper became a "casualty" of returning to the CIO under the umbrella of the Retail, Wholesale, Department Store Union (RWDSU) in 1954. Local 65's paper, which had grown to twenty-four pages, was consolidated into an ever-diminishing space in the *RWDSU Record*, which focused more on leadership than rank and file.[151]

The paper's photo staff also suffered. Internal records do not indicate any decision to curtail union support for photography; nonetheless, as former chairman Ed Roth put it, "Little by little [the photo staff's work] just dribbled out." Roth thought the photo staff received less attention from leaders; the union had "more pressing problems." Some of the photo staff's early leaders moved into upper-level positions and were replaced by less personable leaders who strained to maintain photographers' spirit.[152] The staff was also buffeted by red-baiting against New York's Popular Front. When the federal

government hounded the New York Photo League out of existence in 1951, Local 65 lost an important ally, one of the "best schools in the world," according to Ed Roth.[153]

But for many years the photo staff's "organizing eye" built the union. One shutterbug, Manny Molofsky, corresponded with friends through *New Voices*. He trained as a G.I. photographer in Denver. His open letter to members described his pride in devoting union-won skills to the nation's defense. He looked forward to returning home and "repaying his debt" to the union by training new member-photographers. Molofsky shared an anecdote about meeting another 65er in boot camp:

> In my class there was a boy arguing about the photo Union. Another one said it was a racket, while a third one said he didn't think so. He also said he was a member of a Union. In fact the best in the country. Naturally I was curious so I asked him what Union it was. He promptly replied Local 65. When I told him I too was a member of 65, he called me Brother.[154]

Imagine—two New Yorkers, finding their "Brother" halfway across the continent because of their shared commitments to Local 65, the "photo Union."

Conclusion

Americans fought over the status of workers and organized labor in the political and economic spheres, but also in the cultural realm; by the late 1930s, U.S. culture was increasingly nationalized, massified, standardized, and visual. Understanding labor's successes and failures in the mid-twentieth century requires grappling with workers' and union culture, and the larger culture organized labor operated within. Unions, business, and media corporations waged symbolic battles about organized labor and its prospects with photographic imagery. Their battles indicate the fluid relationships between culture and politics, and labor and business under consumer capitalism.

Labor's tension-laden portrayal in the news suggests that mid-century visual culture cannot be reduced to a celebration of "the people," in aesthetics or content. The populism of documentary photographs, government-sponsored murals, regional scene painting, and political propaganda was characteristic and powerful. If not, corporations would not have parroted this style in advertising and internal publications. But the news photos about organized labor studied here, that suffused union papers, mass-market magazines, daily newspapers, corporate publications, and public relations campaigns suggest that scholars must go beyond the documentary and populist aesthetic when studying the 1930s and 1940s.

The heroic male laborer symbolized labor's collective muscle, but in *LIFE* he represented the inter- and intraclass warfare besetting the United States. If Dorothea Lange's "Migrant Mother" and Walker Evans's southern tenant farmer Annie Mae Gudger represented America's backbone through a threatened maternal survival, in labor papers and mass media magazines, working women appeared as striking girls with glorious gams, ever attentive to their "prinking." And when the populist, proto-feminist Rosie arrived, magazines and union papers celebrated her and betrayed a degree of discomfort toward her. The labor press and the mass media portrayed workers picketing to establish unions as an exciting element of America's political and economic landscape—but strikers were also visualized as a threat to America and its values—or not represented at all, as we saw with *Steel Labor*. And as common as the heroic laborer was in the mid-century, so were stern portraits of union's statesmanlike leaders, or a rank and file joined in a consumerist frolic.

America's contradictory visual culture parallels mid-century popular culture more generally.[1] But a lacuna in scholarship on the visual culture of the 1930s and 1940s mars our understanding of the nation's new "culture of sight and sound." Photojournalism as an institutional practice is woefully understudied by historians. Perhaps contributing to this gap are the banality of many photos, the anonymity of their makers, the difficulty in attributing intent given the multiple "authors" of the work, the added difficulty of interpretation once sequencing and text is added, and an enormous obstacle: the complicated nature of its archiving. But Americans became increasingly attuned to the visual during the 1930s and 1940s—especially in the news. It is difficult to know what had more pull: the strong emotionalism of documentary photography, the colorful, vibrant murals of this era, the mundane photos encountered in publicity shots or union papers, or the visually enticing photos of *LIFE*. The continued focus on a subset of imagery ignores the commercial and institutional media saturating Americans' lives. As art critic Elizabeth McCausland wrote in the Springfield *Sunday Union and Republican* in 1941, "Every American who sees a newspaper experiences photography in an incessant and intimate relation, thanks to the invention of the half tone in 1880. Photography today is actually a second language of daily use."[2] Emphasis on the populist or documentary aesthetic misses a cultural sphere crammed with inconsistent messages about everyday working Americans that shaped workers' destiny, and the nation's.[3]

From its invention in the nineteenth century, critics touted the camera's egalitarian potential. Anyone dexterous enough to manipulate a mechanical instrument and some chemicals could recreate reality. By the late nineteenth century, advertisements for George Eastman's Kodak promised, "You push the button, we do the rest." His mass production innovations enabled the middle class and then workers to represent their lives.[4] Eastman imagined a classless leisure pastime, but others articulated a class-specific photography. Lewis Hine, for example, took up photography to document the Machine Age's burgeoning social inequalities. Hine's expansive notion of democracy assumed workers contributed to, and could draw upon, the promise of American life. He argued that the "popularizing of camera work . . . by those . . . in the thick of the battle" offered workers a crucial "lever for social uplift." Hine believed workers' photographs could illustrate their vital contributions to American life and point to gaps in the nation's promise.[5]

Hine's notion of a self-conscious, working-class photography was realized in other industrialized Western nations. German Communists initiated some 125 camera clubs, and membership ultimately extended past the party. Workers then formed camera clubs throughout Western and Central Europe. German workers had their own photo journal, *Arbeiter Illustrierte Zeitung*, or *AIZ*, and worker photographers captured the social conditions of their lives and their class activism, though companies prohibited them from taking work site photos.[6]

But American workers, consistent with Eastman's marketing strategies, typically photographed a narrow slice of their domestic lives.[7] Close to a century after Hine visited the steel-making town of Homestead, Pennsylvania, two academic investigators retraced his steps. They found that "few people in Homestead had snapshot versions of laboring and learning to labor. Outsiders take pictures of work, but insiders do not." Technical requirements made it difficult—work sites could be dark and dangerous, requiring special equipment. More significantly, companies controlled work sites. In many industrial areas, workers could not talk about labor, much less photograph it. Even the adept Hine saw himself as a "spy" who disguised his mission to get his photos. A final reason for the limits on what workers represented might be linked to mass consumerism's rise. In the twentieth-century "pleasure economy," fulfillment was to be found not in productive labors, but in consumer enjoyments. Workers in the United States had the possibility of visualizing their collective needs and ambitions with the camera, but with a few exceptions discussed below, this was uncommon.[8]

Institutions did not hesitate to use the camera to define U.S. workers' labors and their collective needs and ambitions. Unions increasingly used photographs to draw members into specific visions of union life. Thirty million union papers reached American workingmen and -women by 1953.[9] The labor press evolved with the CIO revolution. Its journalism was a far cry from the "treatises on the humanities and labor ideology" found in earlier AFL papers. Ben Pearse, writing for the *Nation*, echoed J. B. S. Hardman's assessment of the labor press, arguing that a "mass-production journalism" accompanied CIO industrial unionism with national editions, clip sheets, columns, and editorials. The labor press was more professional and standardized. Pearse claimed that "there were still too many pages of solid type and too many pictures of officials shaking hands" and "smudgy mat-service photos of an individual laying a cornerstone in Peewee, Ohio." Nonetheless, he found *Steel Labor* and *New Voices* exemplars of the labor press's "trend" toward "readability"—though he might also have said visuality. Even with the CIO's dynamism, however, the labor press tended more often to promote a union's agenda than to envision a broad-based movement with workers at the center, remaking the world around them. The labor press moved toward bureaucratization, infrequently providing an alternative to the news and news photographs that surrounded workers in their daily lives. It became, in one labor editor's opinion, less vernacular, less fresh, less energetic, and less partisan.[10]

Corporations also shaped conceptions of organized labor with photos. By the late nineteenth century, many major corporations employed in-house photographers. Taking advantage of the halftone's joining of image and text, corporations with a national reach used photos to define their industrial might and quell labor antagonism. Photographs of the work process typically erased workers, or included them as part of the well-ordered "machinery" of

the factory floor. Such photos emphasized factory organization, an organization that managers established, with workers appearing mostly as machine appendages.[11] The grandeur and technological precision of American industry preoccupied some of the best 1920s modernist photographers. Lewis Hine called such photos "mere photographic jazz," because they ignored "the real men [needed] to make and direct" the machine. But Luce publications promoted this "industrial sublime," first in *Fortune* to the nation's managerial elite, and then in *LIFE* to millions of Americans.[12]

Workers did appear in corporations' in-house publications, part of welfare-capitalist strategies. As discussed in Chapter 1, from the 1910s companies imagined their labor force as family, albeit a patriarchal, hierarchical family, and WWI-era labor discord intensified corporate use of this strategy.[13] In the early Depression many companies dispensed with such magazines when cutting costs, but returned to them by the mid-1930s. Magazines displayed workers in company-led holiday parties, sports teams, or health facilities, and also in photos taken in workers' gardens or at their hobbies. Employee magazines appropriated labor's leisure for the corporation. These in-house publications aped trendsetters like *LIFE*, integrating the corporation and its workers into a productive, contented image of America.[14]

Public relations' strategies also shaped news about labor. In quaint Hershey, Pennsylvania, and Newton, Iowa, in the begrimed mill towns of Tonawanda, New York, or Canton, Ohio, and in industrial behemoths like Chicago, corporations and peak associations' public relations strategies employed photos to make unions seem violent and anti-American to a nationwide audience. Corporations' ability to reach Americans was far greater than unions'. David Nye estimated that General Electric transmitted some two hundred million visual messages in the last half of 1925 alone. Corporations had multiple ways to reach citizens. In annual reports, movies, market research, instructional booklets, exhibitions, and of course advertisements, they confronted the general public with a visual world they created. By the late 1930s most major corporations had hired public relations experts; the field "mushroomed" as America entered the postwar era. With World War II, business succeeded in asserting itself simultaneously as a "good neighbor" and the nation's central institution. Needless to say, it did not share its position in the limelight with companies' workforces or with organized labor.[15]

Mass media corporations also defined labor in photographs. Prior to the 1930s the mass media were more apt to ignore workers, or to treat them voyeuristically, as a type, or "Other" to be viewed with little "compassion." Another common approach was to view them "romantically," as part of a new urban scene. Contemporary critic Elizabeth McCausland described such portrayals as "picturesque bits of life torn out of sordid context," identifying the lack of empathy implicit in many such representations.[16] As late as 1931, *Fortune* featured a story, "The American Workingman," that joined Margaret

Bourke-White's modern portraits and photomontages of artisan silversmiths and glassblowers, skyscraper laborers, and packinghouse workers with such backward-looking ethnic-typing, and romanticism. *Fortune* portrayed the nation's unskilled labor as "not, in a certain and very common sense of the word, 'American' at all." This section, titled, "Jigs, Hunkies, Dagoes and Kikes," commented on marginalized groups' exclusion from the AFL, even as *Fortune* suggested that white laborers were "constantly driven upwards like sap in a tree." The images for this photo-essay were a bizarre hodgepodge. Bourke-White's's portraits joined Max Kalish's bronzes of heroic labor; Reginald Marsh's "The Bowery," an urban, immigrant maelstrom; regionalist Thomas Benton's construction workers; and Gerrit Beneker's colorful illustrations of worker types.[17] Such a confused picture would not likely have been published even later that decade. The news dailies and the news magazines that shaped how Americans saw events around them—*LIFE, TIME,* and *Newsweek*—increasingly represented workers and organized labor in news photographs.[18] No longer "exotic" aliens to be wondered at, workers became players in the nation's economic and political landscape.

Labor's growing stature within public imagination can be traced through press coverage of its leaders. During Samuel Gompers's life, no publication beyond the middle-class opinion or muckraking journals gave Gompers the attention devoted to America's industrial titans. His successor, William Green, merited even less, a mere handful of articles in the *Literary Digest* or the *Review of Reviews*.[19] Contrasted to coverage of industrial heads like Henry Ford, Walter Chrysler, Judge Gary, or even Myron Taylor, labor was not much on the public mind or labor's face before the public eye, in part because national magazines did not put it there. This changed with the CIO's rise. Its leaders, John Lewis, Philip Murray, Harry Bridges, David Dubinsky, Sidney Hillman, and Walter Reuther, appeared again and again in a variety of mass media venues—sometimes as chieftains of colorful warring tribes, but other times as statesmanlike administrators shaping the nation's economic life.

Workers themselves participated in this new America. They filled the streets and their work sites with their political and economic demands. They were productive labor in the pages of *LIFE* or *Steel Labor*; men brandishing the vacation checks brought to them by their union in *Steel Labor*; content homeowners in *LIFE* or *Steel Labor*; and couples kicking up their heels in communal recreation in the pictures of *LIFE* or *New Voices*. With cash in hand and glee in their hearts, workers partook of the leisure and consumer activities other Americans had long enjoyed.

News photos showed workers—typically white workers only—sharing in the American Dream. As James Truslow Adams, who first coined the term at the Depression's beginning, wrote, "The American Dream has been unique in the social annals of mankind"; it was the nation's "contribution to the civilization of the world." Adams claimed that the American Dream was greater than

political, legal, economic, or educational equality; it was available to "the humblest as well as the most exalted." For Adams, "This belief has been that it was possible to create and order a society in which . . . every man and woman would nevertheless have the opportunity of rising to full stature and living the fullest possible life of which they were capable."[20] Adam's classless dream paralleled many mid-century Americans' aspirations. News photos in union papers and mass circulations publications helped fulfill such promises by weaving workers and their unions into this new America.

Simultaneously, however, news photographs of organized labor helped contain its aspirations. Ironically, the absence of imagery documenting labor's distance from mainstream America might have made it more difficult for workers to press for greater security. Union papers *Steel Labor* and *New Voices* rarely represented the real deficiencies in workers' lives: how miniscule wages led to execrable housing for many workers and absolute limits in clothing and food choices.

In advertisers' world of consumer abundance, stylish women could match their wardrobes to their bathrooms by the 1920s, as bathrooms came in nearly twenty "pastel and sea-pearl tints." A decade later, in working-class homes in Flint, Michigan, however, "half or more . . . had no private indoor toilet, bath or hot running water." Even in Manhattan, in one working-class neighborhood, a third of the homes lacked toilets and bathing facilities, and half lacked heat.[21]

Members knew the problems they faced. One Chicago CIO women's auxiliary activist complained about the "insecurity, poor wages and continual want" of steel families, and the "sordid surroundings and hopeless outlook" that resulted. Her words paralleled documentary pioneer Jacob Riis's rhetoric, when she wrote, "Verily, one half of this country knows not how the other half lives, or at least does not bother to describe . . . such underprivileged as the steel workers, unless their pitiful stories can be embellished with picturesque or notorious surroundings."[22] Her words betray an ambivalent relationship to workers' representation. She acknowledged workers' wants, even as she bridled at the "pitiful stories" and "embellishment" of the documentary tradition. Despite this aesthetic's pervasiveness and its success in building support for the New Deal, her husband's union paper never described member-workers as "the other half" in photographs. Similarly, underpaid New York distributive workers seemed more comfortable describing the utopian possibilities of unionism. *New Voices* never documented the gap between union aspirations and workers' reality. Their camera club members took such photographs, but the photos were not printed in the paper (Fig. C.1). Perhaps unions shielded members from the "intrusive eye" of the camera, insisting on workers' respectability. Perhaps, as the *Packinghouse Worker*'s editor, Les Orear, suggested, "We didn't need to convince ourselves that we had a miserable home life. That would be great for some *LIFE* magazine picture, but there's no point." Representing the everyday

FIGURE C.1 *Photo taken for Style Rite Optical shop drive, ca. 1946. Though workers took photographs like these as part of a documentary project of workers' housing,* New Voices *rarely printed such imagery. United Automobile Workers of America, District 65 Photograph Collection, Tamiment Library, New York University.*

texture of workers' lives was no stir to action in this labor editor's mind. Perhaps unions thought that an aspirational message was a better strategy. But the failure to represent the burdens of workers' lives also raises the possibility that workers had a harder time convincing the larger public of their needs. Such needs were invisible. [23]

Similarly the failure of magazines like *LIFE*, but also union papers like *Steel Labor* to portray rank-and-file members as active creators of union life may have affected workers' sense of possibility. In both venues workers were recipients of union's success. Unions found material ways to limit member participation, by cutting off members from organizers, keeping them in the dark about the union's inner workings, retarding their leadership, or developing social activities and communal spaces that excluded women or African Americans. Representation matters also. Labor news editors and even mass media editors might have educated unionists and the general public about rank-and-file involvement as solidarity, as collective labor, or even citizenship, but they rarely did.

Workers' representation in news photographs stratified members by race and gender, which limited union power. Embracing all unionists had tactical benefits that some editors understood. Orear discussed printing photographs of African-American and Mexican laborers to dispel white workers' racism as whites discounted others' activism. Or photographs could help unionists

aspire to an egalitarian community in which men and women, black and white, worked, played, and organized together, as in *New Voices*. Such inclusiveness was rare. In *LIFE*, African Americans were barely represented, much less as union members. In *Steel Labor*, African Americans were represented with great decorum. The women of the Timken Rolling Mills appeared dignified and committed, with the full-bust portrait reserved for leaders. This portrayal was used for the black community and civil rights leaders as well. *Steel Labor* respected African Americans, while simultaneously marking their difference. Such representations could mask real inequalities within a union, even as African Americans became an ever greater proportion of membership.

Similarly, women were represented as distinct from the average member. The percentage of women workers increased in the Depression's midst despite pressures to stay out of the workforce. In the war years, the numbers of workingwomen increased again. Even when women were forced out of plum jobs for returning veterans, their numbers in the workforce multiplied.[24] Yet the labor press and the mass media typically identified labor as a male worker, ignoring women's labor and women's needs. Representations of female labor often sexualized and erased women's class status. The focus on gender difference made it hard for women's participation in the union movement to be taken seriously. Women were perceived as subsidiary players in the union movement, pleasing to look at perhaps, but not full-fledged activists. White men might have had a harder time understanding their community of interests with women and black members given their clear demarcation; even their own union papers suggested that these workers were dissimilar.[25]

Finally, union power was limited by the consistent link between union activism and threats to the social order, and news photography's particular power to sustain this idea. Unions described the toll of bad press—and imagery. Chicago steelworker and union activist George Patterson described press photographers seeking "some action," whose write-ups and pictures were "disastrous" to the "cause." He referenced the strike at Fansteel Metallurgical Corporation in 1937, where company heads created a "Trojan Horse" with which police dislodged sit-downers from a Chicago area plant. Patterson claimed that corporate publicity stunts were a "mecca for cameramen and reporters" who clicked their cameras and wrote their stories—this photo story was spread nationally.[26] Also conscious of the power of photographs was Henry Kraus, onetime editor of the UAW's newspaper and an active participant in the 1936–1937 Flint sit-down strike. Kraus wrote of Pearl Bergoff's "streamlined . . . new times, new methods" strikebreaking. He explained the "core idea" of the campaign, which echoed Bergoff's description of the Mohawk Valley Plan. The activities "exalted" a "peace loving, contented, 'American' *majority*," who sought to dominate a "violent, trouble-making, radical *minority*" (emphasis his). General Motors' in-house publication promoted this message. For Kraus, the *IMA News* "blossomed" from a "neuter sports and fraternal sheet" with cartoons "into a news

organ devoted to printing 'items of fact.'" The *IMA News*'s photos "emphasized" union violence, "showing a small group of fist-waving, frenzied men standing at the plant gates." Kraus observed that Detroit papers simultaneously printed large, eight-column-spread photos of "several thousand workers waiting for their checks." Papers' captioning said the photos were of a "protest meeting," documenting workers' "ugly mood."[27]

That an in-house corporate paper promoted anti-unionism with photographs is no surprise. And press photographers did seek out violence—their job was to capture the newsworthy and the spectacular. The turmoil arising from strikes offered both.[28] But the Mohawk Valley Plan formulated by James Rand, promulgated by NAM, and instituted by professional strikebreakers like Pearl Bergoff and corporate heads like Tom Girdler, Ernest Weir, and Alfred Sloan tried to equate labor with violence in the public's mind. To a large degree they succeeded. The La Follette Committee, helped by labor allies, established corporate and state responsibility for such violence, but in the press, unions—not corporations—were typically called to account for this violence. Unions themselves, as we saw with *Steel Labor*, even shied away from addressing strike violence. If "public opinion" was a determinant in labor struggles, and there's no question that business thought it was, unions, despite their long-term victory at stemming corporate violence, could not seem to shake the image that labor was at the bottom of these troubles. Strikes seemed anarchic and anti-American, making the tactic far riskier for unions to employ.

Expanding what we see in the 1930s and 1940s revises our understanding of that era's visual culture and its political culture. Scholars have argued that corporations developed a pro-business publicity attack to assert managerial prerogatives and stem union growth in the 1940s. But corporate heads, seen as on the defensive in the 1930s, never stopped fighting organized labor, the CIO, the Wagner Act, and other instances of labor strength. We can see in the incidents at Maytag in Newton, Ohio, at Hershey Chocolate, and at Republic Steel corporate ability to shape the very texture of reality for millions of Americans. Companies could no longer rely on guns, gas, and knuckles in their fight with unions. But by the mid-1930s, their public relations campaigns exploited an increasingly visual news to identify corporations with core American values and interests, helping them in the war for minds.[29]

News photography's contradictory messages about labor in this period of its galvanic rise also qualify scholarship on mass culture and labor. News photos about labor were double-edged. The culture that unionists labored so hard to create was at times a culture of rank-and-file passivity, dependence on leadership, or inequality among different groups of workers. Labor's "culture of unity," as Lizabeth Cohen describes it, nurtured by an ever more pervasive national mass culture, sometimes thwarted workers' capacity to enhance their role in the union, and unions' capacity to expand a role for themselves within

the polity.[30] Michael Denning's concept of a "laboring of culture" in America's mid-century also must be modified. Expressing Lewis Hine's concept of being a "lever" for social change, several Popular Front photojournalistic experiments did attempt to represent labor, its demands, and working Americans' distance from the nation's largesse. These experiments self-consciously opposed commercial media's views of labor; however, they were far more limited than Denning suggests.

The Popular Front publication *Photo History* devoted one issue, "Labor's Challenge," to a retrospective look at labor's struggle and future prospects. Edward Levinson edited *Photo History*. His career began at eighteen at a socialist paper, and by the 1930s he was labor correspondent for the *New York Post*. His exposé on Pearl Bergoff became the book *I Break Strikes*; he also authored *Labor on the March*, detailing the CIO's rise.[31] *Photo History*'s editors, who also included Richard Storrs Childs, Ernest Galarza, Sidney Pollatsek, and John Bobbitt, sought a photo magazine appropriate for a modern era, and their innovative publication offered layouts even bolder than those in *LIFE*.[32] *Photo History*'s avant-garde photomontages mocked Herbert Hoover's New Era prosperity and *LIFE*'s industrial majesty, contrasting industry's might as registered in the nation's soaring smokestacks, thrusting girders and massive gears with workers' squalid lives, their dingy, broken-down homesteads. And they monumentalized labor's sacrifices by printing panoramic shots of the Memorial Day Massacre paired with Meyer Levin's eyewitness account of the tragedy. The lively *Photo History* ran only four issues.

Friday, another Popular Front effort, published stories on the average New York City worker. One intimate portrait photographically depicted a worker's spare home life. *Friday* was published for just over a year.[33] Similarly, the better-known *PM* was published by Henry Luce's former staffer Ralph Ingersoll, known for being a staunch labor supporter. It published stories on rank-and-file unionism, corporations' continued use of force against labor, and the economically ravaged steel towns, showing the gap between working Americans' lives and mass consumerism's promises. Photos were central to *PM*. Modernist photographer Ralph Steiner was its photo editor; he allowed photographers to find their vision, or personal "twist." One of the mid-century's most famous photojournalists, Arthur Fellig, or "Weegee," made his name there.[34] But this experiment in photojournalism failed when reactionary news publishers convinced Associated Press to deny *PM* a contract in the mid-1940s. *PM* was forced to add advertisements, cut pages, and ultimately shut its doors in 1948.[35] By 1950, *LIFE*'s vision of promise for workers, an optimistic, if glossy and glossed over image, prevailed in the commercial press.

Simultaneously the documentary aesthetic lost its luster. In the late 1930s, documentary photographers applauded government's role in sustaining photographers and alternative photographic visions with the FSA.[36] By the end of FDR's New Deal, however, conservative opposition shut off funds to such

work. In 1943, after heading documentary efforts under the Office of War In-
formation, Roy Stryker left for Standard Oil of New Jersey, which employed
the documentary aesthetic for corporate public relations. By 1948 conservative
members of Congress took to the floor to ridicule the FSA project, saying that
its photos "made no sense." Hearst publications and *LIFE* printed stories about
the photos that were the object of this congressional derision. Committed
photographers took note of these attacks. Without federal sponsorship, pho-
tographers struggled to have their photographs seen by the broad audiences
the FSA had commanded.[37]

More seriously, government anticommunists hounded out of existence
one of the most significant collective efforts at promoting the documentary
aesthetic, New York's Photo League. The Photo League developed in the late
1930s out of the Communist Party-connected Film and Photo League.
The Photo League drew admiration from the nation's top photographers.
Edward Weston, Margaret Bourke-White, Ansel Adams, Dorothea Lange,
Arthur Rothstein, Berenice Abbott, Weegee, and W. Eugene Smith all
exhibited or lectured at the Photo League. Museum of Modern Art staff
Beaumont and Nancy Newhall, and Edward Steichen advised league leaders
and wrote in their publication, *Photo Notes*. Paul Strand nurtured the
group's aesthetic and political understanding. The league corralled diver-
gent opinions on what documentary should be and how it might influence
U.S. culture.

As part of their progressive commitments, the Photo League ran inexpensive
photography classes for working-class New Yorkers. Sounding much like Lewis
Hine, whose work the league championed, and ultimately archived, the editors
of their bulletin *Photo Notes* wrote, "The Photo League's task is to put the camera
back in to the hands of honest photographers, who will use it to photograph
America. We must include within our ranks the thousands of New York's ama-
teurs . . . [and] . . . the established workers who have creative desires and who do
not find an adequate outlet in their day-to-day tasks.[38] Photographers they taught
went on to staff and freelance at the nation's top photo journals, such as *LOOK*
and *LIFE*, and to work for the government during the war and for businesses. In
this sense Popular Front sensibilities shaped the news.

The Photo League desired a reciprocal relationship with unions, which they
attained only in part. They believed that unions might provide financial re-
sources. The Fur, Floor and Shipping Union did provide in-kind support by
exhibiting the "Harlem Document," though this seems a lone example. The
National Maritime Union and UAW Local 600 also formed their own "camera
clubs," and the Photo League reported on Local 65's efforts. Evidence touching
on Photo League projects with workers engaged in a self-conscious movement
is thin. The league's community-based surveys, Harlem Document, or the
Chelsea or Pitt Street documentary projects were more ambitious, and left
more records.[39] With these projects, cameramen and women illustrated the

gritty but joyful lives of New York's working population. The league functioned well as a training ground for working people to record the lives around them. It less actively promoted unionism or recorded organized labor's realities and aspirations.

Political repression decimated even such efforts. On December 4, 1947, President Harry Truman's Loyalty Program led U.S. attorney general Tom Clark to identify a list of "totalitarian, fascist, communist or subversive groups." Clark named the Photo League with the Ku Klux Klan and the CP as subversive. Some key members had CP ties: Sid Grossman, the league's noted teacher who traveled to Arkansas to photograph the Southern Tenant Farmers Union, promoted his politics; and J. Edgar Hoover's FBI investigated Paul Strand, a founder, as a Communist. Yet many league members were clueless about any party influence, and most participants denied such ties. The accusations took a toll, however. Well-known league supporters the Newhalls and Ansel Adams resigned, and membership fell off. Within three years, a thriving organization collapsed.[40]

One Photo League supporter telegrammed the organization: "The camera itself is subversive." But supplanting the league's socially incisive photography was the vague humanist and classless spirit of the "Family of Man" exhibition that Edward Steichen curated for the Museum of Modern Art. Organized around life activities such as romance, childbirth, motherhood, work, education, and culture, the exhibition proposed that peoples from all corners of the globe shared universal values. Contributing most of the photographs were *LIFE* cameramen and -women. Documentary photography didn't go away. But it lost its civic importance through ridicule, repression, and cultural gatekeeping that promoted the subjective and apolitical over the engaged. The documentary came to seem passé, heavy-handed, even suspect.[41] Television soon transformed the visual and cultural landscape.

During WWII, and then into the postwar era, an uneasy truce prevailed between corporations and the labor movement. Unions gained institutional stability when the National War Labor Board (NWLB) imposed maintenance of membership provisions in contracts on corporations doing business with the federal government. Once the war ended, a massive wave of strikes ensued, but labor remained a player in the economic and political landscape, striking more in the 1950s than in the turbulent 1930s. As America entered the twentieth century's second half, one of every three workers had union representation. Over time, many workers' lives stabilized, with increased wages and greater security as corporations acceded to a far-reaching public-private welfare state.[42]

But labor never achieved its utopian goals, Sidney Hillman's dream that "labor shall rule." For reasons intrinsic and extrinsic to organized labor, its path was not quite the one it had hoped for. Some believe that the administrative unionism of the Wagner Act and the no-strike pledge of the war tied

labor's hands. Labor leaders muzzled rank-and-file activism to maintain union stability and to keep their own power, but in so doing labor lost its propulsive drive. The UAW's demand that GM "open the books" to the general public during its 1945 strike so the public could see that wage increases were not hurting GM profitability failed. This defeat kept managerial prerogatives intact, indicating the limits of public, political oversight. The CIO ousted communist unions in the late 1940s, blunting labor's radical edge and losing its best organizers. These banished unions had been the most committed to bringing marginalized workers into the labor movement: women, African Americans, ethnic workers, and white-collar and service industry workers. The nation's segmented labor force would pit workers against other workers.[43] Labor's failure to alter the nation's political calculus with Operation Dixie, which aimed to break the South's historically racist, anti-union political oligarchy, also stymied labor's prospects. And the Taft-Hartley Act further eroded labor's choices. Labor's allies built a public welfare state that protected many Americans, and they strengthened unionists' company-run private welfare programs, but the deals and compromises they accepted in establishing these programs endangered the whole two generations later.[44]

A current bumper sticker reminds us: "Unions, the folks that brought you the weekend." The bumper sticker works because it highlights a "forgotten" element of American history. Many of us have enjoyed weekends, health insurance, access to consumer goods, welfare, and unemployment insurance because two generations ago workers and their unions fought to extend them to working Americans. These advances have been challenged and stripped away, but as Jack Metzgar's *Striking Steel* reminds us, "The dramatic improvements in working conditions and life standards that we still take for granted today would not be there for us to defend or lose if the unions of the 50s had been as weak, corrupt and inconsequential as they appear in the official memory of postwar America."[45] Traditional histories and cultural critics, he says, slight labor's contributions, and at the same time they erase the difficulties of workers' lives, then and now.

News photographs documented and contributed to labor's dynamic history. News photography visualized workers enjoying the American Dream. Economically, American industrial workers had a new pull with their employers, and having coalesced into a voting bloc and an alliance with the Democratic Party, workers were politically incorporated into American life. Workers were culturally incorporated as well. As a topic in the news, and as consumers of goods, workers participated in mass culture as never before. Organized labor also used news photographs to shape representations of itself and its struggles. But labor's achievements were limited, even at the moment of its greatest strides. Workers' representation divided them by race and gender, restricting their sense of joined interest; photos often fostered a leader-driven unionism while minimizing rank-and-file input. In sketching

a secure future for workers based on private gain, but ignoring laborers' real individual needs and their collective possibilities, mass media venues and union papers promoted limited gains. News photos narrowed labor's political and economic strategies, ultimately constricting workers' place within the American Dream.

{ NOTES }

Introduction

1. Wendy Kozol, *LIFE's America: Family and Nation in Postwar Photojournalism* (Philadelphia: Temple University Press, 1994), 32; Warren Susman, *Culture as History: The Transformation of American Society in the Twentieth Century* (New York: Pantheon Books, 1973), 158–160.
2. James Agee and Walker Evans, *Let Us Now Praise Famous Men* (New York: Houghton Mifflin, 1941; New York: Ballantine Books, 1976), 11.
3. Robert Lynd and Helen Merrell Lynd, *Middletown in Transition: A Study in Cultural Conflicts* (New York: Harcourt Brace, 1937), 37, 374–375, 383. Bergoff in NLRB Dist. Council Office Equipment Workers Case No. C–145, quoted in Senate Comm. of Education and Labor, *Violations of Free Speech and Labor, National Association of Manufacturers*, 75th Congress, 1st sess., Part 17, Exhibits 3861 and 2821 (1937), 7960–7972. Elspeth Brown, *The Corporate Eye: Photography and the Rationalization of American Commercial Culture* (Baltimore: Johns Hopkins University Press, 2005). Richard Tedlow and Stuart Ewen both examine NAM's anti-union campaigns, without exploring news photography. Ewen, *PR!: A Social History of Spin* (New York: Basic Books, 1996), 307–316; Tedlow, *Keeping the Corporate Image, Public Relations and Business* (Greenwich, Conn.: JAI Press, 1979), 59–105. Elizabeth Fones-Wolf and Howell John Harris analyze the import of attacks by NAM, the Chamber of Commerce, and the more liberal Committee on Economic Development. Both acknowledge 1930s anti-union campaigns, but their primary focus is on the war and afterward. Neither examines news photography. Fones-Wolf, *Selling Free Enterprise: The Business Assault on Labor and Liberty: 1945–1960* (Urbana: University of Illinois Press, 1994), 1–10 and 32–57; Harris, *The Right to Manage: Industrial Relations Policies of American Business in the 1940s* (Madison: University of Wisconsin Press, 1982), 39–40, 192–199. Kim Phillips-Fein's detailed analysis of corporate anti-unionism in *Invisible Hands: The Making of the Conservative Movement from the New Deal to Reagan* (New York: W. W. Norton, 2009) examines publicity campaigns, but not photography.
4. Taken from a survey by Phil Ziegler (editor of *Railway Clerk*) and published initially in J. B. S. Hardman's *American Labor Dynamics* (New York: Harcourt and Brace, 1928). As quoted in J. B. S. Hardman and Maurice Neufeld, "Union Communication: Publicity, Public Relations," *The House of Labor: Internal Operations of American Unions* (New York: Prentice Hall, 1951), 171–225, especially 210.
5. Nelson Lichtenstein's *Labor's War at Home: The CIO in World War II* (Cambridge: Cambridge University Press, 1982), 79–81, 233; David Brody, *Workers in Industrial America: Essays on the 20th Century Struggle* (New York: Oxford University Press, 1980), 173–192.

6. Arthur Schlesinger, *The Coming of the New Deal* (Boston: Houghton and Mifflin, 1959), 315; Louis Hacker, *The Shaping of the American Tradition* (New York: Columbia University Press, 1947), 1125; Carl Degler, *Out of the Past* (New York: Harper and Row, 1959), 416. More recent summaries include Melvyn Dubofsky, "Not So 'Turbulent Years': Another Look at American 1930's," *American Studies* 24 (1979): 5–20; Gary Gerstle and Steve Fraser, *The Rise and Fall of the New World Order* (Princeton, N.J.: Princeton University Press, 1989); Joshua Freeman, "Delivering the Goods: Industrial Unionism During World War II," *Labor History* 19, no. 4 (1978): 570–593, and Nelson Lichtenstein, *State of the Union: A Century of American Labor* (Princeton, N.J.: Princeton University Press, 2002).

7. William Stott, *Documentary Expression and Thirties America* (New York: Oxford University Press, 1973); F. Jack Hurley, *Portrait of a Decade: Roy Stryker and the Development of Documentary Photography in the Thirties* (Baton Rouge: Louisiana State University Press, 1972).

8. Robert Ray, *A Certain Tendency of the Hollywood Cinema* (Princeton, N.J.: Princeton University Press, 1985), 57. See also Robert Sklar, *Movie-Made America: A Cultural History of American Movies*, 2nd ed. (New York: Vintage Books, 1994); and Richard Maltby, "*Baby Face* or How Joe Breen Made Barbara Stanwyck Atone for Causing the Wall Street Crash," in *Screen Histories: A Screen Reader*, edited by Jackie Stacey and Annette Kuhn (New York: Oxford University Press, 1998).

9. Analyses emphasizing the democratic impulse include Gerald Markowitz and Marlene Park, *Democratic Vistas: Post Offices and Public Art in the New Deal* (Philadelphia: Temple University Press, 1984); and Francis O'Connor's *Federal Support for the Visual Arts: The New Deal and Now* (Greenwich, Conn.: New York Graphics Society, 1969). Feminist critics include Elizabeth Faue, *Community of Suffering and Struggle: Women, Men and the Labor Movement in Minneapolis, 1915–1945* (Chapel Hill: University of North Carolina Press, 1991); and Barbara Melosh, *Engendering Culture, Manhood and Womanhood in New Deal Public Art and Theater* (Washington, D.C.: Smithsonian Institution Press, 1991).

10. Photographer-critics Alan Sekula and Martha Rosler offered an early critique of the documentary tradition. Rosler, "In, Around and Afterthoughts (On Documentary Photography)," in *The Contest of Meaning: Critical Histories of Photography*, edited by Richard Bolton (Cambridge, Mass.: MIT Press, 1989), 317; Sekula, "On the Invention of Photographic Meaning," in *Photography in Print: Writings from 1816 to Present*, edited by Vicki Goldberg (Albuquerque: University of New Mexico Press, 1981), 452–473. Scholars then followed: James Curtis, *Mind's Eye, Mind's Truth: FSA Photography Reconsidered* (Philadelphia: Temple University Press, 1989); Maren Stange, "*Symbols of an Ideal Life*": *Social Documentary Photography in America, 1890–1950* (Cambridge: Cambridge University Press, 1989), 130. F. Jack Hurley rebuts this revisionism in: "The Farm Security Administration File: In and Out of Focus," *History of Photography* 17 no. 3 (Autumn 1993): 244–252; and Peter Daniel et al., *Official Images: New Deal Photography* (Washington, D.C.: Smithsonian Institution Press, 1987).

11. Maureen Honey, *Creating Rosie the Riveter: Class, Gender, and Propaganda During World War II* (Amherst: University of Massachusetts Press, 1984); William Bird and Harry Rubenstein, *Design for Victory: World War II Posters on the American Home Front* (New York: Princeton Architectural Press, 1998), 66–75.

12. Roland Marchand, *Advertising the American Dream: Making Way for Modernity, 1920–1940* (Berkeley: University of California Press, 1985); Steve Ross, *Working-Class Hollywood: Silent Film and the Shaping of Class in America* (Princeton, N.J.: Princeton University Press, 1998). The political effects of film and television have received greater attention from historians of journalism and media. Hanna Hardt and Bonnie Brennan "Newswork, History and Photographic Evidence: A Visual Analysis of a 1930's Newsroom," in *Picturing the Past: Media, History, and Photography*, edited by Bonnie Brennen and Hanno Hardt (Champaign: University of Illinois Press, 1999), 14.

13. Analyses of labor iconography include Gary Gerstle, *Working Class Americanism: The Politics of Labor in a Textile City, 1914–1960* (Cambridge: Cambridge University Press, 1989); and Faue, *Community of Suffering*. Paul Buhle offers a labor-centric view in "The Iconographics of American Labor," in *From the Knights of Labor to the New World Order: Essays on Labor and Culture* (New York: Garland, 1997), 161–197; Ross, *Working-Class Hollywood*; Nan Enstad, *Ladies of Labor, Girls of Adventure: Working Women, Popular Culture, and Labor Politics at the Turn of the Twentieth Century* (New York: Columbia University Press, 1999).

14. Denning and Cohen challenged earlier assessments of a mass culture that "enslaves" workers into "'obedience' to the social hierarchy," the Frankfurt school dicta. Max Horkheimer and Theodor Adorno, "The Culture Industry: Enlightenment as Mass Deception," in *The Dialectic of Enlightenment*, translated by John Cumming (New York: Herder and Herder, 1972), 121–127. See also Michael Kammen, *American Culture, American Tastes: Social Change and the Twentieth Century* (New York: Knopf Press, 1999). Lizabeth Cohen, *Making a New Deal: Industrial Workers in Chicago, 1919–1939* (Cambridge: Cambridge University Press, 1990), 324–333, 341–347; and Michael Denning, *The Cultural Front: The Laboring of American Culture in the Twentieth Century* (New York: Verso, 1997), xvi–xvii.

15. Erika Doss, ed., *Looking at LIFE* (Washington, D.C.: Smithsonian Institution Press, 2001), 2, 42–43.

16. Roy Stryker and Nancy Wood, *In This Proud Land* (New York: Galahad Books, 1973), 8.

17. Arthur Rothstein, *Photojournalism* (New York: American Photographic, 1956), 23. Doss, *Looking*, 15–16.

18. *LIFE*, March 25, 1940, 78–79.

19. ASMP quote in Rothstein, *Photojournalism*, 52.

20. Michael Schudson, *Discovering the News: A Social History of American Newspapers* (New York: Basic Books, 1978), 151–152; Lynd and Lynd, *Middletown in Transition*, 377–378; and Frank Luther Mott, *American Journalism: A History of Newspapers in the United States Through 260 years: 1690–1950* (New York: MacMillan, 1950).

21. Christopher Wilson, "The Rhetoric of Consumption: Mass-Market Magazines and the Decline of the Gentle Reader," in *The Culture of Consumption: Critical Essays in American History*, edited by Richard Wightman Fox and T. J. Jackson Lears (New York: Pantheon Books, 1983), 39–64.

22. Notable exceptions include Enstad, *Ladies of Labor*; Anne Loftis, *Witness to the Struggle: Imaging the 1930s California Labor Movement* (Reno: University of Las Vegas Press, 1998); and Richard Steven Street, "Salinas on Strike: News Photographers and the Salinas Lettuce Packers' Strike of 1936: The First Photo Essay on a California Farm Labor Dispute," *History of Photography* 12, no. 2 (April–June 1988): 165–174. Also see

Faue, *Community of Suffering*; Buhle, *From the Knights*; and Gerstle, *Working-Class Americanism*.

23. Linda Nochlin, *Realism* (New York: Penguin Books, 1971), 13–56. Oliver Wendell Holmes, "The Stereoscope and the Stereograph," *Atlantic Monthly*, June 1859, 738–747; "Sun Painting and Sun Sculpture," *Atlantic Monthly*, July 1861, 13–19; "Doings of the Sunbeam," *Atlantic Monthly*, 1–15. The quote comes from "Sun Painting," 28. Analyses of early photography include Geoffrey Batchen, *Burning with Desire: The Conception of Photography* (Cambridge, Mass.: MIT Press, 1997); Alan Trachtenberg, "Photography: Emergence of a Key Word," in *Photography in Nineteenth-Century America*, edited by Martha Sandweiss (Fort Worth, Tex.: Amon Carter Museum, 1991), 17–47; and Miles Orvell's *The Real Thing: Imitation and Authenticity in American Culture, 1880–1940* (Chapel Hill: University of North Carolina Press, 1989).

24. Louis Masur, "'Pictures Have Now Become a Necessity': The Use of Images in American History Textbooks," *Journal of American History* 84, no. 4 (March 1998): 1409–1424; Kiku Adatto, *Picture Perfect: Life in the Age of the Photo Op* (Princeton, N.J.: Princeton University Press, 2008), 1–7, 47–48.

25. Peter Bacon Hales, *Silver Cities: The Photography of American Urbanization, 1839–1915* (Philadelphia: Temple University Press, 1984), 3.

26. Alan Trachtenberg, *Reading American Photographs: Images as History, Matthew Brady to Walker Evans* (New York: Noonday Press, 1989), xiv; see also Lawrence Levine, "The Historian and the Icon" in *Documenting America: 1935–1943*, edited by Carl Fleishhauer and Beverly Brannan (Berkeley: University of California Press, 1988), 40.

27. Rothstein, *Photojournalism*, 28. Roland Barthes argues that the text of the photograph "anchors" what would otherwise be a "polysemic" image. Barthes, "The Rhetoric of the Image," *Image, Music, Text*, translated by Stephen Heath (New York: Noonday Press, 1977), 25, 39.

28. The Communist *Daily Worker* employed this strategy to suggest labor's strength, but also an overly powerful anti-labor state: January 31, 1937; "50,000 Marchers Back Akron Rubber Strike," April 7, 1937; "The Troops Are Still in Flint," January 21, 1937, 3; and "Graduation Goose Stepping to Capitalist Tune," which showed Rutgers graduates as "foot soldiers of capitalism," June 10, 1929, 2.

29. John Tagg argues that photography per se has no meaning; the institution employing it creates its meaning. See *The Burden of Representation: Essays on Photographies and Histories* (Amherst: University of Massachusetts Press, 1988), 63. Tagg minimizes how composition, lighting, and other aspects of the photographic language contribute meaning. Nonetheless, the idea that photographs "perform" different work in different settings is important to this analysis, and is central to current photographic theory and history. See essays in Bolton's *Contest of Meaning*; and Abigail Solomon-Godeau, *Photography at the Dock: Essays on Photographic History, Institutions and Practices* (Minneapolis: University of Minnesota Press, 1991).

30. Tagg, *The Burden*, 97–98.

31. Lange, letter to Roy Stryker, in Milton Meltzer, *Dorothea Lange: A Photographer's Life* (New York: Farrar, Straus, and Giroux, 1978), 168.

32. On corporate photography, see David Nye, *Image Worlds: Corporate Identities at General Electric* (Cambridge, Mass.: MIT Press, 1985), 49, 9, 27–29. Nye uses the term "mundane realism," which is helpful in understanding their innocuous look; also see

Roland Marchand, *Creating the Corporate Soul: The Rise of Public Relations and Corporate Imagery in Big Business* (Berkeley: University of California Press, 1998); and Brown, *Corporate Eye.*

33. Patricia Johnston, *Real Fantasies: Edward Steichen's Advertising Photography* (Berkeley: University of California Press, 1997), 93–102, demonstrates the fluidity between documentary and advertising realism in the 1920s and 1930s; and Michael Schudson, *Advertising: The Uneasy Profession* (New York: Basic Books, 1984), 8, uses the term "capitalist realism." James Guimond's *American Photography and the American Dream* (Chapel Hill: University of North Carolina Press, 1991), argues that the photo journals *LIFE* and *LOOK* excelled at this rhetoric.

34. Rosler, as quoted in Paula Rabinowitz, *They Must Be Represented: The Politics of Documentary* (New York, Verso, 1994), 17.

35. Levine, "The Historian," 24.

36. Johnston, *Real Fantasies*, 84, 86.

37. Others employing this method include Marchand, *Advertising*, xx; Nye, *Image Worlds*; Hales, *Silver Cities*, 5; and Alan Trachtenberg, "Image and Ideology: New York in the Photographer's Eye," *Journal of Urban History* 10, no. 4 (August 1984): 453–464.

38. For the CIO and mass culture, see Cohen, *Making a New Deal*; Denning, *The Culture Front*; and Elizabeth Fones-Wolf, "Promoting a Labor Perspective in the American Mass Media: Unions and Radio in the CIO Era, 1936–1956," *Media, Culture, and Society* 22 (2000): 285–306. For AFL and CIO possibility, see Christopher Tomlins, "AFL Unions in the 1930s: Their Performance in Historical Perspective," *Journal of American History* 65, no. 4 (March 1979): 1021–1042; and Robert Zieger, *The CIO: 1935–1955* (Chapel Hill: University of North Carolina Press, 1995), 333–371.

39. Hardman and Neufeld, "Union Communication," 177–225.

40. T. Jackson Lears, *Fables of Abundance: A Cultural History of Advertising in America* (New York: Basic Books, 1994). Roland Marchand describes 1930s advertising vernacular for workers as the "Parable of the Democracy of Goods." Marchand, *Advertising the American Dream*, 217–222.

41. *CIO News*, February 19, 1938. See also *Steel Labor*, October 1944, 10; and the racist "The Jungle Brotherhood," which appeared in the *UAW Worker*, December 1945, 7, and the *United Rubber Worker*, the CIO's United Rubber Workers' newspaper. The cartoon shows "labor," a white man, tied to the tree of "the high cost of living." Standing in front of a boiling pot of "public opinion" are four NAM "savages," who look like primitives in blackface. Labor's use of such racist caricature deserves greater study.

Chapter 1

1. Milton Brooks, "Battle at River Rouge, 1941," in Sheryle Leekey and John Leekey, *Moments: The Pulitzer Prize Photographs* (New York: Crown, 1978), 12–13.

2. *Pittsburgh Revealed: Photographs Since 1850* (Pittsburgh: Carnegie Museum of Art, 1997), 149, 155; "The Great Railroad Strike of 1877," accessed January 15, 2011, from www.library.pitt.edu/labor_legacy/rrstrike1877.html; and for stereograph use, see Richard Masteller, "Western Views in Eastern Parlors: The Contribution of the Stereograph Photographer to the Conquest of the West," *Prospects* 6 (1981): 55–71.

3. Larry Peterson, "Producing Visual Traditions Among Workers: The Uses of Photography at Pullman," *International Labor and Working-Class History* no. 42 (Fall 1992): 50.

4. Joshua Brown, "Reconstructing Representation: Social Types, Readers, and the Pictorial Press, 1865–1877," *Radical History Review* 38 (Fall 1996): 5–38; Joshua Brown, *Beyond the Lines: Pictorial Reporting, Everyday Life and the Crisis of Gilded Age America* (Berkeley: University of California Press, 2002), 131–136, 152–169, 174–188, and 196–211.

5. David Demarest, ed., *"The River Ran Red": Homestead, 1892* (Pittsburgh: University of Pittsburgh Press, 1992). *Frank Leslie's Illustrated Weekly's* July 14, 1892, cover of woman protester, 87; Dabbs on 90, 160–161; and Library of Congress, Prints and Photographs Division, *Harper's Weekly*, vol. 36, July 16, 1892; 673, negative no. LC-USZ62-126046.

6. "Shoemaker, Broome Street," in Jacob Riis, *How the Other Half Lives* (New York: Dover, 1971), 16; "Flashes from the Slums," *New York Sun*, February 12, 1888. Peter Bacon Hales, *Silver Cities: Photographing American Urbanization: 1839–1939*, 2nd ed. (Albuquerque: University of New Mexico Press, 2005), 285–286; Daniel Czitrom and Bonnie Yochelson, *Rediscovering Jacob Riis: Exposure Journalism and Photography in Turn of the Century New York* (New York: New Press, 2007); Michael Carlebach, *The Origins of Photojournalism in America* (Washington, D.C.: Smithsonian Institution Press, 1992), 153–157.

7. Carlebach, *Origins*, 162; Michael Carlebach, *American Photojournalism Comes of Age* (Washington, D.C.: Smithsonian Institution Press, 1997), 28; Luther Mott, *American Journalism: A History of Newspapers in the United States Through 260 Years: 1690–1950* (New York: MacMillan, 1950), 503. For a history of the halftone, Richard Benson, *The Printed Picture* (New York: Museum of Modern Art, 2008); Hales, *Silver Cities*, 296; "lunatic" in Jack Price, *News Photos* (New York: Round Table Press, 1937), 173; Czitrom and Yochelson, *Rediscovering Jacob Riis*, 157, 199; and Neil Harris, "Iconography and Intellectual History: The Half-Tone Effect," in *New Directions in American Intellectual History*, edited by John Higham and Paul Conkin (Baltimore: Johns Hopkins University Press, 1980), 196–211.

8. Carlebach, *American Photojournalism*, 13–15, 43; Columbia Photographic Society, *Camera: A Practical Magazine for Photographers* 6 (1902): 429; Hales, *Silver Cities*, 393–413.

9. Kate Sampsell-Willmann, *Lewis Hine as Social Critic* (Jackson, Miss: University Press of Mississippi, 2009). James Guimond, *American Photography and the American Dream* (Chapel Hill: University of North Carolina Press, 1991), 78–81; Maren Stange, *Symbols of Ideal Life: Social Documentary Photography in America, 1890–1950* (Cambridge: Cambridge University Press, 1989), 47–87; "Heroes of the Cherry Mine," *McClure's* 34, no. 5 (March 1910): 473–492; "Working-Girls Budgets," *McClure's* 35 no. 6 (October 1910): 595–614; John Andrews Fitch, *The Steel Workers* (New York: Russell Sage Foundation, 1911).

10. "Politics in Philadelphia's Strike," *Literary Digest*, March 5, 1910, 421–423, "Mob Rule in Philadelphia," *New York Times*, February 21, 1910, 1. The *Los Angeles Times* did offer front-page photos. Joyce Kornbluh, *Rebel Voices: An IWW Anthology* (Ann Arbor: University of Michigan Press, 1964), 158–196; Ray Stannard Baker, "The Revolutionary Strike," *American Magazine* 74, no. 1 (May 1912): 19–30.

11. Annelise Orleck, *Common Sense and a Little Fire: Women and Working-Class Politics in the United States, 1900–1965* (Chapel Hill: University of North Carolina Press, 1995), 53–63.

12. Nan Enstad, *Ladies of Labor: Girls of Adventure: Working Women, Popular Culture, and Labor Politics at the Turn of the Twentieth Century* (New York: Columbia University Press, 1999), 119–160; Ellen Wiley Todd, "Photojournalism, Visual Culture, and the Triangle Shirtwaist Fire," *Labor* 2, no. 2 (2005): 9–27. "Rich and Poor in the Shirtwaist Strike," *Literary Digest*, January 1, 1910; "Why 150 Girls Were Burned," *Literary Digest* April 8, 1911, 661–663; Arthur McFarlane, "Fire and the Skyscraper," *McClure's* 37, no 5 (September 1911): 467–482.

13. Sloan's cover, *The Masses*, June 5, 1912, in Rebecca Zurier, *Art for the Masses: A Radical Magazine and Its Graphics* (Philadelphia: Temple University Press, 1988), 82.

14. David Montgomery, *The Fall of the House of Labor: The Workplace, the State, and American Labor Activism* (New York: Cambridge University Press, 1987, 343–352; Elspeth Brown, *The Corporate Eye: Photography and the Rationalization of American Commercial Culture* (Baltimore: Johns Hopkins University Press, 2005), 132–146. Brown's nuanced study demonstrates how corporations sought to make workers loyal, and some workers' disdain toward such attempts; Stuart Ewen, *PR!: A Social History of Spin* (New York: Basic Books, 1996), 72–83.

15. Todd, "Photojournalism," 11; Alice Willis, "The Kodak in the Hawaiian Islands," *American Annual of Photography* 33 (1918): 113; C. H. Claudy, "How the Inauguration Is Photographed," *Camera and Dark-Room* 8, no. 4 (April 1905): 101–107; Price, *News Pictures*, 113–114. Circulation data: *IMS N. W. Ayer and Sons Directory of Publications* (Philadelphia: N. W. Ayer and Sons), 1910; hereafter *Ayer Directory*. The *Literary Digest*, which had many photos, was read by nearly 200,000 Americans, the same as *Scribner's*; *Harper's* had only 125,000; Hales, 406.

16. Hales, *Silver Cities*, 406.

17. Benson, *Printed Picture*, 236–238.

18. Carlebach, *American Photojournalism*, 146.

19. Descriptions of the 1919 strike wave include Montgomery, *Fall*, 332, 385–395; and David Brody, *Workers in Industrial American: Essays on the 20th Century Struggle* (New York: Oxford University Press, 1980), 3–47. On specific industries or locales, see Dana Frank's *Purchasing Power: Consumer Organizing, Gender and the Seattle Labor Movement, 1919–1929* (Cambridge: Cambridge University Press, 1994), 15, 34–39; and David Brody, *Steelworkers in America: The Non-Union Era* (Urbana: University of Illinois Press, 1998), 231–262. New York strike information is found in notes below. For the coal strike, see *Daily News* (hereafter *DN*), November 13, 1919.

20. Brody, *Workers*, 41–42, Melvyn Dubofsky, *Industrialism and the American Worker* (Arlington Heights: AHM, 1975), 122–123; Frank, *Purchasing Power*, 25, 30; and Montgomery, *Workers Control in America: Studies in the History of Work, Technology, and Labor Struggles* (New York: Cambridge University Press, 1979), 91–122; and Montgomery, *Fall*, 332, 370, 373, 378.

21. Frank, *Purchasing*, 25–27; Montgomery, *Fall*, 388–391.

22. Dubofsky, *Industrialism*, 123; Brody, *Workers*, 44. Montgomery, *Fall*, 392.

23. William Preston Jr., *Aliens and Dissenters: Federal Suppression of Radicals, 1903–1933* (Urbana: University of Illinois Press, 1994), 180–237; Frank, *Purchasing Power*, 33–34; and Montgomery, *Fall*, 393, 395.

24. Carlebach, *American Photojournalism*, 183–184.

25. The *Pictorial*'s (hereafter *MWP*) 1919 coverage had fifty-eight photographs on labor troubles, with fourteen portraits of corporate and governmental officials, and fifteen shots of soldiers or constabulary. Of nine strike photographs, there were no picketers, and only two or three of men massing, parading, or walking in the street.

26. "Boston Police Strike," *MWP*, September 25, 1919, 4–6; "Steel Strike Now in Progress," *MWP*, October 2, 1919, 6–7.

27. "Coal Miner Typical of 400,000," *MWP*, November 13, 1919, cover, and 8–11.

28. Lewis Hine, "Steelworkers at Russian Boarding House, Homestead, Pennsylvania," taken in 1907/1908 in Walter Rosenblum, Naomi Rosenblum, and Alan Trachtenberg, *American and Lewis Hine: Photographs: 1904–1940* (New York: Aperture, 1977), 62. See also Alan Trachtenberg, *Reading American Photographs: Images as History, Matthew Brady to Walker Evans* (New York: Noonday Press, 1989), 164–209; James Guimond, *American Photography*, 55–98; Stange, *Symbols of Ideal Life*, 47–87.

29. Trachtenberg, *Reading American Photographs*, 52–60; Elizabeth Edwards, "The Resonance of Anthropology," in *Native Nations: Journeys in American Photography*, edited by Jane Alison (London: Barbican Gallery, 1998), n.p.; Sandra Phillips, ed., *Police Pictures: The Photograph as Evidence* (San Francisco: Chronicle Books, 1997).

30. *MWP*, November 13, 1919. David Nye, *Image Worlds: Corporate Identities at General Electric* (Cambridge, Mass.: MIT Press, 1985), 55, 66–69.

31. Szarkowski, *Photography Until Now* (New York: Museum of Modern Art, 1989), 194; Sammy Schulman, *Where's Sammy?* edited by Robert Considine (New York: Random House, 1943), 3; Carlebach, *American Photojournalism*, 165–167.

32. Carlebach, *American Photojournalism*, 159–160, 176; Arthur Leipzig, interview by author, audio-recording, Sea Cliff, New York, January 5, 2010; Larry Millett, *Strange Days, Dangerous Nights: Photos from the Speed Graphic Era* (St. Paul, Minn.: Borealis Books, 2004), vii, 5; Price, *News Pictures*, 102.

33. I compared circulation data from *Ayer Directory* against U.S. population for every five years between 1900 and 1950. U.S. Census Bureau, "Historical National Population Estimates, July 1, 1900–July, 1999," accessed January 23, 2011, from http://www.census.gov/popest/archives/1990s/popclockest.txt.

34. The *Pictorial* reported a circulation of 434,157 in 1919, but 70,000 the following year. The former figure corresponds to the *New York Times*'s circulation, so it seems likely that the latter figure is the *Pictorial*'s distribution outside New York. *Ayer Directory*, 1919. William Randolph Hearst and Joseph Pulitzer's "new journalism" of the turn of the century is perceived to rely on illustrations. Schudson, *Discovering the News*, 91–106; Carlebach, *American Photojournalism*, 14–15, 165, 175.

35. Carlebach, *American Photojournalism*, 40.

36. Carlebach, *American Photojournalism*, 144–147.

37. The *Daily News* photo of Gompers appeared on August 27, 1919, and was accompanied by a portrait of Eldred Gary. Gary was seen on September 4, 1919, with heads of other unions, and "capitalists" John D. Rockefeller and J. P. Morgan, and again on September 2, 1919. On September 28, 1919, he appeared on the cover in a photo with his bodyguard, implying he had been menaced, *DN*.

38. John H. M. Laslett, "Samuel Gompers and the Rise of American Business Unionism," in *Labor Leaders in America*, edited by Melvyn Dubofsky and Warren Van Tine

(Urbana: University of Illinois Press, 1987), 62–88. Attacks on radicalism include "I.W.W. Controls Harbor," and "Troops Act as Detectives to Trap the Gary "Reds," both *DN*, October 16, 1919.

39. For Harvard anti-unionists, see September 12, 1919; the Pennsylvania Constabulary, September 22, 1919; and soldiers as longshoremen, October 15, 1919, *DN*.

40. Gompers appeared on the cover with other union leaders, August 30, 1919. For mug shots, see New York Transit leaders, August 8, 1919. Leaders also appeared speaking to members, September 24, 1919, or in group portraits with the stature commensurate to corporate heads, September 25, 1919, and October 3, 1919. New Yorkers carrying trunks, October 14, 1919; transit rider "legging it," August 7, 1919. Photos of rapid transit workers helping pedestrians, August 9, 1919; New York laundresses on October 11, 1919. For miners, November 5, 1919, and November 6, 1919. Steelworkers appeared on September 23, 1919; and coal miners on November 6, 1919, all *DN*. *Ayer Directory* has no circulation numbers for the *Daily News* in 1919 or 1920. Roland Marchand, *Advertising the American Dream*, 59, claims the *Daily News* was New York's top paper by 1921, quoting Mott, *American Journalism*, 666–669, 672.

41. Boston businessmen, September 12, 1919; Harvard student, September 16, 1919, all *DN*.

42. Gary strike, October 10, 1919; Wilson's labor summit, September 4, 1919; and "A Touch of Comedy," August 19, 1919, 1, both *DN*.

43. DeValera with Chippewa Indian and the longshoremen's strike, October 23, 1919; Wellesley girls with coal strike, November 6, 1919, all *DN*.

44. Carlebach, *American Photojournalism*, 145–146.

45. Interchurch World Movement of North America (IWM) *Report on the Steel Strike of 1919* (New York: Harcourt, Brace and Howe, 1920); IWM, *Public Opinion and the Steel Strike* (New York: Harcourt and Brace, 1921), 131, 113, 88–91. See also Robert R. R. Brooks, *As Steel Goes: Unionism in a Basic Industry* (New Haven, Conn.: Yale University Press, 1940), 39–40.

46. IWM, *Public Opinion*, 307, 89; Montgomery, *Fall*, 433.

47. IMW, *Public Opinion*, 310.

48. Montgomery, *Fall*, 402, 407.

49. Ibid., 406. See also Brody, *Workers*, 45; Irving Bernstein, *The Lean Years: A History of the American Worker, 1920–1933* (Boston: Houghton Mifflin, 1960), 84.

50. Montgomery, *Fall*, 406–408, 423–424, 454; and Brody, *Workers*, 45.

51. Cohen, *Making a New Deal*, 160.

52. Ibid., 163, 175–179; Brody, *Workers*, 48; Gerald Zahavi, "Negotiated Loyalty: Welfare Capitalism and the Shoe Workers of Endicott Johnson," *Journal of American History* 71 no. 3 (December 1983): 602–620. For a contrary view, see Bernstein, *Lean Years*, 170–189.

53. Edward Bellamy, *Looking Backwards* (1888; New York: Signet Classics, 1960). On Patten, William Leach, *Land of Desire: Merchants, Power, and the Rise of a New American Culture* (New York: Vintage, 1993), 231–244. Quote in Robert H. Wiebe, *The Search for Order: 1877–1920* (New York: Hill and Wang, 1967), 141.

54. Consumer industries, vulnerable to public opinion, were most apt to develop such programs. Susan Porter Benson, *Counter Cultures: Workers, Managers, and Customers in American Department Stores, 1890–1940* (Urbana: University of Illinois Press, 1986);

Katherine Kish Sklar, *Florence Kelley and the Nation's Work* (New Haven, Conn.: Yale University Press, 1995), 307–310.

55. Bernstein, *Lean Years*, 73, claims the U.S. Department of Labor's *Handbook of Labor Statistics* records only vacation with pay, which few enjoyed; Brody, *Workers*, 59–60; Montgomery, *Fall*, 403, 411–415, 421, 437–438, 456, for corporate welfare and ERP chronology; Cohen, *Making a New Deal*, 184–185, 188, 190, and 238–246.

56. Bernstein, *Lean Years*, 319–321.

57. Frank Stricker, "Affluence for Whom?—Another Look at Prosperity and the Working Classes in the 1920s," *Labor History* (1983): 15–17; Bernstein, *Lean Years*, 70, 9–11, 180–181; on steel, Mary Heaton Vorse, *Labor's New Millions* (New York: Modern Age Books, 1938), 51. Brody, *Workers*, 59.

58. Cohen, *Making a New Deal*, 102, 185; Bernstein, *Lean Years*, 59; William Stott, *Documentary Expression and Thirties America* (New York: Oxford University Press, 1973), 71; Stricker, "Affluence," 20, 32–33.

59. Robert S. Lynd and Helen Merrell Lynd, *Middletown in Transition: A Study in Cultural Conflicts* (New York: Harcourt Brace and Company, 1937), as quoted in Leuchtenberg, *Franklin D. Roosevelt and the New Deal, 1932–1940* (New York: Harper Torch Books, 1963), xii. Leuchtenberg, *Roosevelt*, 3–4, 22–23; Bernstein, *Lean Years*, 259, 313, 325–330; Cohen, *Making a New Deal*, 242.

60. Robert McElvaine, The Great *Depression: America, 1929–1941* (New York: Times Books, 1984), 75, 134; Leuchtenberg, *Roosevelt*, 1, 19; Bernstein, *Lean Years*, 254, 316.

61. McElvaine, *Depression*, 187–188; Bernstein, *Lean Years*, 254–255, 314–316; Leuchtenberg, *Roosevelt*, 19, 23.

62. McElvaine, *Depression*, 115–116, describes workers' adulation.

63. John Abt, *Activist and Advocate: Memoirs of an American Communist Lawyer* (Urbana: University of Illinois Press, 1993), 24.

64. Martin Sklar, *Corporate Reconstruction of American Capitalism, 1890–1916: The Market, the Law, and Politics* (New York: Cambridge University Press, 1988); Thomas Ferguson, "Industrial Conflict and the Coming of the New Deal: The Triumph of Multinational Liberalism in America," in *The Rise and Fall of the New Deal Order, 1930–1980*, edited by Steven Fraser and Gary Gerstle (Princeton, N.J.: Princeton University Press, 1989), 7–11, 19–20; Steven Fraser, "The Labor Question," in Fraser and Gerstle's *Rise and Fall*, 59–60; on Perkins see David Von Drehle, *Triangle: The Fire that Changed America* (New York: Grove Press, 2003), 194–200.

65. McElvaine, *Depression*, 151–155; Leuchtenberg, *Roosevelt*, 52.

66. Alan Brinkley, *The End of Reform: New Deal Liberalism in Recession and War* (New York: Alfred A. Knopf, 1995), 37–44; McElvaine, *Depression*, 59; and Ferguson, "Industrial Conflict," 4.

67. McElvaine, *Depression*, 170–195; Cohen, *Making a New Deal*, 251–368. Fictional or semifictional accounts include Jack Conroy, *The Disinherited* (1933; reprint, with an introduction by Daniel Aaron, New York: Hill and Wang, 1963); and the reportage of Meridel LeSueur, in *Ripening: Selected Work, 1927–1980*, edited by Elaine Hedges (Old Westbury, N.Y.: Feminist Press, 1982). McElvaine, *Depression*, 135, on penny auctions. For Unemployment Councils, Daniel Leab, "United We Eat: The Creation and Organization of Unemployed Councils in 1930," *Labor History* 8, no. 3 (1967): 300–315.

68. The building and printing trades "held their own" in the 1920s, and the ACWU grew in the 1920s with management-labor cooperation. Bernstein, *Lean Years*, 86, 102–103; Steven Fraser, *Labor Will Rule: Sidney Hillman and the Rise of American Labor* (Ithaca, N.Y.: Cornell University Press, 1991), 121, 165.

69. Bernstein, *Lean Years*, 314–344.

70. Ibid., 346–353; Edward Levinson, *Labor on the March*, with an introduction by Robert Zieger (1938; Ithaca, N.Y.: ILR Press, 1995), 50–51.

71. From Melvyn Dubofsky, *The State and Labor in Modern America* (Chapel Hill: University of North Carolina Press, 1994), 112; McElvaine, *Depression*, 161.

72. Levinson, *Labor*, 52. Fraser, "Labor Question," 68.

73. *Newsweek*, June 16, 1934, 3; McElvaine, *Depression*, 225–228, and Levinson, *Labor*, 52–77; LeSeuer, *Ripening*, 158–165; Elizabeth Faue, *Community of Suffering and Struggle: Women and Men in the Labor Movement in Minneapolis, 1915–1945* (Chapel Hill: University of North Carolina Press, 1991), 47–99.

74. "Paralysis on the Pacific," *TIME*, July 23, 1934, 10.

75. *TIME*, July 23, 1934, June 4, 1934, and July 30, 1934.

76. "Murdered by Police," *Newsweek*, July 14, 1934, 5.

77. "Mopping Up in Minneapolis," *Newsweek*, July 28, 1934, cover.

78. "Strike!" *Newsweek*, September 22, 1934, cover.

79. Loudon Wainwright, *The Great American Magazine: An Inside History of LIFE* (New York: Knopf, 1986), 21; and Carlebach, *American Photojournalism*, 184–185.

80. McElvaine, *Depression*, 161; Leuchtenberg, *Roosevelt*, 108; Zieger, *CIO*, 17.

81. Levinson, *Labor*, 56–76.

82. Ferguson, "The Coming," 18–19; Brinkley, *End of Reform*, 18; McElvaine, *Depression*, 162.

83. Levinson, *Labor*, 65–78; Vorse, *Labor's New Millions*, 55.

84. Bernstein, *Lean Years*, 263–267; Frances Perkins, *The Roosevelt I Knew* (New York: Viking Press, 1946), 12, 22, 239–243; Fraser, "'Labor Question,'" 68–69; Ferguson, "Industrial Conflict," 20, 29 n. 41.

85. Leuchtenberg, *Roosevelt*, 150–151; Brody, *Workers*, 100–103. Recent assessments of the NLRA include: Robert Zieger, "Historians and the U.S. Industrial Regime," *Journal of Policy History* 9 no. 4 (October 1997): 475–489; and Bill Winders, "Maintaining the Coalition: Class Coalitions and Policy Trajectories," *Politics & Society* 33, no. 3 (September 2005): 387–423.

86. Two excellent biographies are Melvyn Dubofsky and Warren Van Tine, *John L. Lewis: A Biography* (Urbana: University of Illinois Press, 1986), 13, 33, 35; and Fraser, *Labor Will Rule*.

87. Robert Zieger, *The CIO: 1935–1955* (Chapel Hill: University of North Carolina Press, 1995), 23–36.

88. Levinson, *Labor*, 169.

89. Florence Peterson, "Review of Strikes in United States," *Monthly Labor Review* 46 (May 1938): 1062–1063; Brody, *Workers*, 139, says that more than half the strikes were for the right to unionize; and Zieger, *CIO*, 52–53.

90. Peterson, "Review," 1063. Two contemporary accounts are Henry Kraus, *The Many and the Few: A Chronicle of the Dynamic Auto Workers*, 2nd ed. (Urbana: University of Illinois Press, 1985); and Levinson, *Labor*. For wet nurses, see *LIFE*, April 5, 1937, 21; for golf ball makers, char women, and lunch delivery boys, see Howard Zinn, Dana Frank,

and Robin D. G. Kelley, *Three Strikes: Miners, Musicians, Salesgirls, and the Fighting Spirit of Labor's Last Century* (Boston: Beacon Press, 2001); 76 CIO Executive Board meeting notes, March 9, 1937, Reel One, *CIO papers*, Catholic University of America (hereafter *CUA*).

91. Michael Denning, *The Cultural Front: The Laboring of American Culture in the Twentieth Century* (New York: Verso Press, 1996), 7, 23.

92. Carlebach, *American Photojournalism*, 177–188; Robert Elson, *Time Inc.: The Intimate History of a Publishing Enterprise, 1923–1941* (New York: Atheneum, 1968), 271; and James Baughman, *Henry R. Luce and the Rise of the American New Media* (Boston: Twayne, 1987), 85.

93. Millett, *Strange Days*, vii; Price, *News Pictures*, 131; Shulman, *Where's Sammy?* 42.

94. Wainright, *Great American Magazine*, 8, 11; Alan Brinkley, *The Publisher: Henry Luce and His American Century* (New York: Alfred Knopf, 2010), 217.

95. For the "miniature camera revolution," see Baughman, *Henry R. Luce*, 98. John Loengard, *LIFE Photographers: What They Saw* (Boston: Little Brown, 1998), 7.

96. Price, *News Pictures*, 177–178; Laura Vitray, John Mills, and Roscoe Ellard, *Pictorial Journalism* (New York: McGraw Hill, 1939), 18–22.

97. Stott's *Documentary Expression and Thirties America* is the classic articulation of this argument. John Raeburn, *A Staggering Revolution: A Cultural History of Thirties Photography* (Urbana, Ill: University of Illinois Press, 2006), 30–47, 94, establishes a similar periodization for social, as well as art and amateur photography.

98. Leah Ollman, *Camera as Weapon: Worker Photography Between the Wars* (San Diego: Museum of Photographic Arts, 1991). Milton Meltzer, *Dorothea Lange: A Photographer's Life* (New York: Farrar, Straus, and Giroux, 1978), 71–83; Lewis Hine, "Social Photography; How the Camera May Help in Social Uplift," *Proceedings, National Conference of Charities and Corrections*, 1909, reprinted in *Classic Essays on Photography*, edited by Alan Trachtenberg (New Haven, Conn.: Leete's Island Books, 1980), 109–113; Raeburn, *Staggering Revolution*, 216.

99. Sally Stein, "Good Fences Make Good Neighbors: American Resistance to Photomontage Between the Wars," in *Montage and Modern Life, 1919–1942*, edited by Matthew Teitelbaum (Cambridge, Mass.: MIT Press, 1992), 153.

100. Carl Fleishhauer and Beverly Brannan, *Documenting America: 1935–1943* (Berkeley: University of California Press, 1988); Ewen, *PR!*, 273; and Hartley Howell, "You Have Seen Their Pictures," *Survey Graphic* (April 1940): 236–241.

101. Guimond, *American Photography*, 101–102. Photo books include Richard Wright, *12 Million Black Voices*, photo direction by Edwin Rosskam (New York: Viking Press, 1941); Dorothea Lange and Paul Schuster Taylor, *An American Exodus: A Record of Human Erosion* (New York: Reynal and Hitchcock, 1939); James Agee and Walker Evans, *Let Us Now Praise Famous Men* (New York: Houghton Mifflin, 1941); and Margaret Bourke-White and Erskine Caldwell, *You Have Seen Their Faces* (New York: Viking Press, 1937). Paula Rabinowitz, *They Must Be Represented: The Politics of Documentary* (New York: Verso Press, 1994); Stott, *Documentary Expression* 211–237.

102. Marchand, *Advertising the America Dream*, 149–153; see also his *Creating the Corporate Soul: The Rise of Public Relations and Corporate Imagery in American Big Business* (Berkeley: University of California Press, 1998) and Patricia Johnston, *Real Fantasies: Edward Steichen's Advertising Photography* (Berkeley: University of California Press, 1997).

103. Loengard, *LIFE Photographers*; Interview with Peter Stackpole, San Francisco, August 16, 1993, 59, 8.

104. For SWOC, *Proceedings of the First Wage and Policy* Convention (December 1937), 64; SWOC, *Second Wage and Policy Convention* (May 1940), 28; and United Steel Workers of America, *Proceedings of the First United Steel Workers Convention* (May 1942), 41. *New Voices* Report to Executive Committee October 23, 1941, b1f6. *New Voices* increased circulation to over 20,000 in 1946. "Report on Union Voice," Thomas Mooney Hall Association Notes, b67f21, 1946, District 65 UAW papers at the Tamiment Institute and Wagner Labor Archives. Estimates on labor papers' general circulation from J. B. S. Hardman and Maurice Neufeld, *House of Labor: Internal Operations of American Unions* (New York: Prentice Hall, 1951), 180, 188, and 214.

105. Hardman and Neufeld, *House of Labor*, 222, 224, and 17.

106. Ibid., 197–198, 204, 223. Interview with William Garvey, USWA Chicago Office publicity staff, by Helmut Golatz, March 4, 1975, for the Historical Collections and Labor Archives at Pennsylvania State University (hereafter *PSU*), 20A.

107. SWOC, *Proceedings of the First Wage and Policy Convention*, 64.

108. Hardman and Neufeld, *House of Labor*, 192.

109. Edward Bernays, "The Engineering of Consent," *Annals of the American Academy of Political and Social Sciences* 250 (March 1947): 113–120.

110. Taken from a survey by Phil Ziegler (*Railway Clerk*'s editor) and published initially in *American Labor Dynamics*, edited by J. B. S. Hardman (New York: Harcourt and Brace, 1928). Quoted in Hardman and Neufeld, *House of Labor*, 210.

111. Les Orear, interview by author, tape recording, Chicago, Illinois, August 1, 2003.

112. Christopher Wood, "Iconoclasm and Iconophobia," in *Encyclopedia of Aesthetics*, edited by Michael Kelly (Oxford: Oxford University Press, 1998), 453; E. L. Godkin, "Chromo-Civilization," in *Reflections and Comments, 1865–1895* (New York: Charles Scribner's Sons, 1895), 192–205; and Georgia Barnhill, Joshua Brown, and Ian Gordon, "Seeing a Different Visual World: Graphics in Nineteenth-Century America," *Common Place* 7, no. 3, at http//www.commonplace.org/vol-07/no-03/intro/, accessed August 26, 2010.

113. Wainwright, *American Magazine*, 41, 63–64. Wainwright described this disdain continuing into the 1940s, 136–137. Baughman, *Henry R. Luce*, 84. Ingersoll believed even *LIFE*'s photos appeared as "ornaments," Milkman, *PM: A New Deal in Journalism: 1940–1948* (New Brunswick, N.J.: Rutgers University Press, 1997), 40.

114. Agee and Evans, *Let Us Now Praise Famous Men*, 11; Baughman, *Henry R. Luce*, 84.

115. John Vachon, "Newsstand, Omaha, Nebraska, 1938," Farm Security Administration Records, Library of Congress. The FSA archive has dozens of pictures of the newsstand and Americans enjoying magazines.

116. Quoddy, Maine Photography Workshop, "An All Night Session of the Rag Chewers Club," NYA119-G-3250-D, National Archives; Marion Post Wolcott, "Reading Magazine Beside His Trailer Home, Sarasota, Florida," Library of Congress, LC-USF34–05707-D.

117. Alfred Kazin, *On Native Grounds: An Interpretation of Modern American Prose Literature* (New York: Reynal and Hitchcock, 1942), 494–496.

118. Wainwright, *American Magazine*, 21.

Chapter 2

1. Loudon Wainwright, *The Great American Magazine: An Insider History of LIFE* (New York: Alfred Knopf, 1986), 33; and John Jessup, ed., *The Ideas of Henry Luce* (New York: Atheneum, 1969), 43.

2. *LIFE*, March 22, 1937, 20–21; Daniel Nelson, "Origins of the Sit-Down Era: Worker Militancy and Innovation in the Rubber Industry, 1934–1938," *Labor History* (1982): 198–225; George Morris, "Sit Down!" *Sunday Worker Magazine*, January 17, 1937, 1.

3. Wainwright, *American Magazine*, 82, 98. James Baughman, "Who Read *LIFE*? The Circulation of America's Favorite Magazine," in *Looking at LIFE*, edited by Erika Doss (Washington, D.C.: Smithsonian Institution Press, 2001), 44; Erika Doss, *Looking*, 2–5; William Stott, *Documentary Expression and Thirties America* (New York: Oxford University Press, 1973), 129; and Wendy Kozol, *LIFE's America: Family and Nation in Postwar Photojournalism* (Philadelphia: Temple University Press, 1994), 35.

4. Baughman, "Who Read *LIFE*?" 42 n. 7.

5. Alan Brinkley, *The Publisher: Henry Luce and His American Century* (New York: Alfred Knopf, 2010), 15–16.

6. Jessup, *Ideas of Henry Luce*, 378, 382.

7. Stott, *Documentary Expression*, 130.

8. "*LIFE* Begins," *LIFE*, December 7, 1936, 7; Kozol, *LIFE's America*, 6; for Goldwyn, van Doren, and Flagg quotes, see Wainwright, *American Magazine*, 82; Russell Miller, *Magnum: Fifty Years at the Front Line* (London: Pimilco, 1999), 107. Baughman, *Henry R. Luce and the Rise of the American News Media* (Boston: Twayne, 1987), 94. Stott, *Documentary Expression*, 129–130; Richard Pells, *Radical Visions and American Dreams: Culture and Social Thought in the Depression Years* (New York: Harper and Row, 1973), 263.

9. W. A. Swanberg, *Luce and His Empire* (New York: Charles Scribner's Sons, 1972), 50, 57, 59.

10. Luther Mott, *American Journalism: A History of Newspapers in the United States Through 260 years: 1690–1950* (New York: MacMillan, 1950), 554, 557; Helen Damon-Moore, *Magazines for the Millions: Gender and Commerce in the Ladies' Home Journal and the Saturday Evening Post, 1880–1910* (Albany: State University of New York, 1994); Matthew Schneirov, *The Dream of a New Social Order: Popular Magazines in America, 1893–1914* (New York: Columbia University Press, 1994); Michael Kammen, *American Culture, American Tastes: Social Change and the Twentieth Century* (New York: Knopf Press, 1999), 82 n. 26, 87 n. 40, and Chapter 7 nn. 17 and 21.

11. Dwight MacDonald, "*TIME* and Henry Luce," *Nation*, May 1, 1937, 501; Swanberg, *Luce*, 53, 57, 60, 87, 122, 123; James Guimond, *American Photography and the American Dream* (Chapel Hill: University of North Carolina Press, 1991), 154; Jessup, *Ideas of Henry Luce*, 53.

12. Wainwright, *American Magazine*, 2–4. Time Inc. set up a photo magazine research division in 1933 under Daniel Longwell, Wainwright, *American Magazine*, 6, 18. Roy Hoopes, *Ralph Ingersoll: A Biography* (New York: Atheneum, 1985), 13–15.

13. Kozol, *LIFE's America*, 29; Carol Squiers, "Looking at *LIFE*," *Artforum* 20, no. 4 (December 1981): 59; Elson, *Time Inc.: The Intimate History of a Publishing Enterprise, 1923–1941* (New York: Atheneum, 1968), 270 and 272, on *Newsweek*. Wainwright, *American Magazine*, 6.

14. Wilson Hicks, *Words and Pictures: An Introduction to Photojournalism* (New York: Harper, 1952), 58. On Korff, see Elson, *Time Inc.*, 272; Wainwright, *American Magazine*, 15–16, 27, 28. For AP, see Wainwright, *American Magazine*, 34; on staff responsibility, Wainwright, *American Magazine*, 50; and Hoopes, *Ingersoll*, 183.

15. Both ads, *LIFE*, July 12, 1937.

16. *LIFE*, March 25, 1940, 78–79. Wainwright, *American Magazine*, 42, 14. For Macy's executive, see Brinkley, *Publisher*, 215.

17. Most of the photos in this analysis appeared in the "*Life* on the American Newsfront" section or in cover stories, and as a result did not intermingle with ads—even so, readers enjoyed a text that liberally mixed the two.

18. For Macdonald's firing, see Brinkley, *Publisher*, 164. For his politics, see Jeffrey Thomas, "Ex-'Revolutionist' Visits Yale," in Michael Wrezin, ed., *Interviews with Macdonald* (Oxford: University of Mississippi Press, 2003), 4. Macdonald, "*TIME*," 501. Luce personally oversaw each schedule, but he sought an open-ended product. Jessup, *Ideas*, 27. Billings managed layouts. Elson, *Time Inc.*, 307. James Baughman, *Henry R. Luce*, 31. For *TIME*'s "group journalism," Baughman, *Henry R. Luce*, 41. Hoopes, *Ingersoll*, 151.

19. Elson, *Time Inc.*, 359; Swanberg, *Luce*, 150; and John Loengard, *LIFE Photographers: What They Saw* (Boston: Little Brown, 1998), 37; and Wainwright, *American Magazine*, 83; Baughman, *Henry R. Luce*, 46–47, uses the term *omniscience*. The chains, particularly Hearst's, were seen as partisan.

20. Wainwright, *American Magazine*, 93. For Carnegie, see Warren Susman, *Culture as History: The Transformation of American Society in the Twentieth Century* (New York: Pantheon Books, 1973), 165–166, 200.

21. Wainwright, *American Magazine*, 28, 74, 161.

22. Film scholars' conception of "regulated difference" among mass-produced studio fare explains *LIFE*'s mix. Richard Maltby, *Hollywood Cinema: An Introduction* (Oxford: Blackwell, 1995), 37–46.

23. Hoopes, *Ingersoll*, viii, 166; and Miller, *Magnum*, 107.

24. Doss, *Looking*, 2; Wainwright, *American Magazine*, 29; Elson, *Time Inc.*, 278–279. Wainwright, *American Magazine*, 35.

25. Hicks, *Words and Pictures*, 85.

26. Jessup, *Ideas of Henry Luce*, 28–29, 42.

27. Harold Evans, *Pictures on a Page: Photojournalism, Graphics and Picture Editing* (London: Pimlico, 1978), 245.

28. Hoopes, *Ingersoll*, 146; and Wainwright, *American Magazine*, 30.

29. A tenet of current photographic theory is that the photograph is polysemous, shifting meanings can be attached to it. For an explanation of the third effect, see Evans, *Pictures on a Page*, 237, 255; and Elson, *Time Inc.*, 305.

30. Wainwright, *American Magazine*, 30; Elson, *Time Inc.*, 304, 306; and Baughman, *Henry R. Luce*, 44.

31. *LIFE*, March 25, 1940, 78–79.

32. Doss, *Looking*, 17.

33. Wainwright, *American Magazine*, 33; Guimond, *American Photography*, 151–162.

34. *LIFE*, November 23, 1936.

35. Wilson, "The Rhetoric," 55–59; Kozol, *LIFE's America*, 31; Wainwright, *American Magazine*, 30–32, 38, 60–61; Elson, *Time Inc.*, 285; Wainwright, *American Magazine*, 38;

Hoopes, *Ingersoll*, 143–144; Baughman, *Henry R. Luce*, 89. "Bigger'n We Thought!" *LIFE*, April 15, 1940.

36. Baughman, "Who Read *LIFE*," 41–48; Baughman, *Henry R. Luce*, 9. On middlebrow, see Joan Shelley Rubin, *The Making of Middlebrow Culture* (Chapel Hill: University of North Carolina Press, 1992), x–xi; and Janice Radway, "Mail-Order Culture and Its Critics: The Book of the Month Club, Commodification and Consumption, and the Problem of Cultural Authority," in *Cultural Studies*, edited by Lawrence Grossberg, Cary Nelson, and Paula Treichler (New York: Routledge: 1992), 512–531.

37. Jessup, *Ideas of Henry Luce*, 13, 21, 99; on business, see Hoopes, *Ingersoll*, 84.

38. Macdonald, "*TIME, Fortune, LIFE*," *Nation*, May 22, 1937, 586; Hoopes, *Ingersoll*, 156, 168, 179;

39. Elson, *Time Inc.*, 322; Hoopes, *Ingersoll*, 15; and Swanberg, *Luce*, 148.

40. Jessup, *Ideas of Henry Luce*, 25, 56; Elson, *Time Inc.*, 347.

41. Jessup, 24, 26, 225–226; "The Roosevelt Rule: A Pictorial Record," *LIFE*, January 4, 1937, 23–45.

42. See "Liberals, Conservatives and Liberty," April 1934; and "Calculability of Abundance," to the Ohio Bankers Association, November 1937, in Jessup, *Ideas of Henry Luce*, 224–223; *FORTUNE*, March 1939.

43. Jessup, *Ideas of Henry Luce*, 54–58. Peacock to H. W. Prentis, Jr., Armstrong Cork Company, November 29 and December 4, 1943, and H. W. Prentis to Fred Crawford, President NAM, December 1, 1943, in Mr. Weisenburger's files, 1938–1943, *NAM papers*, SIIIb847, the Hagley Archive (hereafter *Hagley*). On unionization, see Elson, *Time Inc.*, 392–401; David Nasaw, *The Chief: The Life of William Randolph Hearst* (New York: Houghton Mifflin, 2000), 518–520.

44. Guimond, *American Photography*, 158. Retrospectively *LIFE* touted its depiction of the Great Depression, but few articles addressed economic difficulties. Rare exceptions include May 10, 1937, 15–24, and August 3, 1937, 18. *LIFE* did print photographs of poverty to advertise its camera eye. See "The South of Erskine Caldwell Is Photographed by Margaret Bourke-White," *LIFE*, November 22, 1937, 48–52; "Speaking of Pictures . . . These by *LIFE* Prove Facts in 'Grapes of Wrath,'" *LIFE*, February 19, 1940, 10–12.

45. Exceptions include "Negroes: The U.S. Also Has a Minority Problem" in October 1938; Wainwright, *Great American Magazine*, 100. Photo stories were degrading: an image of an African-American man with his mouth spread wide by golf balls, February 27, 1939; and a cover story on watermelon farming featuring the backside of a black man and inside pictures of a "pickaninny" eating watermelon, August 9, 1937. Lynchings and black-on-black crime appeared as spectacle, April 26, 1937.

46. Based on *LIFE* from November of 1936 through December of 1937. For "Newsfront," see Wainwright, *American Magazine*, 75. On Luce and organized labor, Wainwright, *American Magazine*, 8.

47. Luce Memo to staff, March 1937, Wainwright, *American Magazine*, 92.

48. *LIFE*, March 15, 1937, 4–5.

49. *LIFE*, January 18, 1937; Karen Lucic, *Charles Sheeler and the Cult of the Machine* (London: Reaktion Press, 1991); and Naomi Rosenblum, *A World History of Photography*, 3rd ed. (New York: Abbeville Press, 1997), 460.

50. Stephen Norwood, *Strike-Breaking and Intimidation: Mercenaries and Masculinity in Twentieth Century America* (Chapel Hill: University of North Carolina Press, 2002), 4.

51. *LIFE*, January 18, 1937, 9.

52. Maren Stange, *Symbols of Ideal Life: Social Documentary Photography in America, 1890–1950* (Cambridge: Cambridge University Press, 1989). David Nye, *Image Worlds: Corporate Identities at General Electric, 1890–1930* (Cambridge, Mass.: MIT Press, 1985), 55, 63–69.

53. *LIFE*, January 18, 1937, 10–11.

54. For portraiture's authority, see Richard Brilliant, *Portraiture* (London: Reaktion Books, 1991), 10–11; and Alan Trachtenberg, *Reading American Photographs: Images as History, Mathew Brady to Walker Evans* (New York: Hill and Wang, 1989), 21–52.

55. *LIFE*, January 18, 1937, 12–13.

56. Henry Kraus, *The Many and the Few: A Chronicle of the Dynamic Auto Workers* (1947; Urbana: University of Illinois Press, 1985), 88–97.

57. *LIFE*, January 18, 1937, 14–15; Kozol, *LIFE's America*, 32.

58. For discourse linking women and consumption, Helen Damon Moore's *Magazine's for the Millions*, 12, 147, 155, 192; and Roland Marchand, *Advertising the American Dream: Making Way for Modernity* (Berkeley: University of California Press, 1985), 117–205.

59. Kozol argues that *LIFE* depicted strikes as "anarchic and un-American," *LIFE's America*, 32.

60. *LIFE*, March 22, 1937, 72–73. See, too, "*LIFE* Goes to a Party in General Electric's Big Turbine Shop in Schenectady," *LIFE*, February 7, 1938, 62–65.

61. *LIFE*, March 22, 1937, 74–75.

62. Dana Frank, "Girl Strikers Occupy Chain Store, Win Big: The Detroit Woolworth's Strike of 1937," in Howard Zinn, Dana Frank, and Robin D. G. Kelley, *Three Strikes: Miners, Musicians, Salesgirls, and the Fighting Spirit of Labor's Last Century* (Boston: Beacon Press, 2001), 61–2, 92–95, 110, 113–115. Dorothy Sue Cobble, "Visions of Equality: The Lost Origins of the New Women's Movement," *Labor's Heritage* 12, no. 1 (Winter/Spring 2003): 6–23.

63. Sumsky, *LIFE*, November 22, 1937, 72; "Button King," April 26, 1937, 24; "Lie Down Strikes," *LIFE*, December 14, 1936, 36; for the maid strike, see *LIFE*, March 29, 1937. See also "Champaign Waltz," *LIFE*, January 18, 1937, 21, which compared a Hollywood movie still to a sit-down; and "lounging sailors" on a shipping strike, April 26, 1937, 25. Lewis, "Speaking of Pictures," May 3, 1937, 10–12.

64. *LIFE*, November 30, 1936, 15; and *LIFE*, February 1, 1937, 22–23.

65. *LIFE*, March 8, 1937, 17.

66. *LIFE*, September 26, 1938, 22–23; and, January 2, 1939, 14. Rickie Solinger examines how the "babe" managed women's complex transition from worker to wife in the postwar period. She argues women represented, even when sexualized, an innocence corresponding to the nation's good intentions, "The Smutty Side of *LIFE*: Picturing Babes as Icons of Gender Difference in the Early 1950s," in Doss, *Looking*, 202–206.

67. *Collier's* censured labor's activism, claiming "public opinion" as its standard. The family magazine offered little coverage of socioeconomic issues and ignored anti-union violence. During the winter of 1937 stories appeared on skiing every single week, but in all of 1937 there was only one story on unionization. Photos were rare in *Collier's*; and there were few of labor's uprising. To the *Saturday Evening Post* the sit-down was leading America down the Hobbesian path of might is right. The few photos the *Post* ran were evidentiary-style photos to condemn labor. The *Post* attacked class tensions

while maintaining America was classless. It ran stories on Henry Ford and a series on Walter Chrysler titled the "Life of an American Workman." *LOOK* ignored the sit-down strike, with the exception of one photo of Mahatma Gandhi "Father of Sit-Down Strikers." *LOOK*, May 11, 1937.

 LIFE often combined approaches. For example, in 1941 *LIFE*'s "Picture of the Week" feature showed Detroit auto workers recreating a sit-down in their Labor Day parade with broad grins across their faces, but the accompanying text told readers that 20,000 machine guns, a thousand fighter planes, and 800 tanks were lost from strikes. September 15, 1941, 37.

68. Michael Denning, *Culture Front: The Laboring of American Culture in the Twentieth Century* (New York: Verso, 1997), 83–85; Brinkley, *Publisher*, 160–165.

69. Alan Brinkley, *The End of Reform: New Deal Liberalism in Recession and War* (New York: Vintage Books, 1995), 15–32. William Leuchtenberg, *Franklin D. Roosevelt and the New Deal, 1932–1940* (New York: Harper Torch Books, 1963), 261. On the AFL, see Edward Levinson, *Labor on the March*, with an introduction by Robert Zieger (1938; Ithaca: ILR Press, 1995), 179–186; and Kraus, *Many and the Few*, 120–121. Also Baughman, *Henry R. Luce*, 107–108.

70. *LIFE*, February 15, 1937, 16–17.

71. Kraus, *Many and the Few*, 129–145; Mary Heaton Vorse, "The Emergency Brigade at Flint" in *Rebel Pen: The Writings of Mary Heaton Vorse*, edited by Dee Garrison (New York: Monthly Review Press, 1985), 182.

72. *LIFE*, April 5, 1937, 13–21; for NAM, see chapter 3 on the Hershey strike.

73. John Tagg, *The Burden of Representation: Essays on Photographies and Histories* (Amherst: University of Massachusetts Press, 1988), 97–98.

74. *LIFE*, January 25, 1937, 18–19.

75. *LIFE*, April 19, 1937, 24–25.

76. Bernstein, *The Turbulent Years: A History of the American Worker, 1933–1941* (Boston: Houghton Mifflin, 1970), 444–446.

77. *LIFE*, August 8, 1938, 11–15.

78. Rosemary Feuer, *Radical Unionism in the Midwest, 1900–1950* (Champaign: University of Illinois Press, 2006), 87–103, offers a thoughtful analysis of how local CP leadership of the UE galvanized a class-conscious unionism that demanded "human rights" for determination of work rights, but also control over the contours of community life—even as the national CIO ignored such possibilities.

79. *LIFE*, May 2, 1938, 13; July 4, 1938; August 1, 1938; January 3, 1938, 15; May 29, 1939, 26; "Storekeeper Queen Bites a Customer's Wrist," May 24, 1937, 27.

80. "Public Loses Patience," August 14, 1939, 11.

81. *LIFE*, June 28, 1937, 28–29.

82. Ibid.; Bernstein, *Turbulent Years*, 478–497. See Carl Mydans's photo of "Bill Benninghof, open hearth slagger," in "Weir's Weirton: A West Virginia Steel Town with a Difference," *LIFE*, September 13, 1937, 36; and "'It's Wheeling Steel': A New Way to Use Radio," *LIFE*, March 21, 1938, 28–29.

83. *LIFE*, July 5, 1937, 16; and Vorse, "Steel Strike," *Rebel Pen*, 202–203.

84. Norwood, *Strike-Breaking*, 3–4. Contemporary accounts include Paul Strand and Leo Hurwitz, *Native Land*, Frontier Films, 1942; reports by Mary Heaton Vorse, in *Rebel Pen*; and Edward Levinson, *I Break Strikes: The Technique of Pearl L. Bergoff* (New York: R. M. McBride, 1935).

85. Norwood, *Strike-Breaking*, 171–193.

86. *LIFE*, July 19, 1937, 26; *Nation* June 12, 1937, 662–663.

87. *LIFE*, July 12, 1937, 72–73.

88. See also "Senate Rattles Bones of 1935 Strike," *LIFE*, August 1, 1938, 20.

89. "Ford and Textiles to Be Wagnerized," *LIFE*, April 21, 1937, 21.

90. Cedric Fowler, Asst. Publicity Dir. to Miss. Jean Potter, September 28, 1937, b91f9 in CIO Central Office Correspondence, Catholic University of America (*CUA*). In late August of 1936, Brophy, then a CIO director, was encouraging about a CIO profile to editor Russell Davenport, but unhappy about a John Jessup biographical portrait of John L. Lewis. John Brophy to Russell Davenport, August 27, 1936, b91f6; and response August 30, 1936, b91f5. For Brophy's irritation with Lewis biography, see John Brophy to John Jessup, August 22, 1936, in b91f3 and August 28, 1936, b91f7. For unwillingness to respond to Girdler, see Davenport to John Lewis, November 19, 1937, and the reply, Ralph Hetzel to Russell Davenport, December 10, 1937, b91f9, all in CIO Central Office Correspondence, *CUA*.

91. *LIFE*'s "Letter to the Editors" and "Pictures to the Editors" section offered a paltry response to its labor coverage. "Alcoa Affair," *LIFE*, August 3, 1937, 79; "She Speaks for Herself," September 4, 1939, 2.

92. Olivier Zunz, *Why the American Century?* (Chicago: University of Chicago Press, 1998), xi–xii; "The American Century," *LIFE*, February 15, 1941.

93. For Alger, see Warren Susman, *Culture as History*, 244, 132. On working-class culture and film, Robert Sklar, *Movie-Made America: A Cultural History of American Movies*, revised (New York: Vintage Books, 1994), 16–32; and Lea Jacobs, *The Wages of Sin: Censorship and the Fallen Woman Film, 1928–1942* (Madison: University of Wisconsin Press, 1991). For advertisers, see Marchand, *Advertising the American Dream*, 300.

94. "The Common Steel Worker Gets His Pay Raised to $5 a Day," *LIFE*, March 15, 1937, 13–21. SWOC may have worked with editors on the story. I. Van Meter, editor's assistant, offered a "Hearty thanks for your valued assistance in the preparation of our report on the steel industry" to John Brophy. Letter, March 10, 1937, CIO collection b101f10, *CUA*.

95. "Common Steel Worker," 14–15; Guimond, *American Photography*, 160–161.

96. For Perkins, see Bernstein, *Turbulent Years*, 434.

97. "Common Steel Worker," 18–19.

98. For Luce and the powerful, Swanberg, *Luce*, 81–82. For attacks on Lewis, see "John L. Lewis Wins a Big Labor Victory: But Strife-Torn Labor Is Losing the Public's Sympathy" May 22, 1939, 20; and "Feuds of American Labor Leaders Imperil Both Labor and National Defense," *LIFE*, December 2, 1940, 23–29.

99. Leuchtenberg, *Franklin D. Roosevelt*, 177.

100. Zieger, *CIO*, 59, 79; for Weir see Arthur Schlesinger, *Coming of the New Deal*, 404. For Weirton's red-baiting, see June 18th, 1937, leaflet to Weirton Employees, in CIO National and International Union Series, b19f8, and "The Weir Formula," the CIO response, in CIO National and International Union Series, b19f17, *CUA*.

101. Bernstein, *Turbulent Years*, 470.

102. "Common Steel Worker," 20–21.

103. Margaret Bourke-White, *Portrait of Myself* (Boston: G. K. Hall, 1985).

104. "Great and Good Union," *LIFE*, August 1, 1938, 42–53.

105. Alexander Alland et al., *Reframing America* (Tucson, Ariz.: Center for Creative Photography, 1995), 30; Loengard, *LIFE Photographers*, 59; Anne Loftis, *Witnesses to the Struggle: Imaging the 1930s California Labor Movement* (Reno: University of Nevada Press, 1998), 28.

106. "Great and Good," 42–43.

107. Zieger, *CIO*, 115–116, reports workers' ambiguous attitudes toward activism and leadership; polls still registered workers with more liberal opinions than other classes.

108. Katherine Kish Sklar, *Florence Kelley and the Nation's Work* (New Haven, Conn.: Yale University Press, 1995); and Annaliese Orleck, *Common Sense and a Little Fire: Women and Working-Class Politics in the United States, 1900–1965* (Chapel Hill: University of North Carolina Press, 1995).

109. "Great and Good," 46–47.

110. Ibid., 48–51.

111. Robert Parmet, *The Master of Seventh Avenue: David Dubinsky and the American Labor Movement* (New York: New York University Press, 2005), 1, 4, 9, 15.

112. "Great and Good," 52–53. Dubinsky's ILG rejoined the AFL in 1939. Steven Fraser, *Labor Will Rule: Sidney Hillman and the Rise of American Labor* (Ithaca, N.Y.: Cornell University Press, 1991), 341–342, 372, 438–439.

113. Colin Gordon, *New Deals: Business, Labor and Politics in America, 1920–1935* (Cambridge: Cambridge University Press, 1994); Nelson Lichtenstein, *State of the Union: A Century of American Labor* (Princeton, N.J.: Princeton University Press, 2002); and Fraser, *Labor Will Rule*.

114. Dubinsky claimed the story brought the union an enthusiastic "flood of letters and telegrams at national headquarters." Writers to *LIFE* thought Dubinsky a "tremendous force for peace and advancement." One letter to the editor astutely noted that *LIFE*'s "magnificent saga of a labor union" could not be produced in Hollywood given the Hays Office's constraints on labor in film; *LIFE*, August 23, 1938, 6.

115. "Ivory Tower Editors," *LIFE*, June 5, 1939; "Ford Worker," *LIFE*, June 28, 1937, 6–7.

116. Fraser, *Labor Will Rule*, 276, 432–433; Zieger, *CIO*, 107–109.

117. Zieger, *CIO*, 129–190; additional *LIFE* promotion of Hillman on March 10, 1941, and March 24, 1941.

118. *LIFE*, August 25, 1941, 64–71.

119. Murray was a loyalist, who Lewis treated poorly. Zieger, *CIO*, 59, 110, 135–139.

120. *LIFE*, August 25, 1941, 66–67.

121. *LIFE* painted unions as responsible for violence from March of 1937. *LIFE*, "Bethlehem Steel Strike Poses Tough Problem of Defense Labor Disputes," March 10, 1941, 34–35; "Public Anger at Labor Leaders Rises as Strikes Delay Defense Production," April 7, 1941, 19–25; "New Strike Battles Bring Threat of Federal Action," April 14, 1941, 30; "President Roosevelt Breaks a Red Strike," June 23, 1941, 32–34; and "Lewis Calls Off His Coal-Mine Strike in Response to President's Final Plea," December 1, 1941, 25–27.

122. Norwood, *Strike-Breaking*, 190.

123. Some scholars sustain John Lewis's stance of this Faustian bargain. Nelson Lichtenstein, *Labor's War at Home: The CIO in World War II* (Cambridge: Cambridge University Press, 1982). Others argue unions required government support. David Brody, *Workers in Industrial America: Essays in Twentieth Century Struggle* (Oxford: Oxford University Press, 1980), 136. See also Christopher Tomlins, "AFL Unions in the 1930s:

Their Performance in Historical Perspective," *Journal of American History* 65 (March 1979): 1021–1042; Joshua Freeman, "Delivering the Goods: Industrial Unionism During WWII," *Labor History* 19, no. 4 (1978): 570–559; David Montgomery, "Labor and the Political Leadership of New Deal America," *International Review of Social History* 39 (1994): 335–360; and Nelson Lichtenstein, *The State of the Union: A Century of American Labor* (Princeton, N.J.: Princeton University Press, 2002), 64–67.

124. "The Workers Show Spirit," *LIFE*, October 12, 1942, 106–107; "The Douglas Aircraft Day Shift," March 2, 1942, 27; and "Manpower," October 26, 1942, 29–35.

Chapter 3

1. Senator Paul Shafer, Michigan, 75th Cong., 1st sess., *Congressional Record*, April 19, 1937. National Association of Manufacturers papers, s7b140f "strikes," the Hagley Archive (hereafter *NAM papers*).

2. R. Eugene Harper, "Bittersweet Experience: Hershey, Pennsylvania as a Paternalistic, Industrial New Town," *Journal of the West Virginia Historical Association* 10, no. 1 (1986): 34–51, examines the events from a local perspective. Michael D'Antonio, *Hershey: Milton S. Hershey's Extraordinary Life of Wealth, Empire, and Utopia* (New York: Simon and Schuster, 2006), 218–219, discusses the strike but ignores anti-union propaganda.

3. Charles Lobdell, "Barefoot," *Liberty Magazine*, September 13, 1924. b2f53, Alexander Stoddart Files. *Hershey Community Archive* (hereafter *Stoddart, HCA*). Stoddart was Hershey's corporate public relations officer. He relied on hundreds of meticulously organized concepts and anecdotes, such as "M.S. Hershey jokes" or "Hershey, M.S.— Likes a glass of beer once in a while." Hershey's nephew Joseph Snavely wrote *Milton S. Hershey, Builder* (1935) and *An Intimate Story of Milton S. Hershey* (1957). See also Charles Schuyler Castner, *One of a Kind: Milton Snavely Hershey, 1857–1945* (Hershey, Pa.: Derry Literary Guild, 1983); and Samuel Hinkle, *Hershey: Farsighted Confectioner, Famous Chocolate, Fine Community* (New York: Newcomen Society, 1964).

Mass-market coverage of the Hershey story seemed unchanging over three decades. See "Mr. Hershey Gives His Fortune Away," *Fortune*, September 1933; John Oliver La Gorce, "Penn's Land of Modern Miracles," *National Geographic* 68, no. 1 (July 1935): 1–58; "Hotel Hershey 'Best in USA for Comfort, Good Taste and Value," *American Business*, July 20, 1935; "Model Community of Hershey Fruit of a Millionaire Idealist's Dream," *Philadelphia Inquirer*, July 15, 1934; "A Pennsylvanian's Gift to Orphan Boys," *The Baltimore Sun*, December 30, 1934. Radio broadcasts include "Interviews with Farm Champions," Firestone Voice of the Farm, n.d. (about 1938); b2f53 *Stoddart, HCA*. Map write-ups include "Esso Tours Says Hershey Is 'One of the World's Most Interesting Industrial Communities,'" February 8, 1936, b2f43, *Stoddart, HCA*. Ira and George Gershwin's "They All Laughed," written in 1937, references Hershey's chocolate bars. See www.songwritershalloffame.org/exhibits/c70, accessed on January 18, 2012. Kevin Burns and Lawrence Williams produced an A&E Entertainment video on Hershey, *Milton Hershey: The Chocolate King*, 1995. Most ironic is the Hershey store in New York's Times Square, where one can visit for a "one-of-a-kind interactive experience in sweetness," which could have graced one of the marquees in the old Times Square; www.hersheys.com/discover/timessquare.asp. For an analysis of corporate

towns that "sell," see Mark Weiner, "We Are What We Eat: or, Democracy, Community, and the Politics of Corporate Food Displays," *American Quarterly* 46, no. 2 (June 1994): 227–250.

4. Hinkle, *Farsighted Confectioner*, 8; and *New York Herald* clipping, n.d., Stoddart, HCA, b2f51; Lobdell, "Barefoot"; "Hershey Park," and "How Hershey Park Was Founded," Stoddart, HCA, b2f58; "Co-operative Enterprise," Stoddart, HCA, b2f55.

5. "For Frank Finney's Book," n.d., b1f67; and Hershey Park Brochure, 1940, both b1f63, Stoddart, HCA; see also *House and Garden* article in September of 1946, Stoddart, HCA, b1f72; Hinkle, *Farsighted Confectioner*, 8–10. Snavely, *Meet Mr. Hershey* (1939); *America's Recreation Center: Hershey, the Chocolate Town, Souvenir Commemorating 30th Anniversary* (Hershey, Pa.: Hershey Chocolate Corporation, 1933), 1.

6. Paul Gallico, "$80,000,000 Worth of Orphans," *American Weekly*, December 23, 1945, 12–15, in Stoddart, HCA, b2f47; Snavely, *Meet Mr. Hershey*, 6; and Hinkle, *Farsighted Confectioner*, 10.

7. For company towns, see Jacqueline Dowd Hall et al., *Like a Family: The Making of a Southern Cotton Mill Town* (New York: W. W. Norton, 1987), 114–180; and Janice Reiff, "Rethinking Pullman: Urban Space and Working-Class Activism," *Social Science History* 24, no. 1 (Spring 2000): 7–32. Snavely, *Meet Mr. Hershey*, 16–17, "Hershey Biography," n.d., b2f53, Stoddart, HCA; Lobdell, "Barefoot."

8. Publicity anecdotes b2f55 and b2f53, Stoddart, HCA; Victor Henderson, "Model Community of Hershey Fruit of a Millionaire Idealist's Dream," *Philadelphia Inquirer*, July 15, 1934, in b2f62, Stoddart, HCA; and Hershey Biography, *Practical Knowledge*, 1944 or 1945, b1f67, Stoddart, HCA.

9. "A Brief Description of the Hershey Industrial School," n.d. (approximately 1934), Herco.002 B1f79. Neva Deardorff, "The New Pied Pipers," *Survey Graphic* (1924): 31–35. "Hershey Biography," b1f67, Stoddart, HCA.

10. Interview, Samuel Hinkle. September 19, 1960, Oral History 91OH01, 5 HCA; interview with A. P. Heilman, February 23, 1954, b2f108, Wallace Lenz File, HCA. For striker, see Interview, Rose Gasper, September 22, 1992, Oral History 92OH35, 16; and Interview, Frank Simione, January 19, 1993, Oral History 92OH02, 13, both HCA.

11. Susan Strasser, *Satisfaction Guaranteed: The Making of the American Mass Market* (New York: Pantheon Books: 1989), 6, 10, 12, 19; "AP interview," b2f59, Stoddart, HCA; Hinkle, *Farsighted Confectioner*, 11; "Mr. Hershey," *Fortune*, 72.

12. Hershey bought farms under cover, Heilman interview; "Never Felt Need to Advertise," *Advertising Age* (December 1948); HERCO.0002, b2.

13. *Reading Railroad Magazine*, August 1947, b2f48, Stoddart, HCA; for development in Hershey, Cuba, see P. A. Staples biography; and *Business Week*, n.d. (approximately 1947), b1f42, Stoddart, HCA; "Mr. Hershey," *Fortune*, 72, 74.

14. Hershey hired an ad agency after WWII, "Never Felt," *Advertising Age*; "William F. R. Murrie Retires," March 22,1947, HERCO.0002 b1f33. For Hershey's consumption, *Cosmopolitan*, October 1949, b2f43, Stoddart, HCA.

15. "A Kiss for You," Hershey Foods Corporation, 1991, in author's possession. Now part of a Dart Flipcards Inc. trading cards set, which quotes Hershey ephemera prices, attesting to Americans brand identification.

16. Strasser argues that branding and fully coordinated marketing strategies were rare through 1900. Hershey's recipe books and public histories, *The Story of Chocolate and*

Cocoa, and his use of testimonial experts and packaging innovations like the kiss place him in the vanguard of mass consumer industries. Companies often chose sentimental, nostalgic imagery or modern production processes for sales. Hershey mixed both. Strasser, *Satisfaction Guaranteed*, 30–57, 97–123. Hershey Trading Cards: the Collector's Series, nos. 31, 34, 55, and 50 and postcard from Scenic Arts, Inc., and *The Story of Chocolate and Cocoa* (Hershey, Pa.: Hershey Chocolate Corporation, 1926), cover, in author's possession. Postcards in *Stoddart, HCA*, and HERCO.002 b2; and clipping in b2f108.

17. Hershey Chocolate Company, "A Cookery Expert's New Recipes," n.d., in author's possession.

18. *The Story of Chocolate*, inside cover.

19. See pc133, t96.33, 1915–1920; pc565, t96.59; and pc572, t96.36, *Stoddart, HCA*.

20. HERCO.002 b1f49, *Stoddart, HCA*; "Back to Land Plan Evolved for Welfare of Employees," b2f53, *Stoddart, HCA*; Article for *Greyhound Lines*, n.d., b1f66, *Stoddart, HCA*.

21. Image from "Hershey Park Brochure," 1940, b1f63, *Stoddart, HCA*.

22. Curtiss Demmy, Middletown Press, n.d., HERCO b1f40. And "How Hershey Park Was Founded," b2f58, *Stoddart, HCA*. The Hershey Community Archives' *Hershey Chronology 1724–1992* is helpful here; and "Murrie Retires," b1f33, *Stoddart, HCA*.

23. "Visitors the World Over Come to Hershey to See Chocolate Made," b2f16 and b1f51, *Stoddart, HCA*; *Lancaster Motorist*, n.d., b1f49, *Stoddart, HCA*. For Hershey Park profitability, see "Schedule B—1924: Statement of Profit and Loss," b15f4, accession #87006; and Arthur Anderson: "Report on Examination of Various Departments," December 31, 1945, in b3, *William Crouse Papers*, Hershey Estates, *HCA* (hereafter *Crouse, HCA*).

24. "Mr. Hershey," *Fortune*, 76; *American Business World*, December 1, 1930, b4, HTC.001, *Crouse, HCA*; and Interview, Samuel Tancredi, July, 30, 1990, Oral History 90OH18, 11, *HCA*.

25. *The Story of Chocolate*, cover.

26. Ibid., 2.

27. The aerial shot appeared as a cover photo for the thirty-year commemorative booklet, *America's Recreation Center*, along with mass media stories of the 1930s.

28. Hinkle, *Farsighted Confectioner*, 16; David Nye, *Image Worlds: Corporate Identities at General Electric, 1890–1930* (Cambridge, Mass.: MIT Press, 1985), 55, 66–69.

29. "Mr. Hershey," *Fortune*, 80, claimed that Hershey's control sapped community self-reliance; such criticism was unusual.

30. Harold Fey, "Chocolate Paradise Lost," *Christian Century*, April 28, 1937, 549.

31. A. P. Heilman, plant superintendent, called Hershey "economical." Interview, February 23, 1954, 4 *HCA*. Samuel Tancredi, the tabulating department supervisor, had access to Pennsylvania wage rates, S. Tancredi, 18, 20; and Interview, Edward Tancredi, November 8, 1991, 91OH27, 21; Interview, Theodore Mandes, April 23, 1991, Oral History 91OH09, 10, both *HCA*, stated employees worked only two or three days a week during the Depression.

32. Interview with Warren Plebani and Stearl Sponaugle by Alice Hoffman, March 14, 1974, 6, in Penn State University, Historical Collections and Labor Archive (hereafter *PSU*).

33. Letter to Milton Hershey from a "Hershey Citizen," March 14, 1937, HTC.001, *HCA*; Plebani and Sponaugle, 5–5A; Workers believed they had nowhere to take wage

discrepancy complaints. Interview, Paul Miller, November 25, 1992, 92OH46, 6–7, *HCA*; Gasper, 5; S. Tancredi, 21; and E. Tancredi, 21–22.

34. Interview, Alda Garosi Walenkiewicz, November 15, 1989, 89OH26, Oral History, n.p., *HCA*. Workers remember Italians sheltered in boxcars in early Hershey. For occupational segmentation, see Miller, 10, 13; and "Chocolate Paradise Lost," *Christian Century*, 549. For anti-Italian actions, see E Tancredi, 21; Plebani, 3; E. Tancredi, 8, remembers the KKK burning crosses in nearby fields during his youth. For "sweatshops," see Ignzaio Romanucci, Interview by Peter Smith, n.d., 2, 6–7, *PSU*: and Plebani and Spaunagle, 6.

35. S. Tancredi, 11, *HCA*; Romanucci, 17–18.

36. Plebani and Sponaugle, 4–7; Lawrence Pellegrini said that as a "stipulation" of employment, workers had to move to Hershey, Interview, December 8, 1992, 92OH49, Oral History,18, *HCA*; Romanucci, 17; Harold Fey, *Christian Century*, May 19, 1937, 653.

37. For the firing of workers, see Romanucci, 17–20; and Plebani and Sponaugle, 3–4. For "secret marriages," see Interview, Richard Uhrich, June 8, 1989, 89OH02, Oral History, 10, *HCA*. Also John Elting, "Trouble in Paradise: Why Hershey Workers Want a Union," *Forbes*, May 1, 1937, 14–15. Workers "tattled" about employee behavior during the strike, b32, HTC001, *Ezra Hershey Papers, HCA*; Hinkle interview, 20.

38. Hinkle became the company's president and chairman of the board, Hinkle, 20; Fey, "Chocolate Paradise," 549. He maintained that 70 percent of the workers found annual membership rates too high. Romanucci, 22, and Elting, "Trouble in Paradise," 14.

39. Fey, "Chocolate Paradise," 549; Simione, 15; Mandes, 10; Romanucci, 7; Plebani and Sponaugle, 6, and Garosi Walenkiewicz, n.p. Managers concurred, see Hinkle, 20.

40. Some 1700–1800 workers signed up. Plebani and Sponaugle, 9; Romanucci, 7–13; and "Sit-Down Strike," b2f100, *Stoddart, HCA*.

41. Plebani and Sponaugle, 15–16; Romanucci, 22. Samuel Tancredi remembers an *Inquirer*'s photogravure story with the same effect. S. Tancredi, 22. Other workers were irked that orphans' weekly allowance of 25 cents was more discretionary income than they had. E. Tancredi, 16.

42. E. Tancredi, 21; S. Tancredi, 32–33; Simione, 15; Plebani and Sponaugle, 8; Fey, "Chocolate Paradise," 47; and Hinkle, 21.

43. Plant superintendent A. P. Heilman, his assistant Clarence Speicher, plant engineer Bowman Snavely, and the employment manager John Zoll all fought the union. Hershey then fired the company's attorney, who urged signing with the union. Interview with John Zoll and Clarence Speicher, March 22, 1955, *John Zoll papers, HCA*. Others remember Krause being fired over the question of wages. Uhrich, 17B; and Hinkle, 7; and "Sit-Down Strike" *Stoddart*, b2 f100, *HCA*.

44. Plebani and Sponaugle, 8.

45. Ibid., 8–10; and Romanucci, 9; Uhrich, 11.

46. Edward Tancredi, 20; Plebani and Sponaugle, 12; Uhrich, 11; and Simione, 16–18; picture from local paper "Chocolate Strikers Hold 'Candy Fort," n.d., from scrapbook, Derry Township Historical Society (hereafter *DTHS*), and Gasper, 15, *HCA*; Interview, B. Francis Gorman, March 12, 1990, 90OH03, Oral History, 17, *HCA*.

47. News clipping, *Evening News*, n.d., *DTHS*.

48. Miller, 7; and "Sit Down Strike Is a Strike Against Orphan Boys"; S. Tancredi, 23. Townspeople perceived the conflict in ethnic terms. April 5, 1937, HTC.001. The union

negotiating committee was one-third Italian. "Big Chocolate Plant Is Closed by Sit-Down," news clippings, *DTHS*.

49. *Harrisburg Patriot*, April 8, 1937, 11; and *Evening News*, n.d., *Patriot*, n.d., and *Harrisburg Telegraph*, April 8, 1937, 1, *DTHS*.

50. *Harrisburg Evening News*, April 6, 1937; April 7, 1937, 1; *Patriot*, n.d.; and *Telegraph*, April 7, 1937, *DTHS*.

51. American Legion Hershey Post No. 368 led the parade, *Harrisburg Evening News*, April 7, 1937, 11; *Patriot*, April 8, 1937, 10, *DTHS*. See Uhrich, 11; and Hinkle, 7; Romanucci, 13; and Plebani and Sponaugle, 13.

52. Romanucci, 13; Plebani and Sponaugle, 13; Interview of Ralph Hoar, 21, on May 24, 1991, 91OH16, *HCA*; Simione, 17–19; Ulrich 11–12; and Gasper, 16.

53. Interview, Elwood Myers, July 20, 1976, 17, 91OH18, *HCA*; Romanucci, 5. The *Harrisburg Evening News*. April 7, 1937 reported the CIO's commitment to letting the milk division continue operations, 11; E. Tancredi, 22; S. Tancredi, 27; Plebani and Sponaugle, 4; and *Harrisburg Evening News*, n.d. (most likely April 5 or 6, 1937), 1, clipping, *DTHS*.

54. *Harrisburg Patriot*, 11; and *Harrisburg Telegraph*, April 7, 1937, 1. Leaflet, "Is Hallman a Stooge," Scrapbooks, HECO.0001; Miller, 10; and Romanucci, 5; *Harrisburg Evening News*, n.d., 1, *DTHS*.

55. E. Tancredi, 21; Romanucci, 5. Local news photographs are not definitive, though the men with weapons who did the beating looked like "roughs," with their caps, fedoras and tight jackets more than the Mennonite farmers they were reported to be. A fuller study might take up the question of local news coverage in contrast to national coverage; *Harrisburg Patriot*, April 7, 1937, 10 and April 8, 1938, 1, 10; and *Harrisburg Telegraph*, April 7, 1937, *DTHS*. On Estates workers' participation, Miller, 10; and Gasper, 15.

56. Managers kept one laboratory worker inside until the moment before the strikers came in. Myers, 17; Miller, 10, *HCA*; Police Constabulary in Stephen Norwood, *Strike-Breaking and Intimidation: Mercenaries and Masculinity in Twentieth Century America* (Chapel Hill: University of North Carolina Press, 2002), 120–127; *The Patriot*, April 8, 1937, 1, 10–11; *Harrisburg Telegram*, April 7, 1937, 1; *DTHS*; and Simione, 19.

57. Sponaugle and Plebani, 13; *Harrisburg Patriot*, April 8, 1937, 1, 10, *DTHS*.

58. Hinkle, 21, *HCA*; Zoll interview; on letter added to April 12, 1937 agreement between Hershey Chocolate Company and the United Chocolate Workers of America, b4f5, HTC.0001, *Crouse, HCA*.

59. Hinkle, 8; "Dear Fellow Worker," and "To Employees of the Hershey Chocolate Company," in "Scrapbooks," HERCO.001, *HCA*; "The Man Behind the Hershey Bar," Hinkle interview, and b20 HTC.001, Ezra Hershey Strike Papers.

60. Romanucci, 5, 3; Plebani and Sponaugle, 26, 17–18, 28–29.

61. Hinkle, 8. Romanucci claimed hundreds were fired and that during WWII Hershey fired Italian and German workers wholesale. The AFL allowed a contract provision that U.S. citizens would be employed, 9–10; Donations for 1938, b145 Ledger II Vol. IV, 107, *HCA*.

62. "Employees of M.S. Hershey Celebrate his 80th Birthday Anniversary with Party at Arena," September 18, 1937, b2f54 HERCO.002, *Stoddart, HCA*; Simione, 19–20; and E Tancredi, 22. S. Tancredi, 21; and Gaspar, 20; *The Patriot*, April 8, 1937, 10.

63. Hinkle, 7.

64. Romanucci, 7, claimed Hershey was a NAM member, but I've found no independent confirmation in the Hershey Archives or the NAM papers. For NAM's resistance to unions, see Richard Tedlow, *Keeping the Corporate Image, Public Relations and Business* (Greenwich: JAI Press, 1979), 60–61; David Brody, *Workers in Industrial America: Essays on the Twentieth Century Struggle* (New York: Oxford University Press, 1980), 25–27; and to the National Labor Relations Act, Steve Fraser and Gary Gerstle, *The Rise and Fall of the New Deal Order, 1930–1980* (Princeton, N.J.: Princeton University Press, 1989), 134.

65. "The Engineering of Consent," *The Annals of the American Academy of Political and Social Science*, 250 (March 1947): 113–120; and Edward Bernays, *Biography of an Idea: Memoirs of a Public Relations Counsel* (New York: Simon and Schuster, 1965), 377–394.

66. Tedlow, *Keeping the Corporate Image*, 60, 62–63; and Stuart Ewen, *PR!: A Social History of Spin* (New York: Basic Books, 1996), 301; Senate Committee on Education and Labor, *Investigation on Labor Policies of Employers' Associations*, Part III, Report no. 6, part 6, "The National Association of Manufacturers," 76th Cong., 1st sess., August 14, 1939, 220 (hereafter "NAM Report"). For contributors from 1933–1937, see "NAM Report," 247–255.

67. "Community Public Information Programs to combat Radical Tendencies and Present the Constructive Story of Industry." See "NAM Report," 281; James Selvage, s1Xb150f "1937 Committee Reports"; and William Warner, Board Meeting, January 22, 1937, s13b199, all *NAM papers*.

68. By February NAM advocated state legislation defining the "right to work," and "prohibiting intimidation," Board Minutes, February 17, 1937, s13b199; and Release, April 22, 1937, s13b199; Selvage, s1Xb150f "1937 Committee Reports," all *NAM papers*; Ewen, *PR!*, 303, 306–321; Tedlow, *Keeping*, 65. "Suggested Public Relations Program for Committee on Labor Management Problems," SIIIb844f "labor problems speech." See also W. B. Weisenburger to Ira Mosher, March 8, 1945, s7b125, *NAM papers*.

69. Rand was a member of the National Industrial Information Committee, founded by NAM to strengthen industry's public relations. "NAM Report": 243, Marc Steven Kolopsky, "Remington Rand Workers in the Tonowandas of Western New York, 1927–1956: A History of the Mohawk Valley Formula" (Ph.D. diss., State University of New York, Buffalo, 1986), 138. Senate Committee on Education and Labor, Violations of Free Speech, *Employers' Associations and 'Citizens' Committees*, Part 17, 75th Cong., 3rd sess., March 1938 (hereafter "Employers Associations"), 7950–7951.

70. The NLRB codified these tactics as "steps" in its decision against that company; Irving Bernstein, *The Turbulent Years: A History of the American Worker, 1933–1941* (Boston: Houghton Mifflin, 1970), 432–498, especially 478–480.

71. Labor historians have focused on the Little Steel Strike in May of 1937. Both Tedlow, *Keeping*, 59–79, and Ewen, *PR!*, 288–336, explore NAM's anti-unionism, without examining news photography.

72. "Employers Associations," Exhibit 3821; Edward Levinson, *I Break Strikes! The Technique of Pearl Bergoff* (New York: R. M. McBride, 1935); Norwood, *Strike-Breaking*, 65–69, 230–231.

73. From the decision of the NLRB in the Matter of Remington Rand, Inc., and the Remington Rand Joint Protective Board of the District Council Office Equipment Workers Case No. C-145 as quoted in "Employer Associations," Exhibits 3861 and 2821, 7972. Kolopsky, "Remington Rand Workers," 217.

74. "Employer Associations," 7966–7968; and "National Manufacturers Urge End of Labor Violence: That Unions Be Made Responsible," Press Release, June 30, 1937, s13b199, *NAM papers.*

75. The sixteen-page, three-color pamphlet "Civil War in Hersheytown" is archived at the Hershey Community Archives and Senator Robert La Follette's Committee Files at the National Archives, 50.25. It reprints a May 1937 *Mill and Factory* article. Samuel Tancredi termed it "hate material," 23. For *Mill and Factory*'s NAM membership, see title page. For *Mill and Factory* at Weirton, and its asserted circulation, see "What Tragedy," *TIME,* December 13, 1937.

76. "Civil War," 5. Barclay became a *New York Times* business writer, and his career path from journalism and managerial consultant to public relations was quite typical. *New York Times,* November 14, 1978, B19.

77. "Civil War," 3.

78. Ibid., 7.

79. Ibid., 8. Houses were shot from below, exaggerating their height.

80. Ibid., 9.

81. "Never touched by human hands," see Commonwealth of Pennsylvania, Department of Internal Affairs, 10, no. 1 (December 1941): 15; and *"Department Store Selling,"* n.d., *Stoddart, HCA,* b1f49.

82. "Civil War," 4.

83. Ibid., 12, 13.

84. Ibid., 16.

85. Ibid., 11.

86. Ibid., 11, 16; and clipping, *DTHS.*

87. "Civil War," 13.

88. Ibid., 2–3, 13.

89. Ibid., 6. This dramatic angling line, a staple of war graphics, is seen in Civil War panoramic photographs and Currier & Ives prints. William C. Davis, *The Illustrated History of the Civil War* (Philadelphia: Courage Books, 1997). Returning WWI parades were often depicted this way, and 1930s strike photos used this composition.

90. "Civil War," 15.

91. Ibid., 1.

92. See the work of Art Young, Robert Minor, Max Becker, and John Sloan in Rebecca Zurier, *Art for the Masses (1911–1917): A Radical Magazine and Its Graphics* (New Haven, Conn.: Yale University Art Gallery, 1985), 82–135.

93. "Civil War," 16.

94. Ibid., 17, 4, 16.

95. Ben Frobes to Ezra Hershey, April 8, 1937, HTC.001, b32f5, Ezra Hershey Files.

96. NAM's National Industrial Council organized eighteen "Labor Relations Clinics." NAM Business Report, March 19–April 19, 1937, s13b199. William Warner to NAM Board, May 25, 1937, s13b199, *NAM papers.* NAM fought the NLRA, then pursued overturning it. They used the sit-down to attack the NLRA. "Law Department to NAM Board of Directors," May 13, 1937; letter from "executive vice president of the National Industrial Council," January 27, 1937, s7B140f "picketing"; and Labor Relations Industrial Association of San Francisco, March 1937, in s7b140, "picketing." Also "Minutes of Employee Relations Bureau," February 12, 1937, s13b199, and February 17, 1938, s9B150f

"committee notes"; "press release," NAM, Nov. 19, 1938, in s7B143f "employee relations committee policy statements"; "Labor Union Responsibility," in s7b142f "employee relations committee policy, 1937"; "NAM Shows All Elements of Public Opinion in Opposition to Wagner Labor Law," March 26, 1939, and "Who Wants the Wagner Act Amended?" in s7b137f "employee relations-NLRA 1939," *NAM papers*.

97. William Frew Long, "Are Sit-Downs Strikes Legal or Ethical?" Address to Cuyahoga County Bar Association, April 14, 1937, *NAM papers*, s7b140f "strikes," *Hagley*.

98. NAM denied responsibility for spreading the Mohawk Valley Plan, "Press release," March 15, 1937, s7b1937, "NLRB 1937–1939," *NAM* papers. When NAM listed the plan's steps for their Memphis pamphlet, they used a speech by the SWOC's Philip Murray, making it seem as if labor concocted it. The Memphis Chamber of Commerce and the Memphis Business Advisory Council, "Industrial Strife and the Third Party," in *NAM papers*, s7, b140, "strikes."

99. Statement, Robert E. Woodside and William E. Habbyshaw, Pennsylvania House of Representatives, April 1937, "Scrapbooks," HERCO.0001, *HCA*; Shafer, s7b40f "strikes," *NAM papers*.

100. Letter, Alexander Stoddart to Mr. Majer, May 11, 1937, Ezra Hershey Files, HTC.001, b32f15; *New York Times*, April 9, 1937; and *Christian Science Monitor*, June 10, 1937; *Inquirer* cartoon, "Scrapbooks," HERCO.001; Ezra Hershey Strike Papers, b20.

101. Fey, "Chocolate Paradise," 547. Many pulled word-for-word from Stoddart's prolific, unvaried output; others used the general narrative arc. The two lone critics were Harold Fey, "Chocolate Paradise," and Elting, "Trouble in Paradise."

102. "Hershey: Candyland, City of Dreams, Sees Milk Cause Human Unkindness," *Newsweek*, April 17, 1937, 10–12.

103. "Upheaval in Utopia," *TIME*, April 19, 1937, 15. "In Mr. Hershey's Utopia Farmers and Strikers War," *LIFE*, April 19, 1937, 24–25, called the "model town . . . Hershey's utopia." "Behind the Strife in Hershey," *Business Week*, April 17, 1937, 22, recycled the quote that Hershey looks "more like a college town," from Alexander Stoddart and J. Horace McFarland, "Pennsylvania's Chocolate Town," *Planning and Civic Comment* (April 1937): 9–11.

104. *LIFE*, April 19, 1937, 24–25; Hershey Chocolate Company, "Cookery," and "Hershey Park: Playground of Pennsylvania," 1940, b1f63, *Stoddart, HCA*.

105. Peter Hales, *Silver Cities: The Photography of American Urbanization, 1839–1915* (Philadelphia: Temple University Press, 1984), 133–124.

106. Nye's analysis of commercial photography's "mundane realism" is pertinent, *Image Worlds*, 49; and Paul Frosh, *The Image Factory: Consumer Culture, Photography and the Visual Content Industry* (Oxford: Berg, 2003), 1.

107. Arthur Rothstein, Farm Security photographer and *LOOK*'s technical director, claimed the news photographer must capture "the dramatic highlights of a fast-moving event" at the height of the unfolding drama. *Photojournalism* (New York: American Photographic Book, 1956), 23. One contemporary textbook defined "action" as news photography's most critical characteristic. "The ideal toward which all sections of the newspaper should strike is that of more interest through more action." Laura Vitray et al., *Pictorial Journalism* (New York: McGraw-Hill, 1939), 37–38.

108. Following literary critic Dagmar Barnouw's concept of a "topos of looking" in analyzing Holocaust photography, I suggest *LIFE* constructed a "moral order." Dagmar Barnouw,

"American Photography During the War," lecture given at the CUNY Graduate Center, December 7, 1996. Paper based on her *Germany 1945: Views of War and Violence* (Bloomington: Indiana University Press, 1997).

109. *Newsweek*, April 7, 1937, 11.

110. *Business Week* attributed the photos to International Pictures; in Hershey's 1926 *The Story of Chocolate*, 2.

111. "Congress and the Sit-Down Strikes," *Congressional Digest* 16 (May 1937): 151–152.

112. Daniel Boorstin, *The Image: A Guide to Pseudo Events in America* (New York: Atheneum Press, 1971), 237–238. Polls can have nonrepresentative samples and ask leading questions. Those who commission polling can affect the result. Polls become "statistical applause tracks" where "the measurement of public opinion and its manufacture [become] less and less distinguishable." It is unclear who contracted with Gallup to "gauge" public opinion about CIO sit-downs; Ewen, *PR!*, 182–190; and Sarah Igo, *The Averaged American: Surveys, Citizens, and the Making of a Mass Public* (Cambridge, Mass.: Harvard University Press, 2007), 18–21, 103–149.

113. Len De Caux, *Labor Radical: From the Wobblies to the CIO, a Personal History* (Boston: Beacon Press, 1970), 193; and "Sitdown Hysteria," *Nation*, April 3, 1937, 368–369.

Chapter 4

1. Meyer Levin, *Citizens* (New York: Viking Press, 1940), 73.

2. *Fortune Magazine* (November 1937): 172, in Jerold Auerbach, *Labor and Liberty: The La Follette Committee and the New Deal* (Indianapolis: Bobbs-Merrill, 1966), 124; and Fred Friendly, "Justice White and Reporter Caldwell: Finding a Common Ground," *Columbia Journalism Review* 6, no. 3 (Sept./Oct. 1972): 32.

3. William Stott, *Documentary Expression and Thirties America* (New York: Oxford University Press, 1973), 67. Philip Evergood, "American Tragedy," in Barbara Haskell, *American Century: Art and Culture, 1900–1950* (New York: W. W. Norton, 1999), 282; Leo Hurwitz and Paul Strand, *Native Land* (Frontier Films, 1942). Levin, *Citizens*; Howard Fast, "An Occurrence at Republic Steel," in *The Aspirin Age: 1919–1940*, edited by Isabel Leighton (New York: Simon and Schuster, 1949). For textbooks: Mary Beth Norton et al., *A People and a Nation*, vol. 2 (Boston: Houghton MiffliHoughton Mifflinn, 1990), 74; Bruce Levine et al., *Who Built America? Working People and the Nation's Economy, Politics, Culture, and Society* (New York: Pantheon Books, 1992), 416–417. Popular histories include *Our Glorious Century* (Pleasantville, N.Y.: Readers Digest Press, 1994); and Peter Jennings and Todd Brewster, *The Century* (New York: Doubleday, 1998), 197. For film: Henry Hampton, *The Great Depression* (Blackside Films), 1993; and Jim Martin, *Wrapped in Steel*, 1985. In 1997 the Library of Congress included the Paramount footage in the National Film Registry. *The Federal Register*, March 13, 2003.

4. Barbara Warne Newell, *Chicago and the Labor Movement: Metropolitan Unionism in the 1930's* (Urbana: University of Illinois Press, 1961), 134–147; and David Brody, *Workers in Industrial America: Essays on the 20th Century Struggle* (New York: Oxford University Press, 1980).

5. Donald Solfchalk, "The Memorial Day Incident: An Episode of Mass Action," *Labor History* 6, no. 1 (Winter 1965): 29, 10, 19, and 43; quoting the *AFL Weekly News Service*

XXVII, no. 25 (June 19, 1937), 1. Daniel Leab, "The Memorial Day Massacre," *Midcontinent American Studies Journal* 8, no. 2 (Fall 1967): 3–17. Additional accounts include Irving Bernstein, *The Turbulent Years: A History of the American Worker, 1933–1941* (Boston: Houghton Mifflin, 1970), 432–498; and Auerbach, *Labor*, 120–130.

6. Arthur Osman, *Organizing Wholesale*, in United Automobile, Aircraft and Vehicle Workers of America, *District 65 Papers*, Robert F. Wagner Labor Archives, Tamiment Library, New York University (hereafter *D65 papers*), b67f18.

7. The recent exception is Michael Dennis, *The Memorial Day Massacre and the Movement for Industrial Democracy* (New York: Palgrave/Macmillan, 2010). Dennis rejects workers' conservatism, seeing unionists as demanding economic and political justice; he carefully assesses the high cost of violence upon SWOC and strikers, see pp. 6–11. For the dearth of scholarship on SWOC, see Ronald Filippelli, "The History Is Missing Almost: Philip Murray, the Steelworkers, and the Historians," in *Forging a Union of Steel: Philip Murray, SWOC and the United Steelworkers*, edited by Paul Clark, Peter Gottlieb, and Donald Kennedy (Ithaca, N.Y.: ILR Press, 1987), 12, v. A related study is Robert Slayton, "Labor and Urban Politics: District 31, Steel Workers Organizing Committee and the Chicago Machine," *Journal of Urban History* 23, no. 1 (November 1996): 29–65.

8. W. Carroll Munro, "Cameras Don't Lie," *Current History* 46, no. 5 (August 1937): 40.

9. Auerbach's nuanced examination of public opinion, labor, and civil rights does not analyze imagery's interpretation and dissemination. *Labor and Liberty*, 121–128.

10. "SWOC January–June 37 District 31," *Patterson*, b6f4; "Clippings," Louis Jacques Papers (hereafter *Jacques*), b2, *CHS*.

11. On Mills, see John Abt with Michel Myerson, *Advocate and Activist: Memoirs of an American Communist Lawyer* (Urbana: University of Illinois Press, 1993), 17–22; "Embryo of a Steel Worker," *Patterson*, b9f6.

12. David Brody, *Steelworkers in America: The Nonunion Era*, 2nd ed. (Champaign: University of Illinois Press, 1998), 50; Bernstein, *Turbulent Years*, 432.

13. This description is taken from several accounts, which do not differ in any substantive way unless noted. It is consonant with the outline—if not the slant—of press accounts from May 26 through July of 1937. Bernstein, *The Turbulent Years*; Walter Galenson, *The CIO Challenge to the AFL: A History of the American Labor Movement, 1935–1941* (Cambridge, Mass.: Harvard University Press, 1960), 75–122; Leab, "The Memorial Day Massacre"; Newell, *Chicago and Labor*; and David Bensman and Roberta Lynch, *Rusted Dreams: Hard Times in a Steel Community* (Berkeley: University of California Press, 1988), 7.

14. SWOC, "Report of the Officers to the Wage and Policy Convention," December 14–16, 1937, 10, in *Patterson*, b6f5.

15. *65 News*, May 1965; *1033 News*, May 1957; *Labor Today*, September 1974, 6. See also Leab, "Memorial Day," 4.

16. Joseph Germano scrapbook, Vol. 11, Series III, Subseries 1, in USWA District 31 papers (hereafter *D31 papers*), *CHS*; *St. Louis Post-Dispatch*, June 18, 1937; Galenson, *CIO Challenge*, 97; and Thomas Girdler, *Boot Straps: The Autobiography of Tom M. Girdler*, in collaboration with Boyden Sparkes (New York: Charles Scribner's Sons, 1943), 164–182.

17. Newell, *Chicago and Labor*, 137; "This Is Your Union," May 23, 1971, Local 1033, 7, in *Patterson*, b11f2; Richard Tedlow, *Keeping the Corporate Image* (Greenwich, Conn.: JAI

Press, 1979), 62, 99; SWOC, *Proceedings of the First Wage and Policy Convention,* December 1937, 31.

18. Puff pieces about Girdler appeared right after the massacre. "Tom Girdler, the Head of Republic Steel Is a Leader in Industrial Planning," *Review of Reviews,* June 1937, 30–31; *Nation,* June 5, 1937: 683. Republic harassed meeting attendees, and organizers believed the company laid off prospective members. "SWOC Fieldworkers Staff Minutes," *D31 papers,* b124f6; *Nation,* June 12, 1937, 668.

19. Republic Steel Corporation "The Real Issues," May 27, 1937, s7b140f "strikes," American Iron and Steel Institute Papers (hereafter *AISI*), *Hagley.* Bernstein, *Turbulent Years,* 483; Testimonies of John Riffe and Gus Yuratovic. Senate Committee on Education and Labor, *The Chicago Memorial Day Incident,* Part 14, 75th Cong., 1st sess., 1937, 4864, 4874 (hereafter *Memorial Incident*), 14.

20. *65 News,* May 1965, 1. Republic was the third largest steel manufacturer, employing 49,000 workers, after U.S. Steel and Bethlehem Steel, Galenson, *CIO Challenge,* 87. See also SWOC, *First Wage and Policy,* 32.

21. "Fieldworkers Staff Minutes," b124f4 and b124f6, *D31 paper;* "This Is Your Union," May 23, 1971, Local 1033, *Patterson,* b11f2. Chicago had a higher proportion of foreign-born steel workers than other region. Newell, *Chicago and Labor,* 116–117; Cohen, *Making a New Deal,* 17, 21.

22. Newell claimed the Republic drive was "spotty," *Chicago and Labor,* 135–137. But organizers believed they had increasing support. By December 1936, Republic's main organizer Joe Riffe believed that over 1,000 cards were circulating in the plant, b124f4 and b124 f6, *D31 papers.* Organizer Nick Pitzele, in the *Daily Calumet,* May 25, 1937, said that over 3,000 men showed up at a South Chicago rally for the impending strike. Patterson claimed the Republic drive was from the "bottom up," and considered its support "overwhelming," despite scabs who stayed in the plant, "Embryo," 150, b9f6, *Patterson.*

23. The union claimed 200 men inside the plant, the company 1,400. Newspapers reported 1,000, close to half the workforce. *St. Louis Post-Dispatch,* June 16, 1937; *Chicago Daily Times,* June 2, 1937.

24. Inland Steel in Indian Harbor, Indiana, employed 13,500, *Daily Calumet,* May 26, 1937, 1; Youngstown Sheet and Tube had 7,500 in Indiana Harbor and 650 at their South Chicago plant. The *Daily Times* claimed 25,000 were out on strike, June 2, 1937, 16: "This Is Your Union," May 23, 1971, Local 1033, 8–10, b11f2, *Patterson;* and "Embryo," Book Two, 16–17, b9f6, *Patterson.*

25. Riffe, *Memorial Incident,* 14: 4865; Leab, "Memorial Day" 5–6; Solfchalk, "Memorial Incident," 8, 11. Police claimed picketers could assemble up to 100, strikers said often fewer than ten were allowed in front of the plant. Senate Committee on Education and Labor, *Report: The Chicago Memorial Day Incident* (hereafter *Report*) 75th Cong., 1st sess., July 22, 1937, 6.

26. *Chicago Daily News,* May 29, 1937; "Mob Is Beaten Back," *New York Times,* May 29, 1937, 1, 7.

27. Bittner claimed Republic Steel used police as a "common strike breaking agency." *New York Times,* May 30, 1937, 7; Patterson before LaFollette, *Memorial Incident,* 14: 4880; SWOC asked the Attorney General's office to investigate. SWOC, *First Wage and Policy,* 37, b6f5, *Patterson.* For "shoot to kill": *Chicago Daily News,* May 27, 1937, 3;

St. Louis Post-Dispatch, June 16, 1937, for harassment by police and paid strikebreakers and Republic's response.

28. *The Nation*, June 12, 1937, 670. "The Steel Strike Battle and Death on the Prairie," *Chicago Tribune*, May 28, 1972, sec. 1A, 3; *Daily Calumet*, July 2, 1937. Riffe claimed 1,500 protesters, *Memorial Incident*, 14: 4869. Police thought between 2,500 and 3000. *Washington Evening Star*, July 2, 1937, Jacques b2, *CHS*; and "Incident at Republic Steel," March 9, 1966, b10f1, *Patterson*.

29. For crowd atmosphere see the following testimonies to the La Follette Committee in, *Memorial Day Incident*, 14: Harper, 4964; and Riffe, 4870; *Jacques*, b2; and "Embryo," Book Two, 20, b9f6, *Patterson*.

30. On "skirmish line," see "This Is Your Union," May 23, 1971, Local 1033, b11f2, *Patterson*; Leab, "Memorial Day," 7; and *Memorial Incident*, 14D: 4665.

31. M. B. Schnapper, *American Labor, A Pictorial Social History* (Washington, D.C. Public Affairs Press, 1972); *New York Times*, June 1, 1937, 9; Series III, Joe Germano Scrapbooks, Vol. 11, *D31 papers*.

32. The ten killed were: Alfred Causey, Joe Rothmund, Hilding Anderson, Lee Tisdale, Leon Francisco, Sam Popovic, Earl Handley, Anthony Tagliore, Otis Jones, and Kenneth Reid. Information on victims in *Memorial Incident*, Exhibit 131: 5007, and Exhibits 1441–1449: 5075–5089; and *Jacques*, b2. *Daily Calumet*, June 10, 1937, 2; and *Nation*, July 3, 1937, 26, and *Nation*, August 7, 1937, 146.

33. Meyer Levin, "Slaughter in Chicago," *Nation*, July 12, 1937, 668–669. For police hospital policies: *New York Times*, June 1, 1937, 9; *Washington Post*, May 31, 1937, 2; and Germano Scrapbooks, Vol. II, *D31 papers*.

34. *New York Times*, June 2, 1937, 10; *Chicago Daily News*, June 1, 1937, 1, 3; and *Steel Labor*, June 21, 1937, 7; *Daily Calumet*, June 5, 1937, June 1 and 9, 1937, 1.

35. Brotherhood Resolution and Chicago Church Federation Resolution, *D31 papers*. Resolution signed by James Stewart, President #65; A. Sweeney, President #1068; Ed Johnson President #1181; and Clement Nowakowski, President #1167, to Mayor Kelly and President Roosevelt, n.d., b6f5, *Patterson*.

36. Sofchalk, "Memorial Incident," 19; *New York Times*, June 1, 1937, 9, and *Chicago Daily Tribune*, June 1, 1937, 1.

37. *New York Times*, June 2, 1937, 10; Krzycki in *New York Times*, June 3, 1937, 16.

38. *Chicago Daily News*, June 3, 1937, 7; *New York Times*, June 4, 1937, 15.

39. *Chicago Daily News*, June 17, 1937, June 1, 3, and 18, 1937, 16; *St. Louis Post-Dispatch*, June 17, 1937, 1; *Chicago American*, July 18, 1937, b2, *Jacques, CHS*.

40. *St. Louis Post-Dispatch*, June 24, 1937, 1.

41. *Chicago Tribune*, May 31 and June 1, 1937; *Chicago Daily News*, May 31 and June 1 and 2, 1937; *New York Times*, May 31 and June 1, 1937. Bernstein's *Turbulent Years*, 826 n. 8, claims the public relations firm of Hill and Knowlton promoted Republic Steel's stance. Upton Sinclair's novel *Little Steel* (New York: Farrar and Rinehart Inc., 1938) turns on the facility of the new public relations firm's entrance into labor relations. See also Sofchalk, "Memorial Incident," 19–27.

42. See Chicago's *Tribune* and *Daily News* and *New York Times* coverage, May 31, June 1 and June 2, 1937. *St . Louis Post-Dispatch*, June 22, 1937, 8a, criticized the *Tribune* for such coverage. Washington news correspondents rated the paper the least reliable in the United States. John Eberhardt and Raymond Bauer, "Analysis of the Influences on

Recall of a Controversial Event: The *Chicago Tribune* and the Republic Steel Strike," *Journal of Social Psychology, SPSSI Bulletin* (1941): 211. The *Chicago Herald American*, a Hearst paper, claimed the massacre was "directed from the Chicago Communist Headquarters" in a 1941 article. Series III, Germano Scrapbooks, Vol. 11, *D31 Papers*. George Patterson claims he was harassed, and then "outed" as a communist by the Chicago Police, charges he denied, b9f6, *Patterson*.

43. The *New York Times* had its own Chicago correspondent. See May 31, 1937, 1, and *TIME*, June 7, 1937, 14–15. But most stories in the *San Francisco Chronicle*, the *Washington Post*, the *New York Herald Tribune*, the *New York Daily News*, the *New Orleans Times Picayune*, and the *New York Herald Examiner* used either United Press (UP) or Associated Press (AP) wire stories.

44. *New York Times*, May 31, 1937, 1, 7, and June 2, 1937, 10; *New York Times*, June 7, 1937, 8. The paper printed whole Girdler's letter to employees rationalizing the decision not to sign a contract with the CIO. Girdler attacked CIO irresponsibility, claiming it violated workingman's rights by "swiping" their paychecks. *New York Times* June 16, 1937, 8; *New York Times*, June 3, 1937, 16.

45. See *Time*, June 7, 1937, 14–15, and June 14, 1937, 13; *LIFE*, June 14, 1937, 30–31; and *Newsweek*, June 5, 1937, 5, and June 12, 1937, 15; "Telegram to Asst. Secretary M. H. McIntyre," May 31, 1937, Container 11, F 407-B, Franklin Roosevelt Library.

46. *Chicago Tribune*, June 1, 1937, 32.

47. Photo in the *Chicago Daily News*, June 1, 1937, 36. "Steel Strike Riots," is the headline of the *Chicago Tribune*, June 1, 1937, 1, 12; June 3, 1937, 14.

48. *Chicago Tribune*, May 31, 1937, 30.

49. Ibid.

50. *Chicago Tribune*, June 6, 1937, 10.

51. Roland Barthes, "The Photographic Message," in *Image, Music, Text*, translated by Stephen Heath (New York: Noonday Press, 1977), 15–31; and Walter Benjamin, "A Short History of Photography," in *Classic Essays in Photography*, edited by Alan Trachtenberg (New Haven, Conn.: Leete's Island Books, 1980), 199–216. Alan Trachtenberg, *Reading American Photographs: Images as History, Mathew Brady to Walker Evans* (New York: Hill and Wang, 1989); Maren Stange's *Symbols of Ideal Life: Social Documentary Photography in America, 1890–1950* (New York: Cambridge University Press, 1989).

52. *San Francisco Chronicle*, May 31, 1937, 1.

53. The AP photo appeared in the *Chicago Tribune*, June 1, 1937, 32; *TIME*, June 7, 1937, 15; the *New York Times*, June 1, 1937, 9; the *New York Herald Tribune*, June 1, 1937, 7; and the *Washington Post*, May 31, 1937, 1.

54. *New York Times*, June 1, 1937.

55. *Chicago Tribune*, May 31, 1937, 30; *New York Times*, May 31, 1937, 5. Though metropolitan dailies in Chicago, Washington, D.C., and New York carried multiple images of the massacre, most papers offered only one image. *TIME*, June 7, 1937, 15.

56. *Chicago Daily News*, June 1, 1937; Bernstein, *Turbulent Years*, 478–490.

57. *Chicago Tribune*, May 31, 1937, 30.

58. Cultural theorists argue that audiences create the text but are given strong clues to appropriate readings. Lawrence Levine, "The Folklore of Industrial Society: Popular Culture and Its Audiences," *American Historical Review* 97, no. 5 (December 1992):

1381; T. Jackson Lears, "Making Fun of Popular Culture," *American Historical Review* 97, no. 5 (December 1992): 1416–1426.

59. "SWOC Fieldworkers Staff Minutes, June 28, 1937, b124f6, *D31 papers*; Patterson interview with Ed Sadlowski, December 1970, 114–115, b10f7, *Patterson*; and Book Two, 30, b9f6, *Patterson*; Francisco in *Midwest Daily Record* May 28, 1938, 3, in Series III, Germano Scrapbooks, Vol. 11, *D31 papers*.

60. Raymond Fielding, *The American Newsreel, 1911–1967* (Norman: University of Oklahoma Press, 1972), 155, 173, 194–195, 223.

61. *Steel Strike Riots Sharpen CIO Crisis*, Grinberg Film Libraries, Chatsworth, California, PMN 6318/6140.

62. On extradiegetic music, David Bordwell, Janet Staiger, and Kristin Thompson, *The Classic Hollywood Cinema: Film Style and Mode of Production to 1960* (New York: Columbia University Press, 1985), 34–5.

63. *New York Times*, June 9, 1937, 8; *Chicago Herald Examiner*, June 8, 1937, in *Jacques*, b2; *Daily Calumet*, June 9, 1937, 2.

64. On Levin, see *New York Times*, April 23, 1933, March 28, 1937, and March 31, 1940, 86; and Lawrence Graver, *An Obsession with Anne Frank: Meyer Levin and the Diary* (Berkeley: University of California Press, 1995), 3–8; *Chicago Daily Times*, June 2, 1937.

65. *The Nation*, June 12, 1937, 664, editorialized that Paramount would have exhibited it if footage showed "strikers beating up police"; *Steel Labor*, June 21, 1937, 3. Mary Heaton Vorse, "The Steel Strike," in the *New Republic*, included in *Rebel Pen: The Writings of Mary Heaton Vorse*, edited by Dee Garrison (New York: Monthly Review Press, 1985), 203.

66. Fielding, *American Newsreel*, 48–51, 223, argues for uncontroversial nature of news-reels. On regulation of class conflict in film, see Steven Ross, *Working Class Hollywood: Silent Film and the Shaping of Class in America* (Princeton, N.J.: Princeton University Press, 1998); and Gregory Black, *Hollywood Censored: Morality Codes, Catholics and the Movies* (New York: Cambridge University Press, 1994), chapters 1, 2, and 8.

67. Paul Douglas to Robert La Follette, June 8, 1937, La Follette Committee Files, 50.25 (here-after *La Follette*), National Archives (hereafter *NA*); *New York Times*, June 8, 1937, 8.

68. Abt to Paul Douglas, June 9, 1937, *La Follette*, b8, 50.25. See also interview transcript of Robert Wohlforth by Jerold Auerbach, November 6, 1963, 53–54, in the Oral History Collection of Columbia University (hereafter Wohlforth, *COHC*).

69. For the Illinois State's Attorney's interest, see *St. Louis Post-Dispatch*, June 19, 1937, 1. *New York Times*, June 9, 1937, 8; and June 14, 1937, 3; *TIME*, June 28, 1937, 13; *Chicago Daily News*, July 8, 1937, 3; and for Judge Padden's interest, see also note 116, below.

70. Auerbach, *Labor and Liberty*, 63. Lillian Elkin, "The Nation's Angry Man," *Nation*, May 31, 1965, 584–587; and "National Headliners Club Broadcast," Columbia Broadcast Systems, July 19, 1937, *La Follette*, b8, 50.25, NA.

71. Paul Anderson, "Senators See Suppressed Movie of Chicago Police Killing Steel Strikers," *St. Louis Post-Dispatch*, June 16, 1937, 1–2.

72. Paul Anderson, "Suppressed News Reel Shows Police Shooting at Fleeing Strikers," and "Senator Thomas Says Police Attacked Strikers," *St. Louis Post-Dispatch*, June 17, 1937, 1 and 3.

73. "Eye Witnesses Tell of Killing of Steel Strikers," *St. Louis Post-Dispatch*, June 20, 1937, 1, 30.

74. On Lewis, *New York Times*, June 18, 1937, 4. See also *St. Louis Post-Dispatch*, June 18, 1937, 1, 10; *New York Times*, June 20, 1937, 4; *Chicago Daily Times*, June 18, 1937, 2; *TIME*, June 28, 1937: 13; *Chicago Daily News*, June 18, 1937; *Daily Worker*, June 19, 1937.

75. Auerbach, *Labor and Liberty*, 127. Levine, *Who Built*, 416–418, quotes from Anderson's account without attributing it. Leab uses Anderson's description to great effect, "Memorial Day Massacre," 11 and 18, note 23. Sofchalk, "Memorial Incident," 32, also shared Anderson's story, which "speaks for itself." Auerbach, *Labor and Liberty*, 123; and "National Headliners Club Broadcast," in *La Follette*, 50.25.

76. Patrick Maney, *"Young Bob" La Follette: A Biography of Robert M. La Follette, 1895–1953* (Columbia: University of Missouri Press, 1978), 174; Auberbach, *Labor and Liberty*, 6, 82.

77. Abt, *Advocate*, 58, 32; Auerbach, *Labor*, 6, 59–63, 75–82; and Gilbert Gall, "Heber Blankenhorn: The Publicist as Reformer," *Historian* 45, no. 4 (1983): 513–528; "Report," September 29, 1936, "Statement by Philip Murray," November 8, 1936; and "Murray Correspondence," all in Murray, b19f7, CIO, National/International Union files, Catholic University of America.

78. Wohlforth, *COHC*, 53, and Abt, *Advocate*, 60–67; Maney, *"Young Bob,"* 170, 185.

79. *Memorial Incident*, 14: Exhibit 1341, 5132.

80. *Memorial Incident*, 14: 4682–4724, especially 4712–4719.

81. *Memorial Incident*, 14, Exhibit 1350, 5134.

82. Kilroy's testimony, *Memorial Incident*, 14: 4724–4750; "posing" in *Memorial Incident*, 14: 4743.

83. Auerbach, *Labor and Liberty*, 79–80, offers a similar analysis; *Christian Science Monitor*, June 30, 1937, 1.

84. *Chicago Herald Examiner*, July 2, 1937, 1, b2, *Jacques*.

85. *New York Daily News*, July 2, 1937, 7; *Memorial Incident*, 14: 4751–4789; *Christian Science Monitor*, July 1, 1937, 16.

86. *Memorial Incident*, 14: 4788–4827; on spectators: *Chicago Herald Examiner*, July 2, 1937, 1, in Jacques, b2, *CHS*; *Time*, July 12, 1937, 17.

87. *Memorial Incident*, 14: 4830–4850.

88. Clipping in b2, *Jacques*. The La Follette Committee report counterpoised Beck's clarity to striker and police bias, though Beck substantiated the union in large part; *Memorial Report*, 12, 16; *Memorial Incident*, 14: 4850–4862.

89. *Memorial Incident*, 4969–4973 and 4973–4976; and *Memorial Report*, 12.

90. Zaragosa Vargas, *Labor Rights Are Civil Rights: Mexican American Workers in Twentieth Century America* (Princeton, N.J.: Princeton University Press, 2005), 1–3, demonstrates Mexican-American contributions to the campaign. He believes Marshall was a CP member.

91. *Memorial Incident*, 14: 4945–4957.

92. "National Headliners Club Broadcast," CBS, July 19, 1937, b8, 50.25, La Follette, *NA*.

93. *Washington Evening Star*, July 2, 1937, b2, *Jacques*; *Memorial Incident*, 14: 4959–4964; Leab, "Memorial Day Massacre," 12.

94. *Memorial Incident*, 14: 4863–4873; 4873–4878, 4908–4924. James Stewart and Joe Weber's testimony is striking in this regard.

95. Wohlforth, *COHC*, 15; *Washington Evening Star*, July 2, 1937, b2, *Jacques*.

96. *Memorial Incident*, 14: 4891; *Christian Science Monitor*, July 3, 1937, 3; *Washington Evening Star*, July 2, 1937, b2, *Jacques*.

97. Lippert took establishing shots of Republic Steel's plant after the massacre, but these appeared first in the hearing's footage. *Memorial Incident*, 14: 4887–4891.

98. Clipping, and *Washington Post*, July 3, 1937; and *Washington Evening Star*, July 2, 1937, both in b2, *Jacques*.

99. The *Washington Post* also saw it as a climax, July 3, 1937, in b2, *Jacques*; quotes from Auerbach, *Labor and Liberty*, 127, and Dennis, *Memorial Day*, 208; see also Sofchalk, "Memorial Incident," 36.

100. *Christian Science Monitor*, July 2, 1937, 2; *Time*, July 12, 1937, 17; *Newsweek*, July 17, 1937, 9.

101. *Memorial Report*, 20–21, 32.

102. *New York Times*, July 1, 1937, 5; and July 2, 1937, 5; *Washington Post*, July 2, 1937; columnist Herbert Agar called police "bungling amateurs," b2, *Jacques*; and for the *Vindicator* reference, Friendly, "Justice White and Reporter Caldwell," 34; *Steel Labor*, August 6, 1937, 8; *Chicago American*, n.d. (probably July 23, 1937), b2, *Jacques*.

103. *LIFE*, July 12, 1937, 72–73.

104. *New York Times*, July 3, 1937; *New York Daily News*, July 3, 1937, 14, 28.

105. *Memorial Incident*, Dr. Lawrence Jacques, 4986.

106. Paramount destroyed almost all their corporate newsreel records, making it difficult to know with certainty which movies were exhibited where. *Conflict Between Police and Strikers Near the South Chicago Plant of the Republic Steel Company, Memorial Day, 1937*, Motion Picture, Sound, and Video Branch of the National Archives in College Park, Maryland. Record Group 46.3, U.S. Senate (hereafter, *Mot-NA*).

107. *Motion Picture Herald*, July 10, 1937, 27. La Follette restricted *Conflict Between Police and Strikers* viewing to "an official agency of the Federal Government," lifting it only in 1944. Sen. La Follette to Dr. Solon Buck of the Legislative Branch of the National Archives, January 15, 1944. Accession papers No. 1519 for *Republic Steel Strike: Conflict Between Police and Strikers, Mot-NA*. *Conflict* has its own copyright listing. Its entry stands out as newsreels are typically untitled and listed by copyright code and date, under the production company. *Catalogue of Copyright Entries: Cumulative Series. Motion Pictures, 1912–1939* (Washington, D.C.: Library of Congress Copyright Office, 1951), 635. Its code is listed as MU7542. This film was copyrighted on June 29, 1937, three days before its committee screening. An MU code, unlike an MP code, indicates that the work was "unpublished" at the time of copyright; it had not been theatrically released. Lippert's testimony verifies this hypothesis, as he claimed earlier footage from Avenue O was included in the film. Something "unpublished" at the time of copyright could be released later. Rosemary Hanes at the Library of Congress, Motion Picture Branch was extremely helpful in sorting this out.

108. *What Happened at South Chicago, Memorial Day, 1937*, PMN 6359 and 6559, 95A, Grinberg Film Libraries.

109. Paramount Release Sheet, Issue No. 95A, August 11, 1937, Motion Picture Branch, Library of Congress. Each year the *Catalogue of Copyright Entries* lists 104 entries corresponding to the twice-weekly newsreel release schedule. Only *What Happened at South Chicago* MP7695's code indicates theatrical release, *Motion Pictures, 1912–1939*, 635. It was copyrighted on July 1, the day before the film's exhibition in the committee. Usually each number corresponds to a grouping of stories released on any one day. See Fielding's *The American Newsreel*. Library of Congress records of copyright information for newsreels indicate the same. 95A is a special entry, it is the only film listed

under this number. Paramount provided the Library of Congress a "release sheet" with a film synopsis as advance advertising to theater owners. Unlike other newsreels listed together on such broadsides, *What Happened at South Chicago* had its own release sheet.

Not an infallible guide to film release, the *Herald* also is an important clue. "Paramount Releases Steel Strike Films," *Motion Picture Herald*, July 10, 1937, 27. The industry paper ran a long story on the film's release that describes *What Happened at South Chicago*'s storyline. See also *Daily Worker*, July 2, 1937, in 50.25, *La Follette*; and *New York Times*, July 3, 1937, 5.

110. In 1972 CBS News president Fred Friendly references a "pejorative version" that seems to correspond to *Steel Strike Riots*. No other evidence indicates this was released. Friendly, "Justice White," 34. The title has a copyright mark; however, studios added it in postproduction, and this does not prove the film was copyrighted. The Library of Congress has no record.

111. *Steel Strike Riots* stated that five were dead, indicating this version was completed prior to the June 1 death of Anthony Tagliore. *Motion Picture Herald*, July 10, 1937, 27; *TIME*, June 28, 1937, 13.

112. *Motion Picture Herald*, July 10, 1937, 27; *Chicago Herald and Examiner*, July 4, 1937, b2, *Jacques*; "Women in Steel," September 1937, 5, *CHS*; and "Embryo," Book Two, 88, b9f6, *Patterson*.

113. "Let Chicago See Film of Riot," "Clipping," b2, *Jacques*.

114. *Daily Calumet*, June 9, 1937, 1; and July 16, 1937.

115. Hearings Before the Senate Committee on Post Offices and Post Roads, *Delivery or Nondelivery of Mail in Industrial Strife Areas*, 75th Cong., 1st sess., June 11 to June 24, 1937, 173, 35, 2–3 (hereafter *Delivery of Mail*); *TIME*, August 9, 1937, 12. For NAM's tactic, "An Act to Provide for the Investigation of Controversies Interrupting or Threatening to Interrupt Interstate or Foreign Commerce" memo, in NAM Board Minutes, February 17, 1937, s13b199, *NAM papers, Hagley*.

116. *Delivery of Mail*, 207, 235, 208, 235–236, 254, 255.

117. "Weapons of Industrial Warfare Are Seen by the U.S. Senate," *LIFE*, July 5, 1937, 16.

118. *Christian Science Monitor*, June 18, 1937, 1; and June 16, 1937, 1; June 23, 1937, 1; 24; June 1937, 3, and June 25, 1937, 3. Girdler, address to the Illinois Manufacturers Association, "What's Ahead in Industrial Relations," December 14, 1937, 11, b122f, "speeches by steel men," *AISI*.

119. *Delivery of Mail*, 275; and *St. Louis Post-Dispatch*, June 24, 1937, 2.

120. *Delivery of Mail*, 283, 286, 291; *St. Louis Post-Dispatch*, June 24, 1937, 2.

121. *Delivery of Mail*, 49.

122. *Daily Calumet*, July 14, 1937, 1.

123. *Daily Calumet*, July 20, 1937; July 14, 1937, 1; and *Daily Times*, July 14, 1937, b2, *Jacques*.

124. *Chicago Daily News*, July 19, 1937, b2, *Jacques*.

125. *Daily Calumet* July 14, 1937; and "clipping," *Daily Times*, n.d., 10; *Chicago Daily Times*, July 22, 1937, both in b2, *Jacques*; *Chicago Tribune*, July 4, 1937, 4.

126. *Daily Calumet*, July 19, 1937; *Chicago Tribune*, July 3, 1937; "Weapons Used by Rioters," *Chicago Tribune*, July 4, 1937.

127. "Clipping," July 23, 1937, *Jacques*, b2; *Christian Science Monitor*, July 21, 1937, 6; *Washington Post*, July 21, 1937.

128. *St. Louis Post-Dispatch*, June 18, 1937; *New York Times*, June 18, 1937, 4.

129. Wohlforth, *COHC*, 41; Fillipelli, "The History Is Missing," 104–106.

130. Wohlforth, *COHC*, 53 and 73; and Interview of John Abt by Auerbach, March 22, 1963, *COHC*, 5. See also Stephen Norwood, *Strike-Breaking and Intimidation: Mercenaries and Masculinity in Twentieth Century America* (Chapel Hill: University of North Carolina Press, 2002), 228–229.

131. Paul Anderson, "Armed Rebellion on the Right," *Nation*, August 7, 1937, 146–147. For photos, see SWOC, *First Wage and Policy*, 64, in *Patterson* b6f5. For FDR quote, *New York Times*, June 30, 1937, 1.

132. On strike's cost, news clipping (probably *New York Times*), August 1, n.d., b6f5, *Patterson*. *Steel Labor*, November 19, 1937, 2. One Republic stockholder sued the corporation, claiming that nearly $13 million were lost fighting the CIO. *New York Times* and *New York Herald Tribune*, October 19, 1940, both in b31, *AISI*; other articles addressing the cost of anti-unionism are in July 14, 1937, 6, and July 30, 1937, 25, both *New York Times*.

133. SWOC, *First Wage and Policy*, 37–38, in *Patterson*, b6f5. Ben Myers letter, n.d., Ben Myers papers, *CHS*; and *Steel Labor*, March 1945, 2, which reported a payment of $350,000 to victims in Ohio and Chicago, including $20,000 to Harry Harper. *Business Week*, January 6, 1945, 108, b2, *Jacques*, *CHS*; Sofchalk, "Memorial Incident," 31, 40–41. Correspondence from Lodge No. 1033 to Lewis, Pressman, Murray, and Bittner, Received October 17, 1938, CIO National/International files, b19f16, *CIO papers*.

134. SWOC, *First Wage and Policy*, 157, in b9f6, *Patterson*.

135. *In Commemoration United Steel Workers of America, D31 and Local 1033*, May 30, 1979, 17, b11f2*Patterson*; and Joe Glazer, *Labor's Troubadour* (Champaign: University of Illinois Press), 61–62.

136. William Kornblum, *Blue Collar Community* (Chicago: University of Chicago Press, 1974), 101–106, 166; see "This Is Your Union" May 23, 1971, Local 1033; and Remember Memorial Day, May 30, 1937, *In Commemoration*, 14, b11f2, *Patterson*. Patterson's Lodge, at nearby U.S. Steel, was named the Hilding Anderson Lodge by 1939. *Union and Shop News*, June 1939, b9f1, *Patterson*.

Chapter 5

1. *Steel Labor* (hereafter *SL*), August 1, 1936, 1.

2. *SL*, September 5, 1936, 1. Two good histories include Irving Bernstein, *The Turbulent Years: A History of the American Worker, 1933–1941* (Boston: Houghton Mifflin, 1970); and Walter Galenson, *The CIO Challenge to the AFL: A History of the American Labor Movement, 1935–1941* (Cambridge, Mass.: Harvard University Press, 1960).

3. Nelson Lichtenstein, *State of the Union: A Century of American Labor* (Princeton, N.J.: Princeton University Press, 2002), 5–11, 32–35.

4. "Murray Charges: Truman Proposal First Step Toward More Savage Laws Against Labor," *SL*, January 1946, 3.

5. Ron Schatz, "Philip Murray and the Subordination of the Industrial Unions to the United States Government," in *Labor Leaders in America*, edited by Melvyn Dubofsky and Warren Van Tine (Urbana: University of Illinois Press, 1987), 234–257.

6. *SL*, January 1946, 3; Lichtenstein, *State of the Union*, 12, quoting Steven Fraser, "American Trade Unions and the 'Labor Question': Past and Present," in *What's Next for Organized*

Labor? The Report of the Century Task Force on the Future of Unions (New York: Century Foundation Press, 1999), 59–117.

7. Howard Fast, "An Occurrence at Republic Steel," in *Aspirin Age: 1919–1941*, edited by Isabel Leighton (New York: Simon and Schuster, 1949), 389; Judith Stein, *Running Steel, Running America: Race, Economic Policy and the Decline of Liberalism* (Chapel Hill: University of North Carolina Press, 1998), 3.

8. "Embryo of a Steelworker," 72–73, in George Patterson Papers, b9f6 (hereafter *Patterson*); Frank Palmer to Patterson, June 23 and June 26, 1936; Murray to Patterson, July 6, 1936, b6f3, *Patterson*, at the Chicago Historical Society (hereafter *CHS*). In SWOC's first annual budget, less than 1 percent of each dues dollar went to the paper, seemingly a miniscule proportion. If monies returned to the lodges, lodge supplies, salaries, field office, and strike expenses were added up, about 92 percent of the SWOC expenditures are accounted for. Of what remained, *SL* accounted for somewhere between 16 and 20 percent of the budget. Funds for *SL*'s production and distribution, and staff and administration almost equaled expenditures for the legal work so critical to union consolidation. Secretary-Treasurer's Report to the *Proceedings of the First Wage and Policy Convention*, December 1937, 48. Later budget data are less clear. Expenses were reported as a proportion of "dues per month per member." Actual dues were low then, as the USWA was funded by CIO member organizations. The union did not report actual expenses. SWOC, *Proceedings of the Second Wage and Policy Convention*, May 1940, 23–30; USWA, *Proceedings of the First Convention of the United Steel Workers*, May 1942, 107–109.

9. For 1936 circulation, "Philip Murray Report to SWOC, September, 29, 1936," in CIO National/International Union September–November 1936, b19f7, *CIO papers*, Catholic University of America (hereafter *CUA*); 1940 figures in *Proceedings of the United Steel Workers of America*; for 1948 circulation, "How Your Paper Is Printed," April 1948, 6–7; Stein, *Running Steel*, 15.

10. J. B. S. Hardman and Maurice Neufeld, *The House of Labor: Internal Operations of American Unions* (New York: Prentice Hall, 1951), 212.

11. Steven Fraser, *Labor Will Rule: Sidney Hillman and the Rise of American Labor* (Ithaca, N.Y.: Cornell University Press, 1991), 344. Correspondence and oral history, b6; unpublished manuscript, "Odyssey," b6f49–50, J. B. S. Hardman papers, Robert F. Wagner Labor Archives, Tamiment Library, New York University.

12. Eric Hobsbawm, "Man and Women in Socialist Iconography," *History Workshop Journal* 6 (Autumn 1978): 121–138.

13. Sean Wilentz, *Chants Democratic: New York City and the Rise of the American Working Class* (New York: Oxford University Press, 1984); David Montgomery *The Fall of the House of Labor* (Cambridge: Cambridge University Press, 1987), 22–23, 33, 196–203. Mary Bluett argues that such images must be historicized over time and space. "Manhood and the Market," in *Work Engendered: Toward a New History of American Labor*, edited by Ava Baron (Ithaca, N.Y.: Cornell University Press, 1991), 92–113.

14. Lichtenstein, *State of the Union*, 9.

15. Gerald Markowitz and Marlene Park, *Democratic Vistas: Post Offices and Public Art in the New Deal* (Philadelphia: Temple University Press, 1984). This gendering restricted solidarity by neglecting women's role in unionism as Elizabeth Faue's study of Minneapolis unionists points out, *Community of Suffering and Struggle: Women, Men and*

the Labor Movement in Minneapolis, 1915–1945 (Chapel Hill: University of North Carolina Press, 1991); Barbara Melosh, *Engendering Culture, Manhood and Womanhood in New Deal Public Art and Theater* (Washington, D.C.: Smithsonian Institution Press, 1991), especially 87–90, where she discusses racial typing. Some artists broke from the typical white worker; best known is Hugo Gellert: see Zoltan Deak, ed., *Hugo Gellert, 1892–1985: People's Artist* (New York: Hugo Gellert Memorial Committee, 1986); and Hugo Gellert, *Karl Marx' 'Capital' in Lithographs* (New York: Ray Long and Richard Smith, 1933).

16. *SL*, September 5, 1936, 3.

17. *SL*, December 5, 1936, 6; *SL*, January 9, 1937, 4; "How a Steel Worker Views the Meaning of the CIO," *SL*, March 6, 1937, 6.

18. Joyce Kornbluh, *Rebel Voices: An I.W.W. Anthology* (Ann Arbor: University of Michigan Press, 1972), 33, 198. Roland Marchand, *Advertising the American Dream: Making Way for Modernity* (Berkeley: University of California Press, 1985), 235–284.

19. *SL*, September 25, 1936, 4–5.

20. *SL*, December 5, 1936.

21. When 660 workers came out at Hubbard Steel, 800 workers struck for two weeks at the Eastern Rolling Mill, and workers came out at Wheeling, *SL*'s issue featured not one photo. An issue later one photo of *SL* distribution at the Rolling Mill strike appeared. *SL*, August 8, 1936. Striking workers at the Standard Steel Spring Company in Corapolis, Pennsylvania, received no visual coverage. *SL*, September 5, 1936, 3. Les Orear describes commissioning photographers, and also buying the rights to photos for the *Packinghouse Worker*. Les Orear, interview by author, tape recording, Chicago, Illinois, August 1, 2003.

22. Graham Clarke, ed., *The Portrait in Photography* (London: Reaktion Books, 1992); Alan Trachtenberg, *Reading American Photographs: Images as History, Matthew Brady to Walker Evans* (New York: Noonday Press, 1998), 21–70.

23. John Bodnar, *Workers World: Kinship, Community, and Protest in an Industrial Society* (Baltimore: Johns Hopkins University Press, 1982), 1–2, 166.

24. *SL*, February 1946, 1.

25. Thanks to *SEIU-1199 News*'s Patricia Kenney, for the "grab and grin" description. Moe Foner, *Not for Bread Alone: A Memoir* (Ithaca, N.Y.: Cornell University Press, 2002), 128. In Hardman's *Advance*, photos of the membership outnumber leaders by a 5 to 1 ratio. See *Advance*, January 1935, May 1935, or July 1936.

26. *Advance* showcased members far more than leaders, presented international labor issues, and examined women's concerns. See "A Page from a Miner's Life," "Songs and Ballads of the Anthracite Miners," *Advance*, January 1935, 17; "The Woman Who Works: Her Job, Her Pay, Her Prospects," January 1935, 19; "Workers the World Over Are Brothers. They All Want: Security-Freedom-Justice-Peace," May 1935, 8–9; "The Steelworkers—As Hard as the Metal Itself," July 1936, 4–5; "A.C.W. Women Ask Wage Law," July 1936, 12; "Labor Is Big in Big Steel," June 1937, 10–11; cartoons for "The Murder of Steel Workers in Chicago," May 31, 1937, 8; "Fifty Thousands Union Workers Mass in Cleveland; Protest Police Brutality Against Steel Workers," September 1937, 13.

27. Obituary, *Pittsburgh Press*, May 22, 1967, 28. Robert R. R. Brooks, *As Steel Goes: Unionism in a Basic Industry* (New Haven, Conn.: Yale University Press, 1940), 187.

28. See Hardman and Neufeld, *The House of Labor*, 188; and Stuart Ewen, *P.R.! A Social History of Spin* (New York: Basic Books, 1996), 82–101; *First Wage and Policy Convention*, 63–64. Correspondence, Sweeney to Murray, September 25 and 30, 1945; and October 8, 1945, in *Murray papers* (Publicity Department), *CUA*.

29. By 1946 Sweeney's report was less than a paragraph; other departments were pages long. Sweeney's silence speaks to the ways in which media and representation are deemed unworthy of discussion and hidden and naturalized. "Report of Publicity Department," SWOC, *Second Wage and Policy Convention*, 36.

30. Len DeCaux, *Labor Radical: From the Wobblies to the CIO* (Boston: Beacon Press, 1970), 281, 286–287.

31. Ibid., 280, 7; Paul Clark, Peter Gottlieb, and Donald Kennedy, *Forging a Union of Steel: Phillip Murray, SWOC and the United Steelworkers* (Ithaca, N.Y.: ILR Press, 1987), 5. David Brody, *Workers in Industrial America: Essays on the 20th Century Struggle* (New York: Oxford University Press, 1980), 19, 27; "Embryo," 136, 148, b9f6, *Patterson*; Murray memo, "The Problem Before the SWOC on June 17, 1936," November 8, 1938, b19f7, *CIO papers*.

32. Murray argued for union responsibility for productivity. In 1946 he failed to stress corporation's role in inflation, unlike Walter Reuther's push for GM to "open the books." *Forging a Union*, Harold Ruttenberg, "Comments," 124; Ronald Fillipelli, "The History Is Missing Almost: Philip Murray, the Steelworkers, and the Historians," 8–10; and Abe Raskin, "Comments," 116.

33. "The Answer Is Yes," *SL*, January 9, 1937, 8. One exception is "And they have proved it," *SL*, June 21, 1937, 5.

34. Brody, *Worker in Industrial American*, 113–115. Nelson Lichtenstein, *Labor's War at Home: The CIO in World War II* (Cambridge: Cambridge University Press, 1982), 81; Zieger, *The CIO*, 145–147.

35. Illustration in *SL*, June 30, 1942, 4; see also "We'll Do Our Share," July 26, 1942, 1; "They're Not Going to Push Me Around," July 31, 1942, 3; and "Okay Boys; You Asked for It!" all *SL*. For utopian unionism during the war, November 17, 1942, 1.

36. In 1941 and 1942 *LIFE* was full of ads with the heroic laborer; the trope diminished by 1943. Coca-Cola, November 2, 1942, 35; Philco, September 6, 1943, 1; Fairchild Engine and Airplane Corporation, July 5, 1943, 92; and United States Rubber, April 19, 1943, 18–19, and May 17, 1943, 48–49.

37. Stephen Hess and Milton Kaplan, *The Ungentlemanly Art: A History of American Political Cartoons* (New York: Macmillan, 1968); Stephen Hess and Sandy Northrop, *Drawn and Quartered: The History of American Political Cartoons* (Montgomery, Ala.: River City, 1996).

38. Hess and Northrop, *Drawn*. For the *Masses*, see Rebecca Zurier, *Art for the Masses: A Radical Magazine and Its Graphics* (New Haven, Conn.: Yale University Press, 1985), 13–119; Kornbluh, *Rebel Voices*, 41, 46, 57. "Rich Uncle Milburn Pennybags," public relations communication to author, from Parker Brothers, Beverly, Massachusetts, November 1997. See Rivera's 1928 "The Capitalist Dinner," on Mexico City's Ministry of Education. Desmond Rochfort, *Mexican Muralists: Orozco, Rivera, Siqueiros* (San Francisco: Chronicle Books, 1998), 1963.

39. *SL*, August 1, 1936, 8; and "Steel Workers Say, 'No!,'" *SL*, November 3, 1936, 2.

40. Dale Rooks, "Group Pictures," *Encyclopedia of Photography*, vol. 5 (New York: Educational Alliance Press, 1949), 1942.

41. "News of SWOC Union in Pictures," *SL*, August 30, 1940; May 23, 1941, 8; and January 22, 1943, 12. Among examples, see "17,000 Vote Yes," June 5, 1937; and "How Gary Did It," May 26, 1939, 6; all *SL*.

42. "25,000 Represented in Philadelphia District Convention," *SL*, March 29 1940, 8. See also "They Pay Their Dues a Year in Advance," *SL*, July 1942, 13; "South Chicago Steelworkers Hear Wage Program," *SL*, November 19, 1943, 10; *SL*, Convention shot, September 30, 1937, 5 and "500 Delegates," *SL*, March 1945, 8.

43. "Your Duty Is to Vote," *SL*, January 26, 1940, 3; also *SL*, March 20, 1937, 8; "Not Quiet on the Western Front," April 15, 1938, 8; and February 1945, 5. Editorial cartoons or illustrations stressing discipline include "Another Chapter Is Written," May 24, 1937, 4; "17,000 Vote Yes for Signed Pact at J&L," June 5, 1937, 6. Photos putting order to the fore include "J-L Men Fight for Signed Contract—And Win," June 5, 1937, 3.

44. *SL*, January 26, 1940, 3; February 27, 1942, 7; and May 26, 1939, 6, offer three examples.

45. Issues from 1942 are full of such images. *SL*, September 25, 1941, 3; and February 28, 1941, 6.

46. *SL*, December 13, 1937, 6. See also "There's One in Every Steel Mill," October 29, 1937; "Only a Union Can Bring That Feeling," February 18, 1938; and "You Can't Fool the Workingman," January 21, 1938, 4.

47. Faue, *Community of Suffering*, 75.

48. *SL*, November 19, 1937, 6. Lizabeth Cohen claims this cartoon shows SWOC's support of women's domestic decision making but women's portrayal throughout *SL* obviates against her interpretation. *Making a New Deal: Industrial Workers in Chicago, 1919–1939* (Cambridge: Cambridge University Press, 1990), 346. See also "Don't Beg the Boss for a Raise. Join the Union and Get It!" *SL*, October 20, 1936, 3; *SL*, August 20, 1937, 6; and *SL*, July 1947, 10.

49. For mass media comic strips, see Moira Davison Reynolds, *Comic Strips in American Newspapers, 1945-1980* (Jefferson, N.C.: McFarland, 2003), 34–35; for two cartoonists of this era who use gender tropes, see J. R. Williams *Out Our Way*, and *Liberty* 1, no. 11 (Winter 1973): 28; and Denys Wortman, whose *Metropolitan Movies*, was featured in *LIFE* February 27, 1939: Denys Wortman, *Denys Wortman's New York: Portrait of the City in the 30s and 40s* (Montreal: Drawn and Quarterly, 2010).

50. Ethel Erickson, "Women's Employment in the Making of Steel, 1943," *Bulletin of the Women's Bureau*, nos. 192–195, 1944, 3.

51. Erickson, "Women's Employment," 4. The survey, while not comprehensive, was based upon employment records of forty-one major mills nationwide. It did not include steel fabrication works. Female employment rates varied from plant to plant. In one mill 16 percent of the production employees were women, in another only 3 percent. By December 1943, SWOC believed 80,000 women worked in steel. See USWA, *Second Constitutional Convention of the United Steel Workers of America*, 1944, 42.

52. Erickson, "Women's Employment," 4–20.

53. "Virginia Auxiliary of SWOC in the South," *SL*, October 28, 1938, 8.

54. *SL*, May 1944, 1, 8. Elizabeth and Stuart Ewen, *Channels of Desire: Mass Images and the Shaping of American Consciousness* (Minneapolis: University of Minnesota Press, 1992), 95–115.

55. The Office of War Information (OWI) provided many of *Steel Labor*'s Rosie-style images.

56. Maureen Honey, *Creating Rosie the Riveter: Class, Gender and Propaganda During WWII* (Amherst: University of Massachusetts Press, 1984).

57. *SL*, January 1945, 9. See also "Steelwomen—USA," *SL*, May 1945. Eileen Boris discusses the ambiguity of dress, and tensions over female and male apparel in, "Desirable Dress: Rosies, Sky Girls, and the Politics of Appearance," *International Labor and Working-Class History* 69 (Spring 2006): 123–142. Unlike "workplace regulations" that "restrained" women's "aura as sexual beings in the name of output and efficiency," *Steel Labor* capitalized on this.

58. "News of USA-CIO Locals in Pictures," *SL*, May 28, 1943, 12. See also *SL*, January 22, 1943, 12.

59. *SL*, December 12, 1936, 3.

60. Philadelphia *Record*'s photographer, Martin Hyman, "Publicity Photography," *Encyclopedia of Photography: A Complete Guide to Amateur and Professional Photography*, vol. VIII (New York: National Education Alliance, 1949), 3020.

61. *SL*, January 22, 1943, 4.

62. Thomas Cripps, *Slow Fade to Black: The Negro in Film* (Oxford: Oxford University Press, 1993), discusses typecasting in film; David Nasaw, *Going Out: The Rise and Fall of Public Amusements* (New York: Basic Books, 1993), 47–61. Marchand, *Advertising the American Dream*, 200–205; Brooks, *As Steel Goes*, 18; and Lichtenstein, *State of the Union*, 73–76, discuss the steelworkers' internal culture of racism.

63. *SL*, April 28, 1944, 14.

64. John Berger, *Ways of Seeing* (Harmondsmorth, England: Pelican Press, 1972), 45–47, 52, 63–64, argues "Men act, women appear." Film theorist Laura Mulvey, "Visual Pleasure and Narrative Cinema," *Visual and Other Pleasures* (Bloomington: Indiana University Press, 1989), 19, employs a psychoanalytic analysis. One critic is E. Ann Kaplan, "Is the Gaze Male?" in *Powers of Desire: The Politics of Sexuality*, edited by Ann Snitow, Christine Stansell, and Sharon Thompson (New York: Monthly Review Press, 1983), 309–327.

65. Erickson, "Women's Employment," 33–34. Kordich and response in USWA, *First Convention* 296, 298.

66. Angel Kwollek-Folland, "Gender, Self, and Work in the Life Insurance Industry, 1880–1930," in *Work Engendered: Toward a New History of American Labor*, edited by Ava Baron (Ithaca, N.Y.: Cornell University Press, 1991), 184, 188–189; see also Rickie Solinger, "The Smutty Side of *LIFE*: Picturing Babes as Icons of Gender Difference in the Early 1950's," in *Looking at LIFE Magazine*, edited by Erika Doss (Washington, D.C.: Smithsonian Institution Press, 2001), 201–219; and Griselda Pollock, "Missing Women: Rethinking Early Thoughts on Images of Women," in *The Critical Image: Essays on Contemporary Photography*, edited by Carol Squiers (Seattle: Bay Press, 1990), 212.

67. First two cartoons: *SL*, March 26, 1943, 10; "Sweetheart," *SL*, May 1944, 5.

68. *SL*, February 1946, 2–3.

69. Women were infrequently represented as wage earners after the war. Ibid., 4.

70. The union gendered women but no longer sexualized them. See *SL*, August 1947, 6; September 1947, 6; January 1948, 4; February 1949, 9; March 1950, 12; and September 1950, 8. Kelley, SWOC, *Second Wage and Policy Convention*, 109.

71. Dana Frank, *Purchasing Power: Consumer Organizing, Gender and the Seattle Labor Movement, 1919–1929* (New York: Cambridge University Press, 1994), 248–249; Lizabeth Cohen, *A Consumers' Republic: The Politics of Mass Consumption in Postwar America* (New York: Alfred A. Knopf, 2003), 40–41; and Faue, *Community of Suffering*, 126–146.

72. Patterson, "Embryo," Book Two, 88–92; b9f6; and USWA, *Second Constitutional Convention*, 220.

73. Patricia Cooper, "The Faces of Gender: Sex Segregation and Work Relations at Philco, 1928–1938," and Ava Baron, "Gender and Labor History: Learning from the Past, Looking to the Future," in Baron's *Work Engendered*, 332, 13; Cohen, *Consumers' Republic*, 135, 75.

74. *SL*, September 1945, 3.

75. One exception was the USWA's 1941 victory over Bethlehem Steel in which Sweeney printed photographs emphasizing mobilization. "SWOC Demonstration at Bethlehem, PA" April 18, 1941, 6–7, and "One Year Later—Bethlehem Is Organized," October 31, 1941, 8.

76. Filippelli, "The History Is Missing," 12; and Clark et al., *Forging a Union*, vol.

77. See a strike in Lorain, Ohio, *SL*, October 15, 1937, 2; a five-month strike at Crucible Steel in Harrison and Jersey City, New Jersey, in *SL* February 18, 1938, 2; and May 13, 1938, 1; an eight-month strike of 400 employees at Penn Iron and Steel Company, *SL*, July 15, 1938, 6; a five-week strike of 700 at Roberts and Manders Stove/Hatboro Foundry, April 15, 1938, 8; a two-day strike of 200 at Chicago's Steel Sales Company, *SL*, February 23, 1940, 1; and a strike of 100 employees at American Welding and Manufacturing Company in the anti-union bastion of Warren, Ohio, *SL*, October 25, 1940.

78. Jack Metzgar, *Striking Steel: Solidarity Remembered* (Philadelphia: Temple University Press, 2000), 29.

79. "Community Leaders Join Steel Workers' Parade and Picket Lines," *SL*, March 1946, 9.

80. "Peaceful, Quiet, Efficient," in *SL*, March 1946, 6; "USA Pickets Strong," *SL*, March 1946, 4–12.

81. Cover, "To the People of the U.S.A.," *SL*, February 1946. See also "Action Pictures of Steel Strike"; "Steelworkers Are Right, Priest Says"; and "100,000 Ex-GI's Back Union in Strike," *SL*, February 1946, 6–9; and "Baldwin Locomotive and Roebling's Sons Among Last to Sign," *SL*, April 1946, 12; and *LIFE*, February 4, 1946, 17–23. The African-American worker was sitting out picket duty, and had not joined in the 1919 strike—his inclusion could be read as *LIFE*'s deploying race to limit workers' solidarity.

82. For the slogan, see *SL*, June 1949, 6–7, and photo November 1949, 5. "Let's Be Ready!" on the cover of the former.

83. "On the Verge of a STRIKE!" *SL*, August 1949.

84. "'We're Ready for Strike,' Say USA," October 1949, *SL*, shows that the newspaper retained older formulas.

85. "Coast to Coast," *SL*, November 1949, 6–7.

86. SWOC could have used such photographs. Members took them, and local papers featured them. "Events, Demonstrations, Strikes, Steel Industry," ICH-i24992–24994, and DN #c-8769, *CHS*. Similarly, the CIO publicity director once sought photos of their organizing drives from the World Wide Photo agency. He discouraged their sending images of "riot scenes." Len De Caux to Wide World Photos, September 29, 1937, in

Murray, Central Office Correspondence, b112f9. I discussed the memory and forgetting of the massacre in two conference papers: "'That Deep, Deep Red Will Never Fade': Chicago's Memorial Day Massacre," at the 2007 Organization of American Historians, and "Celebrating Martyrs: The Popular Front and Chicago's Memorial Day Massacre," at the 2009 American Studies Association.

87. "We Will Not Forget," *New Voices*, July 1938, 8; and the Amalgamated's *Advance*, July 1937, 8–9. *SL* printed a cartoon that showed a single dead body before Republic Steel's gate, August 19, 1938, 3. The *CIO News* and the *Packinghouse Worker* printed a two-page photo essay against the Ball, Burton, and Hatch legislation that showed the Memorial Day Massacre, as spectators watched the film at the La Follette hearings, October 1, 1945, 4–5.

88. "The First Ten Years," *SL*, September 1946, 10; "Is This What Mr. White Means?" *SL*, September 1949, 5.

89. *United Automobile Worker*, December 1945, 1; and January 1946, 1; and *UE News*, January 12, 1946; January 19, 1946; and January 25, 1946.

90. See also *UE News*, January 26, 1946; and February 16, 1946. Orear, interview, discussed his use of the vernacular to engage the rank and file.

91. "Violence Breaks Out as Nation's Strikes Spread," *LIFE*, January 28, 1946; "Police Attack on GE Strikers Shocks Country," *UE News*, March 9, 1946, 1–3. See also "He Didn't Fight for This," January 26, 1946, 8; and Kim Phillips-Fein's *Invisible Hands: The Making of the Conservative Movement from the New Deal to Reagan* (New York: W.W. Norton, 2009), 93–103, analyzes the UE's spectacular win, which instigated new forms of anti-unionism.

92. "Knocked Unconscious," February 16, 1946, 5. "A Study in Contrasts," February 9, 1946, 10, both *UE News*. For Avery, see John Faber, *Great News Photos and the Stories Behind Them* (New York: Dover, 1978), 86; and *TIME*, May 8, 1944. For Murray on Avery, USWA, *Second Constitutional Convention*, 1944, 161.

93. *LIFE*, January 28, 1946, 34; February 4, 1946, 17–24.

94. "The Boss's Strategy," *TIME*, January 14, 1946, 16–17; and January 21, 1946, cover. *TIME*'s 1946 strike coverage focused on violence in Philadelphia and Los Angeles, *TIME*, February 28, 1946, 20; and March 11, 1934, 22. In 1949 photos depicted violence in eastern coalfields, and western loading docks, *TIME*, October 10, 1949, 22–23. *Newsweek* was more temperate. It showed violence on the UE lines in Kearney, New Jersey, and Los Angeles, and Chicago Westinghouse workers in paddy wagons. "Strike Wave Rolling to Crest Threatens Essential U.S. Needs," *Newsweek*, January 14, 1946, 23; January 28, 1946, 20–21; and "The Massed Pickets, *Newsweek*, March 11, 1946, 30–31. But it also put a smiling picketer on the cover, his grin and the snow swirling around him a joyful counterpoint to the title "Picket: The Line Spreads Across the Nation," February 4, 1946, cover.

95. Michael Schudson, *Advertising, The Uneasy Profession* (New York: Basic Books, 1984), as quoted in James Guimond, *American Photography and the American Dream* (Chapel Hill: University of North Carolina Press, 1991), 153. For cartoons about violence, see *SL*, "Now See if You Can Cover That," and "A Black Mark on Their Records," August 6, 1937, 4, 8; and "No Wonder They Hate the Wagner Act," September 10, 1937, 4.

96. "CIO: What It Is and What It Does," *SL*, December 1949, 6. See Zieger, *CIO*, for the USWA's "voluminous studies" and lobbying efforts in this period, 170.

97. Lawrence Glickman, in *A Living Wage: American Workers and the Making of Consumer Society* (Ithaca: Cornell University Press, 1997), 84, argues that labor's demands for the American standard of living and a living wage predate consumerism's rise in the 1920s. In the 1870s George McNeill called for "a parlor with a carpet in it, a mantelpiece with ornaments on it, pictures on the wall, books on the table, kitchens with facilities." For Murray, see Foner, *Not for Bread Alone*, 102.

98. See *SL*, February 1946, 3, and January 1946, 3.

99. *SL*, July 1947, 7.

100. Hine's work is featured in the Russell Sage–funded Pittsburgh Survey. John Fitch, *The Steel Workers* (New York: Charities Publication Committee, 1910). Farm Security photographs in the Library of Congress's online American Memory Project. Walker Evans in Birmingham, Alabama, and Bethlehem, Pennsylvania, 1936, LC-USF342-008014-A, 013-A; and November 1935, LC-USF342-001167-A, LC-USF342-001165-A; Arthur Rothstein, in Midland, Pennsylvania, LC-USF 34-026526-D, LC-USF 34-051864, LC-USF34-026518D, LC-USF34-026519-D through 026523-D, in Clairton, Pennsylvania, LC-USF34-026551-D, in Aliquippa, Pennsylvania, LC-USF34-026549-D, all July 1938; and Birmingham, February 1937, LC-USF34-005975-E; Marion Post Wolcott's photographs of Birmingham, May 1939, LC-USF34-051864; and John Vachon December 1940, LC-USF34-062113-D. See also "Thrown Out of House by Mill Deputies," *Daily Worker*, May 10, 1929, 1.

101. "America Needs More and Better Homes" condemned workingmen's slums, *SL*, November 19, 1937, 4; and "Dear Mr. President," *SL*, January 21, 1938, 3.

102. The *UE News* used photos this way. "UE Halts Eviction of Family Which Exploded GE High Pay Myth" told of Brother Robert Morrison, whose "high pay" wasn't enough to cover a low-rent, subsidized housing project. February 16, 1946, 12.

103. Roland Barthes describes photos as "indexical"; their "thingness" underscores the image's veracity. Roland Barthes, "The Photographic Message," *Image, Music, Text* (New York: Noonday Press, 1977, 15–31). See Stott's *Documentary Expression*, 137–139, for 1930s obsession with documentary detail. *SL*, March 18, 1938, 6. Similar imagery throughout *SL*. June 28, 1940, "$5,000 Back Pay at Florence Pipe Foundry," and November 29, 1940, "$900 in Back Pay to Union Men," offer just two examples.

104. "J. & L. Workers Get $10,000 in Back Pay," August 6, 1937, 2.

105. "Jackpot" image in August 30, 1940, 2; "SWOC Members Win $1,400 in Back Pay," June 17, 1938, 8, "SWOC Iron Ore Miners win $12,500 in Back Pay," August 19, 1938, 6; and "Arbitration Board Favors SWOC Member," September 23, 1936, 6; all *SL*.

106. "Republic Steel Forced to Pay Half-Million Dollars in Vacation Money to SWOC Men," *SL*, January 31, 1941, 8. *LIFE* also used this strategy. "Old Age: The Old in America Have Become a Political Force and Economic Menace," November 7, 1938, 56–57.

107. *SL*, December 1944, 5.

108. *SL*, March 1947, 8.

109. "The New Social Security Law and You!" *SL*, August 1950, 1. *SL* had photographs of local attempts at cooperative house building, and it discussed the USWA's public housing lobbying. *SL*, September 1948, 8. For the single-family home ideal, see Cohen, *Consumers' Republic*, 73–75.

110. Stein, *Running Steel*, 8–9.

111. The changes that Metzgar details were not realized until 1960. He examined wage increases, vacation time and pay, retirement security, health insurance, along with workers' voice on the job; *Striking Steel*, 40. Lichtenstein, *State of the Union*, 25–26.

112. Speeches of Skolnik and Chown, *First United Steelworkers of America Convention*, May 1942, 107.

113. Broadfoot, Murray, and Cook, ibid., 107–109. Early on Chicago's Sub-District 3 staff criticized *Steel Labor*, arguing that it conflated communism, Nazism, and fascism. George Patterson and John Dorwalski to Van Bittner and Phil Murray, August 7, 1939. Bittner reprimanded the men, demanding that they retract their letter, which they did. Van Bittner, August 9, 1939, b7f1, *Patterson*.

114. This was the last year of any serious criticism. USWA, *Second Convention*, 1944, 96–100. Sweeney preempted attacks by letting delegates air concerns in small meetings. Sweeney, USWA, *Proceedings of the Third United Steel Workers of America Convention*, 1946, 73.

115. USWA, *First Convention*, 107. Michael Denning's arguments on participation and hegemony inform this argument, "The End of Mass Culture," *International Labor and Working Class History* 37 (Spring 1990): 14. Orear interview on limiting coverage of leaders.

116. As quoted in Jennifer Klein, *For All These Rights: Business, Labor, and the Shaping of America's Public-Private Welfare State* (Princeton, N.J.: Princeton University Press, 2003), 144.

117. Denning, "The End," 6; Frances Perkins, *The Roosevelt I Knew* (New York: Viking Press, 1946), 217–221.

118. Foner, *Not for Bread Alone*, 128.

Chapter 6

1. Barney Cole, "Union Camera Club," *Popular Photography* (September 1945): 54–55, 120.

2. The union's name changed multiple times, with growth and changing affiliations. Beginning as the Wholesale Drivers Workers Union in 1933, the union affiliated with the United Hebrew Trades that same year. In 1934 they joined the AFL, switching to the CIO in July 1937, when they became Local 65, taking the Textile Workers Organizing Committee's number. The CIO asked them to affiliate with the United Retail Wholesale and Department Store Employees (URWDE), which they did for a decade as the Wholesale and Warehouse Employees Union. In November of 1948, Local 65 broke with the CIO, preempting a probable ouster over its refusal to sign Taft-Hartley anticommunist affidavits. It joined the Distributive Trades Council in New York City. In February 1950 they reorganized as the Distributive Workers Union (DWU), making their union the second largest local after UAW local 600. That September they affiliated with the Food, Tobacco, Agricultural and Allied Workers of America (FTA) and the United Office and Professional Workers of America (UOPWA) to form the national Distributive, Processing, and Office Workers Union (DPO). In 1953, fearing McCarthyism's impact, they reaffiliated with the URWDE, and they were renamed District 65. United Automobile, Aircraft and Vehicle Workers of America, *District 65 Papers*, Wagner 006, Robert F. Wagner Labor Archives, Tamiment Library, New York University, b1f1 and b1f2 (hereafter *D65 papers*). Arthur Osman, *Organizing Wholesale,*

b67f18, *D65 papers*; Lisa Ann Wunderlich Phillips, "The Labor Movement and Black Economic Equality in New York City and District 65, 1934–1954" (Ph.D. diss., Rutgers University, 2002); and David Paskin, "District 65 United Auto Workers," in *Encyclopedia of the American Left*, 2nd ed., edited by Mari Jo Buhle, Paul Buhle, and Dan Georgakas (New York: Oxford University Press), 192–194.

3. *New Voices* (hereafter *NV*), October 7, 1951, M2; *NV*, March 15, 1940, 5; for "second home," see "Executive Board Meeting Minutes," October 23, 1941, b1f6, *D65 papers*.

4. Dorothy Fennell, "The Union's Inspiration: Making Trade Unionists Among New York City Wholesale Workers, 1933–1937" (paper presented at the Conference on David Montgomery's Work and Teaching, University of Pittsburgh at Greensburg, June 1993), 4, 33 n. 15; Arthur Osman, interview by Herbert Hill, July 12, 1968, Walter Reuther Library, Wayne State University (hereafter Osman interview), 5, 18, 6; and *NV*, September 12, 1943.

5. Livingston interview by Debra Bernhardt, October 25, 1979, Tamiment Library and Wagner Labor Archives, 1, in United Automobile, Aircraft, and Vehicle Workers of America, District 65, Oral Histories (hereafter *D65 orals*); Executive Committee Notes, b1f2, *D65 papers*.

6. House Committee on Education and Labor, "Investigation of Communism in New York City Distributive Trades," 80th Cong., 2nd sess., 1948, 430. Osman interview, 26–27; Osman, *Organizing Wholesale*, 8; Jay Tabb, "A Study of White Collar Unionism: Tactics and Policies Pursued in Building the Wholesale and Warehouse Workers Union of New York" (Ph.D. diss., University of Chicago, 1952), 1–2. Phillips, "Labor Movement," claimed that Local 65 was New York City's third largest local after the ILG and the ACWU, 197.

7. Recreation Report, December 23, 1942, b6f26, *D65 papers*.

8. Interview, Edward Roth by Mary Allison Farley and Erika Gottfried, May 24, 1990, *D65 orals*. Photo League member Sid Grossman, photographed the Southern Tenant Farmers Union and the Farmers Union Local 576. Lili Corbus Bezner, *Photography and Politics in America: From the New Deal into the Cold War* (Baltimore: Johns Hopkins Press, 1999), 80. See also Michael Denning, *The Culture Front: The Laboring of American Culture in the Twentieth Century* (New York: Verso Press, 1997), 62, 68, on New York's Transit Workers Union photo classes.

9. Roth interview, 4; *NV*, April 11, 1943; *NV*, April 16, 1944, 8; *UV*, April 19, 1953, 12; "Art with a Punch," *UV*, February 25, 1951, 14; *UV*, September 23, 1951, 3; *UV*, April 28, 1946, 11. The paper changed its name to *Union Voice* in January of 1945, until it was folded into the *RWDSU Record* in June 1954. To limit confusion, the chapter's text will use *New Voices*, but the notes use *UV* for *Union Voice*; and *NV*, November 8, 1942.

10. Leah Ollman, *Camera as Weapon: Worker Photography Between the Wars* (San Diego: Museum of Photographic Arts, 1991).

11. The Wagner Archives has some 30,000 District 65 negatives. *New Voices* had photos from 1937. I read published photos against archived negatives to understand the paper's "patterns of meaning." Bylines were rare enough that it is impossible to generalize about a particular photographer's style. United Automobile, Aircraft and Vehicle Workers of America, District 65 Non-Print Records, Wagner NP23, Robert F. Wagner Archives, Tamiment (hereafter *D65 photos*).

12. "Education Committee Notes," June 24, 1937 b1f1; and November 17, 1938, b1f2; *NV*, November 1939, 6; *NV*, April 1939, 6; "Camera Group Report," May 2, 1940; August 12,

1940; July 18, 1940; September 12, 1940; b6f3, *D65 papers*; and *NV*, February 1939, 7; and *Union Voices* (hereafter *UV*), April 22, 1951, 2.

13. Roth interview, 29; "Camera Club Notes," September 12, 1940; May 2, 1940; b6f3, *D65 papers*; and *NV*, February 1939, 7; *UV*, March 25, 1951, 9; May 20, 1951 3; July 1, 1951, 6; April 20, 1952.

14. Recreation Director Paley influenced both groups. Jack Paley, interview by David Paskin, tape recording, Kopek, New York, July 15, 1982, *D65 orals*. For cross pollination, "Camera Club Notes," May 2, 1940, and September 27, 1941, b6f3, *D65 papers*. The photo staff had about twelve members, with consistent turnover. *NV*, April 15, 1941, 5; *NV*, April 1939; *NV*, October 15, 1940, 7; *NV*, December 1, 1941, 8; and *NV*, August 29, 1943, 6; "Joint Meeting Notes," January 17, 1941, b6f3, *D65 papers*. "Recreational Council Meeting," February 2, 1941, b6f4, *D65 papers*.

15. "Photographic Staff Meeting," November 13, 1940; January 4, 1941; March 22, 1941, all in b6f3; and November 18, 1940, b6f6, *D65 papers*, Roth interview, 22, *D65 orals*; *UV*, April 28, 1946, 11.

16. "Ashcan School" painters and illustrators clustered around New York painter Robert Henri. For European avant-garde and left-wing photographers, Abigail Solomon Goudeau, "The Armed Vision Disarmed: Radical Formalism from Weapon to Style," in *Photography at the Dock: Essays on Photographic History, Institutions and Practices* (Minneapolis: Media and Society, 1991), 52–84; and Margarita Tupisyn, "Lenin's Death and the Birth of Political Photomontage," *The Soviet Photograph* (New Haven, Conn.: Yale University Press, 1996), 12–23. The photo murals in union headquarters were more experimental, akin to Edward Steichen's work for the Museum of Modern Art, as were *New Voices* WWII era montages; both were less avant-garde than European radicals' work. See "9 Year Offensive Built 65's Home," *NV*, September 27, 1942, 6. U.S. photographers' work tends toward the "transparent," realist, and psychological, though Lewis Hine created photomontages for the *Survey Graphic*. James Guimond, *American Photography and the American Dream* (Chapel Hill: University of North Carolina Press, 1991), 82; and Matthew Teitelbaum, ed., *Montage and Modern Life: 1919–1942* (Cambridge, Mass.: MIT Press, 1992).

17. *UV*, April 28, 1946, 11; Roth interview, 22–23.

18. Roth interview, 32; "Photo Staff Notes," January 1, 1941, b6f6, and April 12, 1941; and May 10, 1941, b6f3, *D65 papers*.

19. "Photo Staff Notes," April 12, 1941; May 10, 1941; September 13 1941; April 12, 1941; December 21, 1940; January 4, 1941; and June 7, 1941, b6f3, *D65 papers*; and Roth interview, 3, 24. For upgrades, see notes n.d. (probably after September 27, 1941), b3f3, *D65 papers*. On insurance, see "Photo Staff Notes," March 1941, b6f6, *D65 papers*. On badges, "Photo Staff Notes," April 12, 1941, b6f6, *D65 papers*.

20. Roth interview, 1, 17; "Photo Staff Notes," March 8 and 22, 1941, b6f3 and b6f6, *D65 papers*; *UV*, January 14, 1951, M7.

21. "Photo Staff Notes," December 7, 1940; June 7, 1941; December 21, 1940; b6f3, *D65 papers*, Roth interview, 48, 11; Paley interviews; for photographers lost to the war, see *NV*, October 10, 1943, 3; *NV*, n.d. (probably 1942), 12; and *NV*, June 6, 1943, 13. Roth's description of men printing nude photos of wives, and joking about being able to pee in the darkroom would qualify as sexual harassment today. His description of photographers needing to bully their way through demonstrations, and the single men's

obsession with the hobby also suggests a masculinization of photography at Local 65. Clearly women did not feel welcomed, as only two women stuck it out on the photo staff for any length of time. Roth interview, 11, 19.

22. *NV*, August 30, 1942, 6; "Executive Committee Notes," May 5, 1934, and May 13, 1935, b1f2; and "General Meeting Minutes," May 13, 1937, and November 12, 1936, b1f1; Osman, *Organizing Wholesale*, b67f8, *D65 papers*.

23. *NV*, August 30, 1942, 6; Paley, *D65 orals*; *NV*, April 15, 1941, 7; *NV*, July 1939, 4; and April 16, 1944, B-19, on semimonthly coverage. On circulation, see *NV*, August 30, 1942, 6; September 1940, 4; and report on *Union Voice*, b67f21, *D65 papers*.

24. "Recreation Council Notes," July 29, 1940, b6f4; "New Editor," *NV*, May 28, 1944, 3. Notes indicate Baldinger took over in 1940, but Paley is referred to as editor-in-chief through 1944. "Education Committee Notes," May 13, 1937; "4th Regular Steward Council Meeting," April 12, 1943, b6f1; November 14, 1937, and November 3, 1941, b1f2; "Recreation Board Minutes," September 8, 1941, b6f4, and July 29, 1940, "Recreation Committee," *D65 papers*. The paper kept *Union Voice* until it was folded into the *RWDSU Record* in June 1954.

25. Neg. # 01617, February 18, 1944, *D65 photos*.

26. "Stewards Council Meeting," April 12, 1943 b6f1, *D65 papers*. Printed letters lauded union policies, but criticism was not uncommon. Members balked at the length of meetings, January 30 and February 13, 1944; the union's about-face on entry into WWII, its involvement in May Day parades, women's involvement, April 25, 1941; and the lack of Spanish language articles, December 1941, 4, all *NV*. Letters from soldiers, March 14, 1943, 15; February 14, 1943, 13 and August 16, 1942, 13, all *NV*.

27. The "Inquiring Photographer" ran from August 6, 1944, until the paper was bundled into the *RWDSU Record* in 1954. *NV*, October 15, 1944; *NV*, September 1938, 7; *NV*, October 12, 1947; *NV*, April 18, 1954, M2, and *UV*, 12 September, *UV*, September 26, 1954, 5A; and *UV*, August 9, 1953, 7.

28. *NV*, November 8, 1942, 8–9.

29. "*New Voices* Report to Executive Board," October 23, 1941, b1f6, *D65 papers*.

30. Foner moved to Local 1199, the pharmacists and hospital workers' union, and founded Bread and Roses, one of the nation's few union-based cultural organizations. Moe Foner, interviewed by Robert Master, New York City, 1986, at the Columbia Oral History Center (hereafter *COHC*), 194.

31. Foner, *COHC*, 192.

32. Tabb, "White-Collar Union," 158–159, 196, 218; "Recreation Reports," August 25, 1941; September 1941 and February 8, 1940, b1f6, *D65 papers*; Paley interview, *D65 orals*.

33. "Executive Committee Notes," November 27, 1934; June 11, 1936; January 14, 1937, b1f1, *D65 papers*.

34. Tabb, "White-Collar Union," 150, 256. For Welfare Department goals, *NV*, September 15, 1941, 5–6.

35. Foner, *COHC*, 172. "General Stewards Meeting Notes," October 2, 1941 b1f6, *D65 papers*. See *NV*, February 15, 1942, 9.

36. For Club 65, *UV*, June 10, 1945, 12–13. In 1938 they estimated overall participation rates at 10 percent. Osman, *Organizing Wholesale*, 18. In 1939–1940, participation in recreation climbed to about 15 percent. February 8, 1940, b1f6, *D65 papers*. A year later organizers thought that due to geographic dispersal, only 8 percent of membership was

active. "Recreation Report," September 4, 1941, b1f6, *D65 papers*. Tabb estimated that "one half of the membership attends at one time or another the various social and recreational functions." "White-Collar Union," 145, 149, 146. Plaints about unionists turning out for meetings, the tenor of meetings, and the "sadly lacking 65 spirit" were heard at all levels of union governance. The union's culture was one in which unionists were constantly being whipped into shape. Foner, *COHC*, 163–164, 194–198, and 206; and "General Meeting Minutes," November 23, 1936; and "Education Committee," October 22, 1936b1f1, *D65 papers*. From the fall of 1940 to the spring of 1941, over 11,000 attended such socials—this when Local 65's membership had not yet reached 10,000. The drama troupe's *Wholesale Mikado*, which won awards at the 1939 World's Fair, attracted half the union's membership to performances. May 27, 1941, b1f2, *D65 papers*; and *NV*, March 15, 1942.

37. *NV*, May 1, 1940, 5. *NV*, October 1, 1940, 12; and *NV*, April 16, 1944, B24. See neg. # 63, Union Headquarters, and also negs. # 1704–1708, and 3221, all April 5, 1944, *D65 photos*.

38. Robert R. R. Brooks, *As Steel Goes: Unionism is a Basic Industry* (New Haven, Conn.: Yale University Press, 1940) 18.

39. Tabb, "White-Collar Union," 144, 149; "Executive Committee Notes," November 9, 1933, and December 14, 1933, b1f1, *D65 papers*. Boat rides generated ticket income equal to 20 percent of dues. January 4, 1941–May 31, 1941, b57f1, *D65 papers*. Dances brought in 10 percent. March 15, 1941, b58f1, *D65 papers*.

40. "United Nations" in *New Voices*, December 9, 1943, 9; and April 16, 1944, B-5. Tabb, "White-Collar Union," 217–220, 159; Robinson, quoted in Phillips, "Labor Movement," 166; Foner, *COHC*, 172.

41. *NV*, May 1937, 3–4; Tabb, "White-Collar Union," 150–151; "Recreation Department Notes," December 23, 1942, b6f26; "Report to General Executive Board," February 8, 1940, b1f6; "Recreation Report to Executive Board," October 23, 1941, b1f6, *D65 papers*.

42. Paley and Roth interviews, *D65 orals*, and Osman interview.

43. Tabb, "White-Collar Union," 241, 247, 159, and 148.

44. See Arthur Liebman, *Jews and the Left: Genesis to Exodus* (New York: Wiley, 1979); David Leviatin, *Followers on the Trail: Jewish Working Class Radicals in America* (New Haven, Conn.: Yale University Press, 1989); Denning, *Culture Front*, 74–77; Foner, *COHC*, 172.

45. Osman interview. Fennell, "Union's Inspiration," 5–6, 23, 13, 23, 28. Early leaders never admitted being CP members. Paley claimed leaders could have signed anticommunist affidavits in 1948, indicating a break with the party, *D65 orals*. By May 1952 David Livingston attacked the *Daily Worker* and the union sought to limit any UOPWA influence. They reorganized the union, demoting party members. Phillips, "The Labor Movement," 248–257, and Foner interview, *COHC*, 178, 197–220. Joshua Freeman, *Working Class New York: Life and Labor Since World War II* (New York: New Press, 2000), 89; "Education Committee," April 22, 1937, b1f1, *D65 papers*. Foner, *COHC*, 157; Paskin, "District 65 United Auto Workers," 192–194.

46. Denning, *The Cultural Front*, 73, 77; Michael E. Brown et al., eds., *New Studies in the Politics and Culture of U.S. Communism* (New York: Monthly Review Press, 1993). For an alternate view, see Lewis Coser and Irving Howe, *The American Communist Party: A Critical History* (New York: Da Capo Press, 1974), 383, 332. For "high-brow" union

culture, see Steven Fraser, *Labor Will Rule: Sidney Hillman and the Rise of American Labor* (New York: Free Press, 1991), 225–226.

47. Foner, *COHC*, 92.

48. Germany's worker camera clubs were sparked by the *Internationale Arbeiterhilfe* (IAH), or Workers International Relief. *History of Photography* 18, no. 2 (Summer 1994). Walter Rosenblum quote in Anne Tucker, "A History of the Photo League: The Members Speak" in this issue, 176. See also Beverly Bethune's "A Case of Overkill: The FBI and the New York City Photo League," *Journalism History* 7, nos. 3–4 (Autumn–Winter 1980): 87–108; and Bezner, *Photography and Politics*, 73–75.

49. "Camera Club Minutes," September 12, 1940, and September 1939, 6, b6f3, and May 23 1940, b6f6, *D65 papers*; Roth interview, 27, 18–19, 3, 6.

50. Paley interview; Osman interview, 1, 6, 13; Roth interview, 63; Fennell, "Union's Inspiration," 9.

51. Phillips, "Labor Movement," 123, 74; Paley interview.

52. Osman interview, 5–6; Fennell, "Union's Inspiration," 11 n. 52; 17 n. 80; David Paskin, "Local 65: A Union for All," *Distributive Worker*, March 1984, 9; Tabb, "White Collar Union," 2.

53. By 1948 African Americans comprised over twenty percent of the membership. Women became the majority in August 1943. Osman interview, 16, 13; *NV*, August 29, 1943, 2; Phillips, "Labor Movement," 1–2, 11, 33–34, 62, 78, 150; and "Recreation Report," September 4, 1941, b1f6, *D65 papers*.

54. Osman interview, 17, 4–5; Phillips, "The Labor Movement," 1; Paskin, "Local 65," 9.

55. Tabb, "White Collar Union," 111, 212, 220, 249; "Recreation Department Reports," December 18, 1941; and August 25, 1940, b1f6, *D65 papers*. Osman interview, 8–9; and *NV*, June 1, 1940; and August 23, 1953.

56. The union grew steadily from 1933, and from 3,400 members in July 1937 it grew to 6,000 in June 1940, "Welfare Department Report, Executive Board," July 21, 1941, b1f2, and b6f2; "General Executive Board Minutes," July 22, 1937; September 23, 1937 b1f2. June 24, 1941, b6f2, 65 papers. For member loss during the war, see Osman, "Report to the General Stewards Meeting," June 14, 1943, b6f1 *D65 papers*. When the union reaffiliated with the CIO in 1954, it had 18,000 members. Tabb, "White Collar Union," 18.

57. *NV*, March 15, 1940, 5; Phillips, "The Labor Movement," 164; Executive Committee Notes, October 2, 1936, b1f1, *D65 papers*; Fennell, "Union's Inspiration," 7; Collette Hyman, *Staging Strikes: Workers' Theatre and the American Labor Movement* (Philadelphia: Temple University Press, 1997), 92; and "Investigation of Communism," 403, 439; Tabb, "White Collar Union," 203–205; Paley interview. For meeting complaints, *NV*, May 1937; and November 15, 1940, 4.

58. Alice Cook, *Union Democracy: Practice and Ideal* (Ithaca, N.Y.: Cornell University Press, 1963), 45. See also "Letters to the Editor," *NV*, November 15, 1940." Foner said Osman thought activity inhibited factionalism, *COHC*, 206.

59. Freeman, *Working-Class New York*, 72–95; Organizing Committee Notes, November 14, 1942, b57f2, *D65 papers*.

60. Hill argues this in his 1968 interview with Osman, 28–29; and Tabb, "White Collar Union," 159, 205; see also Phillips, "The Labor Movement," 80, 200.

61. "Executive Committee Notes," December 16, 1937, b1f2, *D65 papers*; and "Investigation of Communism," Testimony of Mr. Dale, 141.

62. Paley interview.

63. Letter from Sam Potash, *NV*, March 1, 1942; *NV*, August 30, 1942, 6; and Cole, "Union Camera Club," 54–55.

64. For distribution, October 1–7, 1942, and October 19–24, no year indicated (probably 1942), b57f2; "Woolworth Report," December 5, 1942, b57f2, *D65 papers* and *NV*, September 1938.

65. "General Stewards Meeting," October 30, 1941, b1f6; Woolworth Report October 10, 1942, b57f2, *D65 papers*; Phillips, "Labor Movement," 166; *NV*, August 20, 1944, 3; "*NV* Distribution," *NV*, December 1, 1941, 8; "Planning to Use *NV*," *NV*, August 20, 1944, 3; and "Next Stop Is Interstate," *NV*, November 12, 1944, 8.

66. "Report to Executive Committee," October 23, 1941, b1f6; and "Thomas Mooney Hall Association Notes," b67f21, 1946, *D65 papers*; Nelson Lichtenstein, *Labor's War at Home: The CIO in World War II* (New York: Cambridge University Press, 1982), 61–66; Steve Fraser, *Labor Will Rule*, 466–469. For reversion to the formula at WWII's end, see *NV*, July 22, 1945, 12–13; and *NV*, October 14, 1945, 1.

67. Neg. # 312, *D65 photos*. "Picketing for Pact" *NV*, May 15, 1940, 1. See also *NV*, December 1937; *NV*, December 1939, 2; *NV*, June 15, 1940, 2; *NV*, August 1940, 1; *NV*, September 15, 1940, 3; *NV*, January 15, 1941; and *NV*, March 15, 1941, 1.

68. *NV*, November 1, 1941, 3; and *NV*, February 15, 1941. Laura Katzman, "Ben Shahn's New York: Scenes from the Living Theater," in Deborah Martin Kao et al., *Ben Shahn's New York: The Photography of Modern Times* (New Haven, Conn.: Yale University Press, 2000), 16.

69. Osman interview, and Roth interview, 40–43.

70. *NV*, July 1, 1941, 1.

71. For a birds-eye view, see Peter Hales, *Silver Cities: The Photography of American Urbanization, 1839–1915* (Philadelphia: Temple University Press, 1984), 133–134; and Rudolph Arnheim, *Art and Visual Perception: A Psychology of the Creative Eye* (Berkeley: University of California Press, 1969), 269.

72. "Telling New York," *NV*, April 15, 1940, 1; and neg. # 309, *D65 photos*. Billy Collins, "The Death of the Hat," http://www.whysanity.net/creative/collins.html#hat, accessed September 9, 2009. See also *NV*, June 1, 1940, 3; *NV*, October 1, 1940, 1; *NV*, February 1, 1940, 1.

73. "Union Wide Mobilization," *NV*, June 1, 1941, 1; see also *NV*, September 1, 1941, 1. *New Voices* compositions were less abstract and modern than other radical photographers' work, for example that of the Artists' Union's *Art Front*. Deborah Martin Kao, "Ben Shahn and the Public Use of Art," in *Ben Shahn's New York*, 52.

74. Roth interview, 36; *NV*, October 15, 1940, 1; and neg. # 309, *D65 photos*.

75. "10,000 Members March," *NV*, August 15, 1941; "The Pickover Story," *NV*, July 29, 1951; *NV*, November 1939, 1; and February 1, 1941, 5; "Slugged," *NV*, February 15, 1940, 2; "Stabbed by Strikebreaker," *NV*, November 1939, 1.

76. "National Container Mass Demonstration," neg. # 600, February 1941, *D65 photos*.

77. On Strand, see Bezner, *Photography and Politics*, 22–23; and Paul Strand, "The Art Motive in Photography"; in Vicki Goldberg, *Photography in Print: Writings from 1816 to the Present* (Albuquerque: University of New Mexico Press, 1981), 276–294.

78. Roth interview, 8.

79. I examined periods with high union strike activity, including every *Steel Labor* from 1936 to 1950; every issue of the *AFL Auto Worker* from September 9, 1939, through June

1943; the *United Auto Worker* of the UAW from January of 1945 through June 1946; at the United Electrical Workers' *UE News* from January through June 1946; and the ILG's *Justice*, every issue from January through February 1938; the biweekly issue from January through March 1945; and then every third issue through December 1945, along with every third issue of the *Packinghouse Worker* from 1942 to 1950. *Steel Labor* and the *AFL Auto Worker* had little member involvement. The UAW, UE, and ILG papers showcased activism, and had a leftist politics and a focus on culture. Although not a systematic assessment, this range still allowed for comparison. *UE News* was especially strong on 1946 strike violence, as was the *Packinghouse Worker*; see "Thousands Walk in Picket's Funeral," April 30, 1948, 1, and "Pickets Scars Prove Kansas Police Violence," May 14, 1948, 4–5. Of twenty-two photographs in *Justice*'s January 1938 issue, over half were head shots, or shots identifying individuals within a group. Only three shots addressed strikes. In sheer numbers these photos matter less; they spoke less to activism.

80. "Wielding Clubs," *NV*, February 1, 1941. 5. Such polarizing visual rhetoric was common in the communist *Daily Worker (DW)*.

81. Phillips, "Labor Movement," 155. "Locked Out," *NV*, October 10, 1943, 5, and "Public Exposure," *NV*, June 25, 1944, 3, offer rare examples of the use of the formula when the corporation initiated aggressions. For static strike photos during the war: *NV*, September 12, 1943, 1; *NV*, April 25, 1943, 1; *NV*, March 15, 1942; and *NV*, September 3, 1944, 1.

82. *NV*, October 1, 1941, 1; *NV*, December 1, 1941, 2; *NV*, January 1, 1942, 1. For the resumption of strike photos in WWII's aftermath there were many stories, including *UV*, July 8, 1945, 3; *UV*, July 22, 1945, 12–13; *UV*, November 11, 1945, 1; the collage of strike photographs on January 20, 1946, 3; and *UV*, June 9, 1946, 24. Photo essays found on August 15, 1948, 12–13, and October 13, 1945, 12–13, respectively.

83. Neg. # 2191, 1945, *D65 photos*.

84. *UV*, January 15, 1941, 2; *NV*, August 1939, 1; *NV*, December 1, 1940, 1; *NV*, May 1, 1941, 3; *NV*, October 15, 1944, 1; *NV*, September 17, 1944, 6.

85. "Solidarity with Si-He-Go Strikers," *NV*, May 1, 1940.

86. "Uptown Minute Men," *NV*, September 26, 1943, 3.

87. "The Winner," *NV*, July 1940, 1.

88. Alan Trachtenberg suggests Hine's photos exhibit "sociality," they demand a relation of equality with the subject. *Reading American Photographs: Images as History, Mathew Brady to Walker Evans* (New York: Hill and Wang, 1989), 201–209. Walter Rosenblum, Naomi Rosenblum, and Alan Trachtenberg, *American and Lewis Hine: Photographs: 1904–1940* (New York: Aperture, 1977), 62.

89. "Sea of Upraised Hands," *NV*, February 15, 1941, 1. Neg. # 542 and neg. #526, February 14, 1941. See also negs. # 499–500, 549–566, 597–608, all February 1941, *D65 photos*.

90. Of many examples, see *NV*, July 1939, 9; *NV*, March 15, 1941, 1; *NV*, August 1940, 3; *NV*, September 1, 1941, 2; *NV*, January 17, 1943, 3; *NV*, October 10, 1943, 5; *NV*, September 17, 1944, 3; and *UV*, October 14, 1948, 12–13.

91. "Recreation Report to the Executive Board," December 10, 1941, b1f6, *D65 papers*.

92. *NV*, December 15, 1941, 8. Cover photo, *NV*, January 15, 1942, reprinted, August 2, 1942, 13.

93. "65 Unites Us—Americans All," *NV*, April 16, 1944, B-5.

94. "Sixth Regular Stewards Council Meeting," 26, b6f1, *65 papers*.

95. *NV*, April 16, 1944, B-5.

96. On the first woman member, see Fennell, "Union Inspiration," 17, 39 n. 80; "United Nations in a Local 65 Shop!" December 9, 1943, 9. Osman on the first black member, Interview, 9; and "During Working Hours," *NV*, March 1938. On gentiles, *NV*, March 14, 1943, 8.

97. For the AFL, see Phillips, "Labor Movement," 57. Fair discrimination, "Unemployment Committee Notes," b6f2. See also "Unemployment Committee Notes," b6f2, in *D65 papers*; and *NV*, April 25, 1943, 13; July 4, 1943, 8–9; and, May 28, 1944, 7. Baseball, see *NV*, May 15, 1940. For Stuyvesant Homes, see *UV*, January 14, 1951, January 28, 1951, and February 25, 1951; for Cicero mob, see *UV*, July 29, 1951; and NAACP, "Mr. Civil Rights at '65' Negro History Fete," *UV*, March 7, 1954.

98. See "Union Maid" on boycotting, *NV*, December 1937. Against rent hikes: *NV*, September 12, 1943, 5; *NV*, January 1938, 3; September 12, 1943, 5; September 26, 1943, 7; and September 3, 1944, 11. Elizabeth Faue, *Community of Suffering and Struggle: Women, Men and the Labor Movement in Minneapolis, 1915–1945* (Chapel Hill: University of North Carolina Press, 1991). Dana Frank, *Purchasing Power: Consumer Organizing, Gender and the Seattle Labor Movement, 1919–1929* (Cambridge: Cambridge University Press, 1994), 32, 248.

99. *NV*, May 28, 1944, 14–15; and *NV*, February 1939, 4; and September 3, 1944.

100. For the Conference on Women, see *NV*, February 15, 1942, 1, 12; "Girls 'Click,'" *NV*, February 28, 1945, 14; Roth interview, 11, 19.

101. Satellite headquarters, Phillips, "Labor Movement," 81–2, 110–111. For noncompliant firms, see Tabb, "White Collar Union," 123; and Osman interview, 16. Also *NV*, December 19, 1943, 5; *NV*, January 3, 1941, 10; *NV*, February 15, 1941, 3, and, *NV*, March 1, 1941, 7; *UV*, March 25, 1951.

102. *NV*, February 27, 1944, 8–9. Herbert Hill contrasted Local 65's inclusion with the ILG, Osman interview, 17–20. Union leaders diversified staff, to make them more "typically American," bringing in native-born Americans and new ethnicities. "Executive Board Meeting Notes," July 18, 1941, b1f6, *D65 papers*.

103. Cleve Robinson interview, *D65 orals*, *NV*, February 13 and February 27, 1944; *NV*, January 31, 1943; *NV*, June 25, 1944; *NV*, January 2, 1944, and *NV*, February 15, 1941, 3; *NV*, February 1, 1942, 9.

104. Tabb, "White Collar Union," 242; and neg. # 7273, October 28, 1950. Also neg. # 15582, December 1, 1956, *D65 photos*. For Easter Uprising celebration, see *UV*, May 2, 1954, M2. On Jewish and Italian festivals, see *NV*, October 27, 1944, 11; and *NV*, September 3, 1944, 9. On Irish anticolonialism, see *UV*, November, 1951; and *NV*, September 26, 1943, 7. *La Voz Hispana* was printed by 1948. For St. Patrick, *NV*, March 12, 1944, 8–9. For Negro history, *NV*, February 13, 1944, 3; NAACP, *UV*, March 7, 1953, 12; and Negro History, *UV*, February 8, 1953, M2.

105. Brooks, *As Steel Goes*, 18; and Eileen Boris, "You Wouldn't Want One of 'Em Dancing with Your Wife': Racialized Bodies on the Job in World War II," *American Quarterly* 50, no. 77 (March 1998): 77–108.

106. Phillips, "Labor Movement," 166; and Doswell, b6f2, *D65 orals*.

107. "Third Biennial Convention," May 30, 1948, in Tabb, "White Collar Union," 236; and *NV*, April 1, 1942, 4.

108. *NV*, November 4, 1951, M8.

109. Neg. # 1620, March 1, 1944, in *NV*, April 16, 1944.

110. For typing, *NV*, May 21, 1954; neg. # 155 82, December 1, 1956; *NV*, May 14, 1944, 16; and *UV*, April 15, 1953, M2. "A Cargo of Lovely Contenders for Union Voice Beauty Crown" includes black and white women, *UV*, May 9, 1948, 22; for Northern social segregation, see Barney Josephson with Terry Trilling Josephson, *Café Society: The Right Place for the Wrong People* (Urbana, Ill.: University of Illinois Press, 2009).

111. Nancy Quam-Wickham, "In Search of Labor's Culture," *Labor History* 39, no. 3 (1998): 329, argues that the ILG "segregated" women members into a special "Women's Division," and they were "prohibited from attending general membership meetings until the early war years." See also Phillips, "Labor Movement," 137–140. The ILG never allowed more than one woman on the executive board. Analiese Orleck, *Common Sense and a Little Fire: Women and Working-Class Politics in the United States, 1900–1965* (Chapel Hill: University of North Carolina Press, 1991), 172–173, 201; and Freeman, *Working-Class New York*, 45–47, on the ILG's lack of racial diversity, and n. 131.For black workers in steel, see Dennis Dickerson, *Out of the Crucible: Black Steelworkers in Western Pennsylvania, 1875–1980* (Albany: New York State University Press, 1986); Herbert Hill and James Jones, eds., *Race in America: The Struggle for Equality* (Madison: University of Wisconsin Press, 1993), 311; and Robert Zieger, *The CIO: 1935–1955* (Chapel Hill: University of North Carolina Press, 1995), 83, 152.

112. Guimond, *American Photography*, 172–173.

113. Mel Watkins, *On the Real Side: Laughing, Lying, and Signifying the Underground Tradition of African-American Humor that Transformed American Culture from Slavery to Richard Pryor* (New York: Simon and Schuster, 1994), 255, 258, 322.

114. *LIFE*, February 27, 1939; and August 9, 1937, cover, 50–52; and Guimond, *American Photography*, 156–161.

115. Bezner discusses Arthur Leipzig's firing from Hearst's International News Photos, *Photography and Politics*, 50–51, 97–98. For Eckstine, see *LIFE*, April 24, 1950, 101, interview with Martha Holmes, New York City, May 18, 1993, in John Loengard, *LIFE Photographers, What They Saw* (Boston: Little Brown, 1998), 207. For blood drives, see *NV*, October 10, 1943, 9; "Union Solidarity Spelled Out in Blood," *UV*, February 11, 1951, 4.

116. See *NV*, November 7, 1943, 11; *NV*, March 15, 1942, 9; and *UV*, March 9, 1948, 22.

117. "Bevy of Eye Fillers," *NV*, November 7, 1943, 11; *NV*, September 12, 1943, 5; and *NV*, April 30, 1944, 3; on complaints, *NV*, May 28, 1947.

118. Rickie Solinger, "The Smutty Side of *LIFE*: Picturing Babes as Icons of Gender Difference in the Early 1950's," in *Looking at LIFE Magazine*, edited by Erika Doss (Washington, D.C.: Smithsonian Institution Press, 2001), 201–219; Angel Kwollek-Folland, "Gender, Self, and Work in the Life Insurance Industry, 1880–1930," in *Work Engendered: Toward a New History of American Labor*, edited by Ava Baron (Ithaca, N.Y.: Cornell University Press, 1991), 168–190.

119. *Steel Labor*, April 28, 1944, 14; January 1945, 9; and January 22, 1943, 4. The *United Automobile Worker* also presented bikini-clad pinups. "Morale Builder," April 15, 1946, 6.

120. *NV*, December 20, 1942, 16; see also *NV*, January 3, 1943, 16.

121. Faue, *Community of Suffering*, 83–95; Barbara Melosh, *Engendering Culture, Manhood and Womanhood in New Deal Public Art and Theater* (Washington, D.C.: Smithsonian Institution Press, 1991).

122. Faue, *Community*, 99.

123. "Study and Play in the Organized Way": *CIO News*, May 6, 1939, quoted in *NV*, May 1939, 6; also *NV*, June 11, 1944, 10.

124. *UV*, April 15, 1953, M2.

125. "Club 65," Ibid.

126. Danton Walker, *Daily News*, September 26, 1949 in Foner, *COHC*, 190; "Introducing Club 65!" *NV*, May 14, 1944, 16.

127. *NV*, March 15, 1941, 5.

128. Osman interview, 18; and Dorothy Kuhn Oko, New York Public Library, "Library Services to Trade Unions," Press Release, February 1, 1954, b67f1, *D65 papers*.

129. Recreation Department Report, August 25, 1941, b1f6, *D65 papers*.

130. Ibid.; "Organizing Wholesale"; and Moe Foner, *Not For Bread Alone: A Memoir* (Ithaca, N.Y.: Cornell University Press, 2002), 26–31.

131. For singles, see "Meet the Members," *NV*, April 15, 1942; *NV*, January 1, 1941, 7; *NV*, August 1, 1943, 10; *NV*, September 17, 1945, 1; and *NV*, November 26, 1944, 6.

132. Francis Couvares, *The Remaking of Pittsburgh: Class and Culture in an Industrializing City, 1877–1919* (Albany: State University of New York Press, 1984); and Roy Rosenzweig, *Eight Hours for What We Will: Workers and Leisure in an Industrial City, 1870–1920* (New York: Cambridge University Press, 1983), 35–64. Liebman, *Jews and the Left*; Leviatin, *Followers on the Trail*; *NV*, August 16, 1942. Kathy Peiss, *Cheap Amusements: Working Women and Leisure in Turn of the Century New York* (Philadelphia: Temple University Press, 1986); and David Nasaw, *Going Out: The Rise and Fall of Public Amusements* (New York: Basic Books, 1993).

133. Leviatin, *Followers of the Trail*, 33–35. "Wholesale Mikado," *NV*, August 2, 1942, 8.

134. For Vaughn and Hine, *NV*, April 1, 1943; and *NV*, August 3, 1939, 6. For *Native Land*, see *NV*, May 10, 1942, 5; *NV*, June 20, 1943, 11. For movies, see *NV*, April 29, 1944, 11; and December 24, 1944, 10.

135. *NV*, March 1, 1940, 6.

136. "New Union Book Shop," June 29, 1944, neg. # 1865, *D65 photos*.

137. "Lindy-hopper," see "1941 Boat Ride," neg. # 690; and 1939 Boat ride, neg. # 229; the "mambo" shot from Spanish Fiesta, October 1949, neg. # 5648, the waltz, "Social Hall," neg. #116, October, 17, 1940; all *D65 photos*.

138. "1939 Boat Ride," neg. # 232, *D65 photos*; "Sol Leaves a Trail of Happy Memories . . . ," *NV*, August 2, 1942, 8.

139. *NV*, October 1939, back cover.

140. "Members Demand More Union Socials," *NV*, April 1, 1940, 6; "To a Community Party on Long Island," *UV*, July 12, 1953; *NV*, June 20, 1943, 11; *NV*, October 1, 1940, 4; *NV*, May 2, 1954; October 27, 1944, 11; and September 3, 1944, 9.

141. "A Tale of Two Night Clubs," *UV*, June 17, 1951, M8; and *NV*, October 1, 1940, 6.

142. David Nye, *Image Worlds: Corporate Identities at General Electric, 1890–1930* (Cambridge, Mass.: MIT Press, 1985), 93–111.

143. Orleck shows how leadership pioneered such programming while giving it short shrift. *Common Sense*, 172–180. Collette Hyman demonstrates the same in her examination of the ILG and Local 65 drama programs, *Staging Strikes*, 85–89, 93, and 102.

144. In 1938 there were only three photos of cultural activity in *Justice*. "Senator Wagner Says Swell Show," *Justice*; and February 1, 1945, 12.

145. For the *Nation* story, see *UV*, August 23, 1953, sec. 2, m-1.

146. "A Hearn Striker Talks to New York," *UV*, June 28, 1953, 16.

147. See also *UV*, May 31, 1953, 16; *UV*, June 14, 1954, cover; *UV*, June 14, 1953, M2; and *UV*, August 23, 1953, cover.

148. *UV*, June 14, 1953, m3; *UV*, September 6, 1953, M2–3; *UV*, July 12, 1953, cover; television, *UV*, May 31, 1953; bachelors, *UV*, February 15, 1948, 17. For scholarship on women and postwar labor, see Orleck, *Common Sense*, 253–288; George Lipsitz, *Rainbow at Midnight: Labor and Culture in the 1940s* (Urbana: University of Illinois Press, 1994), 46–57; and Dorothy Sue Cobble, "Drawing the Line: The Construction of a Gendered Workforce in the Food Service Industry," in *Work Engendered: Toward a New History of American Labor*, edited by Ava Baron (Ithaca, N.Y.: Cornell University Press, 1991), 216–242.

149. See *UV*, May 2, 1954, 16; and *UV*, January 28, 1954, 2.

150. For Local 65's repudiation of communism, and the resulting internal "bloodbath," see Foner, *COHC*, 196–206; New York papers red-baited Local 65 from 1936, *NV*, March 15, 1941, 3. In 1948 the union was investigated for "plugging" May Day parades, contributing to Henry Wallace's campaign and Osman's endorsement of the *Daily Worker*, "Investigation of Communism," 367–390, 400–445. On the 1952 arrests, see *UV*, April 20, 1952, 1–4, and m1–5; and Osman Interview, pt. 2, 2. On Taft-Hartley Votes, *UV*, August 1, 1948, 17.

151. Phillips, "Labor Movement," 15, 250–251. *Record*, June 6, 1954, 1; and *Record*, June 20, 1954, 6–7.

152. Roth interview, 68.

153. For attacks on the Photo League, see Bezner, *Photography and Politics*, 16–113; Bethune, "A Case of Overkill," and *History of Photography* 18, no. 2 (Summer 1994).

154. "Letters from our Fighting Forces," *NV*, July 4, 1943, 14.

Conclusion

1. Warren Susman, *Culture as History: The Transformation of American Society in the Twentieth Century* (New York: Pantheon Books, 1984), 164; Lawrence Levine, "The Folklore of Industrial Society: Popular Culture and Its Audiences," *American Historical Review* 97, no. 5 (December 1992): 1369–1399; and Morris Dickstein, *Dancing in the Dark: A Cultural History of the Great Depression* (New York: W. W. Norton, 2010).

2. McCausland quoted in *Photo Notes*, February 1941, 3. An analysis of scholarship addressing mid-century American photography in *American History and Life* from 1995 to 2005 found approximately 100 citations. Admittedly "unscientific," the record showed interesting gaps. There were more citations on war photography, the OWI, and art photography than on photojournalism. A quarter of the citations addressed the FSA or individual photographers. A scan of Project Muse replicated this finding, with a few additional articles on the photojournalist Arthur Fellig (Weegee).

3. *American History and Life* and *Project Muse* have few citations addressing organized labor or workers and photography, though one can assume that of the dozens of citations on the documentary, some address working Americans.

4. Susan Strasser, *Satisfaction Guaranteed: The Making of the American Mass Market* (New York: Pantheon Books, 1989), 102–106.

5. Lewis Hine, "Social Photography: How the Camera May Help in Social Uplift," *Proceedings, National Conference on Charities and Correction* (1909), in Alan Trachtenberg, *Classic Essays on Photography* (New Haven, Conn.: Leete's Island Books, 1980), 109–113; and Lewis Hine, *Men at Work: Photographic Studies of Men and Machines*, 2nd. ed. (New York: Dover Editions, 1977). James Guimond, *American Photography and the American Dream* (Chapel Hill: University of North Carolina Press, 1991), 57–98.

6. Leah Ollman, *Camera as Weapon: Worker Photography Between the Wars* (San Diego: Museum of Photographic Arts, 1991); and "The Photo League's Forgotten Past," *History of Photography* 18, no. 2 (Summer 1994): 154–158. Mary Warner Marien, *Photography: A Cultural History*, 2nd ed. (London: Lawrence King, 2006), 290.

7. Bourdieu and Luc Boltanksi, *Photography: A Middle-Brow Art*, translated by Shaun Whiteside (Stanford, Calif.: Stanford University Press, 1990). Don Slater, "Consuming Kodak," in *Family Snaps: The Meanings of Domestic Photography*, edited by Jo Spence and Patricia Holland (London: Virago Press, 1991), 49–59. Douglas Nickel, "The Snapshot: Some Notes," in *Snapshots: The Photography of Everyday Life* (San Francisco Museum of Art, 1998), 9–14.

8. Judith Modell and Charlee Brodsky, *A Town Without Steel: Envisioning Homestead* (Pittsburgh, Pa.: University of Pittsburgh Press, 1998), xv; Larry Peterson, "Producing Visual Traditions Among Workers: The Uses of Photography at Pullman," *International Labor and Working-Class History*, no. 42 (Fall 1992): 56, 61.

9. Ben Pearse, "The Labor Press," *Nation*, July 25, 1953, 71.

10. Ibid., 72–73; Les Orear, interview by author, tape recording, Chicago, Illinois, August 1, 2003; see also, Nathan Godfried, *WCLF, Chicago's Voice of Labor, 1926–1978* (Urbana: University of Illinois Press, 1997), 10–16; Sam Pizzigati and Fred Solowey, *The New Labor Press: Journalism for a Changing Union Movement* (Ithaca, N.Y.: Cornell University Press, 1992).

11. Richard Lindstrom, "'They All Believe They Are Undiscovered Mary Pickfords': Workers, Photography and Scientific Management," *Technology and Culture* 4, no. 1 (2000): 725–751; David Nye, *Image Worlds: Corporate Identities at General Electric* (Cambridge, Mass.: MIT Press, 1985), 59–92; and Peterson, "Producing Visual Traditions," 40–69.

12. Nye, *Image Worlds*, 82–92 and 148–160; Peterson, "Producing Visual Tradition," 41–42; on Hine, see Guimond, *American Photography*, 92; and Kevin S. Reilly "Dilettantes at the Gate: Fortune Magazine and the Cultural Politics of Business Journalism in the 1930s," *Business and Economic History* 28, no. 2 (Winter 1999): 213–222.

13. Elspeth Brown, *The Corporate Eye: Photography and the Rationalization of American Commercial Culture* (Baltimore: Johns Hopkins University Press, 2005), 130–149.

14. Peterson, "Producing Visual Tradition," 47; and Roland Marchand, *Creating the Corporate Soul: The Rise of Public Relations and Corporate Imagery in American Big Business* (Berkeley: University of California Press, 1998), 238–242.

15. Nye, *Image Worlds*, 125–134; Marchand, *Creating the Corporate Soul*, 245–248, 257–261.

16. Peter Seixas, "Lewis Hine: From 'Social to 'Interpretive' Photographer," *American Quarterly* 39, no. 3 (Autumn 1987): 381–382; *Photo Notes* (January 1939): 6.

17. "The American Workingman," *Fortune* (August 1931): 54–69.

18. The *Saturday Evening Post* never stopped condemning organized labor, but other mass-circulation magazines like *Collier's* forswore its enchantment with winter ski slopes and middle-class leisure and covered labor's organization during the war years.

19. Gompers's death in 1924 was covered by most mass magazines: *Collier's, New Republic,* and the *Literary Digest.* See also J. Spargo, "Passing of Gompers and the Future of Organized Labor," *North American Review* 221 (March 1925): 405–416; "Will the Death of Samuel Gompers Split Labor?" *Literary Digest,* December 27, 1924, 10–11. On Green see "Green vs. Red in the A. F. of L," *Literary Digest,* October 24, 1925, 12–13; and "Labor's Chief: William Green," *Review of Reviews,* November 1933, 21–23.

20. James Truslow Adams first used the term in his *The American Epic;* quote from "What of 'the American Dream'?" *New York Times,* May 14, 1933; and Michael Schudson, "American Dreams," *American Literary History* 16, no. 3 (September 2004): 566–573. James Guimond's *American Photography,* 12–16, informs my analysis.

21. Marchand, *Advertising,* 123–126; Henry Kraus, *The Many and the Few: A Chronicle of the Dynamic Auto Workers,* 2nd ed. (Urbana: University of Illinois Press, 1985), 6; Elizabeth McCausland, *Photo Notes* (May 1940): 4.

22. "The Convenient Forgotten," *Women in Steel* 6 (March 1937): 3, CHS.

23. *New Voices* did one project documenting workers' homes, almost all of which were made to look like the suburban ideal, with family joined in a spacious living room with nice furniture and television sets. Photos depicting privations were not printed. *New Voices,* May 12, 1946. Orear interview. A similar argument is made by Tami Friedman, "'Acute Depression . . . in . . . the Age of Plenty': Capital Migration, Economic Dislocation, and the Missing Social Contract of the 1950s," *Labor* 8, no. 4 (Winter 2011): 89–113.

24. Orear interview; Paul Frymer, *Black and Blue: African Americans, Labor, and the Decline of the Democratic Party* (Princeton, N.J.: Princeton University Press, 2008), 1. Alice Kessler-Harris, *Out-to-Work: A History of Wage-Earning Women in the United States* (New York: Oxford University Press, 1982), 276–301.

25. Elizabeth Faue, *Community of Suffering and Struggle: Women, Men and the Labor Movement in Minneapolis, 1915–1945* (Chapel Hill: University of North Carolina Press, 1991); Angel Kwollek-Folland, "Gender, Self, and Work in the Life Insurance Industry, 1880–1930," in *Work Engendered: Toward a New History of American Labor,* edited by Ava Baron (Ithaca, N.Y.: Cornell University Press, 1991), 168–190; Patricia Cooper, "The Faces of Gender: Sex Segregation and Work Relations at Philco, 1928–1938," in Baron, *Work Engendered,* 320–330.

26. Patterson, "Embryo of a Steel Worker," 160–161, b9f6, and his interview by Ed Sadlowski, b10f7, in Patterson Papers, CHS. *LIFE,* March 8, 1937, 16.

27. Kraus, *The Many and the Few,* 116–120.

28. Jack Price, *News Pictures* (New York: Round Table Press, 1937), 34–35.

29. Elizabeth Fones-Wolf, *Selling Free Enterprise: The Business Assault on Labor and Liberalism* (Urbana: University of Illinois Press, 1991), 1–10, and 32–57; Howell John Harris, *The Right to Manage: Industrial Relations Policies of American Business in the 1940's* (Madison: University of Wisconsin Press, 1982), 39–40, 192–199. Richard Tedlow, *Keeping the Corporate Image, Public Relations and Business* (Greenwich, Conn.: JAI Press, 1979), 59–105. Stuart Ewen, *PR!: A Social History of Spin* (New York: Basic Books, 1996), 307–316. More recent scholars are pushing back this periodization into the 1930s, see Kim Phillips-Fein's *Invisible Hands: The Making of the Conservative*

Movement from the New Deal to Reagan (New York: W. W. Norton, 2009); and Jenni-
fer Klein and Nancy MacClean's essays in "Scholarly Controversy: Rethinking the
Place of the New Deal in History," in *International Labor and Working Class History* 74
(Fall 2008): 42–55.

30. Lizabeth Cohen, *Making a New Deal: Industrial Workers in Chicago, 1919–1939* (Cam-
bridge: Cambridge University Press, 1990), 324–333, 341–347; and Michael Denning,
The Cultural Front: The Laboring of American Culture in the Twentieth Century (New
York: Verso, 1997), xvi–xvii.

31. Edward Levinson, *Labor on the March*, with an introduction by Robert Zieger (1938;
Ithaca, N.Y.: ILR Press, 1995), ix–xvi.

32. On Childs, see *New York Times*, April 19, 1988; on Galarza, see Denning, *Cultural Front*.
I have found no additional information on Bobbitt or Pollatsek. "Labor's Challenge,"
Photo History 1, July 2, 1937. *Photo History* ran from April 1937 to 1938.

33. *Friday* began publication in March 1940 and ended publication in September 1941.

34. For *PM*'s interest in labor, see Paul Milkman, *PM: A New Deal in Journalism: 1940–1948*
(New Brunswick, N.J.: Rutgers University Press, 1997), 108, 114, 116, 125, 129, 131–135, 138–
145; and Roy Hoopes, *Ralph Ingersoll: A Biography* (New York: Atheneum, 1985). Arthur
Leipzig, interview by author, audio recording, Sea Cliff, New York, January 5, 2010.

35. Anthony Lee and Richard Meyer, *Weegee and Naked City* (Berkeley: University of Cal-
ifornia Press, 2008), 106.

36. *Photo Notes*, March/April 1940, 1.

37. Guimond discusses this in *American Photography*, 141. "Senator on Warpath," *LIFE*,
June 7, 1948, 40–41, and "FSA Attacked," *Photo Notes*, Fall 1948, 4–7.

38. *Photo Notes*, August 1938, 1.

39. *Photo Notes*, March 1940; November 1941, 2; August 1942, 1; December 1943, 2.

40. *Photo Notes*, September, 1940, 6, and January 1948; Scott Allen Nollen, *Paul
Robeson, Film Pioneer* (Jefferson, N.C.: McFarland, 2010), 153; Maren Stange,
ed., *Paul Strand: Essays on His Life and Work* (Millerton, N.Y.: Aperture Press,
1990), 138–147, 156–157.

41. Jack Levine telegram, *Photo Notes*, January 1948, 4; Russell Miller, *Magnum: Fifty Years
at the Front Line of History* (New York: Grove Press, 1997), 127; Lili Corbus Bezner,
Photography and Politics in America: From the New Deal into the Cold War (Baltimore:
Johns Hopkins Press, 1999), 16–113; Abigail Solomon-Godeau, *Photography at the
Dock: Essays on Photographic History, Institutions, and Practices* (Minneapolis: Univer-
sity of Minnesota, 1991), 76–84; and Christopher Phillips, "The Judgment Seat of
Photography," in *The Contest of Meaning: Critical Histories of Photography*, edited by
Richard Bolton (Cambridge, Mass: MIT Press, 1993), 15–47.

42. Aaron Brenner, Benjamin Day, and Immanuel Ness, *The Encyclopedia of Strikes in
American History* (Armonk, N.Y.: M. E. Sharpe, 2009), 216–238; Nelson Lichtenstein's
Labor's War at Home: The CIO in World War II (Cambridge: Cambridge University
Press, 1982), 79–81, 233; David Brody, *Workers in Industrial America: Essays on the 20th
Century Struggle* (New York: Oxford University Press, 1980), 173–192.

43. Eileen Boris, "You Wouldn't Want One of 'Em Dancing with Your Wife: Racialized
Bodies on the Job in WWII," *American Quarterly* 50, no. 1 (March 1988): 77–98; Robert
Korstad and Nelson Lichtenstein, "Opportunities Found and Lost: Labor, Radicals,
and the Early Civil Rights Movement," *Journal of American History* 75 (December

1988): 786–811; Ellen Schreker, "McCarthyism's Ghosts: Anticommunism and Ameri-
can Labor," *New Labor Forum* (Spring/Summer 1999): 7–17.

44. Excellent syntheses to these arguments include Gary Gerstle and Steve Fraser, *The Rise
and Fall of the New World Order* (Princeton, N.J.: Princeton University Press, 1989);
Nelson Lichtenstein, *State of the Union: A Century of American Labor* (Princeton, N.J.:
Princeton University Press, 2002); Melvyn Dubofsky, *The State and Labor in Modern
America* (Chapel Hill: University of North Carolina Press, 1994); Robert Zieger, *The
CIO: 1935–1955* (Chapel Hill: University of North Carolina Press, 1995); and Jennifer
Klein, *For All These Rights: Business, Labor and the Shaping of America's Public-Private
Welfare State* (Princeton, N.J.: Princeton University Press, 2003).

45. Jack Metzgar, *Striking Steel: Solidarity Remembered* (Philadelphia: Temple University
Press, 2000), 209.

{ BIBLIOGRAPHY }

Published Primary Sources

ARTICLES AND BOOKS

Bernays, Edward. "The Engineering of Consent." *Annals of the American Academy of Political and Social Sciences* 250 (March 1947): 113–120.

DeCaux, Len. *Labor Radical: From the Wobblies to the CIO*. Boston: Beacon Press, 1970.

Erickson, Ethel. "Women's Employment in the Making of Steel, 1943." *Bulletin of the Women's Bureau*, nos. 192–195 (1944).

Hardman, J. B. S. *American Labor Dynamics*. New York: Harcourt Brace, 1928.

———, and Neufeld, Maurice. *The House of Labor: Internal Operations of American Unions*. New York: Prentice Hall, 1951.

Hicks, Wilson. *Words and Pictures: An Introduction to Photojournalism*. New York: Harper and Row, 1952.

Hine, Lewis. "Social Photography: How the Camera May Help in Social Uplift." *Proceedings, National Conference of Charities and Corrections*, 1909. In *Classic Essays on Photography*, edited by Alan Trachtenberg, 109–113. New Haven, Conn.: Leete's Island Books, 1980.

Holmes, Oliver Wendell. "The Stereoscope and the Stereograph," *Atlantic Monthly*, June 1859, 738–747.

Interchurch World Movement. *Public Opinion and the Steel Strike: Supplementary Reports of the Investigators to the Commission of Inquiry, The Interchurch World Movement*. New York: Harcourt Brace, 1921.

Levinson, Edward. *I Break Strikes: The Technique of Pearl L. Berghoff*. New York: R. M. McBride, 1935.

———. *Labor on the March*. With an introduction by Robert Zieger. Ithaca, N.Y.: ILR Press, 1995. First published 1938.

Lynd, Alice, and Staughton Lynd, eds. *Rank and File: Personal Histories by Working Class Organizers* Boston: Beacon Press, 1973.

Price, Jack. *News Pictures*. New York: Round Table Press, 1937.

Rothstein, Arthur. *Photojournalism*. New York: American Photographic, 1956.

Vitray, Laura, John Mills, and Roscoe Ellard. *Pictorial Journalism*. New York: McGraw-Hill, 1939.

NEWSPAPERS AND PERIODICALS

Advance
Chicago Daily News
Chicago Tribune

CIO News
Collier's
Daily Calumet
Justice
LIFE
LOOK
Mid-Week Pictorial
Newsweek
New Voices
New York Daily News
New York Times
Photo Notes
Saturday Evening Post
Steel Labor
UE News
United Auto Worker

Manuscript Sources and Archives

Archives of Labor and Urban Affairs, Wayne State University, Detroit, Michigan
 Arthur Osman Interview
Catholic University of America, Washington, D.C.
 CIO Central Correspondence Files
 CIO National and International Union Papers
 Philip Murray Papers
Chicago Historical Society, Chicago, Illinois
 District 31 Papers of the United Steelworkers of America
 Louis Jacques Papers
 George Patterson Papers
Derry Township Historical Society, Hershey, Pennsylvania
 Strike Scrapbooks
Grinberg Film Library, Chatsworth, California
 Paramount Newsreels
The Hagley Museum and Library, Wilmington, Delaware
 American Iron and Steel Institute Papers
 National Association of Manufacturers Papers
 National Industrial Information Council Papers
The Hershey Community Archives, Hershey, Pennsylvania
 William Crouse Papers
 Hershey Chocolate Company Papers
 Hershey Estates Papers
 Ezra Hershey Papers
 Milton Hershey Papers
 Oral Histories
 Scrapbooks
 John Sollenberger Papers

Alexander Stoddard Papers

John Zoll Papers

Historical Collections and Labor Archives, Pennsylvania State University, University Park, Pennsylvania

Ignazio Romanucci Interview

Warren Plebani and Stearl Sponaugle Interview

The National Archives, Washington, D.C., and College Park, Maryland

Motion Picture, Sound and Video Branch

Records of the U.S. Senate, Robert M. La Follette Committee Files

Rare Books and Manuscript Library, Columbia University, New York, New York

Columbia Oral History Center

Robert F. Wagner Labor Archives, Tamiment Library, New York University, New York, New York

District 65, United Automobile, Aircraft and Vehicle Workers of America, Oral Histories, Papers, and Non-Print Collections

J. B. S. Hardman Papers

Published Secondary Sources

Adatto, Kiku. *Picture Perfect: Life in the Age of the Photo Op*. Princeton, N.J.: Princeton University Press, 2008.

Auerbach, Jerold. *Labor and Liberty: The La Follette Committee and the New Deal*. Indianapolis: Bobbs-Merrill, 1966.

Baron, Ava, ed. *Work Engendered: Toward a New History of American Labor*. Ithaca, N.Y.: Cornell University Press, 1991.

Baughman, James. *Henry R. Luce and the Rise of the American News Media*. Boston: Twayne, 1987.

Bernstein, Irving. *The Turbulent Years: A History of the American Worker, 1933–1941*. Boston: Houghton Mifflin, 1970.

Bezner, Lili Corbus. *Photography and Politics in America: From the New Deal into the Cold War*. Baltimore: Johns Hopkins Press, 1999.

Brennan, Bonnie, and Hardt, Hanno. *Picturing the Past: Media, History and Photography*. Urbana: University of Illinois Press, 1999.

Brinkley, Alan. *The Publisher: Henry Luce and His American Century*. New York: Alfred Knopf, 2010.

Brody, David. *Workers in Industrial America: Essays on the 20th Century Struggle*. New York: Oxford University Press, 1980.

Brown, Elspeth. *The Corporate Eye: Photography and the Rationalization of American Commercial Culture*. Baltimore: Johns Hopkins University Press, 2005.

Brown, Joshua. *Beyond the Lines: Pictorial Reporting, Everyday Life, and the Crisis of Gilded Age America*. Berkeley: University of California Press, 2002.

Carlebach, Michael. *American Photojournalism Comes of Age*. Washington, D.C.: Smithsonian Institution Press, 1997.

———. *The Origins of Photojournalism in America*. Washington, D.C.: Smithsonian Institution Press, 1992.

Clark, Paul, Peter Gottlieb, and Donald Kennedy. *Forging a Union of Steel: Phillip Murray, SWOC and the United Steelworkers.* Ithaca, N.Y.: ILR Press, 1987.

Cohen, Lizabeth. *A Consumer's Republic: The Politics of Mass Consumption in Postwar America.* New York: Alfred A. Knopf, 2003.

———. *Making a New Deal: Industrial Workers in Chicago, 1919–1939.* Cambridge: Cambridge University Press, 1990.

Dennis, Michael. *The Memorial Day Massacre and the Movement to Industrial Democracy.* New York: Palgrave Macmillan, 2010.

Denning, Michael. *The Cultural Front: The Laboring of American Culture in the Twentieth Century.* New York: Verso, 1997.

Doss, Erika, ed. *Looking at LIFE.* Washington, D.C.: Smithsonian Institution Press, 2001.

Ewen, Stuart. *PR! A Social History of Spin.* New York: Basic Books, 1996.

Faue, Elizabeth. *Community of Suffering and Struggle: Women, Men and the Labor Movement in Minneapolis, 1915–1945.* Chapel Hill: University of North Carolina Press, 1991.

Fones-Wolf, Elizabeth. *Selling Free Enterprise: The Business Assault on Labor and Liberalism.* Urbana: University of Illinois Press, 1991.

Fraser, Steven. *Labor Will Rule: Sidney Hillman and the Rise of American Labor.* Ithaca, N.Y.: Cornell University Press, 1991.

Freeman, Joshua. *Working-Class New York: Life and Labor Since World War II.* New York: New Press, 2000.

Galenson, Walter. *The CIO Challenge to the AFL: A History of the American Labor Movement, 1935–1941.* Cambridge, Mass.: Harvard University Press, 1960.

Gerstle, Gary. *Working Class Americanism: The Politics of Labor in a Textile City, 1914–1960.* Cambridge: Cambridge University Press, 1989.

Gerstle, Gary, and Fraser, Steve. *The Rise and Fall of the New World Order.* Princeton, N.J.: Princeton University Press, 1989.

Guimond, James. *American Photography and the American Dream.* Chapel Hill: University of North Carolina Press, 1991.

Hales, Peter Bacon. *Silver Cities: The Photography of American Urbanization, 1839–1915.* Revised edition. Albuquerque: University of New Mexico Press, 2006.

Harris, Howell John. *The Right to Manage: Industrial Relations Policies of American Business in the 1940s.* Madison: University of Wisconsin Press, 1982.

Johnston, Patricia. *Real Fantasies: Edward Steichen's Advertising Photography.* Berkeley: University of California Press, 1997.

Kammen, Michael. *American Culture, American Tastes: Social Change and the Twentieth Century.* New York: Alfred A. Knopf Press, 1999.

Klein, Jennifer. *For All These Rights: Business, Labor, and the Shaping of America's Public-Private Welfare State.* Princeton, N.J.: Princeton University Press, 2003.

Kozol, Wendy. *LIFE's America: Family and Nation in Postwar Photojournalism.* Philadelphia: Temple University Press, 1994.

Lichtenstein, Nelson. *Labor's War at Home: The CIO in World War II.* Cambridge: Cambridge University Press, 1982.

———. *State of the Union: A Century of American Labor.* Princeton, N.J.: Princeton University Press, 2002.

Lipsitz, George. *Rainbow at Midnight: Labor and Culture in the 1940s.* Urbana: University of Illinois Press, 1994.

Marchand, Roland. *Advertising the American Dream: Making Way for Modernity, 1920–1940*. Berkeley: University of California Press, 1985.

———. *Creating the Corporate Soul: The Rise of Public Relations and Corporate Imagery in American Big Business*. Berkeley: University of California Press, 1998.

Melosh, Barbara. *Engendering Culture, Manhood and Womanhood in New Deal Public Art and Theater*. Washington, D.C.: Smithsonian Institution Press, 1991.

Metzgar, Jack. *Striking Steel: Solidarity Remembered*. Philadelphia: Temple University Press, 2000.

Milkman, Paul. *PM: A New Deal in Journalism, 1940–1948*. New Brunswick, N.J.: Rutgers University Press, 1997.

Montgomery, David. *The Fall of the House of Labor: The Workplace, the State, and American Labor Activism*. New York: Cambridge University Press, 1987.

Nye, David. *Image Worlds: Corporate Identities at General Electric, 1890–1930*. Cambridge, Mass.: MIT Press, 1985.

Ollman, Leah. *Camera as Weapon: Worker Photography between the Wars*. San Diego: Museum of Photographic Arts, 1991.

Orleck, Annelise. *Common Sense and a Little Fire: Women and Working-Class Society in the United States, 1900–1965*. Chapel Hill: University of North Carolina Press, 1995.

Orvell, Miles. *The Real Thing: Imitation and Authenticity in American Culture, 1880–1940*. Chapel Hill: University of North Carolina Press, 1989.

Rabinowitz, Paula. *They Must Be Represented: The Politics of Documentary*. New York: Verso Press, 1994.

Ross, Steven. *Working-Class Hollywood: Silent Film and the Shaping of Class in America*. Princeton, N.J.: Princeton University Press, 1998.

Sampsell-Willman, Kate. *Lewis Hine as Social Critic*. Jackson, Miss.: University Press of Mississippi, 2009.

Schudson, Michael. *Discovering the News: A Social History of American Newspapers*. New York: Basic Books, 1978.

Stange, Maren. *"Symbols of Ideal Life": Social Documentary Photography in America, 1890–1950*. Cambridge: Cambridge University Press, 1989.

Stott, William. *Documentary Expression and Thirties America*. New York: Oxford University Press, 1973.

Susman, Warren. *Culture as History: The Transformation of American Society in the Twentieth Century*. New York: Pantheon Books, 1973.

Tagg, Jonathon. *The Burden of Representation: Essays on Photographies and Histories*. Amherst: University of Massachusetts Press, 1988.

Tedlow, Richard. *Keeping the Corporate Image, Public Relations and Business*. Greenwich, Conn.: JAI Press, 1979.

Trachtenberg, Alan. *Reading American Photographs: Images as History, Matthew Brady to Walker Evans*. New York: Noonday Press, 1989.

Zieger, Robert. *The CIO, 1935–1955*. Chapel Hill: University of North Carolina Press, 1995.

Zinn, Howard, Frank, Dana Frank, and Kelley, Robin D. G. *Three Strikes: Miners, Musicians, Salesgirls, and the Fighting Spirit of Labor's Last Century*. Boston: Beacon Press, 2001.

Zurier, Rebecca. *Art for the Masses: A Radical Magazine and Its Graphics*. New Haven, Conn.: Yale University Press, 1985.

Articles

Boris, Eileen. "Desirable Dress: Rosies, Sky Girls, and the Politics of Appearance." *International Labor and Working-Class History* 69 (Spring 2006): 123–142.

———. "You Wouldn't Want One of 'Em Dancing with Your Wife': Racialized Bodies on the Job in World War II." *American Quarterly* 50, no. 77 (March 1998): 77–108.

Denning, Michael. "The End of Mass Culture." *International Labor and Working-Class History*. 37 (Spring 1990): 4–34.

Dubofsky, Melvyn. "Not so 'Turbulent Years': Another Look at American 1930s." *American Studies* 24 (1979): 5–20.

History of Photography 18, no. 2 (special issue on the Photo League, Summer 1994): 154–184.

Kelly, Robin. "Notes on Deconstructing 'the Folk.'" *American Historical Review* 97, no. 5 (December 1992): 1400–1408.

Leab, Daniel. "The Memorial Day Massacre." *Midcontinent American Studies Journal* 8, no. 2 (Fall 1967): 3–17.

Lears, T. Jackson. "Making Fun of Popular Culture." *American Historical Review* 97, no. 5 (December 1992): 1416–1426.

Levine, Lawrence. "The Folklore of Industrial Society, Popular Culture and Its Audiences." *American Historical Review* 97, no. 5 (December 1992): 1379–1393, 1427–14330.

Nelson, Daniel. "Origins of the Sit-Down Era: Worker Militancy and Innovation in the Rubber Industry, 1934–1938." *Labor History* (1982): 198–225.

Peterson, Larry. "Producing Visual Traditions among Workers: The Uses of Photography at Pullman," *International Labor and Working-Class History* no. 42 (Fall 1992): 40–69.

Sofchalk, Donald. "The Chicago Memorial Day Incident: An Episode of Mass Action." *Labor History* 6, no. 1 (Winter 1965), 3–43.

Squiers, Carol. "Looking at LIFE." *Artforum* 20, no. 4 (December 1981): 59–66.

Unpublished Secondary Sources

DISSERTATIONS

Bork, William Hal. 1975. "The Memorial Day 'Massacre' of 1937 and Its Significance in the Unionization of the Republic Steel Corporation." Masters thesis, University of Illinois, Champaign-Urbana.

Kopolsky, Marc Steven. 1986. "Remington Rand Workers in the Tonawandas of Western New York, 1927–1956: A History of the Mohawk Valley Formula." Ph.D. diss., State University of New York, Buffalo.

Phillips, Lisa Ann Wunderlich. 2002. "The Labor Movement and Black Economic Equality in New York City District 65, 1934–1954." Ph.D. diss., Rutgers University.

Printed in the USA/Agawam, MA
December 17, 2012

571282.040